AMERICAN IMPRESSIONISM AND REALISM

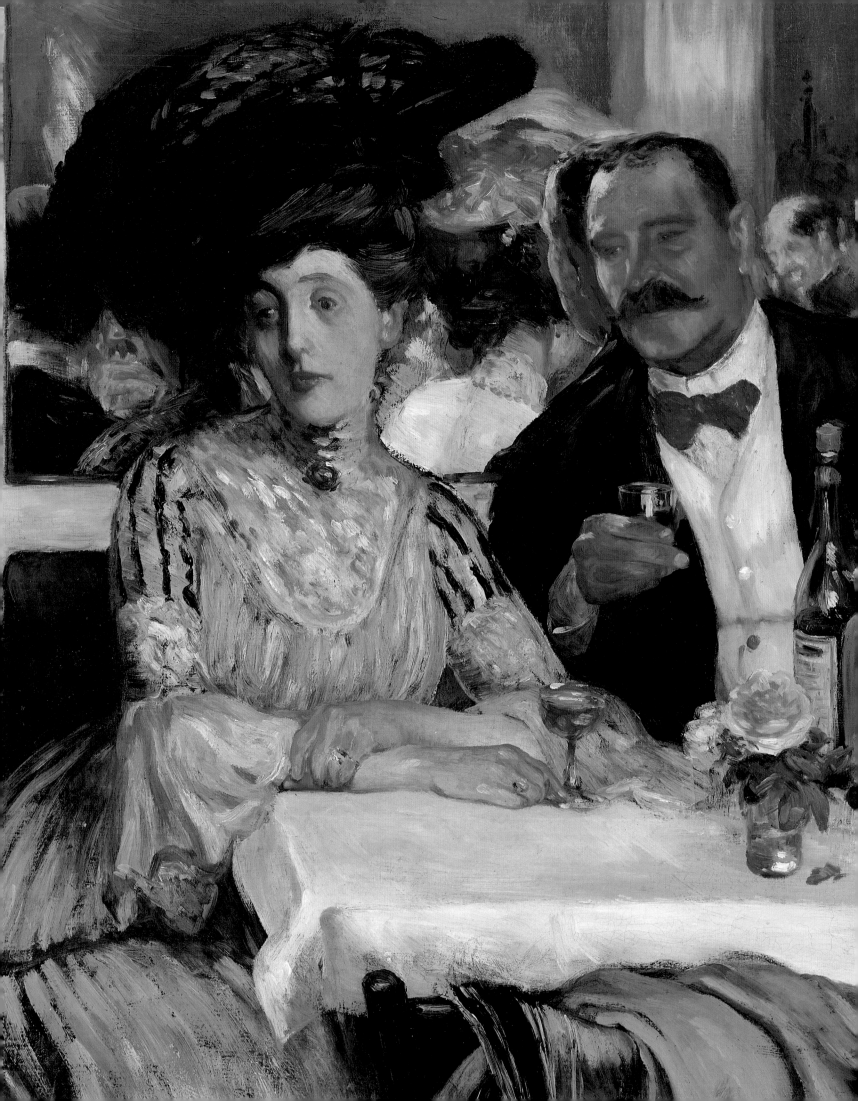

AMERICAN IMPRESSIONISM AND REALISM

The Painting of Modern Life, 1885–1915

H. BARBARA WEINBERG

DOREEN BOLGER

DAVID PARK CURRY

with the assistance of N. Mishoe Brennecke

The Metropolitan Museum of Art, New York

Distributed by Harry N. Abrams, Inc., New York

This publication is issued in conjunction with the exhibition *American Impressionism and Realism: The Painting of Modern Life, 1885–1915*, organized by The Metropolitan Museum of Art, New York, and the Amon Carter Museum, Fort Worth, and held at The Metropolitan Museum of Art from May 10 to July 24, 1994; the Amon Carter Museum from August 21 to October 30, 1994; The Denver Art Museum from December 3, 1994, to February 5, 1995; and the Los Angeles County Museum of Art from March 12 to May 14, 1995.

The exhibition is made possible by Alamo Rent A Car.

Published by The Metropolitan Museum of Art, New York
Copyright © 1994 The Metropolitan Museum of Art, New York

John P. O'Neill, Editor in Chief
Carol Fuerstein, Editor
Malcolm Grear Designers, Inc., Design
Susan Chun and Gwen Roginsky, Production

New photography at the Metropolitan Museum by the Photograph Studio,
The Metropolitan Museum of Art, New York
Set in Sabon by U.S. Lithograph, typographers, New York
Separations by Arnoldo Mondadori, S.p.A., Verona, Italy, and Professional Graphics, Rockford, Illinois
Printed and bound by Arnoldo Mondadori. S.p.A., Verona, Italy

Jacket/Cover Illustration
Detail, fig. 100, Chase, *At the Seaside*, ca. 1892

Frontispiece
Detail, fig. 207, Glackens, *Chez Mouquin*, 1905

Library of Congress Cataloging in Publication Data

Weinberg, H. Barbara (Helene Barbara).
 American impressionism and realism : the painting of modern life, 1885–1915 /
 H. Barbara Weinberg, Doreen Bolger, and David Park Curry.
 p. cm.
 Exhibition catalog.
 Includes bibliographical references and index.
 ISBN 0-87099-700-9.—ISBN 0-87099-701-7 (pbk.).—ISBN 0-8109-6437-6
(Abrams)
 1. Impressionism (Art)—United States—Exhibitions. 2. Painting,
American—Exhibitions. 3. Painting, Modern—19th century—United
States—Exhibitions. 4. Painting, Modern—20th century—United States—
Exhibitions. 5. Realism in art— United States—Exhibitions.
I. Bolger, Doreen. II. Curry, David Park.
III. Metropolitan Museum of Art (New York, N.Y.) IV. Title.
ND210.5.I4W456 1994
759.13'09'0340747471—dc20 94-2762
 CIP

CONTENTS

DIRECTORS' FOREWORD

American Impressionism and Realism: The Painting of Modern Life, 1885–1915 brings together the appealing works of two generations of American painters and presents them from a fresh point of view. The American Impressionists and Realists have been categorized as separate or even opposing groups, but, in fact, they shared significant experiences and goals—notably Parisian training, an enthusiasm for modern French painting, and a desire to translate these sources into a peculiarly American idiom. The continuities between these two groups are more impressive and the contrasts more subtle than generally perceived, while the relationships between their paintings and the actualities of the period in which they worked are much more complicated than previously assumed. To highlight these connections and complexities, the works in the exhibition are arranged not by artist or by chronology but by broad subject categories: the country, the city, and the home. This thematic organization offers avenues for rich and detailed interpretation, which we trust will bring to life the era that inspired the creation of these paintings and also suggest the dual process of transcription and transformation that the artists adopted.

The turn of the last century was a time of unprecedented political, economic, and social change. Industrialization and its concomitant urbanization irrevocably altered where and how people lived and worked. Members of the growing and increasingly powerful middle class availed themselves of new educational and professional opportunities. Innovations in the workplace redefined the family and the accepted roles of men and women, created and began to meet the need for leisure and recreation, and engendered an abundance that fostered consumerism. Scientific inquiry revised understanding of the natural world, challenging many established religious beliefs. People were acutely aware that they were living in a new age, and modernity became a key concept in their definition of themselves and their times. The American painters who concern us here, like the French Impressionists who inspired them, took up Charles Baudelaire's mandate, posited in his essay "The Painting of Modern Life" in 1863, that modernity must accompany true beauty in painting. In their dazzling sunlit landscapes, bustling city views, and glimpses of the domestic scene, the American Impressionists and Realists

became Baudelairean painters of modern life yet also expressed the nationalism, optimism, euphemism, and nostalgia that typified the American response to the exciting and daunting developments of the new era.

American Impressionism and Realism: The Painting of Modern Life, 1885–1915 results from the collaboration of H. Barbara Weinberg, Curator of American Paintings and Sculpture at The Metropolitan Museum of Art, New York, Doreen Bolger, Curator of Paintings and Sculpture at the Amon Carter Museum, Fort Worth, and David Park Curry, Curator of American Arts at the Virginia Museum of Fine Arts, Richmond, with the assistance of N. Mishoe Brennecke, Research Associate at the Metropolitan Museum. The generosity of the many public and private lenders who have parted with treasured works for the exhibition was indispensable. Alamo Rent A Car provided the substantial support that makes this exhibition available to appreciative audiences nationwide. For this inspired sponsorship, part of the corporation's program Alamo Presents the Art of America, we are deeply grateful.

PHILIPPE DE MONTEBELLO
Director
The Metropolitan Museum of Art

JAN KEENE MUHLERT
Director
Amon Carter Museum

SPONSOR'S STATEMENT

At the turn of the last century the American spirit was as diverse, energetic, and imaginative as it is today. Americans took on the challenges of the modern world then as they do now. The painters of modern life represented in the current exhibition vigorously portrayed the society that Americans confronted, interpreting both the pastoral scene and the industrialization and urbanization of the United States; they just as vigorously pursued new developments in the form of the visual arts, thereby enhancing the quality of our culture. *American Impressionism and Realism: The Painting of Modern Life, 1885–1915* relights the street lamps of the turn of the century and illuminates the world of the people who lived and worked in the cities and enjoyed the nearby country. The exhibition reveals a nation in the grip of monumental change.

Only The Metropolitan Museum of Art could envision and produce such a grand celebration of America's coming of age; Alamo Rent A Car and our family members are proud to sponsor the exhibition that this great institution has coorganized with the Amon Carter Museum in Fort Worth. The presentation opens brilliantly at the Metropolitan and travels across the country to the Amon Carter Museum, The Denver Art Museum, and the Los Angeles County Museum of Art. A condensed version, *America Around 1900: Impressionism, Realism, and Modern Life*, will be shown subsequently at the Museum of Fine Arts in Richmond and the Museum of Art in Fort Lauderdale.

We hope that all who see the paintings in these exhibitions will find a new pride in our country and in our diversity and will repledge their dedication to the values of freedom, artistic expression, and the progressive spirit that are the hallmarks of American belief.

MICHAEL S. EGAN
Chairman
Alamo Rent A Car

ACKNOWLEDGMENTS

American Impressionism and Realism: The Painting of Modern Life, 1885–1915 has a long and rather complicated history. Nearly a decade ago John K. Howat, Lawrence A. Fleischman Chairman of the Departments of American Art at the Metropolitan Museum, suggested American Impressionism as the subject for an exhibition. This survey of painters who achieved prominence in the 1880s was to be mounted only at the Metropolitan. The scope of the show broadened to include works by Realists of Robert Henri's circle when the decision was made to merge it with a project proposed by Doreen Bolger, then Associate Curator, that focused on American painting of about 1900. The individuals participating at this early stage included Lewis I. Sharp, then Curator and Administrator of the American Wing, and N. Mishoe Brennecke, Research Associate.

When Sharp left the Metropolitan to assume the directorship of The Denver Art Museum, that institution became a venue for the exhibition and David Park Curry, then Gates Foundation Curator of American Art at Denver, joined the scholarly team. H. Barbara Weinberg, who was Professor of Art History at Queens College and the Graduate School, The City University of New York, was invited to cocurate the exhibition with Bolger and Curry. Since then the three cocurators have changed affiliations but have remained actively involved in the enterprise. Bolger was made Curator of Paintings and Sculpture at the Amon Carter Museum, Fort Worth, which became the coorganizer of the exhibition as well as a venue for it; Curry moved to the Virginia Museum of Fine Arts, Richmond, where he is Curator of American Arts; and Weinberg was elected Curator of American Paintings and Sculpture at the Metropolitan and assumed responsibility for directing the project from New York. Throughout the evolution of the show and its catalogue, Brennecke has played an important role, conducting and overseeing research and taking charge of many administrative details.

In 1991 substantial funding from Alamo Rent A Car allowed us to continue the research required to realize both exhibition and catalogue and also made it possible to share our ideas with an even wider audience than we had anticipated: the Los Angeles County Museum of Art was added as a venue; an installation at the Metropolitan of related drawings, prints, and photographs was planned to coincide with the exhibition in New York; and a related exhibition was conceived for presentation at the Virginia Museum of Fine Arts and the Museum of Art, Fort Lauderdale, after the national tour. Alamo's extraordinary generosity makes all of these events possible.

We would like to acknowledge the many staff members at the coorganizing institutions whose help and encouragement assured our progress over the past several years. Philippe de Montebello, Director of the Metropolitan, recognized the potential of the exhibition from the outset and consistently supported it, as did Jan Keene Muhlert, Director of the Amon Carter. At the

Metropolitan Mahrukh Tarapor, Associate Director for Exhibitions, ably coordinated all preparations with the assistance of Martha Deese. Jennifer Russell enthusiastically contributed her efforts, first as Assistant Director at the Whitney Museum of American Art, New York, and then as the Metropolitan's Associate Director for Administration. Emily Kernan Rafferty, Vice President for Development and Membership, secured our splendid corporate sponsorship from Alamo Rent A Car with the aid of Nina McN. Diefenbach; their staff, particularly Lynne M. Winter and her assistant Ana Buenaventura cooperated closely with Alamo.

Melissa G. Thompson, Registrar at the Amon Carter, together with her staff, Julie Causey and Amy Kelly, planned and efficiently implemented registration for the exhibition. At the Metropolitan John Buchanan, Chief Registrar, now retired, offered his expertise in the early stages of the project, and Herbert M. Moskowitz and Nina S. Maruca efficiently handled many arrangements.

For unstinting help with the exhibition and publication, we owe a great debt to a loyal corps of researchers who also wrote the artists' biographies for this volume: Brennecke, Arlene Katz Nichols, Victoria Jennings Ross, Kate Rubin, Lois Stainman, and Thayer Tolles. Additional research was carried out by interns and volunteers Ariel Childs, Jane Clark, Walton Eagan, Merrill Falkenberg, Jean Gridley, Amanda MacKenzie, the late Barbara Robinson-Duff, Ellen L. Schwartz, and Elizabeth Venn. Students at the Graduate School of the City University of New York who participated in Weinberg's fall 1990 seminar on turn-of-the-century American painting provided a forum for the testing of ideas explored in the exhibition and shared their research with the curators; the contributions of many of them are cited in our endnotes. At the Metropolitan the gathering of information was expedited by William B. Walker, Arthur K. Watson Chief Librarian, and Katria Czerwoniak and Doralynn Pines, members of his able staff. Jeanie M. James, Archivist, and her assistants verified data on the works from the Metropolitan's collection. At the Amon Carter Librarian Milan Hughston with Sherman Clarke graciously checked references, pursued numerous queries, and secured many hard-to-find sources for photographs.

Members of the curatorial and conservation staffs at both the Metropolitan and the Amon Carter were most helpful. In departments at the former we acknowledge Beth Alberty, Kimberly S. Fink, and Caroline S. Goldthorpe, The Costume Institute; Elliot Bostwick Davis, Drawings and Prints; Gary Tinterow and Susan Alyson Stein, European Paintings; Laurence B. Kanter, Curator in Charge, Robert Lehman Collection; Laurence Libin, Frederick P. Rose Curator in Charge, Musical Instruments; Malcolm Daniel and Jeff L. Rosenheim, Photographs; Ida Balboul, Kay Bearman, and Lisa M. Messinger, Twentieth Century Art; and Hubert von Sonnenburg, Sherman Fairchild Chairman, Paintings Conservation, and his colleague Dorothy Mahon. At the latter we thank Thomas W. Southall and Jane Myers, Curator of Photography and Curator of Prints and Drawings, respectively. Crucial assistance was provided by Claire M. Barry, Chief Conservator, and Michael Gallagher of the joint Amon Carter-Kimbell Art Museum conservation program, with the advice of Jane Webber of The Chrysler Museum, Norfolk, Virginia.

Alan Brinkley, Professor of History, Columbia University, New York, served as an adviser, contributing insights about turn-of-the-century America. The manuscript of the catalogue was read by two perceptive colleagues, Elizabeth Johns, Silfen Term Professor of American Art History, University of Pennsylvania, Philadelphia, and Marc Simpson, The Ednah Root Curator of American Paintings, The Fine Arts Museums of San Francisco, whose suggestions were extremely helpful to the authors.

Throughout the period of our research we depended upon numerous institutions and individuals for information. Several repositories deserve special notice: Columbia University Libraries; Frick Art Reference Library, New York; New-York Historical Society; and New York Public Library. Among those who merit acknowledgment are Lawrence Campbell, Art Students League, New York; Mary Connaly, Ipswich Historical Society, Massachusetts; Daniel Gallo; Stephanie Gaskins, Ipswich, Massachusetts; Katherine H. Griffin, Massachusetts Historical Society, Boston; Paul Hurd, Medfield Historical Society, Massachusetts; Bertram Lippincott III, Newport Historical Society; Judith McCulloch and Mary Ann Harding, Cape Ann Historical Association, Gloucester, Massachusetts; Laura L. Meixner, Cornell University, Ithaca, New York; Elizabeth Milroy, Wesleyan University, Middletown, Connecticut; Robert A. Olmsted; Helen Sanger, Frick Art Reference Library; Robert Schumacher; George T. M. Shackelford, Museum of Fine Arts, Houston; Anne G. Terhune; Jane E. Ward, Peabody and Essex Museum, Salem, Massachusetts; Rebecca Zurier, University of Michigan, Ann Arbor.

We deeply appreciate information on painters in the exhibition received from: Faith Andrews Bedford on Frank W. Benson; Kathleen Burnside, Hirschl and Adler Galleries, New York, on Childe Hassam; Kathryn Corbin on John Leslie Breck; Rowland Elzea, Delaware Art Museum, Wilmington, and Grant Holcomb, Memorial Art Gallery of the University of Rochester, on John Sloan; Janet J. Le Clair on Robert Henri; Doreen D. McCabe, Connecticut Historical Society, Hartford, and Judith H. O'Toole, Sordoni Art Gallery, Wilkes College, Wilkes-Barre, Pennsylvania, on George Luks; Jesse Parra on Edward Lamson Henry; Carole Pesner, Kraushaar Galleries, New York, on William Glackens; Lisa N. Peters, Spanierman Gallery, New York, on John H. Twachtman; Ronald G. Pisano on William Merritt Chase; Richard Wattenmaker, Archives of American Art, Smithsonian Institution, Washington, D.C., on William Glackens; and Whitney Wendel on Theodore Wendel.

The forty-six lenders to the national tour, both public institu-

tions and private collectors, not only sacrificed their enjoyment of their pictures for many months but also furnished information about them. William S. Lieberman, Jacques and Natasha Gelman Chairman, Department of Twentieth Century Art, at the Metropolitan, made an important painting available and will provide other loans for the Richmond and Fort Lauderdale version of the exhibition. We extend our thanks to him and to the following individuals who facilitated loans and supplied information about the works in their collections: Jock Reynolds and Susan Faxon, Addison Gallery of American Art, Phillips Academy, Andover, Massachusetts; Teri J. Edelstein, Charles F. Stuckey, Judith A. Barter, Gloria Groom, and Anndora Morginson, The Art Institute of Chicago; Sona Johnston, The Baltimore Museum of Art; Mattie Kelly, Bowdoin College Museum of Art, Brunswick, Maine; Linda S. Ferber, Barbara Dayer Gallati, and Teresa A. Carbone, The Brooklyn Museum; H. Nichols B. Clark, The Chrysler Museum; Nannette Maciejunes, Columbus Museum of Art, Ohio; Lauretta Dimmick and Sally E. Mansfield, The Denver Art Museum; Nancy Rivard Shaw, The Detroit Institute of Arts; Phyllis Rosenzweig and Judith Zilczer, Hirshhorn Museum and Sculpture Garden, Smithsonian Institution, Washington, D.C.; Grant Holcomb, Laurene Buckley, and Maria Via, Memorial Art Gallery of the University of Rochester, New York; Cheryl Robertson and Dean Sobel, Milwaukee Art Museum; Maureen C. O'Brien, Museum of Art, Rhode Island School of Design, Providence; Theodore E. Stebbins, Jr., Carol Troyen, Erica E. Hirshler, and Trevor J. Fairbrother, Museum of Fine Arts, Boston; Nicolai Cikovsky, Jr., Franklin Kelly, and Deborah Chotner, National Gallery of Art, Washington, D.C.; Marie Lugli, National Gallery of Canada, Ottawa; Abigail Terrones and Betsy Anderson, National Museum of American Art, Smithsonian Institution, Washington, D.C.; Linda Bantel, Sylvia Yount, Cheryl Liebold, Barbara Katus, and Susan Danly, Pennsylvania Academy of the Fine Arts, Philadelphia; Joseph J. Rishel, Darrel Sewell, Nancy S. Quail, and Jennifer Vanim, Philadelphia Museum of Art; Stephen B. Phillips, The Phillips Collection, Washington, D.C.; Linda Muehlig, Smith College Museum of Art, Northampton, Massachusetts; D. Scott Atkinson, Holly Wagoner, and Jochen Wierich, Terra Museum of American Art, Chicago; David L. Prince, University Art Collection, Syracuse University; Lisa Hancock, Virginia Museum of Fine Arts; Susan Angevin and Constance Evans, Weir Farm Heritage Trust, Wilton, Connecticut; Adam Weinberg, Ellin Burke, and Alan Myers, Whitney Museum of American Art; and Helen Cooper and Beverly Rogers, Yale University Art Gallery, New Haven. Loan requests for paintings owned by private collectors were facilitated by Joan E. Barnes, Joan Hester, David Nisinson, and Rita O'Neill and also by Frederick D. Hill, Berry-Hill Galleries, Inc., New York; James Maroney, Christie, Manson, and Woods, New York; and Richard York and Susan Menconi, Richard York Gallery, New York.

This volume includes rare illustrations that were provided by a host of generous institutions and individuals. Special recognition is due to staff members of the coorganizing museums for photographing numerous images from period magazines and journals and many of the paintings reproduced herein. We acknowledge at the Metropolitan Barbara Bridgers, Manager, Photograph Studio, and her staff, particularly Bruce Schwarz and Josephine Freeman, as well as Deanna D. Cross, Photograph/Slide Library Coordinator; and at the Amon Carter Rynda Lempke, Photographer, Steve Watson, and Dorothy Tuma. For their help in supplying visual material we are also indebted to the following: Judith Throm, Archives of American Art, Smithsonian Institution, Washington, D.C.; Aaron Schmidt, Boston Public Library; Philip Bergen, The Bostonian Society; Linda Docherty, Bowdoin College; Karen Tates, The Brooklyn Museum; Marion Harding, Cape Ann Historical Association; Bruce Chambers; Mary Holahan, Delaware Art Museum; Mrs. Herbert A. Goldstone; Barbara Guggenheim Associates, Inc., New York; Robert J. Killie; Diana C. Landreth; Sean Fisher, Metropolitan District Commission, Boston; Herbert Mitchell; Marguerite Lavin and Anthony Pisani, Museum of the City of New York; Alicia Longwell, The Parrish Art Museum, Southampton, New York; Tamatha Kuenz, Philadelphia Museum of Art; Betty Krulik, Spanierman Gallery; and Texas Christian University Library, Fort Worth.

The publication achieved its final form through the remarkable efforts of the Metropolitan's Editorial Department. John P. O'Neill, Editor in Chief and General Manager of Publications, championed this ambitious volume and provided wise counsel throughout its development. We extend our most profound gratitude to Carol Fuerstein, our editor, who guided us with imagination, patience, and devotion and with her own literary gifts transformed the efforts of three writers into essays that can be read with pleasure, even by their authors. To borrow an expression from one of Carl Sandburg's characters in *More Rootabagas*: "You have given us new syllables and new adjectives and we thank you a thousand times for learning us how to learn more knowledge to be useful." Jean Wagner, Barbara Cavaliere, Cynthia Clark, and Tonia Payne assisted in the editorial process. Susan Chun skillfully managed the book's complex production, with initial help from Helen Watt. Malcolm Grear Designers, Providence, devised the handsome design, and Steffie Kaplan executed its mechanicals. Gwen Roginsky superbly supervised the printing.

Educators in Fort Worth and New York prepared the many materials and programs that accompany the exhibition. At the Amon Carter Allison Perkins, Education Director, helped by Mary Lampe, supervised the creation of the video produced by Katina Simmons of Mayah Productions, Dallas, based on a script by Andrea Boardman and picture research by Caroline

Robbins. Perkins also developed the concept of brochures for visitors; these were edited by Nancy Stevens, Coordinator of Publications, and designed by Mark LaChapelle. At the Metropolitan Kent Lydecker, Associate Director for Education, with Stella Paul formulated other educational tools. Aline Hill-Ries organized training programs and prepared teachers' resources for use at all venues.

Henriette Montgomery scheduled a film series, Hilde Limond-jian coordinated concerts, and Linda Komaroff arranged lectures, gallery talks, and a symposium for presentation at the Metropolitan. Educational programs in New York also involved the participation of Nicholas Ruocco, Evan Levine, Alice W. Schwarz, Nellie Silagy, Amy Silva, Mary Grace Whalen, and Robert Dickey. Susan Melick Bresnan oversaw the production of slides and transparencies for public programs.

For implementing arrangements for the exhibition at the Metropolitan we single out for special thanks members of the Metropolitan's Department of American Paintings and Sculpture: Howat, Kevin Avery, Carrie Rebora, and Tolles, who offered their expertise, and Elisabeth R. Agro, Jeanmarie Kraemer, and Irene Papanestor, who attended to innumerable details. American Wing Administrator Peter M. Kenny, assisted by Emely Bramson, arranged for the Metropolitan's loans, together with the Museum's Loans Coordinator, Marceline McKee. We are also most grateful to Harold Holzer, Chief Communications Officer, and his staff members Elyse Topalian and Jill Schoenbach; Sharon H. Cott, Secretary and General Counsel, and Lee White Galvis and Douglass Fleming, who assisted her; Richard R. Morsches, Vice President for Operations, J. Nicholas Cameron and Linda M. Sylling; and for producing merchandise inspired by the paintings, Lisa Cook Koch, General Merchandise Manager, and her staff, especially Valerie Troyansky, Steve Zane, Emily Eisenberg, and Lisa Timmins. The dazzling installation of the exhibition at the Metropolitan was the work of David Harvey, its lighting of Zack Zanolli and Anita Jorgensen, and its graphic components of Sophia Geronimus; Chief Designer Jeffrey L. Daly gave welcome advice. American Wing technicians Don E. Templeton, Gary Burnett, Edward Di Farnecio, and Sean Farrell provided their characteristically invaluable help.

At the Amon Carter Irvin Lippman, Assistant Director, offered administrative support, Ruth Ann Rugg managed local publicity, and Judith M. Gibbs secured supplementary funding from the National Endowment for the Arts for the Fort Worth venue. Carolyn LeMaster oversaw loan negotiations. Christopher Rauhoff collaborated on the elegant installation in Fort Worth.

At The Denver Art Museum the presentation and interpretation of the exhibition were implemented by Sharp, Lauretta Dimmick, Gates Foundation Curator of Painting and Sculpture, and Patterson Williams, Dean of Education, and at the Los Angeles County Museum of Art by Earl A. Powell III, former Director, Stephanie Barron, Acting Director for Curatorial Affairs, John P. Passi, Head, Exhibition Programs, and Ilene Susan Fort, Curator of American Art.

At the Virginia Museum of Fine Arts Director Katharine C. Lee and Associate Director for Exhibitions and Programs Richard B. Woodward gave their support, working with Curry and David B. Bradley, Associate Director, Development and Marketing, to obtain additional funding for the version of the exhibition shown in Richmond. Caroline Doswell Smith provided significant administrative and research assistance. Librarian Elizabeth Stacey and her staff tracked down elusive books and articles.

The National Endowment for the Arts provided additional funding for the Fort Worth venue; and the National Endowment for the Humanities awarded a Travel to Collections Grant that aided Bolger's research. Finally, Alamo Rent A Car merits yet another acknowledgment for its enlightened interest in American art and in this exhibition. In particular, we thank Michael S. Egan, Chairman, and Marc Cannon, Senior Director of Advertising and Marketing Resources.

H. BARBARA WEINBERG
Curator of American Paintings and Sculpture
The Metropolitan Museum of Art

DOREEN BOLGER
Curator of Paintings and Sculpture
Amon Carter Museum

DAVID PARK CURRY
Curator of American Arts
Virginia Museum of Fine Arts

CATALOGUE

INTRODUCTION

Passionate Spectators

A Record of the Epoch

For the perfect flâneur, *for the passionate spectator, it is an immense joy to set up house in the heart of the multitude, amid the ebb and flow of movement, in the midst of the fugitive and the infinite.*

CHARLES BAUDELAIRE (1863)

A true historical painter, it seems to me, is one who paints the life he sees about him, and so makes a record of his own epoch.

CHILDE HASSAM (1892)

The American who is useful as an artist is one who studies his own life and records his experiences.

ROBERT HENRI (1923)

Much of the most engaging American painting from the turn of the last century has been classified handily by style: Impressionist for the lightly brushed, high-key works that such artists as William Merritt Chase and Childe Hassam executed in the late 1800s and Realist for the darker-toned urban scenes that Robert Henri, John Sloan, and their colleagues produced from about 1905. *American Impressionism and Realism: The Painting of Modern Life, 1885–1915* proposes that this dichotomy is deceptive, exaggerated by the formalist, monographic focus that governs most studies of these artists.[1] We argue that the continuities between the two groups are probably at least as meaningful as the differences, which are more subtle than previously assumed, especially when they are illuminated by a thematic consideration of the paintings within a framework of their social context. We will indicate how the tensions and ambivalence associated with the emergence of the new America and the new century affected both kinds of painters and will explore the complicated relationships between the actualities of the period and the responses of its artists.

The sympathy of the late nineteenth-century painters for French Impressionism was entirely consistent with their habitual interest in French styles and with the material and cultural energy of the United States, which echoed and amplified the changes that had generated the revolutionary style in France. (For simplicity we will use the term *French Impressionism* to denote the work of the entire circle of painters who constituted the avant-garde from the mid-1860s through the mid-1880s; we include in this circle of artists Edgar Degas, who was a key organizer of their group exhibitions but did not share their devotion to outdoor work, and Edouard Manet, who pioneered their vision but refused to show with them.) Beginning in the 1860s American painters had avidly absorbed European ideals, especially the French academic commitment to elevated subjects,

laborious execution, and high finish and the Barbizon School's love of poetic landscape that privileges mood and expression over topography. As students in Paris or after they returned home, through imported paintings and the example of the work of friends, some of these Americans were exposed to the French Impressionists' direct, rapidly rendered, rough-textured, light-saturated portrayals of modern life. Mary Cassatt aligned herself personally and stylistically with Manet and Degas in the mid-1870s. John Singer Sargent declared an involvement with the new style by 1879, painting Impressionist-inspired outdoor scenes and often refreshing his more conservative efforts as a portraitist with experiments in the new idiom. These two prominent expatriates were unusual not only because they adopted Impressionism early but also because most of their compatriots who remained in Europe after their student years preferred to pursue academic and Barbizon impulses.

American painters who came home from Europe (usually to New York, Boston, or Philadelphia) found the United States in the throes of rapid change from an agrarian to an industrialized, increasingly urban society. Some—Thomas Eakins, for example—adhered to the academic styles in which they were schooled and painted carefully constructed images of modern incidents and types. Others, although similarly trained, divested themselves of academic constraints, were drawn to the work of the French Impressionists, and espoused the new mode beginning in the late 1880s.

Impressionism disdains established hierarchies of subject, order, and finish; avoids clear narrative; embraces the spontaneous; is alert to the trivial incident; and empowers the ordinary viewer, insisting on his or her engagement with and esteem for fragments of familiar—specifically local and national—experience. Some of the American Impressionists imitated the new French painting only superficially, but the most interesting of them grasped its essence. The work of the more sensitive Americans reflects a profound immersion in distinctive resonant locales and an adoption of French Impressionist methods and practices—especially outdoor painting—to nourish their portrayals. The statements of the Americans reiterate their fundamental understanding that personal experience could constitute the subject matter of art. "Hitherto historical painting has been considered the highest branch of art; but, after all, see what a misnomer it was," observed Hassam in 1892, reflecting on the new priorities he and his colleagues had learned from the French Impressionists. "The painter was always depicting the manners, customs, dress and life of an epoch of which he knew nothing. A true historical painter, it seems to me, is one who paints the life he sees about him, and so makes a record of his own epoch."[2]

The leading American Impressionists who chose to work at home—most notably Hassam, Chase, and Theodore Robinson—consistently involved themselves with modern life, producing an artistic register of the energetic nation on the brink of the twentieth century. Often capturing the vignette rather than the grand panorama, these painters could respond nimbly and directly to the bustle and fragmentation that characterized the new order of things. They had at their disposal a vigorous style that was particularly effective for interpreting a dynamic time in a democratic place, or at least the portion of it that they and their patrons—most of them white, middle-class urbanites of Anglo-Saxon Protestant background living in the northeastern United States—were familiar with and preferred to view and record. These painters reached an apogee of achievement in the 1890s, when their work reflected the country's burgeoning spirit of nationalism. After the turn of the century American Impressionism lost vitality, becoming a mainstream style identified with obdurate artistic conservatives.[3] Yet the aging originators of the movement—especially Sargent and Hassam—could demonstrate considerable strength even as late as 1920.

About 1900, younger artists, whom we shall call Realists, set themselves apart from and challenged American Impressionism, although some of them had experimented in that mode. The core of this group—Henri, Sloan, William Glackens, George Luks, Everett Shinn, and Henri's student George Bellows—have been referred to as the Ashcan School, the New York Realists, and even as the Revolutionary Black Gang. Sometimes these painters have been incorrectly equated with The Eight, a more varied circle of artists with whom all but Bellows exhibited at the Macbeth Galleries in New York in 1908.[4]

With the exception of Henri and Bellows, the American Realists had apprenticed as newspaper and magazine illustrators in Philadelphia before settling in New York. In their paintings, as in their illustrations, etchings, and lithographs, they turned away from the landscapes that the American Impressionists favored and disdained their predecessors' tendency toward gentility. They concentrated on the city, especially on New York, striving to portray its vitality and its seamier side. Conditioned by their experience as illustrators, they kept a keen eye on current events, advocated a programmatic immersion in modern life, and sought visual analogues for the urban-oriented progressivist social and political rhetoric of their time. As Holger Cahill and Alfred H. Barr, Jr. explained: "They were interested in social and political ideas, in the writings of Edward Bellamy and Henry George, the optimistic Americanism of Walt Whitman, the humanitarianism of Tolstoy, the economic and historical theories of Karl Marx, in the labor movement, in the whole complex of late nineteenth century idealism which ranged from old-fashioned liberalism to socialism and communism."[5] Like their literary contemporaries Ida M. Tarbell, Frank Norris, Lincoln Steffens, and Upton Sinclair, they were fond of editorializing and muckraking.

Consonant with their quest for a new subject matter they turned away from the high-key canvases of Claude Monet, Pierre-

Auguste Renoir, Camille Pissarro, and like French painters—and even from these artists' highly chromatic depictions of Parisian streets, parks, and railway stations, which had inspired the American Impressionists. They depended instead upon the darker manner of Manet and Degas, who had often recorded grittier aspects of modern Paris. The American Realists' preference for broadly rendered forms was supported by the model of Manet and Degas and by their appreciation of an earlier urban painter, Honoré Daumier; their predilection for summary execution was also encouraged by their habit of working from memory, a practice Degas had followed and one they had learned as illustrators.

Yet, despite the American Realists' indebtedness to Manet, Degas, and Daumier, their vision is not as tough, bitter, and pessimistic as that of their French predecessors, for they still were touched by the euphemistic spirit that buoyed the American Impressionists. And although the Realists identified with the working class, sympathized with liberal social doctrine, and concerned themselves with the grimmest aspects of urban existence, they nevertheless subordinated their role as propagandists to their role as artists. As a result their works are never as harsh or disturbing as the reformist images produced at the turn of the century by such photographers as Jacob A. Riis.[6] The Realists' commitment to a specific vision diminished about 1915, as their pioneering spirit faded and as the radical art introduced at the Armory Show of 1913 provoked some of them to experiment with a variety of modernist ideas. Again, however, there are a few fine late canvases that retain the earlier energy.

The American Impressionists and Realists may have seen themselves as two opposed circles of artists, and they are usually presented as such. We might suppose that their backgrounds conditioned their respective emphases on either gentility or dismal actuality. Many of the American Impressionists came from comfortable families long established in the United States, particularly in New England: Frank W. Benson and Hassam were sons of wealthy Massachusetts merchants; the New England forebears of Robinson, Edmund C. Tarbell, and Dennis Miller Bunker were less affluent but had deep American roots; Edward E. Simmons, nephew of Ralph Waldo Emerson, was reared in the Old Manse in Concord; even foreign-born Sargent, son of a peripatetic Philadelphia physician, was descended from one of Gloucester's earliest merchant families; and Cassatt and Cecilia Beaux were daughters of wealthy or reasonably well-to-do Pennsylvania families. By contrast the Realists were more socially and economically diverse: Glackens was the son of a railroad worker; Shinn the offspring of a bank teller; Luks was raised in Pennsylvania coal country by activists who fought for miners' rights; Sloan's father was a struggling cabinetmaker; and Henri, despite his descent from the same Huguenot ancestors claimed by Cassatt, was the son of a gambler who lived on the fringe of legitimacy. Yet the sociocultural and economic profiles of the two

groups are blurred: among the Impressionists Willard Metcalf, from Lowell, Massachusetts, was the son of a loom tender and a carpenter; John H. Twachtman and Theodore Wendel were sons of German immigrants of modest circumstances; Chase's connections to the upper middle class in New York and Southampton were acquired rather than inherited; and Realist Bellows, born in Columbus, Ohio, traced his descent from the eighteenth-century founder of Walpole, Vermont, through a seafaring Long Island grandfather.

The overlapping backgrounds of the American Impressionists and Realists are paralleled in their art by significant intersections in style and choice of subject. There were painters in each group who experimented in the style of the other. Henri painted Impressionist glimpses of country and city during the 1890s, before taking up his more characteristic Realist palette and vigorous brushwork. Glackens turned to Impressionism after producing some of his most distinctive paintings in the Realist mode. Ernest Lawson saw the city with the ideological bias of his fellow Realists but used an Impressionist palette and technique. Chase executed portraits and still lifes that are akin in spirit and style to works by the Realists as well as to paintings by Manet.

Both the American Impressionists and Realists felt impelled to depict the contemporary scene; together they did so from the mid-1880s to World War I, relying on the example of the same movement, French Impressionism, albeit different adherents of that movement, and successfully translating a foreign idiom into an American one. Like the French, the Americans wished to be of their own time and place, and painters and critics alike saw both the Impressionists and Realists of the United States as helping to reestablish a national artistic voice. Both groups rejected the traditional notion that art must draw its inspiration from myth, religion, history, or other art, inverting the academic emphasis on culture over nature. Like their French predecessors, they recorded the timely moment in contemporary life yet did not renounce a desire to create a timeless art. Again like the French, the American painters of modern life appropriated elements from the art of the past to lend power and credibility to their visions of the present, despite their revolutionary stance. They were attracted to certain old masters, especially Velázquez and Hals, whose work had inspired Degas and Manet to monumentalize commonplace people and insignificant incidents and to experiment boldly with composition, color, and paint application in the interest of seizing the most spontaneous impression of their subjects.

Displaying in their pictures the same duality between new and old that is diagrammed in turn-of-the-century skyscraper design (see fig. 7), the American Impressionists and Realists also echoed the resistance of many American intellectuals to what George Cotkin has termed "the imperative to be absolutely modern, to reject the wisdom of tradition."[7] Finally, the Ameri-

can Impressionists and Realists together defined the avant-garde in the United States until the Armory Show challenged their shared artistic canon by introducing the work of Henri Matisse, Pablo Picasso, Marcel Duchamp, and other advanced European artists to the American public.

Critics who were the contemporaries or near contemporaries of the painters and then the commentators who followed them ignored similarities between the American Impressionists and Realists in order to emphasize their differences. Having passed its heyday at the close of the last century, American Impressionism has been understood by twentieth-century observers as an homage to bygone days, while American Realism, which came to the fore after 1900, is credited with having begun afresh. It is likely that the rift was exaggerated by such cultural-nationalist writers as H. L. Mencken and Van Wyck Brooks and by curators of similar bent, including Lloyd Goodrich and Edgar P. Richardson. Searching for a usable American past and demanding that their colleagues limit their focus to American life, these authors and museum people preferred the Realists, who rejected an ostensibly European-tainted gentility and cosmopolitanism, and they aggrandized their Americanness.[8] In fact, from about 1915 to 1945, when the cultural-nationalist search for what was American in American art guided the interests of American scholars, curators, and collectors, American Impressionism was deemed too French to reward much scrutiny.

That the American Impressionists and Realists reached their maturity in different centuries has reinforced the perceived dichotomy between them. The American Impressionists have been interpreted as the heirs to a painterly tradition originating in the seventeenth century and studied by scholars of nineteenth-century art, while the Realists are in the province of twentieth-century specialists who have searched their work for harbingers of later developments. Their pictures have suffered an analogous artificial division and are often shown in museums and galleries by separate curatorial departments that emphasize the year 1900 as a divider.

The Impressionists and Realists painted during the same period in American culture, an unsettling, transitional time in which confidence and doubt, excitement and trepidation coexisted. Tantalized by the American Impressionists' belief that "the great record of America must come from Americans themselves," as Chase put it in 1910, and by the Realists' credo that "the American who is useful as an artist is one who studies his own life and records his experiences; in this way he gives evidence," as Henri explained it in 1923,[9] we have explored the context in which these artists worked to discover in their paintings meanings beyond formal expression. Consistently the pictures that announced themselves as essential for inclusion in our exhibition and for discussion in this publication disclosed a triad of broad

interests shared by both groups: the country, the city, and the home. These works also reflect changes in the way their creators perceived themselves, as their social and professional roles and new stylistic and formal concerns evolved. Such changes in the self-image of these artists were sometimes crystallized in depictions of the painters in their studios.

Artists distill the underlying assumptions and changing values of the culture in which they work. Because they were free to choose and alter realities, the American Impressionists and Realists left us an edited record, incomplete evidence of the country, the city, and the home as they appeared to some of them in France and to most of them back in the United States. Acknowledging manifold complexities and trying to avoid preconceptions in reading and describing the paintings, we relied primarily on the works of art themselves to present the record and the evidence, to lead us to the most appropriate means of interpretation. But in attempting to draw from the pictures clues to prevailing attitudes toward modern life between 1885 and 1915, we have observed the warning uttered by John La Farge in 1899: "It is not possible that a work of art should define like science and still move like poetry.... Because of the peculiarities of [the artist's] work ... no person can explain that work perfectly in terms of words."[10]

Because we are not wedded to a single method, we have attended to the accounts offered by texts as well as by images, pursuing patterns between them. However, the paintings have always guided us to the extrinsic sources in social commentary and history that might verify or refute our hypotheses. Our effort has been to pinpoint pictorial strategies, to seek relationships between strategies and contexts, to suggest issues that the artists and their contemporaries might have considered in creating and understanding these paintings, to allow the paintings to reveal their complexity and meaning and sometimes even to remain inscrutable. We do not offer a social history of the United States at the turn of the century with American Impressionist and Realist illustrations. Rather, we propose that our selective group of pictures—chosen for their artistic quality as much as for their value as expressions of the temper of the times—can illuminate some of the ways in which the American Impressionists and Realists responded to life around them.

Our treatment of individual paintings was conditioned by the sorts of subjects portrayed, which range from generic landscapes and figural images to depictions of specific sites and individuals. Apposite texts, both primary and secondary, include synthetic treatments of broad issues such as the changing roles of women or the development of a consumer culture as well as detailed accounts of particular phenomena and places. Because our voice necessarily shifts in response to the images and issues under consideration, we invoke James McNeill Whistler's acidic reply

to P. G. Hamerton's complaint that his *Symphony in White, No. 3* (Barber Institute of Fine Arts, University of Birmingham, England) was "not precisely a symphony in white," since yellow, brown, blue, red, and flesh color also appeared: "Bon Dieu! did this wise person expect white hair and chalked faces? And does he then, in his astounding consequence, believe that a symphony in F contains no other note, but shall be a continued repetition of F, F, F?—Fool!"[11]

Recent scholarship on French Impressionism has already revised long-standing formalist notions that Monet and his contemporaries selected and presented motifs only in terms of their value as visual stimuli. With the help of Robert L. Herbert and other perceptive art historians, we have come to appreciate the significance of French Impressionist subject choice and to understand the reciprocal relationship between the sites that the Impressionists chose to paint in the new Second Empire and Third Republic Paris and environs and the new style in which they painted them.[12] Taking some of these writers as models—and like other scholars who have begun to reexamine familiar American paintings and place them in a cultural context[13]—we have shown American Impressionism and Realism in the light of turn-of-the-century society. In this way we have sought to remedy the formalist isolation of artist and work of art. By pinpointing the themes and subjects that the Americans depicted, as well as those that they chose to avoid, we propose to explicate the ways in which Americans adapted the French Impressionist pattern of engagement and elision.

The repatriated American Impressionists and the Realists confronted a country in the throes of revolutionary transformation from a conservative agrarian society based on a home-centered economy, personal relationships, and cooperation to an expanding, dynamic, urban, industrialized nation with a workplace-centered economy marked by anonymity and competition.[14] Furious debates raged over trusts, tariffs, and taxes. There were labor disputes so intense that the era was dubbed the Great Upheaval. Manufacturing and trade vastly increased the national wealth, but the gap between rich and poor widened; by 1890, 1 percent of Americans held more wealth than the entire remainder of the population. An unfamiliar mingling of classes brought about by industrialization, urbanization, and immigration led the wealthy to wonder how the other half lives and simultaneously to withdraw into a restricted society devoted to fashion and social extravagance. Meanwhile a self-conscious middle class continued to define its values, shape its image, and enjoy new comforts. Between the Civil War and World War I twelve new states were admitted to the Union, increasing the area of the United States by about one third. Agents in Europe sought settlers for the land opened up by the two hundred thousand miles of rail in operation by 1900. Increased immigration, especially from southern

and eastern Europe, and the resettlement of growing numbers of African-Americans in northern cities altered urban demographics and magnified awareness of ethnic, racial, and class differences and barriers. Divisions between the public and private realms as well as between work and the family were clarified and gender roles were reconfigured. Professionalization and specialization emerged in all areas, from manufacturing and medicine to academe and art. Caught in this unprecedented economic, social, and cultural shift, Americans were coming to terms philosophically with the end of a world that once had seemed timeless and literally adjusting to standard time and time clocks, rapid transit, assembly lines, and efficiency experts.

Industrialization created a consumer culture that also separated the new America from the old.[15] Thriftiness and chronic scarcity gave way to somewhat more liberal spending and relative abundance. A new and bewildering variety of goods and services appeared, and, for most, there was more leisure time in which to enjoy them. There was evident tension between the sense of loss of the simpler rural past and the heady excitement of the new: telegraphs and telephones, automobiles, typewriters and adding machines, apartment houses, elevators, electric lightbulbs, water closets, phonographs, flying machines, fountain pens, wireless radios, Bakelite, safety razors, zippers, moving pictures, Kodak pocket cameras, Linotype and mimeograph machines, and mass-circulation journals. Activities associated with the production of goods and services were joined by activities associated with the production of desire for those commodities. By the 1880s works of art were newly important to consumers learning unfamiliar habits of accumulation and display.

Impressionists and Realists were not the only artists who treated the new America in their paintings. Immigration and bitter labor disputes were among the emotive topics that lent themselves to epic scenes rendered in the grand academic manner. Charles Ulrich's *In the Land of Promise—Castle Garden* and Robert Koehler's *Strike* (figs. 1, 2), for example, offer melodramatic, moralizing narratives on these themes. However, controversial subjects could be detrimental to an artist's commercial success. *The Strike*, apparently based on an 1877 railroad workers' strike in Pittsburgh, provoked unfavorable comment when it was exhibited at the National Academy of Design in New York in 1886, a year of extreme labor unrest that included the Haymarket Square riot in Chicago.[16] Highly charged messages of this kind did not reappear in Koehler's work.

Few painters of the late nineteenth century portrayed the problems of modern life in the United States, and the American Impressionists avoided them almost entirely. Given the political, economic, and social confusion prevailing in the 1880s, it is not surprising that these well-bred Impressionist artists downplayed the drearier aspects of the American scene. They were, to be sure,

trying to make a living, as were a host of other American painters, ranging from Edward Lamson Henry to William H. Lippincott (see figs. 55, 239), who eschewed controversial themes as well as the liberating effect of French Impressionism on their style.

Despite their openness to fresh ideas regarding style and subject choice, the American Impressionists were ambivalent about social change. The inclination of both the Impressionists and the more conservative painters to enhance the positive elements of

reality echoed the attitudes of such American writers as William Dean Howells, who recommended in his *Criticism and Fiction* of 1891 that novelists "concern themselves with the more smiling aspects of life, which are the more American."[17] In some measure the American Impressionists recapitulated the idealizing tendencies of mid-nineteenth-century landscape painters, recasting their euphemism and optimism in more modern stylistic terms and replacing their devotion to nationally significant sites with a devotion to personally meaningful places. Not until the early 1900s, after several decades of turbulent social change had made tough, plebeian subjects more familiar to the public at large, did the American Realists self-consciously embrace dissent, controversy, and social commentary. But even these supposed radicals took some care to avoid what was most unpleasant in modern life. As we tested the visual record—the works of art—against written accounts, we found almost inevitably that both the American Impressionists and Realists tempered a commitment to portraying turn-of-the-century life with a tendency toward euphemism, optimism, nationalism, and nostalgia.

Euphemism and optimism distinguish the works of American artists from those of their French mentors and counterparts—academic, Barbizon, and Impressionist.[18] The duality between American euphemism and optimism and European, especially French, candor is apparent not only in painting but also in other cultural manifestations. Turn-of-the-century American novels, for example, avoid the cynicism that marks comparable French efforts. Theodore Dreiser's tale of hard times written in 1900, *Sister Carrie*, or Stephen Crane's account of a prostitute, *Maggie: A Girl of the Streets* of 1893, do not approach in frankness the drama of class struggle, urban malaise, bleak poverty, and degra-

Fig. 1 Charles Ulrich. *In the Land of Promise— Castle Garden*, 1884. Oil on wood, 28⅜ x 35¼ in. (72.1 x 90.8 cm). The Corcoran Gallery of Art, Washington, D.C., Gallery Fund 00.2

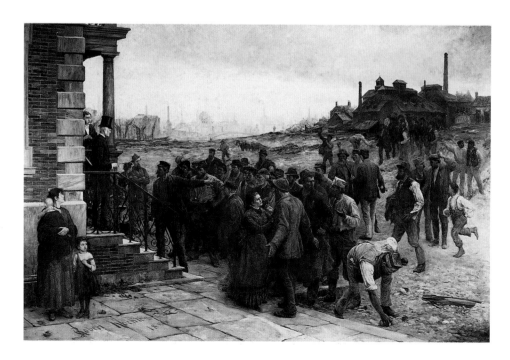

Fig. 2 Robert Koehler. *The Strike*, 1886. Oil on canvas, 72⅝ x 110¾ in. (184.5 x 281.3 cm). Deutsches Historisches Museum, Berlin, Purchase, Funded by Arne Psille, Berlin

dation portrayed in Emile Zola's *Nana* of 1880. The French stories, told in paint or in words, almost always are far more direct and brutal than their American analogues. The French paintings and books are outspoken, full of dissonance, confrontation, ambiguity, alienation; the American, by comparison, are studies in harmony or, at least, accommodation.

We can merely speculate on the reasons for the prevalence of positive impulses among American artists, on why, for example, the painters never show workers to be as oppressed as the toilers in French pictures: the decorously posed figures in the American academic Thomas Anshutz's *Way They Live* (fig. 3) and the exhausted peasants in the Frenchman Jules Bastien-Lepage's *Les Foins* (*Haymakers*) (fig. 4) are cases in point. We can only begin to suggest why the American paintings that respond to French Impressionist models do not look French, even when they were executed by expatriates in France.

The desire to make their pictures marketable—particularly in competition with more dour French works—may have persuaded American painters to banish or at least dilute negative messages about contemporary America. They were, after all, distilling in their accounts of modern life the results of their patrons' enterprise and perhaps felt obliged to put these collectors and their achievements in the best possible light, to celebrate rather than to fault familiar places and people.[19] With their emphasis on sunlight, American Impressionists could conjure up an especially agreeable world for their patrons, who did not have to know the classics, the Bible, or the events of history in order to appreciate the pictures of everyday realities with which they were presented. Tenacious American prudishness—which required American academics to adopt subterfuges, for example, painting scenes of Native American life if they wished to depict the nude—hampered investigation of such earthy subjects as prostitutes, who were often portrayed by Degas and Manet. The rarity of prostitutes in American paintings contradicted their presence in late nineteenth-century life. In fact, Stanley Coben has noted, "The large number of mostly lower-class female prostitutes in American as well as in European Victorian cities served as one of the landmarks of the age."[20]

Finally, faith in newness and a repudiation of Old World pessimism were integral to the founding and growth of the United States. In postbellum America the sense of renewal that followed the restoration of peace and the reconfiguration of the lives of whites and blacks alike could inspire any number of positive responses; it could, for example, prompt Anshutz to suggest in his subjects a measure of personal productivity and composure that was unavailable to eternally downtrodden French peasants. The extreme of American optimism, and its most vivid metaphor, was the notion that magnetized turn-of-the-century immigrants: in America the streets are paved with gold. The evident tendency of American painters and writers to organize their

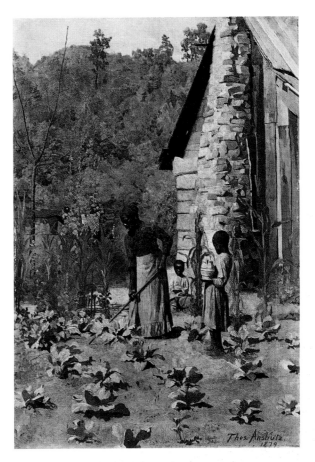

Fig. 3 Thomas Anshutz. *The Way They Live*, 1879. Oil on canvas, 24 x 17 in. (61 x 43.2 cm). The Metropolitan Museum of Art, New York, Morris K. Jesup Fund, 1940 40.40

Fig. 4 Jules Bastien-Lepage. *Les Foins* (*Haymakers*), 1878. Oil on canvas, 61 x 70⅞ in. (154.9 x 180 cm). Musée d'Orsay, Paris

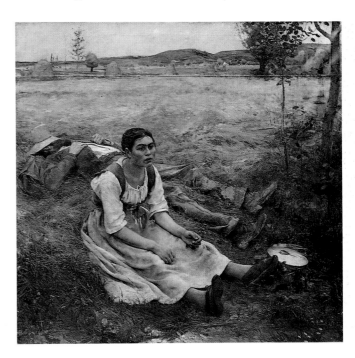

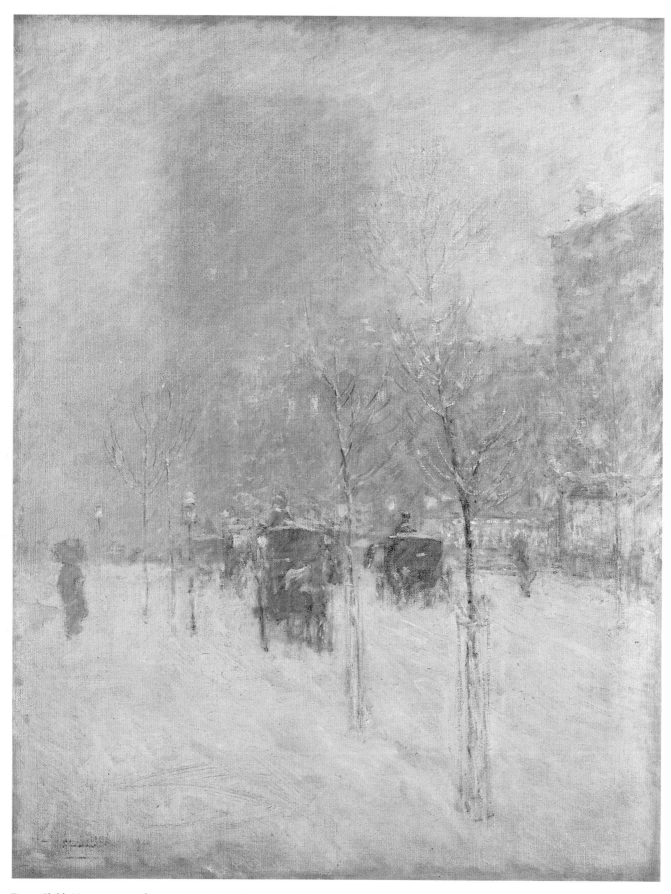

Fig. 5 Childe Hassam. *Late Afternoon, New York: Winter*, 1900. Oil on canvas, 37 x 29 in. (94 x 73.7 cm). The Brooklyn Museum, New York, Dick S. Ramsay Fund 62.68

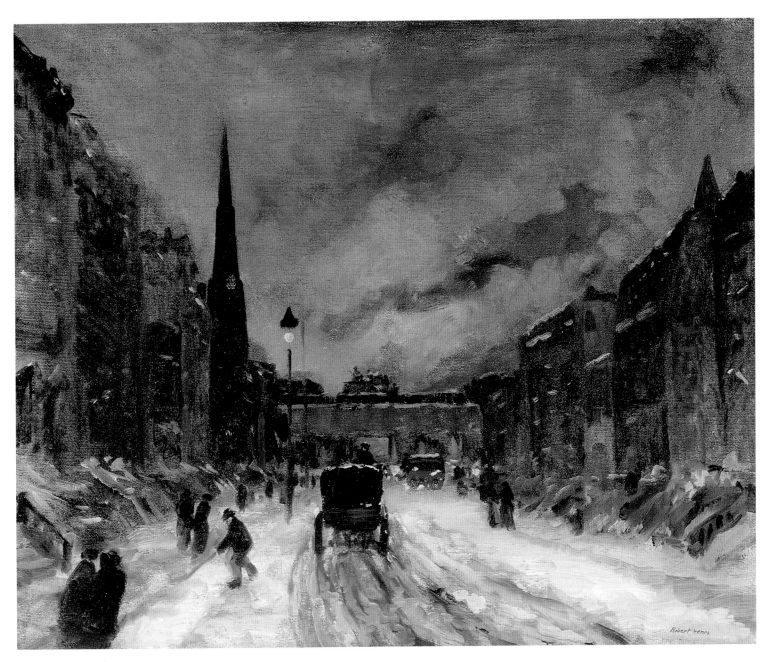

Fig. 6 Robert Henri. *Street Scene with Snow (57th Street, N.Y.C.)*, 1902. Oil on canvas, 26 x 32 in. (66 x 81.3 cm). Yale University Art Gallery, New Haven, The Mabel Brady Garvan Collection 1947.185

sense of the world according to optimistic national ideals helps to explain their lack of acerbity, even when their intention was to deny "the more smiling aspects" and to record the most dreary.

Hassam's *Late Afternoon, New York: Winter* and Henri's *Street Scene with Snow (57th Street, N.Y.C.)* (figs. 5, 6), two nearly contemporaneous city scenes, exemplify the attitudes of the American Impressionists and Realists, respectively. Together these paintings reveal the continuities between the approaches of the two generations of artists as well as the gentility of the American treatment of urban imagery relative to French practice. If we consider them within the French Impressionist spectrum, both pictures are much further removed from Gustave Caillebotte's ambiguous and vaguely disturbing *Paris Street; Rainy Day* (fig. 160) than from Monet's seemingly pleasant *Rue Montorgueil, Paris. Festival of June 30, 1878* (fig. 180) — and they are yet more distant from Manet's or Degas's unremittingly cynical accounts of Parisian people and places.

Hassam's vertical format allows him to enlist elements of the urban scene to create an elegant tapestry, featuring the distant skyscraper, with its roofline lost in the snowstorm. By using this indubitably modern building only as a part of a faraway backdrop, Hassam increases its potential to fulfill his own description of a skyscraper as "more beautiful than many of the old castles in Europe, especially if viewed in the early evening when just a few flickering lights are seen here and there and the city is a magical evocation of blended strength and mystery."[21] Hansom cabs and a trolley car, saplings surrounded by railings, and a few figures trudging in the snow seem embroidered into the web of the city and the weave of the canvas by Hassam's delicate stitches of paint. Like sequins sewn onto lavender fabric, a few lighted windows and shop fronts provide sparkling accents against the dark buildings. These windows, illuminated by electric light, which was still new at the time the picture was painted, offer a subtle contrast to the old-fashioned gas lamps shown along the curb at the left.

The scene is soft and shimmering, a romanticized commentary on the modern city. Although Hassam has probably depicted a specific site—it may be Fifty-ninth Street and Central Park South looking east toward Seventh Avenue[22]—he seems far more interested in urban poetry than in topography. A single overall tone punctuated by brilliant touches of light and evoking the delicate half shadow of the day's end unifies the composition. The image echoes the nocturnes based on urban scenes that Whistler painted beginning in the 1860s and recalls his remarks, made in 1885, on the expressive potential of evening light: "When the evening mist clothes the riverside with poetry, as with a veil, and the poor buildings lose themselves in the dim sky, and the tall chimneys become campanili, and the warehouses are palaces in the night, and the whole city hangs in the heavens, and fairy-land is before us . . . Nature, who, for once, has sung in

tune, sings her exquisite song to the artist alone, her son and master."[23] Hassam adds to twilight another softening element— snow that covers the pavements, suggests the muffling of the city's harsh sounds, and further veils the edges of the forms that the failing light has begun to obscure. Hassam's New York was already a frenetic place, but his image conveys a feeling of serenity, with associations of leisure and pleasure rather than of the competitive struggles of the workaday world.

Executed only two years after the Impressionist view was completed, Henri's *Street Scene with Snow (57th Street, N.Y.C.)* also provides a firsthand account of the mundane elements of contemporary life in a winter storm.[24] By comparison with Hassam's restrained and evocative street scene, it is less aestheticized and more energetic. Snow no longer falls, as it does in Hassam's painting, and so does not soften forms as markedly; here it covers the streets and has become slippery and dirty, inconvenient rather than beautiful. And Henri portrays the snow, as well as other elements in his picture, with a loaded brush carrying thick dollops of viscous paint. The medium itself embodies the vigor of the urban subject, the raw actuality of a New York street, and seems as thick and heavy as the wet snow shoveled by the man shown at the left. Henri places no buffer between the audience and his scene, unlike Hassam, who uses a broad and delicately painted expanse of snow-covered foreground street to distance the viewer from his pedestrians and hansom cabs. Instead, slushy tracks left behind Henri's cab as it retreats up the center of the street pull the viewer into an activated pictorial space. We participate directly in an entirely familiar event—most of us probably have experienced a snowstorm in the city in much the same way that Henri himself, and the pedestrians he portrays hurrying along the sidewalks, did. Painting "is the study of our lives, our environment,"[25] proclaimed Henri, and he demonstrates his faith in that credo here.

Henri's horizontal format takes in a broader urban vista than Hassam presents. Henri gives us more of the city than Hassam does and possibly even reiterates a panoramic movie of 1901–2, *New York in a Blizzard*—a very modern portrayal of modern life.[26] The artist looked east on Fifty-seventh Street from Seventh Avenue toward Sixth, along which ran the spur line of the elevated railway that ended one block to the north; the signal tower of the el appears above the tracks.[27] We are urged into the distance by the convergence of long lines of elegant four-story brownstones on either side of the wide thoroughfare. The rhythmic procession of the houses toward the el in the background is accented by the sequence of their high stoops and is interrupted, at the left, on the north side of Fifty-seventh Street, by the distinctive spire of the old Calvary Church, which pierces the turbulent sky.[28] The Realist's painterly vigor contrasts with the Impressionist's delicacy, but even his picture has a patina of nostalgia. While Hassam had romanticized a modern skyscraper

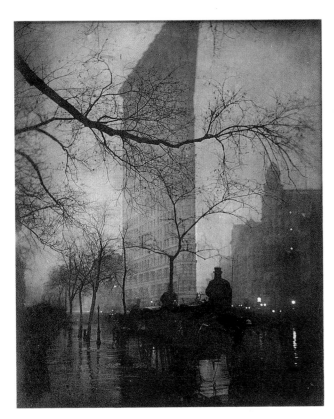

Fig. 7 Edward Steichen. *The Flatiron*, 1904. Gumbichromate over gelatin silver print, 19⅝ x 15⅜ in. (49.8 x 39.1 cm). The Metropolitan Museum of Art, New York, Alfred Stieglitz Collection, 1933 33.43.44

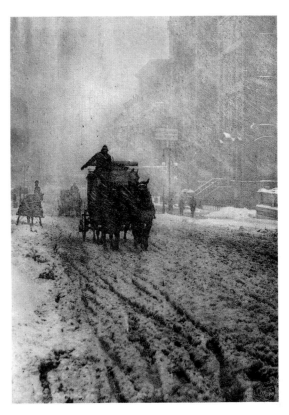

Fig. 8 Alfred Stieglitz. *Winter—Fifth Avenue*, 1892. Photogravure, 8½ x 6 in. (21.6 x 15.2 cm). The Metropolitan Museum of Art, New York, Gift of J. B. Neumann, 1958 58.577.20

by obscuring it with shimmering veils of color, Henri tempers the currency of his more modern street scene by including a neo-Gothic structure that symbolizes long-established religious values. Contrary to what we might expect, Henri announces his link to the past more decisively than Hassam, not only by depicting the church but also by emulating the agitated skies and distant steeples of seventeenth-century Dutch landscapes.

And Henri also shares some of Hassam's gentility through his choice of site, two blocks south of the locale that Hassam may have portrayed. Fifty-seventh Street was flanked by elegant houses that were attracting prominent New York families by the 1880s; as Henri's account of brownstones indicates, the street was still principally residential when he painted it. (It would become known as New York's Rue de la Paix by the 1920s.)[29] The western half of Fifty-seventh Street was also an important cultural center for the city at the turn of the century, for it was home to many artists' studios—including Hassam's and Henri's own[30]—to Chase's New York School of Art, where Henri had begun to teach in 1902, and to the American Fine Arts Society, which housed the Society of American Artists, the Architectural League, and the Art Students League. Carnegie Hall was on the corner of Seventh Avenue, a block away from this exalted area. In depicting refined Fifty-seventh Street, Henri remarks on his own rarefied environment. Like Hassam, he eschews more pointed commen-

tary on urban life, portraying a snowy evening in a genteel neighborhood and ignoring less affluent parts of the city where the poor suffered under midwinter conditions.

Hassam and Henri were not the only artists who portrayed the snowbound city in positive, euphemistic terms. Such photographers as Edward Steichen and Alfred Stieglitz recorded Pictorialist cityscapes (see figs. 7, 8) that share with Hassam's and Henri's nearly contemporaneous paintings a common vision: all are realistic in that they are candid accounts of mundane elements of modern life but romantic in their veiling of those everyday facts and events in snow or steam, twilight or haze.[31] Even Riis—whose photographs and articles are usually far more uncompromising than Realist paintings or Pictorialist photographs in describing the grim facts of city life—saw a silver lining in winter storms. They inspired charity, he said, adding with determined cheerfulness: "I do not believe even an unusual spell of winter carries in its trail in New York such hopeless martyrdom to the poor as in Old-World cities, London, for instance. There is something in the clear skies and bracing air of our city that keeps the spirits up to the successful defiance of anything short of actual hunger."[32] To some degree, as commentators on turn-of-the-century life, Hassam and Henri, Steichen, Stieglitz, and Riis all reinvented reality in a positive light in their art and in so doing typified the American tendency toward euphemism and optimism.

Academics Made Modern

*[I saw a show] of a new school which call themselves
"Impressionalists."... It was worse than the Chamber of
Horrors.*

J. ALDEN WEIR (1877)

*A thing that is finished is dead.... A finished technique
without relation to life is a piece of mechanics, it is not a
work of art.*

ROBERT HENRI (1910)

After only fifteen minutes J. Alden Weir fled the 1877 exhibition of the French Impressionists in Paris. He wrote home, "[I saw a show] of a new school which call themselves 'Impressionalists.' I never in my life saw more horrible things.... They do not observe drawing nor form but give you an impression of what they call nature. It was worse than the Chamber of Horrors."[33] Thus he expressed the conservative resistance to the new painting shared by many artists of his generation, both American and European, as they completed their academic training and launched careers, aspiring to critical and commercial success. Although they decried the French Impressionists' rejection of academic standards at first, Weir, Robinson, Twachtman, and other painters who returned to the United States after studying abroad eventually synthesized an American Impressionist style. They joined the broken brushwork and light palette of French Impressionism to a strong academic armature and, like the French Impressionists, found their subjects in everyday experience.[34]

The American Realists, who emerged after 1900, built upon their predecessors' commitment to making art about life, but they eschewed the Impressionists' technical virtuosity and denigrated their efforts as art for art's sake. Their urge to replace the polite aristocratic themes of the Impressionists with a dark urban subject matter and their espousal of progressivist doctrine we have already mentioned. The American Realists' challenge was visual as well as ideological. They favored strong, coarse brushwork and simplified forms in rejection of academic finish and of the controlled feathery stroke used by the American Impressionists. As we have noted, they employed a somber palette that banished the American Impressionists' bright, cheering colors and high key. They adopted such bold and startling compositional formats that it is easy to see how their paintings affronted viewers accustomed to more conventional pictures. They were able to repudiate much that was traditional, in part because their academic training was limited compared with that of the American Impressionists, yet they were willing to draw inspiration from older art.

Finally, the Realists proposed that expression of palpable emotion should take precedence over any concern for style, especially as it related to the finish they disdained. Declared Henri in 1910: "A thing that is finished is dead.... A thing that has the greatest expression of life itself, however roughly it may be expressed, is in reality the most finished work of art. A finished technique without relation to life is a piece of mechanics, it is not a work of art."[35] With such pronouncements Henri and his colleagues reordered the priorities of the previous generation. For them "art that expresses the *spirit* of the people of today" was the only necessary art.[36] "Art cannot be separated from life," said Henri. "It is the expression of the greatest need of which life is capable, and we value art not because of the skilled product, but because of its revelation of a life's experience."[37]

A comparison of Hassam's *At the Florist* (fig. 9)[38] with Sloan's *Easter Eve* (fig. 10) suggests aspects of the relationship of American Impressionism and Realism to modern French painting; it illustrates as well the continuities and contrasts between the two schools, in particular demonstrating that the Impressionists manifested a greater concern with academic foundations than did the Realists who followed them.[39] Rather than painting a celebration of Flora or an allegory of Spring, such as an academic might have invented, both artists depict flower shops, ordinary fixtures of bourgeois commerce. The two canvases address the remoteness of city dwellers from unspoiled nature, a central issue of urban existence that engaged painters of modern life in France and the United States.

Both Hassam and Sloan let an incidental transaction—the sale of hothouse flowers—stand as a visual metaphor for the commodification of nature in the city and for the transformation of nature from a necessity into a luxury. Although they eschew the pointed narrative we would expect from an academic painter, both artists convey a message by presenting a mixture of types and classes, subtly reminding the viewer that not all city dwellers could afford to refresh their urban surroundings with purchased floral arrangements. Both base their pictures on personal observation: Hassam's serene Parisian tableau is distilled from the kind of picturesque exchange that he could have witnessed near his Montmartre studio at 11, boulevard Clichy; Sloan's subject is a New York flower shop across the street from his home at 165 West Twenty-third Street.

Hassam juxtaposes two women of distinctly different circumstances in *At the Florist*. A flower vendor who wears an old-fashioned peasant cap and is enfolded in a crisp white apron, in the same way that her bouquets and potted plants are wrapped in white paper coverings, gathers up pots of primroses and azaleas selected by a customer in up-to-date urban street dress. The country-city juxtaposition provided by the contrasting garb of the two women is reinforced by the telling counterpoint of the

living plants held by the vendor and the artificial flowers on her patron's hat. Like the urbanite who has given up direct contact with nature, the plants and bouquets that are for sale—the rose tree on the right and the wrapped pink and purple azaleas on the left, for example—have been adapted to the city, pruned to standards, subjected to the attention and manipulation of gardeners.[40] The customer tilts her head; perhaps she considers adding to her purchases the potted yellow primrose held up by the small child at the left. Although the child and the two figures behind her wear white caps like that of the aproned flower seller, the relationship among these three women and the little girl is as ambiguous as are the circumstances and identity of the solitary shopper, and the picture is open to multiple interpretations.

Sloan's *Easter Eve* parallels Hassam's *At the Florist* in its focus on feminine pursuits and avoidance of straightforward narrative. In Sloan's painting the woman shopping for flowers is accompanied by a top-hatted male companion. She reaches for the lilies she has chosen, in a gesture that is echoed by the open hand of the flower vendor. The only clear human relationship is grounded in this transaction, for Sloan does not tell us how the man and woman are connected to each other. The three figures form a tight group, sheltered from the rain under an open umbrella. Another woman, who is unaccompanied, looks on at the vignette, while a second top-hatted man, walking out of the picture space on the left, ignores it. In contrast to Hassam's static tableau, Sloan offers what seems like a fleeting moment observed in the city, although his painting, like Hassam's, was executed in the studio. The scene takes place in New York, but a sign with the French word *café*, made prominent in a rectangle of yellow light, stirs associations with France, and by extension, with the French art—perhaps the café scenes of Manet and Degas—that nourished Sloan.

Sloan's figures embody a detachment that the artist himself seems to have felt as he observed this modern moment. In 1907, three days before Easter, Sloan wrote in his diary: "I saw an idea for a picture in the Flower Shop across the way. Stock out in front and open all night on account of Easter."[41] Two years earlier a writer for *Harper's Weekly* had described the "great outpouring" of Easter flowers: "The churches are filled with them, the worshippers wear them, friends send them to one another, one sees them in the streets and in the windows of dwellings. Everyone who feels the Easter spirit and can lay hands on a flower keeps the flower in sight in evidence of sympathy with the prevailing sentiment."[42] But Sloan, who referred to this canvas simply as "the Flower Stand picture" in his diary, did not share "the prevailing sentiment." He wrote of his Easter Sunday that year with evident cynicism: "While out for papers as usual, I stopped on Fifth Avenue and stood for nearly an hour watching the Easter dressed throngs coming from their honorable Easter

services—very funny humans. I didn't feel at all one of them, just then."[43]

Sloan casts himself here in the role of *flâneur*—the neutral observer of contemporary life who keeps his engagement artfully hidden. That a modified version of this role was possible for Sloan and the other American painters of modern life is illuminated by Charles Baudelaire's exquisite insight: "For the perfect *flâneur*, for the passionate spectator, it is an immense joy to set up house in the heart of the multitude, amid the ebb and flow of movement, in the midst of the fugitive and the infinite."[44]

At the Florist is a conservative essay by Hassam, who often was more adventurous; as such it reminds us that he and his colleagues painted hybrids, emphasizing to varying degrees at different times the academic or Impressionist component of their styles. Immersed in traditional techniques, they sometimes produced pictures that are distinguished from works by the American academics who were their contemporaries only by an Impressionist veneer. *At the Florist* is a case in point: while Hassam uses the Impressionists' high-key chromatic palette in the painting, he retains a strong academic scaffolding, including the firm outlines and crisp drawing associated with academic methods. Although an experienced draftsman, with skills honed in illustration, Sloan, by contrast, flouts the academic canon with his painterly style in *Easter Eve*, sacrificing detail to patterns of light and shade, summarizing the specifics of anatomy and physiognomy. Hassam devises a traditional stagelike space, measured off with paving blocks and diagonal puddles, across which he strings his principal elements in a shallow stately frieze. Sloan, on the other hand, abruptly disposes arrhythmic patches of light and dark to convey a far greater sense of action, one more strategy in the complex of expressive and stylistic continuities and contrasts that makes his painting and Hassam's paradigmatic of the relationship between the American Impressionists and Realists.

The degree to which academic procedures are evident in the works of the American painters of modern life generally reflects the extent of their exposure to or detachment from Beaux-Arts instruction. Beginning in the 1860s the ambitious program at the Ecole des Beaux-Arts in Paris, the prestigious government-sponsored academy, established the standard for artistic practice not only in private schools that began to flourish in the French capital[45] but also ultimately in the United States. American painters, who had always been responsive to European influences, started to go abroad in the 1870s in huge numbers, usually to Paris, to learn their craft. Aspiring painters who had scraped together precious funds for limited foreign schooling followed their teachers' advice to visit the Louvre to study the old masters and to emulate the Salon stars. One conservative American pupil, H. Siddons Mowbray, recalled that "the Beaux Arts students regarded their school as the sole rampart against realism,

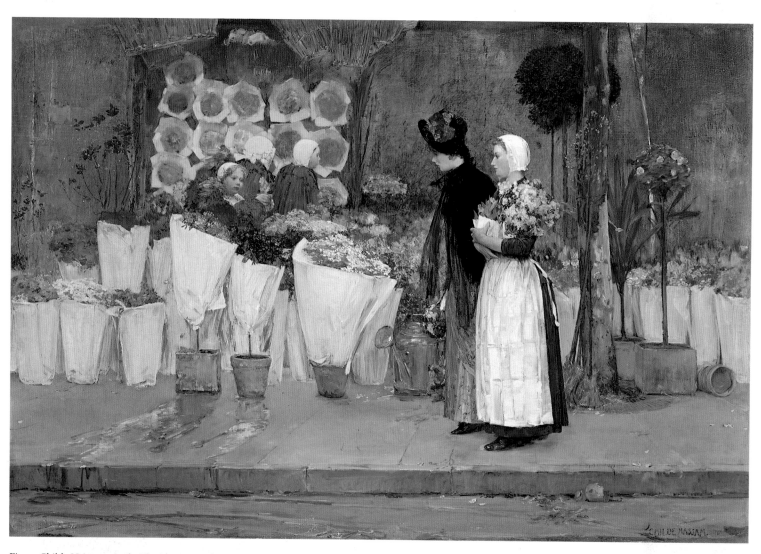

Fig. 9 Childe Hassam. *At the Florist*, 1889. Oil on canvas, 36¾ x 54¼ in.
(93.4 x 137.8 cm). The Chrysler Museum, Norfolk, Virginia, Gift of
Walter P. Chrysler, Jr. 71.500

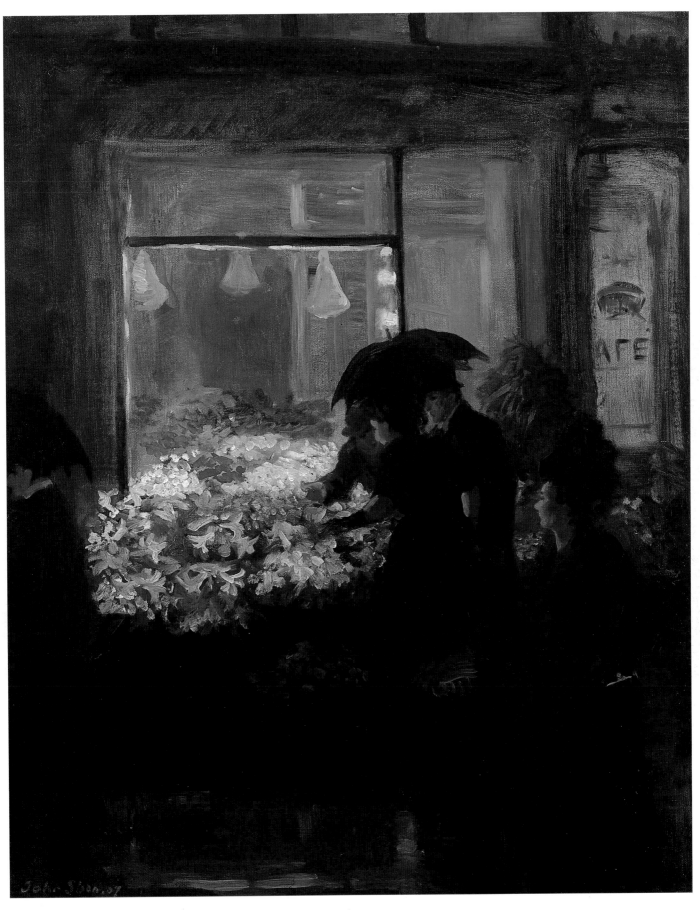

Fig. 10 John Sloan. *Easter Eve*, 1907. Oil on canvas, 32 x 26 in. (81.3 x 66 cm).
Collection of Deborah and Edward Shein

Fig. 11 J. Alden Weir. *At the Water Trough*, 1876–77. Oil on canvas, 17¼ x 14¼ in. (43.8 x 36.2 cm). National Museum of American Art, Smithsonian Institution, Washington, D.C., Museum Purchase 1978.125

impressionism and other vagaries of a rebellious nature."[46] "The Americans come over here, and what do they admire?" complained George Moore as late as 1886. "Is it Degas or Manet? No, Bouguereau and Lefebvre."[47]

At the Water Trough (fig. 11), completed by Weir at about the same time he penned his denunciation of Impressionism, reflects the lessons of his student years in Paris and testifies to the accuracy of Moore's lament. With an academic's disdain for the familiar, Weir chose a picturesque glimpse of Spanish life as his subject, presenting it in the same way that his Beaux-Arts teacher, Jean-Léon Gérôme, had portrayed an exotic courtyard in *The Draughts Players* (fig. 12). Weir's pyramidal group of graceful peasants on a shallow foreground stage filled with diverting props closely mimics Gérôme's composition and depends upon

careful notes and travel sketches that he refined back in his Paris studio, working from Latin models hired for additional study.

Even in the late 1880s in works by the Americans in Monet's circle, traces of academicism could still be found. An example is *La Vachère* (fig. 13), painted by Robinson on a monumental Salon scale the year after he became Monet's neighbor at Giverny. Here the American constructs an organized space according to a classical arrangement of carefully drawn solid forms, over which he lays a veneer of Impressionist color in broken strokes. Robinson was reluctant to renounce academic attitudes with respect not only to scale, composition, and form but also to subject choice—he shows a charming Frenchwoman of the type that Daniel Ridgway Knight, Charles Sprague Pearce, and other American and French painters of peasants habitually depicted in more conservative styles.[48]

Fig. 12 Jean-Léon Gérôme. *The Draughts Players*, 1859. Oil on poplar, 16 x 11¼ in. (40.6 x 28.6 cm). The Wallace Collection, London

Fig. 13 Theodore Robinson. *La Vachère*, 1888. Oil on canvas, 86⅜ x 59⅝ in. (219.4 x 151.4 cm). The Baltimore Museum of Art, Given in Memory of Joseph Katz by His Children BMA 1966.46

The new movement in painting that would be dubbed Impressionism attracted little notice from American art students who were in Paris in the 1870s and 1880s; even the future American Impressionists, most of whom were in the French capital during the controversial heyday of the style, paid scant attention to the exhibitions of the radical group. But these avant-garde displays on the grand boulevards near the Opéra were as remote from the Latin Quarter and Montmartre art schools as the French modernists' lively technique and engagement with contemporary life were from academic lessons. Weir's caustic assessment of the 1877 exhibition is one of the few reactions to the Impressionist revolution by nineteenth-century American painters in Paris that have been found. Only one American, Cassatt, participated in the Impressionist exhibitions (she showed in four, from 1879

to 1886). Not until French Impressionism lost its radical edge and was validated in the art marketplace of the late 1880s—especially by American patrons—would Weir, Twachtman, and other Americans who had studied abroad and had by now returned home adopt the palette and procedures of the style.

In the United States interest in French Impressionism began to emerge in the late 1870s and grew stronger throughout the 1880s and 1890s.[49] Henry James reviewed the second Impressionist exhibition for the *New York Tribune* in 1876, uttering the usual complaints about portrayals of the commonplace: "The effect of it was to make me think better than ever of the good old rules which decree that beauty is beauty and ugliness ugliness."[50] In 1878 Louisine Elder, the future Mrs. H. O. Havemeyer, lent Degas's pastel *Rehearsal of the Ballet* (fig. 14), which she had

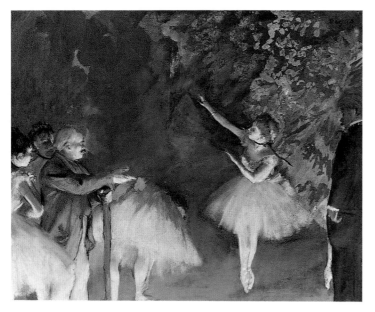

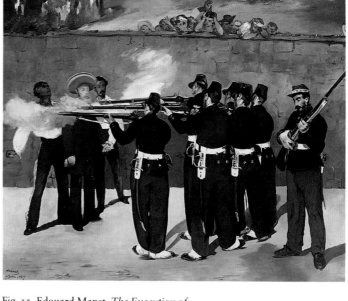

Fig. 14 Edgar Degas. *Rehearsal of the Ballet*, ca. 1876. Gouache and pastel over monotype on paper, 21¾ x 26¾ in. (55.2 x 67.9 cm). The Nelson-Atkins Museum of Art, Kansas City, Missouri, Purchase, the Kenneth A. and Helen F. Spencer Foundation Acquisition Fund F73–30

Fig. 15 Edouard Manet. *The Execution of Maximilian*, 1868–69. Oil on canvas, 8 ft. 3¼ in. x 9 ft. 10½ in. (2.4 x 3 m). Städtische Kunsthalle, Mannheim M 281

purchased with Cassatt's advice in 1877, to the American Water Color Society annual (where it was greeted with limited enthusiasm). In 1879 the Impressionists were brought to the attention of American readers through a comprehensive but skeptical account in *Lippincott's Magazine*.[51]

Manet was the first painter associated with Impressionism to receive extensive critical notice in the United States. His *Execution of Maximilian* (fig. 15) was lauded for its originality when it was shown in New York and Boston in the winter of 1879–80, and he was cited for his alliance with Zola and literary naturalism.[52] All commentary was not positive, however. For example, painter Kenyon Cox, a rabid defender of academic standards, carped about the poor technique in Manet's *Boating* (fig. 17) in a review of the 1879 Salon exhibition for his hometown newspaper, the Cincinnati *Daily Gazette*.[53] Although Manet continued to be berated by certain American critics for lapses of taste and craft, he was becoming increasingly familiar to collectors, artists, and even the general public. In 1881 Weir, assisted by Chase, helped New York collector Erwin Davis acquire Manet's *Boy with a Sword* of 1861 and *Woman with a Parrot* of 1866, both of which Davis gave to The Metropolitan Museum of Art in 1889.[54]

In the 1880s several exhibitions stimulated interest in the new French painting, especially in New York and in Boston; the latter had no entrenched academic tradition and was more receptive to Impressionism at an earlier date than was any other American city. Seventeen canvases by Pissarro, Renoir, Alfred Sisley, and Monet, offered by the Parisian dealer Paul Durand-Ruel, were

among the many pictures shown in Boston by the Foreign Exhibition Association in 1883. At the end of the same year the *Pedestal Fund Art Loan Exhibition*, whose organizers were guided by Chase, presented New Yorkers with examples of the new painting, which received the same sort of mixed reviews that had greeted Impressionist works in Boston.[55]

Durand-Ruel increased public awareness of the French Impressionists when, at the invitation of James F. Sutton of the American Art Association, he brought a huge number of their works to New York in 1886, the same year that the group held its last joint exhibition in Paris.[56] Among the 290 paintings and pastels in Durand-Ruel's display were dozens of works by each of the leading painters—including 48 by Monet and 42 by Pissarro. As one critic exclaimed, they represented "virtually an entire school of art . . . transported bodily from one country to another."[57] Extensive commentary on the presentation heralded widespread interest in Impressionism, which would now be covered in the popular press as well as in art journals. Sales of paintings from the exhibition also suggested that American collectors were ready to support radical art.[58] Durand-Ruel obliged prospective buyers by opening a gallery in New York in 1888 and by mounting monographic and group exhibitions of most of the leading French Impressionists there. The pioneering American patrons—the Havemeyers, Davis, and Alexander Cassatt, the painter's brother—were joined by less prescient collectors, such as Albert Spencer and William H. Fuller, who turned from academic and Barbizon painters to the French Impressionists with the ardor of converts.[59]

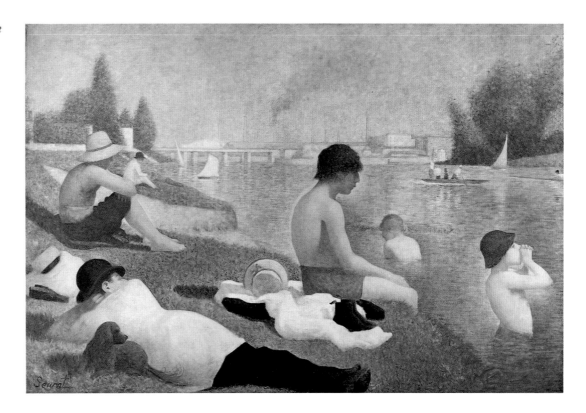

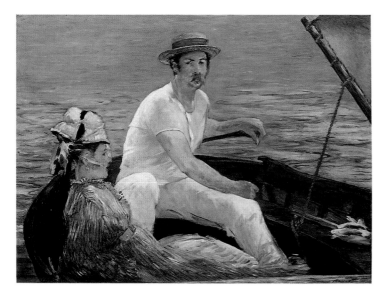

Fig. 17 Edouard Manet. *Boating*, 1874. Oil on canvas, 38¼ x 51¼ in. (97.2 x 130.2 cm). The Metropolitan Museum of Art, New York, H. O. Havemeyer Collection, Bequest of Mrs. H. O. Havemeyer, 1929 29.100.115

The growing commitment of these patrons to Impressionism soon encouraged American painters to investigate the style.

Critics for most newspapers and journals renounced their conservative antipathy to the new idiom reluctantly.[60] William Howe Downes groused that French Impressionist paintings had "the same impossible and painty texture of an old piece of tapestry."[61] An Impressionist painting was not "what we are in the habit of regarding as a finished picture," according to Roger Riordan.[62] One acerbic writer likened Georges-Pierre Seurat's *Bathers at Asnières (Une Baignade, Asnières)* (fig. 16) to "an early Italian fresco" and suggested that "if placed at the top of Trinity steeple and viewed from Wall Street Ferry it might look very well."[63]

The French Impressionists' high-key and chromatic palette seemed discordant to American viewers. "Some of the colors here do not cry, they yelp," quipped a *New York Times* critic of the 1886 Durand-Ruel display.[64] The palette was considered distorted as well as glaring. "Some of them . . . ," observed Theodore Child, "have a tendency to see blue everywhere, and allow their ruling passion to cast a sympathetic azure over rural nature."[65] The mundane subject matter also provoked complaints from audiences accustomed to academic renderings of myths, literary stories, historic events, and exotic scenes. Monet's works displayed "the common fault of impressionistic painting" for one disgruntled writer. "After a first feeling of surprise at the verity of the *impression*, there is nothing more to hold one's attention," he lamented.[66]

American critics preferred the French Impressionists' views of nature to their figure studies, likening the landscapes to "the feminine principle" and the figures to the masculine.[67] A commentator on the Durand-Ruel exhibition of 1886 mused: "The complex problems of human life which make the figure subjects so terrible in their pessimism and seem to fill the air with cries of uneasy souls, have no part in the landscapes. These are wholly lovely, with the loveliness of repose and the tenderness of charity. They are full of a heavenly calm."[68] American critics, loath to approve radical treatment of the exalted figural mode, deemed landscape the most appropriate subject for Impressionist interpretation; in this assessment they were influenced by academic standards, which esteemed figure painting over landscape. Similarly, painters who had devoted years to mastering academic portrayal of the human form were reluctant to adopt Impressionism for figure studies; they found landscape more acceptable for experimentation and innovation. The American Impressionists' selective restraint in regard to subject matter can be demonstrated in a single canvas: Tarbell's *In the Orchard* (fig. 18) shows lifesize figures, with strong academic residues of careful drawing and modeling, inhabiting a brilliantly colored landscape, loosely and expressively brushed.

The degree of its practitioners' devotion to or liberation from academic principles determined the development of American Impressionism, as we have seen. Chase, for instance, was the first major artist to espouse Impressionism in the United States. Trained in Munich and deeply influenced by the direct style of Wilhelm Leibl, Gustave Courbet's friend and alter ego, Chase was relatively detached from Beaux-Arts prejudices. He seems, therefore, to have found it easier than his Parisian-trained compatriots to become a painter of modern life. By 1885, when being a modern artist meant depicting contemporary subjects freshly in the open air, Chase produced modern views of New York's Central and Prospect parks. His accomplishment in these park scenes, which changed the focus of American painting from academic universality to American vernacular experience, coincides with that of Mark Twain in the realm of literature, specifically in his *Adventures of Huckleberry Finn* in 1884.

A few years later young American painters in France began to free themselves from the constraints of their Beaux-Arts training and to embrace French Impressionism. Robinson, Metcalf, Wendel, John Leslie Breck, and other Americans who had studied in Paris were attracted to Giverny (see fig. 80); they were drawn not only by the charms of this rural village on the banks of the Seine but also by a wish to work outdoors in the presence of the by then celebrated Monet, who would soon be painting his most nationalistic works.[69] When they returned to the United States, these acolytes of Monet, as well as Hassam and other Americans who had learned the fundamentals of Impressionism in France in the late 1880s, became important conduits of the style to their

compatriots. They now stimulated the conversion to Impressionism of more painters, Weir and Twachtman among them. The lessons of the repatriated artists were reinforced by accounts of Monet by Boston painter Lilla Cabot Perry and other enthusiasts and, of course, by the growing number of French Impressionist paintings that could be seen in American collections and exhibitions. In addition to the displays of advanced art mounted at Durand-Ruel's New York gallery, monographic and group shows of French Impressionism were held through the 1890s at such private clubs as New York's Union League and Boston's St. Botolph. American Impressionists spread the style further by showing their own works in group and solo exhibitions at commercial galleries and private clubs.[70] The World's Columbian Exposition of 1893 was a key event in the ratification of Impressionism on American soil. By the 1890s the Society of American Artists and even the National Academy of Design were hanging American Impressionist pictures, albeit without much enthusiasm. In 1897, frustrated by the mere scattering of their paintings accepted in the society's exhibitions and pursuing a more sympathetic and harmonious setting for the display of their works, a group that called themselves Ten American Painters or The Ten seceded from the society.[71] In 1898 The Ten opened an exhibition at New York's Durand-Ruel Gallery, initiating a series of annual presentations that would showcase American Impressionism for twenty years. The Ten included the well-established and successful Hassam, Weir, Twachtman, Metcalf, Simmons, Tarbell, Benson, and Chase (who replaced Twachtman after that artist's death), as well as others whose commitment to Impressionism was either slight or episodic.

The American Impressionists did not achieve immediate commercial success. They suffered from comparison, not only with their academic French mentors and more conservative fellow Americans but also with the more easily understood Barbizon painters, as well as with the increasingly esteemed French Impressionists. The American Impressionists were perceived as pale reflections of their French predecessors. "A good Monet is worth money; an imitation is worth nothing," observed art critic Alfred Trumble, who added, "Originality is immortal. Imitation does not outlive its generation, if it lives as long."[72] Moreover, the few dealers who were established in major American cities favored European over American art. As a result, such painters as Robinson and Twachtman, among the earliest and most daring practitioners of American Impressionism, eked out meager incomes (often less than a thousand dollars a year) from the rare sales of their paintings; following Robinson's death in 1896 and Twachtman's in 1902, important works remained in their studios and were disposed of in estate sales.[73] Many resorted to public auctions to find buyers—Chase's less than successful studio sales, held in 1887 and 1896, are notable cases in point. It was not until William Macbeth opened his New York gallery in 1892 that a dealer

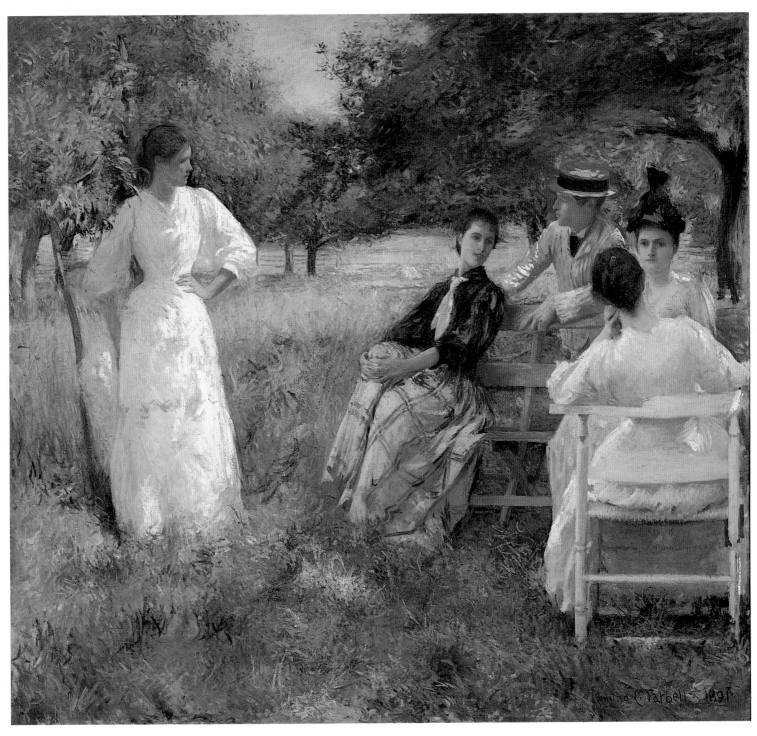

Fig. 18 Edmund C. Tarbell. *In the Orchard*, 1891. Oil on canvas, 60¾ x 65½ in.
(154.3 x 166.4 cm). Daniel J. Terra Collection 1.1992

committed himself to American art exclusively. Interestingly, Macbeth's efforts spanned both generations under consideration here: for he promoted not only the work of the Impressionists—giving Robinson the single retrospective show mounted during the artist's lifetime, for example—but also that of the Realists after the turn of the century.[74]

A few prescient New York and Brooklyn patrons, notably John Gellatly, George A. Hearn, Frank L. Babbott, Samuel T. Shaw, and H. Wood Sullivan, who occasionally purchased American Impressionist works in the 1890s and early 1900s, were joined after 1900 by a second generation of collectors who showed interest in the style, Alexander Morten and William T. Evans, Hugo Reisinger, and Charles Van Cise Wheeler among them.[75] In Boston the Impressionists received perhaps more consistent support from such fellow painters as Perry, Ross Turner, Dwight Blaney, and Sarah Sears, as well as from prominent art collectors Isabella Stewart Gardner and David and Benjamin Kimball.[76] Few institutions offered early encouragement to the American Impressionists, however. After The Metropolitan Museum of Art declined the gift of Robinson's *Port Ben, Delaware and Hudson Canal* (fig. 54) from the Society of American Artists in 1898, this picture was presented to the Pennsylvania Academy of the Fine Arts, which distinguished itself as a pioneer collector of examples of the style, albeit largely in the early 1900s.[77] By the second decade of this century purchasers of Impressionist works became more numerous and more diverse. Public acceptance of the movement reached its zenith at the Panama-Pacific International Exposition, held in San Francisco in 1915; many leading American Impressionists won medals and several were honored with large retrospective displays, but already their supremacy was being encroached upon by new artistic developments.[78]

When the American Realists began to issue their challenge after 1900, Impressionism, whether French or American, was no longer radical. After a few years of activity, the exhibitions of The Ten had become rather routine forums for casual contributions, as the group's collective dissident edge steadily dulled. Such former rebels as Chase and Hassam were now established artists, at the helm of exhibition juries and art organizations. The American Impressionists' simultaneous accommodation of academic rigor and plein-air directness had transformed the ways in which art was taught, exhibited, and perceived. American art schools emphasized painting, not just drawing, and the vogue for outdoor summer classes was by now widespread.[79]

The future American Realists benefited not only from new curricula in the schools but also from new opportunities to see paintings that ranged from old-master canvases to contemporary works. In the years following the 1876 Centennial Exhibition, industrial and economic growth had made Americans eager to show concern for more than money-making by acquiring cultural status.[80] Consequently, new art museums were founded,

and growing numbers of exhibitions were held by industrial fairs, old and new artists' organizations, special-interest groups devoted to less familiar media, and art associations established in cities throughout the United States, with the result that art displays became more accessible and art appreciation flourished.[81]

Because they had been immersed in a newly energized art milieu and for the most part had begun their careers as painters at home, the future American Realists could go abroad to enrich their experience without undertaking extensive formal study there. By the time they arrived in Europe, most of them were already working as artist-journalists, honing their observational abilities and their skills in rapid rendering. The contemporary scene, grist for their illustrations, now would become the principal subject of their paintings done abroad. Upon their return home, they would find twentieth-century American life to be fertile artistic territory.

Back in the United States the Realists also found adequate financial support for their efforts.[82] Most of them earned fairly secure incomes from a combination of sources: illustrating for newspapers and magazines, teaching, painting on commission, and selling paintings through the dealers, especially Macbeth and, in Shinn's case, Boussod, Valadon and Company. Macbeth was particularly important in promoting American art in general and the work of most of the Realists in particular. He took their paintings for sale on consignment, lent them money against the security of their works, lauded them in *Art Notes*, the magazine his gallery published, encouraged collectors to invest in their art, offered his gallery as a meeting place for them, and, in 1908, hosted the landmark exhibition of The Eight. Those who purchased paintings by the American Realists at Macbeth's or elsewhere were most often men involved in modest business enterprises in small cities who came to New York to shop for art that accorded with their generally conservative taste; these were Americans of the sort who would populate the novels of Sinclair Lewis in the 1920s.

The Realists were a commercially enterprising group, deliberately seeking a beachhead for their American painting of modern life in the new century in addition to personal repute and recompense. Henri, for example, a great self-promoter, not only taught, as many of his fellow Realists did, but also accommodated a stream of the kind of portrait sitters who, a decade earlier, might have patronized Chase. Shinn, a prolific pastelist as well as a painter in oils, produced murals for David Belasco's Stuyvesant Theatre. Both he and Glackens had married well—and in Shinn's case often—enough to preclude any serious financial problems. In addition to following his own muse as a painter, drawing for magazines, and teaching from time to time, Bellows executed portraits on commission and set up a lithography press in his studio, establishing a lucrative printmaking enterprise. He and most of his Realist colleagues may not have become rich, but

they seem to have enjoyed steady incomes, to have had comfortable studios and homes, and to have owned summer houses or, at least, to have taken extended vacations. None of them lacked the resources to nourish their bodies and spirits at the restaurants, cafés, and theaters that also nourished their paintings.

Loving the Home Things More

American art must be developed by the artists in happy sympathy with American surroundings, and supported by a public loving the home things more than imported foreign sentiment.

CHARLES FRANCIS BROWNE (1894)

As I see it, there is only one reason for the development of art in America, and that is that the people of America learn the means of expressing themselves in their own time and in their own land.

ROBERT HENRI (1910)

What made the American Impressionists American in the 1890s was not *how* they painted—their use of an academic armature conjoined with Impressionist color and broken stroke continued to be doubly French—but *what* they painted: subjects that were specifically, self-consciously, intentionally American. The best of the American Impressionists did not imitate motifs their mentors might have found in France; rather they chose subjects charged with a national spirit. Their responses to the native landscape and the new urban scene found favor not only because they were genteel, familiar, sunny subjects but also because they offered an antidote to the internationalist tendencies of the 1880s without challenging too forcefully the established academic canon. It is probable that the American Impressionists' stylistic cautiousness, a residue of their academic training, was reinforced by their desire to be true to the sites and subjects that they portrayed.

Nationalism intensified among the Realists, who built upon their predecessors' pattern of creating, displaying, and selling scenes resonant with American pride. Thus, Henri echoed the new nationalism of Presidents Theodore Roosevelt and William Howard Taft and insisted that "the people of America learn the means of expressing themselves in their own time and in their own land."[83] Both groups of painters manifested their love of America through their subjects, but the subjects they chose were often different—for they focused primarily on the country or the city according to their generation, as we have said. And both groups responded to the new realities of modern life in turn-of-the-century America, sometimes by inclusion, sometimes by exclusion.

The American Impressionists were particularly captivated by scenes of life in rural New England, which struck them as comfortable, picturesque, and full of rich and sympathetic historical associations that offered reassurance in a time of bewildering change.[84] Their attraction to the area echoed the tendency of American thinkers of the 1890s to "put a seal of approval on almost every aspect of Puritanism" and hold it up as an ideal for the volatile present, as Warren Susman has written.[85] An interest in this locale and its heritage was probably inevitable for landscapists Breck, Bunker, Hassam, Metcalf, Robinson, and Simmons and for figure painters Benson and Tarbell, who all had New England roots; for Twachtman, Weir, and Wendel, an association with New England was more recent but equally deep.

The patina of age visible in New England seems to have encouraged Weir to address the topic of local industry, which, together with the industry proliferating throughout the country, had profoundly altered the face of the United States since the Civil War. In a series of paintings from the 1890s he chose to portray not a booming industrial metropolis but an old, prosperous manufacturing town not far from Windham, Connecticut, where his wife's family had a country home. *The Factory Village* (fig. 19)[86] depicts the Willimantic Linen Company. Willimantic was located strategically where two rivers meet to form the headwaters of a third; it had the waterpower that allowed many New England villages to develop industry. After the War of 1812 suspended commerce with England, domestic production of textile goods increased and textile mills became so numerous in the area that a writer for the *Windham Herald* quipped: "Are not the people running *cotton mill mad*?"[87] As important connections with the New York and New England Railroad Company were established by the 1890s and more and more factories began to operate in Willimantic, the town expanded, and its population nearly tripled between 1870 and 1890.[88]

Founded in 1854, the Willimantic Linen Company was absorbed by the American Thread Company[89] a year after Weir painted *The Factory Village*. The firm originally had manufactured linen goods, but when the Crimean War stopped imports of flax in the 1850s, it turned to the production of thread from native-grown cotton. English competitors had predicted that Connecticut thread manufacturers would be hampered by the dry climate, but the Willimantic Linen Company so successfully overcame that problem with controlled humidifying devices that its solution was hailed as an example of "Yankee genius."[90]

The Factory Village may not illustrate Yankee genius, but the painting does celebrate a characteristic New England phenomenon—picturesque river-valley industry—and describe its integration with nature. In his choice of subject and pastoral composition, Weir recalls the spirit of such artists as Frederic E. Church, John William Hill, and John Henry Hill, who had earlier portrayed mills and foundries in New England and along the Hudson River. Weir places the factory at the center of a lush

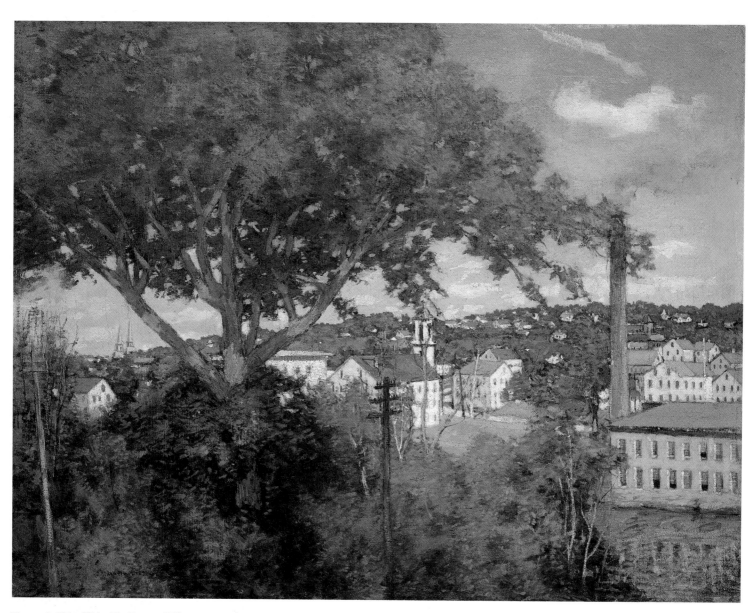

Fig. 19 J. Alden Weir. *The Factory Village*, 1897. Oil on canvas, 29 x 38 in.
(73.7 x 96.5 cm). The Metropolitan Museum of Art, New York, Jointly owned
by The Metropolitan Museum of Art (through Gift of Cora Weir Burlingham)
and The Weir Farm Heritage Trust, Inc., 1979 1979.487

Fig. 20 George Luks. *The Butcher Cart*, 1901. Oil on canvas, 22 x 27 in. (55.9 x 68.6 cm). The Art Institute of Chicago, Friends of American Art Collection 1941.825

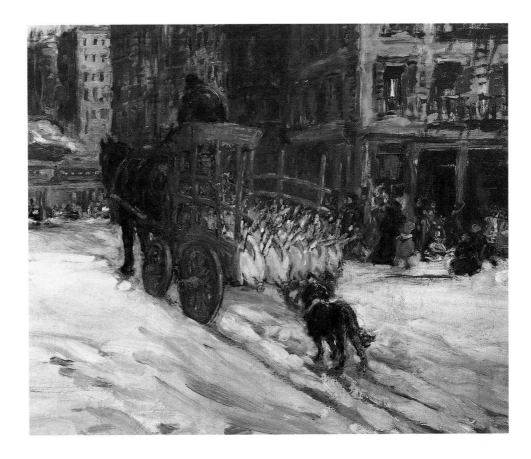

landscape, visually embodying the prevailing idea that America was different from Europe, offering fresh fields where seemingly insurmountable problems could be conquered by energetic, inventive minds (optimistic thinking that would be reiterated by waves of immigrants). In the typical fashion of the American Impressionists, Weir offers the viewer no visual evidence that he knew about the immigrant labor problems experienced by the Willimantic Linen Company in the 1880s or that he was aware of the economic downturn faced by local manufacturers and workers in 1897, when he painted his picture.[91]

In 1901, four years after Weir depicted the thread factory, Luks recorded his quintessentially Realist glimpse of *The Butcher Cart* (fig. 20). Unlike Weir's unremittingly euphemistic industrial scene, this dark view of a slushy Manhattan street near the elevated railway frankly acknowledges technological ingenuity, class stratification, and the facts of hard labor. But the image is more positive and expressive of nationalistic sentiment than it might appear at first glance, as a comparison with a slightly earlier street scene filled with hopeless characters (fig. 21) by a European, Jules Adler, reveals.

Luks shows us a man making his living hunched over the reins of a horse-drawn cart. The man might or might not be a recent immigrant, but he probably belongs among the ranks of urban poor. Nonetheless, he is working, not loitering about or begging— or, like any of Adler's displaced rural workers in Paris, trudging

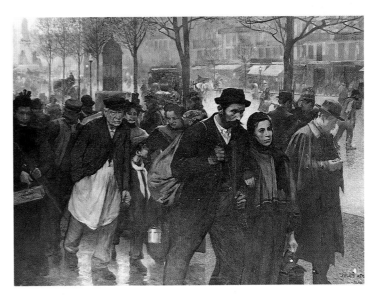

Fig. 21 Jules Adler. *Les Las (The Weary)*, 1897. Oil on canvas, 71 x 98½ in. (180.3 x 250.2 cm). Musée Calvet, Avignon

to a miserable job. And there are hints of progress and energy in Luks's painting. He juxtaposes the old-fashioned cart with the modern elevated railway; a puff of steam suggests that a swiftly moving train has just passed. The multistoried buildings in the background remind the viewer that the skyscraper was an American innovation developed contemporaneously with the growth of mass transportation. Somber as the picture is, it avoids Adler's social-realist propaganda and expresses urban abundance as well as vitality. A load of butchered pigs on his cart separates the driver from the throng on the sidewalk. Central among the crowd is a woman in black, accompanied by a small child with a white scarf; these two are better off than the driver, and they seem to be shopping. Even the dog following the cart wears a collar and appears to be well cared for, not a starving stray. Luks delivers not just a cartload of meat but also a message: America is a land of opportunity, but hard work is required to reap the rewards it offers.

The national pride expressed in the works of the American Impressionists and Realists stands out clearly as a new departure when it is viewed against the extreme internationalism of American art that prevailed through the late 1880s. After the Civil War the defining trait of American taste was an appreciation for contemporary European art, especially for French academic and Barbizon painting. American patrons built collections of impressive size, remarkable cost, and surprising uniformity in cities throughout the United States. The popular press often reported on record-setting prices paid by such collectors as department store magnate Alexander Turney Stewart of New York or railroad president William T. Walters of Baltimore, who eagerly accumulated paintings by Adolphe-William Bouguereau and Gérôme, Jean-François Millet and Camille Corot, along with other French artists who had claimed the spotlight in the Salons.[92]

During this period of cosmopolitan striving, the large majority of painters and art writers alike denied the need for American subject matter. As a new generation of American artists returned home from study abroad, one critic, reviewing the spring annual at New York's National Academy of Design in 1879, articulated the widespread internationalist sentiment: "There is no shallower theory of art than that which requires of the artist that he shall find his inspiration only in that which is before his eyes, or with which he is connected by historical or local association.... The nationality or the race traits of art must be traced in spirit and in manner, or even in technical method, rather than in subject.... We cannot expect from our painters that kind of Americanism in art which consists in finding subjects at home."[93] George William Sheldon, author of *Recent Ideals of American Art*, was perhaps the most ardent spokesman for the internationalist taste of the time. He deemed the European subjects of such young cosmopolitans as Knight, Pearce, and Edwin Lord Weeks "masterpieces...as truly American as the most cherished pro-

ductions of our 'Hudson River School.'"[94] These painters and dozens of others made their reputations in Paris, lived in Europe, painted international subjects according to Salon standards, and were rewarded with French prizes. Sheldon's assertion of the American qualities of their pictures notwithstanding, the French influence upon American artists at the 1889 Exposition Universelle in Paris was so pervasive and overpowering that visitors had to read the "*Etats-Unis*" sign over the door to be convinced that they were in the American section.[95]

The retreat of most American artists from nationalistic subjects after the Civil War reflected the growing impact of their foreign study as well as the mood of the period. Although Americans joined together to celebrate the dedication of the Washington Monument in 1885 and the Statue of Liberty in 1886 and to mark the centennial of George Washington's inauguration in 1889, the national spirit, shattered by the Civil War, had not yet been reformulated; most Americans identified at least as much with their states or local regions as with the reunited United States. The resultant sense of fragmentation and disarray was underscored and intensified by the volatile social, political, and economic situation of a country confronting profound and sometimes violent change. These conditions invited a certain escapism in the form of an artistic canon that favored subjects from distant times and places. Internationalism in the arts also was encouraged by positive developments, for the United States was beginning at this time to participate more consistently in world affairs.

However, as early as the 1870s and through the 1880s, a few American painters who adhered to traditional styles were struggling to apply academic strategies to native subjects. Even Sheldon acknowledged this "influential minority" that made "'America for the Americans'... their watchword."[96] In the 1870s Eakins used American scullers on Philadelphia's Schuylkill River (see fig. 22) as analogues to Gérôme's Egyptian rowers on the Nile (fig. 23). In a picture of 1879 Louis Comfort Tiffany transferred his experience in portraying foreign genre vignettes to the theme of tenement houses on New York's Duane Street; in a number of canvases of the 1880s George de Forest Brush substituted exotic Native Americans for the ubiquitous North Africans of French Salon painting. These subjects allowed them to conjoin French academic emphasis on the nude with American resources and to portray scenes that were closer to home than Brittany or Baghdad. Although they might have been nourished by the new nationalism of the 1890s, all three artists ceased portraying overtly American themes by this decade. Eakins devoted himself to portraits, Tiffany developed an eclectic vocabulary for work in the decorative arts, and Brush turned to secularized neo-Renaissance images of mothers and children.

Academically trained Americans may have been sensitized to issues of nationality during their student years in Paris, in partic-

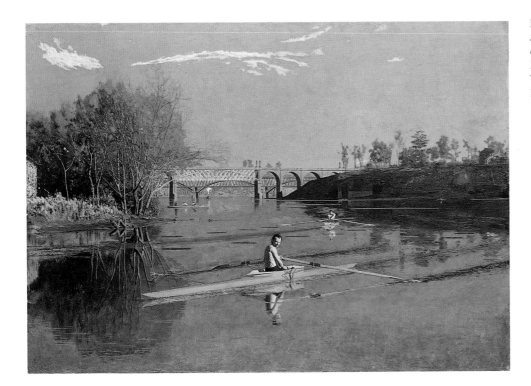

Fig. 22 Thomas Eakins. *Max Schmitt in a Single Scull (The Champion Single Sculls)*, 1871. Oil on canvas, 32¼ x 46¼ in. (81.9 x 117.5 cm). The Metropolitan Museum of Art, New York, Purchase, The Alfred N. Punnett Endowment Fund and George D. Pratt Gift, 1934 34.92

Fig. 23 Jean-Léon Gérôme. *Excursion of the Harem*, 1869. Oil on canvas, 31 x 53 in. (78.7 x 134.6 cm). The Chrysler Museum, Norfolk, Virginia, Gift of Walter P. Chrysler, Jr. 71.511

ular by Hippolyte Taine, an influential French aesthetician who lectured at the Ecole des Beaux-Arts in the 1860s and whose writings appeared in both French and English. Taine espoused a deterministic theory in which racial and environmental influences were invoked to account for differences in artistic approach. "The productions of the human mind . . . can only be explained by their milieu," he proclaimed. He compared works of art to plants and flowers "developed and propagated in a certain soil." Artists, Taine asserted, labored in "a *moral* temperature, consisting of the general state of minds and manners," and he acknowledged "the action of the moral temperature on works of art."[97]

Taine undoubtedly assumed that his tenets would be embodied in academic form, yet those who would express most effectively their national "moral temperature," their own "certain soil," were artists, such as the American Impressionists, who threw off the constraints of academicism.

When the American Impressionists began to escape the confines of academic training in the late 1880s and the 1890s, the radical Monet, who was outspokenly committed to representing his native countryside, was the principal French artist who inspired and reinforced their devotion to native subjects.[98] But even the more conservative French genre painter Jean-François Raffaëlli,

who visited the United States in 1895, presumably had an impact on the Americans. Raffaëlli believed that subjects should be drawn from the home scene and exclaimed about the possibilities of an American landscape school: "Their native land will inspire Americans with the sentiment of grand proportions.... Whence comes our inspiration if not from the art life that surrounds and envelops us?"[99]

Environment and nationalism were much emphasized in the United States during the 1890s, as Americans grappled with self-definition in the face of burgeoning immigration, a crippling economic depression that lasted from 1893 to 1897, and the advent of the new century.[100] Although strikes and political and social radicalism remained common facts of life, the volatile conflicts of the 1880s had to some extent subsided, and the fulfillment of Manifest Destiny encouraged Americans to turn their attention from the edges of their country to its core.[101]

Symptomatic of the new nationalist self-consciousness of the decade were the flourishing of studies of American history and literature and a growing interest in American folklore. So was the success of such naturalistic novels as Crane's *Red Badge of Courage* of 1895, local-color novels, for example Sarah Orne Jewett's *Country of the Pointed Firs* of 1896, and dozens of historical novels about the colonial experience and the American Revolution. Nationalist stirrings were apparent also in the growing dependence of American playwrights on domestic themes and the emergence of America's first school of philosophy, William James's pragmatism, and of John Dewey's American educational theory. In the realm of music and poetry, love of country was reflected in increased approbation of such American composers as George W. Chadwick and Victor Herbert, and of Edward MacDowell and Scott Joplin—both of whom used Native American and African-American melodies—and the birth of ragtime; the immense popularity of "The Old Swimmin'-Hole," James Whitcomb Riley's poem of 1882 and everyone's favorite evocation of rural boyhood in the 1890s; the publication of "On the Banks of the Wabash, Far Away," written by Theodore Dreiser's brother, Paul, and also of John Philip Sousa's rousing "Stars and Stripes Forever" in 1897 as well as the appearance of hundreds of other new songs that expressed nostalgia for the American past. And the establishment of Flag Day on June 14, 1894, and the publication of the song "America the Beautiful" on July 4, 1895, represent apotheoses of the expression of nationalist pride.[102]

Writer Hamlin Garland, a chronicler of life in the Midwest, spoke with the voice of the decade.[103] Garland advocated veritism, a literary naturalism in which the author describes the people, places, and social conditions he or she knows best, helping the reader understand the determining forces of his or her own life. "Local color in a novel," Garland wrote, "means that it has such quality of texture and back-ground that it could not have been written in any other place or by anyone else than a native."[104]

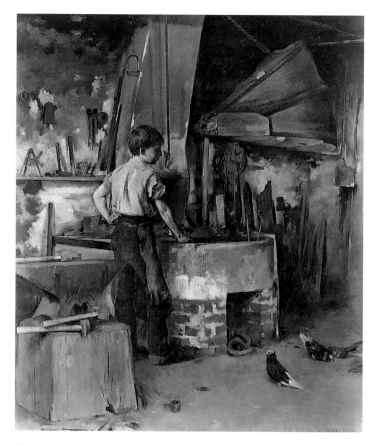

Fig. 24 Theodore Robinson. *The Forge (An Apprentice Blacksmith)*, 1886. Oil on canvas, 60 x 50 in. (152.4 x 127 cm). Berry-Hill Galleries, Inc., New York

Garland applied these literary principles to painting in "Impressionism," his influential essay of 1894: "Art, to be vital, must be local in its subject; its universal appeal must be in its working out,—in the way it is done.... The impressionist is not only a local painter, in choice of subject he deals with the present.... He does not feel that America is without subjects to paint because she has no castles and donjon keeps. He loves nature, not history."[105]

Many critics who earlier had urged American artists to abandon American themes now encouraged a reassertion of a national subject matter. Writing in 1888, Clarence Cook revealed his distaste for changing American demographics as well as for internationalism in painting: "To the sore plague of a swarming immigration of actual European peasants ... is added the weariness of painted ones—German, Italian, Dutch and French—who swarm over the walls of our exhibition-rooms."[106] In 1890 another writer counseled: "We do not believe that the American public will begin to take up American art and back it up, until it is American art in its essence and form, 'racy of the soil.'"[107]

A marked change that took place in the course of the 1890s in the work of one American Impressionist, Robinson, typifies the response of many painters to the nationalist concerns of the mo-

ment. In 1883 Robinson had written to his friend Cox, who, like him, had studied with Gérôme in the late 1870s: "I have nearly got rid of the desire to do 'American' things—mostly because American life is so unpaintable—and a higher kind of art seems to me to exclude the question of nationality. I would like to try a little flight into something Biblical or Mythological."[108] And in 1886 Robinson did eschew unpaintable American subjects to depict a French artisan at a French forge in his ambitious *Forge (An Apprentice Blacksmith)* (fig. 24). Painted while the artist was living in France, this immense canvas exemplifies the will to internationalism that prevailed in the 1880s. However, after he returned home in 1892, Robinson altogether rejected European themes to seek out and paint characteristically American subjects: mountains and villages of his home state, Vermont, canals of New York State, and sailboats and fishing vessels off Connecticut (see figs. 46, 54, 59, 60).

After studying abroad, not all American Impressionists adjusted immediately to being painters at home, and not all turned to native resources without regret at the loss of cosmopolitan stimulation. "If I must go home soon," Twachtman wrote to Weir from Europe in 1885, "I hardly know what will take [the] place of my weekly visit to the Louvre. Perhaps patriotism."[109] Bunker expressed serious doubts about his ability ever to find satisfaction as an artist in America and wrote with evident longing to his friend Joe Evans in 1885, soon after arriving home from Paris: "I am before all a painter. . . . I'll be hanged if I see how the charming verse of Mr. Longfellow or the essays of Mr.

Emerson can make up to a man for the loss of the Louvre or in fact for a single good word from the patron [atelier director Gérôme]."[110] Yet only eight months later he told the same correspondent that he was becoming enamored of his native land: "Like any sweet country the loving this place is only a matter of getting to know it well."[111] His work revalidates Emerson's call in his "American Scholar" essay of 1837: "The millions that around us are rushing into life, cannot always be fed on the sere remains of foreign harvests. Events, actions arise, that must be sung, that will sing themselves."[112] Indeed, not only Bunker but also Twachtman and many other painters who had studied in Europe renounced their devotion to foreign subjects, sooner or later after their repatriation, discovering that American songs could be sung harmoniously in an Impressionist style.

As painters wavered between international and national expression, even conservatives, the muralists of the 1890s, entered the argument. In their work idealized personifications of Electricity and The Telephone competed for wall space with scenes from American history. The ground plan for the World's Columbian Exposition of 1893 in Chicago, one of the most complex artistic enterprises of the period (and, as a celebration of the quadricentennial of the discovery of America, a symptom of national pride), diagrammed the debate. The plan embodied a dialogue between the internationalist Beaux-Arts Court of Honor at the center of the grounds and surrounding structures, such as the Virginia Building (fig. 25), a frank imitation of Washington's home at Mount Vernon. Beyond the fairgrounds the Whitmanesque sprawl

Fig. 25 C. D. Arnold. Virginia Building at the World's Columbian Exposition, Chicago, 1893. Photograph: Ryerson and Burnham Libraries, The Art Institute of Chicago

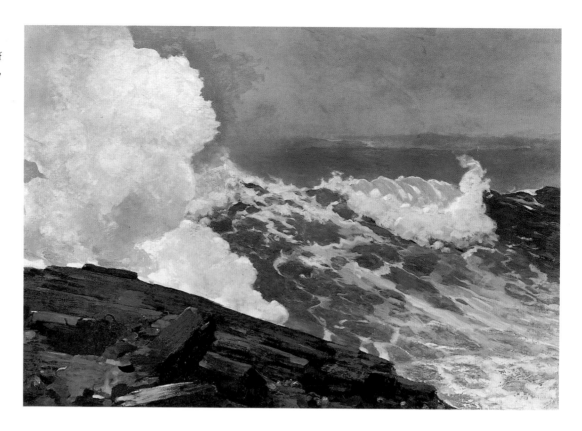

Fig. 26 Winslow Homer. *Northeaster*, 1895. Oil on canvas, 34½ x 50 in. (87.6 x 127 cm). The Metropolitan Museum of Art, New York, Gift of George A. Hearn, 1910 10.64.5

of Chicago and the vast stretches of fertile midwestern prairies announced the vigor of the American people.

Within the art displays at the Columbian Exposition itself, a dichotomy was evident as well, and this was the dichotomy between academicism and Impressionism.[113] Although Gérôme and Bouguereau and other academics dominated the official French galleries, an exciting array of French Impressionist works appeared in a supplementary display assembled from American private collections.[114] The slight of the French Impressionists by their own government set them apart aesthetically as well as politically. They were identified as fresh, modern, and dissident and seemed to speak a new language, revealing a path to freedom from academic strictures. For the Americans, the French Impressionist commitment to landscape offered a corrective to the academic emphasis on the figure and encouragement to return to the traditionally American theme of nature. The French Impressionists showed Americans how to create an American art.[115]

There were not many Impressionist works of either French or American origin at the Chicago fair, but the few that were shown were so vivid and new in relation to the works that dominated the national paintings installations that they attracted substantial attention. The American Impressionist canvases, no more than a handful among a fundamentally academic display, included several of French subjects; these were by Hassam, Robinson, and Robert Vonnoh. Among the American Impressionist images of native scenes were a Hassam view of Fifth Avenue in the snow;

Tarbell's *In the Orchard* (fig. 18); three winter landscapes by Twachtman; a Weir landscape; and one of Chase's pictures of Central Park.[116]

Garland heard in the new language of Impressionism local accents that could support an art of regional authenticity. "The atmosphere and coloring of Russia is not the atmosphere of Holland. The atmosphere of Norway is much clearer and the colors more vivid than in England. One school therefore cannot copy or be based upon the other without loss. Each painter should paint his own surroundings. . . . As I write this, I have just come in from a bee-hunt over Wisconsin hills, amid splendors which would make Monet seem low-keyed." Maintaining in this sensitive defense of the new painting that Impressionism was appropriate for describing such specific locales, Garland noted how useful the style might be for recording the American here and now.[117]

Nationalistic sentiments and approbation of Impressionism were even more clearly articulated in *Impressions on Impressionism*, published in response to the *Seventh Annual Exhibition of American Paintings*, held at The Art Institute of Chicago in 1894. Here Garland, sculptor Lorado Taft, and conservative landscape painter Charles Francis Browne considered the works shown, which included American Impressionist canvases, and urged American artists to continue to adopt native themes. Queried Browne: "Is a Brittany peasant more to us than everything else? Haven't we out-door subjects in our fields, or our

mountains, by our glorious lakes, on the shores of our loud sounding seas? We assuredly have. American art must be developed by the artists in happy sympathy with American surroundings, and supported by a public loving the home things more than imported foreign sentiment." And Garland praised the painters in the exhibition whose works were animated by individualistic Impressionist impulses, counseling them: "The next step is to do interesting American themes and do it naturally."[118]

Garland's enthusiasm for Impressionism was tantamount to a mandate for American artists to adopt the style as a national expression. The Hoosier Group of five midwestern Impressionists would respond most fully to his reformatory efforts.[119] But eastern artists also were sympathetic to Garland's prescription for an American Impressionism, and some—most notably Robinson—can be associated directly with his agenda.

The need for a nationalist American art was felt ever more urgently as the new century dawned. Now painters and writers obsessively struggled to define the character and qualities of American art.[120] Winslow Homer's epic late seascapes (see fig. 26), painted during the last twenty years of his life, offered what many considered a powerful homegrown national statement and helped to determine what "American" meant, as Bruce Robertson has recently argued.[121] Critics characterized Homer's paintings of the rocky New England coast as American, and thus as big, virile, and real. While such adjectives were literally descriptive of his canvases, they were also chosen to differentiate Homer from artists who derived inspiration from Europe, particularly France, and now were deemed genteel, effeminate, idealized. Inevitable targets for such epithets, the American Impressionists qualified as acceptably American only by virtue of their commitment to the American scene.[122] American Realists, notably Henri, Luks, Bellows, and Rockwell Kent, were inspired artistically by Ho-

mer's resistance to prettiness and sentimentality and personally by his vigorous individuality. In their eyes his accounts of the pounding sea overwhelmed the images of calm ocean, with their elegant shapes and color accents, portrayed by French and American Impressionists.

Other turn-of-the-century painters and commentators saw no incongruity in the use of a foreign technique such as Impressionism to make a nationalist statement.[123] In 1904, when the American art display at the Universal Exposition in St. Louis was organized with a nationalist agenda, the foreword to the accompanying catalogue boasted that the United States had "a distinctive national art, so individual that it can be mistaken for no other." The author defined national art thus: "American art, like American literature, is eclectic; but when from the technique of the foreign school the artist comes home for his subject, his interpretation and his atmosphere, we have the American picture."[124]

The American Impressionists had come home for their subjects, reconsidering their attitude toward the unpaintability of American life and reversing their earlier internationalist stance. In choosing to depict modern life, they captured a new vision of the American countryside, city, and home and created memorable American paintings. At the same time they showed the way for the Realists who followed them, painters whose art, as Henri put it, "cannot be separated from life." Both generations provided a resource for later American painters who responded to the American scene and temper in a variety of styles: Max Weber, John Marin, Joseph Stella, Charles Demuth, Charles Sheeler, Stuart Davis, and Edward Hopper, among others. The paintings of the American Impressionists and Realists, in terms of both their actual content and implied significance, impel us to explore issues of concern to turn-of-the-century Americans and offer us images of enduring interest.

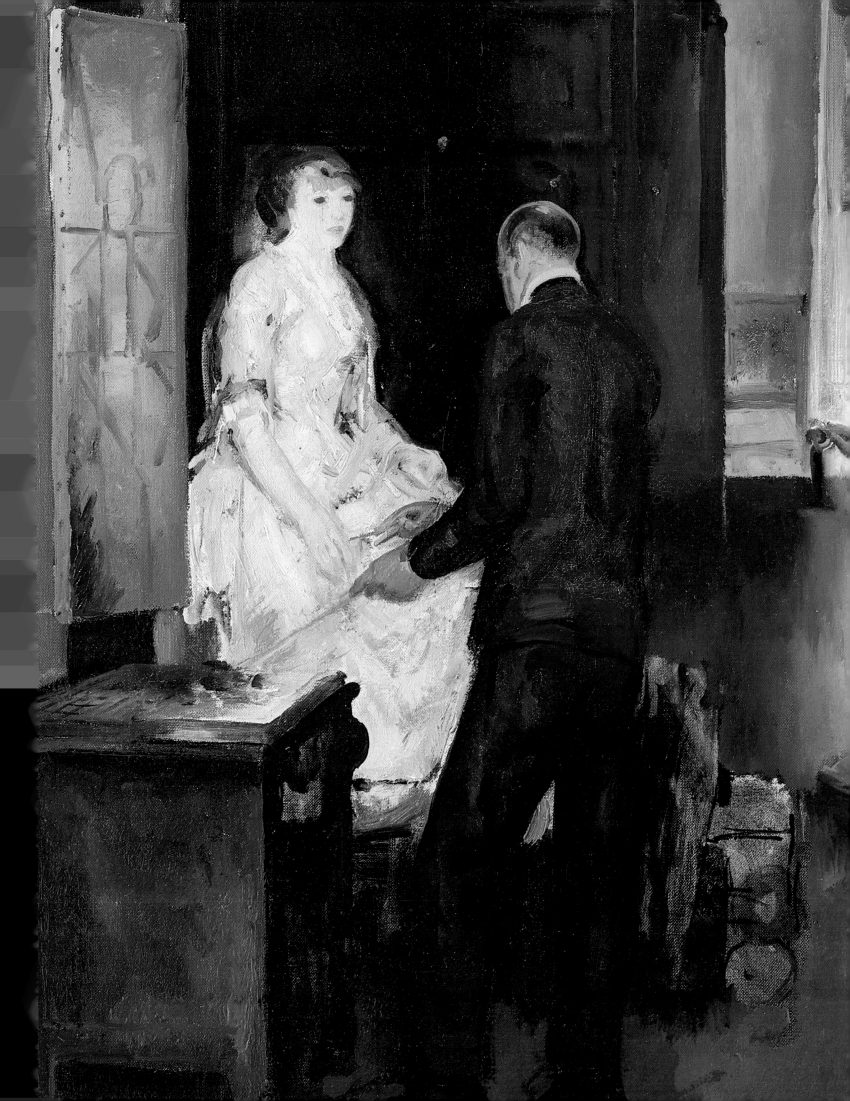

The Studio

The Most Magnificent Profession

I happen to be a member of the most magnificent profession that the world knows. . . . It has a standard established for all time of the highest dignity.

WILLIAM MERRITT CHASE (1916)

Art when really understood is the province of every human being.

ROBERT HENRI (1923)

Assertive and flamboyant in their painting and teaching styles and devoted to depicting the world around them, Impressionist William Merritt Chase and Realist Robert Henri epitomize their respective generations. Chase, born in 1849, typifies the American painters who formed themselves in foreign art schools in the 1870s and then took up Impressionism so effectively that by 1900 it constituted an establishment style in their own country. Henri, born in 1865, is the archetype of the rebellious, socially conscious American Realists, who challenged the supremacy of Chase and his colleagues. Despite their chronological, philosophical, and stylistic differences, their biographies, art training, and professional endeavors were similar. They knew each other, and each other's work, well. Their careers overlapped from 1886, when Henri began his art studies, until Chase's death in 1916. They taught at the same schools, shared students, exhibited in some of the same shows, and sought the attention of patrons and critics within the same market. When we compare their portraits, beach scenes, or city views, they reveal affinities that are sometimes masked by the strident rhetoric in which these two artists often indulged. Certainly Henri's *Girl Seated by the Sea* of 1893 (fig. 107) is a cousin, even a sibling, of Chase's *Fairy Tale* of 1892 (fig. 98). Such pictures are caught up in the complex web that unites the two painters and their generations.

Both Chase and Henri were born in the Midwest and both concocted public images of themselves for eastern consumption. Chase, the son of a harnessmaker who became a dry-goods merchant, affected an elegant white suit, a glittering collection of rings, and a top hat and kept wolfhounds as pets. Henri (né Robert Henry Cozad) was the son of a gambler who eventually legitimized himself as a land speculator. Chase studied in Munich, Henri in Paris, but their reactions to the artistic riches of the Old World were similar. Chase's often-quoted exclamation of 1872, "My God, I'd rather go to Europe than go to heaven,"[1] was echoed by Henri when he was in Paris in 1888 and wrote: "Eureka! I have it! This is what I have longed for!"[2] And when they returned to the United States, both applied their European experiences to the portrayal of American subjects.

Chase, who had been one of the first instructors at the Art Students League, established in New York by disgruntled students

Detail, fig. 38

from the National Academy of Design in 1877, befriended Henri during the 1890s.[3] Both were vital teachers at Chase's New York School of Art, Chase from its founding in 1896 until 1907, and Henri from 1902 until 1909, at which time they could no longer reconcile their different pedagogical approaches. The two played similar roles as movers and shakers in New York's art world. Both were provocative figures, active as exhibition organizers, and, as such, both did much to change the course of American art at the turn of the century. "Their power was, like an orchestra leader's, in that which they could make other men do," observed Guy Pène du Bois of these two remarkable painters.[4] In 1880–81 and from 1885 to 1895 Chase served as president of the Society of American Artists (founded in 1877), when its exhibitions challenged those of the National Academy of Design. But the society, following what seems a predictable pattern of energetic reform succeeded by gradual retrenchment, failed to hold Chase's allegiance. In 1902 (after the death of John H. Twachtman left an opening in the group), Chase joined the Ten American Painters (founded in 1897), adding his voice to their protest against the society's increasingly conservative selection and display policies. In the early twentieth century Henri assumed the rebel's mantle when both the academy and the society rejected progressive works by his friends and students. As Chase had done earlier, Henri organized independent exhibitions, most notably that of The Eight at the Macbeth Galleries in 1908.

Portraits of fellow artists by Chase and Henri signal a series of important changes that took place in the painter's profession at the turn of the last century. Chase's portrayal of James McNeill Whistler (fig. 27) captures the spirit of perhaps the most flamboyant artistic personality of the age, the expatriate American painter, printmaker, and interior designer whose creed of art for art's sake was espoused by Chase and other artists of his generation.[5] Whistler's work and philosophy were founded on this creed, and they were also instrumental in establishing the notion that the professional artist is the preeminent arbiter of good taste. As Russell Lynes has noted, following Whistler's example, the self-confident American artist of the 1880s "sold not just canvas or marble or bronze, he sold theories and he sold himself as their embodiment or as their prophet. He became a tastemaker as well as an art-maker."[6]

Chase does not portray Whistler at work; instead he shows us, with all of its stylized gesture and manner, the public face of Whistler, whom he once described as "the fop, the cynic, the brilliant, flippant, vain, and careless idler. . . . a dainty, sprightly little man, immaculate in spotless linen and perfect-fitting broadcloth." Himself a fashion plate, Chase catalogued his subject's affectations: "He wore yellow gloves and carried his wand poised lightly in his hand. He seemed inordinately proud of his small feet and slender waist; his slight imperial and black mustache were carefully waxed; his monocle was indispensable."[7]

Chase was as concerned with how Whistler painted as with how he looked. His portrait presents the man's art as well as the man himself, celebrating Whistler's style and technical virtuosity as well as Chase's ability to duplicate them. Chase shows his model at full length, silhouetted against an austere backdrop, in the manner of the portraits Whistler himself painted in the 1870s and 1880s. Chase also mimics Whistler by reducing details of costume and setting to enhance the unity of the whole. "Whistler," Chase observed, "made his paint so thin with kerosene that sometimes he had to lay the canvas flat to keep it from running off."[8] In Chase's portrait the use of thin washes and the low-key palette and broad paint application recall Whistler's own working method, which, in turn, was inspired by the study of Velázquez.

Both Whistler and Chase, who were so concerned with cultivating an aesthetic personal image, also strove to create graceful and beautiful pictures, which they deemed reflections of their own elegance. Chase quipped: "A vulgar man might paint an angel, and have it as vulgar as himself; a person of the most sensitive and beautiful nature might paint a potato, and have it a great work of art."[9] In this portrait Whistler's appearance gives us little clue to his profession but instead suggests refinement and leisure. The man Chase portrays is not dressed to work but to play the role of the *flâneur*, to stroll outdoors, to see and to be seen in the streets of London, storing up observations for later artistic use. In interpreting Whistler, Chase, too, assumes the role of the *flâneur*, studying his subject closely, noting his distinctive artistic and personal traits, and presenting him with cynical detachment.[10]

Whistler would have agreed with the appraisal of their calling that Chase offered in an essay of 1916: "I happen to be a member of the most magnificent profession that the world knows. There is no profession that can quite compare to it. It has a standard established for all time of the highest dignity."[11] No wonder Whistler recognized Chase's penetrating characterization of him in his portrait as a "monstrous lampoon." He wailed, "How dared he—Chase—to do this wicked thing? and I, who was charming and made him beautiful on canvass, the master of the avenues."[12]

Unlike Chase's vision of the magnificent professional, the conception of the artist espoused by Henri and his associates was egalitarian, and they expressed it in both print and paint. As Henri wrote in 1923: "Art when really understood is the province of every human being. . . . When the artist is alive in any person, whatever his kind of work may be, he becomes an inventive, searching, daring, self-expressing creature. Where those who are not artists are trying to close the book, he opens it, shows there are still more pages possible."[13]

The ordinariness of artistic existence, the commitment of Realist artists to the mundane, and the underlying premise that

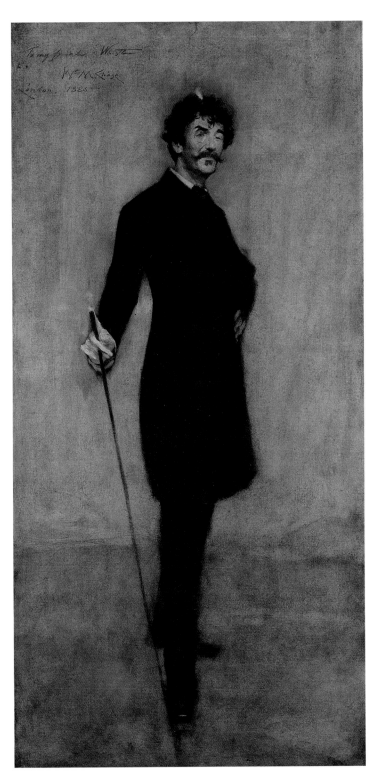

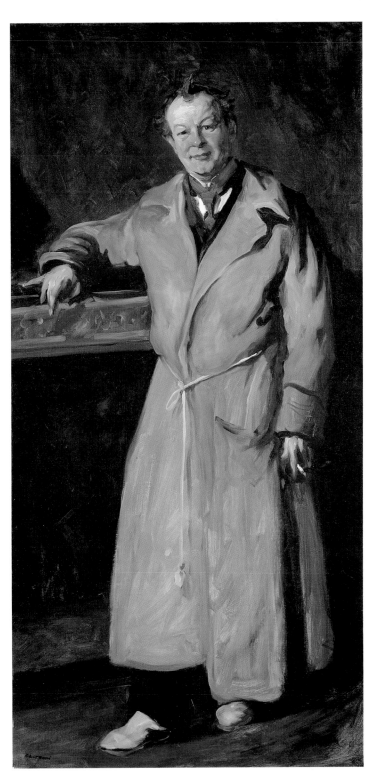

Fig. 27 William Merritt Chase. *James Abbott McNeill Whistler*, 1885. Oil on canvas, 74⅛ x 36¼ in. (188.3 x 92.1 cm). The Metropolitan Museum of Art, New York, Bequest of William H. Walker, 1918 18.22.2

Fig. 28 Robert Henri. *George Luks*, 1904. Oil on canvas, 76½ x 38¼ in. (194.3 x 97.2 cm). National Gallery of Canada, Ottawa 9587

art "is the province of every human being" are suggested in Henri's frank portrait of George Luks (fig. 28). Like other Realist painters of his generation, men who were political and social activists as well as artists, Luks risked being a vulgar man and challenged accepted ideas of decorum. Whistler had handed down to Chase the role of the dandy. "It was a polite rôle calculated to entertain and mildly startle 'Society' without offending potential buyers," explained Forbes Watson as late as 1935. "Luks, on the other hand," Watson continued, "evolved a rougher part. He, as it were, made his entrances from McSorley's Bar as one of those people prepared to hurl mighty shocking phrases at the gentry."[14] Luks was not a member of the gentry; but, in fact, he contrived the image of a rough character as assiduously as Whistler and Chase presented themselves as elegant dandies, and he was as willing as either of them to strike an artistic pose, albeit a different kind of pose, that offered a degree of shock.[15]

Luks led a colorful life as an artist-reporter in Philadelphia and New York, even traveling on assignment to Cuba, where he drew war scenes and got drunk enough to lose his job. In 1896 and 1897 he worked for the *New York World*, drawing illustrations, caricatures, and, after Richard Felton Outcault left the paper, the weekly cartoon page that was known variously as "The Yellow Kid," "Hogan's Alley," and "McFadden's Flats."[16] Newspaper readers who appreciated Luks's illustrations and his comic strip were far more numerous than the refined clients who patronized Whistler and Chase.

Luks's painting style, like his persona, was coarse and provocative rather than aesthetic. In fact, in 1904, the year that Henri painted his portrait of Luks, the two artists and their coexhibitors in a progressive group show at the National Arts Club were hailed by Charles de Kay as representatives of "the vigorous school of picture-making" that sought to capture "the red-hot impression." De Kay described two of Luks's own portraits as "triumphs in their own way, so thoroughgoing is the psychology which the painter has expressed without undue elaboration," exclaiming "that they have nearly produced a riot in the club."[17]

Luks, who in Henri's portrayal looks as if he would be a willing participant in such a riot, was known to be an excessive drinker and a barroom brawler. Here he gazes out at his audience, a lit cigarette dangling from his fingers. He is dressed neither to venture out in public nor to receive proper visitors. His simple at-home attire, an odd choice for a portrait sitting, combines a gentlemanly shirt and tie with far more casual trappings—what appear to be slippers and a dressing gown, which is loosely tied at his ample waist and closed with the hem of one side hanging sloppily far below the other. Henri offers only a little more information about Luks's setting than Chase supplied for Whistler's. Luks rests his arm on a carved and gilded frame that leans against the wall behind him, as if he had hurriedly chosen some random studio prop to help support his pose. Luks seems undisturbed by his indecorous attire and gazes out at us with an insouciant confidence as marked as that flaunted by the soigné Whistler.

Henri's portrait of Luks, like Chase's picture of Whistler, describes his subject's artmaking as well as his visage. Here Henri takes pains to emulate features of Luks's own portrait style. Henri's slashing strokes represent the sitter's hands and facial features with a boldness that approaches crudity, and rich, dark colors are applied with little effort at subtle modeling. Following Luks's practice, Henri makes us acutely aware of the painter's vigorous hand and its expressive power. This nod to Luks's virtuosity and Henri's choice of an imposing full-length format usually reserved for portraits of the wealthy and distinguished (see fig. 253) declare his regard for Luks as a painter. Like Chase, Henri was committed to portraying his own milieu. Believing that modern American artists must record their own lives and experiences, Henri would have found inevitable the subject of an artist friend. What could be more at the heart of his own life than a colleague who joined him in redefining American art and repositioning the American artist at the turn of the century?

Two more portraits by Chase and Henri reflect the stylistic duality between the artistic generations these two painters represent and also make us think about how difficult it was for American women to succeed as painters at the turn of the century. Dora Wheeler, Chase's student as early as 1878 and his sitter in 1883 (fig. 29), worked as a painter, primarily as a portraitist, but she achieved greater prominence in the decorative arts as a book illustrator and a designer of stained glass and greeting cards. Josephine Verstille Nivison, portrayed by Henri as *The Art Student* (fig. 30), sacrificed her own artistic aspirations to her husband's needs. The stories of their careers help us understand why acclaimed women painters were so rare among the American Impressionists and Realists, even though most of Chase's and Henri's students were women.

Chase undertook his lifesize seated portrait of his student Wheeler not on commission but to create an exhibition piece primarily for display in Europe.[18] Always anxious to aggrandize his own image and reputation, Chase intended this painting as a demonstration of his artistic ability; with it he proclaims himself a modern painter of portraits, breaking his ties with the old-master tradition and adopting the more fashionable contemporary styles of Europeans Mariano Fortuny and Alfred Stevens (see fig. 31). Chase depicts his subject with her hand raised to her cheek, using this convention to indicate that the sitter is lost in thought. Indeed, as a woman artist, Wheeler had much to think about. Chase himself would have perceived his model as far less his professional equal than Whistler was. Unlike that notorious expatriate, who enjoyed an international reputation as

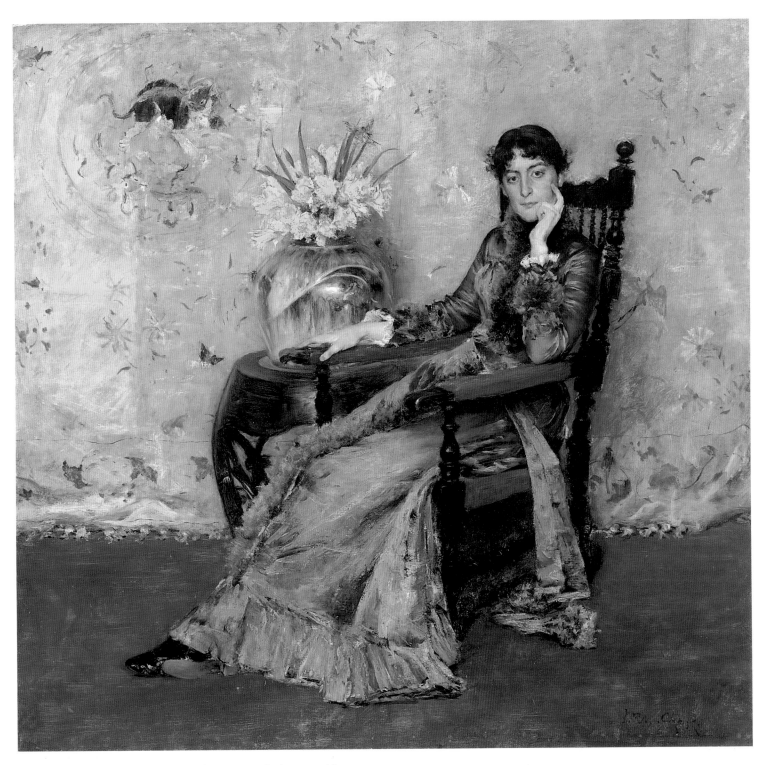

Fig. 29 William Merritt Chase. *Portrait of Miss Dora Wheeler*, 1883. Oil on
canvas, 62½ x 65¼ in. (158.8 x 165.7 cm). The Cleveland Museum of Art,
Gift of Mrs. Boudinot Keith, in memory of Mr. and Mrs. J. H. Wade 21.1239

Fig. 30 Robert Henri. *The Art Student (Miss Josephine Nivison)*, 1906. Oil on canvas, 77¼ x 38½ in. (196.2 x 97.8 cm). Milwaukee Art Museum, Purchase M1965.34

an innovator in both the fine and decorative arts, Wheeler was a less accomplished female artist who was a proponent, though not a leader, of the American Aesthetic Movement that Whistler inspired. The Aesthetic Movement, which began in England and powerfully influenced American interior decoration, reached its height in the early 1880s, when Chase painted this portrait. Dora Wheeler sat for Chase just as she joined forces with her mother, Candace, a distinguished needlework designer, and other women to continue the name and work of the recently dissolved decorating firm Associated American Artists, which Candace and other decorative artists had established.[19] The decorative arts enabled Dora Wheeler, and other women of the period, to achieve a measure of professional artistic status.[20]

An uninformed viewer could not guess that Chase's portrait is set in Wheeler's newly opened New York design studio at 115 East Twenty-third Street. The model is starkly silhouetted against a sumptuous Japanesque wall hanging, perhaps one of her own or her mother's creation. Little else attests to her artistic enterprise. Her elegant fur-trimmed dress, appropriate for the kind of sitter Chase wished to attract, is entirely unsuitable for artmaking. Wheeler is surrounded by an eclectic mix of furniture and decorative objects: a Chinese taboret bearing a flower-filled piece of art pottery beside an Elizabethan-revival easy chair. Although such luxurious appurtenances graced many an artist's studio, including Chase's own, they were also to be found in the homes of Chase's potential patrons, who could thus identify with both Wheeler's setting and costume.

Chase may have been striving to draw attention to himself as well as to his model. The ceramic vase next to Wheeler contains narcissus, a floral reminder of the Greek myth in which a vain youth falls in love with his own reflection, pines away for it, and is transformed into a narcissus flower. This could be interpreted as a subtle reference to his sitter's self-absorption or as evidence of the artist's unconscious acknowledgment of his own vanity. In the Japanesque hanging, within a prominent swirl of color on a field embroidered with flowers, waterfowl, and dragonflies, a cat seems to chase something, offering a visual pun on the name of the painting's creator.[21] This device, if it is an autograph, would recall Whistler's well-known butterfly monogram.

Henri's portrait of Nivison resonates with his connections to both predecessors and successors, illuminating the complex interweaving of careers and influences among several generations of American painters. In style and subject it recalls the work of two older artists then teaching with Henri at the New York School of Art: Thomas Anshutz, Henri's own teacher, who traveled there from Philadelphia to present a series of six lectures on anatomy in early 1906, and Chase, whose success with the full-length society portrait was already legendary.[22] Because of the model's identity—she would become the wife of fellow student Edward Hopper—the portrait also signals Henri's role as a teacher of leading painters of the next generation, as well as of many who—like Nivison—were obliged to curtail their careers.[23]

Nivison's status as an artist is more obvious than was Wheeler's in Chase's portrait. This may be an indication of the modest strides made by American women after the turn of the century. Nivison is still the art student, but at least she looks out at us as if she has been interrupted in the midst of her work. The feeling that this is a sudden encounter with this slender,

Fig. 31 Alfred Stevens. *In the Studio*, 1888. Oil on canvas, 42 x 53½ in. (106.7 x 135.9 cm). The Metropolitan Museum of Art, New York, Gift of Mrs. Charles Wrightsman, 1986 1986.339.2

vivacious figure is heightened by the disorderly mass of her loose brown hair. A dark blue artist's smock covers her clothing—a simple blouse and skirt—and slips from one shoulder; her left hand clutches a sheaf of paintbrushes. The setting is neutralized, as it was in Chase's portrait of Whistler, but Nivison's attire and accessories suggest that she is in her studio.

Despite her training with Henri and her ambition, she subsumed her career into her husband's, working by his side (and insisting that she model for all the female figures he painted), keeping records of his works, shielding him from journalists, and encouraging him. Yet she was judged harshly, for Hopper's friends attributed his moroseness to her unsociability.[24] Painter Raphael Soyer characterized the differences between the esteemed husband and the less well-known wife in a description of their adjoining Cape Cod studios, the one expansive, the other confining: "In Jo Hopper's studio there was a permanent, never-changing exhibition of her paintings—pictures of her small, crammed world, of Truro, flower pieces, interiors of her room, and pictures of cats and pot-bellied stoves. Only once did we see Edward's studio, a large white-washed bare room with an etching press, an easel and nothing on the walls." Mrs. Hopper was the grudging but ladylike hostess, claimed Soyer: "Jo would daintily serve us bread-and-butter sandwiches and tea fragrant with a clove in each cup."[25] She was reduced, as Eleanor Munro has pointed out, to the role of the "'wife who also paints' ... [the] *victim* except in the role of Muse,"[26] when in actuality she deserved to be cast as the survivor.

Modern Conditions Demand Modern Art

I studied the works of the masters. . . . But, in my great desire to build my art on the eternal principles which govern theirs, I fell almost unavoidably into an error. . . . modern conditions and trends of thought demand modern art for their expression.

WILLIAM MERRITT CHASE (1910)

I have no desire to destroy the past, as some are wrongly inclined to believe. I am deeply moved by the great works of former times, but I refuse to be limited by them.

GEORGE BELLOWS (1920)

Studios reflect changes in the status and public personae of artists and in the resources that inspire them. William Sidney Mount's *Painter's Triumph* of 1838 (fig. 32) shows the typically austere studio in which the mid-nineteenth-century American painter conducted business. An engraving after the painting accompanied "The Painter's Study," a short story of 1839 by

Fig. 32 William Sidney Mount. *The Painter's Triumph*, 1838. Oil on wood, 19½ x 23½ in. (49.5 x 59.7 cm). Pennsylvania Academy of the Fine Arts, Philadelphia, Bequest of Henry C. Carey (The Carey Collection) 1879.8.18

A. A. Harwood. In his text, which may have been inspired by Mount's oil, Harwood writes of Raphael Sketchly struggling to convince Farmer Dobbs, whose farm he has depicted, to purchase the scene that delights him. Sketchly's studio, aptly described by Harwood as "an atelier scantily furnished, but strewed with a characteristic disregard to order,"[27] has bare walls and floors and contains little besides the painter's tools: palette, brushes, stretched canvases, an easel, and a chair. The picture reveals that the only adornment and reference to artistic tradition is a drawing after a cast of the Apollo Belvedere—a symbol of academic standards—which seems to turn away in disgust from the landscape on the easel.

By the late nineteenth century, the growing professionalization of American artists resulted in the creation of more numerous and more specialized studios than had been available to Mount's generation. These facilities, which included New York's Tenth Street Studio Building, were designed and erected specifically for the use of artists.[28] Such studios were sometimes quiet retreats from urban confusion, yet painters and sculptors opened them to visits from the public in the hope of attracting critical support and patronage. The public, increasingly interested in art in this period of economic expansion, was enthusiastic. "For a while," remarked one journalist in 1877, "the best-cultured people found it charming, and many more with new riches and nought besides would gladly have paid handsome sums for tickets admitting them among the aristocratic coterie wont to pay gracious homage to Art."[29] The cosmopolitanism of American artists prompted them to gather mementos of foreign study

and travel for display in their studios; here they emulated the lavish quarters of their European mentors and colleagues, who also welcomed visitors. The aesthetically furnished studio became an emblem of the new status of American artists and artisans as arbiters of good taste, a status in part conferred by the Aesthetic Movement, which also promoted the use of decorative objects in domestic and public spaces.[30] For the American Impressionists, then, studios functioned not only as retreats, exhibition halls, and reception places but also as showcases for their taste. "Studios are interesting places," commented painter Walter Pach as he prepared to interview his fellow artist Chase in 1910, "for they reflect the quality of mind of their inhabitants more fully than any other sort of room."[31]

Chase's renowned studio in the Tenth Street Studio Building was often illustrated and discussed in the popular press, becoming a paradigm (fig. 33).[32] A writer catalogued its contents in 1889: "bric-a-brac, splendid and lavish . . . expanses of Persian loom-work, great faded fragments of tapestry; copies of the old masters . . . done by his own hand in the period of his *wanderjähre*; armor, weapons of every country, ancient altars, worm eaten carvings, old brasses, pearl-inlaid long-necked stringed instruments, and even the glittering ebon countenances of prognathous Peruvian mummies suspended by their long black hair."[33] Chase's studio embodied his self-invented public persona. In contrast to photographs of it, which often show Chase standing before an easel that holds his latest canvas, the painter at work is absent or downplayed in paintings that reveal the studio as a place for aesthetic display and contemplation of works of art.[34] In *The Tenth Street Studio* (fig. 34), for example, visitors relax at a table or examine paintings that hang on an elaborately decorated wall; Chase is nowhere to be seen, as either artist or salesman.

In Chase's studio and in his depictions of it, clients could be reassured of the painter's association with tradition while considering undisturbed his collection of objects. Art critic Samuel G. W. Benjamin, who visited Chase's lair in the late 1870s, described it as "rich in attractions which carry the fancy back to other climes and the romance of bygone ages."[35] The seated model for *In the Studio* (fig. 35) wears old-fashioned clothing—her dress, with its billowing sleeves and scooped neck, dates from the 1820s, and her bonnet, decorated with feathers and silk ribbons, would have been popular in the 1830s. She leafs through a portfolio, engrossed in its elaborate illustrations that, like her aesthetic costume, take her to another time and place.

As Chase dressed this woman in a costume to evoke the American past, so he furnished his studio with eclectic bric-a-brac to recall the accumulated artistic achievements of the Old World. His model is nearly engulfed by opulent decorations—an oriental rug lies at her feet; a carved cabinet holds flowers, brushes, vases, casts after sculpture, and a ship's model; the wall behind her is hung with rich silks and patterned rugs as well as

with paintings and prints, including an engraving after *Malle Babbe* by Hals.[36] Chase admired Hals for bringing to life Dutch men and women of the past through portraiture; he believed that Hals contributed to what he called "the import of art": "The knowledge we have of man in his earliest civilizations, and even from the time before that, is to a large extent derived from the relics of art that come to us."[37] Chase hoped that his own paintings would become the "relics of art" of his own age.

Hals was not Chase's only idol. In portrayals of his studio at Shinnecock he aligned himself with the old master he felt was most modern and esteemed above all others—Velázquez. Chase said: "One reason [Velázquez] seems so near to us is that he . . . with all his acquirement from the masters who had gone before him—felt the need of choosing new forms and arrangements, new schemes of color and methods of painting, to fit the time and place he was called on to depict."[38] Chase's *Hall at Shinnecock* (fig. 36) shows the artist at his easel reflected in the mirrored door of a huge black armoire inspired by old Dutch cabinets. His reflected presence alludes both to Velázquez's self-portrait in *Las Meninas (The Ladies-in-Waiting)* (fig. 37) and to the Spanish artist's inclusion on the far wall of a mirror that reflects the image of the king and queen—either as they stand in the room watching the infanta and her retinue or as they are portrayed on his canvas.[39] The references to *Las Meninas* also create an aura of aristocracy for Chase's portrayal of his own "maids of honor"—his wife and daughters. Despite the many-leveled allusions to its Spanish prototype, the high key of the canvas and the mundane domestic interior that Chase records in *Hall at Shinnecock* create a vivid renovation of tradition rather than a slavish imitation. In such works Chase amply succeeded in following the advice he had received from Stevens to cease emulating the old masters. In 1910 Chase recalled that counsel: "I studied the works of the masters. . . . But, in my great desire to build my art on the eternal principles which govern theirs, I fell almost unavoidably into an error. This was brought home to me in striking fashion by Alfred Stevens, who said to me after seeing my picture at the Salon: 'Chase, it is a good work, but don't try to make your pictures look as if they had been done by the old masters.' I saw the truth of his remark; modern conditions and trends of thought demand modern art for their expression."[40]

A comparison of Chase's studio images with a studio scene by Bellows illuminates contrasts and continuities between the way these two artists, and by extension the painters of the Impressionist and Realist generations, saw themselves in terms of their surroundings and of artistic tradition. Chase's student and admirer Bellows uses his home studio as the setting for a family Christmas scene in *The Studio* (fig. 38).[41] Bellows literally painted in the midst of his own life—depicting his family engaged in ordinary activities—and fulfilled his stated credo that "all

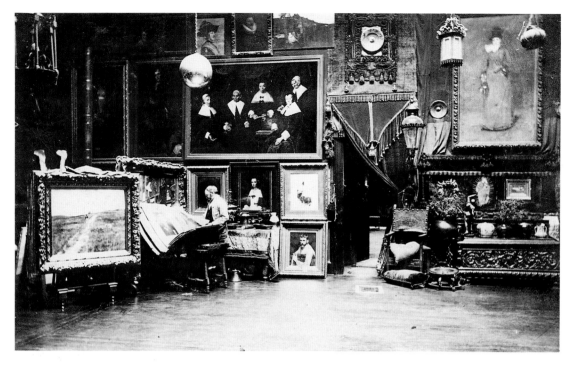

Fig. 33 *William Merritt Chase in His Tenth Street Studio*, ca. 1895. Albumen print. William Merritt Chase Archives, The Parrish Art Museum, Southampton, New York, Gift of Jackson Chase Storm

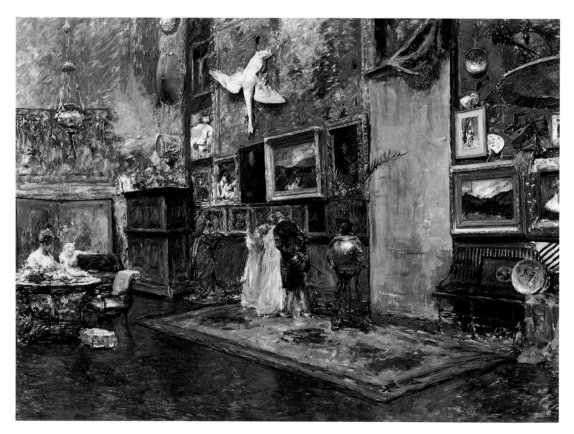

Fig. 34 William Merritt Chase. *The Tenth Street Studio*, ca. 1889–1905. Oil on canvas, 47⅞ x 66 in. (121.6 x 167.6 cm). The Carnegie Museum of Art, Pittsburgh, Purchase 17.22

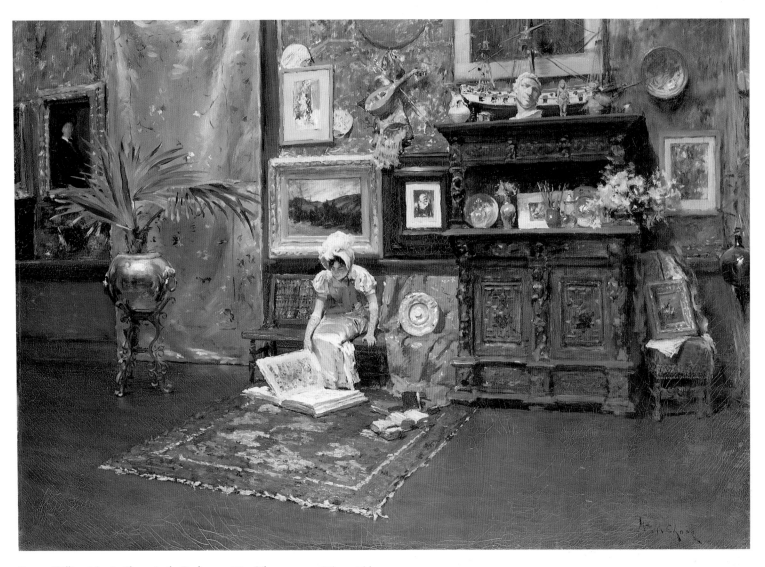

Fig. 35 William Merritt Chase. *In the Studio*, ca. 1880. Oil on canvas, 28⅛ x 40⅛ in.
(71.4 x 101.9 cm). The Brooklyn Museum, New York, Gift of Mrs. Carll
H. de Silver in memory of her husband 13.50

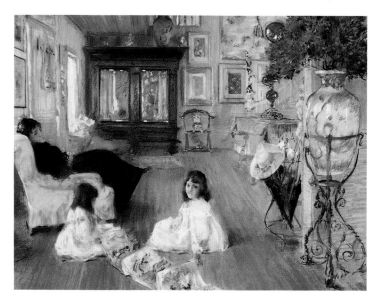

Fig. 36 William Merritt Chase. *Hall at Shinnecock*, 1892. Pastel on canvas, 32⅛ x 41 in. (81.6 x 104.1 cm). Terra Foundation for the Arts, Daniel J. Terra Collection 1988.26

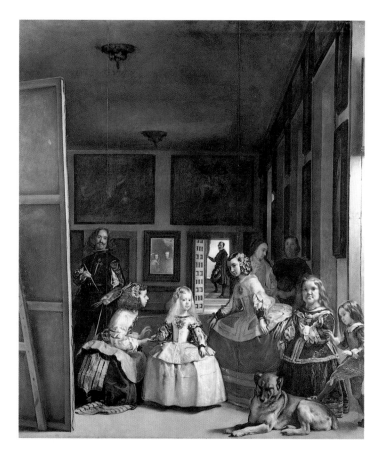

Fig. 37 Diego Velázquez. *Las Meninas (The Ladies-in-Waiting)*, 1656. Oil on canvas, 10 ft. 5 in. x 9 ft. ½ in. (3.2 x 2.8 m). Museo del Prado, Madrid

living art is of its own time."[42] Within a single canvas he explores a wide range of relationships—professional (artist and model, printmaker and printer), personal (husband and wife, sibling and sibling, parents and children, mother-in-law and son-in-law), and social (mistress/master and servant). On the balcony a printer —presumably George Miller, who produced Bellows's lithographs—is at work on a press creating lithographs, which were emerging as a means for American artists to reach a broader public when Bellows executed this picture. Almost everyone is wearing clothes that were commonplace in 1919. But Emma, the painter's wife, has donned an old-fashioned dress to pose for a painting, as had Chase's model for *In the Studio*. Bellows, like Chase, thus recalls the past, underscoring the role of artifice in the creative process, even when a painter is striving for a "living art." As if to emphasize the element of artificiality, Bellows appears to touch his brush to Emma's costume, enlivening it with the brilliant green that dominates the palette of his *Studio*.[43]

Compared with Chase's artistic atelier with its aesthetic clutter, Bellows's home studio seems quite spartan. His paintings hang on unadorned white walls; his paraphernalia—brushes, paint, rags—are contained within functional cabinets; plain brown curtains frame the balcony; two blankets are tossed over the balustrade; the polished wood floor is bare; and the window is covered with simple sheer curtains. Only the leopard skin draped over the balustrade offers a decorative or exotic touch. This austere space reflects new ways of thinking that had emerged after the turn of the century. The American Realists identified with the working classes and repudiated the rarefied atmosphere of the genteel and artful atelier beloved by the Impressionists. A 1903 account of studio life in New York indicates that changes in spirit and decor even generated changes in nomenclature: "'I want to protest against the word studio,' said the young woman who was putting the finishing daubs of green on a landscape. 'I thought we all agreed to call them "workshops."'"[44]

Although Bellows would not draw the inspiration of tradition from his studio surroundings, his artmaking is highly contrived. Typically for this painter, *The Studio* is not merely a record of present-day events but also refers to other works of art and is refined according to a geometric program. Bellows, who must have begun to admire Spanish painting while working with Chase and Henri, based the canvas and the lithograph from which he developed it on *Las Meninas* by Velázquez. Through his reference to *Las Meninas*, which shows Velázquez presumably painting a portrait, Bellows also alludes to the Spaniard's portraits, great paintings that appealed to this Realist as well as to many an American Impressionist.[45]

Bellows's *Studio* demonstrates the playful relationship of new master to old. Like Velázquez, Bellows shows himself hard at work on a portrait, brush in hand, palette on the table beside him. However, in *Las Meninas* a huge canvas, turned away from

Fig. 38 George Bellows. *The Studio*, 1919. Oil on canvas, 48 x 38 in.
(121.9 x 96.5 cm). Collection of Rita and Daniel Fraad

Fig. 39 Bellows's studio, ca. 1924, from advertisement for Devoe Artists' Materials, *International Studio* 79 (April 1924), p. xxxv

us, is cut off at the left edge of the composition and rises almost to its top. Velázquez confronts our gaze from behind this canvas, but we cannot see the image that he is painting. By contrast, Bellows stands with his back toward us. We have no eye contact with him but are allowed to see his work in progress, placed in the same position that is occupied by the enormous canvas in *Las Meninas*. Wearing colorful dresses, Bellows's daughters dominate the foreground of his picture like modern infantas. Seven-year-old Anne and three-year-old Jean play on the floor with some of their Christmas presents. Instead of a distant mirror reflecting an image of the Spanish king and queen, Bellows gives us his mother-in-law, Mrs. Story. Framed by the window, she leans on a table to speak on the indubitably modern telephone, while behind her an African-American servant, a lone reminder of the retinue of attendants in the Velázquez, looks on.

In 1920 an art critic encountered a "painstaking, deliberate, exact" Bellows working at his easel on a portrait and concluded: "He treats his subject as if it were a geometrical problem."[46] This conclusion is borne out by a detail in *The Studio*. Here Bellows's easel displays the beginnings of a three-quarter-length portrait of his wife.[47] Parts of this sketch correspond to her contours, but others obey an abstract system of linear notations. These lines resemble the geometric grids Bellows made when he was guided by such mathematical compositional formats as the golden section, which intrigued him as early as 1908.[48]

The underlying organization of *The Studio*, as well as of the portrait in progress, conforms to a predetermined geometry. Before he began to paint *The Studio*, Bellows calculated the structure of the composition according to an elaborate system of lines that are visible under infrared light.[49] As in many of his pictures, the placement of forms is related to the proportions of the canvas.[50] Bellows has manipulated the space of his home

studio, whose actual proportions are documented in a contemporary photograph (fig. 39). His most obvious artistic liberty is the exaggerated verticality he achieves by raising the balcony in the painting. The everyday scene captured in *The Studio* is as self-conscious and contrived as the studied decoration of Chase's Tenth Street studio and his depictions of it. And like Chase's painted renditions of his studio, Bellows's *Studio* announces its creator's commitment to artifice.

As their analogous comments and studio scenes indicate, Chase and his student Bellows had much in common. Both painters were determined to depict the present and both editorialized on and manipulated their experience of that present, albeit in different ways, in making their pictures. Chase excluded evidence of the artist as workman; Bellows made the artist as worker the focus of his composition yet suggested, as Chase did in his Shinnecock studio scenes, that domestic harmony and artistic excellence can coexist. While creating paintings with up-to-date subjects, Chase and Bellows included models dressed in old-fashioned clothing as reminders of the past. Both were stirred by tradition and praised the achievements of the old masters, particularly Velázquez. Both used *Las Meninas* as a revered point of departure for studio scenes, and both developed their modern studio images by recasting rather than imitating their model. Bellows and his Realist contemporaries tried more self-consciously to detach themselves from tradition than did Chase and the other American Impressionists, but a dual allegiance to the present and the past was essential to both Bellows and Chase, and to their respective colleagues. Indeed, Bellows articulated his double loyalty a year after he painted *The Studio*: "I have no desire to destroy the past, as some are wrongly inclined to believe. I am deeply moved by the great works of former times, but I refuse to be limited by them."[51]

The studio settings that the American Impressionists and Realists occasionally depicted served quite different purposes than did the studios of their predecessors at home and abroad. American painters of modern life used their studios to nourish their art and their personae by providing ambience and decor. They used them as places that said something about those personae, not as retreats for synthesizing major compositions from the results of summer sketching, as the mid-nineteenth-century landscapists had done. They did not adhere to the procedures of French academics and employ studios as facilities in which they made drawings and oil sketches to explore artistic problems, or gather and study costumes and props to insure historical accuracy of details in their canvases, or arrange elaborate setups that would be transformed into narratives based in distant times and places. Breaking with these studio practices, the American Impressionists and Realists followed Edouard Manet, Edgar Degas, and other French Impressionists in revising rather than reiterating lessons gleaned from the old masters.

Fig. 40 John Singer Sargent. *The Sketchers*, 1914. Oil on canvas, 22 x 28 in. (55.9 x 71.1 cm).
Virginia Museum of Fine Arts, Richmond, The Arthur and Margaret Glasgow Fund 58.11

They were uninterested in historical, exotic, or imaginary locales and in what had to be invented within the studio. Instead they found their subjects within the ordinary experience of their own time and place. They continued to work in the studio on the occasional portrait, figure study, and still life but were more often engaged with the rural and urban world outside its confines.

Some sought subjects in the streets, squares, and parks near their studios, and members of both groups spent summers painting outdoors in country retreats, where the Impressionists among them produced pictures such as *The Sketchers* (fig. 40). This engaging view, completed by Sargent in 1914, demonstrates the durability of the Impressionist method into the twentieth

century; painted in San Virgilio, Italy, its locus could be anywhere sunny and green.[52] The setting is removed from the ills and conflicts of urban existence, for Sargent emphasizes a holiday world that would pass away after World War I.[53] For the war wrought international changes that forever altered the social and political fabric that the Impressionists and Realists sought to interpret as what Chase called "the great record of America" and Bellows termed "a living art of its own time."[54] The genteel existence enjoyed and depicted by Sargent and other American artists of his generation was gone, replaced by darker worlds than those encountered and memorialized by the turn-of-the-century Realists.

THE COUNTRY

Modern Painters in Landscape

Detail, fig. 41

Nature as Personal Experience

The tenderness and grace of impressionism are reserved for its landscapes.

CRITIC (1886)

The definition so often given of the work of modern painters in landscape—which is, that they take a motif anywhere, as if looking out of an open window, and paint it just as they see it—is partly erroneous, only a half truth.

CHILDE HASSAM (1903)

When John Singer Sargent painted the French artist Paul Helleu sketching outdoors with his wife (fig. 41) in 1889, he revealed a great deal about both the practice and the purpose of the new movement in landscape painting as it would emerge in the United States. Landscape painting (not just the more common landscape drawing) has been brought outdoors, a point made forcefully by the artist's canvas shown resting directly on the ground, in the midst of the subject he is depicting, and by the presence of his brushes and portable palette. Sargent, already a well-known portraitist, depicts his model, an academically trained figure painter who usually worked in the studio, embracing the plein air method and the commitment to direct observation that recently had become mainstays of his own work.[1]

Sargent had been painting outdoors from time to time in the Worcestershire countryside since 1885, when he left Paris and settled in London. His first summers in the west country were spent in Broadway, about twelve miles south of Stratford-upon-Avon, where he joined an informal colony of artists and writers. In March 1889 he took a house at Fladbury Rectory, near Broadway, on the river Avon. There he was visited by Helleu, a close friend from his Paris days and, like himself, an admirer of Claude Monet's.[2] Helleu's circumstances had changed radically in recent years: in 1886 he had married Alice Guérin, whom he had met two years earlier when she was only fourteen, and traded a bohemian life for one of comfortable domesticity.[3]

Sargent's *Paul Helleu Sketching with His Wife* shows ordinary people as they might actually have been found on a sunny afternoon at the water's edge, instead of the mythological, historical, or picturesque models represented by academic artists. Sargent has chosen an elevated vantage point, viewing the couple from above, the reeds and grass behind them forming a screen that blocks the distant view. The composition creates a balance between the figures and their setting and establishes an enclosed and somewhat private space set off from the surrounding landscape.

The focus on Helleu's hand and its decisive gesture asserts the importance of the act of painting. During the 1870s and 1880s younger American painters, Sargent among them, had

learned the significance of technical virtuosity while studying abroad, and many of them, unlike Sargent, returned home to preach what the critic Mariana Griswold Van Rensselaer called a new "artistic gospel": "The painter's first privilege, first task, first duty [is] *to learn the art of painting*."[4] As serious an endeavor as painting was for Sargent and his artist friends, it was now an enterprise that took place in the midst of life. The bright red canoe that conveyed Helleu and his wife to their grassy retreat cuts across the picture on a diagonal, and a fishing pole is propped against the work in progress, reminding the viewer that the purpose of this outing was recreational as well as artistic. In *Paul Helleu Sketching* art and life—the act of painting and the subject of that art—come together.

Here, too, Sargent strongly but subtly suggests the central role Helleu's wife played in his artmaking. Marcel Proust characterized Helleu as the painter Elstir in his series of autobiographical novels *Remembrance of Things Past* and had much to say about Helleu's wife. Proust, as the narrator, describes visiting the artist's seaside studio, where he met Elstir's/Helleu's wife. Although he initially found her "most tedious," Proust developed an appreciation for her beauty after studying Elstir's paintings and realizing that her physical appearance had served as an inspiration to the artist. "I understood then that to a certain ideal type . . . he had attributed a character that was almost divine," explained Proust.[5] Indeed, the serpentine lines and arabesques recognized by Proust as characteristic of Helleu's own images of women are suggested in Sargent's portrayal of the couple—in their bodies, their accessories, and the canoe behind them.

The distinctly cosmopolitan character of this painting must be acknowledged. It came from the brush of an American artist born, raised, and formed in Europe; it was painted at Sargent's retreat in the English countryside; and it depicts a French artist. Certainly, the painting style is equally European, in many ways an awkward blend of academic figure drawing and the more avant-garde principles of Impressionist landscape painting—the former studied by Sargent first in Florence and perfected at the Ecole des Beaux-Arts in Paris, the latter learned directly from Monet on visits to Giverny. Thus the more resolved treatment of the faces is noticeably different from the flickering brushwork that represents the landscape elements in *Paul Helleu Sketching*. Sargent's dual approach diagrams the characteristic American response to French Impressionism.

When French Impressionism was widely introduced to the American art-loving public in the 1880s, there was a clear critical preference for the school's landscapes over its figural works. A writer for the *Critic* expressed the difference between the two genres: "The tenderness and grace of impressionism are reserved for its landscapes: for humanity there is only the hard brutality of the naked truth."[6] In their figural works the French Impres-

sionists more conspicuously flouted established academic standards of finish and composition as well as conventions about the propriety and hierarchy of subject matter. Landscapes were deemed less important by academics, so challenges to accepted forms were less controversial. Accordingly, landscape painting rather than figure painting offered a readier forum for experimentation in the new mode, especially by academically trained American painters (including Sargent) who would take up Impressionism.

This was, however, a limited experimentation on the part of the Americans. They worked in styles less innovative than those of their French counterparts, and they chose subjects that were less modern, sometimes even looking to the past for inspiration in a manner that seems conservative and resistant to rather than celebratory of progress. In their choice of landscape subjects, the Americans drew almost as heavily on the earlier French Barbizon painters as on the French Impressionists who reached their maturity after 1865. The French Barbizon artists such as Jean-François Millet, Théodore Rousseau, and Camille Corot painted the rural countryside, abandoning the heroic presentation that previously had justified the selection of landscape subjects, and they brought painting outdoors, serving as an inspiration to their Impressionist successors.[7] They were, however, romantic painters who loved quiet scenes filled with old trees, thatched cottages, and antiquated stone bridges, signs of endurance and continuity. For them the past lived on in the countryside. They depicted places apart, where nature could be contemplated in solitude, and they resisted change. "Everything I wanted to paint has been destroyed," grieved the Barbizon painter Charles-François Daubigny about transformations in the French countryside at midcentury, "trees cut down, no more water in the river, houses razed!"[8]

Daubigny and his Barbizon colleagues were well known and much appreciated in the United States, particularly in Boston, where William Morris Hunt promoted interest in their work. Their influence, evident by the 1850s, extended forcefully into the first years of the twentieth century.[9] Early practitioners of the American Barbizon style, such as George Inness (see fig. 42) and Alexander H. Wyant, were joined by a later generation of painters, including Henry Ward Ranger and Dwight William Tryon, who chose landscape subjects that expressed heightened sentiment and emotion. Some of these artists have been categorized as Tonalists.[10] The Tonalists often used evocative light and atmospheric effects, unifying their compositions with an overall single color, choosing delicate accents of one color or even painting the entire canvas in tones of the same color; and, as Wanda M. Corn has put it, they "confronted nature as a private and extremely personal experience."[11] They sought to express what they called sentiment—not only the appearance of a site but also the emotional response it evoked from the painter and, later, from the viewer of the painted image.

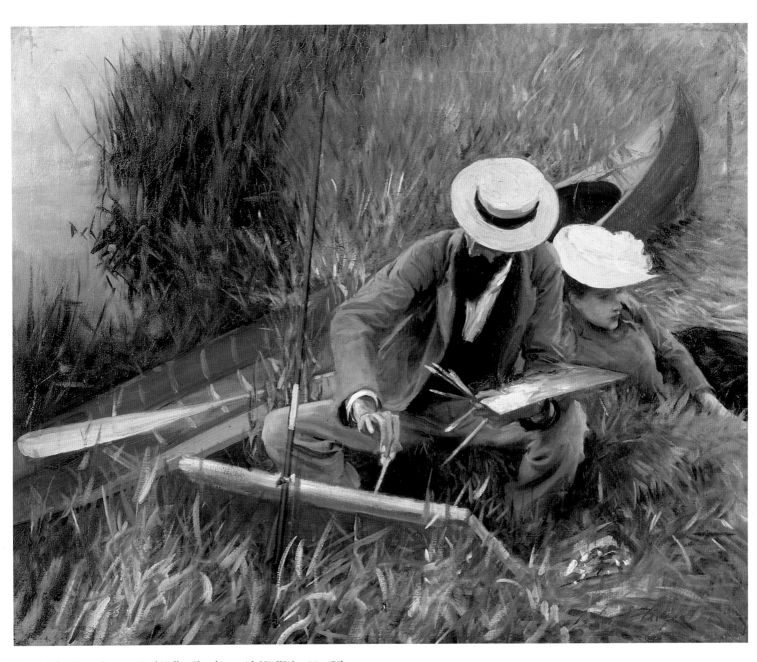

Fig. 41 John Singer Sargent. *Paul Helleu Sketching with His Wife*, 1889. Oil on canvas, 26⅛ x 32⅛ in. (66.4 x 81.6 cm). The Brooklyn Museum, Museum Collection Fund 20.640

Fig. 42 George Inness. *Sunrise*, 1887. Oil on canvas,
30 x 45¼ in. (76.2 x 114.9 cm). The Metropolitan
Museum of Art, New York, Anonymous gift in
memory of Emil Thiele, 1954 54.156

The French Impressionists had long since rejected this sort of overt romanticism and instead had sought a landscape that bore human imprint but was less obviously historical and sentimental. Because they looked to the future, they welcomed, even celebrated change, featuring railroads, roads, and other signs of progress in their views of the French countryside.[12] The landscape painters among the American Impressionists took up some similar subjects—J. Alden Weir's iron truss bridge and factory smokestacks, Theodore Robinson's railroad bridges, John H. Twachtman's shipyards are but a few examples—but they gave these images a noticeable patina of nostalgia. For the American Impressionist painters these subjects became a means for expressing ambivalence or regret about progress and change. This was a highly personal perspective.

Because the American Impressionists tempered narrative description with evocative interpretation, few of their landscapes are close records of the countryside they depict. Childe Hassam acknowledged Twachtman as one of the painters who strove "to give you frankly the aspect of the thing seen in its fundamental and essential truths" yet commented on that artist's willingness to make adjustments in actualities "to get the balance and beauty of the whole, well seen within the frame." To achieve these results, Hassam explained, "Twachtman might have painted,

indeed he did paint, a tree in Nutley, New Jersey, with a distance and middle distance of Gloucester Harbor, Massachusetts."[13]

And, surrendering willingly to romance and nostalgia, the American Impressionists sought out countryside that had strong associations with the past, historic resonances that confirmed their belief in American achievement and stability. Their work appealed to a new American audience that increasingly valued landscape because its beauty was at once threatened and made more accessible by progress. Their landscapes exhibit three related and overlapping tendencies—a nationalistic enthusiasm for the identifiably native site; a nostalgia that sometimes not only privileged the appreciation of the past but also ignored the present; and a euphemistic idealization that softened or even denied the actualities of modern life. When people play a role in these landscapes, they are most likely to be seen at leisure or in contemplation rather than in moments of work or distress. Through their depiction of the landscape, the American Impressionists were able to distance themselves from the city, with its pressures and its ills.

For the American Impressionists' successors, the Realists of the early twentieth century, landscape played a different and less central role. These artists embraced urban life—and modernity—with greater enthusiasm. To be sure, their landscape work,

usually confined to summer excursions or to views on the outskirts of the city, did offer opportunities for formal and expressive experiment. A few notable Realists, such as Rockwell Kent and George Bellows, did paint landscapes regularly, but this is one subject that can be identified primarily, though not exclusively, with the Impressionists, who used it as an effective forum for expression.

While acknowledging the differences between these two groups of painters, we can see that both clearly were motivated by some of the same artistic concerns. In 1903 Hassam disputed the definition of "modern painters in landscape" as artists who "take a *motif* anywhere, as if looking out of an open window, and paint it just as they see it," maintaining that this was "only a half truth."[14] Like the French artists who inspired them, the American Impressionists and Realists did not "paint it just as they [saw] it." Artists and art critics alike may have fostered the myth that "modern" painters recorded people and nature directly and straightforwardly, with little editing or artifice, in part to emphasize the differences between progressive painters and contemporaries working in a more old-fashioned academic manner. But, in fact, the vision of the American Impressionists and Realists is highly selective, and what it omits is as significant as what it represents. These painters chose their landscape subjects deliberately and defined their treatment thoughtfully, carefully considering the ways in which they mirrored or obscured aspects of contemporary life. A close look at the landscapes they painted reveals a complex pattern of choices and intentions that expresses their nationalism, nostalgia, and tendency toward euphemism.

Home Is the Starting Place

Europe palls on me. For some there is no place like home.

J. ALDEN WEIR (1901)

Art, to be vital, must be local in its subject.

HAMLIN GARLAND (1894)

Even while recognizing the French origins of American Impressionism, artists and early critics found national characteristics manifested in the native landscape subjects chosen by the Americans. The American Impressionists and their audience were actively engaged with sites they knew and experienced in the United States, but the international flavor of the American artists' painting style sometimes obscures the national self-consciousness of their subject choices.[15] "No man expresses well in any art what he does not know to the bottom. It is as necessary for him who wishes to paint landscape to live surrounded by what he loves, as for him who would paint an elephant to go and find the animal," wrote the painter Edward E. Simmons in 1903.[16] Hamlin Garland proclaimed in 1894, "Art, to be vital, must be local in its subject,"[17] as we have noted. This association was considered as essential for the viewer as for the painter. John Enneking, who represented sites that could be mistaken for generalized views (see fig. 43), told Garland: "I paint portraits of places, scenes people know and love.... The average man likes to recognize something familiar in a painting."[18]

Fig. 43 John Enneking. *The Rundy House on the Neponset River*, 1890. Oil on canvas, 26 x 36 in. (66 x 91.4 cm). Museum of Fine Arts, Boston, Gift of Morton C. Bradley in memory of Robert C. Vose 1975.753

Fig. 44 Theodore Robinson. *A Bird's-Eye View*, 1889. Oil on canvas,
25 ¾ x 32 in. (65.4 x 81.3 cm). The Metropolitan Museum of Art, New York,
Gift of George A. Hearn, 1910 10.64.9

This dedication to familiar subjects and the assumption that viewers would appreciate them marked a distinct departure from artistic thinking of the 1870s and 1880s, when more cosmopolitan attitudes prevailed, and in some ways reasserted the priorities of the then old-fashioned Hudson River School, which had focused upon views of the United States. But, paradoxically, the Impressionists' renewed commitment to American and most especially to New England landscape subjects was motivated by a desire to create a distinctive amalgam of foreign inspirations and native enthusiasms, which in many of its aspects was an American translation of French ideas.

Ironically, the American Impressionists' engagement with national subject matter was stimulated by the preference for French landscape subjects among French artists. The French Barbizon painters had developed a nationalistic interest in specific locales, and the French Impressionists took up this theme.[19] Monet in particular preferred to depict his native France, where he exalted the rural landscape.[20] Robinson acknowledged Monet's role in awakening his feelings about his own native scenery. "This interests me, the liking for landscape (both in nature and art) in America," Robinson wrote in 1893. "It is very genuine and widespread, and is a good way to begin—something good will come from it if it is directed and taught, as the canvases of Monet and others are doing, or at least beginning to do."[21]

Robinson had been converted to Impressionism through his friendship with Monet, whom he met at the French village of Giverny, which Robinson depicted in *A Bird's-Eye View* (fig. 44).[22] With fellow Americans Willard Metcalf (see fig. 82) and Theodore Wendel, Robinson first visited there in 1887, apparently by chance, and this crucial moment placed the three artists at the home and working site of the leading French Impressionist.[23] Of the many Americans who were drawn to this village by their admiration for Monet, Robinson achieved perhaps the most significant and enduring artistic relationship with the French master, returning to Giverny repeatedly for long stays and working closely with him for months at a time from 1888 to 1892.

The view of Giverny, done two years after Robinson's introduction to the village, is painted from the vantage point of the outsider passing by the site. From a hill above Giverny, Robinson shows quaint stone houses and walls nestled between rolling hills and cultivated fields. Although he includes the architectural mass indicating the clustering of buildings within the confines of the village in the center of the canvas, the emphasis on the surrounding verdant countryside signals the artist's growing interest in landscape painting. The compositional format established here reappears later in more panoramic views by Robinson, such as *Valley of the Seine from Giverny Heights* (fig. 45), that demonstrate his growing confidence in and ability with the Impressionist mode.

Robinson's choice of subject in *A Bird's-Eye View* is a preamble to the artist's last years in America, when "placeness"—the character, history, and local significance of landscape subjects

Fig. 45 Theodore Robinson. *Valley of the Seine from Giverny Heights*, 1892. Oil on canvas, 25⅞ x 32⅛ in. (65.7 x 81.6 cm). The Corcoran Gallery of Art, Washington, D.C., Gallery Fund, 1900 00.5

—would become his central concern. The palpable solidity of the aged village structures, emphasized by the use of firm contours, distinguishes Robinson's work from Monet's. Yet the mentor's influence is strongly revealed in the high horizon line, which effectively flattens the distant landscape, and in the delicate atmospheric effects, rendered in tones of cool blue and lavender. Will H. Low, a painter and a close friend of Robinson's, visited Giverny in 1892 and noted the particular character that made the locale (and, indeed, much of the French countryside) so attractive to artists. He recalled, "Its greatest charm lies in the atmospheric conditions over the lowlands, where the moisture from the rivers, imprisoned through the night by the valleys bordering hills, dissolve[s] before the sun and bathe[s] the landscape in an iridescent flood of vaporous hues."[24]

Some American painters grew so attached to Giverny and its artistic activity that they were reluctant to leave: Theodore Earl Butler married Monet's stepdaughter Suzanne Hoschedé in 1892 and became an intimate member of the Frenchman's family circle; Phillip Leslie Hale worked there for four out of five summers beginning in 1888, claiming that it was too difficult to paint in America; and Lilla Cabot Perry spent nine summers over a period of twenty years in Giverny, working literally and figuratively in Monet's shadow.[25] These Americans did much to spread the French master's artistic creed—including his emphasis on local subjects—among their contemporaries.

American landscape painters who came home from Europe underwent a gradual and sometimes difficult transition as they took up native subject matter. Some of their ambivalence stemmed from their perception that the clear American light and atmosphere created unsympathetic effects harsher than those in Europe. In 1912 Lowell Birge Harrison, a leading Tonalist landscape painter, noted the difference in light he encountered upon returning to the United States: "As the ship approaches the American continent the skies are swept and burnished, the haze disappears and the atmosphere becomes clear and vibrant. Nature states her meaning sharply in unmistakable accents, firm, incisive, and perhaps a little staccato to one who has been accustomed to the dreamy suggestiveness of her European language."[26] Dennis Miller Bunker was also aware of such distinctions and in 1886 had expressed a preference for the gray days more characteristic of the French countryside, "because they don't change and one can paint calmly."[27] Robinson in particular acknowledged the impact that these variations in light wrought on the landscapes he painted in America; they were, he felt, "perhaps a little solider, better grasped, firmer" than his earlier French paintings, and he attributed this in part to "difference in climate, atmosphere."[28]

Robinson's commitment to American subjects emerged gradually and despite some resistance on his part. He had long considered the Midwest of his youth uninspiring. "I don't believe Millet himself would have continued painting in Wisconsin—

had he found himself there," he had written to the Ohio-born painter Kenyon Cox in 1883, concluding that the eastern states at least had the advantage of age, two hundred rather than a mere fifty years of settlement.[29] Perhaps espousing the academic ideal that privileged universality of subject, Robinson had decided at an early stage that "American life is so unpaintable—and a higher kind of art seems to me to exclude the question of nationality."[30] Yet after returning from France in 1891, he sought an American site with which he could feel personal sympathy. The following year, when Monet wrote to him about visiting Etretat, Robinson observed wistfully: "He probably feels the charm (as I do) more and more of a country or place he has worked in and got to know."[31]

By 1894 Robinson's preoccupation with American subjects intensified to such a degree that he gave up foreign travel and consciously sought out views that he deemed illustrative of the "typical . . . American (United States) town."[32] The next year his friend Weir encouraged him "to have a place of [his] own and get acquainted with it—grow up with it."[33] This was what Weir had done in Branchville and Windham, and Twachtman, in Greenwich and Cos Cob, all scenic Connecticut towns. Robinson, however, did not seem satisfied with a place for which he had to acquire a taste: he was longing for a countryside that held individual significance for him. He wanted a landscape with which he had some familiarity, and better still, some connection, not just a new residence or a hostelry but a native place and one of some age.

Finally, in 1895, following the example of many of his contemporaries who had found rural New England a personal and artistic magnet, Robinson spent six months in Vermont, near the small town where he had been born. "I think I am on the right track," he wrote that November to Garland, "my parents came from this country . . . and after a long stay west, and after that, years in France, [I] have got back to what I believe is *my* country. It will take time. I am only beginning to see its beauties and possibilities and to feel that affection for a country, so indispensable to paint it well."[34]

There Robinson developed ideas about an American art that expressed national sentiments.[35] In his New England landscapes, above all in those of Vermont (see fig. 46), Robinson used an Impressionist style particularly suited to capturing the appearance of the local American scene—barns, mills, farmhouses, quaint villages, and mountainous tree-covered countryside. The increased linearity of his American style, a notable departure from French Impressionist precedents, was at least in part prompted by his devotion to representing accurately the landscape he had come to love.

In Vermont Robinson made a conscious effort to study local history, visiting elderly members of the community who remembered its past and his family. He watched farmers and their

Fig. 46 Theodore Robinson. *West River Valley, Townshend, Vermont*, 1895. Oil on canvas, 31½ x 46½ in. (80 x 118.1 cm). Private collection

families practice crafts, such as the making of rag rugs and quilts, and extolled the beauty of New England barns, likening them to the cathedrals or castles of the Old World.[36]

Robinson's enthusiasm for things American was encouraged by his friendship with Garland. The writer's experiences and artistic approach, which emphasized the local character of subjects and made European ideas American by applying them to native situations and themes, were analogous to the painter's. Garland so admired Robinson's paintings that in 1894 he planned to bring some of them to his lectures, according to the artist, "to show people what and why certain things mean, and should be admired."[37] In his last interview with Robinson, Garland articulated his own credo, which clearly exalted subject over technique: the painter could not be successful unless he so loved his subject that his affection for it "offset the drudgery of laying paint to canvas, etc." Robinson concurred: "Now I am painting subjects that are something more than 'good bits.' There is a mysterious quality in the landscapes of one's native place—you quoted something from Whitman once, what was it?" Garland responded with a paraphrase of the poet's words: "You go round the earth; you come back to find the things nearest at hand the sweetest and best after all." "That is what I mean," agreed Robinson.[38]

Unlike his colleague Robinson, Weir experienced few qualms as he took up American landscape subjects. He had been raised beside the Hudson River, at West Point, New York, where his father taught drawing at the United States Military Academy. The elder Weir knew the Hudson River School landscape painters well, and this direct family connection to the first group to

celebrate the beauties of the American scene must have helped shape his son's artistic approach. The younger Weir occasionally had dabbled in landscape painting in the 1880s, producing dark, Barbizon-inspired views of New York State and New England. His interest in landscape intensified in the 1890s, once he began to espouse Impressionism. He became particularly committed to painting the rural countryside around his farm in Branchville, Connecticut, between present-day Wilton and Ridgefield.[39]

Weir had acquired this country retreat in 1882. The following year, while abroad on the honeymoon he and his wife, Anna, had anticipated would last for three years, the homesick artist wrote to his parents: "I have often thought while over here this year that Europe has lost most of its charms, or that I have become a better American, in fact Anna and I have both often wished to be at Old Branchville."[40] A short time later he confessed that they "long[ed] for the quiet, plain little house among the rocks."[41] The newlyweds reduced their trip to less than five months and by October 1883 were back in Branchville. "Here shall we rest and call *content* our home;" this inscription on their country house[42] captures the essence of the Weirs' attachment to it. This love of home never left Alden Weir. In 1901, returning from a European trip that included stimulating visits to the glamorous expatriates Sargent and Whistler, he would observe: "Europe palls on me. For some there is no place like home."[43]

Weir made Branchville *his* home. He expanded the farmhouse, constructed outbuildings, and in 1896 improved the surrounding terrain by building a pond, where he was often joined by his artist friends for fishing as well as painting. Weir

Fig. 47 J. Alden Weir. *The Laundry, Branchville*, ca. 1894. Oil on canvas, 30⅛ x 25¼ in. (76.5 x 64.1 cm). The Weir Farm Heritage Trust, Inc., Gift of Anna Ely Smith and Gregory Smith

strove to protect the landscape he loved: he apparently made a practice of buying trees and simply leaving them standing where they were, a living enrichment for the countryside. "Those are my trees," he told a friend proudly.[44] Weir's Branchville became an American analogue to Monet's Giverny, and the Connecticut landscape became the principal subject of Weir's paintings during the 1890s and early 1900s.

In works such as *The Laundry, Branchville* (fig. 47), Weir sheds the somber palette and heavy brushwork of his earlier landscapes and adopts the Impressionist mode to capture the character of the Connecticut countryside. He uses a brilliant palette and delicate calligraphic brushwork to record vignettes that reveal the beauty of this rural community, where signs of domestication, despite the absence of human figures, make the surroundings appear tame. Weir's house, painted an earthy red familiar to any visitor to New England, is the focal point of the composition, which takes its name from the aftermath of an everyday home task: laundry suspended to dry from two long clotheslines. Weir uses touches of bright green, yellow, and lime green, all grayed in the shadows, to represent rocky fields long since denuded of forest and given over to pasture. Yet, although this is land that has been cleared for agricultural pursuits, Weir reminds us of the enduring presence of old trees: one stands at the center of the composition, reduced to supporting the clothesline, and others, on the perimeter of the field, cast long shadows across the grass. The occasional feisty sapling challenges man's continuing control of this hillside. Building on the Impressionist experiments Weir had begun three or four years earlier, *The Laundry* also reflects the artist's growing interest in Japanese prints; this new enthusiasm prompted his dramatic use of voids, such as the empty field, and of the raised horizon line, which forces the eye to rush precipitously upward to the house and laundry at the crest of the hill.

Branchville was not the only, and, in fact, not the first, Con-

Fig. 48 J. Alden Weir. *Obweebetuck*, mid-1890s.
Oil on canvas, 19½ x 23¼ in. (49.5 x 59.1 cm).
Private collection

necticut site to which Weir became attached: he worked happily
alongside Twachtman and Robinson in Cos Cob during the early
1890s and since the 1880s had been a frequent visitor to Wind-
ham, a small village in the northeast part of the state, where his
wife's family owned a country home.[45] His comments after first
stopping in Windham, in 1882, reveal the impact it had on him:
"This is really the first Connecticut village that I have really ever
known, & now I feel that a charm is connected with all villages,
such as I have read of but never appreciated."[46] Despite his early
affection for this New England town, Weir was unable to
portray its unique local character until a decade later, when he
mastered the new Impressionist style.

If Weir's Branchville paintings celebrate the joys of rural life
and show his appreciation of domesticated nature, the land-
scapes he undertook while summering in Windham often inti-
mate more damaging changes wrought in the countryside as
advances in transportation and industry occurred. In only a few
of his Windham paintings did Weir indicate the village's popular-
ity as a resort—one local newspaper writer called the town
"Summerville" in 1897;[47] instead he often concentrated on views
of industrial buildings, such as those portrayed in *The Factory
Village* (fig. 19). In Branchville Weir the city artist dabbled in
the pleasures of rural life as a gentleman farmer; in Windham he
was a visitor, a summer guest in his in-laws' home. He undoubt-
edly participated in at least some of the countless gatherings,
excursions, and local fairs that filled the social calendar of
Windham.[48] In his *Obweebetuck* (fig. 48) a group of women
elegantly attired in white and relaxing outdoors suggests this
aspect of country living. Here the presence of the family home

is merely hinted at by the porch that shades these women of
seeming leisure. The figures are dwarfed by a tall shade tree and
the rolling mountain beyond; only a ramshackle picket fence
stands between them and nature. No reference to the ugly
realities of industrialization disrupts the idyll.

Twachtman, a close friend and an artistic ally of Weir's, also
pursued American landscape subjects with zeal, developing a
highly individual Impressionist style to capture their appearance
under subtly changing conditions of season and weather. As
early as 1890, at a time when many of his colleagues, notably
Robinson, were still struggling to find new American subjects
they deemed expressive, Twachtman already had dedicated him-
self to the native landscape, as his views of rural Connecticut
make evident. After Twachtman's return from studies in France
in December 1885 or January 1886, he and his family had visited
the Weirs in Branchville.[49] The two painters worked closely
together, Twachtman's love of the American and specifically
New England landscape deepening through his friendship with
Weir. In 1889 Twachtman visited Greenwich, where he discov-
ered a farm on Round Hill Road; he purchased the property the
following year.[50]

As Twachtman developed and expanded his home and garden,
he showed a tremendous respect for the landscape he inhabited—
a respect that is visible in his paintings. "Where hillocks grew,
hillocks were left unleveled," explained Alfred Henry Goodwin.[51]
In Connecticut Twachtman chose simple subjects near at hand:
the rural landscape around his ever-expanding home, vistas from
the top porch of the Holley House in Cos Cob, or views of the
brook and cascade that flowed through his Greenwich property.
By 1891 he was so comfortable in the Connecticut countryside
that he was able to exclaim: "I feel more and more contented
with the isolation of country life. To be isolated is a fine thing
and we are then nearer to nature. I can see how necessary it is to
live always in the country—at all seasons of the year."[52]

Twachtman's *Icebound* (fig. 49) depicts Horseneck Brook,
the stream that had first attracted the artist to the site, its icy blue
water the strongest note of color in a frozen winter landscape.[53]
Twachtman eventually recorded the appearance of this site in all
seasons and under a wide variety of weather conditions. But the
paintings that show it in winter are perhaps the most expressive
of the silent solitude the artist loved. These convey a sense of the
moisture and temperature of the chilled New England air and
suggest that more snow is about to fall on the frozen ground.
This was not the season for tourists seeking refreshment in the
landscape but a quiet time for routine country lives. "Never is
nature more lovely than when it is snowing," Twachtman wrote
to Weir in 1891, proceeding to reveal his appreciation of the
unifying effects of snow: "Everything is so quiet and the whole
earth seems wrapped in a mantle.... All nature is hushed to
silence."[54] Contemplation is the keynote of Twachtman's land-

Fig. 49 John H. Twachtman. *Icebound*, 1889–1900. Oil on canvas,
25 ¼ x 30 ⅛ in. (64.1 x 76.5 cm). The Art Institute of Chicago, Friends of
American Art Collection 1917.200

scape paintings, in which nature has been calmed and repeatedly and lovingly viewed. He chose remarkably few subjects, preferring to return again and again to the same themes to explore familiar things he found mysterious and suggestive. But unlike Monet, who in his series paintings strove to capture the objective specifics of weather, time, and seasons as they changed, Twachtman, through the transformations in the landscapes in his own series, attempted to express subtly varied subjective moods and to evoke similar responses from his audience. Thus, *Icebound* was intended to inspire an empathetic reaction, especially from one familiar with the site.

In 1892 Weir received "The Brook," a poem from his namesake, Twachtman's nine-year-old son, Alden, who had written about Horseneck Brook, "this little stream that runs by [his] home."[55] Weir immediately responded to the larger implications of this motif, perhaps recalling the symbolism of rivers invoked by earlier nineteenth-century American landscape painting.[56] Undoubtedly, Weir's comments reflect his thoughts on his friend Twachtman's paintings of the same site:

> There is another, a greater stream which this little one will teach you much about—the stream of life—home is the starting place and love the guide to your actions. Great men who loved their homes and were kind and generous to their playmates in their youth, learned many truths which were of much value to them all through their lives—
>
> The flowers, rocks and trees which one learns to know in their childhood always seem more beautiful—
>
> When I come out to your father's, which I hope will be before long, we will take a walk by the brook and enjoy these beautiful things together.[57]

Weir recognized the Twachtman home in Greenwich as Alden's "native place" and longed for him to appreciate its generative role.

In two other series of pictures Twachtman turned from the modest brook and falls on his property and depicted well-known and rather grandiose natural wonders that might be considered particularly representative of the United States, East and West— Niagara Falls and Yellowstone Park. At first glance better suited to the temperaments of such Hudson River School painters as Albert Bierstadt and Frederick E. Church than to Twachtman, these locales presumably were selected not by the painter but by the men who commissioned the works. Yet it was, of course, the artist who devised a highly personal manner for depicting these familiar sites. Twachtman received his commission for Niagara from Charles Carey, a Buffalo physician, for whom the falls held some local resonance.[58] The artist, who exhibited the first of some fourteen views of the falls in 1894, favored vantage points that enabled him to give Niagara a human scale. In works such as *Niagara Falls* (fig. 50) the cascading falls are in the distance, raised so high as to strictly limit our view of the empty sky above, and the foreground is filled with rocky outcroppings and riverbanks. We might stand here safely and contemplate the powerful falls without the intrusion of fellow tourists. Niagara is not

Fig. 50 John H. Twachtman. *Niagara Falls*, ca. 1894. Oil on canvas, 30 x 25⅛ in. (76.2 x 63.8 cm). National Museum of American Art, Smithsonian Institution, Washington, D.C., Gift of John Gellatly 1929.6.142

presented as a vast and impersonal natural wonder but as a phenomenon that can be experienced in an individual, intimate way.

When Twachtman went to Yellowstone at the request of another Buffalo resident, Major William A. Wadsworth, in 1895, the landscape was so unfamiliar to him that he commented: "This trip is like the outing of a city boy to the country for the first time."[59] The resulting paintings are abstracted to such a high degree that it is sometimes difficult to recognize the site.[60] The snow and opalescent water in *Emerald Pool, Yellowstone* (fig. 51), for example, are reduced to decorative patterns that reveal Twachtman's deep interest in the Japanese print.[61] It was not the artist's personal preference to paint the distant locales of Niagara and Yellowstone; to the end he remained devoted to the quieter and less dramatic landscape of New England.

Metcalf also joined the ranks of New England enthusiasts, albeit in a more peripatetic manner than some of his contemporaries. After settling in New York in 1889, he made regular sorties from his urban residence to paint his favorite subject, the New England landscape in every season—in full spring or summer bloom, in autumnal foliage, or covered with crisp white winter snow. Metcalf chose the peak moments that accentuated

Fig. 51 John H. Twachtman. *Emerald Pool,
Yellowstone*, ca. 1895. Oil on canvas, 25¼ x 30¼ in.
(64.1 x 76.8 cm). Wadsworth Atheneum, Hartford,
Bequest of George A. Gay, by exchange, and the Ella
Gallup Sumner and Mary Catlin Sumner Collection
Fund

the glories of the region's well-known and much appreciated
seasonal changes. Whatever the time of year Metcalf depicted, he
preferred a beautiful view. The only intrusions on nature permit-
ted were aged farmhouses and churches, characteristic markers
of the region, nestled comfortably into the landscape. "It is the
robust landscape of New England divested of its rigors. For Mr.
Metcalf does not deal in asperities," explained Walter Jack
Duncan in 1925, the year of Metcalf's death. "He was born to
please. From his beauty-shop he dispenses charms and spells
which enchant the eye and conjure us to love."[62] Nevertheless,
Metcalf must have been aware of the uglier aspects of the region
he so lovingly painted. He was born in Lowell, Massachusetts, a
leading textile manufacturing center, but even during his youth
he spent long periods with his mother's family in Maine, where
his devotion to the New England landscape was nurtured.[63]
Much of his career was dedicated to interpreting the landscape
of the Northeast—Connecticut, Vermont, and New Hampshire,
as well as Maine.

Metcalf's *Cornish Hills* (fig. 52) represents the winter land-
scape around Cornish, New Hampshire, a favorite country
retreat for such artists as Augustus Saint-Gaudens, Thomas
Wilmer Dewing, and George de Forest Brush.[64] In fact, between
1885 and 1915 Cornish—or more accurately the townships of
Cornish, Windsor, and Plainfield—near the upper Connecticut
River, was frequented by some thirty artists from Boston, New

York, and Philadelphia. Cornish was located near a train line,
which stopped across the Connecticut River in Windsor, Ver-
mont, and although the trip took five hours from Boston and ten
hours from New York, the scenic town was deemed readily
accessible to city folk seeking country living.[65] Metcalf was only
an occasional visitor to this picturesque area, yet he responded
more evidently to its surrounding landscape than did some of the
town's regular residents, many of whom espoused styles of
painting and sculpture more conservative than his own and
explored figure subjects, not landscapes, in their work.

Metcalf's first visit to the area was in 1909 and may have
been undertaken to escape the unpleasantness of a divorce suit,
but his 1911 sojourn was charged with happier personal signifi-
cance. He and his young bride, actress Henriette Alice McCrea,
were guests at the home of painter-architect Charles Adams Platt.
The newlyweds enjoyed the company of other members of the
Cornish colony; however, the serenity and isolation represented
in *Cornish Hills* suggest the quieter and more private world
sought by the painter and his wife.

In *Cornish Hills* Metcalf shows iced-over Blow-Me-Down
Brook with Dingleton Hill beyond.[66] The only hints of human
presence are a few small buildings in the middle distance, the
house and barns of Charles C. Beaman, a New York lawyer who
helped establish the Cornish colony and first encouraged Saint-
Gaudens to visit the town. While this reference to the origins of

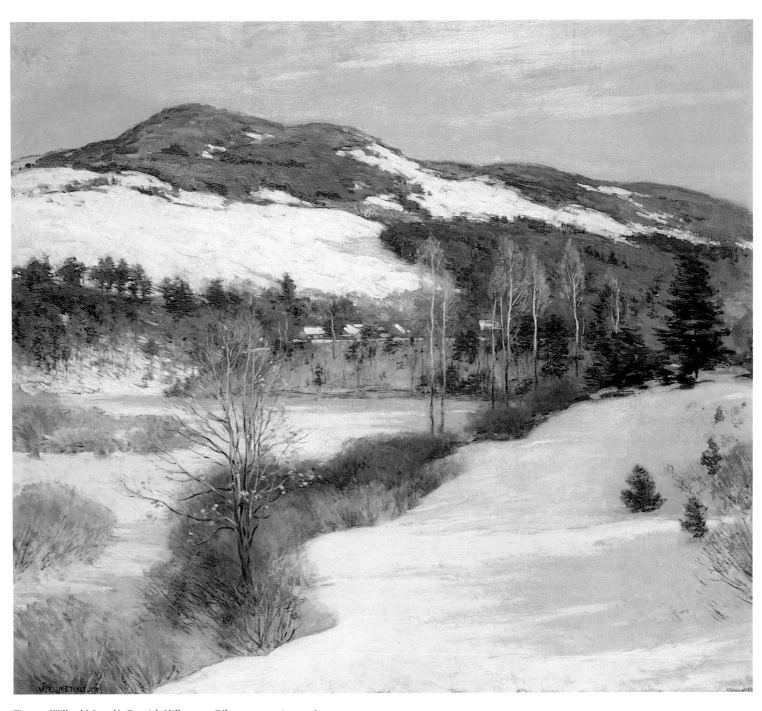

Fig. 52 Willard Metcalf. *Cornish Hills*, 1911. Oil on canvas, 60 x 40 in.
(152.4 x 101.6 cm). Thomas W. and Ann M. Barwick

the colony might well have been a pointed acknowledgment, it is so subtle as to be lost on all but the most knowing viewer. The name of the brook represented also would have been resonant for knowledgeable members of the Cornish colony: it was virtually the same as "Blowmidown," the river described by Henry Wadsworth Longfellow in his poem *Evangeline*.[67]

The artist residents in Cornish frequently used the word "Arcadia" to describe the countryside around their retreat, likening Mount Ascutney, visible in the background of *Cornish Hills*, to Mount Vesuvius.[68] Deborah Elizabeth Van Buren has described the significance of the ideal nature of Cornish for them: "The Arcadian myth was not a nostalgic remembrance of an agrarian past. To them Cornish was pastoral because it was a world that was not yet anthropocentric. They saw themselves as living in an ideal landscape where life was simple and the land provided spiritual rather than economic sustenance."[69] The writers who joined the colony at Cornish took up some of the same themes pursued by the painters, emphasizing the importance this site held as a home for artistic endeavor. Dramatist Percy MacKaye, who lived in Cornish during the years Metcalf visited, described New England as Arcadia in his play *The Antick*. At the play's conclusion the hero is asked if Arcadia is far away and he responds: "Not to-day, my kiddie; to-day it's close by."[70]

For all these associations, *Cornish Hills* impresses us most forcefully with the aura of silence and immobility it projects; there is literally no movement, no life, in this frozen vista. In fact, desolate winter was a fitting choice of season for Metcalf's portrayal, for he depicts a landscape that was in actuality largely unpeopled and empty of human activity. The recently arrived city folk had purchased abandoned farms and uncultivated land left by farmers who, like others throughout New England, had been migrating westward since the 1830s. Ironically, the expansion of the railroad, which gave urbanites access to this country retreat, also encouraged the departure and relocation of farmers.

"The artist shows us that snow is not always the same kind of white," noted Robert Macbeth when the picture was featured at the exhibition of the Ten American Painters in 1911, adding, "we are shown snow under various conditions, broken up beneath the trees on the hillside, smooth and undisturbed on the level plain, shaded by evergreens and also by the clouds, and we feel with Metcalf the very different aspect of the white mantle under such varying conditions."[71] Here Metcalf's Impressionist style, with its precise drawing and solid forms, is tailored to express more effectively the cold, crisp quality of the frozen New England winter. The firm contours and powerful modeling used here by Metcalf exemplify how much the American Impressionists tempered French precedents in depicting the American sites they loved. And the date of *Cornish Hills*—1911—serves as a reminder of the strength and endurance of American Impressionism well into the twentieth century.

The American Impressionists—Hassam, Chase, and others, as well as Robinson, Twachtman, Weir, and Metcalf—were deeply and continually attracted to New England or locales resembling New England, regions associated with the earliest Anglo-Saxon settlements in North America and villages that originally were political, social, and economic paradigms.[72] The paintings of the Impressionists celebrated a vanishing (if not vanished) way of life based on common values and interests. The Impressionist devotion to capturing the local scene—images of New England farm and village life—resulted in the creation of visual parallels to the works of local-color writers of the period, such as Garland, Celia Laighton Thaxter, and Sarah Orne Jewett.

By the turn of the last century New England was still scenic. It preserved some of the charm that the young William Dean Howells described when he arrived there from the Midwest in the 1860s: "The land was lovelier than I have ever seen, with its old farmhouses, and brambled grey stone walls, its stoney hillsides, its staggering orchards, its wooded top and its thick brackened valleys."[73] But New England was in a state of flux. During the first third of the nineteenth century much of the region had been cleared for fields, yet, as farmers resettled farther west, the forest returned gradually, and many farms and villages were commandeered by summer visitors. Despite the transformation it experienced, this area continued to be viewed by Americans, particularly urban dwellers, as pastoral, even idyllic. Historian John Brinckerhoff Jackson has described the national perception of the region: "New England was still envisaged as an open landscape of farms and meadows and tree-embowered villages, fresh and green and beautiful. It was accorded a quality—acquired or retained, it would have been hard to say—that distinguished it from other regions: a smallness of scale, a neatness and simplicity, a rich diversity of scenery that elsewhere in the United States were lacking. Never reluctant to tell its own virtues, New England ascribed them to its being the most truly American part of the country, but the rest of the states ascribed its uniqueness to its age."[74]

New England offered the American Impressionists a native analogue to the picturesque scenery they had so enjoyed during their student years abroad. In this part of the United States, rich not only in historical associations but also in personal significance, painters found subjects that enabled them to express ideas and sentiments that appealed to an audience that cherished tradition and continuity in the face of change. Its popularity lay not only in its great age but also in its usefulness as a source of identifiable national icons that offered reassurance in the face of encroaching immigrant populations and the intrusion of industrialization. As the expatriate Henry James wrote of New England in 1906: "Why was the whole connotation so *delicately* Arcadian, like that of an Arcadia of an old tapestry, an old legend, an old love story in fifteen volumes?"[75]

Solace in Nostalgia

The remoteness of the past is for us a part of its charm.

DAVID LOWENTHAL (1975)

Isolated old farms with memories that bring quivering response.

GILES EDGERTON (1909)

As change became more rampant and the ugliness of urban life became more evident, the American Impressionists sought solace in nostalgic landscape views celebrating a simpler way of life long since past. Although these landscapes often depict recognizable sites, their purpose was as much evocation as topographical accuracy; they express the nostalgic attitudes and emotions of their creators and were intended to arouse analogous responses in others. These painters chose subjects that offered at least a visual relief from the pressing actualities of modern life. "What nostalgia . . . require[s] is a sense of estrangement," explained cultural geographer David Lowenthal, "the object of the quest must be anachronistic. Like the Renaissance devotion to the classical world, the remoteness of the past is for us a part of its charm."[76] The anachronistic features represented in American Impressionist landscapes—farms that no longer harvested crops, canals whose barge traffic had been rendered obsolete by speedier trains, and harbors whose working fishing vessels had been replaced by recreational boats—made them more appealing to turn-of-the-century viewers. This nostalgia is an equally apparent characteristic of present-day American society—in the popularity of phenomena ranging from Colonial Williamsburg to Disneyland, from antiques to other collectibles, from one pop culture revival to the next.[77]

Pursuing the approach of the French Barbizon School and its American exponents, Impressionist landscape painters generally chose simple, familiar scenes, represented whatever was near at hand and, according to the critic Leila Mechlin, depended more upon the artist's "interpretive power" than upon the inherent topographical interest of their subjects.[78] Many turn-of-the-century American artists followed the advice and example of American Barbizon painter Inness, who considered the purpose of art "to awaken an emotion," not to preach or teach, and favored expressive lyrical subjects.[79] Giles Edgerton catalogued these evocative subjects in 1909: "the hush of the woods, the still fragrance of early spring, the ghostly dory in a twilight sea, the hidden pool in the yellow woods, the mysterious radiance of prairie sunsets, the tender, brooding quality of the early snow that comes sometimes as a kindly wonderful garment of beauty, twilight about simple homes, isolated old farms with memories that bring quivering response."[80] These landscapes were meant to arouse a gentle emotion and to convey a nostalgic appreciation of the American scene, even as nature was being transformed by industrialization and the foundations of American society were being shaken by change.

Wendel's *Bridge at Ipswich* (fig. 53) makes its focal point Green Street Bridge, an old-fashioned twin-arched structure that incorporates old materials from the 1881 wooden bridge with stone piers that preceded it.[81] The bridge was built to replace the earlier one in 1894.[82] William Howe Downes, a Boston art critic, maintained that New England stone bridges like this one possessed "almost inevitably the best type of unison between utility and beauty," underscoring the American proclivity for images that recall the gentler, more attractive aspects of the past in the face of modern life.[83] Wendel was inspired by Impressionist paintings by Monet and Camille Pissarro, who used subjects such as bridges and roads both as signs of modern industrialization and reminders of the picturesque past, but he gave his picture a native inflection.[84]

If Wendel's style is French, his message is American. As much as any individual town, Ipswich was associated with the settlement of the British colonies and the origins of the United States. He reminds us of the town's durability in the face of change by setting his scene in the autumn, a time of year that makes us aware of the progress of the seasons and the passage of time. He selects a view that tells us relatively little about twentieth-century life in the village. The buildings we see are domestic in scale and do not include the thread, lace, and hosiery factories that had contributed so much to the town's economy and that, within a few years, would be at the heart of social conflict.[85]

Instead, the artist, who was born in Cincinnati and came to know Ipswich in the late 1890s, after he was educated in Europe, emphasizes elements that recall the town's past. Agriculture had been Ipswich's mainstay, and so Wendel shows the village nestled among farmlands. He also positions a horsedrawn cart, most likely filled with marsh grass that was collected around the town, in the center of the roadway, reminding the viewer of traditional agricultural pursuits and of an older means of conveyance at a time when great advances were being made in industrial development as well as in rail and even automotive transportation. The scene loses its contemporaneity and takes on a historic air.

Nostalgia is also evident in the canal views that Robinson painted in the summer and fall of 1893, when he taught an outdoor painting class at rural Napanoch, New York. (Napanoch was not far from Ellenville and Cragsmoor, a popular artists' summer colony located in the Shawangunk Mountains, once a haunt of the Hudson River School painters.)[86] While in Napanoch, he probably met the prominent local painter Edward Lamson Henry, who specialized in historical genre scenes depicting old-fashioned life in rural America. Like Robinson's renditions of American subjects, Henry's historical pictures are not purely

Fig. 53 Theodore Wendel. *Bridge at Ipswich*, ca. 1905. Oil on canvas, 24¼ x 30 in.
(61.6 x 76.2 cm). Museum of Fine Arts, Boston, Gift of Mr. and Mrs. Daniel S.
Wendel, Tompkins Collection, and Seth K. Sweetser Fund, by exchange 1978.179

American: Henry had studied in Paris with the Swiss artist Charles Gleyre, who often depicted episodes from his own national history; thus Henry's scenes of American life are actually translations of a European model. Henry's fascination with the American past must have reinforced Robinson's predilections, which soon became apparent in his teaching program and in his paintings. At Robinson's urging, his students painted homesteads dating from the Revolutionary period, and even when they chose subjects that seemed more modern, they suggested changes resulting from the passage of time—recording with nostalgia what a contemporary observer termed "an old ruin" of a factory that had once produced straw paper or "the venerable towpath, brown and much travel worn by patient beasts."[87]

Robinson's *Port Ben, Delaware and Hudson Canal* (fig. 54), one of the series of similar views he completed in Napanoch, is the artist's own rendition of the "venerable towpath."[88] It depicts the Delaware and Hudson Canal at lock 27, in Port Benjamin (now Wawarsing), then the location of a canal store, stables built to house the animals that serviced the canal, two dry docks, and two substantial boatyards.[89] The 108-mile canal, constructed between 1825 and 1829 to connect the Delaware and Hudson rivers, had facilitated the transportation of coal from Pennsylvania to New York City in the era before the Civil War. By 1893, however, this artificial waterway was long past its prime, a reminder of the commercial ambitions of another day. *Port Ben* commemorates a mode of travel outdated, if not obsolete, by the turn of the century, since the Delaware and Hudson and, indeed, most American canals had long since lost their business to cheaper and more efficient railroad lines, which could operate with less concern for winter weather.[90] In fact, railroads often were built alongside the inland waterways.[91] This relationship was particularly poignant along the Delaware and Hudson Canal: the first locomotive to operate on a permanent track in the United States did so beside it in 1829.[92] By 1894, the year after Robinson's sojourn at Napanoch, only twenty boats were still in operation—this on a waterway that had generated over a million dollars in tolls annually only thirty years earlier—and by 1904 the canal was completely abandoned.[93] In Robinson's painting the foreground planes are insistently empty, calling our attention to the absence of activity, to the fact that the industries for which this canal and its locks were designed have found newer, better service in the railroad. Time has left the land and its unseen inhabitants behind.

Little wonder, then, that the canal men had ample leisure to entertain Robinson and his students. One contemporary report noted the local residents' interest in their artistic efforts: "The towpath bristles with white umbrellas all day like a field with mushrooms after a fog. Parties board the boats and are towed from one lock to another. The canal men are kindly interested in the progress of art and aid it when they can pointing out 'the fresh greens' and 'tender purples' within sight. This artistic vernacular has become so common that the very drivers stop their horses to point out 'pretty bits' to the aspirants for artistic glory."[94]

If these leisurely activities, so much a part of Robinson's visit to the Delaware and Hudson, are not represented in *Port Ben*, neither are the harsher realities of life along the canal—bedraggled mules so overworked they required protection from the ASPCA, orphaned children hired to drive boats, or broken canal walls and aqueducts that defied maintenance.[95] Robinson's editorial decisions are more obvious when his painting is compared with Henry's *Late Afternoon on the Old Delaware and Hudson Canal, at Port Ben, Ulster County, New York* (fig. 55) of the following year. Henry has made canal life—and even the Shawangunk landscape—a backdrop for a narrative scene; the canal boat, pulled by two mules, is just coming into view behind the foreground figures, who are engrossed in conversation. Nevertheless, small details inform the viewer of the sorry state of affairs along this waterway: it could well be that the two able-bodied men sitting idly on barrels belong to the ranks of the many canal workers who recently had lost their livelihoods and that the two children standing on the berm path to the right are among those exploited for inexpensive labor.

Robinson's *Port Ben* ignores these unpleasant possibilities and focuses instead on the beauties of the landscape, notably the clarifying sunlight and the billowy clouds that fill the sky. Not even the effort required to shift barges from lock to lock is conveyed; a single barge progresses with stately deliberation down the canal, the men and animals needed to move it reduced to summary touches of pigment. The man-made waterway, with its unbending contours flanked by embankments, towpaths, fences, and telegraph lines, actually receives no more attention from Robinson than the cloud-filled sky, which occupies more than half of the composition. The artist acknowledged the role these turbulent clouds played in his Port Ben pictures by quoting in his diary a maxim he attributed to the English landscape painter John Constable identifying the sky as "one of [the artist's] greatest aids."[96]

Robinson regarded his canal scenes as something of a departure from the work he had done abroad, characterizing them as "emancipation from old formulae and ideas of what is interesting or beautiful from the European standpoint"[97]—and yet he invoked the Dutch school of landscape painting in his discussion of these pictures. He maintained: "We have been too much afraid of certain things, and have been choosing things we have painted abroad or similar ones—instead of painting as the Dutchmen did . . . their own kind of house, ugly as it may appear to some. And new beauties, new oddities, new points of interest are waiting discovery."[98] Holland (as well as the British Low

Fig. 54 Theodore Robinson. *Port Ben, Delaware and Hudson Canal*, 1893. Oil
on canvas, 28¼ x 32¼ in. (71.8 x 81.9 cm). Pennsylvania Academy of the Fine
Arts, Philadelphia, Gift of the Society of American Artists as a memorial to
Theodore Robinson 1900.5

Fig. 55 Edward Lamson Henry. *Late Afternoon on the Old Delaware and Hudson Canal, at Port Ben, Ulster County, New York*, 1894. Oil on board, 8½ x 10½ in. (21.6 x 26.7 cm). Ira Spanierman Gallery, New York

Country, where Constable had painted) was renowned for its canals, and it may well be that this coincidence brought Dutch painting to mind for Robinson as he depicted Port Ben. The analogies Robinson drew between his work and that of European masters suggest the complexity of his inspiration in selecting seemingly mundane views.

During the summer of 1894 Robinson continued to search for subjects that more fully expressed his nostalgic appreciation of a particularly American landscape and his recognition of the changes that it, and the nation, were facing. He had been a frequent visitor to his friend Twachtman's Greenwich farm and had boarded nearby in 1893. The following year Robinson decided to relocate in neighboring Cos Cob, where he took up residence at a boarding house owned by Edward and Josephine Holley. Holley House (see fig. 56), as it was called then, was a popular artists' residence that helped make this small fishing village a creative focal point for two generations of American painters and writers, including Robinson, Twachtman, Hassam, and author Lincoln Steffens.

Cos Cob was the first stop out of New York City as the New York, New Haven, and Hartford Railroad made its way northeast; some twenty trains a day linked the village to the center of the city, then only thirty-eight minutes away.[99] "Many people who could not lose touch with the great city went [to Connecticut] for their country homes or board, the rich to parklike Greenwich, the others to picturesque Cos Cob," explained Steffens.[100] Cos Cob clearly had the advantage of offering ready access to the city, yet, as one writer on its local art school pointed out, the

village was "as unspoiled by the summer visitor as if it were miles back in the country."[101]

In 1894, when Robinson undertook an important series of landscapes there, Cos Cob was in a period of transition. The fishing industry that had been the economic mainstay of the Connecticut village was in decline, and the influx of summer visitors, mainly New Yorkers, was giving rise to a new community with the affluence and time to enjoy leisure pursuits that in this seaside location often centered on recreational boating.[102] Robinson's Cos Cob views represent the village's past or its future — the former in his depictions of outdated packet boats and of shipyards, which built and repaired the boats used for commercial fishing, the latter in coastal scenes that feature recreational yachts, which as a rule are shown with the newly founded Riverside Yacht Club in the distance.

For these seaside views Robinson most often selected as his vantage point the railroad bridge over the Mianus River, halfway between the shipyard and the yacht club. This choice acknowledges the artist's awareness of the delicate balance between the fishermen and the new arrivals. Here, as in Napanoch, where trains ran beside the canal and eventually took over its function, the railroad played a central role in the transformation of the village. The railroad made Cos Cob readily accessible to visitors from the city; it replaced the packet boats that had previously brought products from the farm and the dock to the urban markets; and at the same time it raised land values, driving away both the fisherman and the farmer. Robinson's nostalgic appreciation of the vanishing fishing industry of Cos Cob as seen in his views of the shipyard or of packet boats parallels his fascination with the outdated Delaware and Hudson Canal in Napanoch. Both the New York and Connecticut paintings focus on modes of transportation and commerce, indeed on an entire American way of life, that was being rendered obsolete by advances in technology. However, in Cos Cob Robinson highlighted this transformation by recording signs of bygone days in some canvases and signs of more contemporary developments in others.

In *The E. M. J. Betty* (fig. 57) Robinson portrays the *E. M. J. Beatty*, a market boat that sailed between Cos Cob and New York until 1890, four years before the picture was executed, and that was in fact the last of its type to make the voyage.[103] Robinson's prominent placement of the boat's name (albeit incorrectly spelled) demonstrates his interest in the specific details of the vessel's life—its new inactivity as well as its history. The boat has been pulled from the water, across logs, and up on shore, where it seems to lie awaiting repair. The yellow and green grass that grows up around the hull underscores the fact that the *Beatty* has been out of service for a considerable time. The foreground scene is enframed by a railroad bridge, which spans the full width of the picture, enclosing the beached boat and symbolically, if not literally, restricting its

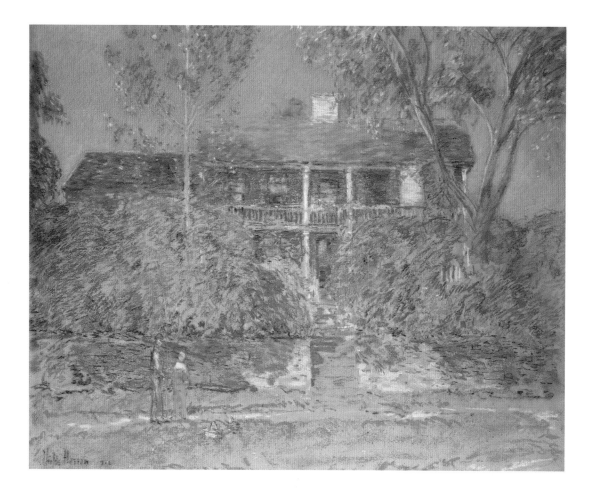

Fig. 56 Childe Hassam, *The Holley Farm*, 1902. Pastel, 18 x 22 in. (45.7 x 55.9 cm). United States Department of State, Washington, D.C., Gift of The Ruth and Vernon Taylor Foundation

movement. Robinson's juxtaposition of boat and bridge must have been intentional: certainly, the railroad had robbed this packet vessel of its function by offering cheaper, more frequent, and quicker access to New York City than it could provide. The *E. M. J. Beatty* may be repaired but will not be returned to service, for it is as useless as the spare planks in the foreground of the canvas, lumber that has been abandoned by shipyard workers, left to the ravages of time and the elements. The dramatic cropping of the boat's mast and halyards across the top of the picture intensifies the feeling of brutal and complete termination; mastless, the boat must lie idle.

Robinson's views of recreational boats, painted the same summer as *The E. M. J. Betty*, offer a strong contrast to his depictions of commercial fishing vessels. *Drawbridge—Long Branch Rail Road, near Mianus* (fig. 58) shows a single small yacht at anchor, its sail furled; this boat, like the stranded *Beatty*, has as its backdrop a railroad track and bridge, which span the width of the canvas and seem to confine the vessel depicted within their reach.[104] Here the boat's stasis is emphasized by its placement parallel to the horizontal expanse of track and bridge, which appear to be flattened against the picture plane. The earth-toned palette Robinson chose for his portrayal of the

packet boat has given way in the recreational boat series to the bright colors of the broad, sun-filled expanses of water and the elegant sailboats that punctuate them, and the geometric structure of the railroad bridge is more forcefully felt.

In two views of recreational boats, which, like his pictures of commercial vessels, were painted in the summer of 1894, Robinson shows the softer line of the shore and seaside buildings in the distance and features the prominent contour of the Riverside Yacht Club. The club, which is recorded accurately, down to the still-unweathered wood shingles of the newly renovated clubhouse, was located in an area recently developed to appeal to summer visitors. It had been established in 1888 and by 1894 had nearly two hundred members.[105] The inclusion of the club in Robinson's paintings underscores the social implications of the yachts at anchor in the foreground. These yachts, unlike the moldering packet boat, are not in need of repair, nor are they a source of income; they await their owners' use at a convenient moment of leisure. In *Low Tide* and *Low Tide, Riverside Yacht Club* (figs. 59, 60) the recreational purpose of the club has been emphasized by its juxtaposition with a less scenic red brick factory, long abandoned, to its right.[106]

Robinson's paintings of pleasure craft in Cos Cob, like his

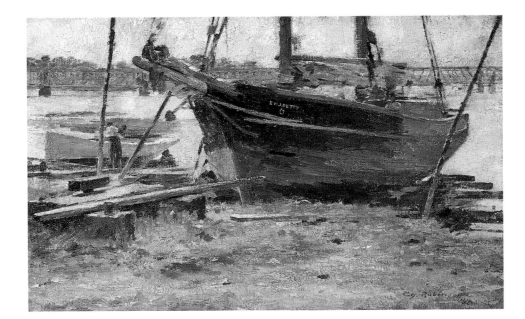

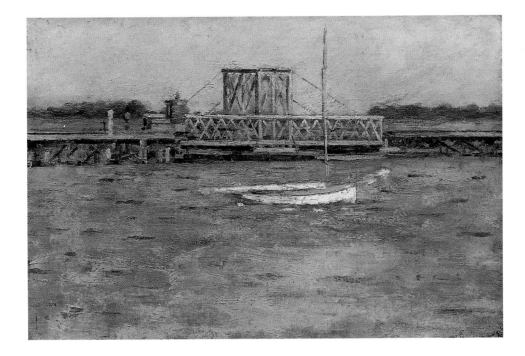

multiple views of the canal at Port Ben, are distinctly American demonstrations that nevertheless rely in part on the working procedure the artist had learned from Monet at Giverny. Robinson saw some of Monet's early views of Rouen Cathedral in 1892, and that same year, before he left France, Robinson painted an important series of three views of Vernon in the Seine valley (see fig. 45). Robinson's pictures are not as exacting as Monet's—although they accurately record their subject's appearance and represent a particular season, summer, they do not capture a specific time of day or especially distinctive weather conditions.[107] Nonetheless, then and later, Robinson was clearly aware of his mentor's approach. Robinson recorded in his diary that in the past the French artist had painted "any thing that pleased him, no matter how transitory... regardless of the inability to go further than one painting." He observed as well, "Now it is only a long continued effort that satisfies him, and it must be an important motif."[108] The American's concluding comment summarizes two considerations that became paramount in his own work once he returned to the United States—the significance of the artist's choice of subject matter and the need

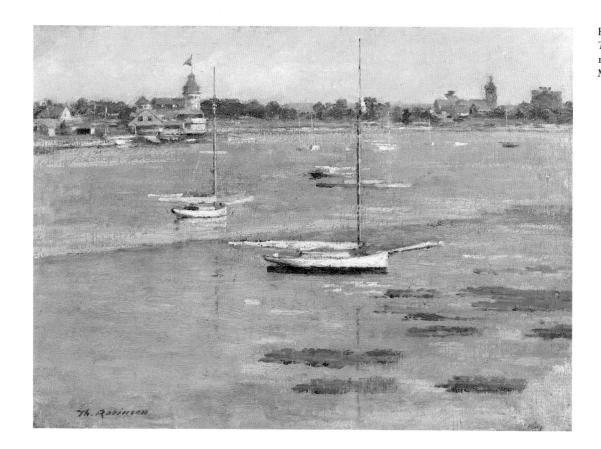

Fig. 59 Theodore Robinson. *Low Tide*, 1894. Oil on canvas, 16 x 22¼ in. (40.6 x 56.5 cm). Manoogian Collection

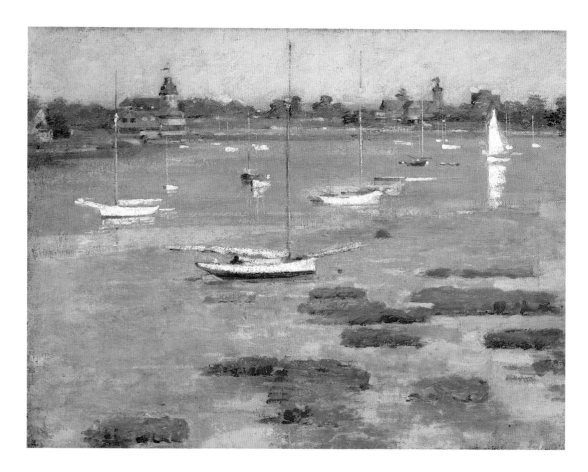

Fig. 60 Theodore Robinson. *Low Tide, Riverside Yacht Club*, 1894. Oil on canvas, 18 x 24 in. (45.7 x 61 cm). Collection of Mr. and Mrs. Raymond J. Horowitz

to explore subjects fully, in sustained efforts, sometimes in multiple canvases. In Cos Cob, as in Napanoch, as he faithfully recorded the relics of bygone days, Robinson was following the example Monet had offered him in 1892.

At times the immediacy of Robinson's paintings and their effectiveness as expressions of nostalgia for the subjects he depicts seem compromised by his adherence to strict compositional structure. In spite of the subtle variations between his two paintings of low tide at Riverside Yacht Club—in the effects of water, light, and reflection and in the number and placement of the boats—both of Robinson's compositions are determined by the careful syncopation of horizontal and vertical lines, of hulls and masts, actual forms and reflections on water and wet sand. Here, as in other works of the period, Robinson's strong sense of design was inspired not merely by the scene he observed in Cos Cob but also by his study of Japanese prints, such as Utagawa Hiroshige's *Fireworks over the Ryōgoku Bridge, Famous Views of Edo* (fig. 61), which was in the collection of his friend Weir.[109] "My Japanese print points in a direction that I must try and take," Robinson had written of a print in his own possession, "an aim for refinement and a kind of precision seen in the best old as well as modern work. The opposite pole to the slap-dash, clumsy . . . sort of thing."[110] He carried his "aim for refinement" to its fullest expression in *Boats at a Landing* (fig. 62). In this picture alternating bands of sand and water rise in layers to a high, flat horizon line and a narrow slice of sky, the simple wooden landings and beached boats offering no clue to the location of the scene or to the identities of the boats' owners.

In *View from the Holley House, Winter* (fig. 63) Twachtman shows us another view of Cos Cob—the Palmer and Duff Shipyard much as it would have been seen from the upper porch of the Holley House.[111] Twachtman, who commuted to New York regularly to fulfill his teaching obligations, could return easily to this country retreat, where he stopped when he was not staying on his farm in Greenwich. It offered opportunities to distill the significant facts of observed reality and create his own artistic synthesis and also to follow the advice he offered to his students: "do not be too literal."[112] This is precisely what Twachtman has done in his view of the shipyard. The buildings are mere suggestions. The activities of the shipyard's employees and the details of its appearance, such as the rows of windows of the buildings, the beached boats, and other debris evident in a period photograph (fig. 64), are eliminated, thanks to the artist's choice of the winter season and to his broad, sketchy technique. Twachtman's use of delicate stains of subtle color and his expressive brushwork capture instead of such particulars the ephemeral effects of fresh white snow and of moisture rising from the harbor.

The artist sought these effects consciously. A letter he wrote to Mrs. Holley about the time he painted this view, when his family

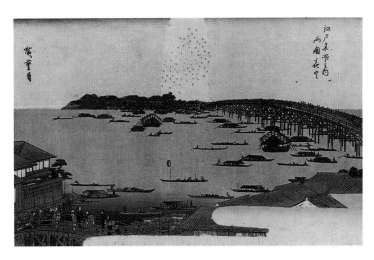

Fig. 61 Utagawa Hiroshige. *Fireworks over the Ryōgoku Bridge, Famous Views of Edo*, 1849–50. Color woodblock print, 9 x 14 in. (22.9 x 35.6 cm). Museum of Art, Brigham Young University, Provo, Utah

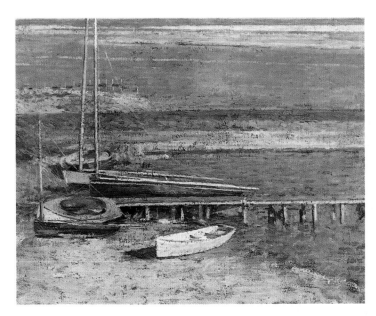

Fig. 62 Theodore Robinson. *Boats at a Landing*, 1894. Oil on canvas, 18½ x 22 in. (47 x 55.9 cm). Mr. and Mrs. Meyer P. Potamkin

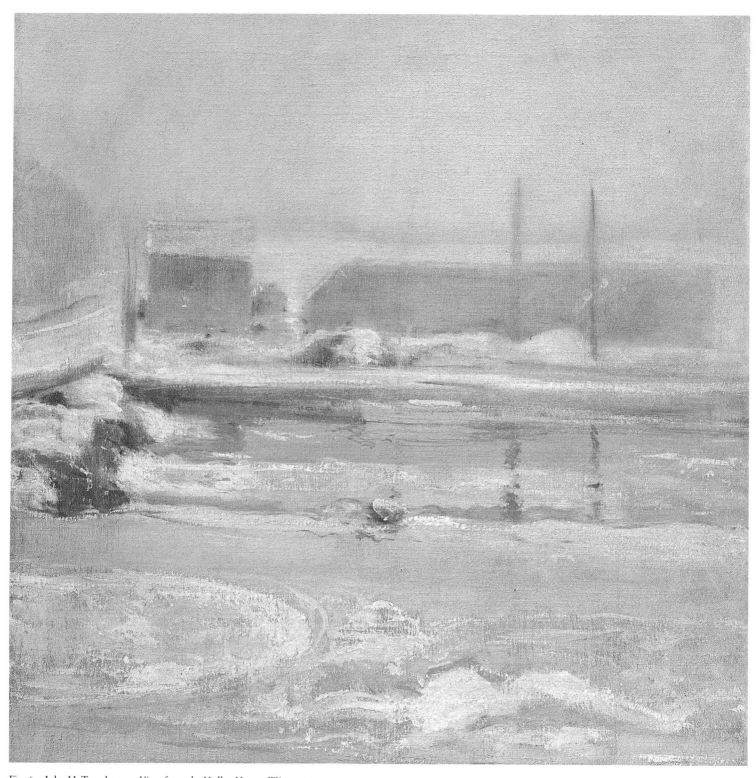

Fig. 63 John H. Twachtman. *View from the Holley House, Winter*, ca. 1901.
Oil on canvas, 25 ⅛ x 25 ⅛ in. (63.8 x 63.8 cm). Hevrdejs Collection of
American Art

Fig. 64 Palmer and Duff Shipyard, Cos Cob, Connecticut, 1906. Photograph: Archives, The Historical Society of the Town of Greenwich, Connecticut

was abroad and he was commuting between the city and Holley House, suggests how aware he was of the way in which snow functioned within his compositions: "In the morning I shall wake up and—no—not walk out onto the upper porch to see what the day is like—but look down into an air-shaft and when in the street see the ugly holes of the sub-way on Fourth Avenue. If the whole thing were only covered with snow and made beautiful."[113] This letter also reveals Twachtman's sensitivity to the contrasts between city and country. His generation of American artists was tied to the urban environment by studios, exhibitions, schools, and audiences but still sought ways to escape its social and visual ills or, at least, to make its uglier features "beautiful." These were painters who often preferred to practice their art in picturesque country retreats, close to the memories of bygone days and far removed from the realities of modern life.

The Highest Phase of Art

The highest phase of art is to be perfectly lovely, gorgeous, or beautiful.

DENNIS MILLER BUNKER (1886)

The American Impressionists clearly were predisposed toward countryside that offered beautiful subjects for their paintings, but even within this context they edited the landscape they encountered, choosing views and utilizing pictorial strategies that enhanced positive elements and eliminated negative ones. The selective vision that Bunker applied to the American landscape

is evident in *The Pool, Medfield* (fig. 65).[114] Bunker spent the summers of 1889 and 1890 in Medfield, the small Massachusetts town in the Charles River valley about fifteen miles southwest of Boston that was the country retreat of landscape painter Inness during the early 1860s and again during the 1870s. There Bunker pursued landscape subjects as an antidote to the rigors of his teaching responsibilities and his studio efforts at figure painting. The light-filled canvases he painted in Medfield are executed in a sophisticated Impressionist style he had mastered while working in England with Sargent in the summer of 1888. Bunker's brushwork—described by Boston painter Edmund C. Tarbell as made "out of fish-hooks"[115]—suggests the vibrancy of summer light glistening over windswept grass, flowers, and water, conveying with intensity the feeling that he has captured a momentary effect on his canvas. The artist was painfully aware of subtle changes that took place in the landscape as he struggled to complete a canvas. "That's a great thing to know that you have time and your subject is to be just the same for hours. In sunlight it is never the same, the shadows which seem to be nearly in the same places when you are not painting them, really move with dreadful swiftness when you are."[116] This changeability made it difficult for Bunker to consider a landscape "thoroughly done, complete finished and not left—en route."[117] Mutable light frustrated Bunker as it did other American artists, such as Robinson and Weir, who embraced Impressionism but sought to reconcile its requirements and effects with precepts of their academic training.

The Pool, Medfield offers tangible evidence of Bunker's artistic philosophy and parallels his seemingly more conservative, figural works, usually idealized depictions of women. "The highest phase of art," explained Bunker, "is to be perfectly

Fig. 65 Dennis Miller Bunker. *The Pool, Medfield*, 1889. Oil on canvas, 18 x 24 in.
(45.7 x 61 cm). Museum of Fine Arts, Boston, Emily L. Ainsley Fund 45.475

lovely, gorgeous, or beautiful, beautiful through some quality, of light, or life, or solemnity, or richness, or loving elaboration of delicate forms, anything so that it be a gracious beautiful canvas to look at. Leaves or flowers or faces or limbs or draperies or skies."[118] Bunker makes this landscape subject beautiful by presenting us with a close-up look at nature. The distant view is restricted by a high horizon line, and only a small patch of sky is visible above the copse of trees, so that the spectator's gaze plunges into the cool water in the foreground and rises precipitously to the horizon rather than proceeding deep into the background. This is an artistic device Bunker borrowed from the French Impressionists, notably Monet, but he used it to achieve personal ends.[119] In Bunker's painting the white wall of the building in the distance, partially screened by tree trunks and foliage, stands as the single reminder of man's presence and problems, concerns he usually only hinted at in his pictures, whereas Monet more often and more willingly represented man's intrusion into the landscape. In choosing his charming site and in tightly framing the boundaries of his view and thus focusing on its lovely details, Bunker has created a natural world as ideal as the models he painted in his Boston studio; the key elements are leaves and flowers, not faces and draperies, but they too have been selected to suggest the "beautiful." Bunker's sensitive figure paintings, such as *Jessica* (fig. 66), have been described by one modern scholar as depicting the type of woman "whose timeless beauty preserves the values of an earlier era, and whose grace and serenity enable the world around her to maintain a certain morality, harmony, and equilibrium in the face of disturbing forces of change."[120] His landscapes serve the same idealizing function as his representations of contemplative, well-cared-for women.

John Leslie Breck's *Grey Day on the Charles* (fig. 67) records an idyllic scene along the river that also passes through Medfield. Here the reflective surface of the water, punctuated by slender reeds, becomes the focal point of the composition. There is no indication of the farmland, factories and mills, or urban sprawl that characterized the Charles River's surroundings at different points along its winding forty-mile course, from its marshy beginnings as a stream in Hopkinton to its entrance into the wide-mouthed estuary at Boston harbor.[121] The exact site depicted has not been identified, but the painting probably represents the Charles at its rural origins, a choice that emphasizes the river's natural beauty rather than its utilitarian functions as a source of power or an active commercial waterway.

The subject of *Grey Day* recalls paintings of Giverny by Monet, whom Breck had met in that French village in 1887. In works such as *Morning on the Seine, near Giverny* (fig. 68), as well as in earlier canvases, Monet captured the subtle effects of light and sky reflected on water, but even he found it difficult to paint this changeable subject. "I have taken up things impossible

Fig. 66 Dennis Miller Bunker. *Jessica*, 1890. Oil on canvas, 26 x 24 in. (66 x 61 cm). Museum of Fine Arts, Boston, Gift by contribution 91.130

to do," he wrote, "water with grass undulating at the bottom. It is wonderful to see but one can go crazy trying to do this thing."[122] Breck's choice of a gray rather than a sunlit day on the river may well have been an effort to select a subject that would remain more constant. His gray day precluded the situation lamented by several of his contemporaries who found American scenery less paintable than European precisely because its bright light resulted in such mutable effects.

In spite of Breck's evident reliance on foreign artistic models, his painting can be seen as expressing self-conscious American values. Like other artists drawn to New England subjects, he might well have considered the historical significance of the Charles, which since the seventeenth century had served as a conduit—initially for settlement and later for goods and materials. "There is no more picturesque water course in New England," maintained writer Augusta W. Kellogg in 1902, just eight years after Breck depicted the river, "and not one moves through more historic ground."[123] The Charles River had received its name from England's reigning monarch in 1614, and many of the towns in its valley are associated with significant figures in colonial history—Captain John Smith, John Winthrop, and John Eliot among them. In the nineteenth century poets James Russell Lowell, Longfellow, and Oliver Wendell Holmes lived along its banks and featured the Charles in their writings.[124]

Fig. 67 John Leslie Breck. *Grey Day on the Charles*, 1894. Oil on canvas,
18 x 22 in. (45.7 x 55.9 cm). Virginia Museum of Fine Arts, Richmond,
The V. J. Harwood and Louise B. Cochrane Fund for American Art 90.151

Fig. 68 Claude Monet. *Morning on the Seine, near Giverny*, 1897. Oil on canvas, 32 x 36½ in. (81.3 x 92.7 cm). Museum of Fine Arts, Boston, Gift of Mrs. W. Scott Fitz 11.1261

In 1894, the year that Breck painted *Grey Day on the Charles*, the river he depicted was at the center of a lively debate. Discussions about improving the Charles had been carried on from as early as 1859; endless proposals, counterproposals, and investigations about sanitary conditions were involved. By the spring of 1894 a report whose authors included the distinguished firm of landscape architects Olmsted, Olmsted, and Eliot called for a plan that would dam the river and transform it into a site for leisure and recreation. The plan was not adopted, and until 1910 the Charles River remained much as it was, surrounded by dilapidated buildings, entered by rotting wharves, and crossed largely by wooden pile bridges.[125] Breck's stand on the issue is not known, but by the mid-1890s he had purchased a home and studio in Auburndale,[126] in the northwest corner of Newton, a suburb of Boston beside the Charles. Thus, the outcome of this public debate over the river must have had personal significance for him.

Clearly Breck has chosen to represent a beautiful aspect of the river and one that ignores the well-documented problems in and around it. The process of idealization pursued by both Breck and Bunker is made all the more evident when their landscapes of the Charles and its valley are contrasted to a scene along the same river described by Howells, a friend of Bunker's and an advocate of literary realism who exerted a tremendous influence over an entire generation of Americans through his writings for *Atlantic Monthly* and *Harper's Magazine*. In a short story in his *Suburban Sketches* of 1871, Howells recorded his impressions of an area of Boston near the Charles River, where one autumn he "moved onward down the street, luminous on either hand with crimsoning and yellowing maples, . . . so filled with the tender serenity of the scene, as not to be troubled by the spectacle of small Irish houses standing miserably about on the flats ankle deep, as it were, in little pools of the tide."[127] His progress was interrupted, however, when the neighborhood's residents discovered the body of a pregnant young woman who had drowned herself in despair the previous Saturday; her pitiful remains were being taken away, ignominiously, in a grocer's cart, in the midst of bags of flour and sugar. Although Howells returns to the physical beauty of the scene in his conclusion—"and the sun dropped its light through the maples and shone bright upon the flooded flats"[128]—he leaves the reader with an uneasy awareness of the threatening proximity of misery and death within the landscape, just outside the frames devised by Bunker and Breck, realities that are alien to the beautiful world they have recorded with paint.

Fig. 69 J. Alden Weir. *The Red Bridge*, ca. 1895. Oil on canvas, 24¼ x 33¼ in. (61.6 x 84.5 cm). The Metropolitan Museum of Art, New York, Gift of Mrs. John A. Rutherfurd, 1914 14.141

In much the same way that Bunker and Breck approached their Massachusetts views, Weir often eliminated negative features and utilized compositional and stylistic strategies to reinforce the positive appearance and thematic significance of the subjects in his Connecticut landscapes. *The Red Bridge* (fig. 69) is a provocative modern image of a truss bridge that spanned the Shetucket River, not far from the site of the Willimantic Linen Company, which appears in Weir's *Factory Village* (fig. 19).[129] About 1900 the former painting acquired the Whistlerian title that has drawn attention to its formal qualities, notably the striking palette, but its original, rather descriptive title—*Iron Bridge at Windham*—may be a better indicator of the artist's thematic concerns.

The bridge pictured was constructed of iron, which had impelled advances in nineteenth-century technology and manufacturing by replacing less durable materials such as wood and facilitating a myriad of developments in transportation, communications, and architecture. Iron bridges became common in the 1830s, and innumerable variations and improvements were made by the end of the century by inventive American engineers and builders.[130] As more iron mills and foundries were built, locomotives increased in size and speed, and more and more railroad tracks were laid; consequently these bridges became familiar features on the American scene. The structure Weir depicts was most likely a railroad bridge, and as such it reminds us of the many changes wrought in the landscape and in American life by improvements in the rail system.[131] The industrial development of Connecticut, represented so felicitously in *The Factory Village*, was made possible by the growth of rail lines across the state. Windham and Willimantic were among the many towns in eastern Connecticut that in the 1840s and 1850s were linked to Boston, Hartford, and thence to New Haven and New York—Windham by the New York, New Haven, and Hartford Railroad, which had absorbed many of the smaller lines in the area, and Willimantic by that line and others.[132]

To twentieth-century eyes this painting seems an endorsement of progress, but in reality this was not Weir's response. He had been "dismayed," his daughter and biographer, Dorothy Weir Young, reported, to discover that the iron bridge had replaced a more familiar, old-fashioned covered bridge.[133] He must have been shocked by the clear functional construction of the bridge: its skeletal support system is in full view, with no outer shell and no ameliorating decoration. Young recalled: "He missed the old landmark and regretted the necessary march of progress until one day he suddenly saw in the ugly modern bridge a picture that I am sure no one but he had ever seen."[134] While expressing his resistance to progress and his nostalgia for a simpler past, then, Weir tolerated this bridge's appearance on the landscape because its geometric structure made an artistic composition.

Fig. 70 Utagawa Kuniyoshi. *Twelfth Act, from the Japanese Kana Copybook Version of the Chūshingura,* 1854. Color woodblock print. Private collection

The strident contrast between the bridge and its setting is heightened by Weir's palette, which sets the red of the structure against the silvery greens and blues of foliage, water, and sky, and by the juxtaposition of geometric man-made forms with the natural curves of tree trunks and branches. The bridge is viewed from below, through a screen of branches placed close to the picture plane. As a result the horizon line is raised, there is little spatial recession, and the flat surface of the canvas is accentuated by the patterning achieved by repeating the horizontal and vertical elements of the bridge in the reflection below. The decorative effects seen here recall the Japanesque approach used by many French artists of the period, and, in fact, the composition itself may have been derived from a Japanese print that Weir owned, Utagawa Kuniyoshi's *Twelfth Act, from the Japanese Kana Copybook Version of the Chūshingura* (fig. 70).[135]

In *The Factory Village* Weir created another idealized image.[136] His subject, a thread factory, represents the many changes wrought by the growth of industry in the nineteenth century, not only on the New England landscape but also on the region's social structure. Early in the century many production tasks had been performed in the home, where such activities as shoemaking, pegging, and sewing were accomplished by hand. The factory promoted mechanization and centralization of tasks and moved them outside the home, transforming the daily lives of many Americans.[137]

Here Weir depicts a modern factory as a harmonious part of the New England landscape rather than as an intrusion on it. Weir portrays a felicitous union of elements; industry's effect on nature is a gentle one, with a quiet accord achieved in the happy combination of the natural and the man-made. The work—as well as the people who accomplish it—is left to our imagina-

Fig. 71 John Ferguson Weir. *Gun Foundry*, 1866.
Oil on canvas, 46½ x 62 in. (118.1 x 157.5 cm).
The Putnam County Historical Society, Cold Spring,
New York

Fig. 72 Fannie Palmer for Currier and Ives. *West
Point Foundry, Cold Spring, New York*, 1862. Color
lithograph, 10⅞ x 15¼ in. (27.6 x 38.7 cm). The
Metropolitan Museum of Art, New York, Bequest of
Adele S. Colgate, 1962 63.550.217

tions. This is a far cry from more narrative representations of industrial subjects, such as his brother John Ferguson Weir's *Gun Foundry* (fig. 71) and *Forging the Shaft* of 1867 (now destroyed, 1877 replica, The Metropolitan Museum of Art, New York). In these earlier pictures nature is not in evidence as men labor in the eerie light of the interior of the West Point Iron and Cannon Foundry in Cold Spring, New York—in the former to cast a cannon shaft and in the latter to cast the shaft of a propeller

for an ocean liner.[138] *The Factory Village* more closely resembles such popular (and highly sentimental) images as Fannie Palmer's depiction of the West Point foundry, reproduced by Currier and Ives in 1862 (fig. 72). Both Alden Weir and Palmer feature smokestacks as a reminder of industry and its effects, yet the presence of these chimneys does not seem to menace the beauty of the scene.

If there is no threat to the landscape in *The Factory Village*,

there also is little or no hint of the economic and social situation that the town was facing at the time Weir represented it so agreeably. In fact, the Willimantic Linen Company was widely acknowledged as an enlightened employer that recognized that well-being among its employees would engender greater profits. According to William Eliot Barrows, treasurer, president, and general manager of the company, the owners of the business tried to beautify the workers' surroundings with colored glass windows, gardens, and interior plants. Factory hands were offered opportunities for self-improvement—access to a library of books and periodicals and the chance to take classes in singing and drawing, reading and writing, the last a requirement for immigrant workers who risked the loss of their jobs if they did not learn to read. Snacks were also provided.[139] With an evident distrust of his immigrant workers, Barrows went as far as hiring a "mission lady," whose job it was to visit their homes, set an example by her behavior, and report any unacceptable home conditions to management.[140]

Barrows painted a happy (if condescending) picture that, needless to say, was not any more complete than Weir's. Willimantic factory workers, by the 1880s many of them immigrants from southern and central Europe, put in sixty-six long hours each week under far from favorable conditions, the women for sixty-one cents a day, the men for a dollar and fourteen cents, and children were included in the labor force.[141] The damp conditions required for thread production also contributed to brown lung disease and drastically shortened the workers' lives. By 1886 there was serious labor unrest in the factory, and after a series of disturbances the Knights of Labor were summoned by the workers to negotiate on their behalf.[142]

Throughout the period of its rapid growth as an industrial center, Willimantic nonetheless remained an attractive town, where many of its residents built homes on the rising ground along the river, which offered what one local writer described as "beautiful and varied views and air as pure as that in most country villages."[143] While painting *The Factory Village*, the artist must have stood on this higher ground, for he looks out through some foliage and down into the riverbed, with the factories and their concealed problems set in the middle distance, well beyond the leafy crown of the tree that fills the left foreground. The composition is divided between nature and history, as represented by the tree, and industry and modernity, as symbolized by the smokestack on the opposite side of the canvas.[144] Weir's decision to make the tree such an important focal point of the composition may have been determined in part by a revival of interest in large, old trees among his New England neighbors.[145]

By 1897, when Weir painted *The Factory Village*, the Willimantic Linen Company and the manufacturing town that surrounded it had fallen on hard times. In July, about a month

before Weir's arrival in the area, the Windham Cotton Manufacturing Company, located on the Willimantic River, closed for an indefinite period (it would remain shut nearly two full months), laying off some 250 operatives, and the following month the Willimantic Linen Company failed to pay the dividend expected by its stockholders.[146] The local newspaper was filled with accounts of the "town's needy poor," many of them affected adversely by these events.[147]

Weir must have been aware of these difficulties but clearly distanced himself from them. He was, after all, a summer visitor, not a year-round resident, and his vacation home was in Windham, a donkey-cart trip (and worlds) away from the factories and their workers; immigrant factory hands obviously were not the sort of people he met at festive social events in Windham. Thus, even when confronted with an example of industrialization and its ill effects, he chose to deny its negative implications and transform the factory town of Willimantic into a scenic New England village.

Unlike Weir, who spent his summers with family and intimate friends, or Chase, who socialized with wealthy vacationers at Long Island's Southampton, near his Shinnecock school, the young Realist Kent was well aware of the fishing community on Monhegan Island, off the coast of Maine, and sought interaction with its residents. Kent's first trip to Monhegan, in 1905, was inspired by Robert Henri, his Realist teacher, who had worked at Monhegan earlier, and, of course, by Winslow Homer, who worked nearby at Prout's Neck.[148] Monhegan was the first of a series of remote northern sites that attracted Kent over the course of his career; Newfoundland, Alaska, Labrador, and Greenland are later examples.[149] At these rugged locations he found both material for his paintings and a welcome release from the pressures of his urban artistic life. Although Monhegan was later visited by other artists in Henri's circle—Bellows and Randall Davey—it was in those early years a more isolated and more private retreat for a painter of Kent's often less than convivial temperament.

In Maine Kent found a forum for expressing the political ideals he had espoused when he joined the Socialist party in 1904.[150] He spent the better part of six years in Monhegan—not just pleasant summers but also long, cold winters—and, in addition to painting, he worked as a carpenter and a fisherman. Monhegan was not a comfortable resort, and his companions were not always painters and writers; they were often the men and women who struggled to exist under difficult, sometimes trying conditions in the landscape he depicted. Despite his sympathy for the Monhegan community and his attempts to become a part of it, Kent acknowledged that while he and his artistic companions "were good, decent, democratic people, it was both natural and inevitable that we should constitute ourselves a society somewhat apart from the indigenous Monheganers."[151]

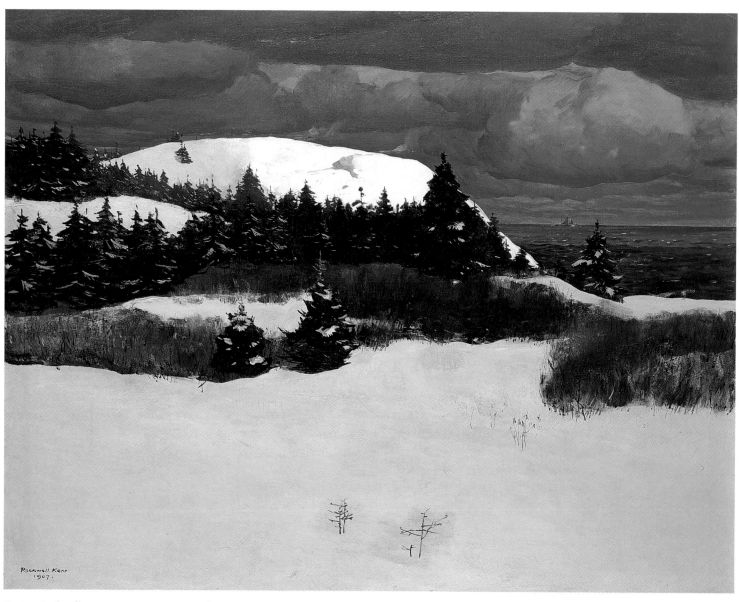

Fig. 73 Rockwell Kent. *Maine Coast*, 1907. Oil on canvas, 34⅛ x 44⅛ in.
(86.7 x 112.1 cm). The Cleveland Museum of Art, Hinman B. Hurlbut Collection
1132.22

Kent's existence in Maine makes an informative contrast to the genteel lifestyle his teacher Chase pursued at Shinnecock. Ironically, Kent had a long association with the community that surrounded Chase's school: his mother and aunt actually owned lodging houses near Chase's Art Village; he summered there as a child; and he returned later to take outdoor painting classes from the master.[152] Kent described Chase as "more interested in *impressions* of the subject than in deeper and more labored probing."[153] Yet he praised his teacher for his insistence on "truth," revealed in the essence of his instruction, which Kent paraphrased: "Go before nature, use your eyes, and then paint what you see."[154] Kent's recollections of Chase were filtered through his subsequent allegiance to socialist political ideals, and he criticized the older artist for his preoccupation with appearances—he was "dapper to the point of foppishness"[155]—and for his desire to attain wealth and stature. "But Chase respected truth and craftsmanship not as in themselves an end but rather as the means essential to the attainment of, to him, the final end: success and money," he concluded.[156]

Despite the different values they espoused, both Chase and Kent produced landscape views that idealized a seaside location and also idealized or even eliminated its residents. Kent's *Maine Coast* (fig. 73), an evocative winter scene in which soft evergreens and calligraphic bushes punctuate dazzling snow below an ominously overcast sky, keeps the everyday life of the fisherman at a distance. The only hint of the actualities of island life is the lone sailboat that remains at sea, its crew vulnerable to the cold air and the impending storm. Kent's socialist inclinations did not prevent him from separating the viewer from the harsher and less attractive realities of the local scene in his art. And others who followed Kent and Henri to Monhegan—Bellows among them—used this coastal setting as an opportunity to escape from urban life and urban ills and the pressure to confront them in their work, often focusing on pure landscape subjects that enabled them to explore significant artistic concerns, such as color, light, and form. The urban scene offered them a more prominent and expressive platform for comment on the contemporary social issues that engaged them.

Landscape, Inventive and Symbolic

While landscapes seem more straightforwardly descriptive than history paintings, they are often equally inventive and symbolic.

WILLIAM CRONON AND SUSAN PRENDERGAST SCHOELWER (1992)

This selection of landscape views by the American Impressionists and cursory look at the Realists' more occasional excursions into the American countryside has treated only a few works by the many artists who employed these styles. It does, however, suggest shared concerns that are often reflected in their work and that of their artistic contemporaries. Pictures discussed in other sections of this book embody the same themes presented here. In choosing their country retreats, for example, the Impressionists sought sites with rich historical associations—Chase's Shinnecock was an early Dutch-English settlement and an Indian reservation; Hassam's and Metcalf's Gloucester was a colonial harbor and fishing village filled with early American architecture; and Hassam's Isles of Shoals were a mercantile outpost of long standing and a traditional resort.

The American Impressionists and Realists selected and treated subjects in ways that speak of their backgrounds and priorities, as well as those of their audience. Their charming views of New England and other American locales are not just beautiful, they are also images that merit interpretation. "While landscapes seem more straightforwardly descriptive than history paintings, they are often equally inventive and symbolic," noted recent writers on views of the American West. "Some depict traces of the past, others envision future changes."[157] Perhaps because they portrayed the contemporary scene, not even a historical landscape, in their paintings, the American Impressionists and Realists have been assumed to have recorded the unadulterated present, what Hassam described as that simple view taken "as if looking out of an open window, and paint[ed] just as they see it." In fact, the landscapes painted by these artists are so vividly colored by their desire to preserve the way of life they enjoyed in the past and their fear of what the future might bring that they are more interpretive than descriptive. And in a sense they are more antimodern than modern. The scenes the Impressionists and Realists depicted express the nationalism, nostalgia, euphemism, and optimism of their age—not of all Americans but of the painters, their patrons, and critics, most of whom held a great deal in common (the majority were middle-class white men, if not well educated, then well traveled). That the Impressionists and Realists memorialized the scenery of their ancestors and ignored the actualities of the present—immigration, industrialization, and so many other aspects of modernity—makes them less than accurate reporters. But the images nevertheless offer us revealing statements on the attitudes and priorities of their creators. The Impressionists and Realists spoke more softly in their American views than the painters of the Hudson River School did in their operatic landscapes, but their voices can be heard clearly.

The Country Retreat and the Suburban Resort

Detail, fig. 108

Emblems of Leisure

We have had somewhat too much of the "gospel of work."
It is time to preach the gospel of relaxation.

HERBERT SPENCER (1882)

The American Impressionists' devotion to landscape subjects was nourished by their summer work in a variety of genteel country retreats. These places themselves were symptomatic of the extraordinary growth of interest in leisure and recreation in late nineteenth-century America. Such refuges also reflected the characteristic cosmopolitanism of postbellum American painters, who shared European artists' enthusiasm for colonies and replaced the more isolated, solitary country studios and occasional group excursions of the members of the Hudson River School with more permanent venues for artistic camaraderie.

The spirit of the leisurely life that the American Impressionists experienced and recorded in these summer haunts is condensed in two paintings by Childe Hassam. Paradigms of the very idea of the rural retreat, these pictures were executed in the early 1890s on Appledore Island, one of the Isles of Shoals, ten miles off the coast of New Hampshire. They portray poet Celia Laighton Thaxter's hospitable garden and house, which drew artists, writers, and musicians. Finding refreshment there, Thaxter and her friends gave their creative energies free rein amid the austere beauty of the islands, remote from the workaday world of the cities.[1]

In the Garden (Celia Thaxter in Her Garden) (fig. 74), which served as the frontispiece to Thaxter's book *An Island Garden* of 1894, sets forth an iconic image of the garden's creator in the midst of her creation. Thaxter appears as a solid yet graceful figure, dressed in white, her hair adorned with the silver crescent she often wore. Lost in reverie, she forms the vertical spindle around which whirls a web of brilliant pigment representing the garden's flowers: Iceland poppies, sweet rockets, bachelor's buttons, coreopsis, crimson phlox, rose campions, asters, hollyhocks, larkspurs. Described impressionistically, not botanically, the blossoms merge in studied confusion. A weathered board fence, its west gate opening beyond the poet's figure, demarcates the boundary between the cultivated brilliance of the foreground garden—"a sea of exquisite color swaying in the light," as Thaxter described it[2]—and wilder nature beyond. Hollyhocks frame the distant shore of the mainland, echo the standing woman and identify her with nature, and, by bracketing the canvas, assert that Hassam's portrayal of the scene is as created and as art-ificial as what he portrays.

The Room of Flowers (fig. 75) shows the parlor of Thaxter's cottage, a room "encrusted," as David Park Curry has observed, with "genteel clutter—paintings, photographs, prints, and plaster casts"[3]—and filled with comfortable furniture in casual disarray,

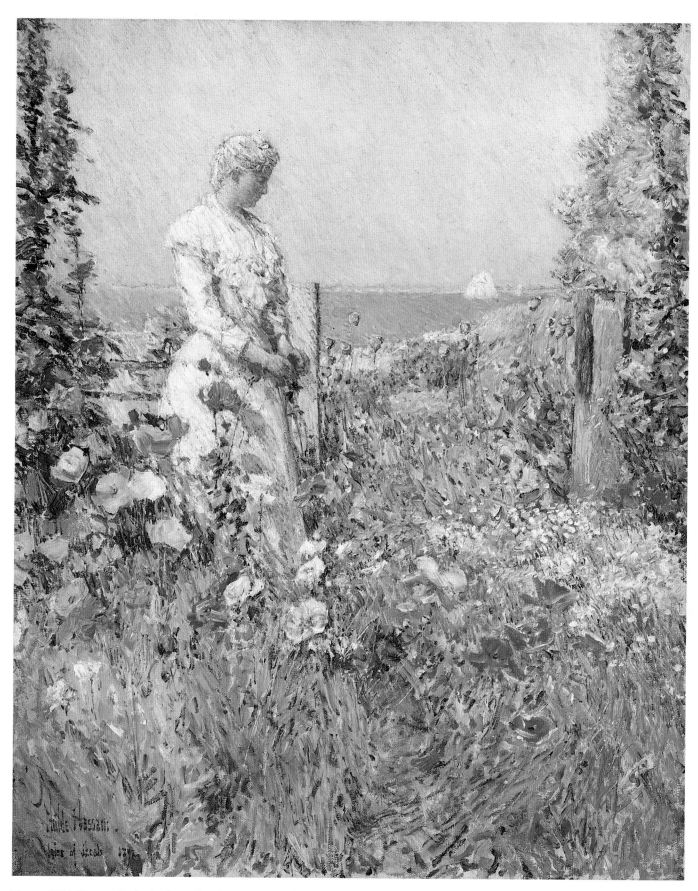

Fig. 74 Childe Hassam. *In the Garden (Celia Thaxter in Her Garden)*, 1892. Oil
on canvas, 22⅛ x 18⅛ in. (56.2 x 46 cm). National Museum of American Art,
Smithsonian Institution, Washington, D.C., Gift of John Gellatly, 1929 1929.6.52

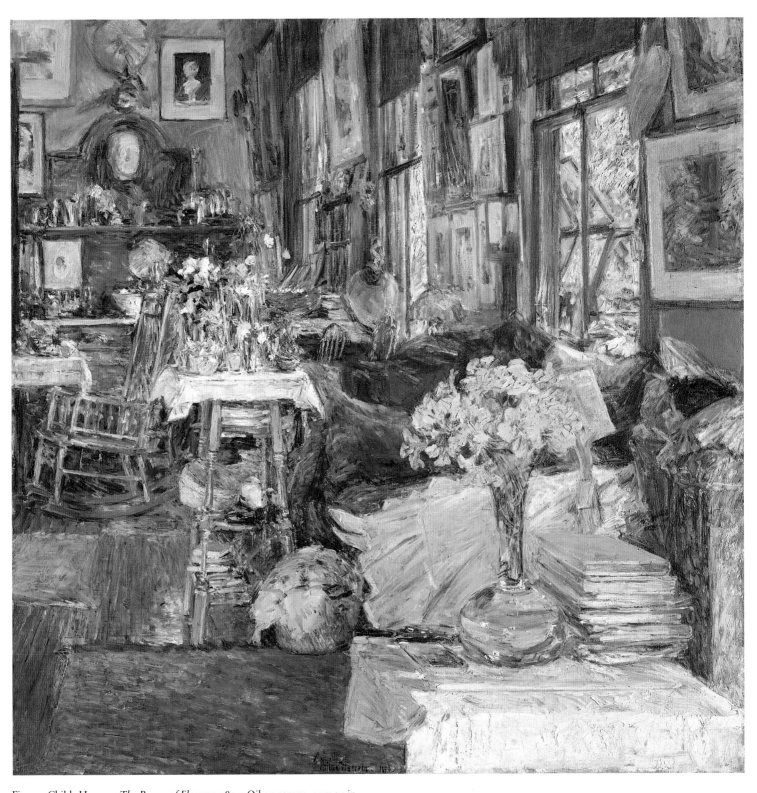

Fig. 75 Childe Hassam. *The Room of Flowers*, 1894. Oil on canvas, 34 x 34 in. (86.4 x 86.4 cm). Private collection

stacks of books, and huge bunches of flowers in bowls and vases. Like the garden, the parlor offers an aesthetic distillation of nature and an invitation to reverie. Here Hassam signals the potential for utter absorption in a private world of beauty and thought by embedding a single figure—a young woman reclining at the lower right—in the web of furnishings and flowers and of paint itself. The woman is usually the last element noticed by a viewer of the light-filled painting. Engaged in glancing through a book and subsumed in her aestheticized surroundings, she becomes the quintessential image of escape into ideas, thoughts, interior experiences, into other worlds such as the world of one's own imagination.

Both *In the Garden* and *The Room of Flowers* present what might be termed concentric summaries of the experience of a country retreat. At the center are individual figures in personal retreat—in reverie or perusing a book. The surrounding garden or parlor is a private world providing a distillation of nature and a habitat for contemplation. Beyond the garden and the parlor is Appledore Island, a retreat from Boston. Finally, like so many venues in which turn-of-the-century Americans pursued leisure, the island itself was a place detached from the new urban life and reassuringly identified—like Thaxter herself and her poetry—with the very bedrock of old New England and earlier America.

The New Leisure and Recreation of Modern Life

What shall we do with our leisure when we get it?

JAMES A. GARFIELD (1880)

Vacation has become a fetish. . . . It is a national hegira, a flux of population, a craze for change.

RAFFORD PYKE (1903)

Among the most distinctive changes that characterized life in the United States in the post-Civil War era were an increase in leisure time for entrepreneurs and almost all nonfarm workers and the acceptance of the concept of leisure by a society that traditionally and single-mindedly had been committed to a work ethic.[4] The new leisure of modern life (see figs. 76, 77) was both generated and necessitated by industrialization and urbanization. To put it simply, the workday and workweek lengthened during the Industrial Revolution, creating a stronger desire for time off for rest; leisure came to be understood as an entitlement of those in nonfarm occupations; as the population of cities grew and urban pressures intensified, a powerful need arose for contact with the country, where leisure pursuits would be centered; and with more time off from work, opportunities and facilities for recreation—that is, for satisfying activities pursued during

leisure time—expanded phenomenally.[5] The characterization of the new age by James A. Garfield, in a speech at Chautauqua, New York, in 1880, seems remarkably prescient: "We may divide the whole struggle of the human race into two chapters; first, the fight to get leisure; and then the second fight of civilization—what shall we do with our leisure when we get it?"[6]

The growth of leisure for almost all sectors of urban society and of new forms of recreation in which it could be spent was not unique to the United States. Similar conditions in Europe had produced similar results.[7] But the new leisure and recreation in the United States were notable in that they indicated a softening of the puritanical celebration of hard work that had long dominated American culture. The new appreciation of indolence was announced in 1882 by Herbert Spencer—vocal partisan of economic competition according to the Darwinian principle of "survival of the fittest"—when he declared: "We have had somewhat too much of the 'gospel of work.' It is time to preach the gospel of relaxation."[8]

In the two decades after the Civil War, most entrepreneurs and their employees began to enjoy ten-hour (rather than twelve-hour) workdays, shorter workweeks—usually no more than five-and-a-half days for factory workers—and higher incomes. More and more public holidays punctuated the calendar; the observances of Independence Day, Decoration Day, Thanksgiving Day, Labor Day, Washington's Birthday and (in the North) Lincoln's Birthday, Christmas Day, and New Year's Day were all established by 1907.[9] The availability of more leisure time gave rise to "the outing habit" on weekends. This generated "the vacation habit," so that vacations with full pay became accepted and expected by the turn of the century.[10]

Several developments fueled and responded to the outing habit: Saturday half-holidays, the increase in the number of urban recreational facilities, and the establishment of trolley lines that gave rise to more seaside and country parks and made them accessible to urban dwellers. Such developments in turn impelled a craze among Americans for participation in athletics and sports; symptomatic of this new enthusiasm was an explosion in the 1880s and 1890s of sports columns in newspapers and the emergence of numerous weekly and monthly magazines devoted to particular sports.[11]

Interest in less physically assertive pastimes grew apace, prompting the creation of gardening groups; reading circles and sewing bees; clubs for amateur artists and actors; historical, political, and cultural societies; patriotic and religious associations; and innumerable social organizations. The fervent pursuit of activities serving socially useful ends was a vestige of the puritanical insistence that time must be spent wisely.

Underlying the perceived need for leisure and conditioning the manner in which it was spent was the belief that city dwellers needed to get close to nature for refreshment, relaxation, and

Fig. 76 Beaman picnic, Cornish, New Hampshire, August 9, 1890. Photograph: Dartmouth College Library, Hanover, New Hampshire, Hugh Mason Wade Papers

Fig. 77 Horse show, Hollywood, Monmouth Park, New Jersey, 1895 or 1896. Photograph: Museum of the City of New York, The Byron Collection

relief from urban confinement and stress. Outings were considered to be physically and spiritually therapeutic. They were socially satisfying as well, easing constraints of deportment and providing opportunities for flirtation and the formation of new friendships.[12] Sports and contact with nature were also thought to result in social betterment, especially for the working classes and for immigrants.[13]

A desire for recreation fueled the expansion of suburbs, where people could enjoy urban incomes and rural amenities simultaneously. Suburban living was at first problematic because of inadequate transportation and the long workweek. But, as a commentator noted in 1901, with the adoption of the Saturday half-holiday and with the new interest in sports, Americans began to believe that the benefits of outdoor life in the suburbs offset the inconveniences. "The Nation is beginning to find as much fascination in driving a golf-ball as in driving a bargain," he said.[14]

By the turn of the century an existence even more exurban than suburban was encouraged, with men commuting as far as fifty miles to work so that their families could benefit from country living. The country increasingly came to be perceived as an antidote—and even a reasonable alternative—to urban life, reversing the inexorable nineteenth-century flow of populations and energy to the cities. An observer noted in 1902 the physical and moral refreshment that the country offered: "It is because it is so well understood that country air and sights and all the processes of country life are necessary to maintain the vigor of family stocks that we see this constant reaching out of the dwellers in towns for all of the country that they can get."[15]

The expansion of vacation time in the late nineteenth century was striking. According to an editorial in the *Andover Review* in

1886: "A larger proportion of our prosperous classes secures a long vacation now than at any former time.... Rest and pleasure are no longer stolen, but are recognized as legitimate and necessary." Not only the prosperous classes who *took* vacations but also their employees who *got* them came to believe that people ought to be able "to separate a portion of time each year from the habitual and to devote it to rest and recreation."[16]

Flourishing cities provided the people who would seek rural recreation and the impetus for them to escape urban throngs and pressure, summer heat and unhealthful air, traffic and noise, and to try to remedy their detachment from rejuvenating nature. And as workingmen and workingwomen gained increasing access to vacation time, women and children outside the workforce swelled the numbers of those pursuing rural refreshment.

Through the turn of the century writers reassured those who took and those who got vacations of the positive forces associated with leisure and recreation.[17] Soon even the impulse to defend leisure by invoking particular benefits subsided, and a writer for the *Atlantic Monthly* in 1904 could advocate daydreaming—play that required neither equipment nor an investment of energy—by suggesting that "idleness opens up for any one who has eyes to see and a mind to dream a playground of infinite variety."[18] Idleness, decried in a more puritanical, moralistic antebellum America, was increasingly approved and celebrated. Painters depicted *Idle Hours* (see fig. 99), reverie, solitude, and other themes that reflected Americans' new willingness to eschew productivity, and they sold their canvases to patrons who enjoyed both the inactivities portrayed and seeing themselves portrayed in inactivities.[19]

Provisions were made to accommodate the people of all regions and classes seeking rest and recreation. By 1903 an

Fig. 78 North veranda, Manhanset House, Shelter Island, New York, early 1900s. Photograph: Henry Ford Museum and Greenfield Village, Dearborn, Michigan

Fig. 79 Camp Iroquois, Glen Eyrie, Lake George, New York, ca. 1910. Photograph: Henry Ford Museum and Greenfield Village, Dearborn, Michigan

author would conclude: "It may be said that there is practically no one in our cities and towns who does not get a vacation or outing."[20] And another commentator of 1903 announced: "In June the regular structure of American life is wholly broken up. Vacation has become a fetish with pretty nearly seventy millions of human beings; and vacation means migration. . . . It is a national hegira, a flux of population, a craze for change."[21]

In response to the unprecedented demand for destinations for outings and vacations, there was an extraordinary increase in the number of country retreats and suburban resorts (see fig. 78). Leisure became big business. "There is not a sheet of water of any size, especially in the middle West and in the East, that is not lined with shacks for summer parties," exclaimed Franklin Matthews in 1903.[22] This same year another observer appraised the development of the vacation idea from the viewpoint of business and noted, "If the cost of moving and caring for our great army of summer migrants for one season were put into one huge sum the amount would probably equal the capital of all the big trusts combined."[23]

The new country retreats and suburban resorts were made accessible by developments in modern life—improved and expanded railroads and steamships, increased service on rural trolley lines, roads that accommodated bicycles and, ultimately, the availability of the automobile itself. The modern life that made these refuges possible to reach also made them necessary, as we have seen: it was usually escape from the pressures of the new urban existence that the thousands of turn-of-the-century vacationers and the artists who joined them sought. Recreation was not only expected to offset the intensity of work but also to remedy problems caused by the disruption of family ties in the new urban-industrial society. For example, middle-class moral standards and respectable recreation could be encouraged by

stays in any number of newly founded vacation sites, which included camp-meeting grounds, centers for popular education such as Chautauqua, and less highly organized but still wholesome resorts such as Asbury Park, New Jersey, or Lake Mohonk, New York, where various amusements were provided.[24]

Camping out (see fig. 79), exploring, or sketching in unspoiled territory—getting in touch with nature in the most fundamental way—as well as hotels flourished. Writing in 1903, a physician, Dr. A. T. Bristow, counseled readers of *World's Work* that they should try roughing it in close contact with nature, like President Theodore Roosevelt.[25] "Hundreds of thousands of farms now take in summer boarders" and "keeping summer boarders is the chief industry of the State of New Hampshire," Franklin Matthews observed in 1903. He added, "'Old Home Week' has stimulated thousands upon thousands to go to their former places of residence in agricultural States."[26] His remarks provide testimony that vestiges of older, gentler times, echoes of a simpler, more rural, more homogeneous American past were among the attractions of many vacation spots.

American Painters and the New Leisure of Modern Life

In 1888 A. W. Greely rhetorically asked the readers of *Scribner's Magazine* to consider "Where Shall We Spend Our Summer?" and noted that "fifty years ago this was a question which was never heard in American homes." Writing principally about city dwellers in the northeastern United States, Greely identified three classes of vacationers. The largest and least affluent—the working class—whose members constituted two-thirds of summer

vacationers, made only brief outings to the most accessible and inexpensive resorts or took day trips to popular amusement parks or beaches such as Coney Island in Brooklyn or Atlantic City on the New Jersey shore to "renew physical vigor and mental tone." The middle class tended to visit coastal or mountain resorts from Canada south to New Jersey to escape city heat and to pursue sports. The "fashionable folk," many of whom could enjoy the luxury of dual residences, were able to spend long holidays in grand hotels and houses in Newport—the most elegant seaside retreat—or at Saratoga in New York, Long Branch in New Jersey, or Mount Desert Island, off Maine.[27]

Reflecting their middle-class origins and occasionally, as in the case of William Merritt Chase, striving for and making connections with the upper class, the American Impressionists recorded aspects of the new leisure and recreation of the late nineteenth century, especially a variety of country vacation retreats. They were attracted not only by the chance for relaxation but also, like the French Impressionists before them, by sites and subjects that called for a bold and rapid technique and nourished an interest in what was indigenous, lively, and fashionable. Avoiding the most accessible lower-class venues, the Americans preferred a small number of New England seaside communities and inland villages and their counterparts in places such as Long Island in New York. These locales—the Isles of Shoals, Cornish in New Hampshire, Gloucester and Nahant on the Massachusetts coast, and Shinnecock and East Hampton on Long Island —are as closely identified with the leading exponents of American Impressionism as the Normandy villages along the Channel coast and the country retreats at Argenteuil or Giverny are with their French mentors. Finding what they needed, personally and professionally, stylistically and expressively, the American Impressionists crafted from the resources of their chosen country retreats vivid American analogues to the works that the Frenchmen had produced.

The Realists of the turn of the century eschewed the genteel middle-class and upper-class places that their American Impressionist predecessors had frequented. Oriented toward social issues, philosophically committed to portraying the working classes, the Realists embraced the resorts that the American Impressionists had avoided: Coney Island, South Beach on Staten Island, Atlantic City, Bellport on the southern coast of Long Island, among others. Maurice Prendergast, who is associated with this younger generation of artists although he was not a Realist, went to Revere Beach in Boston, developed in the 1870s as a decorous middle-class refuge but by the 1890s as overcrowded as Coney Island, and to Nahant, which also had long since lost its original tranquillity. The responses of the Impressionists and the Realists to the new pursuit of rest and recreation in contact with refreshing nature invite inquiry, both separately and in comparison with each other.

Conditioning any of these painters' attachments to particular country retreats or resorts was the question of whether they appealed to artists as well as to vacationers. Most of the American Impressionists and Realists seem to have valued the companionship of colleagues over other attractions. Accordingly, the popularity of certain vacation sites at the turn of the century does not clearly coincide with the incidence of depictions by the adherents of these groups, and it is hazardous to infer the spectrum of vacation sites from the evidence of paintings alone. For every retreat or resort that appears in the works of the American Impressionists and Realists, there were dozens that these artists did not visit and did not portray. Newport, for example, a durable magnet for middle- and upper-class vacationers, did not attract the American Impressionists or Realists. Although it had nourished a small artists' colony surrounding William Morris Hunt in the late 1850s and the 1860s and was portrayed by several artists connected with the Hudson River School, Newport became more and more fashionable. The town was increasingly associated with extravagant displays of wealth, and its turn-of-the-century reputation as a place of unseemly luxury perhaps discouraged would-be American painters of modern life from installing themselves there for summer work.[28] Sometimes, too, an American Impressionist or Realist might visit and might even depict one of the popular summer colonies without actually becoming a member of the artists' community. A case in point is Willard Metcalf, whose winter landscapes of the summer colony of Cornish are discussed above.

Artists' Colonies: French and American

Beginning with Hunt's generation, American painters studying art in Europe had visited, worked in, and even occasionally founded artists' colonies. These communities arose as late nineteenth-century artists increasingly rejected the academic subject hierarchy, studio study, and historical conceits, turned to naturalistic subjects, and sought to record aspects of their own experience freely, freshly, and, more and more often, out of doors. Their concomitant attraction to a new range of subjects —especially nostalgic rural themes, often featuring peasants— reflected their inclination and that of their patrons to find in simpler places, people, and times a corrective to the pressures of modern urban life. Working in groups in the countryside, painters in European artists' colonies enjoyed social contact with other artists and the exchange of ideas and criticism, cheap accommodations, picturesque scenery, and local types who were accustomed to the presence of artists and who were willing to serve as models.[29]

Among the French artists' communities of various kinds were

Fig. 80 *Giverny (Eure)—Paysage d'automne*, n.d.
Postcard. Collection of Robert J. Killie

Fig. 81 *Giverny—L'Hôtel Baudy et la route de
Vernon*, n.d. Postcard. Collection of Robert J. Killie

Barbizon, the earliest large European artists' colony;[30] Grez-sur-Loing, which attracted American Impressionists Metcalf, Theodore Robinson, and Robert Vonnoh;[31] villages associated with the long-term residence of a single painter, such as Giverny (see fig. 80), where Claude Monet lived and worked, often in the company of Americans; Pont-Aven in Brittany, developed by Americans before it became more durably associated with the Synthetists; and picturesque sites, such as Marly-le-Roi, where Mary Cassatt stayed, that were home to one or two American expatriates.

An interesting if problematic American account of artists' life at Giverny is Metcalf's *Ten Cent Breakfast* (fig. 82), which records four individuals in a dramatically lighted interior. Scottish novelist Robert Louis Stevenson is shown seated at the right casually reading *Le Petit Journal*; the figure to his right, seated farthest from the viewer, is almost certainly Theodore Robinson. The third man at the table may be John H. Twachtman (whom he resembles, but who left Europe early in 1886, a year before the picture was executed) or the author of the painting, Metcalf (whom he also resembles). Even less sure is the identity of the thin, mustached young man who stands at the left, lighting his pipe. He has been said to be, among others, the Canadian painter William Blair Bruce, Hassam, Charles Birch (probably as the result of a printer's error), illustrator Reginald Birch, Lowell Birge Harrison, or John Singer Sargent (who visited Monet at Giverny in May 1887).[32]

Although some of the men's identities may be in dispute, the setting is without doubt the Hôtel Baudy at Giverny, the center of the village's art colony (fig. 81)—photographs of the interior of the site verify the location of its doors and the appearance of its gas lamps and fireplaces.[33] Metcalf, who visited with Robinson at Giverny from May to August 1887, produced this vignette of life there in the tonal academic-realist style that accorded with

his prior study at the Académie Julian. Despite the traditional dark palette and the careful modeling of forms, he conveys the effect of a candid snapshot taken with a flashbulb, capturing a casual moment when painters and at least one writer gather to chat. The painting's traditional title, *The Ten Cent Breakfast*, seems at odds with the presence of partially filled wineglasses and an almost empty wine bottle and the strong chiaroscuro, which more likely would be associated with an evening meal.

Its ambiguities notwithstanding, Metcalf's picture is an important document of the connection of Americans with an artists' colony that was key to the development of Impressionism. Monet (see fig. 83) had moved from Vétheuil to Giverny in May 1883, and in ensuing decades he and his adopted village attracted painters from all over the world. Of these it was the Americans who came in the greatest number to seek his advice and inspiration. Metcalf may have been the first, arriving in the summer of 1885; Robinson apparently also visited with Monet in 1885. They soon were followed by other future American Impressionists: Theodore Wendel, who painted Giverny scenes dated 1886, John Leslie Breck, Twachtman, and others.[34] The experience of Giverny stimulated and reinforced the conversion of many of these American visitors to the Impressionist aesthetic, and the village's art colony also would serve as a model for emulation when they resettled elsewhere in Europe or returned home. Monet's growing commitment to a nationalistic expression at the time of the Americans' visits[35] may also have prompted them to seek inspiration in analogous American sites.

Michael Jacobs has noted the complex circumstances under which French artists' colonies were imitated in other countries. Returning home from foreign study or work, many artists—Scandinavians, Russians, Germans, and others, as well as Americans— were nostalgic for the French artists' communities that they had visited. At the same time they wished to find some way to

Fig. 82 Willard Metcalf. *The Ten Cent Breakfast*, 1887. Oil on canvas, 15 ¼ x 22 in. (38.7 x 55.9 cm). The Denver Art Museum, The T. Edward and Tullah Hanley Memorial Gift to the People of Denver and the Area 1974.418

express the nationalistic sentiments that had prompted them to come back home in the first place. According to Jacobs, "By associating themselves with parts of the country where rural and folklore traditions had been well preserved, the artists liked often to feel that they were sowing the seeds of a revival of national culture."[36]

Jacobs's hypothesis is supported by the tendency of repatriated American painters to form communities in areas where the essentials that they had enjoyed or observed in French colonies —inexpensive lodging, picturesque countryside, and accessible local types—were available and where there also prevailed a strong resonance of the American past and the American temper. The likeliest counterparts of Barbizon, Grez, or Giverny for the Americans were such places as Gloucester, Cos Cob, Old Lyme, East Hampton, and other villages on the East Coast.[37] In these New England or New England-like locales, American fundamentals—especially associations with the period of early settlement and colonial growth—were evident in both spirit and physical aspect. These villages provoked a profound nationalist pride in the last decades of the nineteenth century.[38]

Many American artists' colonies revolved around open-air painting classes. Like Giverny in situating a single painter at the center of artistic life was Magnolia, Massachusetts, on Cape Ann, north of Boston, where Hunt offered criticism to a coterie of young women students in the summer of 1877. A durable American Pont-Aven was established in 1880 at nearby Annisquam, on the northern coast of Cape Ann, by William Lamb Picknell, who was joined by other painters who had studied in Parisian academic ateliers and had worked at Pont-

Fig. 83 Theodore Robinson. *Claude Monet*, 1890. Carbon pencil on paper, 21 ¾ x 12 in. (55.2 x 30.5 cm). Collection of Thomas W. and Ann M. Barwick

Aven. East Hampton, on the south fork of Long Island, was dubbed the American Barbizon in an article in *Lippincott's Magazine*,[39] where it was called a town to be cherished for its picturesque dwellings and old farmers and fishermen. Artists as varied as Thomas Moran and Edward Lamson Henry—topographical and sentimental, respectively—and American Impressionist Hassam were succeeded by several generations of painters who found, and still find, East Hampton a nourishing summer or year-round home. Adjacent Southampton, specifically its Shinnecock Hills area, became a popular artists' colony beginning in 1891, when Chase began to offer art instruction there. Chase's teaching was under official art school auspices, whereas Monet's had been informal and by friendly association. Yet in its rural quietude, its proximity to the city, its marvelous light, its combination of wild and cultivated nature, its hospitality to outdoor work, and especially its identification with a single major Impressionist, Shinnecock would seem an American Giverny. And although it was an artists' colony only during Chase's tenure, Shinnecock's strong connections with American foundations made it an appropriate venue for repatriation of the American artistic spirit. The rocky, picturesque fishing village of Gloucester on Cape Ann, by contrast, drew generations of artists both before and after the heyday of the Impressionists.

Other villages on the New England coast, especially Cos Cob, near Greenwich, Connecticut, and Old Lyme, at the mouth of the Connecticut River, were also sites for the development of American Impressionism. Both reiterated conditions that had prevailed at Pont-Aven and Giverny, in particular their focus on hospitable quarters in which many artists resided and others gathered: the boardinghouse Holley House at Cos Cob and the house of Florence Griswold at Old Lyme. Twachtman began teaching at Cos Cob in 1890 and around him gathered many artists who would formulate American Impressionism in the 1890s: J. Alden Weir, Robinson, Hassam, and Metcalf. Although Hassam was active at Old Lyme, that colony was identified with the academization of American Impressionism at the turn of the century and with a struggle between adherents of the style as it became increasingly *retardataire* and partisans of an even more old-fashioned Barbizon manner, artists such as Henry Ward Ranger and Henry Rankin Poore.

Sites to which the American Impressionists retreated individually or in groups of only two or three were Boothbay Harbor, Maine (in the case of Metcalf); Branchville, Connecticut (Weir); Ipswich, Massachusetts (Wendel and Breck); the Isles of Shoals (Hassam); and Napanoch, New York (Robinson). These seem to have been chosen because they made vivid aspects of nature and culture that recalled what these artists had experienced in France and at the same time and with equal force reflected a specifically American spirit.

The impulse to reconnect with American roots and, conse-quently, to gather in New England or New England-like villages was much less pronounced among the Realists than among the American Impressionists. The older artists had more fully assimilated French experiences and attitudes and therefore had more to gain in establishing and frequenting artists' colonies in which they could re-create the camaraderie they had known abroad. They also could use and needed to use the American locales they had chosen for these communities to neutralize what they had encountered in France. The Realists had less experience in foreign colonies to recapitulate and fewer foreignisms to slough off and consequently felt less constrained to follow the summer-colony pattern. And since the clearest expression of the Realists' engagement with modern life appears in their urban images, especially those of the first decade of this century, their interest in outdoor painting in rural settings is both less manifest and less interesting. Their involvement with the country retreat was linked with the period of their detachment from the actualities of modern life and even, in several cases, with the decline of their strength and the demise of their quintessential vision. Additionally, American Realism was in a certain measure a collaborative enterprise. It is not surprising, therefore, to find that its adherents' pursuit of rural subjects was an anticollaborative release, with members of the group scattering to such sites as Bellport (in the case of William Glackens); Gloucester (John Sloan); or Monhegan Island, Maine (George Bellows). Finally, the more genteel, family-oriented—and often more affluent—American Impressionists were predisposed to purchase country homes and to create stable centers for summer work and leisure or to cultivate friends and patrons who could provide such settings. By contrast the Realists were more likely to adopt the outing habit or the vacation habit, like the members of the working class they portrayed, and to remain summer visitors rather than summer residents wherever they went.

At the Seaside: The New Country Retreat by the Shore

Although few perhaps realize the fact, it is nevertheless true that most of the beaches where now the surf curls over networks of lifelines . . . were solitudes but a few years since.

DUFFIELD OSBORNE (1890)

Coastal images appear in art from the very earliest times as an important subset of marine painting.[40] Coast scenes principally are intended to capture the grandeur of the intersection between land and sea, to suggest the power of the sea, and, when they include a few figures, to record the awe of people before nature

Fig. 84 Alfred T. Bricher. *Morning at Grand Manan*, 1878. Oil on canvas, 25 x 50 in. (63.5 x 127 cm). Indianapolis Museum of Art, Martha Delzell Memorial Fund 70.65

or their work in relation to it. Innumerable coast scenes were painted by seventeenth-century Dutch artists and by nineteenth-century English and even some French Romantics, all of whom inspired nineteenth-century American landscape painters, including Thomas Birch, John Frederick Kensett (see fig. 91), Worthington Whittredge, and William Trost Richards. From the late 1870s through the turn of the century American coast scenes were painted by Albert Bierstadt, Thomas Moran, and Alfred T. Bricher (see fig. 84), and they were the primary concern of Winslow Homer (see fig. 26), the painter most closely identified with the mode.

Coastal imagery in which the sea dominates, compositionally or psychologically, was of limited interest to the American Impressionists, who only occasionally recorded nature's awesome power. Unlike Homer, the American Impressionists generally preferred to depict poetic vignettes of nature or people's pleasure and recreation at the seashore, to produce what may be called shorescapes rather than coastal or marine views. There are, nevertheless, a few turbulent American Impressionist coast scenes. For example, in Twachtman's *Sea Scene* (fig. 85) the viewer has no footing at all onshore but is asked to hover over rocks and a treacherous maelstrom of foaming breakers that occupy not only

Fig. 85 John H. Twachtman. *Sea Scene*, 1893. Oil on canvas, 27½ x 33¼ in. (69.9 x 84.5 cm). Delaware Art Museum, Wilmington, Special Purchase Fund, 1963 63–21

Fig. 86 Childe Hassam. *Seaweed and Surf,*
Appledore, at Sunset, 1912. Oil on canvas, 25½ x
27¼ in. (64.8 x 69.2 cm). The Fine Arts Museums
of San Francisco, Gift of the Charles E. Merrill
Trust with matching funds from The de Young
Museum Society 67.23.2

the foreground but also more than three-quarters of the canvas.
However, the overall effect is literally and psychologically light-
ened by the Impressionist palette and frothy stroke, and we tend
to see nature through Twachtman's lens as susceptible to decora-
tive distillation rather than as threatening, as Homer would have
us see it.

Although Twachtman and others painted such subjects oc-
casionally, only Hassam among the American Impressionists
devoted himself with any consistency to the rocky coast and
challenging surf of New England. Yet, like Twachtman's *Sea
Scene*, his images of the New Hampshire coast at the Isles of
Shoals point up, by comparison with Homer's nearly contempo-
raneous paintings, the American Impressionists' tendency to
pursue an art of sweetness and light. What is ominous and
rugged in Homer's pictures of the Maine coast near Prout's Neck
is transmuted by Hassam into brilliant pattern, although the
sites he painted are only a few miles away from Homer's. The
sun rarely shines on Homer's Maine coast, but it is almost always
present, dazzling and fracturing color, in Hassam's canvases, even
when the surf is turbulent, as in *Seaweed and Surf, Appledore, at
Sunset* (fig. 86).⁴¹

"Hassam's summer sojourns on the Isles of Shoals [were]
among the most fruitful of his long career," inspiring almost 10
percent of his works, as Curry has observed.⁴² Among these

paintings, there is rarely a hint of any threat from nature. Instead
in many canvases, especially in his images of poppies in Thaxter's
garden, Hassam stressed the isolation that could be enjoyed at
the Isles of Shoals. As Curry has told us, "'old-fashioned' flower
gardens" such as Thaxter's "were a colonial revival antidote to
the fast pace of modern life," and the sense of retreat into gar-
dens of this sort permeates the poppy paintings.⁴³ In *Poppies*
(fig. 87) and similar images, Hassam brings the viewer close to
the brilliant flowers, filling bands that emphasize the flat surfaces
of his canvases with mixed whites, pinks, and reds; he creates a
world of color that insists on the viewer's undistracted encounter
with the forms of nature alone, with flowers, rocks, water, with
sunshine and fresh air, and that restricts signifiers of human
presence to such details as tiny sails in the distant bay.

Although people swam, presumably for pleasure, in the very
earliest civilizations, and spas existed in Roman times, oceanside
recreation as a widely popular pursuit and the use of beaches as
places for water sports and sunbathing are nineteenth-century
phenomena. By the middle of the century many seaside villages
in England and France evolved into resorts in response to the
desire of urbanites to refresh themselves by contact with nature;
this was a transformation encouraged by the increased wealth of
city dwellers and the easier transportation that permitted their
visits to the shore.

Americans began to journey to seaside towns such as New-
port, Cape May and Long Branch, New Jersey, and Gloucester in
the earlier nineteenth century. Far Rockaway, on the coast of
Long Island south of Jamaica, became a fashionable resort for
New Yorkers in the 1830s. But the great growth of interest in
seaside recreation in the United States did not occur until after
the Civil War. Like so many other social phenomena in that
period, it was stimulated by European developments, including
the popularity and the increasing sophistication of French resorts
on the Channel coast, which became magnets for Parisians during
the Second Empire. At this time Newport, Gloucester, and other
American towns rapidly and acutely modified their colonial
heritage of whaling and fishing to accommodate the new seekers
of seaside recreation; now entire regions with many small pictur-
esque villages and historical resonance—Monmouth County,
New Jersey, for example—became lively and popular watering
places.⁴⁴ Writing in 1890, a commentator recorded the recent
growth of surf bathing (see fig. 89) as a sport in the United
States: "Although few perhaps realize the fact, it is nevertheless
true that most of the beaches where now the surf curls over
net-works of lifelines, and where the brown-faced bathing-master
lounges, lazy yet watchful, before hundreds of gayly clad pleasure-
seekers, were solitudes but a few years since."⁴⁵

The economic and social consequences of new interest in
seaside recreation were immense. In 1896, for example, more
than eleven million visitors, who spent many millions of dollars,

Fig. 87 Childe Hassam. *Poppies*, 1891. Oil on canvas, 19¾ x 24 in.
(50.2 x 61 cm). Collection of Mr. and Mrs. Raymond J. Horowitz

Fig. 88 Eugène Boudin. *The Beach at Villerville*, 1864. Oil on canvas, 18 x 30 in. (45.7 x 76.2 cm). National Gallery of Art, Washington, D.C., Chester Dale Collection 1963.10.4

came to the coast of New Jersey between Sandy Hook and Cape May, and by that year Atlantic City, the largest resort in the area, had four hundred hotels, some of which could accommodate more than a thousand guests, boardinghouses that could take over thirty thousand visitors, and room for twenty thousand more in private cottages.[46]

As American Impressionism developed in the 1890s, the new beach retreats and resorts—Nantucket, East Hampton, Southampton, and Old Lyme among them—invited responses from its practitioners, just as Deauville and Trouville had stimulated Eugène Boudin (see fig. 88) and Sainte-Adresse had provoked some of Monet's most delightful canvases.

Fig. 89 Manhattan Beach, 1897. Photograph: Museum of the City of New York, The Byron Collection

Long Island

A god-send to tired New Yorkers is old Long Island.

LONG ISLAND DEMOCRAT (1880)

For the tired dweller in cities, Long Island holds in waiting every variety of beauty.

NEW YORK SUNDAY PRESS (1892)

Over two hundred miles of coastline and a number of towns on New York's Long Island (see fig. 90) would be transformed from dependence upon fishing and agriculture to flourishing tourist and artistic destinations in the late nineteenth century. Throughout the history of American landscape painting, beginning in the 1820s, Long Island had offered artists a range of subjects as varied as those available in any locale in the United States: Brooklyn panoramas with a distant seashore for topographers such as George Harvey; Setauket farmers and Stony Brook farmhouses for William Sidney Mount; north and south coastlines, village vignettes, and sportsmen shooting ducks for Kensett, John Evers, Arthur Fitzwilliam Tait, and many others. From the 1870s, however, tourism developed as a major Long Island industry, and the island's picturesque villages and recreational facilities became favorite weekend and summer destinations for the growing population of New York. Publications such as *Antiquities of Long Island* of 1874 described early settlements, "manners and customs," and "ancient names and remains," as might a tourist guide to any area with historical resonance.[47]

By 1880 a writer for the *Long Island Democrat* could observe: "A god-send to tired New Yorkers is old Long Island, with ... incalculable store of pleasure in bathing, sailing ... with

Fig. 90 Long Island, 1900. Map Division, The New York
Public Library Astor, Lenox and Tilden Foundations

big hotels and quiet farm houses, her lakes and bays . . . if there is
any more charming place for the idler in summer than Long
Island, it certainly is not to be found anywhere near New York."[48]

Long Island tourism was much encouraged by the Long Island
Railroad, which underwrote and distributed numerous illus-
trated promotional publications.[49] As a result of the railroad's
efforts and of the increasing importance of a convenient, health-
ful, beautiful, and bountiful rural area to a rapidly growing
metropolis, the numbers of Long Island's recreational facilities,
country and suburban homes, and boardinghouses grew; access
to them not only by train but also by automobile and bicycle
improved as better roads were provided; and there were advances
in horticulture and specialized agriculture. Long Island land-
scapes painted near the turn of the century began to be quite
different from Hudson River School and other antebellum views,
for they reflected the increasing settlement of the region and the
transformation of its functions from fishing and farming to
suburban living and tourism by showing the new leisure and
recreational life. Long Island's beaches were particularly es-

teemed. They were distinguished from the narrow and rocky
English Channel beaches in England or France by their great
width and their soft sands and by their close proximity to a city.
Between 1860 and 1880 the beaches of Long Island were occa-
sionally painted by Hudson River School artists, who preferred to
remind the viewer of the grandeur of nature by portraying vast,
almost surreal expanses of empty sand and sea; an example of
such a scene is Kensett's *Eaton's Neck, Long Island* (fig. 91),
depicting one of the most treacherous places on the North Shore
and site of many shipwrecks.[50] By contrast, artists of the later
nineteenth century showed Long Island's beaches filled with
people on holiday, enjoying the release from urban pressure,
being rejuvenated in contact with nature.

Closest to the city, and therefore accessible by railroad, boat,
or bicycle, were beaches at Coney Island, at the south edge of
Brooklyn, and Rockaway Beach, including Far Rockaway, just to
the east, at the south edge of what would become Queens.
Although people had visited these areas to indulge in leisure
activities in earlier decades—the popularity of Rockaway, for

Fig. 91 John Frederick Kensett. *Eaton's Neck, Long
Island*, 1872. Oil on canvas, 18 x 36 in. (45.7 x
91.4 cm). The Metropolitan Museum of Art, New
York, Gift of Thomas Kensett, 1874 74.29

Fig. 92 Francis Augustus Silva. *The Schooner "Progress" Wrecked at Coney Island, July 4th, 1874,* 1875. Oil on canvas, 20⅛ x 38⅛ in. (51.1 x 96.8 cm). Manoogian Collection

example, was established by 1810 and reached its peak in the 1830s—traditional notions of landscape and coastal painting inhibited artists from recording seaside recreation at this time. As late as the 1870s Francis Augustus Silva pursued a Hudson River School aesthetic when he visited the beaches at Coney Island and the Rockaways, as well as Fire Island. Avoiding any suggestion of recreational use, he found there the raw material for romantic coastal scenes. In *The Schooner "Progress" Wrecked at Coney Island, July 4th, 1874* (fig. 92), he memorializes the aftermath of one of the many wrecks that occurred on the Long Island coast, with no indication whatsoever that by 1874 Coney Island was visited frequently by New Yorkers seeking refreshment.

During the 1870s the beaches near the city prompted a few artists with traditional styles to depict people at leisure. Ralph

Albert Blakelock painted *Rockaway Beach, Long Island, New York* in 1869–70 (M. and M. Karolik Collection, Museum of Fine Arts, Boston) in terms of a Hudson River School style that lets grandly scaled nature overwhelm tiny visitors even though elaborate beach pavilions had altered the wild surroundings substantially by this time. Samuel S. Carr, an English-born artist about whom little is known, portrayed Coney Island in a number of unusual small canvases that record people engaging in the variety of available activities.[51] Carr's *Beach Scene* (fig. 93), for example, presents a fascinating frieze of men, women, and children watching a Punch and Judy show, taking a ride on a donkey, digging in the sand, promenading, and posing for a photographer who plies his trade on the beach. The painter himself arranges his figures and seeks a frozen precision in the

Fig. 93 Samuel S. Carr. *Beach Scene*, ca. 1879. Oil on canvas, 12 x 20 in. (30.5 x 50.8 cm). Smith College Museum of Art, Northampton, Massachusetts, Bequest of Annie Swan Coburn (Mrs. Lewis Larned Coburn), 1934 1934:3–10

manner of the photographer whom he depicts; the light of the painting is that of the studio, untouched by fracturing sunshine, unruffled by any breeze. The visitors recorded by Carr have made few concessions to the seaside setting; their interlude at the shore seems a brief and somewhat unaccustomed one. The women in richly colored, elaborately draped dresses and the men in dark business clothes would be more comfortable promenading on city avenues than standing on the beach. Although the children wear sunbonnets, not even they have taken off their shoes to wade or to dig in the sand. The painting's odd charm lies in the coincidence between the visitors' restrained enjoyment of the beach and the artist's own curiously restrained style.

Coney Island, having received several structures—including a Japanese temple and a Chinese pagoda—from the Centennial Exhibition of 1876 in Philadelphia, emerged in the later 1870s as a major amusement park and a source of national pride.[52] By 1880 William H. Bishop would note in *Scribner's Monthly* that "it is quite original, distinctively American, and charming. There is nothing like it abroad. . . . A touch of patriotic pride really ought to mingle with our contemplation of Coney Island."[53] The most popular resort on Long Island, by 1880 Coney Island could attract fifty thousand day-trippers on a summer Sunday. But it was also becoming vulgar and commercial, with prices for all activities boldly displayed on large signs. The tendency to extravaganza at Coney Island was capped by the opening of Steeplechase Park there in 1893. In this huge amusement park, seaside pleasure was insulated from the sea itself by elaborate fantasy architecture and mechanized games and rides. One writer described Coney Island in 1896 as "the great seaside 'safety-valve' of New York City," where eight million visitors came each season to enjoy bathing, dancing, all sorts of shows and music, and restaurants that could comfortably seat as many as four thousand people at one time.[54]

In response to such developments, even Carr, who had recorded the simple pleasures of an earlier age, fled to the artificial rural pastures of Brooklyn's Prospect Park in the 1890s. Simultaneously, Chase, the leading American Impressionist interpreter of the seashore, abandoned Brooklyn entirely. While Chase had made a specialty of Prospect Park, he had also recorded the Brooklyn coastline: the Brooklyn Navy Yard, Bensonhurst, Coney Island, and Gowanus Bay appear in a number of his tranquil, unpopulated coast scenes that more often feature piers than people. He had also used Gravesend Bay as the background for at least one vivid, large-scale, and very genteel figural pastel, *Gravesend Bay* of about 1888 (Hirschl and Adler Galleries, Inc., New York).

However, Chase had not painted Coney Island. Like his American Impressionist colleagues, he avoided the raucous amusement park, whether at Coney Island or on Long Island's North Shore. The American Impressionists would devote themselves

to the gracious and rural retreats of the farther South Shore of Long Island. In 1894 Alfred Trumble noted: "Coney Island and Rockaway became roaring resorts. . . . So the artistic legion was driven steadily eastward, until it found, between Peconic Bay and Montauk Point, an ideal camping place."[55] Rockaway and Coney Island would await the attention of the turn-of-the-century Realists, who preferred the more accessible, more plebeian beaches as inspiration.

The Genteel East End

Those who do not care for the gaudy masquerade of the populous beaches can find on the Island quaint and quiet spots . . . imbued with as restful a charm as the original Sleepy Hollow.

NEW YORK SUNDAY PRESS (1892)

When I asked the artists in New York for the nearest approach to an Artist Colony such as we have abroad . . . they all advised me to come to Shinnecock.

ELIZABETH W. CHAMPNEY (1894)

The members of the Tile Club were among the first American painters to come to the East End—the south fork of Long Island, about one hundred miles east of New York City. This group of New York artists began to meet informally in 1877, together with a few writers and musicians, to decorate ceramic tiles and to find the kind of camaraderie that most of them had experienced when they studied in Europe. Summer trips for the pursuit of artistic subjects and recreation became part of the Tile Club's program. In 1878 the Tilers went to Long Island and visited a number of villages, including Bridgehampton, East Hampton, and Montauk on the East End. Their experiences generated a series of articles in *Scribner's Monthly*, written and illustrated by members; these were later excerpted in a promotional publication for the Long Island Railroad, *The New Long Island: A Handbook of Summer Travel*. They returned to Long Island the summer of 1881, this time to the North Shore in the company of future Impressionists Chase, Twachtman, and Weir.[56] Their intention seems to have been largely to reconnect with American traditions. For example, they admired and recorded remnants of the shipbuilding industry around Port Jefferson and made "a respectful observance to a justly revered memory"[57] of the painter Mount in Stony Brook.

Partly as a result of the Tile Club's well-publicized enthusiasm for the area, a number of landscape painters who worked in traditional styles were attracted to East Hampton, beginning in the late 1870s and the 1880s. They found there picturesque and

Fig. 94 Alfred T. Bricher. *Baby Is King (Beach Scene)*, 1880. Oil on canvas, 17⅝ x 35⅛ in. (44.8 x 89.2 cm). The Fine Arts Museums of San Francisco, Mildred Anna Williams Collection 1942.7

characteristically American analogues of the French, English, and Dutch country villages they had visited during their student years. The region had, after all, been settled in the late seventeenth century by former residents of the Massachusetts Bay Colony, and there were remnants of the colonial spirit in the indigenous architecture, in the form of weathered shingle houses and even windmills, for example, and in the activities of local farmers, shipbuilders, and fishermen. To these artist visitors, and to many who preceded and followed them, the eastern end of Long Island must have seemed like the seventh New England state. In the late 1870s and the succeeding decade East Hampton nourished the work of artists including Thomas Moran and other painters in his family, as well as George Smillie, Bruce Crane, Walter Clark, and Frederick Dielman. By 1885 the writer Elizabeth W. Champney would claim that East Hampton was "the true artist colony, and perhaps the most popular of adjacent sketching-grounds for New York artists."[58] Hassam and other American Impressionists would follow to record this village and neighboring Amagansett and Montauk in the 1890s and well into the twentieth century.

In the 1890s, however, East Hampton's allure for artists was challenged by nearby Southampton. Southampton had first become accessible by railroad in 1870, and in the late 1870s and early 1880s a few traditional artists, Bricher and Alfred C. Howland among them, had painted views of the town. Bricher, who visited Southampton in 1880 and had married a local resident, began to spend summers there in 1881. He occasionally departed from his usual unpopulated coastal scenes with breaking waves (see fig. 84) to record vignettes of the beach and village. His *Baby Is King (Beach Scene)* (fig. 94) and *In My Neighbor's Garden* of 1883 (Daniel J. Terra Collection) anticipate Impressionist subjects but preserve a scrupulously precise style based on rigorous linearity, the use of studio props, and

careful studies of family members, who appear as models in stock poses.

Despite the presence of such artists as Bricher—and despite such curiosities as his handful of hybrid academic-realist scenes—Southampton did not begin to flourish as an artistic venue until 1891, when Chase arrived there to establish a school for outdoor painting and to work at Shinnecock, an area at the western edge of town. Other artists—including hundreds of students—would be attracted to Shinnecock and Southampton by Chase. But his association with the site was as characteristic and mutually defining as Homer's with Prout's Neck, Hassam's

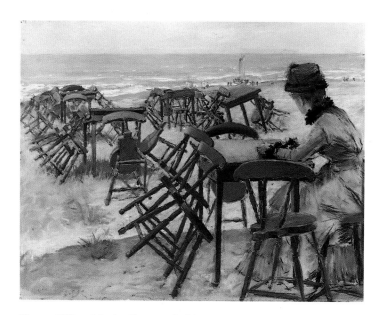

Fig. 95 William Merritt Chase. *End of the Season*, ca. 1885. Pastel on paper, 13¾ x 17¾ in. (34.9 x 45.1 cm). Mount Holyoke College Art Museum, South Hadley, Massachusetts 1976.9

with the Isles of Shoals, Monet's with Giverny, and Boudin's with Deauville and Trouville. Not incidentally Chase owned some of Boudin's work and emulated it in such pastels as *End of the Season* (fig. 95).

Beginning about 1885 Chase had painted a series of New York park views—discussed below in "The Urban Scene"—that provide some of the earliest, freest, and finest statements of pride in the modern American scene expressed in the most up-to-date Impressionist terms. In these pictures he had recorded middle-class Americans at leisure; he transferred this subject matter from the park to Shinnecock at the invitation of Mrs. William S. Hoyt. A wealthy summer resident of Southampton, Mrs. Hoyt suggested that the artist visit in 1890 to consider the advantages of teaching at Shinnecock.[59] Chase would seem to have been an inevitable choice to head a summer art school where students could learn and practice plein air painting: he was one of the most active and popular teachers in New York; a painter sympathetic to and experienced in outdoor work; the creator, in his park paintings, of a new and national vocabulary for American Impressionism; and an artist who, as president of the Society of American Artists, embodied the spirit of a generation of cosmopolitan American painters.

"With many doubts as to the success of the undertaking," according to a contemporary source,[60] Chase was enlisted as the director and principal critic of the Shinnecock Hills Summer School of Art, for which Mrs. Hoyt and her friends, other Southampton summer residents, such as Samuel Parrish, provided land and financial backing. In 1891 Chase took up residence in a local inn and began teaching. He offered criticism on Mondays—the first of two Chase Days each week—in a large studio where students also worked on rainy days. Often the students—who ranged from serious professional painters to dilettantes—were joined by enthusiastic amateurs who were invited to witness the critiques. On Tuesdays Chase led his loyal flock to some outdoor site for work and criticism (see fig. 96). The Shinnecock Art Village ultimately comprised the studio building, which resembled a rustic Adirondack hunting lodge, twelve to fifteen weather-beaten cottages in the Shingle style standing close together in a complex of little hedge-lined lanes that surrounded the studio, and a restaurant.[61] The students either rented the cottages in groups, stayed in Southampton farmhouses or boardinghouses, or lived in the Art Club, a large house in the area that was lent by a supporter and was also used for social events.

In 1892 Chase and his family moved into a large, rambling house designed by Stanford White in the Shingle style with strong colonial echoes, located about three miles away from the school. Simpler than White's usual Newport "cottages," it included a large ground-floor room at the north end that served as private studio space for the artist, a huge two-story hall with a

Fig. 96 William Merritt Chase demonstrating outdoors before the Shinnecock Summer School of Art class, ca. 1892. Albumen print. The Parrish Art Museum, Southampton, New York, William Merritt Chase Archives, Gift of Jackson Chase Storm

stone fireplace that was the heart of the house, and seven bedrooms.[62]

By 1893 an observer could remark that the Shinnecock Hills Summer School of Art had "become an established institution, and bids fair to be known long and favorably in the American world of art."[63] By 1894 Chase's instruction was supplemented by classes given by other teachers in watercolor and preparatory drawing and sketching.[64] The school flourished until 1902, attracting as many as a hundred students—most of whom were women—each summer and becoming not the first but the most famous school for outdoor work in the United States. Champney, who was one of Chase's students, suggested in *Witch Winnie at Shinnecock*, published in 1894, that Chase had created for Americans the perfect analogue to any of the leading French art colonies. According to one of Champney's characters in this fictionalized account of life in the Art Village: "I have only been back a month, and when I asked the artists in New York for the nearest approach to an Artist Colony such as we have abroad at Barbizon and Econen[*sic*], Grez and Giverney [*sic*], they all advised me to come to Shinnecock."[65]

Most of Chase's own Shinnecock paintings were executed near his house and studio or in their interiors. Generally, and certain divergences notwithstanding, they reveal strong and obvious continuities with the content and technique of the earlier park scenes and with the images of his Tenth Street studio in New York that Chase had produced in the 1880s. In 1889 fellow artist and prominent critic Kenyon Cox had described the park paintings in words that could apply with only a few changes to the Shinnecock scenes: "Crisp, fresh, gay, filled with light and air and color and the glitter of water and dancing of boats, or the brightness of green grass in sunshine and the blue depths of shade upon gravel-walks, brilliant with flowers and the dainty

costumes of women and children, they are perfection in their way, and could not be improved upon."[66]

Chase's Shinnecock paintings are perhaps even more thoroughly chromatic and brilliant than those he did in the parks. One of Chase's students, Rockwell Kent, observed that Chase developed his plein air commitments "in reaction to the messy, tobacco-fingered Barbizon school, and the 'greenery yallery Grosvenor Gallery' stuff. . . . He went to nature, stood before nature, and painted it as his eyes beheld it."[67] Despite Chase's direct engagement with his subject, his Shinnecock landscapes— like his park paintings—recall elements of works by European artists to whom the consistently eclectic American painter was attracted, especially Giuseppe de Nittis and Gustave Caillebotte.[68] Thematically, the Shinnecock scenes are more private than Chase's park paintings, concentrating on his wife and children, rather than on mostly anonymous figures, in the context of their retreat not only from the urban and public life of the city but even from the busy and gregarious life of the nearby art school. They are prosaic and antitheatrical, reminiscent of the intimate vignettes of familiar locales painted by seventeenth-century Dutch artists or—among the moderns—of the glimpses of nature recorded under Dutch influence by Charles-François Daubigny and others of his generation.[69]

At Shinnecock Chase found an ideal spot for painting, one so invigorating that he often worked on several canvases simultaneously, indoors and out. As a newspaper account of June 1892 noted, albeit with hyperbole: "Those who do not care for the gaudy masquerade of the populous beaches can find on the Island quaint and quiet spots, possessed of surpassing natural beauty, and imbued with as restful a charm as the original Sleepy Hollow. For the tired dweller in cities, Long Island holds in waiting every variety of beauty, scenery to harmonize with every mood and every heart throb of the natural man. . . . a region that is a dreamland of delight . . . is Shinnecock."[70]

Shinnecock was not only reminiscent of the original Sleepy Hollow. Even more than some of the surrounding areas of the East End, it was connected with the deepest American roots and hence was especially appealing to Chase. The town of Southampton, including the Shinnecock Hills, had been established on land purchased from the Shinnecock tribe by Puritans from Massachusetts in 1640. Southampton was thus the oldest English settlement in New York State and closely matched the Massachusetts Bay Colony in its architecture and other aspects of its appearance.[71]

There were also reminders of earlier Dutch settlers, including a picturesque windmill and the beaches themselves, which recalled those of Holland, where Chase had worked in the summers of 1883 and 1885. In fact, a commentator who wrote about Chase in 1901 maintained that Shinnecock "basks like Holland under an everchanging sky; it is, indeed, Holland without its

windmills, its canals, fences and villages, a monotonous lowland, broken here and there by sand dunes and dwarfed bushes."[72]

Beyond these associations with the colonial and European pasts were resonances of precolonial times to which Chase responded: these emanated from the Shinnecock Indian reservation. By 1892 the Shinnecock tribe was expiring,[73] yet remnants of its traditions lived on. Chase was sensitive to these and maintained friendly relations with the members of the tribe, obtained permission for his students to paint on the reservation, located just to the south of the Art Village, and used some of the Shinnecocks as models.

Chase was conscious that the works that he and his students produced at Shinnecock were characteristically American. In a talk given at an annual exhibition of paintings by his summer-school pupils and published in 1897 he observed: "Many people say that we have no school of art in America; but I do not agree with them. The studies of our Shinnecock School which cover these walls tonight are representative of American art. There is no staining, no tinting, but here is American painting which will produce good results. Let me urge you to strive to prove that our American art is a vital thing."[74]

In addition to its profound resonance with the American past, Southampton offered other attractions that set it apart even from neighboring East Hampton. Whereas East Hampton was considered a particularly nourishing retreat for painters—"East Hampton the Restful," Charles de Kay would call it in 1898, remarking how quiet and picturesque it was[75]—Southampton emerged in the 1880s as dignified yet much more fashionable and lively. Its vacationers, some of whom would construct and occupy grand houses, began to be even richer, more genteel, and more stylish than those of East Hampton. As a local newspaper observed in 1897, Southampton was as "a summer resort for New Yorkers . . . not far behind Newport."[76] Although Chase and his students ranged over the dunes and beaches for their subjects and much more often painted family members than summer residents, these wealthy neighbors supported Chase's school and bought paintings from him and his students. The decorous and euphemistic quality of American Impressionism seems to have been especially well served by the rarefied ambience of Southampton, with the result that Chase's Shinnecock paintings are in many ways canonical examples of the entire movement.

The luxurious tone of Southampton—apparent then as now —was inevitably attractive to the socially striving Chase. That tone may also have provided a stimulating contrast, even a necessary foil, to the landscape that surrounded the art school itself. A writer in 1878 had described the unprepossessing setting: "Shinnecock Hills is a synonym of what is utterly barren and useless . . . sandy knolls densely grown with a chapparral [sic] of scrub oak and pine, alternating with swampy hollows where the moss trails far down from the skeletons of dead trees,

Fig. 97 William Merritt Chase, *The Chase Homestead,*
Shinnecock Hills (The Bayberry Bush), ca. 1895.
Oil on canvas, 25½ x 33⅛ in. (64.8 x 84.1 cm).
The Parrish Art Museum, Southampton, New York,
Littlejohn Collection 61.5.5

and the imagination conjures dreadful inhabitants out of the dark tussocks."[77] Although the Long Island Railroad was developing the area by 1890, Shinnecock still could not have been considered naturally beautiful at the time Chase arrived.

The geographically undistinguished character of the region, so like the flat expanses of Holland, may have accommodated Chase's distrust of the pretty and the grandiose and may, therefore, have seemed particularly inviting as a place for painting and teaching. His early biographer wrote: "He never ceases to warn his pupils against the sin of prettiness. 'I often think,' he has said, 'that those old Dutch masters were fortunate in having had such unlovely subjects.'"[78] And another critic said that Chase told his students: "Do not seek for the distinguished theme, the grandiose, and then try to paint up to it; but paint the commonplace in such a way as to make it distinguished."[79]

Despite the unimpressive topography, it is difficult to imagine the area as other than supremely hospitable, since, in most of Chase's Shinnecock landscapes, it looks so lyrical and poetic and any figures that are included are so serene. Chase records the appearance of the place, but he does this with such selectivity that the locale almost always seems to be thoroughly delightful and inviting in paintings that represent the epitome of languid summer afternoons, family warmth, and simple pleasures.

For example, the prominence of the large scrubby shrub in the foreground of *The Chase Homestead, Shinnecock Hills (The Bayberry Bush)* (fig. 97) veils the fact that it is the only significant vegetation in a generally flat, treeless, featureless stretch of open dunes. The expansive foreground and high horizon line bind all the forms into a web of high tone and color

that seems to incorporate sunlight itself into the medium. The little girls—three of the painter's daughters—are unperturbed by the lack of shade and are scattered through the grasses as harmoniously as if they were indigenous forms—"like so many butterflies," as a contemporary critic characterized the children in Chase's Shinnecock pictures.[80] Seen from the gable end in the distance is Chase's family residence and studio, which gives an air of domesticity to the scene and verifies the artist's presence and participation as observer. The children have not wandered far from reassuring shelter; the nature that they experience is well within the purview of home. The house is new, but its Anglo-Dutch colonial-revival style is entirely consistent with the traditional architecture of the region. In the painting, moreover, it is bound comfortably into the horizon, its gables reiterating the shapes of the foreground tufts of grass and the sunbonnets of the little girls, its red brick chimney echoing the red of ribbons and the scattered spots on the foreground sand, its weathered gray shingles sharing color and tone with the ground itself. The man-made is in perfect accord with nature and nature is entirely pleasant.

A classical harmony prevails in the composition of *The Fairy Tale* (fig. 98), one of Chase's earliest Shinnecock works. The setting, "almost in front of Mr. Chase's house," according to a visiting writer,[81] includes the same large shrub depicted in *The Chase Homestead, Shinnecock Hills,* which again tempers, even conceals, the actuality of the barren landscape. We do not see the nearby house—the view is now to the opposite direction, toward Peconic Bay. Although we do not know for sure that the figures, isolated in nature, are within the range of shelter, we cannot imagine any threat to them. Even the sea is contained here, confined by scrubby foliage and a narrow beach to an inlet protected by Robbin's Island in the distance.[82] In the center foreground a woman who must be reading and a child sit on the expanse of grass and heather. The woman's attire is at the height of fashion: a white cotton dress with lace inserts, tightly fitted bodice, and slightly puffed narrow sleeves, and a large-brimmed pink straw hat that is perched atop a stylishly high coiffure. The child's pink pinafore is the typical uniform of a patrician young girl. Beside them lies an open lace-trimmed parasol.

Chase strikes a charming and timeless balance between the bright and warm forms of the child and the parasol that bracket the graceful reader. The universality of maternal affection and childish delight is supported by the fact that we see the face of neither model—almost certainly Chase's wife and four-year-old second daughter, Koto Robertine. The perfection of the moment seized is emphasized by the painting's romantic title.[83] A fairy tale is being read, and a vision as perfect as a fairy tale—a glorious, sparkling summer day—is also being offered to the viewer.

The genteel group that gathers to spend *Idle Hours* (fig. 99) — Chase's wife (in the red bonnet), two of his daughters,

Fig. 98 William Merritt Chase. *The Fairy Tale*, 1892. Oil on canvas,
16½ x 24½ in. (41.9 x 62.2 cm). Collection of Mr. and Mrs. Raymond J. Horowitz

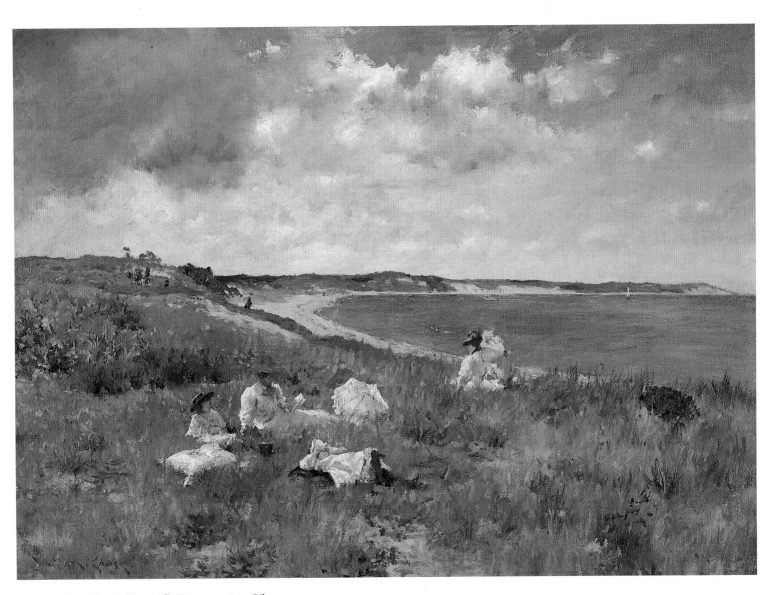

Fig. 99 William Merritt Chase. *Idle Hours*, ca. 1894. Oil on canvas,
25 ½ x 35 ½ in. (64.8 x 90.2 cm). Amon Carter Museum, Fort Worth 1982.1

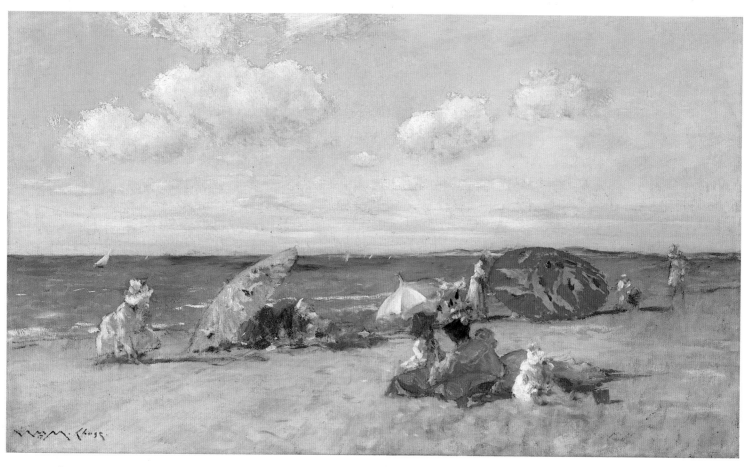

Fig. 100 William Merritt Chase. *At the Seaside*, ca. 1892. Oil on canvas,
20 x 34 in. (50.8 x 86.4 cm). The Metropolitan Museum of Art, New York,
Bequest of Miss Adelaide Milton de Groot (1876–1967), 1967 67.187.123

Fig. 101 Winslow Homer. *Eagle Head, Manchester, Massachusetts (High Tide)*, 1870. Oil on canvas, 26 x 38 in. (66 x 96.5 cm). The Metropolitan Museum of Art, New York, Gift of Mrs. William F. Milton, 1923 23.77.2

Fig. 102 Bathing suits, from "House Parties," *Harper's Bazar* 28 (June 1, 1895), p. 444

and possibly his sister-in-law—is utterly unperturbed by the momentarily clouded sky. There are no premonitions here of a storm that might have thrilled a Hudson River School coastline painter. The setting appears to be a dune overlooking a curve in Shinnecock Bay, within walking distance of Chase's home and studio. The pillows on which the visitors sit probably were carried out from indoors, suggesting the proximity of the site to habitation and yielding a reassuring note of domesticity. With the water held within the bend of the shoreline, nature invites enjoyment rather than provoking awe.

By comparison with the figures in *The Fairy Tale*, those in *Idle Hours* are more distant from the picture plane and more embedded in their natural surroundings. Yet their brilliance and their placement at the center of the grassy stage persuade the viewer that this is more a figure painting than a landscape. In contrast to a relatively drab, spikily brushed expanse of scrubby vegetation, they are rapidly defined in broad strokes of bright white and set off with many of Chase's characteristic red notes. The women continue to be most fashionably attired; two years later than *The Fairy Tale*, the painting shows even more exaggerated sleeves on their summer dresses. The children, wearing hats like their elders' and pinafores, are obviously city dwellers on a visit to the shore, docile and correct in their behavior. Nature is again a delightful setting for human activity, and the suggestion of a halcyon life of leisure in a lovely setting emerges.

In *At the Seaside* (fig. 100) women and children take their ease close to the edge of a beach—probably Shinnecock Bay—without any compromise of dignity, comfort, or tranquillity.[84] They are freed from the heavy garments and stiff poses that Carr had

recorded at Coney Island, and, like their counterparts in *The Fairy Tale* and *Idle Hours*—and even in Bricher's *Baby Is King (Beach Scene)*—they are liberated from adult male company with its constraints of decorum. Women significantly outnumbered men in Chase's summer school, and they predominated in the daily leisure life of Southampton. This was a product of the town's distance from New York City, where men were bound to their desks for the working week. Whereas Carr's Coney Island attracted whole families that took advantage of its accessibility to the city, Chase's (and Bricher's) Southampton was a place where males usually were present only on weekends.[85] Of course, Southampton shared this quality with other country retreats that were beyond easy commuting distance from the cities, areas of the sort that William Dean Howells observed near Boston in *The Rise of Silas Lapham* in 1885: "They had gone about to mountain and sea-side resorts . . . where they witnessed the spectacle which such resorts present throughout New England, of multitudes of girls, lovely, accomplished, exquisitely dressed, humbly glad of the presence of any sort of young man."[86]

Indifferent to the presence of the male observer, Chase, the women and children in *At the Seaside* wear immaculate white or pastel seaside gowns and bonnets. They are not dressed for bathing, although American women bathed recreationally at the beach—even in mixed company—as early as the 1850s, wearing all sorts of ordinary clothing. Bathing suits were available to American women by the early 1870s and are recorded in such paintings as Homer's *Eagle Head, Manchester, Massachusetts (High Tide)* (fig. 101). By the 1890s, when surf and still-water bathing were popular, magazines illustrated costumes that in-

cluded bloomers under knee-length tunics or black stockings under ankle-length bathing dresses, sailor collars, scarves, and laced canvas shoes (see fig. 102). As late as 1890 articles offered guidance to men who might wish to take women surf bathing to provide them enjoyment but also offer them necessary protection.[87] By the end of the 1890s some women had been taught how to swim, and, according to an observer of 1897, "some athletic, dauntless summer girl dared to look pretty in her bathing suit, and her sisters have followed quickly in her footsteps." The summer girl wore "short skirts, long enough to satisfy the veriest prude, but short enough to allow her to give a good frog-like kick without sending her straightaway to the bottom."[88]

But it is not the new summer girl who figures in Chase's painting, and the activity shown is contemplative rather than athletic. Perhaps the absence of protective men from Chase's description of the beach at Shinnecock dictated that the women and children approach the water with extreme caution or not at all. Staying well away from the bay, the children, though barefoot, play quietly, and the women recline on tasseled cushions brought outdoors from parlor sofas, shade themselves with bright Japanese umbrellas that could not have been carried too far from home, and seem immune to getting sand in the folds and ruffles of their dresses, in their very fashionable leg-of-mutton sleeves, or in their shoes. And the wedge of foreground beach in this unusually long and narrow canvas is slightly larger than the wedge of water, subtly dominating the potentially more powerful element. The lapping water, made gentle in reality by the great reefs that protect Shinnecock Bay from the ocean, is further tempered in the painting by the intense yellow and red parasols that cut across it on the picture surface from sandy shore to distant horizon. The umbrellas and other splashes of brilliant warm reds in the garments of near and distant figures set up a vivid vibration in contrast to the cooler blues of the surroundings. The perfect site on the perfect radiant day is capped by a broad expanse of sky that fills the entire upper half of the canvas, with its few clouds echoing the bright white forms of the children's dresses.

Perhaps in none of Chase's Shinnecock paintings is one aspect of the artist's advice to his pupils more vividly demonstrated than in *At the Seaside*. "Try to paint the sky," he told them, "as if we could see through it, not as if it were a flat surface, or so hard that you could crack nuts against it."[89] In none of them did he so successfully display his assimilation of what he perceived to be the fundamentals of French Impressionism. "The school of the Impressionists has been an enormous influence upon almost every painter of this time," Chase once remarked. "The successful men like Monet succeede[d] in rendering a brilliant and almost dazzling impression of light and air."[90] And in none of them is what one observer believed was the characteristic quality of American light better captured: "Perhaps more than any other,

Chase was a representative American artist. In whose landscapes does one better get the tang and thinness and crispness of our air and the whitey brightness of our light?"[91] While it ultimately may be indebted to the coastal scenes of Boudin, *At the Seaside* represents the quintessential American remaking of the French proto-Impressionist and Impressionist aesthetic.

In a few Shinnecock landscapes Chase did record overcast skies, but nature is never threatening in them. Often constructed elements such as breakwaters are included to reinforce the notion of people's mastery over nature. Thus Chase's typical Shinnecock scenes offer so perfected an account of life at the seashore that they seem distillations rather than transcriptions of experience, despite their affiliation with Impressionist candor. So convinced were viewers of Chase's paintings that summer at Shinnecock was as he described it that they began to see the actual landscape as he had shown it. The Shinnecock Hills themselves were portrayed by writers exposed to Chase's work as picture-esque, rather than as "utterly barren and useless." "The advantage of living in such a place is that all an artist has to do is to take out his easel and set it up anywhere, and there in front of him is a lovely picture," wrote a visitor in 1893.[92] And the distinguished critic William Howe Downes, who was skeptical of Impressionism, maintained, "The scenes . . . pretend to nothing more complicated than free and happy descriptive pages which give forth an aroma of summer holidays in a most paintable region of dunes, breezes, wild flowers and blue seas."[93] The "swampy hollows" and "dark tussocks" had not disappeared; Chase simply had taught his audience to see them differently.

In the 1890s, then, the Shinnecock Hills supplanted the New York City parks as settings for Chase's interpretations of genteel leisure, and the paintings' private mood replaced a public one, as the artist began to depict his own family instead of mostly anonymous women. Analogously, Chase's Shinnecock house and studio constituted a summer, and more intimate, alternative and parallel to the Tenth Street studio in New York, which he had depicted throughout the 1880s. The New York studio had embodied the public persona of Chase as a self-inventing artistic personality, representing a reflection of his sophistication and cosmopolitanism and a quasi-public working place and exhibition gallery. Although he made its atmosphere artistic by installing hangings, bric-a-brac, and his own paintings, as he had in his New York studio, Chase's Shinnecock studio was still part of his house, just a short flight of stairs down from the main hall; it was much more private than public, much more likely than the Tenth Street studio to be frequented by wife, children, and only the closest friends. The Long Island house and studio provided many occasions for the depiction of leisure life in a quiet domestic context.

As Nicolai Cikovsky, Jr., has observed, the Shinnecock studio paintings are personal and modern in many ways. They include homages to Velázquez, "the ruling artistic presence at

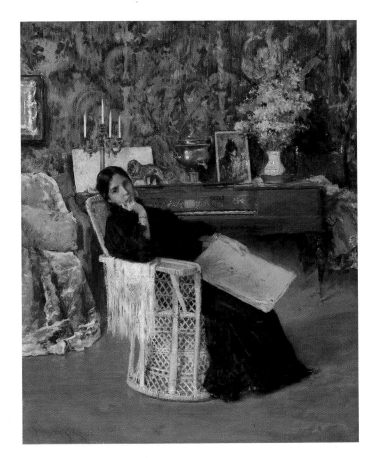

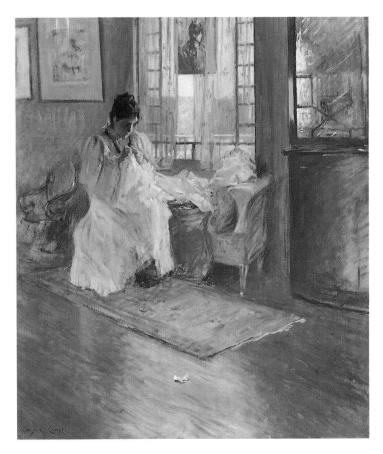

Fig. 103 William Merritt Chase. *In the Studio*, 1892.
Oil on canvas, 29 x 23 in. (73.7 x 58.4 cm). Collection of
Erving and Joyce Wolf

Fig. 104 William Merritt Chase. *For the Little One*,
ca. 1895. Oil on canvas, 40 x 35 ¼ in. (101.6 x 89.5 cm).
The Metropolitan Museum of Art, New York,
Amelia B. Lazarus Fund, by exchange, 1917 13.90

Shinnecock"[94] and the artist considered by Chase (and many
others of his generation and later ones) to be "of all the old
masters . . . the most modern."[95] A number of canvases, including
A Friendly Call (fig. 105), refer specifically for both subject and
arrangement to works by Alfred Stevens, the Belgian artist who
had counseled Chase to stop making his pictures look like those
of the old masters and to become instead a painter of modern
life. Several also suggest that Chase had distilled the most
up-to-date notions of the relationship between reality and depic-
tion, of what art might be in relation to nature, as well as the
most recent thinking about human appearance and interiority.[96]

The Shinnecock studio was a veritable retreat for Chase and
his family in comparison with the New York studio: the artist's
children are often present in images of the former but rarely
appear in portrayals of the latter. In *In the Studio* (fig. 103) and
For the Little One (fig. 104), where the setting is the hall of
the artist's Shinnecock house, Mrs. Chase, shown in moments of
reflection and introspection, in country garb, is accompanied
by a portrait of a woman, probably herself; the figure in each
portrait wears a city dress and hat, looks away and outward, and
thereby serves as a foil to the hermetic image of the seated
Mrs. Chase.

In *For the Little One* Chase sets the figure against a geometri-
cally patterned backdrop that recalls the backdrop that Manet
provided for his portrait of Emile Zola of 1868 (Musée d'Orsay,
Paris).[97] In conjunction with the modernist reference in *For the
Little One*, Chase included bits of the antique furniture that
appropriately filled the colonial-revival house. These furnishings,
which appear in other Shinnecock interior scenes as well, convey
what Duncan Phillips described as "the hint of once familiar
moments long forgotten, a sentiment of the quiet dignity of a
patrician home."[98] Thus, from the macrocosm of Southampton
—self-consciously the earliest English settlement in New York
State—to the microcosm of interior details of his house, Chase
at Shinnecock was associated with, and appears to have enjoyed,
a reconnection with American roots and an American context
with which he could conjoin French Impressionism.

Chase's wife and children seem so entirely at home in his
summer house and studio that they occasionally appear almost
interchangeable with the beautiful inanimate objects with
which the artist surrounded himself. In *A Friendly Call*, for
example, the frilly and luxurious fabrics that clothe the figures
(Mrs. Chase at the right and a visitor) and the rounded shapes of
their dresses, with puffy sleeves and pointed shoulders and hem

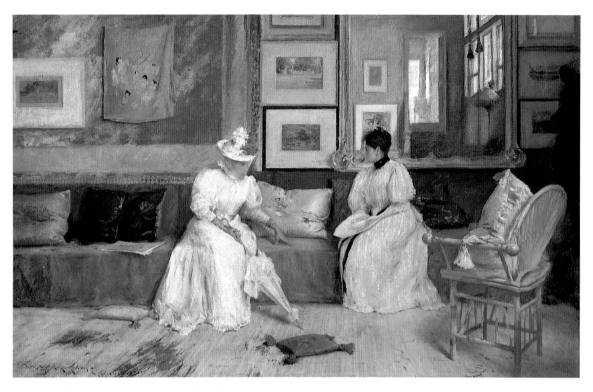

Fig. 105 William Merritt Chase. *A Friendly Call*, 1895. Oil on canvas, 30⅛ x 48¼ in. (76.5 x 122.6 cm). National Gallery of Art, Washington, D.C., Chester Dale Collection 1943.1.2

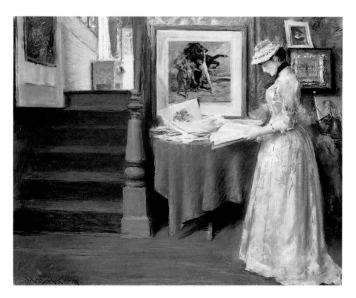

Fig. 106 William Merritt Chase. *In the Studio (Interior: Young Woman at a Table)*, ca. 1892–93. Pastel on paperboard, 22 x 28 in. (55.9 x 71.1 cm). Hirshhorn Museum and Sculpture Garden, Smithsonian Institution, Washington, D.C., Gift of Joseph H. Hirshhorn, 1966 66.878

corners, provide a curious analogy to the textiles and shapes of the cushions scattered on the sofa and floor. "Seated" in the chair to the right is a pillow that suggests a third human presence. Despite the charm of the painting's mood, composition, and color, it is no wonder that a contemporary critic complained about the minor role that the figures seem to play: "They count for almost less than the embroidered cushions and the tall mirror."[99] Like women depicted in numerous other late nineteenth-century paintings, these appear to be collectible objects of beauty, graceful, refined, decorative, and elegantly displayed. Chase as the collector and the arranger of such lovely objects is at times explicitly present in his works. For example, *Hall at Shinnecock* (fig. 36), a large-scale pastel, which shows his wife and daughters and pays homage to Velázquez, portrays the artist at his easel reflected in a mirror—this one on the door of a huge *kas*, a Dutch-inspired chest—in the background.

The predominance of females in Chase's Shinnecock interiors echoes the common association of women with artistic pursuits in the 1890s—an association verified by the predominance of women in Chase's classes—and the character of Shinnecock as a feminine venue. In the foreground of the large-scale pastel *In the Studio (Interior: Young Woman at a Table)* (fig. 106) a young woman pores over drawings in Chase's studio (with the hall seen up the stairs beyond). Chase includes an engraving of the then newsworthy *Automedon and the Horses of Achilles* by Henri Regnault on the studio wall, an image whose muscular figures of a man and horses emphasize by contrast the feminine pursuit of beauty and culture embodied in the young woman.[100]

The Realist Reaction

Why do we love the sea? . . . It is because it has some potent power to make us think things we like to think.

ROBERT HENRI (1923)

The gentility of Chase's Impressionist images of Shinnecock is magnified when they are compared with treatments of analogous subjects by turn-of-the-century Realists. Impressionist leisure generally is replaced by Realist recreation. The beach scenes are paradigmatic. In *At the Seaside*, for example, Chase showed graceful mothers and children isolated from male company and, therefore, from the working world, as well as isolated from any discomforts and dangers of nature. By contrast the urban Realists followed the masses to the beach to record the crowds, the mixing of sexes, and the more willing encounter of men, women, and children with sand and surf: after an arduous week of long hours in the shops and factories of the city, workingmen and workingwomen took weekend excursions to nearby beaches to release tension, to be refreshed by contact with nature, to play vigorously—sometimes even strenuously—and to pursue social relationships with members of the opposite sex.

The leader of the Realists, Robert Henri, first essayed beach imagery in the early 1890s, when he was briefly experimenting with the Impressionist aesthetic. Accordingly, such scenes as *Girl Seated by the Sea* (fig. 107), which Henri painted while he was teaching at Avalon, on the New Jersey shore, are good examples of the continuities between the American Impressionists and the Realists—continuities pursued to some degree well into the new century by some Realists. These paintings concentrate on the leisurely feminine detachment, contemplation, and interiority that Chase was recording at Shinnecock at the same time. For Henri exposure to and emulation of French and American Impressionism provided the foundation for an engagement with the inconsequential moments of modern life and for a commitment to a rapid and direct painting style.

When Henri rejected Impressionism in favor of a grittier Realism after the turn of the century, he portrayed seaside recreation from time to time. In these pictures he manifested a characteristic concern with energy rather than gentility. Henri's *At Far Rockaway* (fig. 108) records a diverse crowd on this popular beach, one of the Rockaways, which were an inexpensive ride away from Manhattan, Brooklyn, and the inland villages of Long Island and a world away from the more refined atmosphere of Chase's Shinnecock. Although the Rockaway peninsula attracted large numbers of visitors by 1830, even at midcentury only a few buildings—mostly fishermen's shacks—stood on its beaches. Following the establishment of steam railroad lines and ferry connections, the area underwent a remarkable period of building—countless hotels were opened, bathhouses were put up on the beaches, and public amusements became commonplace.[101] These innovations determined its character as a suburban resort, which is still very much in evidence in Henri's twentieth-century portrayal.

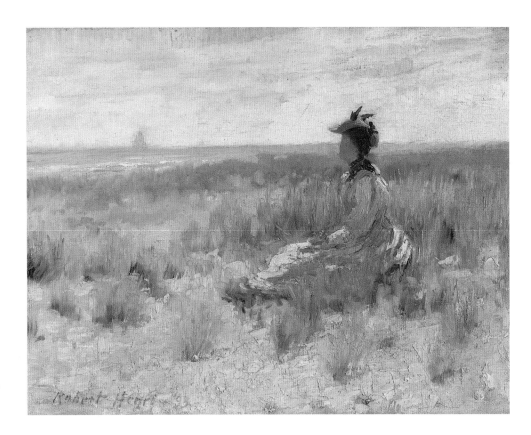

Fig. 107 Robert Henri. *Girl Seated by the Sea*, 1893. Oil on canvas, 18 x 24 in. (45.7 x 61 cm). Collection of Mr. and Mrs. Raymond J. Horowitz

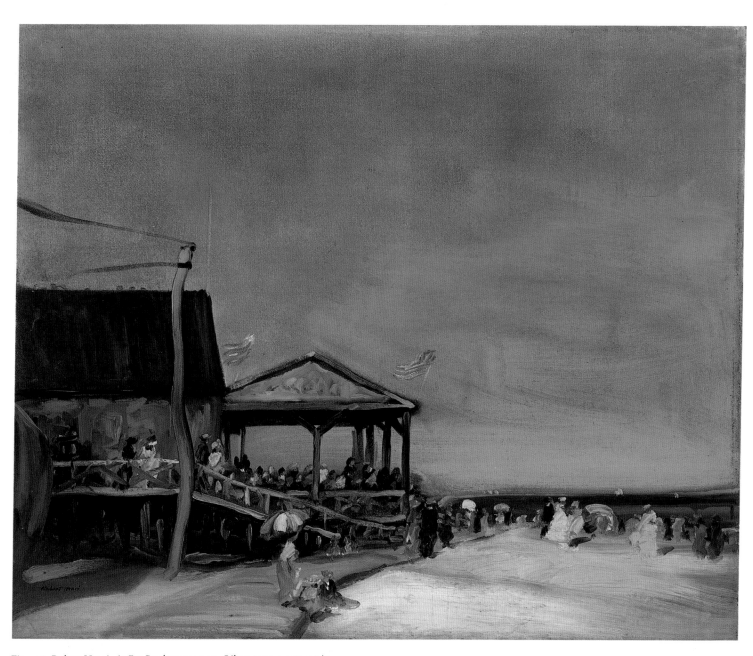

Fig. 108 Robert Henri. *At Far Rockaway*, 1902. Oil on canvas, 26 x 32 in.
(66 x 81.3 cm). Private collection

In Henri's depiction of Far Rockaway, the open vista of the beach and sky—a key feature in Chase's *At the Seaside*—is punctuated by boardwalks, pavilions, even a telephone pole that accentuate the transforming effect of man's presence at the water's edge. The suggestion of retreat that endowed Shinnecock and Chase's portrayals of the region with their special appeal is replaced by reminders of urban and technological developments. For the Realist artist and his models, suburban seaside resorts such as Far Rockaway offered brief respite from the grimmer aspects of the city, restorative interludes away from the vicissitudes of modern life rather than complete and lengthy escapes.

Henri's account suggests that Far Rockaway may be a place for relaxation and socializing but that it is certainly not conducive to contemplation. The painter made the day trip there on July 13, 1902, at the height of the summer season, and by the following day he had determined this composition in a sketch. He enumerated its contents in his diary: "blue sky. sun yellow pavilion . . . tel[ephone] pole brilliant colors of people on beach, walk and in pavilion. blue strip of sea."[102] The festive quality of this picture—the brightly colored pavilion, topped by a waving American flag, and a crowd of beachgoers gathered in the shade of umbrellas—recalls some of Monet's seaside scenes and suggests Henri's own answer to his rhetorical question "Why do we love the sea?," which was: "It is because it has some potent power to make us think things we like to think."[103]

Certainly, Far Rockaway as portrayed by Henri is far livelier than Shinnecock as portrayed by Chase, reflecting the fact that the former resort was easily accessible to crowds of excursionists. However, a contemporaneous literary description of adjacent Rockaway Beach and photographs of it (see fig. 109) suggest the measure of Henri's genteel euphemism in choosing and depicting this site. Howells wrote in 1902 that he had spent a Sunday afternoon in late July at Rockaway Beach four or five years earlier, finding that "swarms and heaps of people in all lolling and lying and wallowing shapes strew the beach, and the water is full of slopping and shouting and shrieking human creatures, clinging with bare white arms to the life-lines that run from the shore to the buoys. . . . It is not picturesque, or poetic, or dramatic; it is queer."[104]

John Sloan's *South Beach Bathers* (fig. 110) is more expressive than Henri's painting of the trespasses upon decorum that Howells perceived at a public beach, and it offers a more striking contrast to the genteel escapism of Chase's Shinnecock scenes. This emblematic example of early twentieth-century Realism captures the boisterous activity of working-class weekend visitors to a Staten Island beach. Although the setting is a dazzling seaside resort, Sloan has brought with him to the beach the earth tones and blacks that identify his city paintings and distinguish them from the candy-box images of the American Impressionists and those of the early Henri. Similarly, the development of forms

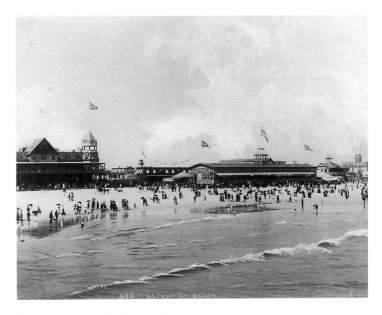

Fig. 109 Rockaway Beach, New York, 1905. Photograph: The New-York Historical Society

depends on coarse brushwork, in contrast to the lightness of touch that Chase as well as Henri employed for such scenes in the 1890s. These technical distinctions are matched by differences in subject choice and treatment that characterize this as a mature work of an American Realist rather than an Impressionist. Yet Sloan preserves the American Impressionists' interest in recording the pleasures of escape from everyday life in the city. Although his portrayal of seaside recreation is not genteel, it is no less genial than the images that Chase produced at Shinnecock.

At the right in Sloan's canvas a seated woman attends to the bathing costume of her impatient child. Her middle-class status is suggested by her white hat and dress, which preclude her from bathing and set her apart from the rowdier types who fill the picture. She is a reminder of gentility and a foil to the gathering of clumsy, uninhibited young men and women. Their attention—and that of others closer to the surf—turns to the standing girl—proportioned according to the taste of the time and prettier than the rest—who tucks her hair into her stylish hat, which echoes the hat of the middle-class mother. Sloan suggests the gentrification of this young woman, her emergence from the mass of seated and reclining figures, whose toes barely graze her form. The coarser workers, by contrast, let their hair down literally and figuratively. Juxtaposed at casual angles and dressed in skimpy bathing suits, they dry off after a dip in the water (the seated woman in the right-hand corner dries her hair on a towel spread over her shoulders). They touch and lean on one another, eat and smoke, and are indifferent to traditional decorum. The prominent hot dogs on buns to which the artist calls attention, even aside from their possible sexual symbolism, signify at the least a plebeian repast in accord with the painting's lively, raucous display of working-class recreation.

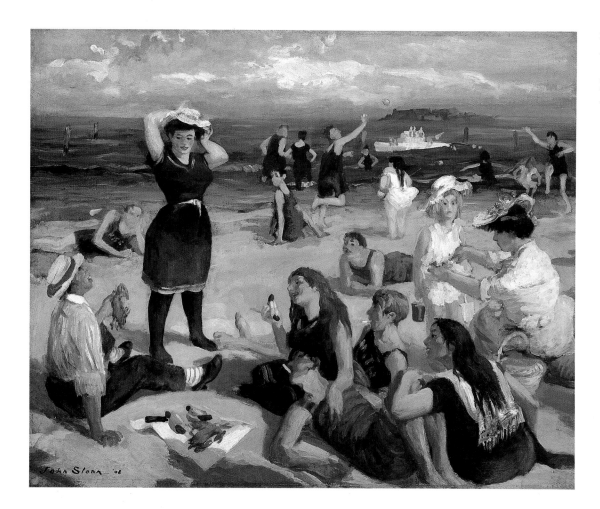

Fig. 110 John Sloan. *South Beach Bathers*, 1907–8. Oil on canvas, 26 x 31¾ in. (66 x 80.6 cm). Walker Art Center, Minneapolis, Gift of the T. B. Walker Foundation, Gilbert M. Walker Fund, 1948 48.27

William Glackens pursued seashore recreation as a subject far more often than Sloan did, beginning with visits to Coney Island between 1905 and 1907.[105] Sloan insisted on taking his urban palette to the seaside, but Glackens had begun to reject the dark tonalities associated with his emulation of Manet by about 1908 and to adopt the sweeter hues and feathery stroke of Pierre-Auguste Renoir. He spent summers working on Cape Cod—where he associated with Prendergast—in 1908, along the coast of Rhode Island and Nova Scotia in 1909 and 1910, at Bellport and Blue Point, on the shore of the Great South Bay of Long Island, from 1911 to 1916, and at Annisquam and Gloucester on Cape Ann in 1919. His seaside images combine Impressionist sweetness and light, sometimes pushed to a rather insistent, audacious, almost Fauve extreme of high color, with the ungraceful costumes and gestures of middle-class and working-class people at play.

The Bellport beach scenes are typical, recording crowds of bathers and picnickers along the shore of a modest village distinguished by the presence of the huge barnlike Vacation Home for the New York shopgirls whom Glackens often por-

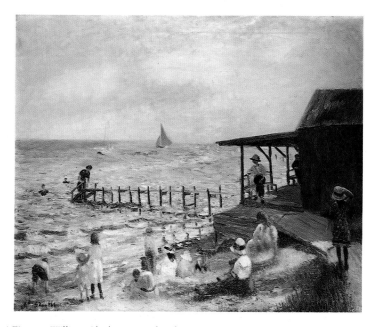

Fig. 111 William Glackens. *Beach Side*, ca. 1913. Oil on canvas, 26¼ x 32⅜ in. (66.7 x 82.2 cm). The Nelson-Atkins Museum of Art, Kansas City, Missouri, Bequest of Frances M. Logan 47–109

trayed in their dark bathing dresses. As Glackens recorded it in many works, such as *Beach Side* (fig. 111), this shoreline was punctuated by rickety gazebos, jetties, rafts and water slides, and dressing sheds and seems extremely commonplace in comparison with the elegant beaches that Boudin depicted at Deauville and Trouville or that Chase recorded at Shinnecock. The liveliness of his figures' poses and of his paint application is entirely consistent with the casual energy and spontaneous activity associated with the young people whom Glackens pictures.

Another stylistic and expressive hybrid was adopted by Edward Potthast. While retaining the high-key tonalities and chromatic palette of the American Impressionists, Potthast was much more willing than they were to portray common, clumsy subjects. His work also reflected other characteristics of American Impressionism and Realism as well as the influence of the popular Spanish painter Joaquin Sorolla, who depicted people at leisure along the Mediterranean coast. Beginning in 1910 Potthast began a large series of beach scenes featuring working-class crowds—and especially their children—at Coney Island and Rockaway Beach. One of his trademark subjects was a group of unsupervised children reveling in the surf. In *A Holiday* (fig. 112), for example, Chase's genteel, elegantly dressed mothers who had kept their pristine children and themselves safely away from the surf are supplanted by coarser women—probably single girls rather than mothers—in dark bathing dresses wading in the ocean and even swimming. Seven children, apparently about the same age and thus from different families, gather at the water's edge and provide a clue to the presence of a crowd onshore. Potthast's broad brushwork, bright colors, and loosely structured compositions seem altogether appropriate to the raucous recreation that provides him with his subjects.

Prendergast often portrayed seaside recreation from the time of his visits to the Channel coast at Dieppe when he was a student in Paris in the early 1890s. Returning to Boston in 1894, he began to depict Revere Beach in watercolors that concentrate on figures strolling on the beach in costumes and configurations that make their association with the seashore at first seem incidental. Except for the presence of water, jetties, and occasional sailboats in the backgrounds, the promenaders might as well be in Boston's Public Garden.

The genteel mood of Prendergast's watercolors of Revere Beach is consistent with the site's turn-of-the-century reputation as a beach resort that was a model because it was controlled by public rather than private interests. An observer of 1902 noted that Boston was exceptional among American cities because it contained seaside resorts within its metropolitan limits. However, he indicated that unrestricted private ownership of such resorts, including Revere Beach, had created overcrowding "in ways that now find their most glaring illustration at Coney Island." Such uncontrolled development had been remedied at

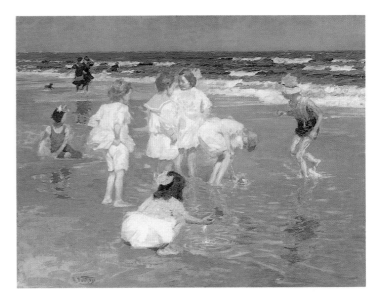

Fig. 112 Edward Potthast. *A Holiday*, 1915. Oil on canvas, 30½ x 40½ in. (77.5 x 102.9 cm). The Art Institute of Chicago, Friends of American Art Collection 1915.560

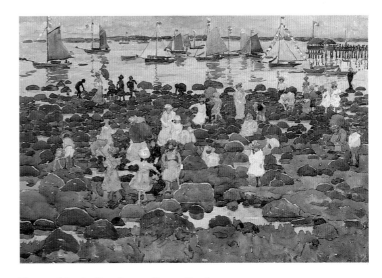

Fig. 113 Maurice Prendergast. *Revere Beach*, ca. 1896–97. Watercolor and pencil on paper, 13⅞ x 20 in. (35.2 x 50.8 cm). Collection of Canajoharie Library and Art Gallery, New York 317198

Revere Beach by the government's seizure of three miles of the shore under the right of eminent domain through a million-dollar municipal appropriation for redesign and development. The result was a new tone of restrained pleasure that prevailed despite the crowds—such as the eight thousand visitors who came in one summer day in 1901 to jam the area's shoreline, theaters, dance halls, amusement rides, and seventeen hundred bathhouse dressing rooms.[106]

Typical of Prendergast's painted distillations of such scenes is *Revere Beach* (fig. 113), a watercolor in which the multitudes who visited that spot are barely suggested. Prendergast shows

Fig. 114 Gloucester and Rockport, 1903, from Cape Ann Directory, 1903. Cape Ann Historical Association Collection, Gloucester, Massachusetts

Fig. 115 Fitz Hugh Lane. *Stage Fort Across Gloucester Harbor*, 1862. Oil on canvas, 38 x 60 in. (96.5 x 152.4 cm). The Metropolitan Museum of Art, New York, Purchase Rogers and Fletcher Funds, Erving and Joyce Wolf Fund, Raymond J. Horowitz Gift, Bequest of Richard De Wolfe Brixey, by exchange, and John Osgood and Elizabeth Amis Cameron Blanchard Memorial Fund, 1978 1978.203

only a handful of women and children who gingerly make their way over and among the boulders that fill the beach. The rounded shapes of the figures' dresses and hats and their undifferentiated faces mimic the forms and surfaces of the rocks, so that they literally seem to be one with nature. Prendergast later painted similar views along the beaches at Ogunquit, Maine, and Marblehead, Massachusetts, finding there seaside venues for leisure and recreation that corresponded to the Boston and New York parks that he often portrayed during the same years and that invited him to echo the American Impressionists' vision.

Gloucester: A Durable Magnet for American Painters of Modern Life

East Gloucester was never so full of artists, and is getting to be called the Brittany of America.

HELEN M. KNOWLTON (1890)

Gloucester bristles with palette knives, flutters with white umbrellas, as never before.

F. W. COBURN (1916)

The distinctive flavor of Gloucester (fig. 114), on the Cape Ann peninsula about forty miles north of Boston, is produced by its history and present status as a bustling old fishing town and

America's oldest commercial seaport. Here there are picturesque wooden houses and bungalows, warehouses, and shipyards bespeaking age and use, sailing ships associated with both work and recreation, handsome granite cliffs offering striking settings and prospects, steady ocean breezes, brilliant sunlight reflected from the sea and rarely compromised by fog, and the mingled scents of sea air, tar, and drying salted fish.[107] Gloucester's history extends back to the first decades of the seventeenth century and involves the presence of Samuel de Champlain and Captain John Smith in the harbor and the region of the cape. Men from Dorchester, England, and from the Plymouth Colony founded fishing outposts in the harbor in the 1620s and pursued abundant cod offshore. The center of their activity was named Gloucester and incorporated as a town in 1642.[108] The launching of the first schooner from Gloucester in 1713 presaged a boom in the village's fishing and shipbuilding industries, its wealth, and its engagement in worldwide trade. The Civil War and the postbellum growth of population and prosperity in America created greater demand for fish and further stimulated Gloucester's activity and success as a maritime center. In 1873 the town was incorporated as a city, and by 1900 Gloucester was deemed the "mistress of the field, the queen of the fishing industries in this country."[109] Celebrated by such poets as Henry Wadsworth Longfellow, Oliver Wendell Holmes, and even Rudyard Kipling, Gloucester became the quintessential New England fishing village in literature as it was in life. Second only to fishing, the granite business fed Gloucester's fortunes. High-grade granite, the dis-

tinctive geological substructure of the entire Cape Ann penin-
sula, added to the scene quarry derricks, faulted rock cliffs,
abandoned quarries, and special ships for transporting stone
from Rockport and Gloucester. All these changed the landscape
and formed peculiar features of the Cape Ann picturesque.[110]

Beginning in the 1840s the North Shore, which stretches along
the Atlantic Coast from Nahant and Swampscott up to and
including Cape Ann, became a summer home for wealthy and
prominent Bostonians who bought old farms and built large
"cottages" at Beverly Farms, Magnolia, Marblehead, and Man-
chester.[111] When middle-class families grew wealthier and trans-
portation improved in the decades after the Civil War, such
North Shore villages became summer suburbs of the city, with
businessmen going to Boston every morning and returning home
in the early afternoon. Although the region was remarked for
being free "from either democratic or plutocratic crowds," its
large tracts of land and imposing houses—which became more
formal in appearance and less cottagelike as the century pro-
gressed—were much more consistent with old family affluence
than with middle-class lifestyle.[112]

By contrast, after Gloucester was linked directly to the Boston
and Maine Railroad in 1847, Cape Ann began to outstrip the
lower portion of the North Shore in developing its tourist in-
dustry. Summer visitors soon filled hundreds of modest houses
and many new hotels. Accompanying tourists in search of re-
freshment and relaxation in an interesting and lively seaside
community were an unusual number of artists, who made Glouces-

ter one of the first and, ultimately, one of the best-known art
colonies in the United States.

Gloucester attracted American painters of many generations,
including some of special talent.[113] Among them were a native
son, Luminist Fitz Hugh Lane, who portrayed the town as early
as 1836 (see fig. 115) and returned as a permanent resident in
1847; visitors such as Kensett, Silva, Sanford Robinson Gifford,
Richards, and Whittredge, who found inspiration for landscapes
and seascapes there from the 1850s through the 1880s; Homer,
who stopped in Gloucester in 1871, had his first sustained
contact with the sea and experimented with watercolor there for
the first time in 1873, and brought the medium to a new level of
fresh expression when he visited again in 1880; and Hunt, who
in 1877 established a studio and school in Magnolia and at-
tracted pupils to Gloucester and the neighboring area, setting a
pattern for Frank Duveneck and several other successors.[114]

The very active Gloucester art colony and the villages in its
vicinity drew many turn-of-the-century artists with traditional
stylistic commitments. Such marine painters as Reginald Cleve-
land Coxe and academic realists, including Augustus W. Buhler,
had permanent studios there, were specifically dependent upon
Gloucester for their subjects, and would be closely identified
with the town and its art life.[115] It is usually their pictures that
offer the most literal records of the daily life of the community of
shipbuilders and fishermen at work—often in carefully com-
posed, occasionally dramatic tableaux—the most detailed ac-
counts of marine architecture and activity, the strongest echoes

Fig. 116 Winslow Homer. *A Basket of Clams*, 1873.
Watercolor on paper, 11½ x 9¾ in. (29.2 x 24.8 cm).
Private collection

of the tradition of Lane. Only they offer even the merest inkling of the extreme dangers of seafaring at Gloucester, with its treacherous waters, shoals, and ledges, where ten thousand fishermen from the town are said to have died at sea over three centuries.[116] By contrast the American Impressionists and Realists who came to Gloucester were for the most part occasional visitors, and they usually adopted a vocabulary of Gloucester elements to expand a more selective, more personal language, a language that was much more self-consciously artistic than transcriptive and one that certainly was antidramatic.

Dazzling maritime light and picturesque places and people made Cape Ann especially attractive to artists interested in outdoor work. During his visit to Gloucester in 1873, Homer had captured the sparkling summer sunlight in his first successful works in watercolor in a series of brilliant—if technically still restrained—scenes of children at play along the shores of the harbor (see fig. 116). By 1890 an artist-observer who remarked that "East Gloucester was never so full of artists, and is getting to be called the Brittany of America" could note a number of painting classes in the vicinity devoted to instruction and practice outdoors: Arthur Wesley Dow's landscape class in Ipswich;

Boston painter Joseph Rodefer DeCamp's class for Philadelphia women at Annisquam; etcher-painter Charles Herbert Woodbury's class in Swampscott; Rhoda Holmes Nicholls's class for a dozen aspiring pleinairists in East Gloucester; Duveneck's class in landscape and even out-of-door work from the model for Boston students; and the class of Monet's Giverny disciple Wendel, briefly taken over from Duveneck, which offered advice on how to capture the effects of light on outdoor color.[117]

Among the American Impressionists who spent summers in Gloucester were—in addition to Wendel—Hassam, Metcalf, Weir, and Twachtman (who died and was buried there in the summer of 1902).[118] All were drawn to Gloucester not only by the seaside town's extraordinary light but also by its traces of both older industry and more recent tourist and resort activity and by its embodiment of American, specifically New England, traditions and values in architecture, activities, and spirit. The Realists and their successors also came to the town. Prendergast, a frequent visitor to Gloucester and other North Shore locales during the first quarter of the twentieth century, may have suggested Cape Ann as an agreeable artistic venue to his New York friends Sloan, Glackens, Edward Hopper, and Stuart Davis. Although Gloucester is only thirty-seven miles north of Boston, its location on the Cape Ann peninsula prevented the rapid industrial growth that affected much of New England after the Civil War. Retaining a certain rural charm in comparison with many other New England sites, Gloucester rivaled more distant Provincetown as the principal art colony on the New England coast from the mid-nineteenth century through the earlier decades of the twentieth. And, although changes had occurred that made Gloucester's fishing industry less picturesque and technological incursions increasingly challenged native traditions, a reporter could still proclaim in 1916 that "Gloucester bristles with palette knives, flutters with white umbrellas, as never before."[119]

The character of Gloucester's citizens that was so appealing to the Impressionists was seen to have been conditioned fundamentally by their profound relationship to the forces of nature. Writing in *New England Magazine* in 1892, an observer noted: "Its people are democratic to the core, recognizing no caste or class, independent, with the sturdy self-reliance born of close companionship with the sea. . . . This living in the shadow of death breeds a race of strong women and brave and loyal men, relying upon their own strength and judgment and bending the knee to no ancient idol in politics, in religion, or in every day affairs."[120] This author's claim that the traits of Gloucester's populace were analogous to those of the archetypal American and his impulse to celebrate the history of such a characteristically American site on the 250th anniversary of its incorporation in a magazine devoted to New England reflect the cultural nationalism burgeoning in the United States in the 1890s. Echoes

of the desire to discover what was reassuring in the American past and to laud what was American in its present still were sounded clearly by writers after 1900.[121]

Retaining a few dwellings from the late seventeenth century and many from the eighteenth, Gloucester invited the visitor, vacationer and artist alike, to experience the flavor of New England before the American Revolution. Fine federal-period and Greek Revival residences and meetinghouses enriched the architectural fabric, which was further enhanced and varied by later structures that reflected the growing sophistication of nineteenth-century American architecture. By the 1880s Eastern Point, overlooking South East Harbor, rivaled Bar Harbor, Newport, and other fashionable resorts for wealthy vacationers. Yet contrasts abounded in the surrounding areas, all providing a plethora of paintable subjects. In Gloucester itself, the fleets of working fishing vessels and pleasure yachts of all kinds, as well as fishermen, net menders, and shipbuilders, were of interest, along with places and people involved in allied activities, such as rigging and ironworking. Across the harbor in East Gloucester fish-drying and -packing plants with vessels tied up alongside were prominent features. It was here and in adjacent Rocky Neck that most of the artists who worked in the Gloucester area actually stayed, in the Rockaway or the Harbor View hotels or in rented bungalows. There was also a long shoreline of rocks, coves, and beaches, as well as hills and ledges, offering diverse views of the harbor. Farther up on Cape Ann, Rockport, with only an eighth of the population of Gloucester and a more quaint port; Pigeon Cove, an adjacent granite-quarrying center; and Annisquam, an attractive village with an inland waterway and views of sand dunes and beaches, were among the many sites with appeal for artists.[122]

To vacationers, writers, and artists, Gloucester, like other New England villages, embodied ideals that were integral to the American character and psyche and that were resistant to the changes that industrialization was bringing. But even the visitors who were determined to have a glimpse of the earlier, simpler life themselves created changes. As Sarah Orne Jewett observed in the 1893 preface to her novel *Deephaven*, first published in 1877: "Small and old-fashioned towns [in New England] . . . were no longer almost self-subsistent. . . . many a mournful villager felt the anxiety that came with these years of change. Tradition and time-honored custom were to be swept away together by the irresistible current."[123]

Yet Gloucester seemed relatively resistant to the twentieth-century forces of change and even to the upheavals that tourism would create, perhaps because of the specific and peculiar character of the town's long association with seafaring and because fisheries and supporting industries continued to flourish here. By the turn of the century Gloucester's combination of healthy industry and growing resort activity was seen to reflect an ideal American vision. "Gloucester," said a writer in 1908, "is one of the most delightful playgrounds in existence, and we believe that that fact comes pretty near to determining its future. Still we think that work is always the best background for play, and is itself the most interesting thing in the world, and every true lover of Gloucester will hope to see industry and beauty develop hand in hand, as they always should."[124] Manifesting the dual energies of work and recreation and offering reassuring echoes of the American past, Gloucester would seem to have been a perfect venue for the turn-of-the-century American painters of modern life. The two generations of artists would seek out and highlight the aspects of the varied scene that suited their own expressive approaches—the Impressionists visiting only in the summers, when the fishing industry was least active, and subordinating or glamorizing the workaday world of Gloucester, and the Realists preferring to focus on fishing rather than fashion.

Metcalf's Gloucester paintings are typical Impressionist essays. Although Metcalf went to Giverny in 1885 and 1887—he was one of the first, if not the very first, of the Americans to go there—his commitment to Impressionism was not liberated until a summer visit to Gloucester in 1895. A brilliant announcement of his interest in Impressionist light, unconventional composition, and free paint application occurred at the Society of American Artists exhibition in March 1896, when he showed five paintings of Gloucester subjects from that summer sojourn. These were the first American landscapes he had executed since he had left the United States to study in Europe in 1883, and they demonstrate the Americanization of Impressionism by reference to New England scenery that would mark much of his subsequent work.[125]

The best known of Metcalf's Gloucester scenes is *Gloucester Harbor* (fig. 117), which won the Webb Prize in the 1896 Society of American Artists exhibition. The painting celebrates the glowing and peaceful panorama seen from East Gloucester: Smith's Cove lies just beyond the rooflines in the foreground; the tip of Rocky Neck with its bright red power-plant chimney appears at the left. A modern fishing schooner under full sail scuds along in the inner harbor. Smaller vessels with fewer rigged sails form a rough circle around it—along the farther shore, on either side of Rocky Neck, and at the end of the nearer jetty. Gloucester itself fills the horizon, with the landmark city-hall clock tower shown as the town's highest point. Although the vantage point is precipitous, the nearly square canvas offers an infinitely calm view of smooth sailing on clear waters, rendered with appropriately long, smooth strokes of bright blue paint. A picturesque wooden jetty and ferry slip direct the eye to the graceful sailing ships whose sheets repeat the vibrant forms of peaked roofs and clock tower and church steeples on the embracing land. The ferry itself floats miniaturized on the farther shore, its billowing smoke barely visible and certainly subordi-

Fig. 117 Willard Metcalf. *Gloucester Harbor*, 1895. Oil on canvas, 26 x 28¾ in.
(66 x 73 cm). Mead Art Museum, Amherst College, Massachusetts, Gift of
George D. Pratt, Class of 1893 P1932.16

nate to the grander forms of the sails. Gloucester's sailing ships, seen under full sail as here, or with their bare masts measuring the space of water and sky, were often the center of painters' attention, along with the town's old wooden houses and fishing shacks, all reassuring remnants of a peaceful and simple American past.

Homer's Gloucester watercolors, such as *A Basket of Clams* (fig. 116), tend to concentrate on small, meticulously composed, principally figural vignettes; by contrast Metcalf's *Gloucester Harbor*, like his other Gloucester scenes, exploits an Impressionist's broader prospect, capturing the dazzle of wide bands of high-key color. Echoes of works by his colleagues among the American Impressionists appear in Metcalf's composition and facture, which may owe a specific debt to Hassam. Indeed, Hassam claimed to have persuaded Metcalf to work in Gloucester in 1895, when he himself was there, and to adopt Impressionism that summer.[126]

One of the most peripatetic of the American Impressionists, Hassam had painted in Gloucester from time to time in the early 1890s, stopping there on his way to the Isles of Shoals; he was in Gloucester again during the summers of 1894 and 1895 and visited once more in 1899. His Gloucester works—oils, watercolors, and a series of lithographs executed in 1918—are varied in subject, including both fragments and panoramas of the town and harbor and figure studies of Gloucester types. Among his oils *Gloucester Harbor* (fig. 118) is one of the most ambitious. Hassam recalls the format of Metcalf's image but shifts his vantage point to the west so that Rocky Neck fills the entire middle ground as we look from East Gloucester over Smith's Cove and the inner harbor toward the main town.[127] The result is an emblematic view, a three-layered panorama: Gloucester proper in the distance with its distinctive city-hall clock tower dominating the skyline and the spire of the First Baptist Church to its right; the Rocky Neck peninsula with the red chimney of the Marine Railways power plant in the middle distance; and, in the foreground, the houses along East Main Street. Smith's Cove is punctuated by bright moored pleasure craft that mark off the progression from the foreground to the distance. The boats' masts, the power-plant chimney, and the city-hall clock tower are like musical notes on the three staffs of land and suggest a perfect harmony of natural and man-made elements. The image speaks of activity and prosperity, but Hassam makes no pictorial mention of any disruptive elements. He features sailing pleasure craft rather than working schooners or steamboats and edits out the power and trolley lines that are recorded along East Main Street in contemporary photographs.

An even more evanescent vision emerges in Twachtman's *Gloucester Harbor* (fig. 119), which was probably painted during 1900, the year of the first of the artist's three documented summers in Gloucester.[128] His early biographer, Eliot Clark, explained

the basis for Twachtman's attraction to this town, where so many of his friends had already spent summers painting: "Harbours and shipping seem always to have held a vague fascination for the painter who enjoyed the pictorial suggestiveness of wharves, water, and their infinite possibilities for artistic arrangement."[129] These features notwithstanding, Twachtman's interest in Gloucester's specific motifs appears to have been fickle, and the majority of the canvases he painted there seem unfinished. Those that are most resolved combine the dash and bravura of his student paintings executed in Munich in the mid-1870s—some of which are of marine subjects—with the high-key palette of his more recent Connecticut landscapes. *Gloucester Harbor*, condensing essential elements of the town—water, sails, houses, docks, and the city-hall clock tower—is one of the most satisfying and complete images from the final episode of the artist's career.

From a vantage point near the one that Metcalf had used, Twachtman constructed a scene of the type that Clark described as the artist's most successful Gloucester compositions: "the motives looking down on the harbor from the hills of East Gloucester, where the fish houses and wharves jutting into the water and the distant city form an effective background for the rocky pastures and patterned trees of the nearer plane."[130]

Here Twachtman subsumes details of the working life of Gloucester—derricks along the edge of the water, a ferry approaching the long slip—into a subtle, pastel-colored, high-key atmosphere. Strong Japanese-inspired diagonals accord with a delicate Whistlerian calligraphy. Man-made elements such as the long pier that bisects the space and surface seem as lacy and fragile as the slender tree trunks on the foreground plane and other natural forms. Only the most evanescent creatures could populate this space; rugged fishermen or shipbuilders—or even boys at play, if they were depicted with Homer's literalism—would seem bizarre inhabitants in this Gloucester.

These images by Metcalf, Hassam, and Twachtman provide a striking foil to the vision that Sloan brought to his depiction of *Gloucester Harbor* (fig. 120). Sloan spent the five summers from 1914 to 1918 at Gloucester, renewing a commitment to landscape that he had expressed in paintings of the Pennsylvania and New Jersey countryside in 1906 and 1908. His stated intention in coming to Gloucester was formal experiment. He wished to pursue challenges suggested in Hardesty Maratta's system of architectonic structure and abstract color relationships, which had begun to preoccupy him in 1909. He was also eager to respond to modernist works he had seen in the Armory Show of 1913, an exposure that intensified his concern with the formal elements of painting. In the paintings of Cézanne, van Gogh, and Braque, for example, he said that he saw "that landscape could be a magnificent source of exciting subject matter," while offering him the chance to investigate color, texture, and composition.[131]

Fig. 118 Childe Hassam. *Gloucester Harbor*, 1899. Oil on canvas, 25 x 26 in. (63.5 x 66 cm). Norton Gallery of Art, West Palm Beach 53.77

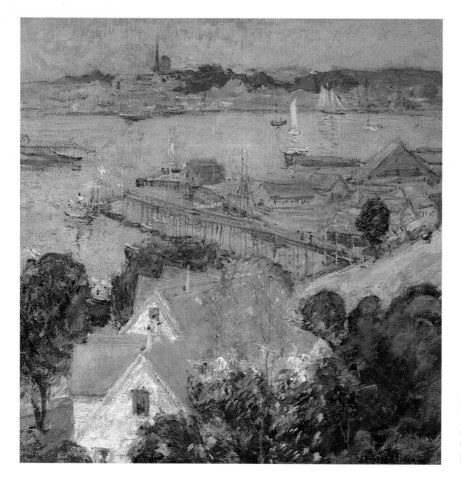

Fig. 119 John H. Twachtman. *Gloucester Harbor*, ca. 1900. Oil on canvas, 25 x 25 in. (63.5 x 63.5 cm). Canajoharie Library and Art Gallery, New York 317235

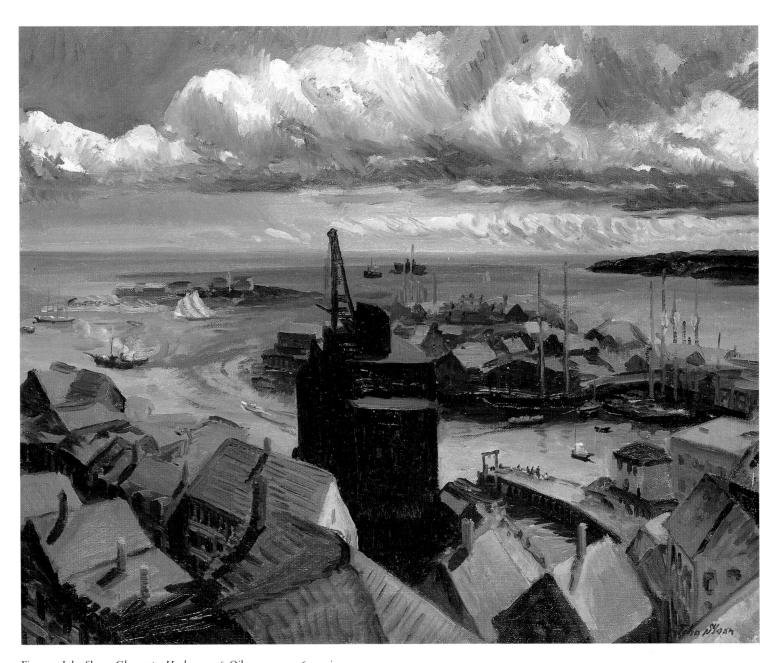

Fig. 120 John Sloan. *Gloucester Harbor*, 1916. Oil on canvas, 26 x 32 in. (66 x 81.3 cm). Syracuse University Art Collection, New York S.U. 62.61

Despite his focus on formalism at Gloucester, Sloan was not immune to the resonance of the place. The town, he said, was "one of the odd corners of America, built against a Puritan landscape, blue-eyed and rocky."[132] The chance to carry out his experiments in the invigorating out-of-doors, the redolent artistic heritage of Gloucester itself, the presence of his family and of artist friends such as Charles Winter and the young Stuart Davis, were all tonic to Sloan. Sloan would produce about three hundred landscapes, seascapes, genre scenes, and portraits at Gloucester. Many of these were realized with a limited palette based on a particular predetermined color sequence, apparently in response to an overriding desire to pose and resolve formal problems and often in specific emulation of Post Impressionist or proto-Cubist compositions. Yet, despite that strong new agenda, Sloan made his expressive choices within the framework of the Realist aesthetic; while temporarily abandoning urban subjects in favor of themes drawn from a place where the American Impressionists had flourished, he would continue to view the world without the rose-colored glasses that those same American Impressionists had worn and would filter aspects of the Gloucester scene through his customary urban Realist vision.

Sloan's radical perspective and general compositional arrangement in *Gloucester Harbor* recall the choices of Metcalf, Hassam, and Twachtman; however, Sloan's view is from Gloucester itself, rather than from East Gloucester, where he had rented a cottage for his family and where he usually painted. The windswept waterfront scene is industrial, punctuated by cranes and wharves, rather than poetic. The identity of several of the land masses is elusive, as Sloan was often willing to shift, enlarge, and readjust forms in order to strengthen a composition in this period of formal experiment. This practice is confirmed by comparing many of his painted images with period photographs. Indeed, Sloan advised: "Don't walk miles looking for a subject. Look down the road and use your imagination."[133] For some paintings imagination could play as great a role as looking, and although he painted on the spot in Gloucester—in contrast to New York, where he often painted from memory—the spot is sometimes difficult to identify.

Sloan's distant view appears to open up to the broad Gloucester Harbor, not to the inner harbor, which the Impressionists had chosen. The prospect is not limited by the strong horizontal bar of Gloucester itself that closes and calms the Impressionists' views. The Impressionists' bright skies give way to a heavy canopy of turbulent clouds in Sloan's painting. Although a few sloops sail along in brisk winds, others are banished to their moorings, and the dark silhouetted crane that interrupts the horizon is a jarring note. Foreground foliage, which softens the picturesque man-made forms, and the glowing chromatic rooftops in the Impressionist canvases become a clutter of strong, architectonic, slightly ominous shapes rendered in heavy pig-

ment that are reminiscent of Cézanne and proto-Cubist painting. The emanation of summer sunlight that pervades the Impressionist scenes yields to the more powerful glow of late afternoon, in which the low sun casts strong shadows, increases the fracturing of surface planes, and invests the color shapes with a brilliance that approaches Fauvist intensity. What is calm, broad, and brilliant in the Impressionist works is replaced by twisting clusters of rooftops and the swirls of turbulent sea and clouds; what is inviting is converted to the prosaic and unbeautiful. Sloan's view stands apart not only from the essays of the Impressionists but also from those of their more traditional contemporaries: the antidramatic workaday subject distinguishes his bit of Gloucester townscape from the encounters with picturesque Gloucester that more academic artists of his time preferred. There is little that is picturesque about this gritty view of the town.

By the turn of the century the dependence of Gloucester fishermen on sailing vessels had begun to diminish. In the spring of 1900, in fact, the first power-assisted fishing vessel was put into use at Gloucester, and it became immensely profitable. By the time Sloan summered there, sails were as likely to signify leisure or the fishing industry's romantic past as industry. Although schooners continued to be used, more efficient ships, ultimately powered by gasoline rather than coal-generated steam, would revolutionize long-distance fishing by the 1920s. At the same time these advances were taking place in the fishing industry, technology was altering the appearance and activity of the town. Even as early as 1901 a writer would observe of Gloucester: "Anything less like a fishing hamlet than the Gloucester of to-day could not be conceived. A city of paved streets, electric cars, free postal collection and delivery, electric lights, and the telephone, and that last mark of commercial greatness, a foreign population and consequent social problems—that is the Gloucester of to-day."[134] These changes became more and more noticeable as the century unfolded.

Sloan's *Gloucester Trolley* (fig. 121) is an animated portrayal of a street scene with a crowd of figures, signifying the new twentieth-century Gloucester. It is an unusual example of the artist's urban vision brought to Gloucester, where he much more often pursued landscape subjects. The setting is East Main Street in East Gloucester at the corner of Rocky Neck Avenue. Sloan's own rented cottage appears at the left. In the foreground his wife, Dolly, waves over her shoulder as she rushes to join the crowd boarding the trolley. The trolley itself is anthropomorphized in the manner of Charles Burchfield and is embraced by the yawning brackets of the tracks below and the telegraph lines above. These forms open at center stage like a giant gaping clamshell, pushing forward toward the viewer and outward against the old cottages that line the street, suggesting almost diagrammatically the effect of advancing technology. Although the unqualified sweetness and light of an Impressionist image is

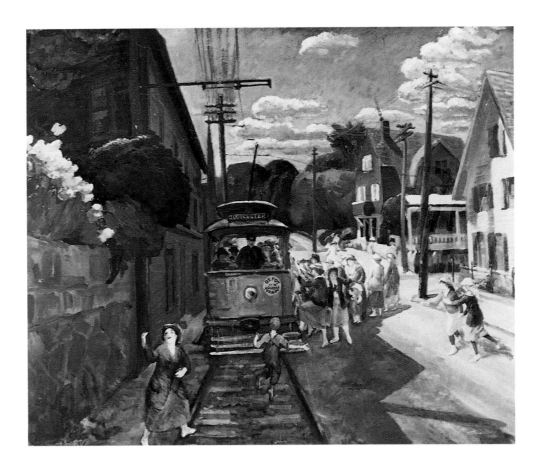

Fig. 121 John Sloan. *Gloucester Trolley*, 1917. Oil on canvas, 26 x 32 in. (66 x 81.3 cm). Canajoharie Library and Art Gallery, New York 317224

absent, Sloan's Toonerville Trolley of Gloucester offers a comforting, cheerful, even humorous commentary on the intrusions of the modern upon the traditional.

Increasingly the realities of the twentieth century infringed upon the picturesque traditions that Gloucester had embodied; the potential for romantic or even euphemistic impressions of the town—in either print or paint—diminished. The commentator of 1901 who remarked upon the new, up-to-date, polyglot Gloucester also observed in her article: "The story-writer whose theme is the fisherman and his environment must not select a coast encircled by an electric car, lighted by electricity, having churches of every denomination and isms of the newest."[135] But remnants of the old traditions were still present in Gloucester, and they provided reassurance and inspiration to those who preferred to ignore unpleasant or unpicturesque facts of modern life.

Having celebrated the recreational features of Gloucester's harbor during the 1890s, Hassam turned his back on the waterfront in the second decade of the new century and found another subject of interest in the town's Universalist Meeting House. Painted a year after Sloan's *Gloucester Trolley*, Hassam's *Church at Gloucester* (fig. 122) excludes both the recreational and the industrial components that characterized the town.[136] It focuses hermetically on the facade of the church itself, locking out people, activity, any expanse of sky, all peripheral elements except an avenue of elms enframing the structure. The painting

thus presents a graphic and timeless icon—both architectural and horticultural—that embodies Gloucester's third identifying feature, its strong resonances of the American past.[137] Here, just as in his views of Appledore Island, detached from the new realities of urban life, Hassam paints a comforting image associated with the bedrock of New England.

From 1900 to 1918 Hassam had spent summers in many New England resorts, including Provincetown, Newport, Old Lyme, Cos Cob, and Gloucester. Among his finest works are images of the churches that were landmarks of these colonial towns: *The Church at Provincetown* of 1900 (Canajoharie Library and Art Gallery, Canajoharie, New York) and the elm-bedecked *Church at Old Lyme, Connecticut* of 1905 (Albright-Knox Art Gallery, Buffalo, New York), for example. These paintings could be construed simply as American counterparts of Monet's Rouen Cathedral facades, as if Hassam were merely searching for an analogous motif—a church to substitute for a church. But it is much likelier that the artist had a more nationalistic, even patriotic agenda for these paintings, an agenda that the Universalist Meeting House at Gloucester served particularly well.

Hassam painted *The Church at Gloucester* during the summer of 1918. Among the last of his church pictures, it follows immediately upon his flag series and, like that sequence, coincides with tensions associated with World War I, which the United States had entered in April 1917. During the summer of

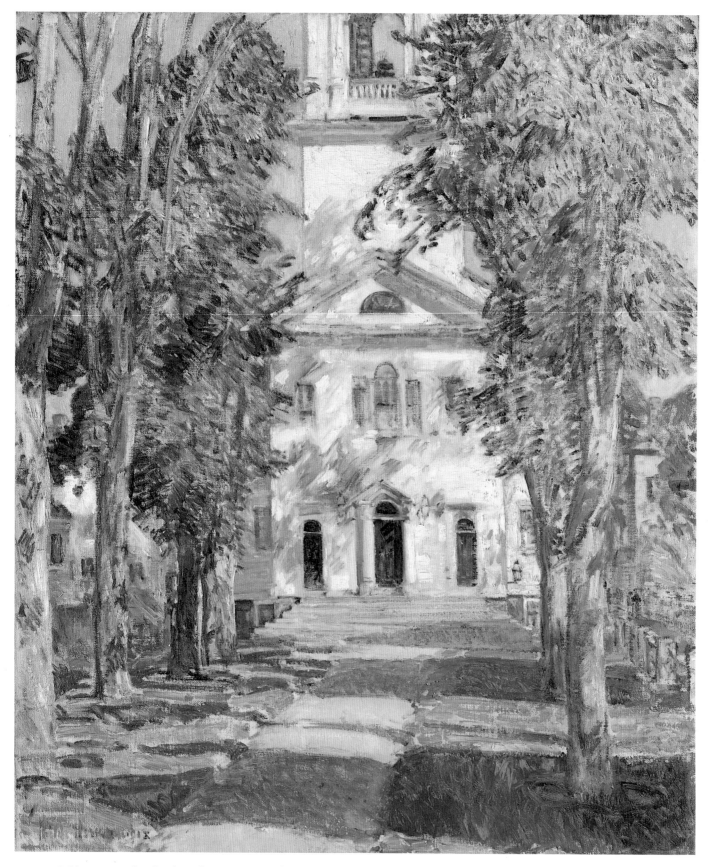

Fig. 122 Childe Hassam. *The Church at Gloucester*, 1918. Oil on canvas,
30 x 25 in. (76.2 x 63.5 cm). The Metropolitan Museum of Art, New York,
Arthur Hoppock Hearn Fund, 1925 25.206

Fig. 123 Independent Christian Church, Gloucester, Massachusetts, 1905. Photograph: Cape Ann Historical Association Collection, Gloucester, Massachusetts

1918 the *Gloucester Daily Times* reported with rage that German U-boats were sinking fishing schooners off the coast of the United States. The war was much on the minds of Gloucester residents and artists. People gathered in the principal East Gloucester gallery, the Gallery-on-the-Moors on Ledge Road, to prepare surgical dressings, and exhibition proceeds were sent to aid wounded French artists. As in the preceding summer, many special events dedicated to war relief were held in the artistic community.[138] The armistice would not be signed until November 11, 1918. Like the flag paintings, *The Church at Gloucester*—as well as the related lithographs that Hassam showed at the Gallery-on-the-Moors in August 1918—probably reflects the mood of American resolve and pride that the war provoked and also Hassam's own pride in his American heritage.

The Universalist Meeting House that Hassam depicted housed America's first Universalist congregation. This congregation was established at Gloucester—"the Mecca or Epworth of Universalism" and an important seat of liberal religion—in 1779 and was associated with early struggles for religious rights in the federal period and with the granting of religious freedom to all denomi-

nations.[139] The church in Hassam's painting was dedicated in 1806 and replaced a simpler meetinghouse. The federal-style building, constructed in clapboard over a brick basement, was designed by Col. Jacob Smith, an early nineteenth-century Cape Ann builder of some repute, who was responsible for other important structures on the cape. Hailed as one of Cape Ann's finest churches, it was also celebrated for its bell, cast at the Paul Revere foundry.

Characteristically, Hassam chose a church that was associated with the foundations of New England, a symbol of the Anglo-Saxon New England tradition and of his own heritage, a church of the sort he had admired since his boyhood in Dorchester, Massachusetts.[140] In this way he defied the new immigrant populations of the town or at least ignored their churches: the large and handsome stone church, rectory, library, and school and several smaller churches of the Irish and the Church of Our Lady of Good Voyage built with a thirty-two-bell carillon by the Portuguese in their own section of Gloucester at the turn of the century. In calling attention to a federal-period landmark, Hassam was also echoing the activity of turn-of-the-century architects and designers who worked in the colonial-revival style or other idioms that evoked early modes that were considered purely American in order to provide archetypal images of this country to immigrant populations and thereby to Americanize them.[141]

Hassam's compositional choices and his editing of reality support the hypothesis that he was pursuing a thoroughly purified traditional American image. In the painting—and in a 1918 lithograph of the same building—Hassam is careful to enframe the facade with branches of the avenue of elms that lined the gravel path to the church. These symmetrical elements bracket and aggrandize the facade and require from the viewer a formal, frontal encounter with it unlike the oblique encounters that Monet dictated in his paintings of Rouen Cathedral. This insistent frontality is particularly apparent in the painting, in which the artist not only closely frames the sides of the building with branches but also crops the upper levels of the spire, allowing the viewer neither lateral nor vertical exit from study of the facade's main components. Moreover, in both the painting and the lithograph, Hassam alters the only jarring aspect of the church—its disproportionately tall spire (fig. 123)—by reducing the blind story that Smith inserted between the gable and the belfry. The defects of Smith's design would certainly have been visible from Hassam's vantage point, but he perfected that design to create a structure that is a paradigm of traditional American values and of the American scene. Coinciding in date with rising cultural nationalism—with a self-conscious pursuit and celebration of the best of the American past—Hassam's painting, like the church itself, functions as an icon of enduring American values and the American scene.

THE CITY

The Urban Scene

The idea was to take away the partition separating the studio from everyday life.

EDMOND DURANTY (1876)

I believe the man who will go down to posterity is the man who paints his own time and the scenes of every-day life around him.

CHILDE HASSAM (1892)

You can learn more in painting one street scene than in six months' work in an atelier.

GEORGE BELLOWS (1917)

When the twenty-three-year-old American expatriate John Singer Sargent painted *In the Luxembourg Gardens* (fig. 125) in Paris in 1879, he declared his participation in the new Impressionist movement in French painting. For his rapid stroke, brilliant palette, and interest in casual urban incident he took for his model Claude Monet, with whom he had begun a lifelong friendship in 1876, and Monet's associates Edouard Manet, Edgar Degas, Pierre-Auguste Renoir, and Gustave Caillebotte.

The French Impressionists, and such Americans as Sargent who were nourished by their example, were committed to the depiction of modern life. No subjects more vividly announced this commitment than those originating in the modern city. The creation of great cities was, after all, one of the epochal developments of the nineteenth century, defining the modern era. A commentator of 1887 summarized the phenomenon: "We live in the age of great cities. It began to be so named nearly half a century ago, and every year since then has added fitness to the title. For size, for number, and for influence, the cities of our time have never been approached."[1] Painters of modern life responded to the extraordinary changes that accompanied the rise of cities with portrayals of urban vignettes. By contrast with earlier images of cities, which are for the most part comprehensive panoramas that resemble vertical maps, their paintings capture not only the architecture of cities but also their urban energy and enlist modern styles to express modern dynamism.

To many in the new era raw nature was of little interest. Such writers as Edmond and Jules de Goncourt, for example, could observe in their journal in 1856, with respect to the city and the demise of landscape painting: "Everything is man-made here, except for a sorry tree growing out of a crack in the pavement — and these ugly walls speak to me as nature never does. The modern generations are too civilized, too advanced, too spoiled, too learned, and too drawn to the artificial to be happy with a little green and blue."[2] To ignore untouched nature and to portray instead the urban scene was to become the quintessential

Detail, fig. 139

artist-*flâneur*, the impartial Baudelairean observer of contemporary life. The interpreter of the urban scene would inevitably fulfill the prescription for the new painting dictated by Edmond Duranty in his important review of the second Impressionist exhibition in 1876: "It was necessary to make the painter leave his skylighted cell, his cloister . . . and to bring him out among men, into the world. The idea was to take away the partition separating the studio from everyday life. We need the particular note of the modern individual, in his clothing, in the midst of his social habits, at home or in the street."[3]

Paris especially, as transformed by Napoleon III under the direction of Baron Georges-Eugène Haussmann,[4] was inextricably tied to the growth of modern styles in painting: its streets, expositions, cafés, restaurants, and theaters are the subjects of the Impressionists' paintings, as Robert L. Herbert has argued.[5] Also among the paradigms of the new look and spirit of Paris to which the Impressionists attended were its parks, which, like parks elsewhere, represented a modern concept, for they were a response to unprecedented urban overcrowding and differed in principle from traditional lavish private, often monarchical, gardens.[6] As Herbert has noted, the revolution of 1848 brought about an exponential increase in the area allocated to parks in Paris, from 47 acres in 1848 to 4,500 acres in 1870. This increase resulted both from the transfer of such private parks as the Luxembourg Gardens to public ownership and the creation and redesign of parks, squares, and gardens. In choosing the Luxembourg Gardens as a subject, Sargent must have known of the Impressionists' many views and vignettes of Parisian parks;[7] he must also, more specifically, have been aware of prevailing interest in the gardens, whose administration was turned over to the Senate of France by a law passed in 1879,[8] the very year he produced the painting.

Sargent appears to have created *In the Luxembourg Gardens* as a Parisian pendant to his first major genre painting, *The Oyster Gatherers of Cancale* (fig. 124)—an investigation of picturesque peasant imagery showing a group of graceful women and children proceeding along a beach in Brittany. In contrast to the sparkling high noon that he captured at Cancale, Sargent records twilight in the park scene with an extraordinary opalescent grayed-lavender palette, reminiscent of the color schemes in James McNeill Whistler's nocturnes and harmonies. The season, as at Cancale, is summer, as evidenced by the attire of the strollers and by the afterglow in the sky—typical of the long evenings of that time of year in the northern latitudes. The moon's reflection glints off the surface of the water in the basin to the right, setting up a dazzling monochromatic foil to the mass of colorful flowers and figures in the left background. The mood is so evanescent, the touches of brilliant color so intense against the even, diffused light of the background, that forms almost seem to float.

Fig. 124 John Singer Sargent. *The Oyster Gatherers of Cancale*, 1878. Oil on canvas, 31⅛ x 48½ in. (79.1 x 123.2 cm). The Corcoran Gallery of Art, Washington, D.C., Museum Purchase, Gallery Fund 17.2

In *The Oyster Gatherers of Cancale* Sargent had joined his painterly, antiacademic style to a conventional frieze of figures set at center stage. Departing further from Beaux-Arts rules in the parkscape, he chooses an asymmetrical arrangement. A broad stretch of gravel walk in the Luxembourg Gardens fills the lower quarter of the canvas, providing a sweeping introduction to a young man and woman who stroll toward the left, her arm linked through his. Rather than unfamiliar peasants, these are the kind of urbanites well known to painters and their audience, an apparently middle-class couple whose presence alerts us to the fact that the gardens had been "the favorite promenade of the entire faubourg Saint-Germain" since they were opened to the public.[9] Walking slowly, the young man is the consummate *flâneur*. Attired in a dark suit, he holds a stylish straw boater, which suggests that he is at the end of an afternoon's excursion. His sophisticated mien is confirmed by his cigarette, a commodity increasingly fashionable from the mid-1850s onward and available in manufactured form beginning in the mid-1860s; that he would smoke in mixed company, and in public, reflects the couple's youth and daring. The glow of the cigarette also establishes this stroller's importance for the narrative of the painting, providing a vivid accent to the subdued atmosphere and participating in the counterpoint of red touches in the background and in his companion's red and pale violet fan. The fan, a ubiquitous ladies' accessory of the period, accents a costume that, like the man's, is completely up-to-date: a walking dress of narrow silhouette with a short, low train that the wearer gathers over her left arm, a high neck, and an unusual belt, and completed by a veiled straw hat appropriate for a summer outing. The gentleman is more responsive to the scene than to his companion; she reciprocates his inattentiveness and seems to meditate more on her surroundings than on him.

Fig. 125 John Singer Sargent. *In the Luxembourg Gardens*, 1879. Oil on canvas,
25 ½ x 36 in. (64.8 x 91.4 cm). Philadelphia Museum of Art, The John G.
Johnson Collection J.C. 1080

In the parks of Paris, and in this painting by Sargent of one of them, the constructed prevails in the late nineteenth-century dialogue between nature and the constructed, and contact with the out-of-doors is mediated by the parkmakers. At Cancale, as Sargent shows, peasants experience nature directly: barefoot children and women in shabby clothes are embraced by nature; their figures coincide with the sandy beach; the sea washes over their feet and into their sabots; the breeze rustles their hair and headkerchiefs. By contrast, in the Luxembourg Gardens and in Sargent's portrayal of it, nature is controlled, dominated by stone and concrete; more sophisticated people experience it from artificial vantage points invented by the parkmakers.

The Luxembourg Gardens offered the most extensive green open space on the Left Bank of Paris, but Sargent's emphasis is on its architectural rather than its natural aspects. This emphasis reflects the radical redesign of the gardens carried out in 1866,[10] as well as the recognition that the venue was dominated by the constructed rather than by the natural, as it had been before its reconfiguration, and that it was now more conspicuously French than ever (see fig. 126). A British guidebook writer of 1869 noted that the site had been transformed from "an irregular sort of English garden" to a more geometric and orderly arrangement in the tradition of the seventeenth-century French artificial garden best exemplified at Versailles. He also remarked that even among geometric French gardens, the new Luxembourg was unusual for the degree of elaboration of its architecture and art.[11]

Although the glimpse Sargent provides of the Luxembourg Gardens is suggestive rather than topographical, he captures some of its most distinctive attributes. We stand with the artist on a sweeping parterre, looking toward the rising moon in the east.[12] A corner of the large octagonal basin located near the crossing of the park's major axes appears at the right. Well-behaved children gather to sail miniature boats on its surface, and a few figures are seated decorously along its rim. Near them is a man who stands, unengaged with his surroundings, reading a newspaper. An urn filled with red flowers and set on a huge pedestal towers at the left of the composition; it is echoed at the right by an anonymous sixteenth-century statue of David that rests on a tall column in the midst of a hemicycle of lawn. At the edge of the parterre, beyond the basin and the urn, trees growing in wooden boxes alternate with statues of queens of France and other illustrious women.[13] Sloping lawns rise beyond the parterres and terminate at a stone balustrade punctuated at brief intervals by urns and statues.

Sargent also indicates one of the most important elements of the Luxembourg's double-terrace design, the upper promenade behind the balustrade, which is reached by the stairway that appears to the right, just behind the hemicycle of lawn. The most extensive and the most natural areas of the gardens lie beyond the upper terrace. Thus Sargent concentrates on the complex

Fig. 126 *Les Parterres*, from Gustave Hirschfeld, *Le Palais du Luxembourg: Le Petit-Luxembourg— Le Jardin* (Paris, 1931), p. 131

sequence of architectural and sculptural forms and ignores the woods and the grassy rose-covered banks beyond the upper terrace that recall the Luxembourg before its renovation, when it still resembled an English garden. As in the modern city itself, the dialogue between nature and the artificial in Sargent's painting is dominated by the artificial.

Where Nature Leaves Off and Art Begins: William Merritt Chase in New York's New Parks

[Chase] is, as it were, a wonderful human camera—a seeing machine.

KENYON COX (1889)

There are charming bits in Central Park and Prospect Park, Brooklyn. . . . When I have found the spot I like, I set up my easel, and paint the picture on the spot.

WILLIAM MERRITT CHASE (1891)

The shift to a predominantly urban culture that occurred in the nineteenth century was most remarkable in the United States. An analyst of the American census of 1900 noted, "Perhaps if we broadly say that in the nineteenth century the people of the United States have multiplied fifteen times, and that in the same

period the population of their incorporated cities and towns has multiplied one hundred and fifty times, we may make at least a start toward grasping the greatness of the thing."[14]

Like the expatriate Sargent, Childe Hassam and Robert Henri were motivated by French Impressionist mentors to depict Paris during their formative years as painters. Later Hassam and Henri made American urban scenes a specialty, as did several of their fellow countrymen who came to know and to practice Impressionism only after they returned home from foreign study. Inevitably American painters pursuing urban imagery found ample inspiration in the burgeoning cities of their own country. Boston, Philadelphia, and especially New York were in some ways even more vividly modern than Paris was, offering no remnants of Medieval, Renaissance, or Baroque architecture, for example, and experiencing more extraordinary growth in infrastructure and population than any European city. The American cities thus afforded to artists opportunities for proud domestications of the foreign modes, for celebrations of distinctively American scenes.

About the urban scenes of the French Impressionists Herbert has cautioned: "The nature of their art which, superficially viewed, seems a whole-hearted adoption of the new city, is extraordinarily complex. In it we shall find not just happy strollers and charming waitresses: we shall find also pensive women alone in cafés or theater loges; couples seated in cafés or offices, bearing troubled expressions; men at windows, looking out on a few isolated pedestrians in the unfriendly expanse of pavement and sidewalk."[15]

The American version of French modernist urban painting is also complex, but in general it is informed by a rather different temperament than the French model. Although the Americans who painted urban scenes emulated the subject choices of such artists as Manet and Degas, they almost always altered their content in the direction of genteel escapism, bringing to it a pastoral, even an arcadian vision. In balancing the natural and the artificial in a park scene, for example, the Americans tended to give more weight to the natural, just as the American park designers recalled the countryside in the city rather than creating the sort of architectural elegance and complicated geometric organization seen in the Luxembourg Gardens and other European sites of the kind. Moreover, the Americans avoided the suggestions of dissonance and confrontation that give many French Impressionist cityscapes their tension and edge; instead they viewed urban places and people through the same filter of optimism, euphemism, and nationalism that they took with them into the modern landscape. The American Impressionists and Realists were attracted to the new order of things but retreated from recording it directly, perhaps because they were daunted by the extreme degree of urban development in the United States. They preferred to seek within the web of the new in the flourishing

American cities reminiscences of the older, more rural nation and amid the clatter and crowds remnants of the poetic and the picturesque.[16]

Among the repatriated American Impressionists, Hassam was the only major artist who absorbed lessons about city imagery at first hand from the French Impressionists and the only one who painted urban scenes during his student years in Paris. However, it is to William Merritt Chase that we must turn for the first truly Impressionist American city scenes. Chase had been immersed in old-master tradition when he studied at the Royal Academy in Munich in the 1870s. He had also emulated the Munich Realist Wilhelm Leibl, an experience that may have made him more open to dissident styles than were his Beaux-Arts–trained American colleagues. Once Chase returned to New York in 1878, his association with the younger generation of European-trained American painters through the Art Students League and the Society of American Artists perhaps reinforced the lessons of Leibl. In any case, Chase certainly was susceptible to detaching himself from tradition when he met the Belgian artist Alfred Stevens in September 1881 during a visit to Europe. Chase had long admired the work of Stevens, who enjoyed international patronage for a stylish blend of genre painting and portraiture (see fig. 31). Stevens counseled Chase to abandon any residue of his Munich Academy training. In response to the advice, Chase began to emulate Stevens, moving from traditional pictures to a more modish, contemporary imagery. In the mid- to late 1880s Chase also started to work outdoors, brightening his palette and turning away from the still lifes, portraits, and indoor studies that had been his major preoccupations. His pursuit of a more modern look in accordance with Stevens's suggestion is nowhere more apparent than in a series of plein air scenes based on New York's Prospect Park and Central Park undertaken at this time and typified by *Prospect Park, Brooklyn* (fig. 139). These paintings are, as one writer has noted recently, "the earliest pictorial manifestation of Impressionism to take place in the United States."[17]

Both parks to which Chase turned his attention were the creation of Frederick Law Olmsted and Calvert Vaux. In association with Vaux, Olmsted had produced designs for Central Park in Manhattan in 1858 and for Prospect Park in Brooklyn in 1866.[18] Central Park was essentially completed by 1876, and Prospect Park by 1874, but both were visited by many people during their construction. These large multipurpose parks were intended to alleviate the stresses of urban overcrowding and of detachment from nature. For their arrangements of the sites, Olmsted and Vaux relied principally on gardens designed in the English naturalistic tradition and on American rural or park cemeteries dating from the 1830s. Although they ardently believed in the naturalistic approach to park design, Olmsted and Vaux also borrowed from the more rigidly organized, conventional French parks for areas such as the Terrace and the Mall in

Fig. 127 Sheep and lambs, ball ground, Central
Park, n.d. Photograph: The New-York Historical Society

Central Park. Thus, by creatively combining pastoral and formal components, they devised parks that echoed and challenged the most successful European gardens.

At first there was some resistance to the park movement because of the costs associated with setting aside urban land for public pleasure grounds and because of suspicion that the parks represented inappropriate luxury. Supporters of the movement pointed up the social, moral, aesthetic, educational, intellectual, health-promoting, and sanitary significance of these urban spaces, which provided an equivalent of country recreation for the growing numbers of city dwellers.[19] The proselytizers perceived Central Park as a demonstration of enlightened city design and as a place that would encourage proper social behavior among New Yorkers, presenting them with opportunities for physical exercise and alternatives to spending time in taverns.[20] By the turn of the century it was believed that proximity to parks reduced urban mortality. Not only was the demolition of old tenements to create new parks seen as having a salutary effect, but the parks were also considered reservoirs for clean air and areas that allowed the "sanitary use" of trees to temper weather and hinder the spread of disease.[21] And, offering the experience of nature aestheticized, the parks were expected to educate popular taste. One writer explained of Central Park: "While the visitor to the park fancies himself merely resting, he is in fact receiving new sensations which insensibly educate both eye and mind . . . [and] have an artistic value which helps to make the humblest more sensitive to beauty, more intelligent as to what constitutes it."[22]

But beyond practical rationales, a key justification for the creation of the parks was sentimental: the parks reminded city dwellers of and provided a substitute for rural life (as they still

can). Central Park's Dairy, for example, was a place where children could sip fresh milk, a scarce commodity in the city, from cows that grazed in a nearby meadow (under present-day Wollman Rink); sheep grazed in another meadow (fig. 127). In 1900 a writer observed that Central Park in winter had a special lure: "The snow attracts some who would not go there save that they wish to see again the festooned trees, and feel the cold, sweet breath of a snowy field, with which they were familiar in years and joys gone forever."[23]

The success and popularity of the great early park designs in New York ultimately overcame resistance,[24] and numerous articles on the benefits and blessings of Central and Prospect parks stimulated national interest in park construction.[25] By the turn of the century writers would claim that Central and Prospect parks, as well as new and developing parks in other cities, were extraordinary jewels in a marvelous national crown and that "park-making" was "a national art." One exclaimed, "The parks and park systems are the most important artistic work which has been done in the United States," displaying true innovation on the part of the "inspiring genius" of Olmsted rather than the derivativeness apparent in American painting, sculpture, and architecture.[26]

Public attention to the development of Central Park and Prospect Park was considerable. As the complicated construction process advanced, the artistic vignettes that Olmsted and Vaux had planned became the subject of a number of enthusiastic newspaper and magazine articles illustrated with wood engravings and lithographs and of many illustrated guidebooks.[27] Independent prints and photographs documenting major sites and typical park activities also appeared. Among these were about a dozen lithographs of Central Park scenes produced by Currier and Ives (see fig. 128). The Currier and Ives prints include dramatic panoramic views of areas such as the Drive, filled with horse-drawn equipages in summer, and the Lake, thronged with skaters in winter, suggesting that the park was an expansive, crowded, and fashionable place.[28]

Despite the proliferation of popular images of Central and Prospect parks, painters produced few views of them. Among those who did, Jervis McEntee, a landscape painter associated with the Hudson River School and brother-in-law of Vaux, sometimes depicted Central Park. Dutch-born Johan Mengels Culverhouse and English-born William Rickarby Miller had a more consistent interest in the site. But they usually executed topographical views or adapted elements of park scenery to formulas derived from the arcadian, Claudian tradition. Frequently they showed crowds of skaters on the grand panoramic stage of the frozen Central Park Lake, recalling picturesque seventeenth-century Dutch winter genre scenes. John O'Brien Inman echoed the drama of the Currier and Ives park prints in *Moonlight Skating—Central Park, the Terrace and Lake* (fig. 129).

Fig. 128 Currier and Ives. *Central Park in Winter*, n.d. Color lithograph, 8½ x 12½ in. (21.6 x 31.8 cm). The Metropolitan Museum of Art, New York, Bequest of Adele S. Colgate, 1962 63.550.337

Fig. 129 John O'Brien Inman. *Moonlight Skating—Central Park, the Terrace and Lake*, ca. 1878. Oil on canvas, 34½ x 52½ in. (87.6 x 133.4 cm). Museum of the City of New York, Anonymous gift 49.415.2

Here fashionably dressed men and women, lively children, and even a dog frolic on snow and skate on the Lake, against a backdrop composed of the recently completed Terrace and the Bethesda Fountain. Inman pictures the full moon between clouds to make the scene vivid and to allow himself the opportunity to investigate the extraordinary chiaroscuro created by moonlight and snow. Winslow Homer made wood engravings of skaters in Central Park in 1860, but he preferred rural subjects and rarely pursued urban imagery, even of this bucolic sort. As a rule major

painters showed little interest in the parks until the 1880s, and there are no American precedents for Chase's fresh, brilliantly chromatic, and remarkably casual, intimate, and impressionistic glimpses of them.

In fact, Chase's paintings of Prospect Park and Central Park are fully realized examples of the Impressionist style. More, perhaps, than any other of Chase's works, they fulfill the description of the artist's gifts as an American *flâneur* offered by his friend Kenyon Cox: "He is, as it were, a wonderful human

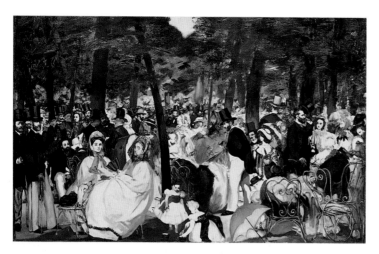

Fig. 130 Edouard Manet. *Music in the Tuileries Gardens*, 1862. Oil on canvas, 30 x 46½ in. (76.2 x 118.1 cm). The National Gallery, London NG 3260

camera—a seeing machine—walking up and down in the world, and in the humblest things as in the finest discovering and fixing for us beauties we had else not thought of. Place him before a palace or a market stall, in Haarlem, Holland, or in Harlem, New York, and he will show us that light is everywhere, and that nature is always infinitely interesting."[29] So effectively do Chase's park scenes express the characteristics and significance of the sites portrayed that they seem to derive not from imitation of French Impressionist models but from a thorough absorption of the fundamental meaning of the style.

The usual explanations for Chase's undertaking park scenes invoke his marriage in 1886: he is said to have given up his customary schedule of foreign travel and turned to subjects close at hand in response to his new duties as a husband and father. It is possible that personal circumstances triggered Chase's engage-

ment with park imagery, and some of his park scenes take advantage of his having a willing model as a wife. Yet other factors could have prompted him to turn his attention to New York's parks for his subjects in the mid-1880s. Chase was a devout eclectic, as is evident in his paintings and his statements. He told an interviewer in 1894, for example: "Absolute originality in art can only be found in a man who has been locked in a dark room from babyhood.... Since we are dependent on others, let us frankly and openly take all that we can.... The man who does that with judgment will produce an original picture that will have value."[30] Before he began his park pictures, Chase may have become susceptible to related works by artists whom he admired.

Of particular importance to Chase was Manet, whose *Music in the Tuileries Gardens* (fig. 130) was the French Realist's characteristic response to Charles Baudelaire's urgent suggestion that an artist should "set up house in the heart of the multitude."[31] It portrays members of Manet's circle and a cross section of contemporary Parisians attending a concert in the quintessential Parisian park. Although Chase may not have seen this painting at the Manet retrospective in Paris in January 1884, he was familiar with and durably supportive of Manet's artistic innovations. In 1881, at the time he received Stevens's advice, Chase had been involved with J. Alden Weir in mediating Erwin Davis's purchases of Manet's *Boy with a Sword* and *Woman with a Parrot*. Moreover, Chase's memory of Manet would have been refreshed by the inclusion of three of the Frenchman's paintings in the *Pedestal Fund Art Loan Exhibition* of 1883, a show that Chase helped organize and on whose selection committee he was a major force.[32]

Also significant for Chase was the popular Italian painter Giuseppe de Nittis (see fig. 131). It is possible that Chase saw the major de Nittis exhibition held in Paris in 1881 and that he acquired a small painting by the Italian then. Pictures by de Nittis,

Fig. 131 Giuseppe de Nittis. *Return from the Races*, 1875. Oil on canvas, 22 x 45 in. (55.9 x 114.3 cm). Philadelphia Museum of Art, The W. P. Wilstach Collection, Given by John G. Johnson W'06-1-10

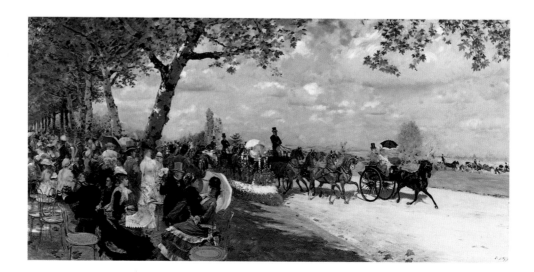

along with those of Manet, Stevens, and a score of others, appeared in the *Pedestal Fund Art Loan Exhibition*. Chase's extensive art collection included works by de Nittis, as well as by Jean Béraud (see fig. 161) and James Tissot—all painters of urban subjects, including parks, in a conservative, rather than an Impressionist style.[33] Conceivably, they confirmed Chase's subject choices, though not his formal approach. On the other hand, Caillebotte's compositions (see fig. 160), with their exaggerated spatial convergences, splayed foregrounds, and compressed backgrounds, in addition to his urban subjects, may have had an impact on some of Chase's park scenes.

The year 1886 saw a notable event on the New York art scene that would have nourished Chase's interest in the urban park as subject and also inspired him to brighten his palette and liberate his brushwork as he moved out of doors. In April the Parisian art dealer Paul Durand-Ruel opened the landmark exhibition of works by the leading French Impressionists at the American Art Galleries that was expanded and moved to the National Academy of Design the following month. Since Chase appears never to have attended the Impressionist exhibitions during his visits to Europe between 1878 and 1885, it is irresistible to speculate on the impact of the Durand-Ruel display on him. Here he would have seen many works by artists who had set up house in the heart of the multitude. He renewed his acquaintance with works by Manet (who was represented by nine paintings) and had access to examples by Degas, Camille Pissarro, Caillebotte, and other painters of modern life.

Three American painters—Sargent, Whistler, and Weir—may also have stimulated Chase's commitment to park imagery. Sargent, whom Chase had met in Paris in 1881 and whom he would esteem as "the greatest living portrait painter,"[34] had executed *In the Luxembourg Gardens* in 1879. The canvas was conspicuous on the New York art scene in the 1880s and may have come to Chase's attention then.[35]

Whistler, like Sargent, was an expatriate; Chase regarded him as "one of the *greatest* masters of his time,"[36] and the two carried on a lively artistic dialogue. Chase's admiration of Whistler is documented by 1884, although it had probably developed earlier, and was based in part on a shared appreciation of Velázquez (in which Sargent joined).[37] Whistler had always been a portrayer of modern city life, especially in his etchings of the Thames set and of country parks. He had painted a number of park scenes between 1872 and 1877, including six nocturnes that feature the milling crowds, colored lights, and glittering fireworks in the Cremorne Gardens amusement park in Chelsea by the Thames.[38] Chase would surely have known of the most infamous canvas of this series, *Nocturne in Black and Gold: The Falling Rocket* of 1875 (The Detroit Institute of Arts), which had provoked the Whistler-Ruskin libel suit in 1878. Whistler's park pictures are analogous to the scenes of bourgeois pleasures in Parisian parks

Fig. 132 After J. Alden Weir. *In the Park*, ca. 1879. Engraving from *New York Daily Graphic*, (March 8, 1879), p. 56

and outdoor cafés that were exhibited during the 1870s and 1880s by the French Impressionists, especially Renoir, and may have served to reinforce the effect on Chase of French depictions of urban recreation.

In addition, Whistler's pastels of Venice almost certainly influenced Chase's experiments in that medium in the mid-1880s. Whistler's etchings and pastels may have been available to Chase and may have been discussed when Chase visited Whistler in the summer of 1885.[39] Moreover, it is possible that Whistler's devotion to careful selection of aesthetic elements from routine reality prompted Chase to see that beauty could be found in and brought out of the commonplaces of New York's parks. Chase, who assumed the stylistic guise of Whistler to paint his portrait (fig. 27) during the visit of 1885, may have brought home with him both Whistler's interest in urban subjects and his commitment to an aestheticizing view of reality.

Weir was also concerned with park imagery, although he did not pursue it wholeheartedly or in a conspicuously modern manner. Chase was friendly with him by 1878, when both were involved in the Tile Club and in the founding of the Society of American Artists. In about 1879 Weir undertook *In the Park*, an ambitious painting in the tradition of Hals's civic company portraits or genre scenes.[40] *In the Park* (see fig. 132), which was included in the society's 1879 exhibition and later cut by the artist into pieces, showed a cross section of New York's populace: a seated man (the painter Wyatt Eaton) with a newspaper and a well-dressed, pretty young woman representing the middle class, a young girl selling flowers, a blind beggar, a rough old man carrying a sack, and another coarse fellow holding a circular, all crowding in on the more elegant figures and suggesting the masses. With a few trees and tenements in the back-

ground, Weir establishes a corner of the city as the site; he would later explicate the location by entitling a fragment of the painting *Union Square* (The Brooklyn Museum). However, Weir's picture itself does not exploit an urban park or square as a setting; stylistically, it suggests the artist's adherence to old-master traditions rather than an acceptance of Impressionism, to which he had recently indicated his resistance in Paris. Yet the ambitious scale of *In the Park*, its appearance in an exhibition that involved Chase, and the friendship of Weir and Chase suggest that this picture should be counted among the influences on Chase's decision to paint the parks himself.

Unlike Weir, Chase approached the parks as fruitful places for experiment in plein air painting, which he had first tried during a visit to Holland in the early 1880s.[41] Later he would associate the essence of his outdoor work with his park paintings, describing his basic strategies in the context of these New York sites: "There are charming bits in Central Park and Prospect Park, Brooklyn.... When I have found the spot I like, I set up my easel, and paint the picture on the spot. I think that is the only way rightly to interpret nature.... You must be right out under the sky."[42]

Most commentaries on Chase's park scenes concentrate on their aesthetic traits and suggest that they were generated by Chase's personal and formal artistic concerns alone. For any of his subject choices Chase himself rarely offered rationales that exceed pictorial issues. Ronald G. Pisano has discouraged investigation of the extrapictorial meanings of Chase's paintings, maintaining that the artist "asserted that the importance of a work of art is in *how* it is painted, not in what is depicted." But Chase's insistence "that a true artist could find beauty in that which does not obviously suggest it"—in Pisano's phrase—does not eliminate the possibility that Chase had expressive agendas beyond narrowly formal ones—intentional or not—in selecting images that were unusual or inconsequential and, at the same time, beautiful.[43]

Chase's depictions of New York's parks not only allowed him to be modern and eclectic, they also gave him the opportunity to make specifically American statements in contrast to the images of Manet, de Nittis, Caillebotte, Sargent, or Whistler. Unlike the squares of New York, which imitated those of London, Prospect Park and Central Park were unmistakably American in their rural associations and in their intentions. Olmsted is said by many to have been particularly self-conscious about the democratic origins and ramifications of his park designs.[44] Turn-of-the-century commentators remarked on the democratic character of American parks that distinguished them from those of Europe and observed that American parks evoked nationalistic elation. Thus, one maintained in 1897, "in America, all pleasure-grounds of large extent have from the beginning been planned for the people; they are a constant source to them of pleasure and pride."[45]

Fig. 133 Central Park, looking southeast across Swan Lake, n.d. Photograph: The New-York Historical Society

If Central Park and Prospect Park provoked national pride, Chase's depictions of them could be viewed as an antidote to cosmopolitanism in American art. For example, Cox wrote of Chase's park views: "Let no artist again complain of lack of material when such things as these are to be seen at his very door, and let the public cease complaining of the un-American quality of American art at least until they have snatched up every one of these marvellous little masterpieces."[46]

Painting the parks announced the ascendancy not only of the nation but also of New York. Charles de Kay invoked civic pride when he asked: "Indeed, why should not [Chase's] exquisite scenes of Central Park find their way from the artist's easel to the walls of citizens as easily as pictures of Niagara, or views taken in Lutetia Parisorum? Few cities can boast so beautiful a park as New York."[47] Civic pride echoes in much of the popular commentary on the parks themselves at the end of the century, as comparisons favorable to New York were drawn between its parks and those of London and Paris, as well as those of Boston, Philadelphia, and other American cities. New York was the center of Chase's world and the parks the artist celebrated as some of the "fairest spot[s] in the land"[48] were at the centers of Manhattan and Brooklyn. If Manet can be characterized as "both the painter of modern Paris and the embodiment of its spirit,"[49] Chase qualifies as the painter and spiritual embodiment of modern New York.

For Chase, so self-conscious about the artmaking process and so self-conscious as an artistic type, the parks seem to have been an obvious subject choice, a choice motivated by the same concerns that drove his aestheticizing of his studio space (fig. 33) and his invention of his own highly aesthetic appearance. Prospect Park and Central Park were ideal themes not only because of their modernity, their eclectic potential, their Ameri-

canness, and their associations with New York but also because they were essentially artistic phenomena. Like his artistically furnished studio, the parks were carefully arranged accumulations of eye-pleasing elements; both were beautiful composites of bric-a-brac, man-made in the case of the studio, both natural and man-made in the case of the parks.

The land chosen for Central Park in the barren wilds of the center of Manhattan (fig. 133) had presented formidable challenges for the designers. In 1873 one writer lamented: "It did not have a single natural advantage.... Long and narrow and flat, it was a despairing task to lay out drives with any variety, and an impossibility to escape the sight of the crowding houses of the future. Without a natural stream or any sheet of water, and with one of the most uninteresting varieties of rock-formation on which forming Nature ever tried her hand, the picturesque seemed impossible."[50] Through Olmsted and Vaux's artistic intervention, however, nature as it existed disappeared and was replaced by beauty.

Although their approach was rooted primarily in the naturalistic tradition, as we have seen, Central Park and, later, Prospect Park were exemplars of nature refined, made artificial, invented by artists. Olmsted has told us that, in the English landscape design tradition of Uvedale Price and William Gilpin, he composed a landscape just as a painter would. Writing with Vaux in the original 1858 Greensward Plan for Central Park, for example, he rationalized the creation of the park's lower lake: "It is conceived that, by introducing such an ornamental sheet of water into the composition at this point, the picturesque effect of the bold bluffs that will run down to its edge and overhang it must be much increased." Concerning the park's planting, Olmsted noted that it was designed to provide "the broadest effects of light and shade which can be obtained upon the ground, and to produce the impression of great space and freedom." Such study and arrangement of individual details, as if the park were a painter's canvas, would create the work of art.[51]

The designers of the park were consistently praised by their contemporaries for improving the reality of the city by producing what one writer of 1873 termed "a much more rural scene than is to be found in many places where it would be naturally looked for."[52] The sense of rural scene predominates despite the necessary rearrangements of nature and despite Olmsted and Vaux's reliance on formal French landscape models in certain areas: Central Park was not so wholly artificial as many European parks. "The original endowment was cleverly utilized," said John C. Van Dyke, and in Central Park, "the stranger to-day does not know where nature leaves off and art begins."[53] Going to Central Park and Prospect Park was like actually going into the country, but the visitor experienced what seemed like nature —imitation nature—rather than nature itself.

The renovation of raw nature that Olmsted and Vaux had

effectuated was remarked on even after its novelty was challenged by familiarity and its artistic perfection compromised by increasing use. In 1894, for example, one observer perceived that the park designers' temperament was like a landscape painter's and that Central Park was "as truly the work of an artist as would be the painting of one of these landscapes on a bit of canvas."[54]

Chase was attracted to many of the patently artificial sites within the parks, those that announce themselves to be works of art, rather than to the areas that seem more rural. He depicted most of the novel and notable places, the ones that often were discussed or recorded in published photographs. These included the Terrace in Central Park, designed by Vaux and praised as "the crowning incident in the park architecture ... the grand open-air reception hall of the park,"[55] and the distinctive concrete Conservatory Water, lying in a direct line with the Terrace, described as "symmetrical and architectural in its construction, being intended as an incident in the artistic rather than the natural physique of the park."[56]

In *The Nursery* (fig. 134) Chase depicts an area at the northern end of Central Park, near East One Hundredth Street between the reservoir and the Harlem Mere.[57] His painting may have satisfied viewers' curiosity about this wooded and serene region of the park, which was rarely described in guidebooks or articles and which was more likely to be seen by the few visitors who rode in carriages than by strollers. The picture suggests a dialogue between the ostensibly untouched nature of the park—however

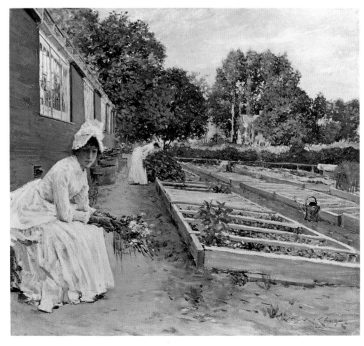

Fig. 134 William Merritt Chase. *The Nursery*, 1890.
Oil on wood, 14⅜ x 16 in. (36.5 x 40.6 cm).
Manoogian Collection

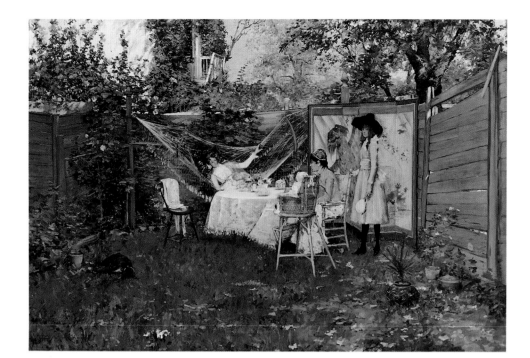

artificial—and its entirely artificial nature. In the right fore-ground and middle ground is a series of long wooden cold frames. When covered with glass, these provided spring condi-tions for germinating seeds and developing plants that would later be moved to flower beds and containers throughout the park. Cold frames, shown here separated by broad sandy man-made pathways, allow the control of nature. The frames are bracketed by another major architectural element—a long red shed clearly delineated at the left; frames, paths, and shed create a series of rushing diagonals that speed the viewer's eye into the distance. Here, in contrast to nature controlled, is nature rela-tively wild. Trees in full leaf are scattered; their unkempt branches seem to consume the only constructed feature in this area, a little house; and a thick underbrush has grown up with summer's warmth. The advent of summer is also announced by the fact that most of the cold frames have been emptied of their seed-lings. The primary dialogue between the cold frames and the background foliage is paralleled in the dialogue between the orderly architecture of the frames and the weeds that have now invaded them.

Two women in white summer dresses and hats punctuate the scene. In the middle distance, one woman bends over as if to inspect a huge clump of vegetation that burgeons from the confines of the cold frame. Her form is echoed by that of a barely visible workman who stoops over the row of cold frames in which a few yellow flowers still stand; he labors to tame nature, rather than merely inspecting or enjoying it. Less susceptible to simple analysis than this bit of possible social commentary is the pensive expression of the young woman who is shown close to

the viewer and who is the most striking single element in the composition.

While this young woman's mood and meaning defy interpre-tation, the bouquet of flowers that she holds seems to condense ideas about the artificiality of the park's supposedly natural beauty that resonate through the painting. The bouquet com-bines bits of almost all the colors of the scene in a single dazzling and variegated splash, which is highlighted by its placement against a brown and yellowish area of the sandy path. A contem-porary writer, aware that a person assembling such a bouquet from the park's plantings would have violated park ordinances, explained that "the lady in front to the left has obtained a dispensation from the rule not to pick the flowers."[58] But she certainly has not picked flowers from the cold frames, already empty of such blooms, nor has she gathered wildflowers from the immediate vicinity of the Nursery, where Chase describes a grassy lawn. Her flowers are apparently imported, despite a regulation that forbade bringing into the park any cut branches or flowers, or at least transported from some more distant part of the park. They thus remind the viewer that the beauties of nature can be moved about to create the most harmonious arrangements.

For Chase, then, park scenes could express the dominance of art over nature, a message reiterated in *The Open Air Breakfast* (fig. 135), where nature is contained by man-made walls and is invaded and improved by art. Although Chase depicts a *hortus conclusus* near Prospect Park in *The Open Air Breakfast*, the painting echoes the decorous vignettes of spaces sequestered from the city that he portrayed in the parks themselves. In such paintings, which are saturated with the intimacy of interior

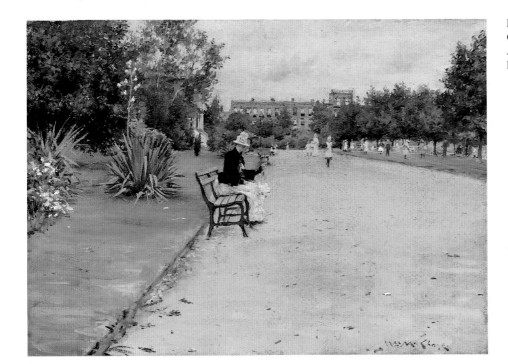

Fig. 136 William Merritt Chase. *The Park*, ca. 1888.
Oil on canvas, 13⅝ x 19⅝ in. (34.6 x 49.8 cm). The
Art Institute of Chicago, Bequest of Dr. John J.
Ireland 1968.88

scenes despite their outdoor locales, the artist rarely revealed
evidence of the surrounding city. In this way he captured a
distinctive trait of the parks remarked by a writer of 1898 as
"their pastoral character and their freedom from the compara-
tive noise and bustle of the quietest city streets."⁵⁹

Chase avoided reference to the life of the city except in a few
evocative images of piers along the waterfront and more than
once expressed his distaste for the most intrusive aspects of the
modern urban scene. These he disdained as "the telegraph
poles . . . the hideous elevated structures, and the brown stone
fronts which were so much in evidence everywhere"⁶⁰ and "the
skyscraping monsters [that] have smothered quite out of exis-
tence as objects of beauty many of the sightly old land marks of
this city."⁶¹ Instead Chase turned to the parks, which, like his
studio and the backyard of *The Open Air Breakfast*, were for
him genteel, feminine venues, enclaves for repose set apart from
the hurly-burly of late nineteenth-century New York.

To visit the parks with Chase is to experience a milieu entirely
dominated by women who are accompanied sometimes by
children and almost never by men. It is to focus on them as
places for pleasant strolls and promenades, areas defined by
paths and lawns. It is to find a refuge from unpleasant urban
realities and to be invited to pause and rest. (There were ten
thousand benches and chairs scattered in Central Park "in public
places to see and be seen, or tucked away in secluded spots,
invisible, quiet, alone.")⁶² To enter the parks through Chase's
paintings is also to be oblivious to the pleasure or business
associated with equestrian traffic. Olmsted had tried to diminish
the impact of such traffic in the parks: "He wanted visitors to

come to the Park for its own sake and to detract as little as
possible from the quiet pastoral scene by unseemly rapidity of
motion," according to a historian of Central Park.⁶³

Despite Olmsted's efforts to subordinate its impact, eques-
trian activity in the parks was immense, and it distracted many
visitors and commentators from "the panorama of wood and
meadow."⁶⁴ Chase, however, seems to have been in particular
sympathy with Olmsted's intentions, depicting visitors to Cen-
tral Park, or Prospect Park, as thoroughly engaged with "the
Park for its own sake" and remaining utterly indifferent to the
portrayal of any "unseemly rapidity of motion."

Chase's parks filled with women were a quiet and uncrowded
white middle-class world of mothers (and, less often, of nurses)
and children that shut out the growing population of the sur-
rounding city. Although democratic in principle, Central Park
and Prospect Park were not near working-class neighborhoods,⁶⁵
and they were not associated with the working class until the
1890s, when Chase abandoned them. He was interested neither
in the crowds that filled the parks nor the increasing racial or
ethnic diversity of the new visitors.

Sports—"exertive" uses, in the language of Olmsted and
Vaux—were not encouraged in either Central Park or Prospect
Park, except on fields set apart from the meadows and prome-
nades and in the sort of occasional playing areas that appear in
Chase's *Park* (fig. 136). In the right background of this small
canvas a large number of people engage in games, including
lawn tennis. An unidentified view of either Central Park or
Prospect Park,⁶⁶ the painting records the use in both venues of
temporary tennis courts for which players themselves provided

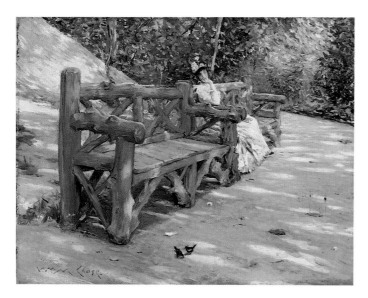

Fig. 137 William Merritt Chase. *Park Bench*, ca. 1890. Oil on canvas, 12 x 16 in. (30.5 x 40.6 cm). Museum of Fine Arts, Boston, Gift of Arthur Weisenberger 49.1790

the nets, installing them only when needed. *The Park* also typifies Chase's experiments with the Impressionists' soft, bright palette and close observation of outdoor light, as well as with their unconventional compositional formats and expressive strategies. The foreground is broad and empty, and a sharp diagonal of the path leads rapidly back into deep space. The seated woman shifts forward, as if the viewer, whom she apparently recognizes, has come upon her suddenly.

With the functional uses separated from the quietly recreational, or "receptive," uses in Central and Prospect parks by means of transverse and other through roads, the contemplative experience of nature on carefully laid out paths was stressed; solitary, not social, pleasures were encouraged, and tamed nature made artistic was to be looked at, not touched. Even children had to stay on the paths. "The enjoyment of the children would be greater yet if the grass covered lawns were not forbidden territory to them," complained a columnist in 1891.[67] In the parks and in images of them by Chase, the paths and the benches delimited contact with nature. The benches themselves—even if they were as rustic as those portrayed in Chase's *Park Bench* (fig. 137)—were constructed, paradigms for the park itself.

Chase's exploration of Central and Prospect parks between 1886 and 1890 seems to involve a dialogue between the painter and the parkmakers, Olmsted and Vaux. That dialogue, or coincidence of intentions, must have confirmed Chase's personal choices and feelings and therefore helps to account for the transformations of Chase's European sources and to explain why the painter, so often willing merely to echo his contemporaries' works, produced paintings of the parks that are so original. For in designing the parks and in recording them, Olmsted and Vaux

and Chase emphasized the same notions of the perfect park experience, especially a sense of holding the city at bay and a devotion to the contemplation of ordered nature.

Indeed, the locales Chase shows look much more like the ideal Olmstedian parks of the 1870s than the parks that existed in the late 1880s, when he painted them. These earlier parks were recorded in innumerable photographs, especially stereographs, from whose original negatives successive printings were made. The stereograph was the leading medium for outdoor photography from the 1850s until handheld cameras marketed for amateurs became popular in the 1890s. Millions of stereographs were created by thousands of professional photographers and disseminated widely to a public eager for entertainment and documentation.[68] The value of stereographs for Chase's park scenes should not be underestimated. Not only did they preserve the idyllic, genteel park of an earlier time for reference but they also emulated actual walks through them, during which the visitor experienced the unfolding of a series of changing scenes. Olmsted and Vaux's design rests on the premise of this kind of real-life travelogue, a travelogue whose evocative potential the traveler Chase well understood.[69]

Stereographs also offer fascinating, fresh compositional strategies: splayed foregrounds, diminished backgrounds, and acute convergences to off-center vanishing points (see fig. 138). When they are viewed in pairs in stereoscopes, stereographs are normalized, so that they give the illusion of undistorted three-dimensionality; viewed singly, they produce effects rather like those in paintings by Caillebotte or in Japanese prints in which extra-sharp convergences become surface patterns. Chase could not have found greater compositional aids than stereographs nor could he have avoided seeing them, given their proliferation.

Chase does not appear to have used a camera himself; even family pictures were probably taken by his wife. But he strove for

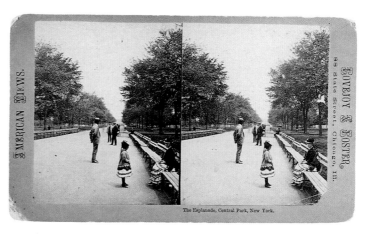

Fig. 138 *The Esplanade, Central Park, New York*, n.d. Stereograph. Herbert Mitchell Collection

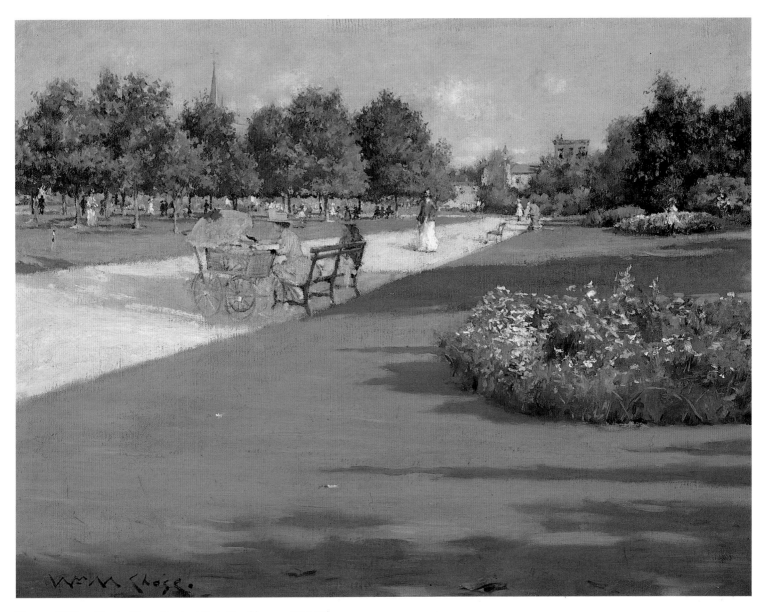

Fig. 139 William Merritt Chase. *Prospect Park, Brooklyn*, ca. 1886. Oil on canvas, 17⅜ x 22⅜ in. (44.1 x 56.8 cm). Colby College Museum of Art, Waterville, Maine, Gift of Miss Adeline F. and Miss Caroline R. Wing 63–P–036

immediacy in compositions, trying to see in a modern way, as if he were a camera, and encouraged his students to paint as if they were seizing camera impressions. Wide-angle lenses that would seem to stretch space became available after the 1860s and may have helped Chase see in a new manner. Thus, photographs—amateur and professional, wide-angle, conventional, and, most likely of all, stereographs—perhaps prompted or reinforced his interest in experimental, eccentric city views. Likewise, Japanese prints that adopt Western perspective with a sort of exaggerated rigor, producing patterns based on extreme convergences—as in the manner of Utagawa Hiroshige—may also have been influential.

In *Prospect Park, Brooklyn* (fig. 139), probably one of Chase's earliest park scenes, a foreground sweep of manicured lawn draws the viewer into a bit of carefully tamed nature on a dazzling summer day. Beds of vivid unruly flowers emphasize artificiality by contrast with the neat lawn into which they have been inserted and by showing the containment of rambunctious nature. (Olmsted, in fact, preferred much more irregular plantings that suggested rural vegetation; he felt that flower beds placed in this way revealed too much of human intervention and contradicted the naturalistic ideal.)[70] Long shadows measure off the lawn and suggest that the time is late afternoon. The extended green introduction to the scene establishes a mood of repose, requiring that the viewer visually experience the expanse of lawn and flowers at a leisurely pace before encountering any sort of activity.

The foreground trapezoid of grass and flower beds initiates a dialogue with elements that are even more artificial than the lawn and the plantings: a broad pathway punctuated by benches, which cuts across the canvas on a sharp diagonal and leads the eye to a glimpse of Prospect Park West. This wide and fashionable street was the boundary between the park and Park Slope, the neighborhood where Chase probably lived. Along the street toward the right appears a group of two- and three-story town houses. Toward the left there is a church steeple, reminding us that the locale is Brooklyn, the borough of churches, and enhancing the sense of peace that prevails in the scene over which it towers. Between the buildings the horizon is obscured by trees in full leaf, a curtain of green that seems to hold the city at bay. Indeed, Olmsted and Vaux had intended that the lawns of the parks would be protected visually from the tumultuous encroaching city by such umbrageous screens.[71]

A young woman seated on the bench nearest the viewer is engrossed in the care of an infant in a wicker baby carriage protected by a pink parasol. Her fashionable hat and pale summer dress suggest that she is an upper-middle-class mother, not a nurse. The curve of her skirt closes the visual parentheses opened by the carriage's hood and echoes the ovals of its wheels. This young mother and her carriage form a complex of curves, in contrast to the straight lines that predominate elsewhere. Sitting at the far end of the same bench on which she is poised is another female figure, this one wearing a white skirt and a stylish hat; her long hair falling down her back identifies her as a teenager. She enjoys nature but avoids contact with her benchmate. A woman wearing a short jacket and white skirt strolls sedately toward us. Although other figures engaged in various forms of restrained recreation are scattered in the dappled sunlight under the distant trees, the contemplative dominates the active. The figures participate in a genteel choreography on a brilliant landscape stage, taking silent and self-absorbed delight in distilled nature in the company of strangers. In the peaceful moment he captures, Chase symbolizes the quintessential late nineteenth-century belief that a park could offer refreshment to urban dwellers by making available pastoral retreats and natural quietude for tranquil promenades and sedentary pleasures.

The appearance and use of the parks changed as New York's urban population grew, facts well documented in photographs and commentaries. The "skyscraping monsters" that Chase decried and that Olmsted and Vaux continually tried to obscure with plants invaded the horizon lines. Central and Prospect parks were increasingly frequented by working-class people of many ethnic groups whose houses had come to surround them. By 1895 they were seen by some to be overrun by the masses; as one writer lamented of Central Park: "The park has been a favorite playground in New York so long, it is so easy of access from the ends of the city, it is so easy to get about when once you

are there, and so many people know these facts and take advantage of them, that in the minds of some New Yorkers it has come to be rather a commonplace picnic spot for the use of the masses, and, except in a carriage or astride a fine horse, to be avoided." In response to the pressure of increased use, the old rules were relaxed, and the same writer acknowledged, "Many of the guarded lawns are thrown open, and hundreds of happy children roll in the soft green grass or chase about with shouts of merriment."[72]

Olmsted had worked on Central Park until 1878, when he ended his official connection with the project. Observing encroachments and destructive innovations in the park, in 1882 he wrote a pamphlet, *Spoils of the Park*, that criticized its care and management. Indeed, the pressures of the later 1880s increasingly violated the great landscape architect's values and intentions. Olmsted's disenchantment coincided with the end of Chase's interest in Prospect and Central parks.

The problems that caused both artists to turn away from the New York parks are made evident by comparing one of Chase's last Central Park scenes, *The Lake for Miniature Yachts* (fig. 140), usually dated about 1890,[73] with a stereograph of the same site made after September 1891 (fig. 141). The Conservatory Water, portrayed here, is located just off Fifth Avenue at Seventy-fourth Street and originally was screened from the street by the perimeter of trees that Olmsted and Vaux designed to separate the park from the city.

In an article that appeared in May 1891, de Kay wrote about *The Lake for Miniature Yachts*: "This view is taken from the south; Fifth Avenue is just on the right, and some of the housetops belonging to that thoroughfare peep above the trees."[74] What would soon loom above these trees was the monumental piece of architecture visible in the stereograph—Temple Beth El, an extraordinary Moorish-revival synagogue with a huge dome that was begun on Fifth Avenue at Seventy-sixth Street in October 1890 and dedicated in September 1891 (it would be razed in 1947). Although Chase does not confront this intrusive new urban reality, he emphasizes the artificial elements of the site to a greater degree than he did in *Prospect Park, Brooklyn*; in fact, in this late interpretation of Central Park he recalls Sargent's *In the Luxembourg Gardens* more than his own earlier park scenes. From the Prospect Park picture Chase recapitulates a broad foreground trapezoid to separate the viewer from the figures that populate the middle ground; however, the area at the front of the new painting is now a pavement rather than a lawn. He reiterates the device of a distant screen of trees punctuated by architectural towers in the Central Park scene but pushes nature farther into the background, devoting about three-fifths of the surface of the canvas to the constructed rather than the natural. The bed of flowers in Prospect Park's lawn—already a bit of nature contained—is replaced by the boat basin, a larger and even more artificial element more than once removed from nature itself.

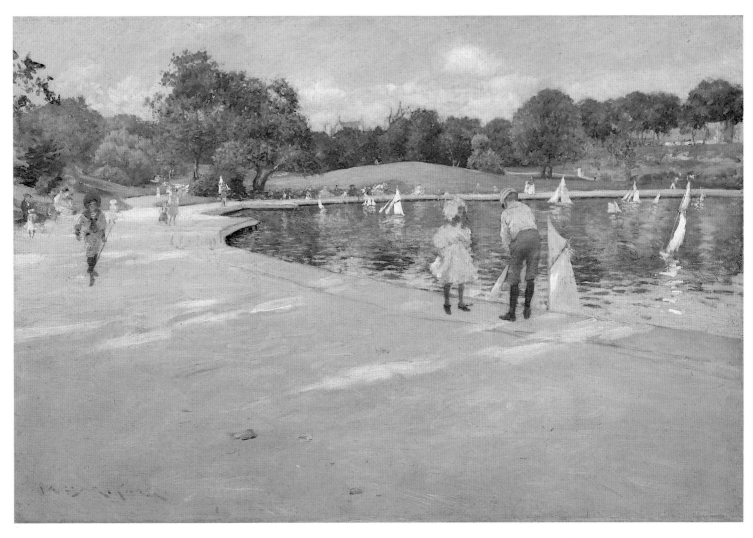

Fig. 140 William Merritt Chase. *The Lake for Miniature Yachts*, ca. 1890. Oil on canvas, 16 x 24 in. (40.6 x 61 cm). Collection of Peter G. Terian, New York

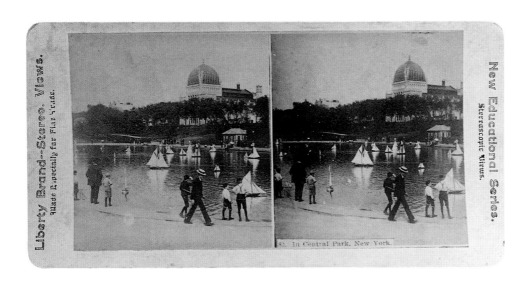

Fig. 141 *In Central Park, New York*, n.d. Stereograph. Herbert Mitchell Collection

The individuals who now enjoy the park are children, as few in number and as self-absorbed as are the women who sit or stroll in *Prospect Park, Brooklyn*. These children are not at all boisterous, as youngsters portrayed by the later American Realists often would be. They participate quietly in miniature yacht racing, a sport that had responded to the fad for pleasure sailing that developed during the Centennial but whose popularity had quickly faded.[75] Thus this activity was already old-fashioned by the time Chase portrayed it here. Contemporary photographs suggest that, although the craze for miniature yacht racing had subsided, Central Park's Conservatory Water remained an attraction. Rather than drawing huge crowds, however, it was still a calm and genteel venue, entirely consistent with the temperament of the artist who chose to paint it about 1890. In such a place the nature that children experience has been tamed by the parkmakers; their knowledge of sailing and the sea depends on Olmsted and Vaux's distillation of nature, on an imitation of the great outdoors in the restricted city, and on a polite out-of-date sport that is an imitation of a more vigorous activity. In Chase's painting of the Central Park boat basin, the boy and girl to the right are embraced by the architectural limits of the pond. Their attire, hardly suitable for rough outdoor play, is appropriate to nature tamed rather than wild. His shirt buttons up the front and has a collar that impedes action. She wears a fashionable cotton dress with a high waist and many frills; her sunbonnet, which peaks on the top, is the sort often worn at the seashore, thus providing an ironic note on her urban experience of nature.

A foppish young lad—a child standing in for a *flâneur*—strolls toward us at the left, entirely remote from the barefoot boys of an earlier rural America often depicted by Homer (see fig. 116). His sailor suit, typically white with blue trim for summer wear, was a ubiquitous article of middle- and upper-class children's dress from the 1860s through the 1920s. This stylish young fellow also wears a wide-brimmed hat and carries a stick that might be used to prod or retrieve sailboats on the pond (and is perhaps a parallel to the walking stick of a *flâneur*). He condenses the experience of the site as it would be described by a writer in 1895: "On bright afternoons when the wind is astir the young yachtsmen of the city, in blue and white sailor uniforms, with gold anchors on their shoulders, and golden curls falling from under their sailor hats, hurry down here with their yachts under their arms.... It is a stirring scene, full of young joyous life."[76]

Although Chase's park scenes attracted favorable notice,[77] the parks themselves were drawing crowds too large to nourish the artist's genteel views. Chase's abandonment of the parks occurred at about the time he began discussions that led to the founding of his summer school in Shinnecock in 1891. He took his commitment to refined outdoor genre scenes—and many of his familiar compositional strategies—to remote Long Island,

where he painted some of his liveliest, freshest, and boldest pictures in his country retreat on the dunes of Peconic and Shinnecock bays.

A Small Paradise: Edward E. Simmons in the Boston Public Garden

In the Public Garden the Boston people take great pride, and have been so generous in its improvement, that every one who passes through it speaks with unbounded enthusiasm in its praise.

MOSES KING (1881)

No man expresses well in any art what he does not know to the bottom.

EDWARD E. SIMMONS (1903)

Like Chase's portrayals of the parks of New York, Edward E. Simmons's *Boston Public Garden* (fig. 142) represents an artist's pursuit of an urban site insulated from the harsh actualities of city life and as suggestive as possible of rural retreats. The Public Garden is a twenty-four-acre park in the heart of the city that bridges the area between old Boston—Beacon Hill and the Common—and new Boston—the Back Bay, whose front yard it forms.[78] Simmons's view is said to have been painted from a second-story window of the St. Botolph Club, a genteel meeting place for artists and authors and for gentlemen interested in the arts. The patrician Simmons was triply qualified for membership: he was a Harvard-educated, Paris-trained painter simultaneously reputed for easel and mural work; a writer whose autobiography would be published in 1922; and a nephew, reared at Concord's Old Manse, of Ralph Waldo Emerson's. The St. Botolph Club, founded in January 1880, had been located since 1887 at 2 Newbury Street, on the southwest corner of Arlington, the boundary of the newly developed Back Bay.[79] A commission from the club or simple convenience may have prompted club member Simmons to select a vantage point for portraying the Public Garden from one of St. Botolph's windows; however, by choosing such an outlook, he also declared on canvas his affiliation with the institution that was perceived as "the literary and artistic club of Boston ... [that] is growing to be more and more the intellectual and social centre of the bright minds of the city" and possibly appealed to its members for patronage.[80]

In the painting an enclosed sleigh and a sledge make their way along snow-covered Arlington Street, which traverses Simmons's composition laterally; the sleigh at the lower left heads west on Newbury Street. The dome of the Massachusetts State House on

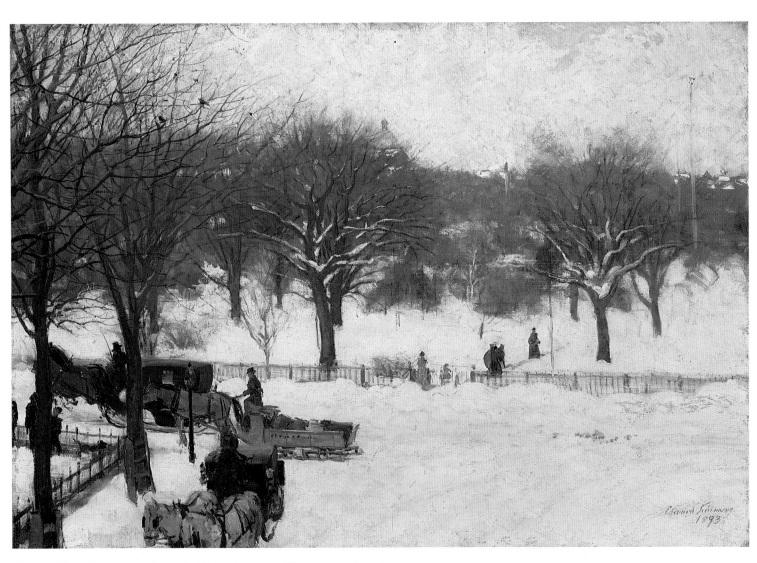

Fig. 142 Edward E. Simmons. *Boston Public Garden*, 1893. Oil on canvas, 18 x 26 in.
(45.7 x 66 cm). Daniel J. Terra Collection 34.1984

Fig. 143 The Boston Public Garden, from Charles W. Stevens, "The Boston Public Garden," *New England Magazine* n.s. 24 (June 1901), p. 351

the crest of Beacon Hill in the distance, the steeple of the Park Street Church rising at the corner of Tremont Street toward the right of the picture, and the rooftops lining Beacon Hill on the horizon identify Simmons's scene as an urban and artificial landscape. The long iron fence that establishes the Public Garden's bounds cuts across the entire canvas and invades the lower left-hand corner, calling attention to the separation of the park's wooded expanses from the city.

Despite the presence of these conspicuous artificial elements, Simmons emphasizes the rural quality of the Public Garden and the possibilities it offers for contact with nature in the heart of the city. At the left of the canvas a lacy tree on which two birds perch provides an introduction to the scene. A few people pass through the iron fence into the wooded areas beyond, into isolation from the tumult of Boston. Although the Public Garden was recognized as "a most attractive place for the *flaneur* from early spring until the late fall"[81] by a writer of 1888, Simmons chooses a moment in winter, the season in which the garden is at its most tranquil, when the possible contact of the *flâneur* with other people is limited, when the patently artificial flower beds are obscured by snow, when untouched nature predominates. Simmons even eschews the opportunity to depict the skaters who made the Public Garden's pond an active and noisy winter gathering place. The urban experience, softened by the shroud of snow, seems restful and picturesque. If the people Simmons portrays wish to reach the golden goal of the state house beyond the park, they must trudge through deep snow across the Public Garden and Common; they must face entirely natural impediments to their activity: they are urbanites challenged by the timeless rigors of the weather.

When compared with a photograph of the site in summer, taken not long after Simmons completed his view from approxi-mately the same location (fig. 143), the painting appears to emphasize the natural components of the Public Garden to a striking degree. The painter's vantage point, lower than that of the photographer, allows trees to screen the landscape, to obscure the statues scattered throughout the garden, and to embed the architecture of Beacon Hill into the umbrageous distance rather than let it loom over the site.

The coincidences between the compositions and subjects of Sargent's *In the Luxembourg Gardens* (fig. 125) and Simmons's *Boston Public Garden* reveal differences between the expatriate artist's approach to artificial French nature and the repatriated painter's portrayal of artificial American nature. Each records a sparsely peopled, tranquil urban park with a horizontal vista characterized by an empty right foreground and framed at its horizon line by a row of trees. But Sargent invites the viewer to join him at eye level with the strollers he depicts and to experience broad terraces that push the Luxembourg's trees into the distance; by contrast Simmons takes a bird's-eye view of the Public Garden, looking down onto an expansive scene still dominated by untouched nature despite the enframement of streets and fences, rooftops and state house dome. Rather than being confined to terraces or paths like Sargent's strollers, the people in Simmons's painting move beyond the restrictive fences to enjoy nature transformed by the snowfall. The tenacious American engagement with untamed nature and the desire to preserve contact with the rural environment even in the urban context that affected the design of the Boston Public Garden and other American parks may also have influenced American painters' depictions of parks in ways to which the French (and even an American expatriate in France) were less susceptible.

Simmons's desire to portray nature did not cause him to ignore entirely the artificial elements of his city park. He selected

a vantage point that allowed the state house dome to appear on the horizon, thereby identifying a specific urban American locale with historical resonance. The Massachusetts state house, designed by Charles Bulfinch in 1787 and built between 1795 and 1798, is a canonical example of American federal-style architecture, an Americanization of a foreign model: the central riverfront pavilion of Sir William Chambers's Somerset House in London, begun in 1778. The state house dome, which had been sheathed in copper by Paul Revere in 1802, had been transformed by the application of gold leaf in 1874, becoming conspicuous not only for its profile but also for its color.

After a history of complications regarding its ownership and uncertainty regarding its use, the Public Garden also had been altered shortly before Simmons painted it.[82] The parallelogram of land on which it stood was originally the lower part of Boston Common, a forty-five-acre eyesore of marsh and mudflats at the foot of Beacon Hill. It was designated for development as a park in 1859, possibly in response to the creation of New York's Central Park.[83]

The plan selected by the special committee appointed by the Boston City Council to improve the Public Garden had been formulated by Boston architect George F. Meacham and had been made more picturesque and irregular by the city engineer, James Slade. Completed by the early 1860s, the Public Garden became a source of pride to Bostonians. Moses King, a leading chronicler of late nineteenth-century American urban development, boasted in 1881 that "in the past twenty years the old marsh land has been transformed into one of the most delightful 24 acres in this country,—in fact, into a small paradise. . . . In the Public Garden the Boston people take great pride, and have been so generous in its improvement, that every one who passes through it speaks with unbounded enthusiasm in its praise."[84] Abundant flowers, plants and trees, gravel-lined paths, and many commemorative sculptures and fountains marked the new landscape, with meandering pathways contrasting with a strong east-west axial avenue. The Lake, an irregularly shaped four-acre pond, was constructed at the center of the park, and a heavy single-span stone bridge was erected over the pond in 1867.[85]

In Boston residents' easy access to the Charles River and the presence of numerous large open areas, such as the Common and the Public Garden, as well as the existence of convenient transportation to rural suburbs, retarded park development in the late nineteenth century.[86] Bostonians may, indeed, have felt complacent because they were closer to rural refreshment than New Yorkers were. In any case, little land was available within the city proper for development as parks that could rival New York's Central Park or Brooklyn's Prospect Park. Nevertheless, the public park effort in Boston had gathered force beginning in the 1860s. Before the areas surrounding Boston became too densely populated, land was reserved, and the city began to

establish a centrally controlled system of rural parks in the adjacent annexed towns, or streetcar suburbs, of Roxbury, West Roxbury, and Dorchester, as well as in the more distant suburbs. By the turn of the century these venues would participate in a great network designed by Olmsted in the 1870s that combined small individual parks, a larger main park at West Roxbury, and scenic boulevards and passageways.[87]

Refuge and Recreation: Painters of the New Century in Urban Parks

If ever snow looked buoyant and cheerful it is that which escapes over the piles of brick and stone to the comparatively natural environment of the Park.

RAYMOND S. SPEARS (1900)

New York, by contrast with Boston, depended on urban parks to offset the extreme growth of its infrastructure and population. A number of painters of modern life drew inspiration from these important urban sites after the turn of the century, retreating into them from the harsh realities of the surrounding city, as Chase had done. As we have noted, the mood of Chase's park paintings was contemplative, recalling the ideal Olmstedian venues of the 1870s rather than reflecting the atmosphere of the parks as they existed when he pictured them; his genteel figures interacted quietly or enjoyed solitude even in the presence of others. Although the parks of twentieth-century New York were now more accessible and more crowded than they had been in the Impressionists' day, Realist artists modified Chase's suggestions of gentility only slightly, continued to pursue his euphemistic approach, and portrayed these sites as charming, refined, quasi-rural refuges. The Realists' emphasis on remnants of the parks' bucolic tone is altogether at odds with facts recorded in other media after the turn of the century. By 1907, for example, the *New York Herald* would describe the "deplorable deterioration of the parks and squares of this city" and "the riffraff of humanity" in Washington, Union, and Madison squares, and in Central Park, "which has its full quota of . . . tramps these days," commenting that "many a tract intended as an oasis where self-respecting working men or tired toilers might rest . . . and women and children might go for outings and exercise, is now practically in the possession of the idle and the vicious . . . [and] the air is tainted by diseased and filthy vagrants who have almost driven away those for whom the parks were intended."[88]

In *Central Park in Winter* (fig. 145), William Glackens not only turns attention to the park as a refuge from urban realities but also shows it blanketed in snow. The members of the Ashcan School, to which Glackens belonged, often portrayed New York

in winter not as a pretext to exaggerate city hardships but rather as an excuse to soften the edges of the urban experience. Glackens's painting—one of several he did of Central Park and Washington Square—includes some relatively democratic subject matter that Chase would have avoided, and his technique is coarser, more spontaneous, and more rugged than the Impressionists'. Yet the image is only marginally less genteel in spirit than the park scenes portrayed by the older artist ten or fifteen years earlier. *Central Park in Winter* recalls Chase's prototypes but also stands apart from them in seeming to consolidate the sort of captioned glimpses of Central Park that Glackens provided for a magazine article of 1900 and to invite a similarly episodic reading.[89]

Glackens's painting immediately announces itself as a depiction of an urban park rather than a rural expanse. The figures are a collection of unrelated individuals gathered for just a moment, not a group involved in an organized activity, such as a country excursion. The assemblage of people of fashion, middle-class citizens, and the poor on common ground suggests the realization of Olmsted and Vaux's democratic intentions; regardless of class or age, they all pursue pleasure.

Unlike rural children, who can play outdoors alone, the city children who are shown here—many of whom are too young to come to a park unaccompanied—are supervised by adults. In the right foreground is a middle-class or upper-middle-class woman dressed in expensive city clothing: stylish hat over upswept hair, skirt well above the ankles, long fur-trimmed jacket, and a muff over her right hand. The swellings of her dark hat and jacket echo and interlock with those of the tree against which she casually leans. Here the intention of the painter may have been parodic. He was, after all, a former artist-reporter who typically caught figures in characteristic fleeting poses and droll situations and a great admirer of Honoré Daumier's. He nonetheless invites us to consider the harmony between the tree and the woman and, by extension, between the park itself and the people who visit it. This woman, larger than any other figure and silhouetted against the snowy field, mediates between the scene and the viewer of the painting. Unlike women who stroll or sit in Chase's pictures, she is not turned away from us and self-absorbed. She seems quite modern, even bold, in comparison with Chase's women, stretching out her arm to seek the tree's support, crossing one ankle in front of the other in a slightly indecorous pose, and engaging the viewer with her glance. Her fashionable dress suggests that she is not a nurse, although, as she faces us, she also seems patiently to oversee the activities of the little girl in the immediate foreground, who holds the rope of a sled.

Bundled against the cold, this child wears a fur jacket from beneath which her dress peeks out; stockings and gaiters cover her lower legs and the tops of her shoes. Well bred, she seems impeded in her movements by her patrician costume and

by her guardian's expectations of decorum. By contrast, behind her is a less grandly dressed girl, who vigorously pulls a sled up the hill. Toward the left is a line of boys who will sled with abandon down the slope to the snowy field below. The activated shapes of the livelier, apparently less affluent children fan out above the fulcrum that the well-behaved little girl provides. The dualities of behavior seem to illustrate the impact of differences in social class on children's activities in the park in winter that a writer of 1900 observed: "Some little tots . . . [pack] uneven snowballs and [throw] them at any one near by, screaming and rolling over for glee. . . . But there is many a child so richly dressed that the nurse clings to it and chides lest the lovely garments get a little snow on them."[90]

Along the ridge of the hill, at the left edge of the canvas, a woman accompanied by a man and an older woman wheels an open perambulator. The man wears a fashionable bowler with an upturned brim and a duster, possibly of fur; the old woman is veiled and is the grandmother, perhaps, of the pram's occupant. Other children fill the snowfield, while their adult companions stand in the middle-ground path or sit on benches and complete this altogether agreeable scene. Glackens's suggestion of the genial pleasures of New York's winter is typical of the artist and distinguishes him temperamentally from the French painters of modern life who inspired him. Although he recognized the analogies between Glackens's subject choices and those of Degas, the American's champion Albert E. Gallatin saw that Glackens was the archetypal optimist and concluded: "The great difference between Degas and Glackens is that where the former too often seeks for the ugly and repulsive, the painfully sordid, the

Fig. 144 Central Park, winter, 1898. Photograph: Museum of the City of New York, The Byron Collection

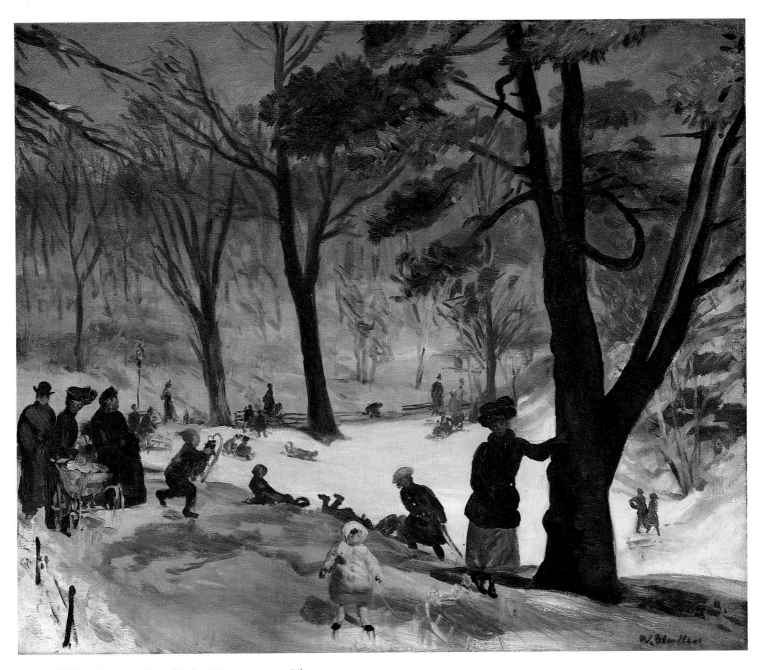

Fig. 145 William Glackens. *Central Park in Winter*, ca. 1905. Oil on canvas,
25 x 30 in. (63.5 x 76.2 cm). The Metropolitan Museum of Art, New York,
George A. Hearn Fund, 1921 21.164

ultra prosaic, the latter looks only for what gayety and humour he may discover in the scene. And Glackens is none the less a faithful recorder, and unflinching realist, because his sympathetic pencil is never dipped in gall, as in the case of the brutal brush of the cynical Degas."[91]

Glackens's painting is distinctive and memorable most of all because of its sharp juxtapositions of light and dark and its palette that expresses the blue chill of the snow. These traits make his picture resonate with contemporary observations on the experience of Central Park in winter, including the following remarks of 1900: "Not only will the snow be interesting to contemplate, but the people one meets, and all the surroundings, have a new charm; for the snow has a distinctive way of bringing out angles and curves, and there are many chances of making unexpected discoveries."[92]

Snow also obscured the distinction that Olmsted and Vaux had sought to create between the areas of Central Park devoted to contemplation and those devoted to active play. The excitement of a snowfall liberated children and adults from normal rules—as it still can—and park visitors may have been more inclined than usual to stray from the paths when their edges were buried in snow. The writer of 1900 noted: "In every direction lead asphalt paths, wide enough for six, to which one must keep during most of the year. But a fall of snow opens the way to any place in the Park."[93]

We cannot judge in Glackens's painting whether the area depicted is officially and permanently or only temporarily dedicated to active rather than contemplative pleasures. In either case Glackens's figures are far more directly engaged with the experience of nature that the park could offer than those portrayed by Chase might ever have been. By comparison with the casually posed figures in Glackens's painting, the people caught in some of the great and frequently reproduced Byron photographs of similar scenes (see fig. 144) seem quite constrained. Showing his city folk so actively and literally connected with elements of the park landscape—touching the trees, sliding on the slopes, wading through the snow—Glackens suggests that these urbanites can immerse themselves in restorative nature despite the impediments of their city costumes and manners. His park visitors are embedded like jewels in the snowy slopes, dwarfed by the broad calligraphy of dark tree trunks, becoming colorful accents in the natural expanse. The park itself and the painter who portrays its winter pleasures keep the city and its winter hardships at bay.

Glackens's view of Central Park is energized by his vigorous brushwork and by the sinuous forms of the lively children he depicts, but the mood of the canvas is subdued by the cool palette and the rhythmic armature of dark tree trunks. By contrast, the keynote of Maurice Prendergast's park scenes is the brilliance of summer. In his *Central Park* (fig. 147), for example, Prendergast captures the festive energy of the park, the press of humanity

there, on a sun-drenched day when the spot is an irresistible magnet for a varied crowd.[94]

Bostonian Prendergast had been exposed to the contemporary art scene in Paris between 1891 and 1894—especially to the paintings of Degas, the posters of Henri de Toulouse-Lautrec, and the paintings and prints of Nabis Pierre Bonnard and Edouard Vuillard (including his panels of a Paris public garden [fig. 146], shown in 1894). After finding in their works inspiration for images he executed of Parisian parks, streets, and boulevards, Prendergast had returned to Boston. He brought with him an appreciation of the expressive potential of the common corners of the contemporary city and a willingness to use the saturated, often arbitrary palette of the Nabis to convey the spirit of sites around and in Boston; he also seems to have transferred the densely patterned claustrophobic surfaces of Vuillard's interiors to some of his own outdoor work. Almost immediately upon his arrival home, he had begun painting at suburban Franklin Park—the former West Roxbury Park, rehabilitated between 1881 and 1886 according to plans by Olmsted[95]—and in the Public Garden.

Prendergast's delight in portraying all sorts of people—adults and children, servants and those whom they serve—enjoying bustling, democratic recreational spaces set him apart from the

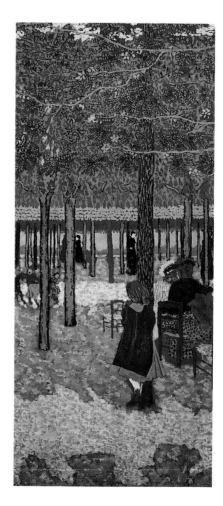

Fig. 146 Edouard Vuillard. *Under the Trees*, 1894. Glue-based paint on canvas, 84¼ x 38 in. (214 x 97.8 cm). The Cleveland Museum of Art, Gift of the Hanna Fund 53.212

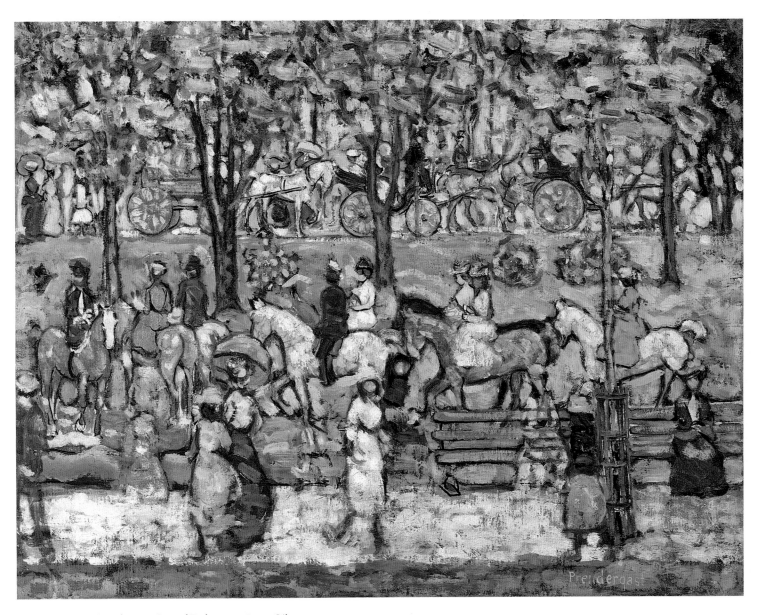

Fig. 147 Maurice Prendergast. *Central Park*, ca. 1908–10. Oil on canvas,
20¾ x 27 in. (52.7 x 68.6 cm). The Metropolitan Museum of Art, New York,
George A. Hearn Fund, 1950 50.25

Boston School of artists in expressive terms, as his Roman Catholic, working-class background set him apart from them in personal terms. The Boston School—Edmund C. Tarbell, Joseph Rodefer DeCamp, and Frank W. Benson, in particular—celebrated their Brahmin patrons' values, socialized with and emulated these aristocrats, and, accordingly, preferred to depict upper-class, cloistered, solitary women in refined interiors or in the private resorts that the wealthy visited. Prendergast, on the other hand, was attracted to more modern women, newly independent and situated in new spaces—the public parks—which were perceived at the turn of the century as important components and signifiers of American democracy.[96]

In his *Large Boston Public Garden Sketchbook* (see fig. 148), Prendergast recorded in watercolor, pencil, and pen-and-ink vignettes of the Boston site between 1895 and 1897.[97] His portrayals of it in this sketchbook suggest that he was aware of resonances between places he had visited or seen depicted in Paris and this American park, but that he was sensitive to the Public Garden's specifically American and Bostonian traits and to its importance as a setting for every kind of small domestic

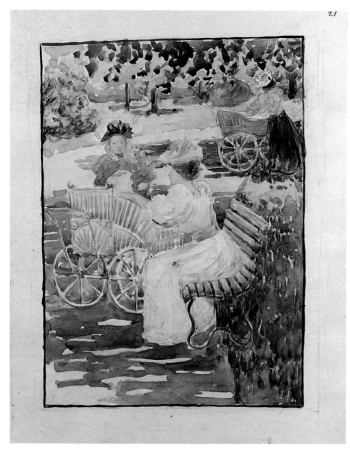

Fig. 148 Maurice Prendergast. *Large Boston Public Garden Sketchbook*, p. 21r, 1895–97. Watercolor over pencil on paper, 14¼ x 11¼ in. (36.2 x 28.6 cm). The Metropolitan Museum of Art, New York, Robert Lehman Collection, 1975 1975.1.944

incident. Prendergast's Public Garden studies reflect this urban park's appeal to mothers and nurses who pushed baby carriages along its walkways; to pretty and fashionably dressed young women who showed off their finery on sunny afternoon strolls or sat on its characteristic slat benches (rather than on the chairs that furnished the Tuileries); to children who played games, rode tricycles, explored its paths, and sat and climbed by its pools and fountains; and to visitors of all ages who found in it a refuge from the clamor of Boston's streets. Prendergast also features in many of these studies the Public Garden's botanical treasures, which were a source of great pride to contemporary observers.

Travel in Italy in 1898 and 1899 reinforced Prendergast's predilection for city imagery, especially for Venetian piazzas and processions. During visits to New York between 1900 and 1903 he portrayed Central Park in a number of delicate, richly detailed watercolor impressions. In *Central Park*, his only oil painting of the site, Prendergast condenses the sort of episodes that he had explored in individual sheets of the *Large Boston Public Garden Sketchbook* and reiterates the vocabulary of architectural armatures and lively processions that had characterized his Venetian watercolors. The painting, which has been titled *Central Park in 1903*, may record a scene of that year. It includes women in dresses and hats whose silhouettes were popular at that date and among vehicles shows neither bicycles nor automobiles but only the horse-drawn carriages that still would have dominated park transport in 1903. Yet the mastery of technique suggests that Prendergast reworked the picture five or more years after its original execution; a date as late as 1914–15 has recently been proposed for it.[98] If the painting is a retrospective vision, Prendergast may be said to have followed Chase in providing a nostalgic view that emphasizes the park's earlier, more genteel aspect and ignores the overcrowding about which commentators increasingly complained as the twentieth century unfolded.

However, by comparison with any of Chase's park scenes—and with Glackens's *Central Park in Winter* as well—Prendergast's *Central Park* is a livelier distillation of the site's flavor. The artist uses dense and opaque oil pigments to develop blunt juxtapositions of complementary colors and to tease the viewer's eye with complex proto-Synchromist whirls of form. Yet he tempers any sense of disorder by coordinating the impression of energy with flat decorative patterns disciplined by broad horizontal bands that emphasize the two-dimensional plane of the canvas.

These bands also comment on the fundamental landscape architecture of the park. Olmsted and Vaux had laid out corridors to separate the various forms of traffic to see "that the enjoyment of one class of visitors must not be allowed to interfere with that of any other" and especially to insure a quiet, meditative experience of beautiful nature.[99] They provided trans-

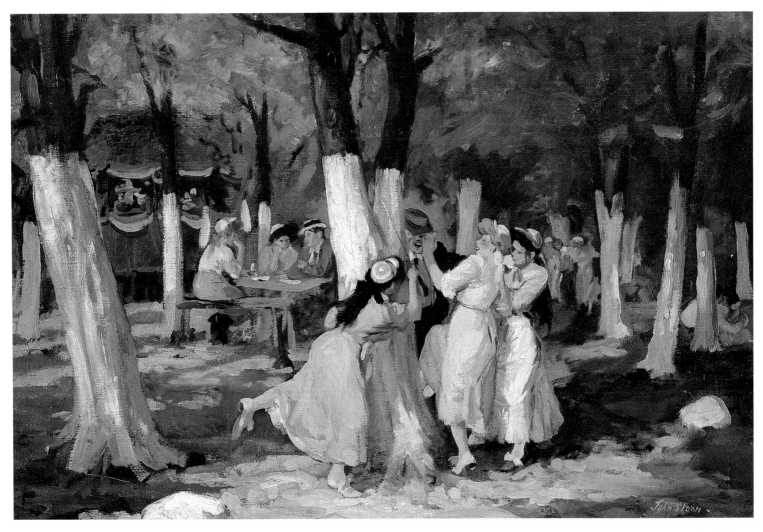

Fig. 149 John Sloan. *The Picnic Grounds*, 1906–7. Oil on canvas, 24 x 36 in.
(61 x 91.4 cm). Whitney Museum of American Art, New York, Purchase 41.34

verse traffic roads for crosstown access by practical vehicles and,
within the park, a tripartite system of circulation accommodat-
ing carriageways, bridle paths, and footpaths.[100]

In *Central Park* Prendergast diagrams part of the system of
pathways. He ignores the utilitarian transverses but shows
pedestrians, horseback riders—principally women in still fash-
ionable sidesaddle costumes—and carriages segregated in three
successive horizontal bands.[101] Equestrian traffic dominates and
attests to the keen interest that park driving and horseback
riding evoked in the period. According to a writer of 1905, eight
thousand to ten thousand horses graced the park every day in
spring and autumn, and the most extravagant equine display was
associated with "that impressive pageant which is put on each
afternoon between the hours of four and seven, and which is
fondly and frequently referred to by the newspapers as 'the
fashionable Park parade.'"[102] It is the spirit and energy of that
parade that infuses the surface of Prendergast's canvas. Nature,
which had become increasingly restricted in Chase's park im-

ages, here is reduced to a few tree trunks that punctuate the
composition at intervals, acting like bar markers on a musical
staff in which the notes are the curved shapes of strollers, horses,
and carriage wheels. If there is a musical analogue to the
painting, it is a lively march, not a stately pavane!

By contrast with the relatively elegiac mood of Glackens's
Central Park in Winter and even with Prendergast's lively, if
nostalgic, *Central Park*, John Sloan's *Picnic Grounds* (fig. 149)
resounds with raucous energy. It is upon this sort of urban genre
painting that critical esteem for Sloan's art largely rests. The
scene is a public park in Bayonne, New Jersey, across the Kill van
Kull from New York City. Sloan's diary tells us that he had made
a visit there on May 30, 1906, Decoration Day, and "watched
picnic grounds, dancing pavilion, young girls of the healthy lusty
type with white caps jauntily perched on their heads" and also
that on June 2 he had "started painting a memory" of the
place.[103] Many years later, in 1939, in his book *Gist of Art*, he
wrote again of the "scene in which these adolescent boys and

girls frolic like bear cubs," remarking on "the grin that surrounds the golden tooth" of the young man who appears behind the central tree and complimenting himself on the painting's "fine greys and whites" and "easy, active graphic character of execution."[104]

Although Sloan did not complete *The Picnic Grounds* until February 1907, his vigorous brushwork bespeaks a rapid execution that echoes the spontaneous mood pervading the scene and animating the youngsters who are portrayed on their holiday outing. The bandstand in the left background is decorated with patriotic bunting. A young man and two young women in the middle ground sit quietly at a picnic table on which the remnants of their meal are scattered. A second group, in the foreground, consists of three girls "of the healthy lusty type" who cavort and flirt with the gold-toothed young man. The skirts and blouses and garish makeup of these more active girls identify them as working class; their short skirts indicate that they are no more than fifteen years old. They sport caps of the sort worn by cricket players, which emphasize their energy and suggest that their flirtation is another sort of game. The object of the girls' attentions raises his left arm to hold off their advances and takes shelter behind the central tree. As Patterson Sims has observed: "By comparison with the conventional, contemporary depictions of women—perceived as silent, confined, and inactive—Sloan's females are communicative, joyous, and lively. *The Picnic Grounds* was conceived in a democratic spirit: whether talking or at play, the men and women are treated as equal beings, co-workers delighting in a special day off."[105] Certainly Sloan's women are liberated from the genteel behavior to which they had been assigned not only by Chase but also by Glackens and even Prendergast in their own portrayals of urban parks.

The Urban Landscape Made Beautiful

[A] shabby corner . . . is not unpicturesque when veiled by night and a rainstorm.

MARIANA GRISWOLD VAN RENSSELAER (1892)

If the whole thing were only covered with snow and made beautiful.

JOHN H. TWACHTMAN (1902)

When, in the 1890s and early 1900s, the repatriated American Impressionists and the American Realists settled in the cities, especially New York, they confronted increasingly unattractive evidence of extreme urban growth and change. Drawn to urban imagery nonetheless, the American painters of modern life, as we have seen, often chose to portray the parks: these urban venues offered some relief from cities that were perceived as "too big, too built up, too crowded, diseased, polluted, artificial, overly commercial, corrupting, and stressful."[106] The American Impressionists in the city also took refuge from the heart of the too-challenging metropolis by depicting urban panoramas, especially the expanses of the forty-four miles of waterfront that surrounded New York City.[107] Encoding the city's power, activity, and new technology within a pastoral tradition, they painted some of their most exceptional and successful works in these sweeping views that captured New York's monumentality from a distance and juxtaposed natural features with constructed and invented elements. In such modern landscapes the American Impressionists obeyed the same escapist inclinations that motivated their scenes of the unspoiled or gently domesticated countryside and of urban parks.[108] For they tended to show the city "made beautiful" by romantic night light; by a veil of haze, rain, or snow; or by an editing that eliminated or ameliorated ugly features. The American Realists broke only gently with this pattern of urban euphemism, and they reveal in their urban landscapes, as in their park scenes, complex continuities and contrasts with analogous works by their American Impressionist predecessors.

Willard Metcalf's rare New York pictures are a case in point. Two of them, *Battery Park, Spring* and *Early Spring Afternoon —Central Park* (figs. 150, 151), offer bird's-eye views of city parks, where greenery, sky, and water balance or mitigate such signs of modern progress as the railroad and the skyscraper. In *Battery Park, Spring* the artist places some of the new realities of the city at the heart of his composition and demonstrates, as a contemporary critic put it, "the pictorial interest that resides in familiar things."[109] He acknowledges two very dissimilar realms in his juxtaposition of railroad and park. This dichotomy is underscored by differences between his treatment of the elevated railroad, which is depicted in dark earth tones applied with breadth and fluidity, and of the park, which is represented in bright greens and yellows brushed on in light, feathery touches that recall the colors and strokes used in his New England landscapes.[110] The elevated railroad track twists through the center of the painting (as it did through the park) and comes to an abrupt end, cut off by the picture's edge; the train, puffing smoke, wends its way toward riders who congregate at its next stop; and in the distance the mercantile activity on the river is suggested by boats, barges, and piers.

Battery Park, a slice of green along the Battery, on the southern tip of Manhattan, had undergone a series of transformations between the time it was laid out as a public park at the end of the seventeenth century and the year Metcalf painted it.[111] This is an area with a past: "New York was born here at the water's edge, on the Battery," which was a place associated with "historical events and past social splendors," explained a com-

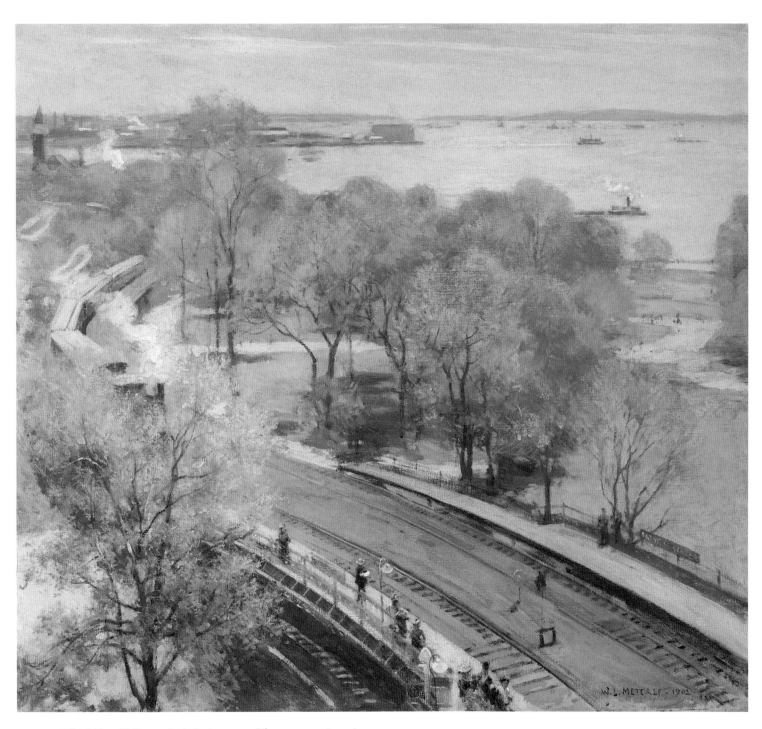

Fig. 150 Willard Metcalf. *Battery Park, Spring*, 1902. Oil on canvas, 26 x 29 in. (66 x 73.7 cm). Private collection

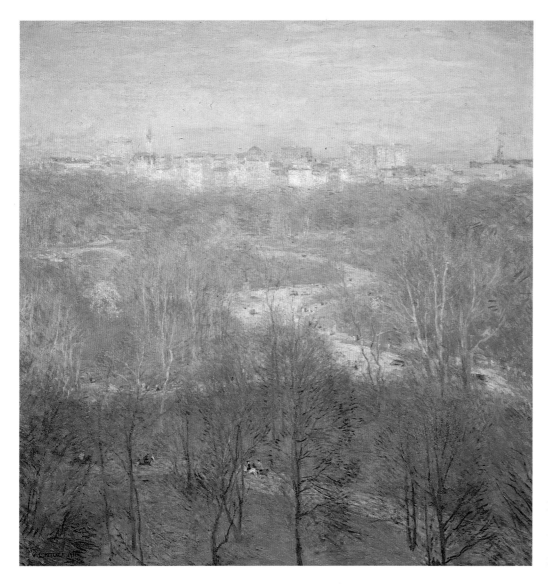

Fig. 151 Willard Metcalf. *Early Spring Afternoon—Central Park*, 1911. Oil on canvas, 36⅛ x 36 in. (91.8 x 91.4 cm). The Brooklyn Museum, New York, Frank L. Babbott Fund 66.85

mentator in 1886.[112] The Battery's heyday was the second quarter of the nineteenth century, when Castle Garden, originally a fort, was converted to a summer garden and concert hall that featured such celebrities as soprano Jenny Lind and productions mounted by impresario P. T. Barnum. As fashionable New York moved farther uptown, Castle Garden fell upon hard times; in 1855 it became an immigration station that processed some 8 million people under disgraceful conditions.[113] Until 1890, when an investigation revealed abuses at Castle Garden, the Battery was often filled with recent arrivals like those depicted by Charles Ulrich in his *In the Land of Promise—Castle Garden* (fig. 1); their presence, thought Viola Roseboro, gave the park "an air of heterogenious [*sic*] foreignness whose catholicity is unsurpassed by even the *mise en scene* of an average comic opera."[114]

Even after Castle Garden ceased to process immigrants, Battery Park remained a haven for New York's lower classes, including many of the newly settled residents of the Lower East Side, who could not escape to the country. Describing this

particular park as "most attractive," Mariana Griswold Van Rensselaer catalogued its benefits in 1901: "Battery Park ... is always cooled by the breath of the sea, and it shows in the foreground a cosmopolitan variety of human types, in the background a splendid stretch of dark-blue water and innumerable swiftly moving lights."[115] Metcalf's distant vantage point makes it impossible to determine the class or ethnic background of the riders waiting on the platform or to guess the sociocultural connections of the few figures shown on the lawns and paths beyond. But these details do not concern the artist; instead the verdant landscape, the river, and the modern modes of transportation that cross them are clearly his principal subject.

Metcalf the euphemist ignores not only the immigrant types who flocked to the Battery but also the park's new popularity. For in 1902, the year he painted the park, Castle Garden, which had been operating as an aquarium for six years, was taken over by the New York Zoological Society, a change that greatly enhanced its appeal as a tourist attraction. Of this development

Metcalf's sparsely peopled lawns offer no hint. Also in 1902 the elevated railroad, which had encroached on the park since 1877, was electrified, eliminating the "noisy little coal-burning locomotives"[116] that had previously disturbed the park's tranquillity. Perhaps nostalgic impulses, so important to the American Impressionists, motivated Metcalf to record the older smoke-puffing steam locomotive before it passed away in the face of progress. New Yorkers were ambivalent about the railroad in the Battery, and Metcalf felt impelled to soften its dark presence in his canvas with greenery. Although one writer of 1891 detested the railroad enough to castigate it as "the Elevated snake" and "a menace to the loveliest spot in the City,"[117] the critic James Huneker, writing in 1915, accepted it as "ugly but characteristic." But Huneker was associated with the Realists, the artistic successors of Metcalf and the other American Impressionists, and he revealed the changes in taste that separated the two generations of painters of modern life when he confessed his attitude toward the park and its intruder: "I'm afraid I can't see in our city anything downright ugly—it is never an absolute for me; as Dostoievsky said, there are no ugly women."[118]

Much more euphemistic with respect to urban realities than the typical Realist response is Metcalf's *Early Spring Afternoon — Central Park*, painted from the window of the artist's apartment on Central Park West. The scene recalls earlier works by Metcalf's friend Hassam, who moved to New York from Boston about the same time as Metcalf did. For such paintings as *Union Square in Spring* (fig. 171) Hassam had adopted an elevated vantage point (which he in turn had borrowed from Monet and other French Impressionists), suggesting the activity of the park only from a distance and diminishing the size of the tall buildings surrounding it by keeping them in the background, beyond an ingratiating pattern of grass and trees. Metcalf employs the same strategy in his view of Central Park: although his site was less challenged by the incursion of high buildings than the Union Square that Hassam had painted fifteen years earlier, Metcalf takes no chances in his apparent attempt to preserve as rural an aspect in the scene as possible. He keeps the distant buildings lining Fifth Avenue shrouded in haze and focuses on a screen of budding trees and a series of lawns, paths, areas of water, and patches of foliage to suggest walking, horseback riding, or rowing—some of the many leisure activities New Yorkers could pursue in the park. Wrote Huneker of the painting a year after its completion: "The air is lazy, it shimmers in the distance.... You seem to be gazing upon the shapes of some remote Eastern city, with its palaces rearing skyward, its turrets, minarets, and mosque.... The entire picture is bathed in mystery, and it is hard to realize that it is the familiar New York."[119]

When the painters of modern life found their subjects on the edges of Manhattan Island, they sometimes looked out toward its surrounding rivers and captured the appearance of areas where the conflict between nature and human intrusion in the landscape is most evident. Between 1910 and 1915, for example, Ernest Lawson devoted himself to subjects such as that portrayed in *Spring Night, Harlem River* (fig. 152), which shows Washington Bridge, spanning the Harlem River at 181st Street, between Manhattan's Washington Heights and the Bronx, at a height of some 110 feet.[120] This was one of many bridges, tunnels, and subways that connected Manhattan Island and the Bronx, Brooklyn, and Queens, which had been consolidated in 1898, along with Staten Island, and it served traffic that was by 1913 largely motorized.[121] The wide arches of Washington Bridge, built between 1887 and 1889, made it an engineering feat that from the first attracted the interest of documentary photographers, among them William Henry Jackson. Jackson recorded the bridge's appearance only a year after its completion (fig. 153).

Unlike the photographers, Lawson has depicted the structure of stone piers and steel arches with an eye guided more by the pursuit of drama and design than by topographical accuracy. Looking east toward the Bronx from the sloping bank of the river on the Manhattan side, Lawson portrayed the bridge at an angle that dramatically foreshortens its second span. This span springs from piers on the Bronx shore and supports the roadway that carries traffic over railroad tracks along the river's edge. The painter also virtually eliminates a series of masonry arches that links this span to the bluff, and he edits out the speedway beneath the bridge, as well as the paths and stairways used by strollers seeking relaxation (see fig. 154). Lawson's artistic intervention is made evident by comparing his picture with a fuller, more informative—and more mundane—account of the subject written by Walter Prichard Eaton two years after the painting was completed: "In front of us the bridge leaves the bank by three stone arches before the first steel span makes its leap. Above these arches roll trolley cars and motors and carriages and drays, with a ceaseless procession of pedestrians beside the rail. The great structure is doing its appointed work."[122] The appointed work is hardly apparent in Lawson's portrayal; even the buildings that have invaded this formerly rural area to line the shore and punctuate the distant bluff are barely visible in the cool blue moonlight that bathes the scene and evokes a decidedly romantic mood.

Although Lawson exhibited his paintings with the rebellious Eight, his style and his treatment of landscape subjects such as *Spring Night, Harlem River* ally him closely to the older American Impressionists, particularly his teachers Weir and John H. Twachtman. Like them, he idealized aspects of modern industry and transportation, showing bridges and rail lines that coexist harmoniously with the surrounding landscape. Weir's *Red Bridge* and *Bridge: Nocturne (Nocturne: Queensboro Bridge)* (figs. 69, 155) provide, respectively, a rural and an urban analogue to Lawson's painting of Washington Bridge. In the New York scene

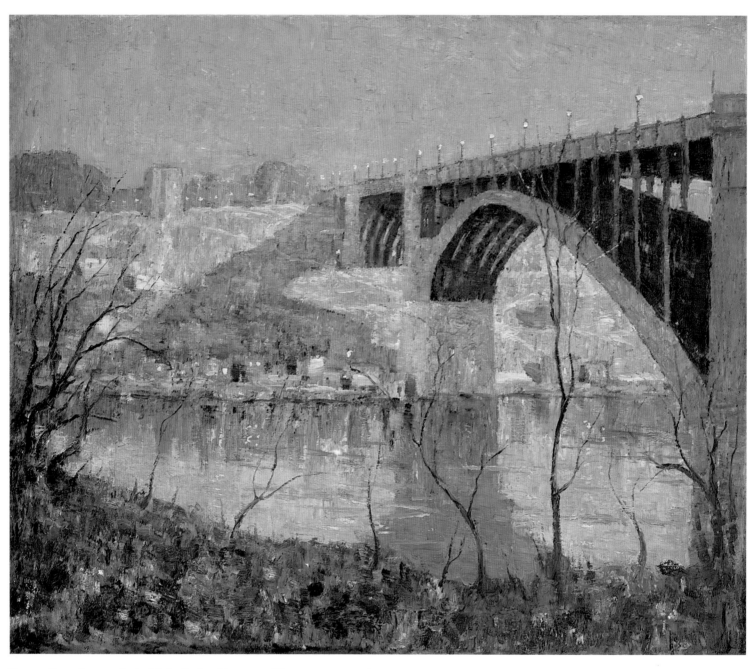

Fig. 152 Ernest Lawson. *Spring Night, Harlem River*, 1913. Oil on canvas mounted on wood, 25⅛ x 30⅛ in. (63.8 x 76.5 cm). The Phillips Collection, Washington, D.C. 1191

Fig. 153 William Henry Jackson, *The Harlem River*, ca. 1895. Photograph, 16⅝ x 22 in. (42 x 55.9 cm). Museum of the City of New York, Donated by Miss Bartlett Cowdrey 48.61.2

Fig. 154 Washington Bridge and the Speedway— Harlem River looking south, from Jesse Lynch Williams, "The Water-Front of New York," *Scribner's Magazine* 26 (October 1899), p. 396

Fig. 155 J. Alden Weir. *The Bridge: Nocturne (Nocturne: Queensboro Bridge)*, ca. 1910. Oil on canvas mounted on wood, 29 x 39½ in. (73.7 x 100.3 cm). Hirshhorn Museum and Sculpture Garden, Smithsonian Institution, Washington, D.C., Gift of Joseph H. Hirshhorn, 1966 66.5507

Weir reduces the visual diversity of the city to a nearly abstract pattern: blue darkness and yellow lights representing illuminated rectangles of windows on the buildings; flashing headlights implying movement in the street below; and twinkling dots of light outlining the distant bridge that crosses the East River, linking Manhattan to Queens.

Moreover, Lawson shares with Weir a poetic and Whistlerian approach to the urban scene; significantly, both artists show their bridges at night. Van Rensselaer's appreciation of nocturnal views of the city, published in 1892, announces the romantic reasons that Weir and other American Impressionists—including latter-day practitioners such as Lawson—chose to paint the city after dark: "The abrupt, extraordinary contrasts of its sky-line are then subdued to a gigantic mystery; its myriad, many-colored lights spangle like those of some supernally large casino; and from the east or south we see one element of rare and solemn beauty—the sweep of the great bridge, defined by starry sparks, as though a bit of the arch of heaven had descended to brood over the surface of the waves."[123]

Duncan Phillips, an early collector of the work of Lawson, as well as that of Twachtman and Weir, perceived that these three painters possessed similarly poetic and subjective temperaments and compared them to their French predecessors. "Lawson, profiting by Monet's experiments, loves the seasons and their lights for the sensations and emotions which they give," noted Phillips in 1917.[124] Here he touched on a devotion to portraying the changing times of the year that Lawson shared with other turn-of-the-century painters who sought the reassurance that the cycle of nature provided in the face of increasingly unpredictable modern life. Phillips continued, "Lawson composes his colors as a romantic composer co-ordinates the orchestral strings, woodwinds, and brasses, upon the varied tones of which he builds his symphony."[125] This choice of a musical analogy is a reminder of the artist's admiration for the nocturnes of Whistler, an admiration made particularly evident by the use of a tonal blue palette accented with flickering touches of yellow in *Spring Night, Harlem River*. Certainly this picture fulfills Whistler's dictum that the painter must create art for art's sake more effectively than it responds to Realist Robert Henri's insistence upon art for life's sake.

George Luks's *Roundhouse at High Bridge* (fig. 156), another view of the Harlem River, also draws on the Whistlerian tradition.[126] The vantage point for this panorama is the western end of High Bridge at 170th Street and the Harlem River, the body of water that separates Manhattan's Washington Heights from the Bronx. Luks stood on High Bridge, which was built between 1839 and 1848 and carried the old Croton Aqueduct across the river to Manhattan, looking south; Washington Bridge, Lawson's subject, was a third of a mile farther to the north, behind him.

Across the river to the south, the Putnam (or Sixth Avenue) Railroad drawbridge at 161st Street and MacComb's Dam Bridge at 155th Street are merely suggested by Luks. At the left of the composition, closest to the artist's vantage point, is High Bridge Station on the New York Central and Hudson River Railroad with its freight yards. Luks portrays the station as an imposing structure with at least two high domes. The roundhouse referred to in the picture's title occupied an area that ran from about 166th Street south to 164th Street.[127] The precise location of this roundhouse was of little interest to the artist; in the painting he reduces it to a dark silhouette that barely emerges against the billowing plumes of white and gray smoke generated by the steam engines. A dense industrial haze fills the purple and dull blue sky. Thus it is difficult to determine whether Luks exaggerates the proximity of the roundhouse to High Bridge, as he exaggerates the curve of the river or whether the painting would be more accurately entitled *High Bridge Station*.

Although no vehicular traffic was possible on High Bridge, a guidebook of 1892 reported that "there is a wide walk for foot-passengers, who are numerous in summer-time, attracted by the beautiful view, and the enjoyment of the park and picnic grounds at each terminus, and the open country at the eastern end."[128] Clearly Luks eschewed recording pleasures or picnics, bright light and sunshine in his account of the site. Yet in choosing to portray atmospheric effects, he did not entirely reject what an Impressionist might have found attractive at High Bridge. Luks reveals his debt to the technique of the previous generation as well, for he applies his paint in delicate washes of color and enlivens the surface with feathery scumbles representing the dissipating smoke. His technique and his dark tonal palette, accented with a few bright notes of color—the red service truck in the lower left and the reddish glow through the station windows—recall Whistler in particular.

By 1913 Luks moved into a studio-residence in upper Manhattan that was a five-minute walk from High Bridge Park. Thereafter the area he had portrayed in *Roundhouse at High Bridge* would become very familiar to him and would inspire him to paint such urban landscapes with increasing frequency. Although his new neighborhood was blessed with a parklike atmosphere, according to his friend Huneker,[129] it did not appeal to him as a subject, and he pursued instead broader views of the city on the outskirts of his comfortable community.

George Bellows, a student of both Henri's and Chase's, also turned his attention to New York's rivers and waterfront life. Beginning in 1908 he executed a series of pictures in which he shows the Hudson River as seen from Riverside Park. These landscapes, painted while the artist was exhibiting more daring views of the excavation of Pennsylvania Station, won him favor with the less progressive members of his audience. Yet they are

Fig. 156 George Luks. *Roundhouse at High Bridge*, 1909–10. Oil on canvas, 30⅜ x 36¼ in. (77.2 x 92.1 cm). Munson-Williams-Proctor Institute, Museum of Art, Utica, New York 50.17

Fig. 157 George Bellows. *Rain on the River*, 1908. Oil on canvas, 32¼ x 38¼ in.
(81.9 x 97.2 cm). Museum of Art, Rhode Island School of Design, Providence,
Jesse Metcalf Fund 15.063

connected to the excavation scenes by their subject: in both sequences Bellows addresses the modernization of the city through the improvement and enlargement of the railroad system.[130] Most of his Hudson River scenes stress the broad expanse of the river and the Palisades opposite, but in *Rain on the River* (fig. 157) the primary focus is the rocky terrain of the park and the constructed elements of the city and their encroachment on the landscape.[131]

Bellows painted this view of the park along the edge of the Hudson River from Riverside Drive in December 1908. In composing it Bellows could easily have been inspired by Metcalf's portrayal of Battery Park (fig. 150), which had been featured in the 1903 exhibition of The Ten. Metcalf and Bellows place equal emphasis on the train, a symbol of modernity, and both divide their compositions roughly in half along the bold diagonal of train tracks. Although he was a dedicated member of the Ashcan School, Bellows had close ties with Metcalf's generation of artists; in particular his connections were with Chase, who, as we have seen, was a devoted painter of the urban scene in the 1880s and depicted not only the parks of Brooklyn and Manhattan but also waterfront images.

As early as 1900 Sadakichi Hartmann had proclaimed that Riverside Park, designed by Olmsted in 1873, offered "a picture genuinely American in spirit" and had called attention to its comfortable juxtaposition of old and new elements, traits that would have attracted Bellows to the site: "Old towering trees stretch their branches towards the Hudson. Almost touching their trunks the trains on the railroad rush by. On the water, heavily loaded canal boats pass on slowly, and now and then a white river steamboat glides by majestically."[132] When Bellows painted *Rain on the River*, Riverside Drive, then the largest parkway along Manhattan's West Side, was being extended northward, with construction nearing completion after four years of effort. Plans included funding for the roadway itself and for two promenades, a bridle path, and landscaping.[133] The next year, 1909, the park was lauded as an especially effective place from which to view the Hudson-Fulton Celebration Parade, and although Bellows is not known to have attended this well-publicized event, its occurrence would have reinforced his interest in Riverside Park and the vistas it offered of the mighty Hudson River.[134]

The broader appeal of the park for Bellows has been articulated eloquently by Marianne Doezema:

> Riverside Park exemplified the modern aspects of life in this twentieth-century city. The park was new and a particular object of civic pride. But it was more than just new: it was distinctly marked by the modern age, in the form of the railroad. Furthermore, the park itself was a slice of land strategically situated at the junction not only of the city and the Hudson, a major commercial thoroughfare, but also Manhattan and suburban regions to the north. The city side of the park, along Riverside Drive, was a site of rapid change and development. Such an area would naturally have attracted the attention of seekers after the new, the dynamic, the pulse points of urban energy.[135]

Bellows's representation of Riverside Park in *Rain on the River*, which celebrated these innovative elements—the smoking train, the commercial piers, the boats that pass on the river—is distinctly more modern than the picture offered in the bucolic descriptions of the park penned by less adventuresome contemporaries. For example, a writer of 1900 enthused: "Along Riverside Drive one may discover a new country by descending from the gravelled or asphalt pavements upon the daisied banks that run down to the river. . . . There are rural features about Riverside. Butterflies flit about, eluding children who pursue them. Birds (alas! chiefly sparrows!) people the trees that here are large and umbrageous."[136]

Bellows shows the park under unpleasant weather conditions—shrouded by fog under leaden, rain-filled sky instead of blanketed by beautifying snow. Thus it is not merely modern but downright uninviting as well. He emphasizes the site's loneliness and inaccessibility by filling the raised foreground of his composition with mammoth rocks that cut off any approach and working in a dark palette to convey the cheerless mood of the overcast day. A single figure braves the wet winds from the river, walking purposefully along the icy path with little in the way of natural beauty and no opportunities for pleasant recreation to tempt dalliance. Most of the action is in the area defined by the diagonal line of the river's edge and the railroad tracks that run along it. There a freight train passes, belching smoke that blends with the haze that hangs over the river; closer to the water's edge small figures load a horse-drawn cart; and on the river a few boats make their way to their destinations over icy water. The park fills half the canvas but seems to offer little relief from work or weather.

The artist's biographer Charles Morgan observed of *Rain on the River*: "No picture of his ever expressed more forcibly the surge of the city toward its water-bound limits."[137] Nevertheless, Bellows's choice of Riverside Park, where the impressive view of the Hudson is interrupted by railroad tracks and docks, draws attention to the often uneasy truce between the land and the river, between the city's business and its much needed recreational spaces.

Bellows provides another wintertime view of Riverside Park in *A Morning Snow—Hudson River* (fig. 158). Here we are closer to the river, on a rise above a pathway at its edge. The green benches, predictably empty in wet and chilly weather, remind us of the recreational purpose of the park. The benches are separated from the workaday world of the docks along the

Fig. 158 George Bellows. *A Morning Snow—Hudson River*, 1910. Oil on canvas, 45⅜ x 63¼ in. (115.3 x 160.7 cm). The Brooklyn Museum, New York, Gift of Mrs. Daniel Catlin 51.96

river's edge only by a low metal railing, a dark green line of demarcation across a field of brilliant white snow. The distant figures—two on a dock near the building and boat at the left and eight trudging toward the pile driver on the right—are represented summarily, with a few masterful strokes of pigment that convey the impression of their limbs, posture, and movement. The three principals in the foreground—a boy with an adult companion and a worker—are more fully realized, but even they are simplified radically. The face of the child is effectively reduced to a swirl of ocher pigment, and rapid, unmodulated touches of color—yellow, pink, flesh, and blood red—suggest the features of the man next to him. The stooped figure at the lower left seems to be clearing a path for these two pedestrians, whose leisurely pace contrasts noticeably with the gait of the men who struggle toward their work over snowbound terrain. The leafless trees and lifeless foliage and the frozen expanse of river water and snow, scarred by dirty tracks and crossed by blue shadows, that fills the center of the composition underscore the deadening effect of the season.

Bellows heightens the sense of emptiness conveyed by the barren underpopulated view by relegating most of the tall vertical elements to the edges of the canvas—he groups the tree trunk and the masts of the docked boat on the left and the pile driver and cluster of tree trunks on the right, leaving the center open. These vertical features and the regularly spaced horizontals of the path, the metal railing, the wooden pylons along the dock, the edge of the ice, the band of cold river water, and the opposite shore create a gridlike compositional structure.[138] Here, as in other paintings, Bellows utilizes a geometric armature that is at odds with the spontaneity and richness of his painting technique. Some creamy pigment is applied with a broad flat brush, even slapped on vigorously with a palette knife. The surface is heavily textured: long ridges of paint duplicate the striations of bark on the tree trunks; the bushes at the right are represented additively with paint laid on with brush and palette knife and subtractively with a pattern of calligraphic lines gouged into wet pigment with the wooden end of a brush; and in many areas lumps and drips of pigment with no representational meaning add to the visual impact of *A Morning Snow—Hudson River* without explicating its subject.

Although far from poetic—as Metcalf's *Early Spring Afternoon —Central Park* or Lawson's *Spring Night, Harlem River* might be said to be—Bellows's Realist urban landscapes are, like their American Impressionist counterparts, the products of a vision that is perfectly satisfied to find inspiration in the periphery of the modern city, rather than to plunge into its chaotic center, and willing to invent selective and fundamentally artistic analogues to the actualities of experience, rather than to offer simple transcriptions.

Beauty Removed from Urban Realities: Hassam on the Boulevards of Boston, Paris, and New York

I lived in Columbus Avenue in Boston. . . . I was always interested in the movements of humanity in the street, and I painted my first picture from my window.

CHILDE HASSAM (1892)

I believe the thoroughfares of the great French metropolis are not one whit more interesting than the streets of New York.

CHILDE HASSAM (1892)

As they had for their portrayals of parks and waterfront panoramas, the American painters of modern life found inspiration for other cityscapes in the works of the French Impressionists. A few even pursued urban projects during their student years in Paris, despite the pressure that most felt to adhere to academic standards, not only of technical execution but also of subject choice. Among these more daring Americans, Hassam was probably the most attuned to modernist urban imagery during his formative years. City scenes painted throughout his career celebrate characteristic vignettes of contemporary Boston, Paris, and, ultimately, New York and express the American Impressionists' tenacious devotion to genteel, optimistic, euphemistic, and nationalistic interpretations of modern life.

Hassam had begun his career as a newspaper and magazine illustrator and as a watercolorist in the early 1880s and had developed his oil-painting style through a variety of encounters with art and artists in Boston and in various European locales. In a series of relatively academic large-scale, tonal canvases painted in Boston about 1885, Hassam disclosed an interest in urban life, possibly under the influence of such popular Salon painters as de Nittis and Béraud, whose works he may have seen during a visit to Europe in 1883 (see figs. 131, 161).[139]

Boston's dramatic growth in the second quarter of the nineteenth century was attributable to the arrival of great waves of immigrants, large numbers of whom were Irish. Destitute and often in poor health, crowds of newcomers settled in the North End and Fort Hill, quickly transforming these established neighborhoods into slums and driving out more prosperous residents. To accommodate those who were displaced, two huge landfill projects were initiated: the South End (begun in 1850) and the Back Bay (begun in 1857).[140]

Both of the new districts contrasted dramatically with Boston's older neighborhoods, such as Beacon Hill, in their grid plans, their flatness, and their long avenues. Columbus Avenue, laid out in 1869, was the South End's main thoroughfare. Like

Fig. 159 Childe Hassam. *Rainy Day, Boston*, 1885. Oil on canvas, 26⅛ x 48 in.
(66.4 x 121.9 cm). The Toledo Museum of Art, Purchased with funds from the
Florence Scott Libbey Bequest in Memory of her Father, Maurice A. Scott 1956.53

Commonwealth Avenue, the east-west axis of the Back Bay, it
embodied and expressed the new Boston. Designed to emulate
the boulevards of Haussmann's new Paris, Columbus Avenue
was lined with handsome swell-front red brick houses with high
stoops and mansard roofs, its regularity punctuated with an
occasional church spire. King proclaimed in 1881 that the street's
great width made it "one of the finest thoroughfares in Boston."[141]
Although, like the Back Bay, the South End had been intended
for fashionable housing, it lost its luxurious air late in the cen-
tury, when private dwellings were converted to lodging houses.

Asked in 1892 how he had begun painting street scenes,
Hassam recalled: "I lived in Columbus Avenue in Boston. The
street was all paved in asphalt, and I used to think it very pretty
when it was wet and shining, and caught the reflections of
passing people and vehicles. I was always interested in the
movements of humanity in the street, and I painted my first
picture from my window."[142] Typical of his early Boston street
views is *Rainy Day, Boston* (fig. 159), which features Columbus
Avenue. Here Hassam depicts the junction of the avenue, leading
toward the Common in the far left background of the painting,
and Appleton Street, running toward the right. The site, near the
intersection of Warren Avenue, was not far from Hassam's
residence at 282 Columbus Avenue, on the left side of the block

across the street from the Second Universal Church, whose spire
is visible in the picture's background.[143]

The choice of an unusual compositional strategy and a wet
day as a subject suggests that *Rainy Day, Boston* may have been
motivated by a desire for formal experimentation with a pano-
ramic view of the joining of two streets, which leaves the central
foreground empty, and rainy weather, which requires a masterly
control of a narrow tonal palette. The fact that Hassam painted
the same scene again from a closer vantage point in *Columbus
Avenue, Rainy Day* of 1885 (Worcester Art Museum) would tend
to support the conjecture that formal experiment was an impor-
tant impulse for him. Perhaps Hassam sought in Boston a
plunging perspective reminiscent of those exploited in modern
Paris by Béraud in such paintings as *The Church of Saint-
Philippe-du-Roule, Paris* (fig. 161) or in a number of canvases
by Nittis. Caillebotte's masterpiece *Paris Street; Rainy Day*
(fig. 160) offers a provocatively similar analogue in terms of
subject and composition but is an unlikely prototype because it
was not on public display at any time Hassam could have seen it
in Paris. A comparison between Hassam's *Rainy Day, Boston*
and the Caillebotte points up the temperamental distance be-
tween what Hubert Beck has characterized as the harmonious
approach of the American to an "urban pastoral" and the

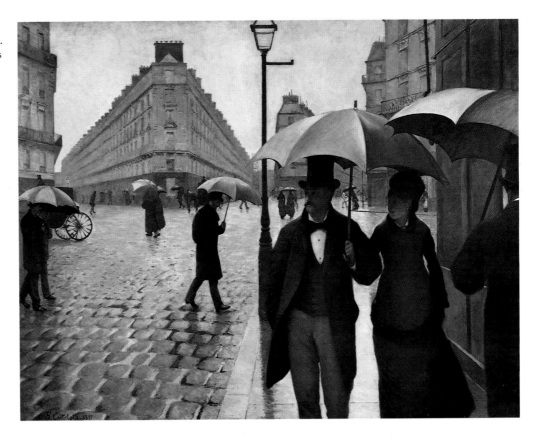

Fig. 160 Gustave Caillebotte. *Paris Street; Rainy Day*, 1877. Oil on canvas, 6 ft. 11½ in. x 9 ft. ¾ in. (2.1 x 2.8 m). The Art Institute of Chicago, Charles H. and Mary F. S. Worcester Collection 1964.336

Fig. 161 Jean Béraud. *The Church of Saint-Philippe-du-Roule, Paris*, 1877. Oil on canvas, 23⅜ x 31⅞ in. (59.4 x 81 cm). The Metropolitan Museum of Art, New York, Gift of Mr. and Mrs. William B. Jaffe, 1955 55.35

"fragmented and ambiguous" urban spaces described by the French painter.[144]

Although Hassam may have depicted this vast Boston intersection principally because he wished to explore formal problems and to emulate conservative contemporary French artists, he also suggests the truths of modern American city life, albeit more gently than Caillebotte. Broad avenues, including the unusually wide Columbus Avenue, typify the new Boston, in contrast to the older winding streets near the distant Common; the resulting spaces, outsize in their scale, challenge the pedestrian; strollers are isolated from one another, their heads turned downward as they try to avoid puddles, their self-containment reinforced by their individual umbrellas; and the gray of city asphalt is unrelieved by blue sky, sunshine, or treetop.[145]

In *Charles River and Beacon Hill* (fig. 162), Hassam would also interpret the Back Bay, the other paradigm of the new Boston, but only after he returned from studying in Europe and settled in New York. Boston's Back Bay is the 450-acre salt marsh that had been developed as the city's second landfill project. The residential district of the Back Bay, however, is limited to only about 200 of those acres.[146] With respect to its clarity and ambition, residential Back Bay ranks with Washington, D.C., as the outstanding example of nineteenth-century

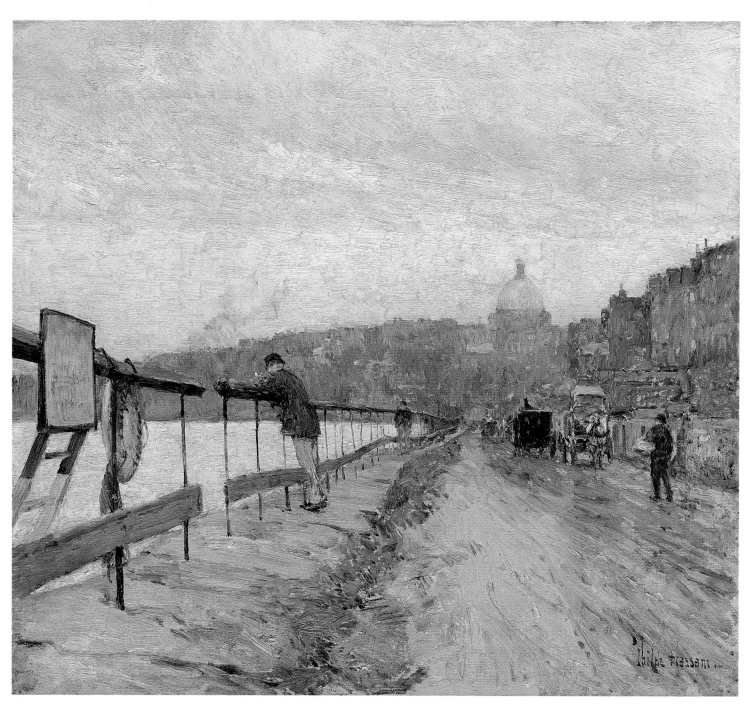

Fig. 162 Childe Hassam. *Charles River and Beacon Hill*, ca. 1892. Oil on
canvas, 18⅞ x 20⅞ in. (47.9 x 53 cm). Museum of Fine Arts, Boston, Tompkins
Collection 1978.178

American city planning. The Back Bay's retrieval from swamp was a testament to modern engineering and technology. On a gravel base twenty feet deep, the broad rationally planned streets of the Back Bay doubled the size of the original city of Boston. The new neighborhood became Boston's "throne of wealth,"[147] its architecture reflecting a sequence of styles as the district developed block by block from east to west. The grand houses of Commonwealth Avenue—"the first American boulevard actually to be built," according to Lewis Mumford[148]—and its cross streets were home to the nouveaux riches, including William Dean Howells's archetypal Silas Lapham. King declared about the Back Bay that it "is one of the grandest architectural sections of the world. It is intersected by the most fashionable thoroughfares of the aristocratic Bostonians; the broad avenues, running parallel to one another, having already done much to take away Boston's fame of being a city of crooked lanes and narrow, winding streets."[149] Mumford elucidated the practical and symbolic impact of the development of the Back Bay: "The draining and filling and building up of the Back Bay marked a turning point in Boston's existence. Here the self-contained provincial town, with its mainly English ancestry and background, turned into a multinational metropolis reaching out far beyond New England for cultural sustenance."[150]

In *Charles River and Beacon Hill* Hassam portrays a dialogue between the old and the new in Boston. His canvas anticipated and may have inspired Simmons's *Boston Public Garden* (fig. 142). Hassam's vantage point, as well as that of his surrogate in the painting, is on the Back Bay street that ran along the Charles River Basin behind the backyards of lower Beacon Street. The view is east toward Beacon Hill; as Carol Troyen has explained, "The artist stood just beyond Massachusetts Avenue at the point where the river bends northward and the land mass widens, providing a dramatically foreshortened view into the city."[151] The scene is bounded by architectural features that signify the duality between the old and the new: the dome of the state house in the distance (the far away, the past) stands in contrast to the buildings of the new Back Bay pictured toward the right edge of the canvas, next to which the back street rushes. That the district was new and on the point of developing even further in 1892 is suggested by the rough and unfinished pavement of the raw and narrow back street, inhospitable to pedestrians. Alongside it a fence with uprights at broad intervals rises from the perpendicular stone seawall.

The houses lining Beacon Street are of the sort constructed by Howells's nouveau riche Silas Lapham, whose heart's desire was to have a dwelling on "the water side of Beacon"[152] and thereby to possess from the rear windows the view across the river to Cambridge. The configuration that turns the backs of houses to the river, peculiar to Boston, was subject to much debate in the 1890s. In 1896 the critic William Howe Downes described the

Fig. 163 Charles River Basin, the Embankment, December 1911. Photograph: Metropolitan District Commission Archives, Boston

area between the Beacon Street backyards and the river in terms that perhaps reveal it to have been even less attractive than it appears in Hassam's portrayal. He noted "the neglected and shabby condition of the alley in the rear of these houses, and the fact that the actual water-front is encumbered with stables, back-yards, board fences and dust heaps." Downes concluded, as had other prominent Bostonians, that the disavowal of the river by the houses on Beacon Street should be remedied by the construction of an additional row of houses facing the river on filled land. Boston would thereby acquire a handsome waterfront prospect like those of other great cities.[153] In 1903, as a result of considerable pressure from influential Beacon Street residents, the proposal that Downes favored was put aside and a decision was made merely to widen the strip of land near the river and to provide a more gracious Charles River Esplanade with drives, walks, trees, and shrubbery (see fig. 163).[154]

Although Beacon Street's untidy backyards and rear-window river views may have been regrettable from the standpoint of urban design and amenity, they were absolutely characteristic of Boston, as revelatory of the identity of the new city in Hassam's *Charles River and Beacon Hill* as the state house dome in the distance of the picture is of the old. And although the current and prospective changes in the configuration and spirit of Boston that Hassam's painting records or implies were momentous, the artist suggests that they were also entirely familiar and inevitable. As Troyen has told us: "He chose an unremarkable, yet significant viewpoint to capture the random activity of the city, while at the same time alluding to historic changes in its social fabric. He made clear that the momentous and the incidental were inseparable in the new city; with the seemingly casual

placement of the figure in the blue overcoat, who looks neither at the artist nor at the new city behind him but rather gazes out at the river in a moment of private introspection, Hassam indicates the anonymity of the new urban life."[155] Hassam stresses the neutrality of the observer he portrays—and, by extension, of himself. He insists on the man's indifference to any detail or event in the scene that might be perceived as dramatic or didactic and fixes this figure's gaze instead on the river, the single element in the picture that is not susceptible to human control and is relatively unchangeable. The modern condition of the observer coincides with the part of the modern city in which he is placed and contrasts with the tradition associated with the state house in the distance.

The new and old Bostons engage in the fundamental dialogue in Hassam's painting, but they also join to carry on a secondary dialogue between the constructed and the natural. Boston was exceptional, urbanists believed, because of its intimate relationship with nature. Thus, an observer of 1907 perceived that "the interpenetration of the land and water has given to Boston a character of its own" and remarked specifically of the Back Bay that "a tract of most valuable real estate was preserved in brine till such time as it was needed for first-class residences."[156] The presence of the river in Hassam's scene reminds the viewer that Back Bay land, where the houses stand, has been reclaimed from shallow waters, that nature has been conquered. Nature, represented by the river, is pressed to the edge of the urban experience and almost entirely overwhelmed by the artificial, the elements of human manufacture: it is measured off—even visually imprisoned—by the regular intervals of the fence at the edge of the embankment and is embraced and enclosed by the curving coastline that leads from the Back Bay to old Boston in the distance. Yet Hassam's composition also celebrates the proximity of settlement to the river and the possibility peculiar to Boston of access to nature within the urban context.

It was only in 1886, after his art was relatively mature, that Hassam had pursued formal training in Paris—at the Académie Julian under orthodox academics Gustave-Rodolphe Boulanger, Jules-Joseph Lefebvre, and Lucien Doucet. However, he seems to have visited exhibitions that included the newest French painting because his Parisian work was distinguished by an unusual awareness of French Impressionism. In Paris he progressed in his appreciation of painting from Béraud and de Nittis to more modern styles, with urban subject matter as the common denominator. Yet in Hassam's own Parisian pictures there is not an unbroken stylistic progression from the more conservative to the more radical. Under the influence of Monet, Pissarro, and Renoir, Hassam interpreted picturesque Parisian people, scenes, and moments in an Impressionist manner. But he could also revert to a more traditional and tonal approach, revealing strong echoes of his earlier Boston works.

Hassam's *Grand Prix Day* (fig. 164), like *Rainy Day, Boston*, is one of a pair of canvases depicting the same subject. (The second version, a larger and less coloristically intense replica of the same title and probably of the same year, is in the New Britain Museum, New Britain, Connecticut.)[157] These Parisian scenes seem to constitute an intentional revision of his tonal Boston cityscapes in the interest of experiment with a chromatic Impressionist palette, the appearance of brilliant sunlight, and flecked brushwork. An academic armature and a respect for draftsmanship underlie the major forms—especially of the horses and carriage at the left, which maintain their volumetric integrity despite the corrosive sunlight that bathes them—but the overall effect is of dazzling color and light in emulation of French Impressionist works that show the boulevards of Paris.

For his subject in *Grand Prix Day* Hassam chose a distinctive Parisian site and an event associated with the elegant eighth arrondissement, which had been renovated during the Second Empire under Haussmann's direction and which attracted the interest of Manet, Caillebotte, Degas, and other French painters of modern life.[158] We are near the Arc de Triomphe, part of whose principal easterly face appears to the left of the canvas. The title given to the canvas now in Boston, where Hassam showed it in 1889—*The Champs Elysées, Day of the Grand Prix*[159]—indicates which of the avenues radiating from the Etoile he has depicted. That it is Grand Prix day tells us that the date is the last Sunday in June, when the great international horse race for three-year-olds was run at the Hippodrome de Longchamp, the course at the corner of the Bois de Boulogne. The glare of the ocher-pink pavement and the short sharp shadows cast by southerly sunlight suggest that it is about noon on that dazzling summer day.

Rather than depicting the race itself, Hassam presents a scene that is even more peculiarly Parisian: elaborate equipages parading in the heart of the city, creating a dynamic spectacle as they gather at the Etoile before the procession to the Bois. At the left a fashionable carriage drawn by graceful horses advances toward us. We view the ladies and gentlemen in this vehicle as they view the lively scene of carriages proceeding west in the direction of the arch and crowds of pedestrians on the sidewalk under the row of trees that screens buildings with characteristic mansard roofs. The informality of the composition and its lack of focus suggest the random vision that a spectator in the city may experience as his or her attention shifts casually from one vignette to another, dwelling for a long moment on what is unimportant—a broad sweep of pavement, for example—before moving on to more compelling details in the scene.

Two years after he completed *Grand Prix Day*, one of the most convincing analogues of a French Impressionist work produced by an American painter in the late 1880s, Hassam executed a canvas that indicates that he had not yet renounced

Fig. 164 Childe Hassam. *Grand Prix Day*, 1887. Oil on canvas, 24 x 31 in. (61 x 78.7 cm). Museum of Fine Arts, Boston, Ernest Wadsworth Longfellow Fund 64.983

academic foundations. This delightful image, *At the Florist* (fig. 9), records an aspect of Parisian life more picturesque than that shown in *Grand Prix Day*, including people dressed in traditional French costume; it also enlists a more traditional composition and technique—appropriate for its inclusion in the Salon of 1890. Hence *At the Florist* reveals the artist's tendency to pick and choose any point along a subject or stylistic spectrum from academic to Impressionist according to the moment and the occasion. Despite his unsteady allegiance to the more progressive mode, Hassam painted a number of canvases in Paris that are among the earliest American responses to everyday urban life executed in an Impressionist manner.

After three years in Paris and the French countryside, Hassam and his wife returned to the United States in October 1889; by this time, however, "the centre of culture and opportunity in art had shifted from Boston to New York," as his early biographer noted, and New York became their home in November or December.[160] New York—which in the late nineteenth century increasingly concentrated American culture, as Paris had since the seventeenth century concentrated French culture—offered superb opportunities for a painter of modern life. Here Hassam continued to manifest his interest in urban imagery, becoming the city's principal interpreter during the 1890s and producing more than seventy-five paintings, watercolors, and pastels based on its avenues and parks.[161]

Hassam was joined in his investigations of life in New York by leading American Impressionists Theodore Robinson and Metcalf,

who both occasionally painted scenes there; by Chase, the prolific chronicler of the parks; and by a score of lesser-known artists, of whom Paul Cornoyer and Colin Campbell Cooper were closest to him in age and in commitment to an Impressionist technique and perhaps most susceptible to his example. For subject matter and stylistic inspiration these painters all depended upon the prototypes of the French Impressionists and also upon one another. Allusions by Hassam, and by his critics, to perceived links between Paris and New York support the hypothesis that American painters of modern life in the 1890s were deeply and willingly indebted to their Parisian predecessors. But a nationalistic pride in conjoining French inspiration with the American scene is also evident in Hassam's remarks. By 1892, for example, he would tell an interviewer: "I believe the thoroughfares of the great French metropolis are not one whit more interesting than the streets of New York. There are days here when the sky and atmosphere are exactly those of Paris, and when the squares and parks are every bit as beautiful in color and grouping."[162]

In addition, the painter expressed a Baudelairean commitment to urban subjects when he proclaimed to the same interviewer that the true historical painter is the painter who depicts the mundane life around him and records his own epoch.[163] Chase would echo Hassam's beliefs when he advised students in 1897 that "the greatest historian is he who paints the things of his own time."[164] Indeed, he and Hassam shaped and were shaped by the turn-of-the-century perception that painters ought

to evoke the new spirit of American life—and especially the American urban scene—in their works.

No American city of the 1890s could have provided a livelier or more challenging arena for the Americanization of advanced Parisian imagery of modern life than did New York. By then New York was considered to resemble Paris in certain important respects, above all in its new architecture and urban design, which reflected American architects' Beaux-Arts training.[165] Even more than Paris, New York was a city of immense energy and of great contrasts; it was a place that could generate in the same year, 1890, Ward McAllister's *Society As I Have Found It*, recording the extremes of conspicuous consumption among New York's "four hundred," and Jacob A. Riis's *How the Other Half Lives*, documenting in prose and photographs the grim poverty that pervaded the city's tenements.[166]

New York's population grew astonishingly from about 60,500 citizens in 1800 to about 515,600 in 1850 and almost 3.5 million in 1900.[167] The architecture of Manhattan especially was undergoing a unique metamorphosis from low-rise brick and brownstone buildings to skyscrapers of a height that only up-to-date technology could allow.[168] By 1907 Henry James would complain that the "multitudinous sky-scrapers" of New York resembled "extravagant pins in a cushion already overplanted."[169] New construction brought unprecedented density and congestion to business districts and residential areas. High buildings, new elevated railways, new suburban and long-distance trains and their new terminals, automobiles, and electric streetlights altered the appearance, the light and air, the rhythm and sound of the city and changed the patterns of use of various neighborhoods. There was more to do, a faster pace at which to do it, and more hours in which it could be done.

Rapid commercial expansion; innovations in transit and the uses of electricity; impressive new buildings of many kinds; extraordinary mansions for the newly rich echoing every imaginable moment in the history of European architecture; new parks and monuments; newly formed and re-formed cultural institutions bespeaking a uniquely cosmopolitan American metropolis; varied types of recreation to occupy leisure time; neighborhood diversity resulting from immigration and population movement; and myriad other aspects of New York life were noted and applauded in the popular press, in new and newly vigorous magazines published in New York for national circulation and in numerous celebratory books. These publications not only recorded present-day realities in prose and in illustrations by such artists as Hassam,[170] they also documented and described New York's history, reflecting prevailing local pride and a desire to offset any doubts about the current direction of the city by pointing to its reassuring earlier achievements.[171] The burgeoning in the 1890s of a self-examining and self-congratulatory literature of New York was one evidence of a sudden fervor to remember a past that was rapidly disappearing and to survey the present before the future—specifically the new century—arrived. This literature paralleled and probably reinforced the interest of American painters of modern life in the city's pictorial possibilities.

By the turn of the century New York, already the most populous urban center in the United States for thirty or forty years, was emerging as the quintessential American city, condensing and defining not only the cultural but also the economic and social life of the nation. In the eyes of many it also challenged the leadership of the great European capitals. Thus by 1904 the outspoken protagonist of Rupert Hughes's novel *The Real New York* would suggest that by comparison with New York, "every other city in the world is a squat little village."[172] Such enthusiasm for New York, together with the urban iconography developed by the American Impressionists and Realists, laid the foundation for the tributes to the city painted by Max Weber, John Marin, Joseph Stella, and other early modernists after 1910.[173]

When American painters of modern life plunged into the heart of New York, rather than remaining in its parks or on its periphery, they tended to maintain a genteel and euphemistic view of city life, tempering urban realities with artistic choices that held the ugly or the stressful at arm's length. These choices include the selection of the particular subject, the vantage point from which it would be painted, and the prevailing season or weather. The usual product of such choices is a benign, optimistic urban image reflecting the contemporary embrace of progress and echoing in visual terms the tone of turn-of-the-century commentaries that exulted in American urban growth and energy, especially those of New York.

Typically such New York scenes record new and altered neighborhoods, new buildings, and unprecedented amenities: they are euphemistic celebrations not only of the appearance of the city but also of aspects of democracy and development much closer to the subjects of McAllister than to those of Riis. Hence the artists often focus on the most attractive, picturesque, or fashionable precincts of the city: Fifth Avenue and the great squares—Union, Madison, and Washington—which, like the parks, were sources of pleasure and pride and retreats from the hurly-burly of New York. Although the Realists more often painted city scenes and treated a wider range of urban themes than the American Impressionists did, they maintained the older artists' tendency to diminish the suggestion of modern urban problems. Chase would complain in 1914 that Henri and his circle "paint the gruesome," that they "go to the wretched part of the city and paint the worst people. They have the nickname of 'the Depressionists.'"[174] Yet the Realists seem to exercise the same kind and almost the same degree of selectivity in their choice of New York images as Chase did, avoiding subjects associated with the problems of urban living in favor of those

linked with pleasure, even in the least fashionable neighborhoods of the city.

It would seem to have been the intention of all of the painters of modern life—an intention supported by their patrons—to suggest that New York was civilized and hospitable despite its rapid growth and that anxiety with respect to the city's crowding and confusion should be subordinated to an appreciation of its picturesqueness. In 1892 Van Rensselaer wrote: "So our young artists are beginning to draw and to etch and to paint New York, and here and there they find corners and vistas of delightfully novel flavor. . . . They do not say that New York is beautiful, but they do say that it is 'most amusing'; and this is the current studio synonym for picturesque."[175]

In its recording of a fashionable neighborhood and emphasis on the genteel aspects of its use, Hassam's *Washington Arch, Spring* (fig. 165) epitomizes the Impressionist approach to a vista of delightfully novel flavor. The painting reassures viewers of the city's civility and past, simultaneously reminding them of Paris and aggrandizing an elegant and historically resonant New York locale. It portrays Fifth Avenue—New York's Champs Elysées—and the triumphal arch in Greenwich Village commemorating the centennial of George Washington's inauguration as the first president of the United States. The arch was New York's equivalent of the Arc de Triomphe, which Hassam had depicted in two canvases in 1887.

From a vantage point on the western sidewalk on the lower end of Fifth Avenue, on the block just north of Washington Square, we look south toward the arch, which dominates the upper part of the canvas and frames a partial view of some of the red brick structures on the south side of the square.[176] Long shadows created by the low angle of the morning sun in spring cross the pavement; the titles under which the painting was shown in 1895 and 1900 reveal that the month is May.[177] It is a bright new day in the new New York in the season of rebirth. Hassam has captured the characteristic atmosphere of the city, which Van Rensselaer described: "the clear, pure, crystalline air of New York, which seems to sparkle with Atlantic salt. . . . our brilliant sky, our crisp lights, and our strong sharp shadows."[178]

The bustling activity of the carriages that clatter up and down the avenue contrasts with the pace of the pedestrians who go about their morning business. A carriage with a liveried coachman is stationed along the curb, next to the row of trees whose budding branches screen the arch; a street sweeper in immaculate white uniform cleans the gutter between the waiting carriage and his wheeled cart. A young woman dressed in white walks toward us on the broad sidewalk, passing a little flowering garden and stairway that mark the entrance of an unseen town house. Near the trees a nurse wheels a fashionable wicker or rattan perambulator shaded by a parasol of white muslin or lace; its occupant is swathed in white as well.[179] The nurse typifies a

ubiquitous character on the lower Fifth Avenue scene, seen parodied in a late nineteenth-century illustration (see fig. 166). As social historian Carol Ruth Berkin has explained: "The majority of women to be seen on the Square were not mistresses of the households in which they resided. They were, instead, domestic servants. . . . the central figure in any household was the surrogate mother: the nurse or governess. Every day, twice a day, the Square was filled with nurses and children, taking their constitutionals up Fifth Avenue."[180]

Behind the nurse in Hassam's view, gentlemen in top hats join the procession uptown. This parade of pedestrians is the very subject to which Hassam enthusiastically referred in an interview in 1892: "There is nothing so interesting to me as people. I am never tired of observing them in everyday life, as they . . . saunter down the promenade on pleasure. Humanity in motion is a continual study to me."[181]

The historical and patriotic meanings of Washington Square were as important to Hassam as the opportunity the locale offered to depict humanity in motion. Indeed, the significance of the particular place to the artist is suggested in the painting by

Fig. 165 Childe Hassam. *Washington Arch, Spring*, 1890. Oil on canvas, 27⅛ x 22½ in. (68.9 x 57.2 cm). The Phillips Collection, Washington, D.C. 0897

Fig. 166 *Fifth Avenue (four years after the death of Madame Restell)*, 1882. Tinted photo-lithograph, from *Puck Magazine*. Museum of the City of New York, The J. Clarence Davies Collection 34.100.19

the looming scale of the architectural forms in relation to the figures. The potter's field and site of the city gallows south of the lower end of Fifth Avenue had been converted to a park and military parade ground in 1826. To commemorate the fiftieth anniversary of the signing of the Declaration of Independence, the area was named Washington Square after the first president. The residential development that followed soon thereafter was marked by the construction of town houses in the Greek Revival style (consonant with the democratic associations of the square). Prominent New Yorkers occupied The Row, the especially fine houses on Washington Square North, which was esteemed as fashionable, elegant, and beautiful. The neighborhood as a whole was designated The American Ward, reflecting the predominance of New York's first families.

The construction of New York University and the Reformed Dutch Church on the eastern side of Washington Square in the 1830s confirmed the distinction of the area. Despite the abandonment of the parade grounds in the 1850s and the subsequent creation of a north-south drive through the square, the section remained a refuge from city clamor, especially since Greenwich Village's winding streets discouraged industrial development. Artists gravitated to the neighborhood: Richard Morris Hunt's Tenth Street Studio Building housed numerous, usually well-established, painters, including Homer and Chase; the Tile Club

met in the Village, and the Salmagundi Club was a popular artists' gathering place that settled down on lower Fifth Avenue after moving from place to place; other artists worked in the New York University building on Washington Square.

Although patrician Washington Square North was relatively immune to lower-class incursions, toward the end of the century it became less and less alluring to the city's elite, who migrated uptown. By 1890 the fashionable associations of the area were being challenged by commercial activity, brothels, and tenements for the growing population of immigrants, all installed in the streets nearby, and by the conversion of some of the town houses ringing the square to apartment hotels, boardinghouses, cafés, and shops.[182] This was the Washington Square that Isabel and Basil March, transplanted Bostonians in Howells's *Hazard of New Fortunes* of 1890, confronted when they searched for an apartment and "met Italian faces, French faces, Spanish faces" amid "the old-fashioned American respectability which keeps the north side of the square in vast mansions of red brick, and the international shabbiness which has invaded the southern border, and broken it up into lodging houses, shops, beer gardens and studios."[183] Leaders of the Ashcan School—Glackens, Sloan, Luks, and Everett Shinn—settled in Greenwich Village, finding inspiration in its foreign types and street scenes and work as illustrators for such Village-based journals as the *Masses*. By about 1910 the identity of Greenwich Village as New York's bohemia or Latin Quarter began to develop in earnest, with more and more artists and writers, including those of only the most modest reputations, as well as teachers and settlement-house workers moving into the neighborhood's quaint, ethnically diverse, and inexpensive mews.[184]

The Washington Arch in the heart of the aristocratic square and at the edge of this social crucible was conceived as a bastion and emblem of American tradition in the face of actual and impending change. The original monument commemorating the centennial of the first president's inauguration was a temporary one that straddled Fifth Avenue on a line with Washington Mews, about a hundred feet north of the square.[185] Commissioned in 1889 from Stanford White by a group of Washington Square residents—principally members of the patrician families associated with The Row—the slender arch was constructed in wood and plaster, ornamented in papier-mâché, painted white to imitate marble, and crowned with a balustrade and a wooden statue of George Washington (fig. 167). Almost immediately after the elaborate centennial celebration of 1889 was held, a committee of distinguished citizens was organized to raise funds to allow White to replicate the arch in white Tuckahoe marble on a site in the square itself, thereby making permanent their statement of pride in an American hero and national values. At the ceremony for the laying of the cornerstone of the marble monument in 1890, Henry G. Marquand, chairman of the Washington Arch Memorial

Fig. 167 Paul C. Oscanyan. *Fifth Avenue at Washington Square*, 1889.
Photograph: Museum of the City of New York

Committee, hinted that the new arch would inspire patriotism and a sense of beauty among the poor immigrant tenement-dwellers who increasingly dominated the neighborhood.[186]

Hassam's painting bears a date of 1890 and has been thought to represent the temporary arch.[187] However, the structure that he depicts more closely resembles the robust marble arch that White designed for the new site. Moreover, the arch Hassam shows lacks the wooden statue of Washington that crowned the temporary structure. The marble arch was completed to the extent visible in Hassam's painting by February 1893, when the carved trophy panels on the second story of the north face were installed. The probability exists, therefore, that the date of 1890 inscribed on the canvas is incorrect and that the picture was completed after February 1893; it certainly was finished by November 1893, when it was reproduced in the *Century*.[188] Hassam's studio was at 95 Fifth Avenue at Seventeenth Street, not far from Washington Square, from the time he moved to New York in November or December 1889 until some point in 1892. His subsequent residence in the Chelsea Hotel at 222 West Twenty-third Street in 1892–93 was also relatively close to the site.

The arch in the painting acts as a hinge between two socio-cultural regions, as it did in Greenwich Village itself, demarcating the boundary between the still elegant precinct of Fifth

Avenue, north of the arch, and the more plebeian, commercialized square to the south. This duality in the neighborhood is echoed in Hassam's picture by smaller dialogues. For example, the dark-liveried coachman in his carriage above is countered by the white-uniformed street sweeper cleaning the gutter below. One is a servant of the elite and the other is a servant of the entire populace, but the street sweeper has his own distinction; his white uniform, white bucket, and red cart identify him as a member of the White Angels, the street cleaners who flourished in New York in the 1890s.[189] In fact, a contemporary reporter wrote that "the street-cleaning of New York has of late so marvelously improved" as to constitute a reassuring sign of New York's new and necessary "civic self-consciousness."[190] The street sweeper in Hassam's painting—a special character in the new New York—may be said to signify pride in the modern city and in its health and well-being. Other symbolic visual dialogues occur between the white-uniformed street sweeper and the white-gowned woman who walks toward us on the sidewalk and between the top-hatted coachman and the top-hatted gentlemen who also approach us. The dark slender trees, signifying energetic organic nature, contrast with the bright architectural backdrop of the monument, stable in shape, linked with millennia of human enterprise; the budding branches of the mature trees and the newly planted saplings that continue their line are associated with the renewal of spring and, perhaps, of the neighborhood in which they bloom.

These dialogues make the viewer aware of the interaction of old and new in New York. Hassam takes us to an area of the city long connected with its old families, where the presence of the handsome new-old classical triumphal arch dedicated to the first president emphasizes the neighborhood's links to the foundations of America and to the Greco-Roman heritage. Against this background of references to American and classical traditions are references to the new New York of immigrants whose tasks include driving carriages, wheeling perambulators, and sweeping the streets. The street sweepers battled New York's chronic filth and, with their sparkling uniforms, called attention to themselves as the agents of cleanliness.[191] The new revivifies the old.

Hassam's *Washington Arch, Spring* offers an emblematic, optimistic image of the new New York, unified despite the complexity of its elements. The looming monument, the embodiment of the ultimate American hero, overwhelms the threat of the encroaching immigrant tides associated with the marginalized southern side of Washington Square. The city is a place where energy and tranquillity coexist, where children can be raised in security and comfort, where workers go about their tasks with dignity, where the rich and the working class, the new and the old are reconciled through the influence of tradition and democracy.

In another depiction of the new New York, *Winter in Union Square* (fig. 168), Hassam uses distance as a device to suggest

harmony, in contrast to the more intimate street-level view presented in *Washington Arch, Spring. Winter in Union Square*, which was probably completed by 1894, is possibly the first of a series of small-scale paintings of the site that he executed before 1896.[192] Within walking distance of either of the lower New York studios he occupied between 1889 and 1893, Union Square offered Hassam a changing tableau and invited a variety of responses. For this painting he took a high, panoramic diagonal view, as Monet had for such city scenes as *Garden of the Princess, Louvre* (fig. 169). Hassam looked south across Union Square Park from the northwest corner of Sixteenth Street toward Fourteenth Street, the southern boundary of the square. The Morton House hotel, filling the blockfront between Broadway and Fourth Avenue on Fourteenth Street, appears in the left background, and the domed Domestic Sewing Machine Company Building is at the right; these two structures bracket the barely visible spire of Grace Church, at Tenth Street and Broadway, in the distance.[193] Hansom cabs are gathered in the right foreground, awaiting patrons, and horse-drawn trolleys crisscross, one proceeding down and the other up Broadway, along the

westerly edge of the square.[194] The huge bronze figure group signifying Charity, designed by Karl Adolph Donndorf and placed on the west side of Union Square Park as a drinking fountain, appears just off Broadway between Sixteenth Street and Fifteenth Street.[195]

Union Square was a broad common originally called Union Place because it joined two old roads that would become Broadway and Fourth Avenue. It comprises about three and a half acres within the embrace of those two long avenues, which function as Union Square West and Union Square East as they run from Seventeenth Street to Fourteenth Street. The square interrupts the long diagonal of Broadway—the distinctive renegade in the grid pattern of the city. Broadway enters the square at its northwest corner and emerges parallel to Fourth Avenue on its Fourteenth Street side. After the square opened as a public park in 1831,[196] an ellipse running north-south was inscribed within the rectangle formed by the grid of boundary streets. In the late 1830s a row of brownstones was constructed along Union Square East; these houses and others on the square and on Fourteenth Street became some of the city's most desirable residences, at-

their circles. Many painters, photographers, and sculptors occupied studios in the upper floors of buildings along Ladies' Mile, the strip of stylish dry-goods emporiums on Broadway that extended north from about Tenth Street to Madison Square.[198] In his memoirs the painter Simmons recalled that "most of the life of those days [the 1890s] centered about Union Square, with tentacles reaching down to Washington and up to Madison Squares."[199]

Increasingly, however, commercial use impinged upon the residential character of the neighborhood, and by the years just after the Civil War Gramercy Park and upper Fifth Avenue already had begun to supplant Union Square as a magnet for the rich and fashionable. Private residences surrounding Union Square were converted into stores or were torn down and replaced by iron or stone commercial structures. The Domestic Sewing Machine Company Building, which opened on Broadway and Fourteenth Street in 1873, characterized the new manufacturing and mercantile function of the Union Square area and, as the city's tallest building upon its completion, symbolized New York's architectural innovations and new energy.[200]

In addition to witnessing the transformation of Union Square from a residential to a commercial and manufacturing district, the 1860s saw it become a center for political gatherings and protests. The square named for marking a union between major avenues became associated with the cause of the Union army in the Civil War: crowds assembled there in response to the Confederate firing upon Fort Sumter and on various subsequent occasions related to the war. The paved plaza at the northern edge of the square was the site of mass meetings, and the balcony of the picturesque cottage that overlooked the plaza served as pulpit and reviewing stand. By the 1870s the area surrounding Union Square was also redefining itself; the neighborhood became New York's most important entertainment center, with theaters moving north into the square as Broadway south of Fourteenth Street grew increasingly commercial.[201] Union Square would remain the focus of the city's theatrical and musical life until it was superseded by Times Square at the end of the century. Among the theaters and concert halls ringing Union Square were the Academy of Music—New York's leading opera house from 1854 to 1887[202]—Steinway Hall, and Wallack's. Moreover, the district was a hub for individuals and activities dedicated to supporting the life of the theater—agents, trade newspapers, stage photographers, and manufacturers of stage properties, costumes, scenery, and scripts; also a center for the construction and sale of pianos, "it was appropriately dubbed 'Piano-forteeenth Street.'"[203] Restaurants and hotels such as Spingler House, Everett House, the Union Square Hotel, and Morton House catered to a theatrical and literary clientele, serving all those in the trade, including resident actors, as well as visiting theatergoers.

With the economic problems and worker unrest that followed

tracting prosperous people interested in moving north from Washington Square and Astor Place and forming a New York equivalent to London's fashionable Belgravia.

By the mid-1840s Union Square Park's ellipse was filled with geometric beds of grass, shrubbery, and trees and enclosed with an iron fence.[197] An iron fountain dedicated in 1842 became the park's focal point by the 1880s, when it was planted with lilies and lotus flowers and other exotic aquatic plants. Between the 1850s and the 1880s other landmarks were added to the area; these included sculpture by Henry Kirke Brown and Frédéric-Auguste Bartholdi, as well as Donndorf's monumental fountain.

From the middle of the century Union Square, developing beauty and cachet, attracted more and more private schools, hotels, restaurants, churches, and other amenities, many of which were associated with the burgeoning artistic life of New York: Thomas Bryan's Gallery of Christian Art; the newly established Metropolitan Museum of Art before it moved to Vaux's building in Central Park; and the Art Students League, for example. By the 1880s Union Square was the center of the city's intellectual life, home to leading writers and critics and

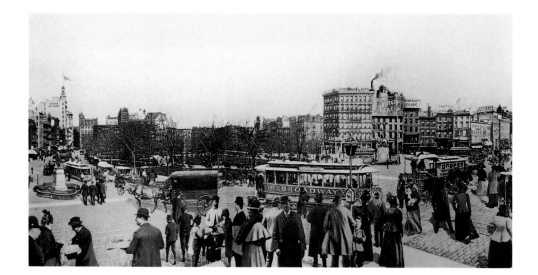

Fig. 170 Union Square, n.d., from D. Appleton, *The New Metropolis* (New York, 1899), following p. 479. Photograph: The New-York Historical Society

the tenacious Depression of 1873, Union Square took on an association with the labor movement and union activities. Increasingly linked with rallies and processions during the 1880s, Union Square emerged as the durable focus of annual Labor Day parades, beginning with the official inception of Labor Day as a holiday in 1887,[204] and was the site of May Day parades from 1890. Ultimately, it would also become a center for demonstrations for woman suffrage.

As its connections with commercial and labor interests grew stronger, Union Square's allure as a theatrical and entertainment center waned, starting in the late 1880s. New theaters around Herald Square and, later, Times Square successfully competed for bookings and audiences. The heyday of Union Square as a fashionable venue for residence or even amusement was over. More and more plebeian businesses opened, coexisting with the stylish older shops and supplying dry goods, silver, confectionery, and all manner of household items. But despite its fading glamour, Union Square was still at the junction of two major north-south avenues that bisected a major crosstown route. Elevated railroad lines ran along Third Avenue and Sixth Avenue, just a few blocks to the east and west. The square was accessible from all directions and was, and would remain, a uniquely lively though not a fashionable urban crossroads.

In his interpretations of Union Square Hassam quiets the positive as well as the negative aspects of its energy and seeks simple, broad patterns instead of confusion in its complex fabric, thereby distancing himself from the dreary realities of a locale identified with rapid change and declining as a residential, theatrical, and even commercial center. In *Winter in Union Square* he muffles the city with snow, softens the sharp edges of buildings and vehicles, and shows us a winterbound park only grazed by pedestrians or traffic. Comparison with a late nineteenth-

century photograph of the site (fig. 170) is instructive; this view of Union Square from Fourteenth Street, rather than toward it, is taken at eye level and immerses the viewer in the heart of the crowds of people and vehicles, including the horsecars that ran along Fourth Avenue, Broadway, and Fourteenth Street.

Hassam, on the other hand, avoids showing turmoil, concentrating, even in depicting an urban subject, on the kind of "beauty removed from urban realities" that Samuel Isham saw in so much American art of the time.[205] A vantage point near the northwest corner of the square allows the artist to ignore the routine grid plan of Manhattan streets and to emphasize the unusual diagonal of Broadway, which crosses the canvas from the lower left corner.[206] Like other artists who celebrated the landmarks that denoted breaks in the grid—the Flatiron Building, for example, or Washington Arch—Hassam found a subject that was a particularly picturesque Manhattan vignette.

Joseph Czestochowski has claimed that Hassam's "Union Square scenes represent visual occurrences, and tend to create a mood: They do not serve a story-telling capacity."[207] Yet we sense in Hassam's *Winter in Union Square* some allusion to the city in transition. The choice of a vantage point looking south allows the artist to encompass an older Union Square, associated with theater and entertainment and embodied in the Morton House hotel; it also enables him to suggest the architectural, functional, and symbolic dialogue that the older tradition engages in with the new one, which is represented by the taller Domestic Sewing Machine Company Building. The vehicular traffic he records echoes the contrasts of the architecture. Although the hansom cabs are for hire, unlike the private carriages of the upper class, they suggest some measure of genteel privilege in dialogue with the trolley cars that transport the masses—the growing numbers of immigrants who worked in the needle-trade shops of Union

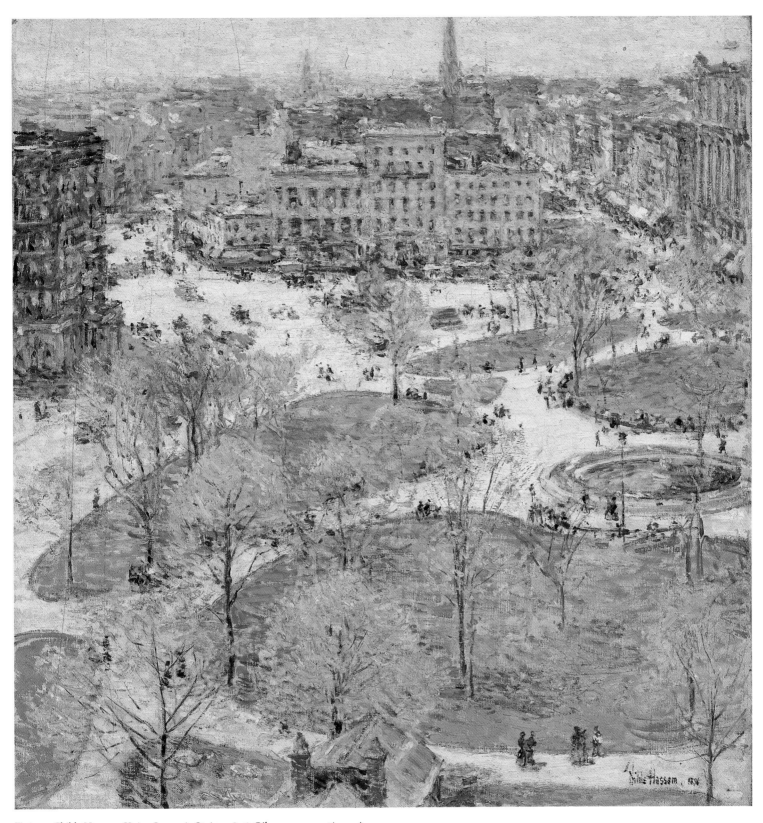

Fig. 171 Childe Hassam. *Union Square in Spring*, 1896. Oil on canvas, 21½ x 21 in.
(54.6 x 53.3 cm). Smith College Museum of Art, Northampton, Massachusetts,
Purchase, 1905 1905:3–1

Square and those who still found employment in the theater and amusement industry.

Compared with this muted and monochromatic winter view, Hassam's *Union Square in Spring* (fig. 171) vibrates with dazzling spring sunlight. The highly chromatic effect recalls Van Rensselaer's remarks of 1892 regarding the peculiarly American approach:

> The modern artist . . . is not afraid of subjects which lack "tone." He has washed the old traditional palette, and set it anew with fresh, cheerful colors; he has learned how to portray the brightest sunshine; and he can rejoice in a place where he must paint sunlight falling on clear whites and yellows, bold reds, bright browns, and vivid greens, no less than one where, as in London, he can confine himself to neutral tones, or where, as in Paris, he can veil his whites, his pale light blues, his soft greens, and occasional notes of a more brilliant kind, with a delicate gauze of airiest gray.[208]

In *Union Square in Spring*, as in *Winter in Union Square*, Hassam adopts a distant vantage point. Here he looks down on the scene from such a precipitous angle that the ground plane tilts steeply upward and the horizon appears near the very top of the canvas, echoing the radical perspectives in cityscapes by Monet (see fig. 169) and by Pissarro. Seen from above, Union Square's bustling crossroads and the delineated greenswards of the park become a brilliant, inviting, decorative pattern. Although its treatment of space is in sharp contrast to the academic stage set that provided the armature for Hassam's *At the Florist* (fig. 9), *Union Square in Spring* recapitulates the dialogue that the earlier painting had proposed between the artificial and the natural. In *At the Florist* drab urban pavements were set against brilliant floral forms; *Union Square in Spring* pairs dark rectilinear buildings with bright green oases and uses curvilinear pathways bathed in golden sunlight to mediate between the artificial and natural elements.

In *Union Square in Spring* we are looking northward toward Seventeenth Street. Broadway enters the square from the upper left, and Fourth Avenue proceeds southward toward the square on the right, past the Union Square Hotel, the large structure that anchors the upper right edge of the canvas. The buildings that form the base of the trapezoid in the upper third of the canvas stand on Union Square North. Toward the right, at the northwest corner of Fourth Avenue and Seventeenth Street, is Everett House, whose distinctive roofline is interrupted by a semicircular pediment. To the west of Everett House is the Century Building, headquarters of the Century Company (publisher of the *Century* and *St. Nicholas* magazines), its three dormers embedded by Hassam within its mansard roofline. Barely visible to the west of the Century Building is a four-story town house, one of the last remaining on the square; this house would be replaced—probably just after Hassam painted *Union Square in Spring*—by the eleven-story Jackson Building, a narrow commercial structure. At the corner of Broadway is another commercial building, and beyond it, running up the east side of Broadway, are smaller structures.

Hassam departs from direct transcription of the architecture of these buildings. For example, he reduces the number of window bays in Everett House from fourteen to seven, diminishes the height of the building at the corner of Broadway relative to that of the Century Building, and almost ignores the town house. His specific vantage point is ambiguous. The partial pediment at the lower edge of the canvas suggests that Hassam found a precipitous perch above and behind the pedimented Morton House on Fourteenth Street, a viewpoint so high as to condense completely the width of Fourteenth Street at the south end of the park. Rather than approaching the scene through a mediating expanse of street, we hover over the park and see its lozenges of green lawn as if they were liberated from their surrounding avenues and were floating on a golden asphalt sea. Drifting free, these large forms radiate an energy that is echoed by the rapid strokes that define the architectural surfaces and delineate the trees with their delicate beginnings of spring foliage.

Late Afternoon, New York: Winter (fig. 5) exemplifies another euphemistic approach to an urban subject: the use by the artist of a filter of poetic atmosphere produced by an evocative time of day. Despite the busyness of the city, the New York that Hassam depicts appears serene because it is seen at twilight, a moment that mutes sharp edges and carries with it associations of leisure and pleasure rather than of work. The results are similar to those in Pictorialist cityscapes by such contemporaneous photographers as Edward Steichen (see fig. 7);[209] they are also consonant with the suggestion offered by Henry James in *The American Scene* of 1907 that Manhattan was "in certain lights almost charming," when "an element of mystery and wonder entered into the impression."[210]

Muted City Clatter: The Realists in Picturesque New York

But we cannot appreciate the picturesqueness which New York wears to both mind and eye unless we go immediately from the stately commercialism of its down-town streets to the adjacent tenement-house districts.

MARIANA GRISWOLD VAN RENSSELAER (1892)

Sloan's *Sunday Afternoon in Union Square* (fig. 172) suggests the contrasts and continuities that typify the relationship between American Impressionist and Realist responses to the same site, in this case Union Square. By 1907 *Leslie's Weekly* would caption a view of Union Square "Central Recreation Space in a District

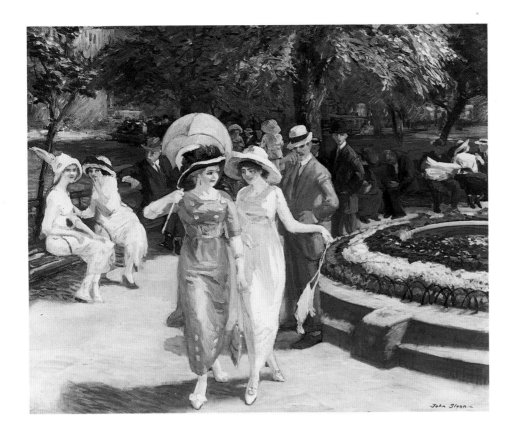

Fig. 172 John Sloan. *Sunday Afternoon in Union Square*, 1912. Oil on canvas, 26¼ x 32¼ in. (66.7 x 81.9 cm). Bowdoin College Museum of Art, Brunswick, Maine, Bequest of Mr. George Otis Hamlin 1961.63

Containing Hundreds of Sweat-Shops and Other Factories."[211] Such unpleasant realities were of little concern to the Impressionists—as the examples of Hassam's portrayals of the square amply demonstrate—and even to the New York Realists. There are, in fact, few depictions of Union Square by members of the Ashcan School: among them only Sloan painted it more than once. His images of the site are actually more euphemistic than those of the Impressionists, although, as befitted a Realist, he was more interested in human spectacle than in the kind of streetscape patterns recorded by Hassam.

In *Sunday Afternoon in Union Square*, for example, Sloan focuses upon two attractive young women.[212] Their costumes and demeanor suggest that they are office or shop workers out for a stroll on their day off at the height of summer. The contrast between their coy expressions and their revealing clothing and provocative postures implies that they are well aware of the stares that they attract. Two men at the edge of the raised flower bed to the right of the composition notice them; two women seated on a bench to the left appear to whisper about them. The strollers seem as lively and liberated as the teasing young girls in Sloan's *Picnic Grounds* (fig. 149) of five years earlier and are a world apart from the discreet patrician women who promenade alone and in silence in Chase's paintings of Central and Prospect parks of the late 1880s.

In Sloan's image of Union Square the crowded benches in the background indicate that this park is heavily used by masses of

people who sit and chat, read newspapers, or enjoy the passing parade. But the energy of their assembly here is entirely positive, and all is pleasant on this dazzling summer afternoon. Sloan was certainly aware of the more serious uses and implications of Union Square in 1912, when he recorded it in this picture. According to his diary, he had "walked to Union Square and watched the thousands of Socialists come in from their parade" on May 1, 1912, although he had not seen the anarchist demonstration that had occurred during the rally.[213] Moreover, Sloan was himself involved with the Socialist Party. Nevertheless, there is no indication in his image of any unrest or of the sweat and toil with which Union Square had become associated. Indeed, he denied any intention other than to capture outdoor light and color, proclaiming in *Gist of Art* that when he had executed the painting, twenty-seven years earlier, "lavender light was in my mind."[214]

As banking, commerce, and retail trade became increasingly dominant in the neighborhood in the ensuing decades, crowded and bustling Union Square offered raw material to the members of the Fourteenth Street School, a younger generation of artists with deliberate urban-realist agendas. These painters—Kenneth Hayes Miller, Reginald Marsh, Raphael Soyer, Isabel Bishop, and Edward Laning—were indebted to the efforts of the turn-of-the-century Realists. They pursued contemporary subject matter available near their studios in the Union Square vicinity, concentrating on depicting women shoppers and office workers and

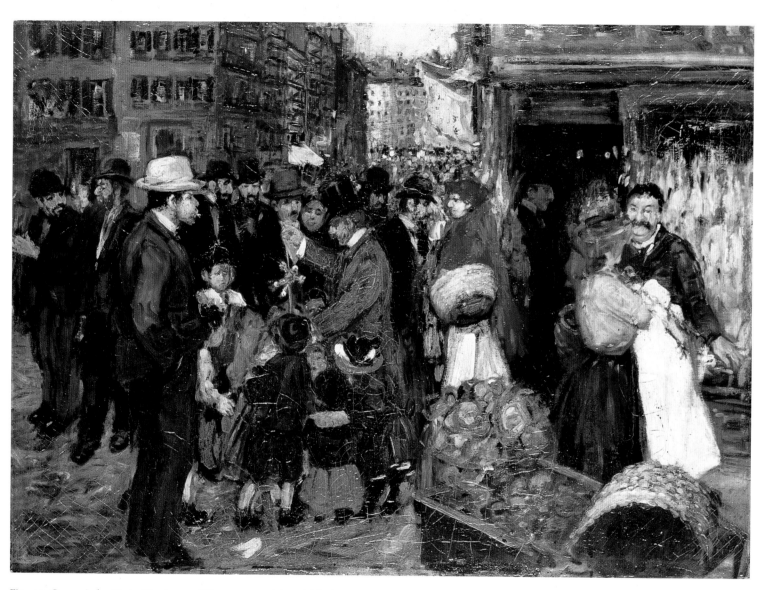

Fig. 173 George Luks. *Hester Street*, 1905. Oil on canvas, 26⅛ x 36⅛ in. (66.4 x 91.8 cm). The Brooklyn Museum, New York, Dick S. Ramsay Fund 40.339

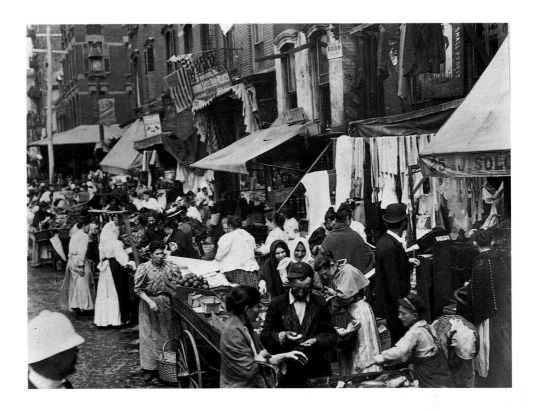

Fig. 174 Street vendors, Hester Street, 1898. Photograph: Museum of the City of New York, The Byron Collection

unemployed and workingmen, often with the same sort of sentimental or illustrative overtones that pervade Sloan's paintings of the area.[215]

Yet another painting that exemplifies the Realist penchant for softening and making picturesque the actualities of New York life is Ashcan School member Luks's *Hester Street* (fig. 173). The locale for Luks's painting is the heart of the Lower East Side of Manhattan—roughly the area north of the Brooklyn Bridge, south of Houston Street, and east of the Bowery—the home of hundreds of thousands of immigrants at the turn of the century.[216] Between 1870 and 1915 New York City's population increased from 1.5 to 5 million, largely as the result of the settlement of huge numbers of Italians, Jews, Irish, and Chinese. During the three decades before World War I, a third of the Jews in eastern Europe left their homelands for America; they accounted for a tenth of all the immigrants to the United States.[217] In 1880 there were 80,000 Jews in New York; by 1910 there were 1.25 million. The Lower East Side was the center of this immense and ever expanding Jewish population and of Jewish culture. Although it was never exclusively Jewish, the Lower East Side provided temporary or permanent shelter to most of the Jews who arrived in the United States between 1899 and 1914. The vast majority of these new Jewish immigrants were from eastern Europe, and they were set apart by their numbers and by their distinctive subculture from the German and western European Jews who had already established themselves in middle-class America. Newly arrived Polish and Russian Jews found in the Lower East Side a neighborhood where a knowledge of English was unnecessary and a home that recapitulated the ethnic complexion and the living conditions that they had experienced in the ghettos of Europe.[218]

At the turn of the century the Lower East Side was one of the world's most densely settled areas, filled with five- and six-story tenement houses sheltering large families, sometimes with boarders, in two-room apartments. The most crowded slum district in the city, the neighborhood averaged 522 people per acre in 1890, in contrast to 114 per acre in other parts of Manhattan and 60 per acre in the city of New York as a whole.[219] By 1905, according to one observer, eleven blocks in the Lower East Side had an average population of 1,100 to the acre; the entire congested area was home to almost 600,000 people.[220]

The needs of the Lower East Side's population were served by the merchants of Hester Street. This long street, one of the neighborhood's main east-west axes, ran one block north of Canal Street from Centre Street on the west to East Broadway on the east. Hester Street formed the spine of a great market lined with glass-windowed and open-fronted shops, many with awnings from which goods were hung to announce the contents within and to attract customers. Goods were also sold from tiny, crowded stalls and from wagons, pushcarts, and makeshift outdoor counters fashioned from boards mounted on barrels. From Hester Street the market spilled into the adjacent side streets—Orchard, Ludlow, Essex, Norfolk, and Suffolk—which ran south to Canal Street and north to Delancey and Houston. The area teemed with peddlers carrying their wares in baskets, on their backs, slung over their arms and shoulders, or displayed

on boards; with ragmen chanting that they would exchange cash for clothes; with organ-grinders and silhouette artists; with tailors and craftsmen mending and making, sewing all sorts of apparel and sharpening all sorts of objects; with hundreds of shoppers swarming, pushing, jostling, shouting, bargaining; with bootblacks, newsboys, and other street kids working or playing; with beggars, prostitutes and procurers, pickpockets, and policemen—a great horde rendering the streets almost impassable. The visual confusion invaded the spaces above the crowded streets, where suspended signs advertising various enterprises and a pattern of iron fire escapes covered the facades of the deeply corniced tenements.

Hester Street's merchants purveyed all manner of wares. With no reliable refrigeration, women shopped every day for food: meat, fish, live poultry and fresh eggs, cheeses, bread, fruit and vegetables, as well as Jewish specialties. Hester Street was known ironically as the pig market because the only commodity not available was pork. Merchants also sold street food, such as pretzels and hot potatoes. They stocked spices and nuts; bolts and remnants of textiles and ready-made clothing; shoes and boots; ribbons, buttons, laces, and thread; jewelry and spectacles; tools and toiletries; wallpapers and oilcloths; crockery, glassware, and pots and pans; books and stationery. Lively all week, the Hester Street market was especially crowded on Friday mornings, when Jews laid in provisions for the Sabbath. Sundays along the street were more active for dry-goods merchants, who served not only the Lower East Side but also people from other neighborhoods where shops were closed.

Contemporary accounts of the Lower East Side ranged from condemnations—sometimes rooted in anti-Semitism—of its overcrowding and squalor to sympathetic commentaries on picturesque aspects of Jewish immigrant life. One columnist for the *New York Times* complained in 1893: "Filthy persons and clothing reeking with vermin are seen on every side. Many of these people are afflicted with diseases of the skin. Children are covered with sores, and hundreds of them are nearly blind with sore eyes. . . . This neighborhood . . . is the eyesore of New York and perhaps the filthiest place on the western continent. It is impossible for a Christian to live there because he will be driven out, either by blows or the dirt and stench. Cleanliness is an unknown quantity to these people."[221] But another reporter for the same paper averred in 1897: "Aye, so are all these people human, intensely so, and many are the sides upon which their lives are keenly interesting, because, while somewhat strange to us, they have the 'touch of nature that makes the whole world kin,' and the very strangeness lends an additional charm and attractiveness to the student of mankind."[222]

The ubiquitous Van Rensselaer, on the other hand, recorded both the actual wretchedness she saw and the picturesqueness she perceived in the city's slums in her article of 1892 entitled "Picturesque New York":

> But we cannot appreciate the picturesqueness which New York wears to both mind and eye unless we go immediately from the stately commercialism of its down-town streets to the adjacent tenement-house districts. Pest-holes to the sanitarian and the moralist, loathsome abodes of filth and horror to the respectable citizen, many parts of these districts gratify the eye that seeks pictorial pleasure. . . . I have seen Hester street . . . when it swarmed so thickly with Jews of a dozen lands . . . that there seemed no room for another, and all were as little like Americans as though they had never left their outlandish homes, and not a sound in their loud Babel was a recognizable part of civilized speech; and Hester street was amazingly like those foreign ghettos which traveling New-Yorkers take such pains to visit.[223]

Luks's account of the Hester Street market echoes the sympathetic descriptions of life on the Lower East Side that were penned by his contemporaries and celebrates the very exoticism and picturesqueness that Van Rensselaer found there. In his painting figures fill a foreground stage that is defined by shops and tenements; others are packed into the narrow street that recedes into the distance. The streets are so crowded, in fact, that the woman with a red shawl and a market basket seems to confront the more fashionably dressed man in a brown derby in whose direction she is turned, although no real contact or recognition is indicated. Yet, despite the lively massing of forms, the scene is not nearly as chaotic as it appears to be in contemporary views of the site captured by the cameras of Byron, Lewis Hine, and other photographers (see fig. 174).

Luks shows men in pairs walking and talking; many wear the dark hats that identify them as Jews observing the religious rule that men cover their heads at all times. A toy peddler, distinguished by his top hat, stands just to the left of the axis of the composition, demonstrating a doll that climbs a string to a group of rapt children. A man set apart from the crowd by the white fedora he sports and the cigarette he smokes looks on at the left, self-contained, his right hand in his pocket. He is the *flâneur*, the artist's surrogate, observing the exotic culture from the edge of the scene without immersing himself in it. Toward the right a mustached butcher, who is differentiated from the other men by his bare head and his long white apron, speaks to a young woman holding a rooster whose feet are silhouetted against the butcher's apron. Behind the butcher is his shop, its window filled with hanging plucked chickens. In the right foreground stands a pushcart, a symbol for the entire neighborhood and its mercantile activities. It is a measure of the editing and euphemism of Luks's painting that the extraordinary clutter of Lower East Side pushcarts (which were said to number 2,500 and constitute a hazard to traffic)[224] is reduced to this single cart. The cart and the objects it contains—a large overturned basket, a pile of

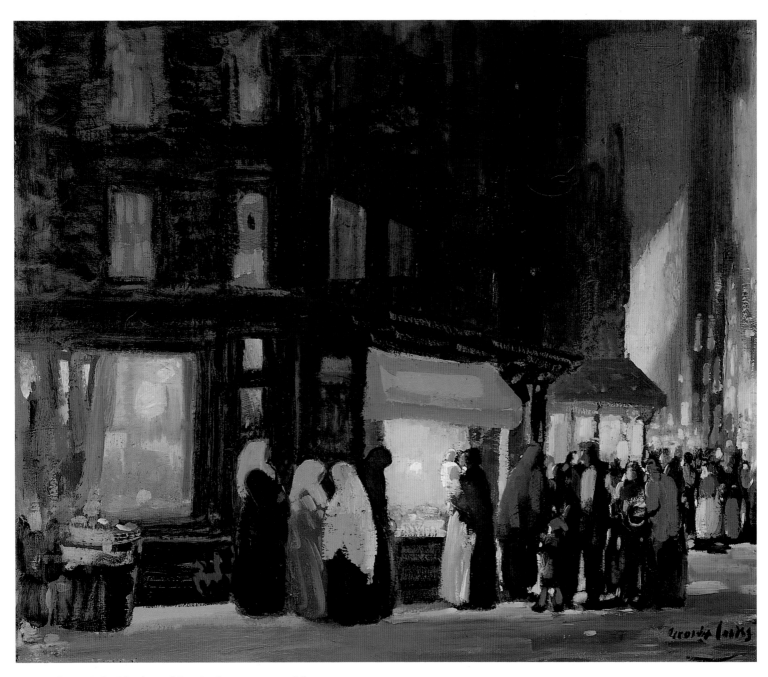

Fig. 175 George Luks. *Bleecker and Carmine Streets*, ca. 1915. Oil on canvas,
25 x 30 in. (63.5 x 76.2 cm). Milwaukee Art Museum, Gift of Mr. and Mrs.
Donald Abert and Mrs. Barbara Abert Tooman M1976.14

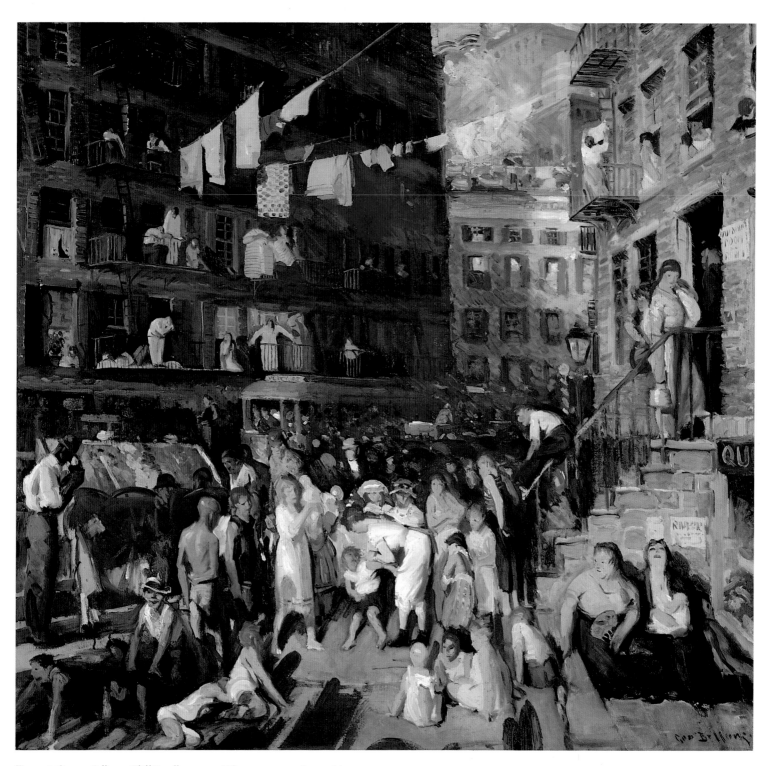

Fig. 176 George Bellows. *Cliff Dwellers*, 1913. Oil on canvas, 40¼ x 42⅛ in.
(102.2 x 107 cm). Los Angeles County Museum of Art, Los Angeles County
Funds 16.4

potatoes, and a stack of blue-green cabbages—press inward from the picture plane toward the crowd, activating an otherwise stagelike space and suggesting the narrow passages of the neighborhood and the dynamic relationship between the crowd and the commerce that brings that mass of humanity to Hester Street.

Luks's *Bleecker and Carmine Streets* (fig. 175) offers a similar account of another overcrowded and exotic Manhattan neighborhood that had been transformed by a wave of immigrants. The locale is the lower West Side at the intersection of meandering Bleecker Street, which runs northwest at this point from Sixth Avenue to Seventh Avenue South, with three-block-long Carmine Street. Although its ethnic persona, like that of the Lower East Side, was not monolithic, this neighborhood was filled with newly arrived Italians from many different regions. The diverse Italians outnumbered even the Jews among the huge influx of immigrants that changed the face of the United States and especially New York in the late nineteenth century.[225] Luks's scene is thus sociologically a pendant to his portrayal of Hester Street as well as compositionally close to it.

The view of shops and tenements, probably on Bleecker Street, is set at twilight, with still open stores whose lights cast puddles of brilliance on the darkened pavement. Three women with long white head shawls—*fazzoletti*—that indicate their peasant origins appear toward the left. A younger woman holding a child stands beneath the awning of the brightly lighted open-fronted market stall at center, gazing at the wares arrayed for sale. We might well imagine that these are the "eatables dear to the Italian stomach—olives, beans, macaroni, cheese, and great queer loaves of bread—spread out in inviting freshness, or being mauled and fingered by so many grimy thumbs that they lose their fresh allurement" described by a commentator of 1895 in the even more crowded Mulberry Bend Italian colony—today's Little Italy.[226] Toward the right on Luks's street a group of women and children gathers, encircling a man who speaks and gestures with his hands; a larger crowd fills the narrow street—probably Carmine—that runs perpendicular to the foreground stage. As at Hester Street, Luks has created a picturesque record of the curiosities associated with unusually dressed immigrants in a crowded section of the city but has softened the harsh realities of slum life.

The intersection of Carmine and Bleecker streets is located within the confines of Greenwich Village; but this is a portion of the Village geographically remote from the exclusive precincts that centered on Washington Square, whose vestigial elegance Hassam had portrayed some fifteen years earlier in his *Washington Arch, Spring* (fig. 165). Luks characteristically plunges into a portion of the Village that had yielded entirely to immigrants, to teeming slums, to crowded boardinghouses and ramshackle cold-water flats, to exotic shops and foreign character. Thus he ignores not only the remnants of patrician old Greenwich Village

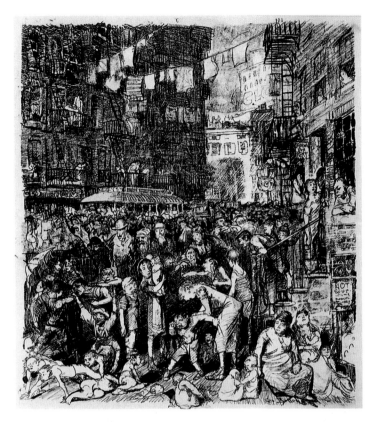

Fig. 177 George Bellows. *Why Don't They Go to the Country for a Vacation?*, 1913. Transfer lithograph reworked with pen, 25 x 22½ in. (63.5 x 57.2 cm). Los Angeles County Museum of Art, Los Angeles County Funds 60.43.1

that Hassam favored but also the elements that might have announced the emerging identity of the area as an intellectual and bohemian stronghold. Luks's somber palette and heavy impastos accord with his expressive agenda and stand in striking contrast to the chromatic brilliance, feathery stroke, and sense of sweetness and light that identify Hassam's Impressionist image.

Despite the clear distinctions that exist between Luks's intentions and those of Hassam, Luks's emphasis is still on the most positive aspects of slum life. And although *Bleecker and Carmine Streets* was completed fifteen years after Howells's *Hazard of New Fortunes* appeared, the canvas remains the painted counterpart of Howells's optimistic account of the new immigrant population of Greenwich Village, in which he wrote: "Foreign faces and foreign tongues prevailed in Greenwich Village. . . . The eyes and earrings of Italians twinkled in and out of the alleyways and basements, and they seemed to abound even in the streets. . . . March liked the swarthy, strange visages; he found nothing menacing for the future in them."[227] Strolling uptown on Madison Avenue, March would say, "I understand now why the poor people don't come up here and live in this clean, handsome, respectable quarter of the town; they would be bored to death.

On the whole I think I should prefer Mott Street [in Little Italy] myself."[228]

Another Realist interpretation of a slum neighborhood that retains at least an edge of euphemism is Bellows's *Cliff Dwellers* (fig. 176). Contemporary critics found much to offend genteel sensibilities in *Cliff Dwellers*. Typical of those who attacked the artist for his grim candor and his attraction to ugliness was Henry McBride, who carped:" 'Cliff Dwellers' is appalling. Can New York really be like that in summer? The dreadful people crowding the street, like naked urchins, the vendors of unhygienic lollypops, the battalion of mothers nursing their infants near the footlights where you have to see them, the street car clanging its mad way through the throng, the gentlemen on the fire escapes doing their toilets and the housewives hanging out the wash, can anything in Bedlam or Hogarth's prints equal this?"[229] As Doezema has observed, early viewers may have found in the painting confirmation of their most dire ideas about tenement-district life.[230] Yet Bellows seems at least as concerned here with providing an exhaustive catalogue of curious slum types and their activities as he is with offering a depressing or polemical account of life in a poor neighborhood.

Bellows made a preparatory drawing for *Cliff Dwellers*, satirically entitled *Why Don't They Go to the Country for a Vacation?* (fig. 177), that was published as the frontispiece in the August 1913 issue of the socialist journal the *Masses*. In the drawing the scene is identified clearly as New York's Lower East Side: the destination on the trolley-car sign, Vesey Street, specifically suggests that the site is East Broadway, a major thoroughfare in the neighborhood that runs southwest from Grand Street to Chatham Square, changes its name to Park Row, and ends at Vesey Street, just south of City Hall Park. The social criticism is acerbic in the drawing, where the artist portrays what Doezema has told us is the "seemingly unbearable overcrowding" that was "the supreme sensation registered by middle- and upper-class observers of New York's tenement districts."[231] The only visible bit of sky is limited to a small portion of the background at the upper right. Humanity in the form of countless figures is packed into the shallow stage of a narrow street, confined and pushed relentlessly forward toward the picture plane by a solid curtain of architecture and even by a streetcar that surely would not be able to proceed through the horde.

In the painting by contrast Bellows tones down some of the drawing's drearier details, shows far fewer people, and mitigates the sense of claustrophobia.[232] Soft light and bright colors selected and arranged according to the theories of Hardesty G. Maratta enliven the scene.[233] A stiff breeze now seems to snap the laundry hung out on lines that activate the upper portion of the composition. By comparison with their prototypes in the drawing, the young mother who holds a child at center stage looks less haggard, less threatened by the crowd, and less burdened by

her charge, and the children playing at the lower left have more space for their boisterous games. As Doezema has observed, another key figure, the young woman entering the tenement at the right, carrying home a bucket of beer, has also undergone a certain transformation. In the drawing she has "allowed her dress to slip tauntingly off her shoulder as she exchanged a few words with an unidentified man"; in the painting "she exposes no bare shoulder, she seems older and more matronly, and she carries a child."[234]

Although *Cliff Dwellers* still suggests the dehumanizing crowding of the slums, those in the crowd seem far from miserable. Bellows's description of the cliff dwellers' streets and habitations provides no rationale for the tenement-house reform that preoccupied social commentators of the period.[235] We certainly cannot recognize it as an illustration of the neighborhood about which Van Dyke so bitterly complained in 1909: "It is a menace to the public health, a prolific source of contagion. Worst of all, it is a sink of crime and immorality. It is not creditable to New York. It is one of the city's most hideous features, one of its most violent and forbidding contrasts."[236]

In fact, Bellows's effect is faintly Zeffirellian; the painter is not revolted by the site but appreciative of its picturesque potential. Rather than recalling Van Dyke's polemic, *Cliff Dwellers* is reminiscent of Howells's gentle and bemused account of the experiences of Isabel and Basil March as they discovered the realms of poverty in New York. Bellows seems to echo Basil March, who exclaimed upon straying into one swarming lower New York street, "I haven't seen a jollier crowd anywhere in New York."[237]

The painter's attraction to the picturesque notwithstanding, *Cliff Dwellers* amply fulfills Bellows's credo, shared by the American Impressionists and his colleagues among the Realists, that a painter of modern life should find his lessons and inspiration in the modern city, rather than in the academy. As he said in 1917: "There are only three things demanded of a painter: to see things, to feel them and to dope them out for the public. You can learn more in painting one street scene than in six months' work in an atelier."[238]

Coda: Hassam's Flag Paintings

No works could more effectively summarize the derivation from French models, the euphemism, optimism, nationalism, and nostalgia that we have identified as fundamental characteristics of American Impressionism and Realism than Hassam's flag paintings—some thirty canvases realized between 1916 and 1919. *Allies Day, May 1917* (fig. 178) is probably the most famous of Hassam's many flag images, the largest number of which

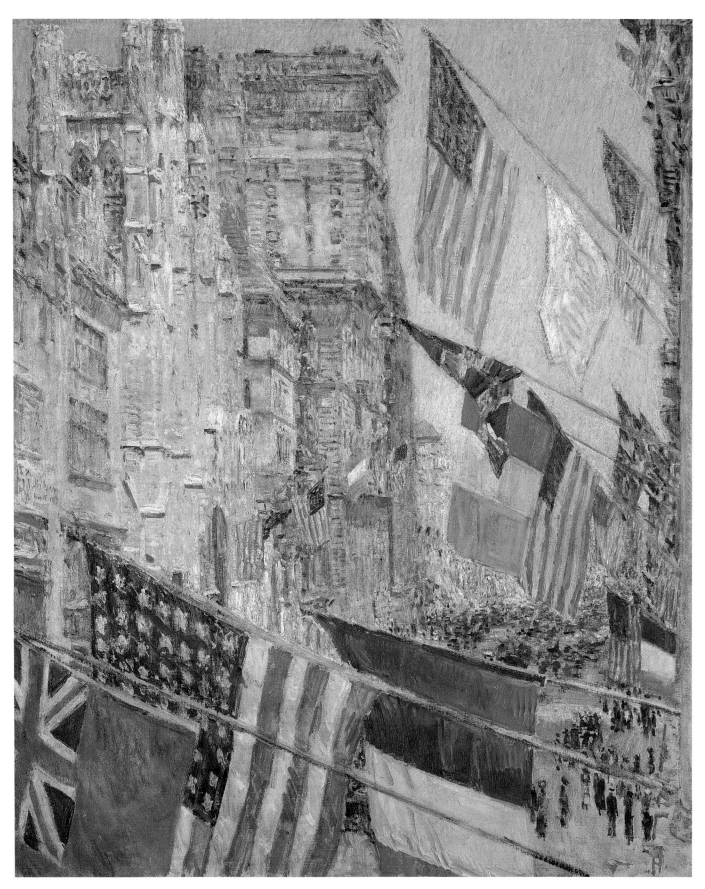

Fig. 178 Childe Hassam. *Allies Day, May 1917*, 1917. Oil on canvas, 36¾ x 30¼ in.
(93.4 x 76.8 cm). National Gallery of Art, Washington, D.C., Gift of Ethelyn
McKinney in memory of her brother, Glenn Ford McKinney 1943.9.1

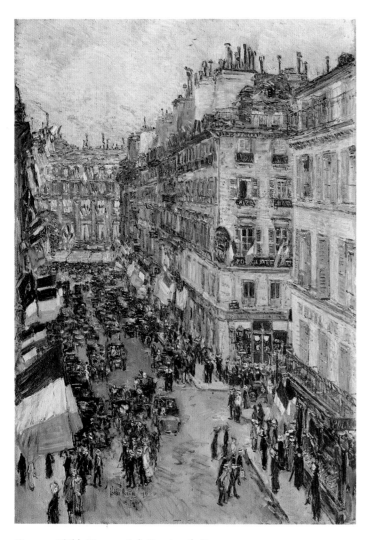

Fig. 179 Childe Hassam. *July Fourteenth, Rue Daunou, 1910*, 1910. Oil on canvas, 29⅛ x 19⅞ in. (74 x 50.5 cm). The Metropolitan Museum of Art, New York, George A. Hearn Fund, 1929 29.86

stands at the northwest corner of Fifty-third Street; McKim, Mead and White's Renaissance palazzo built for the University Club appears a block to the north, with the Gotham Hotel and the Fifth Avenue Presbyterian Church beyond.

Groupings of the flags of the three allies are reiterated in several places. The harmony among the three nations is symbolized by these groupings and, coincidentally, by the fact that their banners are identical in color, offering variations in pattern on the theme of red, white, and blue. But the American flag is ascendant. For there is only one large banner whose surface is not interrupted by a flagpole or partially obscured by another flag: the American flag seen against the sky toward the upper center of the composition, in visual dialogue with the tower of Saint Thomas Church. This unimpeded view of the American flag, its privileged position in relation to an emblem of spiritual authority, and its placement at the pinnacle of the composition suggest the supremacy of the American spirit in the scene and clearly strike the nationalist chord. A critic appraising Hassam's flag paintings in 1919 understood the measure of patriotic pride that underlay them: "In Boston, Paris and London as well as New York, [Hassam] has seen the poetry, the romance and beauty of people walking through architectural canyons of their own creating. To him Fifth Avenue is the most marvelous metropolitan street in the whole world. One can never mistake this impressive Avenue for any other street of any other city; there is nothing approaching it in composition or in realization of man's sense of architectural beauty. In his pictures, lives all that appeals to our patriotic and zealous love of this street."[240]

Given its pronounced nationalistic spirit, *Allies Day, May 1917* may be read as an intentional domestication of a French avant-garde subject: Monet's *Rue Montorgeuil, Festival of June 30, 1878* (fig. 180), a streetscape filled with flags, which was exhibited in Paris in 1889, when Hassam was studying there. Hassam himself depicted a Parisian street decorated for Bastille Day in *July Fourteenth, Rue Daunou, 1910* (fig. 179), a canvas that mediates between Monet's prototype and his own more extensive response to the subject of a banner-lined thoroughfare in the World War I flag series.

Initially, Hassam was moved by the sheer visual richness of the patriotic celebrations held in wartime New York. "I painted the flag series," he told an interviewer, "after we went into the war. There was that Preparedness Day [May 13, 1916], and I looked up the avenue and saw these wonderful flags waving, and I painted the series of flag pictures after that."[241] Thereafter, Fort has suggested, the artist's portrayals of Fifth Avenue draped in Allied flags increasingly seem to have been inspired not just by visual considerations but also by growing war sentiment and by ever more frequent war-related ceremonies and celebrations. Analyzing them individually and at length, she has argued that the flag pictures ultimately were motivated entirely by national-

date from May 1917. Because of its acquisition by the National Gallery of Art in 1943, *Allies Day, May 1917* also seems the most conspicuously national canvas Hassam painted.

Ilene Susan Fort has connected *Allies Day, May 1917* with the parades that were staged for the French and British war commissioners when they came to New York in early May 1917, immediately after the United States entered World War I. Commentators of 1918 wrote that the painting represents "the historic scene . . . when the flags of Great Britain and of France were first hung with the Stars and Stripes and the streets were thronged to greet General Joffre and Mr. Balfour, emissaries of the new comradeship between nations."[239]

The view is of Fifth Avenue from the northeast corner of Fifty-second Street looking northward as the morning sunlight strikes the facades on the west side of the avenue. Ralph Adams Cram's recently completed neo-Gothic Saint Thomas Church

ism and that they became intentionally patriotic statements of America's support of the war effort, of the nation's technological and military superiority, and of the triumph of democracy over tyranny.

For Hassam in the flag series, elements of urban architecture seem to have been as crucial as the flags themselves for suggesting American superiority. The banners often project out over the street and overlap, obscuring parts of the buildings and the mundane details of the avenue itself, leaving only the enframement of skyscraper facades to identify the locale. A skyscraper in isolation, Hassam believed, was "a wildly formed architectural freak." But, he noted, the grandeur of the skyscraper—and, by association, of American technology—could be expressed if the artist composed his picture properly and showed his buildings under sufficiently poetic conditions.[242]

In a painting such as *Allies Day, May 1917*, Hassam, working at the end of the second decade of the twentieth century, maintains the rosy spirit that characterizes American Impressionism from its inception. Conveying patriotic sentiments, the painting remains decorative and provides a dynamic and optimistic view of the modern metropolis. Although ostensibly challenged by the younger generation of American Realists—especially the Ashcan School—the American Impressionists continued to take a euphemistic and cheerful approach to modern subjects well into the twentieth century. *Allies Day, May 1917* might, in fact, be considered an unintentional parody of Bellows's *Cliff Dwellers*, with its Allied flags projecting from Fifth Avenue facades replacing the laundry hanging from tenement windows. If the Realists had rejected completely the heritage of their predecessors in pursuit of a grittier and more straightforward aesthetic, the later works of the American Impressionists would seem extremely anachronistic and old-fashioned. But the differences between the attitudes of the two groups are in many ways superficial, as we have seen, and much of the euphemism and optimism that mark American Impressionism lives on in Realism.

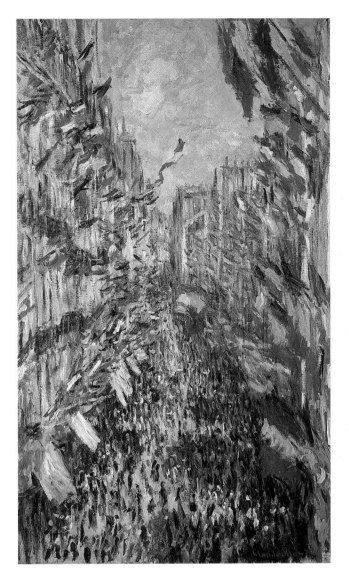

Fig. 180 Claude Monet. *The Rue Montorgueil, Paris. Festival of June 30, 1878*, 1878. Oil on canvas, 32½ x 20⅛ in. (81.3 x 48.6 cm). Musée d'Orsay, Paris

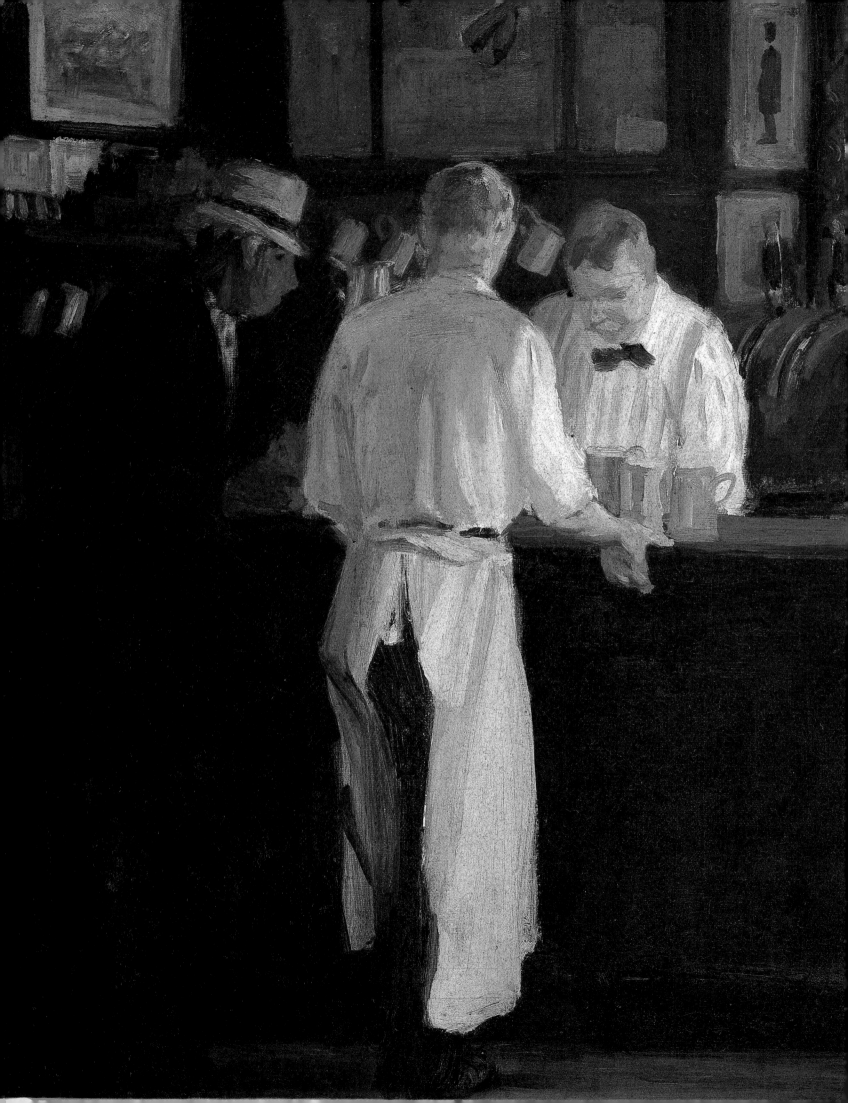

Urban Leisure

Paying and Playing: Some Urban Amusements

It is these large corporate views of amusement as an asset that are most conclusive of our [American] state. We must have amusement; we are in circumstances to gratify it; it is profitable to supply it.

SCRIBNER'S MAGAZINE (1910)

Working before the endless replication of images in advertisements, illustrated journals, and, eventually, moving pictures dulled the public's receptivity to visual phenomena, the American painters of modern life focused on the audience more often than they did on the performer when recording urban entertainments. For turn-of-the-century audiences *looking*—at fine art, at displays of technology or consumer goods, at public performances, and, of course, at one another—had become a self-conscious spectator sport.[1]

To be a spectator in the modern city was to be cast in a role, filling at least a bit part or even taking a star turn. This issue was understood by architects who designed elaborate public spaces to let hotel, restaurant, and theater patrons see and be seen. Resplendent facades, clad in the ornament of the long ago and far away but festooned with the latest electric lights, spilled "their invitations in streams of golden light across the sidewalk," as Mariana Griswold Van Rensselaer observed in 1895.[2] Opulent lobbies and parterre boxes framed one part of the audience for the rest; refreshing roof gardens and private dining clubs at the tops of skyscrapers took in views of the metropolis even as they provided sanctuary from it, offering spectacles of the city that complemented the spectacles onstage.[3] Gilt-framed mirrors encrusted the walls of glittering hotel lobbies, lobster palaces, and drinking establishments, reflecting the city's players upon themselves. After describing alluring nightlife possibilities in seductive detail, the ever wordy literary realist Theodore Dreiser warned in 1900 in *Sister Carrie*, "so long as . . . the human heart views this as the one desirable realm which it must attain, so long, to that heart will this remain the realm of greatness. So long, also, will the atmosphere of this realm work its desperate results in the soul of man. It is like a chemical reagent."[4] As we will see, however, American Impressionist and Realist painters did not subscribe any more fully to the dire viewpoint of the Realist writers than middle-class audiences intended to give up social stability for the actualities of fast living. Urban amusement was a form of commerce in America. The purveyors of entertainments, including fine art, were responsive to the aspirations and the sensibilities of their diverse audiences. As the editors of *Scribner's Magazine* wrote in 1910, "It is these large corporate views of amusement as an asset that are most conclusive of our [American] state. We must have amusement; we are in circumstances to gratify it; it is profitable to supply it."[5]

Detail, fig. 222

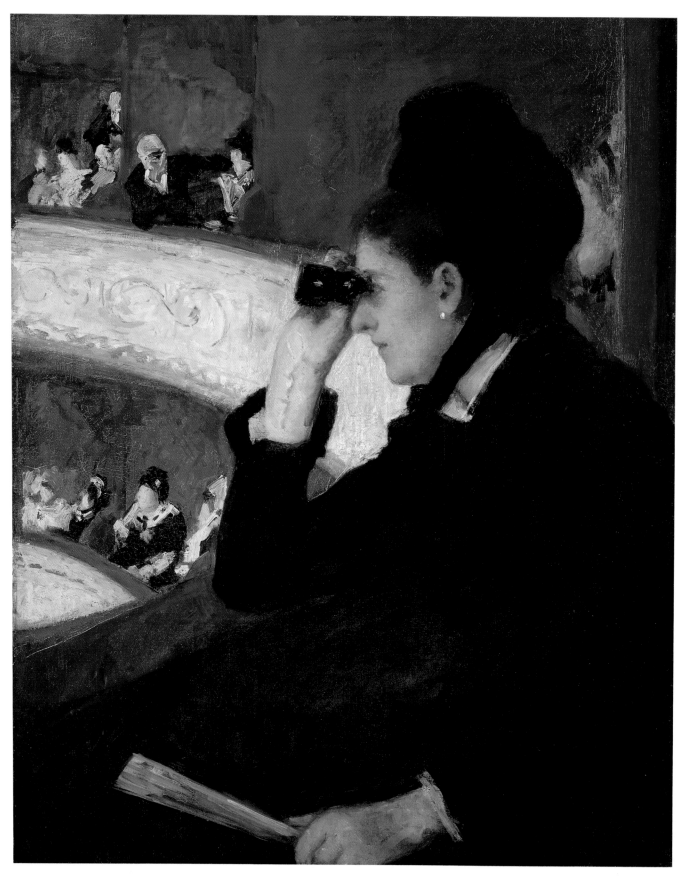

Fig. 181 Mary Cassatt. *At the Opera*, 1879. Oil on canvas, 31½ x 25½ in.
(80 x 64.8 cm). Museum of Fine Arts, Boston, The Hayden Collection 10.35

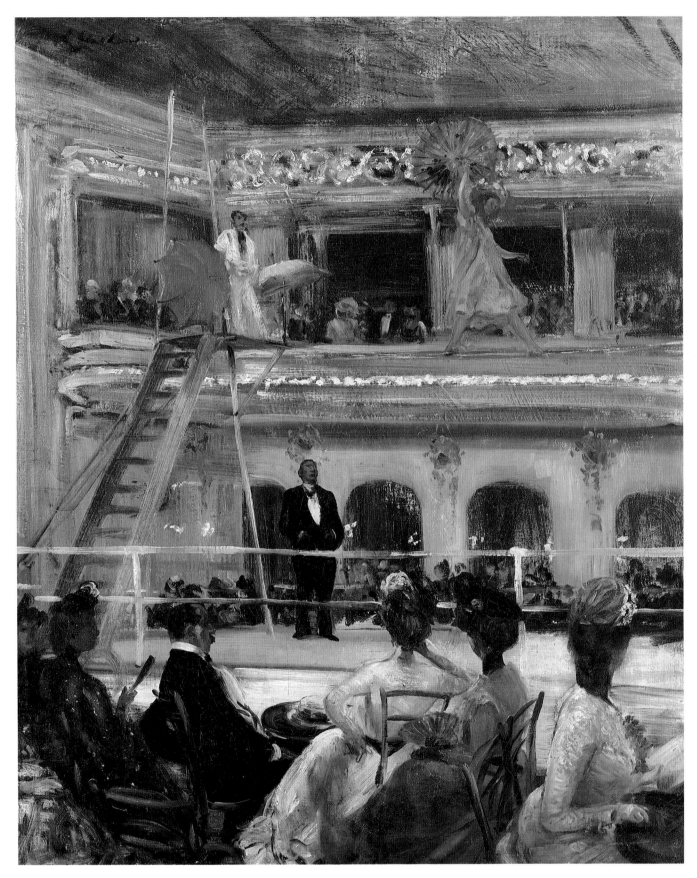

Fig. 182 William Glackens. *Hammerstein's Roof Garden*, ca. 1901.
Oil on canvas, 30 x 25 in. (76.2 x 63.5 cm). Whitney Museum of American Art,
New York, Purchase 53.46

Continuous Performance

Fig. 183 Jean-Antoine Watteau. *Gilles*, 1717–19. Oil on canvas, 72⅝ x 58⅞ in. (184.5 x 149.5 cm). Musée du Louvre, Paris M.I. 1121

Created on both sides of the Atlantic as the nineteenth century gave way to the twentieth, images like *At the Opera* (fig. 181) by Mary Cassatt and *Hammerstein's Roof Garden* by William Glackens (fig. 182) highlight the overarching issue of the city itself as a nonstop performance for and by its inhabitants. As a journalist put it in 1909, "The city sleeps for a few hours . . . like a weary columbine at the theater wing, in all its paint and spangles, expecting its call to 'go on' at any moment."[6]

Succeeding as an artist during this ever-changing, self-conscious, and anxiety-ridden period required a skilled performance, and painters were expected to "go on" with increasing frequency. The late nineteenth century witnessed the celebration of the artist's studio and the artistic house as benchmarks of fashion, the rise of the art press as arbiter of taste, the advent of the solo exhibition, and the establishment of the commercial gallery as the art consumer's most familiar point of purchase. As artists became involved in framing, exhibiting, or publicizing their own work, or in loudly seceding from various art establishments amid extensive press coverage,[7] lines between real life and theater blurred for them.

The growing prominence of painters as public personae during the nineteenth century in England, France, and America reinforced their interest in the stage. Indeed, painters even pictured themselves or were pictured with theatergoers and performers. By the late 1890s, at least in America, theatergoing was the most popular of all urban entertainments. In 1897 Foster Coates told the readers of the *Chautauquan*: "Chief of the places of amusement of New York are the theaters. At the present time there are forty-one theaters, nine music halls, and twelve museums and concert halls open every night in the week except Sunday, and a good many of them give matinees twice or three times a week as well."[8] And by 1913 an Englishman could opine, "You Americans who believe it to be the 'smart' thing to go to Paris for a 'fast' time, do not have to go out of Times Square."[9] But later historians detected the vicarious nature of fast times in urban America, labeled by one perceptive critic "as devilish as deviled ham."[10] How could it be otherwise, asked historian Lewis A.

Erenberg, when middle-class "cabaret goers wanted merely a touch of expressivism in their lives, not a complete renunciation of convention."[11]

Like live performances, theater subjects in the painting of modern life offered both artist and audience a heady cocktail of acceptable artificiality tinctured with current manners. Already one step beyond the bounds of daily life, such themes have always touched profound emotions, permitting the painter to enter the realm of fantasy while resting on a firm foundation of artistic precedent. For centuries artists have used theater subjects to focus on social performances—on the stage, in the audience, or behind the scenes. All the French Impressionist figure painters created images centered on theater and opera, as did many other European painters and illustrators of the late nineteenth century. Predictably, subject matter drawn from the theater would appear

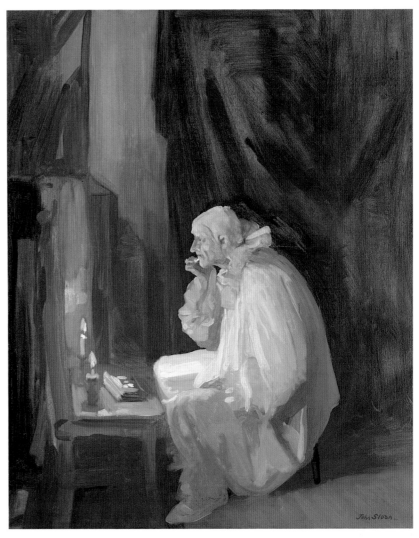

Fig. 184 William Merritt Chase. *Keying Up—The Court Jester*, 1875. Oil on canvas, 39¾ x 24⅞ in. (101 x 63.2 cm). Pennsylvania Academy of the Fine Arts, Philadelphia, Gift of the Chapellier Galleries 1969.37

Fig. 185 John Sloan. *Clown Making Up*, 1909. Oil on canvas, 32 x 26 in. (81.3 x 66 cm). The Phillips Collection, Washington, D.C. 1757

in turn-of-the-century American painting, extending the international visual continuum.

The very real message of the performer's hard life—be it in the legitimate theater with its full-length performances or on some less exalted stage—is given added resonance by the plangent presence of the sad clown. This evocative subject regularly reappears across the centuries in guises that range from Jean-Antoine Watteau's martyrlike *Gilles* (fig. 183) to William Merritt Chase's hunchbacked jester who is shown "keying up" by pouring himself a bracing drink before facing the footlights (fig. 184) to John Sloan's harshly lit *Clown Making Up*, an aging Pierrot upon whom we intrude unexpectedly, as if we had slipped in at the stage door (fig. 185).[12]

American painters of modern life followed French precedent, using a variety of established artistic devices to involve viewers in

their compositions, making them part of the audience captured on canvas or paper. Thus Cassatt and Glackens respectively invite us into *At the Opera* and *Hammerstein's Roof Garden*. Cassatt constructs her picture so that we enter the woman in black's box as a counterpoint to the figure who departs another box in the upper left corner. We can hardly have knocked or received permission to enter—the woman seems unaware of our presence. In *Hammerstein's Roof Garden* we join the spectators craning up at an acrobat in bright blue, inching along her tightrope. In an otherwise rather drab composition, Glackens reserves the richest colors, like this intense blue, to emphasize the performance itself. As the high-wire walker holds her Japanese parasol aloft to negotiate the perilous wire, a man in white—probably her partner in the act—looks on, flanked by festive red-and-white umbrellas that echo her colorful headgear. The

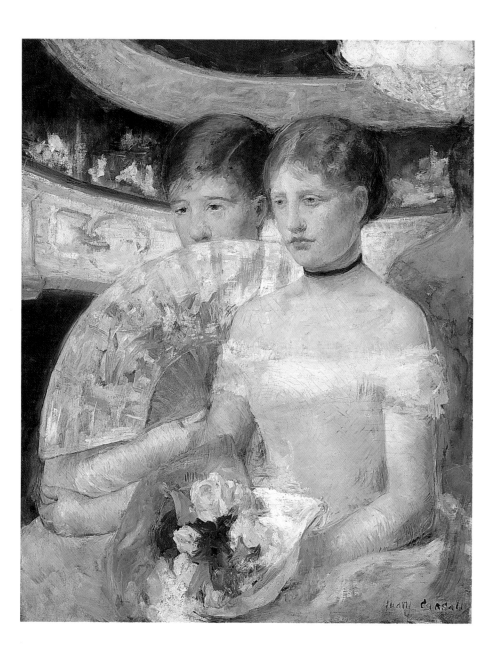

Fig. 186 Mary Cassatt. *The Loge*, 1882. Oil on canvas, 31⅜ x 25⅛ in. (79.7 x 63.8 cm). National Gallery of Art, Washington, D.C., Chester Dale Collection 1963.10.96

umbrellas rest on the platform from which the girl began her precarious journey. By drawing our eye to the tightrope with vivid color, Glackens makes us a part of the audience. The tightrope walkers are linked via the ladder that leads to the platform both to the master of ceremonies who announces their act and to a rather prim woman who observes it. With a gesture of her folded fan, she directs our gaze upward toward the performance, recalling Cassatt's use of a fan in *At the Opera*. Glackens cuts off the tables and chairs, setting them at a sharply tilted angle. Viewers of this canvas easily can imagine themselves crowding around another table, rubbing shoulders with strangers in the intimate space near the stage.

Both Cassatt and Glackens have created memorable works of art that are informed by, but do not editorialize upon, the nature of social change made visible in theaters and cabarets. In both pictures older distinctions between good and bad behavior are

breaking down. Privacy and politesse are at a premium in both, although today an opera house might seem considerably more decorous than a vaudeville stage, and Cassatt's central character, clad in a reserved matinee costume, accented by a small hat, transparent white gloves, and discreet pearl earrings, looks far more elegant to the modern eye than Glackens's garishly costumed tightrope walker. However, at the time she executed it, Cassatt's image, like most Impressionist figure paintings, was a visual affront in the eyes of the public; and the opera houses of the period often provided settings for aggressive displays of wealth and power.

Cassatt's self-possessed operagoer uses tilted-up binoculars to scrutinize not the stage but the unknown, unseen occupant of a loge box outside the picture frame. She herself is stared at boldly through binoculars by a heavyset male figure who leans out from his box opposite hers. Ignoring this boorish behavior, another man

has risen behind him to depart the adjoining box. These abrupt
relationships are visual in every sense: we confront strangers
observing one another without any supporting narrative tale. We
cannot even be sure of the woman's identity, although Robert L.
Herbert notes her resemblance to Cassatt, citing her "no-nonsense
maturity" and her cool self-possession. Just as Cassatt was active
in a male-dominated avant-garde artistic milieu, her subject is an
active spectator, not merely the target of male scrutiny like most
women in theater images contemporary with this one.[13] Cassatt's
brushwork is rapid and sure, and there is an absence of extraneous
detail. Her palette is limited but rich and strong. The woman in
black forms a diagonal wedge, occupying fully half the canvas,
offset by the red, white, and gold of the balconies beyond her.
The artist uses color to link the characters in her picture. As the
curving sweep of red velvet rail and gilt plasterwork tie together
the two black-and-white-clad figures with binoculars, the red,
white, and gold fan pointing toward the unseen third party in this
triangle of strangers reinforces the direction of the woman's
unabashed gaze.

If the well-bred Cassatt's Parisian theater images are not
exactly racy, the artist did fully exploit the function of the theater
box as a showcase for public display, even in her most reserved
treatments of the theme. One such example, *The Loge* (fig. 186),
showcases Stéphane Mallarmé's daughter Geneviève and a visit-
ing American girl, Mary Ellison. The two are posed with a stiff
decorum that is intended to separate them from lower-class
cocottes brought to the theater by their lovers.[14] By implication,
then, Cassatt's picture delicately embraces a distinctive compo-
nent of modern city life—the charged atmosphere where differ-
ent social classes mingle in a public setting.[15]

Cassatt herself, however genteel, had begun to mingle. Several
surviving drawings (see fig. 187) reveal not only the genesis of
At the Opera but also a significant change in the artist's working
methods.[16] She developed the picture from drawings made in a
pocket-size sketchbook she recently had begun to carry for the
purpose of capturing immediate impressions of her surroundings
rather than just relying on studio models. These sketches provide
more than an unusually complete record of Cassatt's creative
processes, however; they also document how she followed the
practice of her French colleagues, taking the role of a *flâneur*, or
detached (usually male) observer of modern life. In addition,
Cassatt's use of such drawings relates the American expatriate
directly to the young American Realists, most of them former
newspaper illustrators, who would follow in her wake, painting
both French and American theater scenes that retain the sponta-
neous flavor of rapidly executed sketches. Glackens was among
them. His elaborate oil of Hammerstein's famous nightspot was
preceded by a more anecdotal illustration, published as *A Summer-
Night Relaxation* (fig. 188). This illustration focuses completely
on the audience—here the entertainers who became the center

Fig. 187 Mary Cassatt. Study for *At the Opera*,
1879. Pencil on paper, 4 x 6 in. (10.2 x 15.2 cm).
Museum of Fine Arts, Boston, Gift of Dr. Hans
Schaeffer 55.28

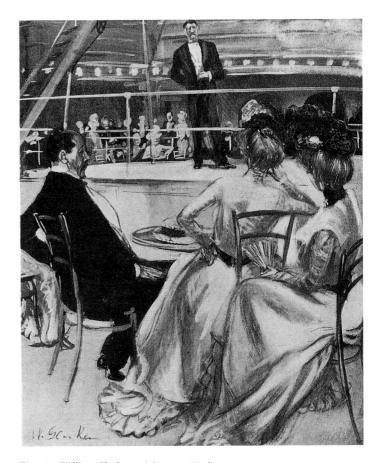

Fig. 188 William Glackens. *A Summer-Night
Relaxation*, from Ada Sterling, "New York's Charm
in Summer," *Harper's Bazar* 33 (August 18, 1900),
p. 972

Fig. 189 William Merritt Chase dressed for a costume ball, ca. 1886. Albumen print. The Parrish Art Museum, Southampton, New York, William Merritt Chase Archives, Gift of Jackson Chase Storm

of attention in his painting are outside the frame. But in both illustration and easel painting, Glackens extends Cassatt's exploration of audience behavior, using visual devices to pull the viewer of the artwork into the crowd.

At the Opera and *Hammerstein's Roof Garden* span the decades in which theater imagery, as an important subject from modern urban life, was transmitted across the Atlantic. Yet a curious hiatus occurs between the Parisian theater views made by such first-wave American expatriates as Cassatt and memorable theater subjects painted back in New York by Glackens and other American Realists. Leading American Impressionists avoided depicting such public urban amusements, although many of them were avid theatergoers, and there were more than forty theaters in New York alone by 1897. Moreover, the Impressionists and even some of the most conservative painters participated in high-toned pageants vaguely based on mainstream fine art, private amateur theatricals, and costume balls (see fig. 189). But while Thomas Wilmer Dewing and other artists of similar stripe produced canvases that related to pseudoclassical pageants, American Impressionists painted almost no counterparts to the Realist theater images of the early twentieth century.[17]

The American Impressionists were family men, often socially prominent pillars of the community. Although Childe Hassam, for one, appreciated and painted the city as a nexus of economic and cultural power, his pictures are nonnarrative, his outlook is patrician, and his entertainments are often rural or private. The august St. Botolph Club in Boston's Back Bay and similar enclaves were among the earliest institutions to hang Impressionist

canvases, but their hushed and well-furnished spaces were hardly hotbeds of bohemian activity. In fact, the most prestigious private clubhouses erected as public monuments in New York between 1890 and 1915 "stood as bastions against the social diversification of the city," according to one recent study.[18] Impressionist painters, along with the writers and actors who were their contemporaries, frequented sedate private preserves like the Players Club in New York, designed by Stanford White in 1888. This club, which displayed a large art collection on its walls, was "born like Minerva, grown up, clothed and well educated," as the *New York Times* phrased it, emphasizing the private nature of entertainments for gentlemen of the Impressionists' generation (see fig. 190).[19]

That a famous performer might stage a visit to a private club provided vicarious contact with fast living, an experience that could have a beneficial impact on membership. An article for *Everybody's*, illustrated by Everett Shinn, chronicles several clubs, including the Tenderloin Club, formed in Thirtieth Street, directly opposite the busy police station in the heart of the entertainment district, the so-called Tenderloin. This club "became a rendezvous for a score or more men, artists, writers, and a few members" of the considerably more prestigious, politically oriented Union League Club, who "found it interesting to drop in there late in the evening and hear the freshest gossip of the theatrical and hotel world."[20] One evening Mlle Otero, a well-known Spanish dancer, suddenly appeared there: "Had she been evolved from the smoke itself the Tenderloiners would not have been more surprised. . . . she whirled in to the music of the band, performed one of the dances which were the rage at that time, and whirled out again. Before the spectators realized that the

Fig. 190 Willard Metcalf. Illustration from John Drew, "The Actor," *Scribner's Magazine* 15 (January 1894), p. 47

dance was over they heard from the street below the slam of her carriage-door, and the first woman guest of the club had gone. . . . If such unexpected things were likely to occur here, many other men wanted to join this queer club."[21] Mlle Otero, who at the time "commanded a higher price for a private performance than a grand-opera star,"[22] was not the only celebrity to favor a studio or private club with her purchased presence. Carmencita danced for Chase in his Tenth Street studio, and Mlle Voclezca danced for Robert Henri at his school, located in the same building as the Lincoln Square Theatre.[23]

Perhaps when they were abroad, Americans shed some of their homegrown constraints about observing public performances, not only in theaters and opera houses but also under the garish lights of café-concerts and the ramshackle stages of public gardens. In American art both before and after the Impressionist era, entertainment themes are charged with the sense of slumming. A frisson from forbidden pleasures is recorded as early as 1805, when Benjamin Silliman warned his American readers that, while London's Vauxhall Gardens was "superlatively elegant," he was nonetheless aware that "no small part of the crowd is composed of courtezans." He surmised that it was "a most successful school of corruption."[24] Similar opportunities for corruption are revealed in Winslow Homer's graphic record of abandoned public dancing at the Bal Mabille in Paris (fig. 191).[25] Such exuberant activities translated awkwardly to American life and hardly at all to the purview of the American Impressionists. The observant yet patrician Van Rensselaer found New York's roof gardens "cool and breezy places . . . although not in the least poetic" and hoped that "some day, perhaps, some one will invent for them forms of entertainment that are neither vulgar nor desperately dull." She also commented on street-level gardens: "some of them highly 'respectable' ones, where New-Yorkers who were brought up in European lands love to gather in family groups, and to eat, drink, smoke, and chatter to the sound of music. And it is well to make a round of these places once at least, to see what our fellow-citizens like, even if we cannot share their likings."[26]

When American Realists followed the American Impressionists in portraying only selected aspects of modern life, their social activism prevented them from maintaining the cool detachment of their predecessors, let alone the exquisite manners and impeccable dress of the true *flâneur*. Nor, as we have noted, did they maintain the Impressionists' distance from theater subjects. Perhaps it was the Realists' grounding in journalism—their reporter's need for a good story in black and white—that impelled them to turn back to theater imagery after a generation of artists had disregarded it. In any case, their journalistic experiences served them well, keeping them in step with the commercialization of leisure as public entertainments—not only theater but also concerts, horse races, baseball and football games, prizefights,

Fig. 191 Winslow Homer. *A Parisian Ball—Dancing at the Bal Mabille, Paris.* Wood engraving, 9⅛ x 13¾ in. (23.2 x 34.9 cm). *Harper's Weekly* 11 (November 23, 1867), p. 744. Museum of Fine Arts, Houston, Kelsey Collection 75.73

even church services—became important topics for early twentieth-century newspapers and magazines. In fact, interest in the entertainment industry had burgeoned so that in 1904 a Chicago journalist could report that in contemporary newspapers, compared to those of twenty or thirty years ago, "ten times the old amount of space is now daily given up to it."[27]

People from all social classes came to public entertainments in America, just as they did in Europe. The American Realists, like their French predecessors, were class-conscious and paid attention to the varieties of people who rubbed shoulders at these events. However, when French modernists addressed entertainment topics, they juxtaposed obviously incongruous types, charging their painting with pathos and power, whereas Americans muted such issues. The comparison of relatively homogeneous audience members in Glackens's *Hammerstein's Roof Garden* with sharply contrasted types—such as the debonair man-about-town seated next to a working girl in Edouard Manet's *Café-Concert* (fig. 192)—provides a case in point.[28]

It is not a quantum leap from Manet's suggestive Parisian *Masked Ball at the Opéra* (fig. 193) to Sloan's *Haymarket* (fig. 194)—each nightspot was a place of assignation, and each artist explored an urban sexual market.[29] Garishly dressed cocottes whisper into gentlemen's ears at Manet's masked ball. And, to the left of the brightly illuminated doorway of Sloan's *Haymarket*, where several women in white dresses enter, presumably without paying, a group of men clusters around an obvious prostitute. Manet shows sexual transactions that are conducted quite openly—in one a brightly clad, bare-armed cocotte lays enticing fingers on the white shirtfront of a gentleman who clutches her elbow. But Sloan, unlike Manet, lacks the sangfroid of a real *flâneur*. His

Fig. 192 Edouard Manet. *Café-Concert*, 1878. Oil
on canvas, 18⅝ x 15⅜ in. (47.3 x 39.1 cm). Walters
Art Gallery, Baltimore 37.893

picture does not rise above a visual homily on good and evil. To
the left an honest woman, the hooker's counterpart, trudges
away from the sordid negotiations, carrying a heavy basket of
laundry and trailing a little daughter who looks back with undis-
guised curiosity—the analogue to the curiosity of a middle-class
audience willing to go slumming so long as it is safe. On the right
a small boy rolls his toy hoop out of the scene, offering a senti-
mentalized contrast between child's play and the recreation of
the lounging loafer at the Haymarket's luridly lit doorway.

In their choices of subjects drawn from modern life, Ameri-
cans, like their European predecessors, favored the new. Just as
opera was a newly chic leisure option in Paris when Cassatt and
Degas painted it, vaudeville outshone opera as a fresh entertain-
ment of the moment in New York when the American Realists
made it a preferred theme in their work. Opera, widely under-
stood as the most expensive entertainment in America and rec-
ognized as an amusement whose chief benefit was the opportunity
for public display on the part of audience members, already had
become a target for satire. By 1897 a journalist complained of
"society butterflies" who could be heard "gobbling like mag-
pies" during performances at the Metropolitan Opera House in

New York. He also observed, "I may be doing an injustice to the
box-holders when I say that they care more for the social promi-
nence that the opera gives than for the music."[30]

Typically, Glackens avoided opera, instead choosing to depict
in *Hammerstein's Roof Garden* an evening in an open-air spot
that had become one of the most popular elements in the new
commercialized leisure of the turn of the century. Roof gardens
spread rapidly from theaters to private clubs, department stores,
and hotels and became ever more elaborate in the process, flour-
ishing until the 1920s, when air-conditioning and Prohibition
made them obsolete as well as unprofitable.[31] The spot Glackens
painted was among the most famous in all New York and be-
longed to Oscar Hammerstein, who took the lead in moving the
city's entertainment district from the Union Square area up to
Times Square.[32] Hammerstein opened the Paradise Roof Garden
atop his most lucrative theater, the Victoria, in 1899.[33] Eventually
known simply as "the corner," the structure stood at the inter-
section of Forty-second Street and Seventh Avenue (fig. 195).
Hammerstein knew how to bring in the paying guests, and he
purposefully preserved a makeshift, secondhand appearance—
the Victoria was built of used materials, allowing audiences to
indulge "the feeling that they were slumming in a run-down
theatre."[34]

The old and the new coexist in urban leisure. Glackens tempers
his choice of a new theater with an old-fashioned entertainment—
tightrope walking—for high-wire artists had performed a century
earlier in suburban parks that eased the strictures of city living in
Europe. Such entertainments also were to be found in Glackens's
day at Coney Island and other modern American versions of the
amusement park.[35] In addition to amusements that had origi-
nated in suburban parks, Hammerstein's roof garden offered
enticements worthy of Marie Antoinette's rural retreat, including
a miniature farm and dairy, complete with revolving windmill,
live animals, and costumed attendants.[36] A contemporary photo-
graph (fig. 196) shows that Hammerstein's conjured up not only
eighteenth-century aristocratic country pleasures but also con-
temporary urban nightspots with nostalgic mills, such as the
Moulin Rouge and the Moulin de la Galette, two lively, louche
cabarets in Paris. Glackens painted *Hammerstein's Roof Garden*
from the west end of the theater, just down the stairs from the
miniature dairy farm. In this back area Hammerstein placed
small tables and chairs and served refreshments, reminding us
that food sales were an important part of a vaudeville king's
income.

Along with tightrope walkers and costumed milkmaids, Ham-
merstein presented more tawdry entertainment. By 1904 his
living tabloid downstairs at the Victoria featured appearances by
people involved in sensational newspaper stories, anticipating
today's talk shows by many decades.[37] Another striking modern
element that was key in turn-of-the-century urban entertainments

Fig. 193 Edouard Manet. *Masked Ball at the Opéra*, 1873. Oil on canvas, 23¼ x 28½ in. (59.1 x 72.4 cm). National Gallery of Art, Washington, D.C., Gift of Mrs. Horace Havemeyer in memory of her mother-in-law, Louisine W. Havemeyer 1982.75.1

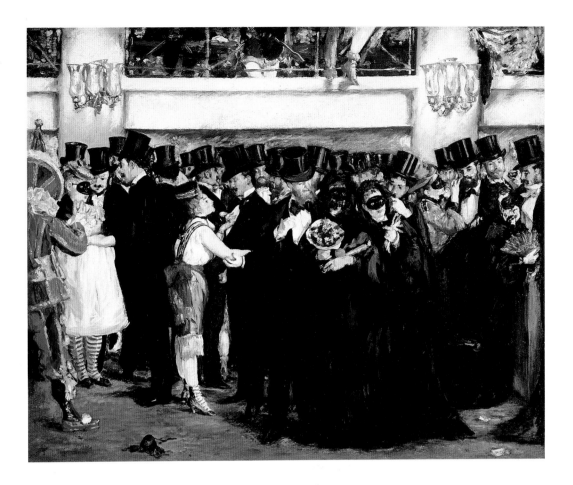

Fig. 194 John Sloan. *The Haymarket*, 1907. Oil on canvas, 26¼ x 32⅛ in. (66.7 x 81.6 cm). The Brooklyn Museum, Gift of Mrs. Harry Payne Whitney 23.60

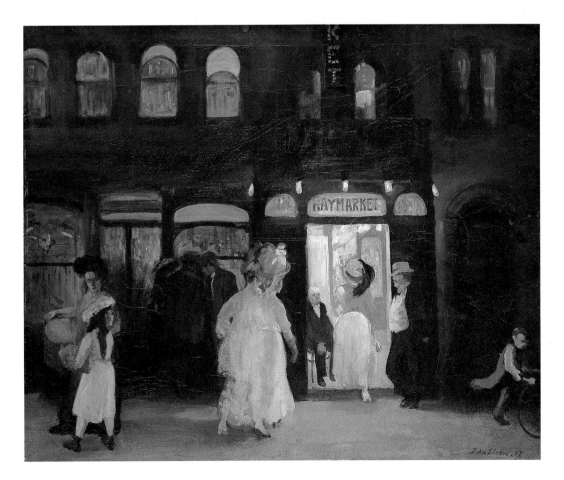

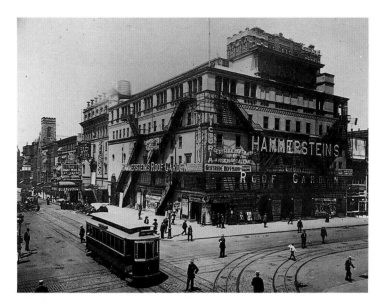

Fig. 195 Victoria Theatre, northwest corner of Seventh Avenue and Forty-second Street, New York, 1908. Photograph: Museum of the City of New York, The Byron Collection

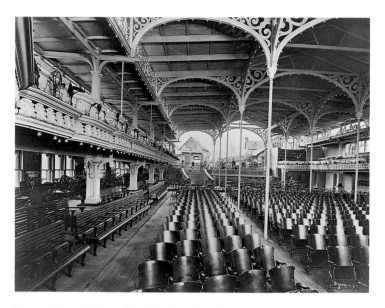

Fig. 196 Victoria Theatre Roof Garden, New York, looking west, n.d. Photograph: Museum of the City of New York, The Byron Collection

held at Hammerstein's and elsewhere seems to have been audience involvement—even participation in the case of the cabaret.[38] Andy Warhol's notion that everyone will be famous for fifteen minutes is foreshadowed in a 1918 publicity shot for the Casino Theatre, whose self-aware audience leans eagerly into the camera (fig. 197).

In creating *Hammerstein's Roof Garden* Glackens made artistic choices that reflect social changes echoed and encouraged by vaudeville, where the famous stage star and the anonymous shop clerk shared common ground. He paints the audience very broadly, turning the heads of the three figures closest in the foreground away from us while keeping the others in low light. The characters in Glackens's painting remain strangers to us as they would to one another in an actual urban crowd. The stolid middle-aged man directly under the ladder is outnumbered by women. He has had the bad manners to lay his straw boater territorially upon a shared café table and almost entirely cover its surface. The hat signals summertime, when roof garden programs were in full swing, offering relief to wage earners stuck in the sweltering city. The prevalence of ladies recalls that at the turn of the century vaudeville theaters, like department stores, provided new settings where women could participate in the public life of the city. Some of these theaters even managed to simulate a domestic air. Hammerstein called the Theatre Republic, his seventh Broadway venture, established in 1900, "the perfect parlor theatre," a regular "drawing room of the drama."[39] The Gaiety, which opened in 1908, offered "a reception parlor, where a theatre party may retire between acts and enjoy themselves in an atmosphere as exclusive as that of their own homes."[40] The design for the Little Theatre, built in 1912, drew on domestic

imagery to such an extent that it suggested patrons were "guests for the nonce in an old colonial house behind a garden wall left behind in the march of progress the simple front untouched and the interior remodeled by an amateur of the stage."[41]

The woman in white resting her elbow on a chairback in *Hammerstein's Roof Garden* could be a housewife or a shopgirl. She may or may not be accompanied by the man with the straw boater, a detail that Glackens leaves vague in both illustration and painting. The implications of the casual relationship of these

Fig. 197 Rebuilt Casino Theatre auditorium, New York, August 11, 1918. Photograph: Shubert Archives, New York

two figures and, by extension, of the others in the audience, are illuminated by Gunther Barth's analysis of the vaudeville house's impact on social behavior: "An emphases [sic] on poise and appearance generated a matter-of-fact attitude pervading the meeting of men and women on the urban scene. The celebrated star and the mixed audience which allowed women to appear in the vaudeville house shaped attitudes of urban behavior that facilitated contact but maintained independence, mingling the opportunity for pleasure with freedom of choice."[42] Another woman in Glackens's picture has an open fan in her hand; the woman behind her holds a menu or program. Each individual is set off from the others, expressing the kind of neutrality and isolation characteristic of the modern urban environment and already seen in French painting of the second half of the nineteenth century.

The featured performer here is female. The self-possession, balance, poise, and independence of such female stars became behavioral benchmarks for urban women, who could aspire to the fairy-tale success of actresses and chorus girls as endlessly retailed in the popular press.[43] A shining example was the Floradora Girls, a sextet fitted out with frilly pink walking costumes and graceful parasols, who starred in *Floradora*. Shortly after this musical comedy opened in 1900, the members of the sextet were dubbed "goddesses, the first of their class to immortalize the chorus girl." All six of the original actresses married millionaires; eventually the play was performed more than five hundred times, giving seventy-three Broadway beauties the chance to better themselves economically.[44]

As leisure was commercialized, once-clear demarcations of class and status became ever more blurred. At an early stage in the development of New York's theater district, patrician families, including the Morgans, Tiffanys, Goulds, Vanderbilts, and Roosevelts, had put money into the Casino Theatre, which opened on Broadway at Thirty-ninth Street in 1882.[45] And in 1909 a socially prominent group led by John Jacob Astor, Henry Clay Frick, J. P. Morgan, Cornelius Vanderbilt, and Harry Payne Whitney tried to found a national theater on Central Park West at Sixty-second Street, but its elitist programming and West Side location quickly brought it to failure. Meanwhile the entrepreneurial Hammerstein and his son had made so much money on "the corner" that the father was able to realize his dream of establishing an opera house, which he built on Thirty-fourth Street in 1907; called the Manhattan Opera House, it was meant to compete with the Metropolitan Opera and to appeal to a broader-based audience than that of its predecessor.[46] All these projects raise issues of shifting social aspirations, which remained in flux well into the twentieth century and sometimes resonate in the work of the American painters of modern life.

Over fifty years after Cassatt scrutinized opera audiences in Paris, Reginald Marsh, heir to the turn-of-the-century Realists, surveyed a New York opera scene in *Monday Night at the*

Fig. 198 Reginald Marsh. *Monday Night at the Metropolitan*, 1936. Tempera and oil on wood, 39½ x 29½ in. (100.3 x 74.9 cm). The University of Arizona Museum of Art, Tucson, Gift of C. Leonard Pfeiffer 45.5.1

Metropolitan (fig. 198) with a sardonic eye. He reduces the subtle visual elements pioneered by Cassatt, along with Degas and Pierre-Auguste Renoir, to the stuff of farce. Again black, red, and gold dominate the color scheme. But there is nothing elegant about this night at the opera. Structured as a geometric grid, the composition spins around a triangle of operagoers, set dead center and clutching binoculars, by now a time-honored metaphor for unashamed staring at one's fellow audience members. The assembled crowd represents a cross section of well-heeled types—top-hatted old men, bejeweled dowagers, buxom young matrons, and debutantes. Marsh gives them all exaggerated, cartoonish expressions. Although he is somewhat heavy-handed, Marsh joins Cassatt in observing that rich apparel worn in an expensive opera box does not always indicate good breeding.

Marsh produced his opera scene at the height of the Great Depression, satirizing social privileges that went unchallenged by earlier painters.[47] But it cannot be argued successfully that Cassatt and her contemporaries simply confined themselves to

Fig. 199 William Strickland. *New Theatre, Chestnut Street*, 1808. Watercolor and ink on paper, 25½ x 33½ in. (64.8 x 85.1 cm). Pennsylvania Academy of the Fine Arts, Philadelphia, Gift of Mr. and Mrs. William Jeanes 1975.19

opera and ballet as elite pastimes, while the likes of Glackens, Shinn, and Marsh among twentieth-century American artists chronicled the more vulgar performances of vaudeville and burlesque houses. Cassatt's protagonist in *At the Opera* is, after all, behaving rather boldly for an unescorted woman in public in the late 1870s. Degas's dark and suggestive readings of backstage arrangements between young ballet dancers and elderly patrons are well known. And, for that matter, as we have seen, artists and commentators alike recognized that the opera, in New York as in Paris, was not the preserve of good manners and good taste, but an arena for vulgar display and ostentatious jockeying for social position.

Issues of upward mobility provide a common thread in the lives as well as in the art of the American painters of modern life. Herbert Croly lamented in the *Architectural Record* that "literature or art has had no social standing" and averred: "While it is no part of [artists'] business to do honor to 'society,' it is well for society to do honor to them—to grant them the tribute of recognition which eminent French men of letters and artists receive from their fellow countrymen. The natural heroes of the American are not artists or men of letters; they are politicians and millionaires."[48] Mabelle Gilman Corey, a singing star who had married very well, echoed these sentiments, suggesting that

Fig. 200 John Sloan. *The White Way*, ca. 1926. Oil on canvas, 30¼ x 32¼ in. (76.8 x 81.9 cm). Philadelphia Museum of Art, Gift of Mrs. Cyrus McCormick, 1946 46.10.2

American social leaders follow the example of Europeans by raising artists to the ranks of social prominence and welcoming them to the "great houses."[49] Unlike Corey, Croly grounded his hope that artists and writers might enjoy a more "positive and formative influence" on the increased power of critics rather than on "the direct mixture of artists and men of letters in society."[50] But whether under the watchful gaze of a highborn hostess or in an effort to attract a critic's eye, artists were compelled to take display and performance into account.

The theater had offered American artists an outlet for their talents since 1808, when William Rush carved his statuesque allegories *Tragedy* and *Comedy* to embellish the facade of Philadelphia's New Theatre on Chestnut Street, recorded as an elegant, almost empty thoroughfare in William Strickland's view (fig. 199).[51] Moreover, in the fertile field of portraiture, an area of upper-crust patronage that few artists could afford to ignore, upwardly mobile actors and actresses appeared regularly, strengthening the links between artists, writers, and the theater.[52] As early as the 1860s Manet, Whistler, Degas, and others were involved in efforts to modernize portraiture, and actors, actresses, playwrights, and journalists provided some of their most suitable sitters.[53] But the subject of performers, like other themes relating to the theater, was not addressed with any frequency by Ameri-can Impressionists, whose figure paintings primarily concerned privileged private lives.

By the time Sloan produced *The White Way* (fig. 200), punning on freshly fallen snow as well as referring to the bright lights of Broadway in New York, a province of hurly-burly utterly unlike Strickland's staid Chestnut Street, the American painters of modern life had returned to the theater, creating stage sets or decorations behind the bright lights and again depicting performers. Given the fastidious reticence of American Impressionists, it is worth pointing out that the strong undercurrent of sexual availability that often provides a subtext in entertainment imagery reemerged at the hands of the Realists. In the early 1860s Manet posed the daughter of a friend as a blank-faced vagabond street singer leaving a cheap cabaret as she slightly lifts her skirt and munches symbolic cherries (fig. 201). Decades later Henri painted the actress Mlle Voclezca costumed for her role as Salome in Oscar Wilde's opera (fig. 202). Henri revealed considerably more flesh than Manet. But, despite changing levels of permissiveness, his diaphanously clad subject conveys essentially the same message of theatrical sexuality as does Manet's *Street Singer*, who carelessly hitches her skirt to titillate Parisian viewers with a bit of petticoat.[54]

Henri was often called the Manet of Manhattan. Since Ameri-

Fig. 201 Edouard Manet. *The Street Singer*, ca. 1862. Oil on canvas, 67⅜ x 41⅝ in. (171.1 x 105.7 cm). Museum of Fine Arts, Boston, Bequest of Sarah Choate Sears in memory of her husband, Joshua Montgomery Sears 66.304

Fig. 202 Robert Henri. *Salome* (*No. 2*), 1909. Oil on canvas, 77 x 37 in. (195.6 x 94 cm). John and Mable Ringling Museum of Art, Sarasota 937

Fig. 203 Everett Shinn. *The Orchestra Pit, Old Proctor's Fifth Avenue Theatre,*
ca. 1906–7. Oil on canvas, 17¼ x 19½ in. (43.8 x 49.5 cm). Collection of Arthur
G. Altschul

can paintings on the theme of theater appeared many years after those created in France, Henri and his followers are open to charges that they are derivative. The extensive theater imagery of Shinn is noticeably close to the work of Degas and other nineteenth-century French painters, although it is distanced not only in time—a period of almost forty years—but also in artistic purpose and in the level of chilled sophistication with which urban life is perceived. A number of devices in Shinn's *Orchestra Pit, Old Proctor's Fifth Avenue Theatre* (fig. 203) recall strategies Degas employed in his first radical opera image, *The Orchestra of the Opéra* (fig. 204).[55] In each a sharply angled parapet or brass rail separates audience from orchestra; the edge of the stage is also a prominent diagonal design element; and bright footlights blur the costumes of performers. But Degas's picture was an early attempt to modernize portraiture, while Shinn had no such intention. Degas presents individual portraits of orchestra members, which he contrasts with anonymous corps de ballet dancers whose heads he cuts off. Shinn, in letting the viewer see the dancers' faces, diminishes our concentration on the orchestra pit and its dominant occupant. The lighting effects that link stage and orchestra pit in Shinn's painting have none of the sexual suggestiveness of the double bass neck that pops up between male musician and female dancer in Degas's work.

In her analysis of Shinn's theater imagery, Linda Ferber has pointed out that contemporary critics were well aware of Shinn's sources for the stylish visual conventions that he employed in his depictions of modern life. Although some observers found Shinn's prototypes "too apparent," it is significant that others "accepted these models as providing appropriate pictorial vehicles with which to interpret experience once excluded from the canon of acceptable subjects for American artists." Ferber explained, "In the habit of glamorizing home-grown talent by association with European masters, many even took a measure of pride in dubbing Shinn the 'American' Degas, Forain, or Raffaëlli."[56]

Shinn's travels abroad, where he frequented the Parisian café-concert and intimate cabaret, parallel the slightly earlier pilgrimages of many an American Impressionist to the countryside around Giverny, and his translation of foreign music-hall subjects into American vaudeville scenes has its counterpart in the filtering of New England landscapes through an Impressionist lens by his French-trained American predecessors. Despite such correspondences, however, Shinn and his generation were set apart from the American Impressionists by their embrace of themes beyond those supplied by the privately owned country retreat: for the canon of acceptable American subjects clearly expanded as a concomitant of the egalitarian opportunities provided by the development of modern cities. The former actress Corey observed: "Much has been said about the total lack of artistic appreciation in America. Singers, noted actors, and others have publicly commented upon it. I think the statement that

Fig. 204 Edgar Degas. *The Orchestra of the Opéra*, 1868–69. Oil on canvas, 22½ x 18½ in. (57.2 x 47 cm). Musée d'Orsay, Paris R.F. 2417

it is totally lacking is too sweeping, for there is indeed a deep and growing appreciation of art, but it is not to be found among people of wealth and social position so much . . . as it is among the middle classes."[57] It was the middle class that patronized vaudeville in American cities. "All are equals here," pronounced a vaudeville actress in a long dedicatory poem that marked the opening of B. F. Keith's New Boston Theatre, a splendid vaudeville house, in 1894.[58]

In general, artistic and theatrical circles reveal in microcosm the fluid nature of status in American life. An illustrator might become an artist, an actress could be transformed into a society matron. Frederick Proctor, a contemporary of Keith's and Hammerstein's and a leader in the development of vaudeville, made news in the entertainment industry by acquiring the Fifth Avenue Theatre at Broadway and Twenty-eighth Street in 1900. The Fifth Avenue was the first legitimate theater to be converted from playhouse to vaudeville stage, stimulating the flow of talent from one kind of performance to another.[59] Lillie Langtry was among the scores of stars Proctor brought from the legitimate stage into vaudeville. The *New York Herald* reported, "The invasion of the heart of the Broadway theatre district by the prominent 'continu-

ous performance' manager is indeed a surprise."[60] As the reporter's comment suggests, the establishment of a vaudeville beachhead on Broadway was not the only change Proctor wrought upon New York's entertainment world. He had previously introduced the concept of the continuous show—"After Breakfast Go to Proctor's, After Proctor's Go to Bed" was his often repeated advertising slogan.[61] The impact of this innovation on the new middle-class theater patrons has been analyzed by Barth:

> Audiences generally liked the studied casualness of the "continuous," which softened the formality of the theater. People moved in and out of the house at their leisure, after they had learned to find their seats in the section of the auditorium that corresponded to the tickets they had purchased for fifty, thirty-five, or fifteen cents. The freedom of movement and the disappearance of reserved seats encouraged the same independent and egalitarian spirit that the modern city had fostered. Vaudeville's aggressive format, repeated each afternoon and evening, brought the momentum of the modern city from the sphere of work into that of amusement.[62]

Shinn seems to sound variations on the theme of the continuous show in his *Orchestra Pit*, his formal devices echoing and reinforcing the sense of the continuous nature of the performances in which his musicians and dancers are engaged. Like the repetitious brass rings that support the foreground curtain, the heads in the pit draw the eye in an endless circular movement from the nearest figure with his back to us over to a pair of musicians seen in profile and three-quarter views, then up and across the stage, where three brightly lit dancers look at the audience. Their heads descend from left to right—up, out, and down—beginning the circular movement again. The continuous performance was a mixed blessing for such vaudeville performers, who "needed the energy to create the magic that unified the separate acts like the continued vibration of a tone linking the breaks between the notes of a staccato phrase in a piece of music. In contrast to an ordinary actor or actress, the vaudeville performer had to generate the magnetism to attract a large audience, year after year, in a world of entertainment that knew no season."[63]

This was taxing at best, and successful vaudevillians considered themselves workmanlike and dependable performers; they were "finished, resourceful, technically expert," according to one witness, who also found actors' private lives characterized by "sobriety, orderliness, and dullness."[64] Diaries, journals, and memoirs reveal that, like many actors, most of the painters of modern life—Realists as well as Impressionists—lived orderly private lives. For painters, as well as vaudeville artists, were dependent upon continuous performance to make their livelihood and so labored to create a continuous stream of saleable artwork.

Shinn's performers probably were not getting rich for their labors. Inexpensive ticket prices helped vaudeville give legitimate theaters a run for their money. When Proctor's Fifth Avenue Theatre opened in the heart of the entertainment district, a journalist noted, "the prices . . . will astonish Broadway—fifty cents for the best orchestra seat and twenty-five cents for the balcony."[65] But despite the eager crowds, vaudeville performers were not safe from exploitation and blacklisting by powerful booking agents, who dominated the vaudeville business by the turn of the century: "The vaudeville czars shrewdly recognized their precarious position in a business where artists were both labor and product. During disputes they asserted their power by showing movies."[66]

A history of New York theaters as they served up an evolving menu of various urban entertainments during the twentieth century—hosting live performances and then films, and in some cases giving way to sleazy burlesque houses or television soundstages and in one sad instance to a discount art gallery—tells us that audiences would continue to change, posing a never ending challenge to painters, writers, and performers alike.

Sloan's *Movies, Five Cents* (fig. 205), painted at about the same time as Shinn's *Orchestra Pit*, is a visual reminder that continuous performance heralded, and eventually would be replaced by, entertainments on film. Readily duplicated, and in the early days less expensive than live performances, movies soon dominated the entertainment industry.[67] As the pace of modern life speeded up, technologies and entertainment options changed, and changed with increasing rapidity, just as they continue to change, at an ever more accelerated rate, today. Thomas Lamb's Strand Theatre, the first Broadway house especially built for moving pictures, went up in 1913, the year that the Armory Show shocked the art public with modernisms far more radical than anything the American Impressionists and Realists had attempted.[68]

In the face of such change, artists sought stable footing on the bedrock of tradition, offering, if you will, a continuous performance of old themes reworked for modern times. Sloan's movie house composition strongly recalls *Le Dram*, an earlier theater image by Honoré Daumier (fig. 206). Each artist shows us spectators who are deeply engaged with a play or film in progress, and the chief interest of each is in how the audience reacts to what is being presented onstage. Sloan, like Daumier, seems to have understood that an actor is crucially dependent upon making a connection with the audience. So, by implication, is the draftsman or painter, who chooses to perform with pencil or brush.

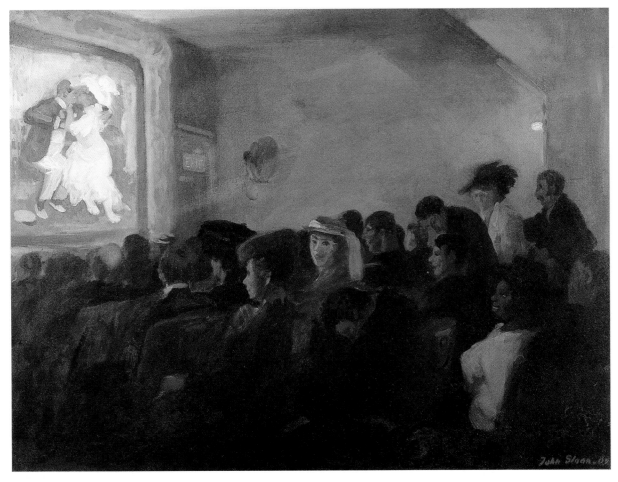

Fig. 205 John Sloan. *Movies, Five Cents*, 1907. Oil on canvas, 23½ x 31½ in. (59.7 x 80 cm). Private collection

Fig. 206 Honoré Daumier. *Le Drame*, ca. 1860. Oil on canvas, 38⅝ x 35½ in. (98.1 x 90.2 cm). Bayerische Staatsgemäldesammlungen, Neue Pinakothek, Munich

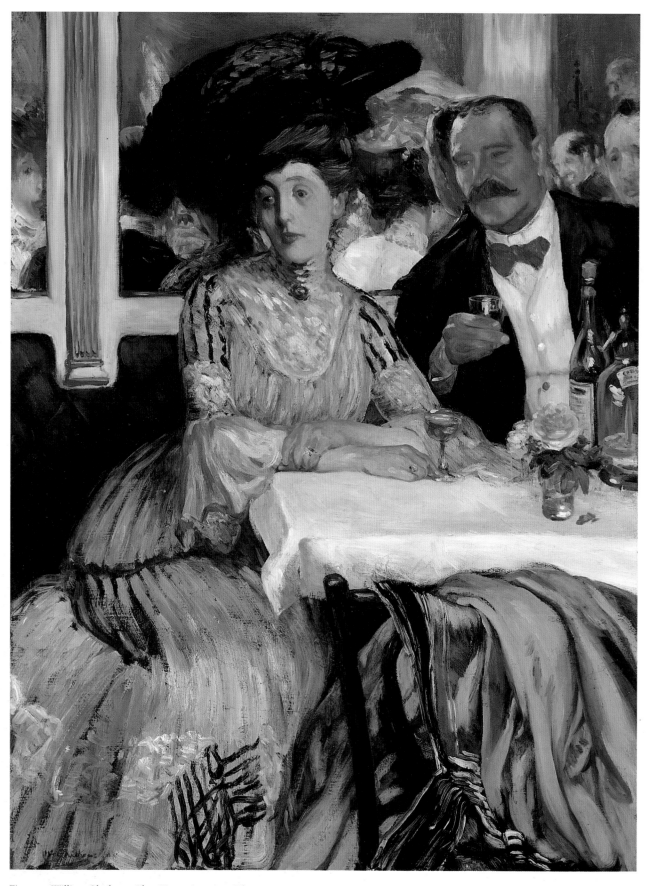

Fig. 207 William Glackens. *Chez Mouquin*, 1905. Oil on canvas, 48 x 39 in.
(121.9 x 99.1 cm). The Art Institute of Chicago, Friends of American Art
1925.295

Dining Out: Propriety and License

We are cheerful sinners, it seems. If we love luxury, we love it in its social aspect rather than as individuals.

SCRIBNER'S MAGAZINE (1910)

One entered Mouquin's to shed all forms of seriousness.

BENJAMIN DECASSERES (1932)

Among the most familiar of all early twentieth-century American paintings, the Realist images *Chez Mouquin* (fig. 207) by Glackens, *Chinese Restaurant*, and *McSorley's Bar* (figs. 215, 222), both by Sloan, address multiple hungers in turn-of-the-century America. Painted to challenge viewers but also to please them, these canvases are concerned not only with publicly consumed food and drink but also with purchased companionship. The first two works show us harlots, high and low; the last depicts the kind of drinking establishment around which controversy raged for decades, culminating in the baldly class-oriented strictures of the Prohibition era, which began in 1919. Yet Glackens and Sloan broach their topics gently—the wistful faces at Glackens's immaculate linen-covered table and the cheerful figures in Sloan's cluttered, clattering eatery suggest the essentially positive terms with which America was often contrasted with Europe; they are colored with the euphemistic brush that warmly tints American painting, as compared with the chill vision of its French prototypes. Indeed, in 1910 one European visitor who toured the Great White Way was struck by "the spectacle of numbers of people eating expensive dishes at midnight and in public to the sounds of what make for the lute and the lyre" and concluded that "gayety in America is universal." A journalist responded to the visitor's enthusiasm by noting that "we are cheerful sinners, it seems. If we love luxury, we love it in its social aspect rather than as individuals."[69]

The American debt to French modernist painting is palpable and strong in the realm of restaurant themes, as it is in the area of theater imagery. And American restaurant pictures, like theater scenes, were usually the province of early twentieth-century Realists, rather than of the Impressionists, whose respectable airs and private club memberships diverted their interest from such subjects. Private dining clubs encouraged detachment, allowing members to view the madding crowds at a comfortable remove through large plate-glass windows. Hassam's distanced city views, such as *Union Square in Spring* (fig. 171), capture the same sort of panoramas that patrons saw through the windows of private dining clubs crowning the summits of downtown skyscrapers (see fig. 208). The elevators to these establishments sped the weary man of affairs—be he artist, banker, or manufacturer—"as much out of New York as if he had made an hour's journey into the country. The din dies away. He is far above dust and clanging cars. He can breathe pure air. And, sinking back in the arms of a hospitable leather chair, he looks down over the city as a tired traveler might look down from a mountain crag."[70]

However, by the turn of the century the tremendous growth of the middle class in American cities brought burgeoning demand for gustatory entertainments that were more accessible than those confined to private homes and clubs or provided by a small number of exclusive restaurants like Delmonico's or Sherry's in New York. Restaurateurs were there to meet the demand. Not surprisingly, new restaurants aimed at middle-class consumers took their lead from aristocratic establishments such as Delmonico's (fig. 209), where elegant meals epitomized New York's upper-class social life by the mid-1880s: "Many persons . . . learned for the first time at Delmonico's that dinner was not merely an ingestion, but an observance. . . . When we compare the commensalities of our country before the Delmonico period . . . with our condition in respect of dinner now, and think how large a share of the difference is due to Delmonico's, we shall not think it extravagant to call Delmonico's an agency of civilization."[71]

By the early years of the new century the majority of urban restaurants were ethnic, including Chinese, French, German,

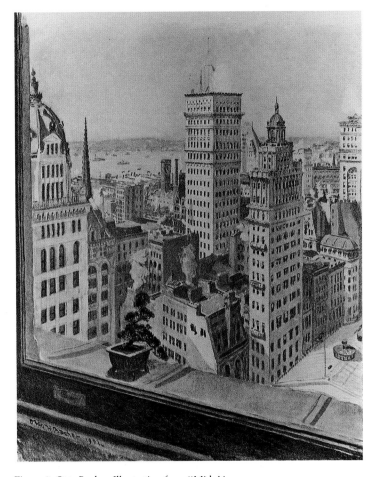

Fig. 208 Otto Bacher. Illustration from "Mid-Air Dining Clubs," *Century Magazine* 62 (September 1901), p. 642

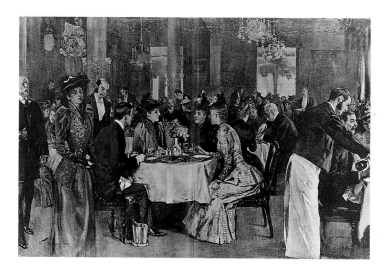

Fig. 209 W.T. Smedley. *A Luncheon at Delmonico's,*
Harper's Weekly 35 (December 5, 1891), pp. 982–83

Greek, Hungarian, Italian, Mexican, Russian, and Spanish establishments. Most were less expensive than Sherry's or Delmonico's, and there were many places where "for from forty to seventy-five cents, one [could] lunch or dine in the atmosphere of foreign cookery, with a little music thrown in for good measure."[72] By 1909 *Good Housekeeping* reported on a plethora of ethnic establishments, asserting that "New York has more good restaurants than any other city in the world, save Paris." New and better culinary havens were springing up in other American cities as well.[73]

While a number of the most fashionable new dining spots opened their doors on Fifth Avenue, the liveliest were located in the theater district, or Tenderloin. Broadway restaurants like Chez Mouquin let middle-class patrons experience splendors they could not find at home and were as frivolous as the staged entertainments enjoyed at nearby theaters and vaudeville houses after dinner or before a bird-and-bottle midnight supper.[74] "One entered Mouquin's to shed all forms of seriousness," a habitué recalled.[75] The decoration of restaurants, like that of theaters, made use of exotic artistic themes—the exterior of Murray's Roman Gardens, for example, imitated a Parisian hotel enriched with allegorical and mythological statuary, and its main dining room conjured up the ancient city of Pompeii, trenchantly described in the *Architects' and Builders' Magazine* as "the Newport of Rome."[76]

Like theaters, restaurants frequented by the American painters of modern life ran the gamut from the chic and fashionable to the disreputable and bawdy. These artists often depicted restaurants in the vicinity of their studios. In *Renganeschi's, Saturday Night* (fig. 210) Sloan captures the lively crowd at a popular Italian restaurant on West Tenth Street, "a stone's throw from Jefferson Market Jail," and close to the painter's new studio at

35 Sixth Avenue.[77] Nostalgia—a hallmark of American paintings of modern life—coexisted comfortably with commercialism on many levels in urban restaurants. For recent immigrants, of course, the many ethnic nightspots, of which Renganeschi's was typical, were reminders of home. After he executed *Renganeschi's, Saturday Night,* Sloan recalled that the proprietor, born in San Marino, Italy, kept "a watercolor drawing on the wall . . . a full length and breadth portrait of the native land of which he was so proud. These matters all explained by Signor Renganeschi in person to all interested."[78] The message of Sloan's picture, which features the restaurateur's treasured watercolor, is one of boisterous prosperity coupled with a longing for the old country.

Glackens too dined close to home, for Chez Mouquin was in his immediate neighborhood. A few years before painting the glittering establishment, which stood on the corner of Twenty-eighth Street and Sixth Avenue, Glackens had taken a studio at 13 West Thirtieth Street, only two blocks away. He dined often at the downstairs café of the conveniently located food emporium.[79] Mouquin's was also near many publishers' offices, including McClure's and Scribner's. This must have been handy for Glackens and other artists in the area, since periodicals proved a dependable commercial outlet for restaurant and other urban imagery, in turn providing the wherewithal for artists' sojourns in restaurants, cafés, and nightclubs.

Doubtless Chez Mouquin appealed to Glackens not only because of its proximity but also for its historic and artistic associations. Glackens painted the flashy new branch of Chez Mouquin, which had opened in the Tenderloin in 1898, but it is likely that he knew the property on Twenty-eighth Street already had served as a tavern as early as 1810. Certainly he also would have known the history of Mouquin's much older establishment on Fulton Street. Members of The Eight, the circle to which Glackens belonged, were among the many artists and writers who frequented both restaurants, and their lively semipublic discussions on current art topics may well have been bolstered by the awareness that earlier movers and shakers had once frequented the bar at Mouquin's on Fulton Street.[80]

Moreover, the new Mouquin's was one of the best French restaurants in New York (fig. 211). With its "mirrors and . . . cushioned seats around the walls, in true Parisian style," this "veritable café francais"[81] must have been a welcome reminder to Glackens and his colleagues of student days in Paris. Indulging in an evening's entertainment at so resplendent a watering hole, "one might well imagine himself . . . transported to the Quartier Latin," according to a writer for *Good Housekeeping,* who also remarked: "There is music, there are Frenchmen, with pointed shoes and luxuriant beards, playing checkers, sipping their Quinquina Raspail or Dubonnet and listening to French music played by French musicians. When the theater crowd pours in, everyone is gay and sings and rises with uncovered head when

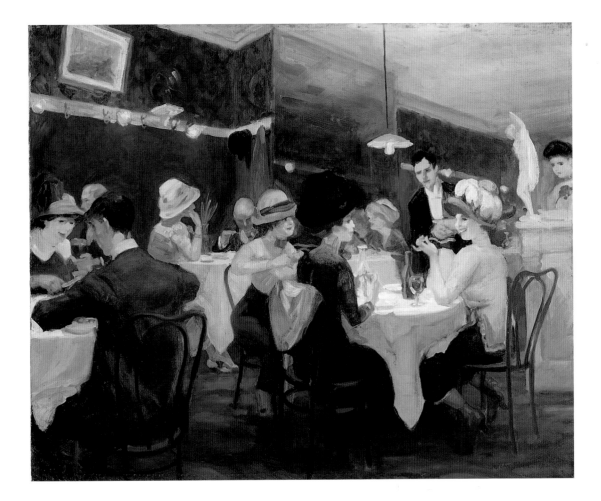

Fig. 210 John Sloan. *Renganeschi's, Saturday Night*, 1912. Oil on canvas, 26¼ x 32 in. (66.7 x 81.3 cm). The Art Institute of Chicago, Gift of Mary Otis Jenkins 1926.1580

the Marseillaise is played."[82] Meeting together at a spot like Mouquin's surely re-created the spirit of camaraderie that informed earlier student gatherings in Europe like the one Willard Metcalf recorded in *The Ten Cent Breakfast* (fig. 82).

As one would expect, Glackens's broadly painted canvas is far less explicit than one of the magazine illustrations that he or his Realist confrères might have executed; but it nevertheless quite clearly expresses ideas about urban social relationships that already had been formulated by Manet, Degas, James McNeill Whistler, and other late nineteenth-century artists. *Chez Mouquin* portrays James B. Moore, who owned yet another restaurant, the Café Francis. He is seated at the right, eyes averted from the viewer, lifting a small glass of whiskey or perhaps even the Dubonnet or Quinquina Raspail mentioned in *Good House-keeping*. His companion, who turns away from him, glances away from us wearing an enigmatic expression and touches the stem of a well-filled cocktail glass. Like the open pink rose in the little tabletop still life, the nameless woman is in full bloom. Behind the Manet-like roses a suggestive bottle stands tall. Remarking upon "that still life which makes life at Mouquin's café far from still," one contemporary newspaper critic announced, "It is the moment of liqueurs and soft asides."[83] An independently wealthy bon vivant, Moore was noted in artistic and

Fig. 211 *Mouquin's Sixth Avenue Restaurant in New York*, from Amy Lyman Phillips et al., "Famous American Restaurants and Some of the Delicacies for Which They Are Noted," *Good Housekeeping* 48 (January 1909), p. 26

Fig. 212 Everett Shinn. *Within a stone's-throw of gray old Washington Square,* from George B. Mallon, "The Hunt for Bohemia," *Everybody's Magazine* 12 (February 1905), p. 193

literary circles for his amorous peccadilloes involving a series of young women whom he referred to as his daughters.[84]

Such extravagant and fraught scenes are also played out in contemporary literature. For example, the central character in Dreiser's once scandalous novel *Sister Carrie* contemplates her previous impoverished innocence, "poor, hungry, drifting at her wits' ends," while supping with her lover at Sherry's.[85] In this restaurant, which was in reality famed as New York's leading haunt of the young, smart set,[86] Dreiser tells us: "The air of assurance and dignity about it all was exceedingly noticeable to the novitiate. Incandescent lights, the reflection of their glow in polished glasses, and the shine of gilt upon the walls, combined into one tone of light which it requires minutes of complacent observation to separate and take particular note of. The white shirt fronts of the gentlemen, the bright costumes of the ladies, diamonds, jewels, fine feathers—all were exceedingly noticeable." Like Glackens, Dreiser makes us aware of mirrors in every direction, "tall, brilliant, bevel-edged mirrors—reflecting and re-reflecting forms, faces, and candelabra a score and a hundred times."[87]

In 1905, the same year *Chez Mouquin* was painted, a perceptive journalist wrote of a far less pretentious French restaurant in New York (fig. 212), "within a stone's-throw of gray old Washington Square," a place where classes mixed, offering observers "a continuous human comedy":

There are artists from the near-by studios, occasionally with their models, representatives of old New York families who cling to their down-town homes unmoved by the up-town progress of fashion, newspaper writers and literary men, bachelors from a Washington Square apartment-house, brokers and lawyers, and that undefined quantity commonly known as "men about town." . . . The woman

whose family has been socially conspicuous in New York for several generations is under no delusions regarding the picturesque creature, who looks as if she might be a walking advertisement for a diamond counter, sitting at the adjoining table with a man who was the defendant in the latest society divorce scandal. She does not see the man, or pretends not to, but she furtively inventories the woman's jewellery display, and finds it all a part of the entertainment of the place.[88]

The general message of Glackens's *Chez Mouquin*, like the meaning of the picturesque creature in the little French restaurant, is accessible to anyone; however, as is often the case with nonnarrative images of modern life, some of the relationships here are so personal to the artist that the uninitiated viewer cannot possibly perceive them or interpret their significance. Moore, who had served as Glackens's best man, depended upon his own Café Francis as a means of contact with the artists, writers, and lawyers who frequented it. The face shown in the mirror over Moore's shoulder is that of Charles FitzGerald, an editorial writer who championed the painter's work in the *New York Evening Sun* and who eventually would marry the painter's wife's sister Irene. Here FitzGerald's reflected visage mirrors our own act of witnessing the assignation. Glackens's wife, Edith, is the woman in the red-ribboned hat posed with her back to the handsome couple on the banquette. Edith, like FitzGerald, is just a reflection in the mirror, and she is set like a gentle moral rebuke, separating Moore from the current target of his affections.

Similar incidents from the comedy of manners motivate other Realist restaurant paintings, for example Sloan's *Rathskeller* (fig. 213), which depicts Soula's Rathskeller in Philadelphia.[89] Sloan himself described the motif of this canvas as "the divided attention noticeable in the young lady with a beer escort whose lonely neighbor is buying champagne."[90] A New York critic amplified Sloan's visual story line, which already borders on a narrative tableau, calling the picture "a transcript of a phase of life metropolitan. The silhouette of the young woman, the fatigue in her attitude, the 'mug' of the chap near her—a spider watching for the fly that is, in popular parlance, born every minute."[91]

Optimism distances these slightly tawdry American scenes from their French models: tough images of working women and prostitutes in public cafés, such as Degas's *Women on a Café Terrace, Evening* (fig. 214).[92] Degas's streetwalkers are hemmed in by a grid of crowded tables, chairs, and mirrors, while Sloan's female figure floats more freely in the ample space between the two men—formal strategies that call to mind differences in social mobility of these women. We cannot quite imagine the Frenchwoman who makes a rude gesture with her thumb to her teeth in Degas's café escaping her sordid surroundings through marriage. But just such an escape was a constant theme in American life—whether actual or fictive. Sloan's democratic suggestion of a possible rise from beer to champagne in *The Rathskeller,* and the relative decorum of the picture, remind us

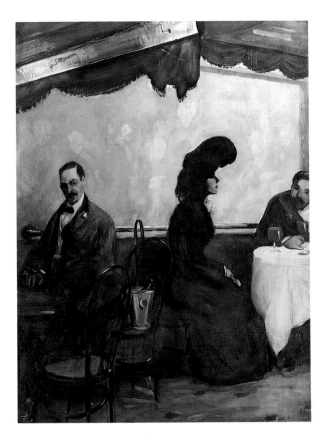

Fig. 213 John Sloan. *The Rathskeller*, 1901. Oil on canvas, 35½ x 27¼ in. (90.2 x 69.2 cm). Cleveland Museum of Art, Gift of the Hanna Fund 46.164

that American restaurant scenes, like their theater counterparts, addressed the aspirations and fantasies of a middle-class audience.

Although the hooker with a heart of gold has remained a stock character in American fiction and film throughout the twentieth century, there has been, to be sure, a certain amount of resistance to the parading of the cliché. One outraged critic who encountered *Chez Mouquin* at the Macbeth Galleries in 1908 complained that "vulgarity smites one in the face at this exhibition" and asked, "is it fine art to exhibit our sores?"[93] But the bars, cafés, and restaurants chosen as subjects by American painters of modern life were pleasant enough for the most part, places of convivial exchange, for the American city was a place of open-ended—if not always equal—opportunity.

The sensibility that views such themes as benign pertains even when the exchange involved is completely outside the bounds of conventional middle-class morality, as Sloan's *Chinese Restaurant* (fig. 215) demonstrates.[94] In 1909 Sloan painted his picture of a restaurant on Sixth Avenue, probably near Thirtieth Street, after recording this encounter: "felt restless so went to the Chinese restaurant and was glad I did for I saw a strikingly gotten up girl with dashing red feathers in her hat playing with the restaurant's fat cat. It would be a good thing to paint."[95]

In *Chinese Restaurant* Sloan ranges four figures across a grid of red window frames. Each head is isolated, but the hands form a chain across the canvas, and additional visual cues tie the protagonists together. With her vivid red plume the single woman

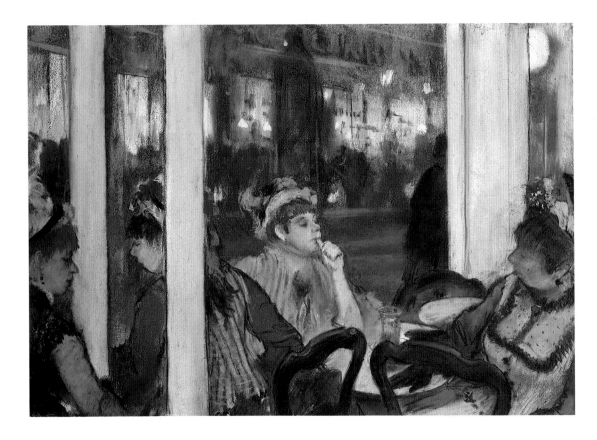

Fig. 214 Edgar Degas. *Women on a Café Terrace, Evening*, 1877. Pastel over monotype on paper, 16⅛ x 23⅝ in. (41 x 60 cm). Musée d'Orsay, Paris R.F. 12257

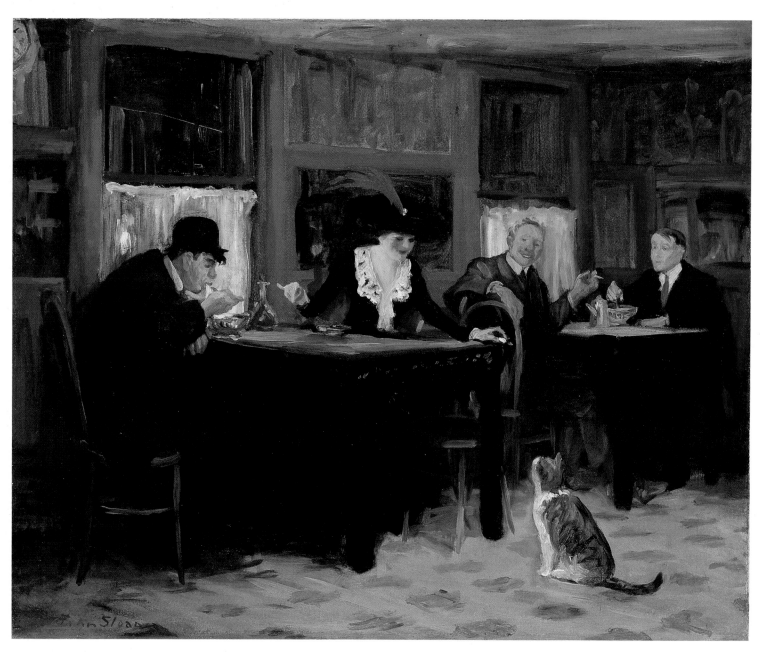

Fig. 215 John Sloan. *Chinese Restaurant*, 1909. Oil on canvas, 26 x 32 in.
(66 x 81.3 cm). Memorial Art Gallery of the University of Rochester, New York,
Marion Stratton Gould Fund 51.12

dominates the scene. A common decorative motif in Chinese restaurants to this day, the stylized Chinese characters painted above her on the wall signify good fortune. We may be observing a woman of easy virtue, but Sloan sees her as having a heart of gold, for she dispenses good fortune in the various forms of food, companionship, and amusement. Her red plume arches over toward a man, who, like her, wears a hat. He ignores her to slurp noodles from a blue-and-white bowl. Shortly the woman will be paying for his dinner, just as she now feeds the cat that sits in rapt attention at her feet. Sloan himself articulated this interpretation when he wrote, "The girl is feeding her boy friend, before taking him home, in one of the many Chinese restaurants of that day."[96] The woman's delicately extended fingers point at the cat on the floor and the man on the other side of the table. The linkage of figures effected by her fingers, her looping plume, and the chain of hands is also carried through by repetitions of costume: her stark black dress and frilly white collar are echoed in the sober suits and collars of her escort and the laughing men at the next table; even the cat has a somber gray coat with a white collar. Like us, the two men at the right side of the picture are an audience for this essentially good-natured little performance.

Contemporary descriptions of low-ceilinged, noisy Chinese restaurants in lower Manhattan underscore the accuracy of Sloan's vivid image. As one such account of a place in Chinatown tells us: "Some of the patrons have before them huge bowls of steaming rice, which they eat by bringing the dish to their lips, and then literally shoveling the food into the open mouth. . . . the odor of fuming cigarettes fills the air; an incessant babble prevails. . . . a greedy cat munches away under one of the tables. . . . the 'slummers' eat, drink and are merry in their new experience with strange dishes."[97] Characteristic details of Sloan's interior are also reiterated in surviving vintage photographs, which suggest that, like the vaudeville theater and the rathskeller, the Chinese restaurant relied upon predictable decor (see fig. 216).

Another sort of ethnic eatery that attracted both the public and the painters of modern life was discussed by George Barry Mallon in "The Hunt for Bohemia," an article of 1905. Mallon informed the readers of *Everybody's* that the desire of country visitors "to see something of the bohemian side of New York [meant] demand very naturally has created a supply." The journalist drew a parallel between a Greenwich Village restaurant and the stage, considering each an arena for public performance and underscoring our perception of affinities between the two realms: "In this place one Saturday night is so much like another that it suggests a tiresome vaudeville performance. . . . That there are many conventional people who hope to discover something akin to the bohemia of fiction, a shadowy province peopled exclusively by abnormally clever fellows, which is a neutral ground between propriety and license, is shown by the thousands who visit such restaurants."[98]

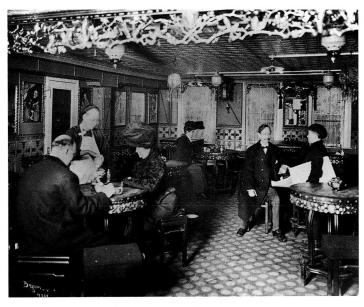

Fig. 216 Restaurant in Chinatown, 24 Pell Street, New York, 1905. Photograph: Museum of the City of New York, The Byron Collection

Mallon dismissed some of the more determinedly bohemian restaurants as tourist traps but wrote an enticing description of an unnamed café in the heart of the Hungarian neighborhood— almost certainly the well-known Little Hungary. One of the two largest and most popular Hungarian restaurants in New York, Little Hungary had achieved special fame after President Roosevelt visited it; among the less exalted patrons were neighborhood tradesmen, painters, decorators, and musicians, as well as the occasional well-heeled customer. Mallon's observations on the establishment's more prosperous clients make it clear that slumming was common practice at the turn of the century not only in theaters but also in restaurants: "Half a dozen of the people 'from up-town,' who come to the place only on Friday nights, arrive, the men in evening clothes, and the women in their opera-wraps, and . . . a table is cleared for them near the orchestra. Though they are people from another world, there is no objectionable inspection of them by the Hungarians. A stranger in a box at the opera attracts more curious eyes."[99]

Among Shinn's illustrations for "The Hunt for Bohemia," one calls attention to the orchestra at Little Hungary, underscoring how, as performance subjects, theaters and restaurants overlap for the observers of modern life. Shinn was not the only Realist who visited Little Hungary; we know that Sloan also went there— and that he found it too expensive.[100] Glackens, for his part, executed an illustration of another popular Hungarian restaurant, the Café Boulevard at Second Avenue and Tenth Street,[101] which a journalist of the period praised, although she was well aware that the commercialized atmosphere was not entirely spontaneous: "No more popular table d'hôte restaurant is to be found in New York . . . characterized by an air of refinement which one would hardly expect to find in a place of its size and locality."[102]

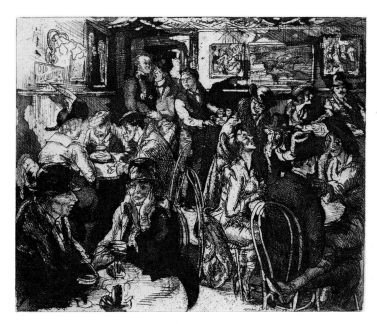

Fig. 217 John Sloan. *Hell Hole*, 1917. Etching and aquatint, 8 x 10 in. (20.3 x 25.4 cm). The Metropolitan Museum of Art, New York, Gift of Mrs. Harry Payne Whitney, 1926 26.30.60

This and similar comments in the popular press reveal that the Realists' choices of restaurant subjects were on the safe side.

The Realists also played it safe with themes relating to organized gambling and prostitution, confronting these serious urban problems in turn-of-the-century America[103] with discretion if at all. The premises of such notorious madams as Mrs. Sadie West, Miss Maud Harvey, and Five Penny Fan Bennett, for example, did not stimulate the American painters of modern life to create brothel images in the manner of Degas. Sloan, who claimed never to have gone slumming for subject matter, stayed *outside* such hot spots as the Haymarket (fig. 194), which combined the features of a restaurant, dance hall, and variety show.

Even Sloan's Hogarthian etching *Hell Hole* (fig. 217) is reasonably sedate, for all its cigarette smoke and stemmed glasses.

We are rather disappointed to learn that this backroom hangout for artists, writers, and other bohemians in Greenwich Village was nicknamed Hell Hole in the etching and was actually called The Golden Swan.[104] Not until world war and international economic depression had taken their toll did American restaurant and café scenes assume a coarse, knowing, decadent tinge.

When American Realists addressed convivial scenes, they had many art-historical precedents, both staid and indecorous, upon which to draw. Charles Webster Hawthorne's early image *The Story* (fig. 219) embodies the comfortable balance that turn-of-the-century painters of modern life often struck between homage to masters of the past and engagement with contemporary issues. Hawthorne, like George Luks and Henri—not to mention Chase, Hawthorne's most important teacher—wielded a self-consciously vigorous brush. The old master in question here is Hals, whose inspiration was acknowledged in Hawthorne's own day. Sadakichi Hartmann recognized the dark tonalities, sharp contrasts, and rather crude brushwork of *The Story* as a young modernist's stilted bow to Hals, but he wrote also that Hawthorne "boldly opens up, in native soil, new nuggets of beauty and surprise, in sympathetic touch with American genius and taste."[105] The impact of French modernism on the painting's mood of personal isolation amid public revelry seems clear to us now but was less evident to early twentieth-century viewers.

Hawthorne probably began his picture shortly after he traveled in Europe during the summer of 1898, at which time he visited the Frans Hals Museum in Haarlem to examine that old master's work at first hand. (*The Story* was one of several "Holland sketches" that he exhibited in New York the following summer.)[106] In Haarlem Hawthorne would have seen several large group portraits showing officers seated around banquet or meeting tables. A detail from one of these, *Banquet of the Officers of the St. George Civic Guard Company* (fig. 218), provides the obvious source for his composition.[107] He reversed

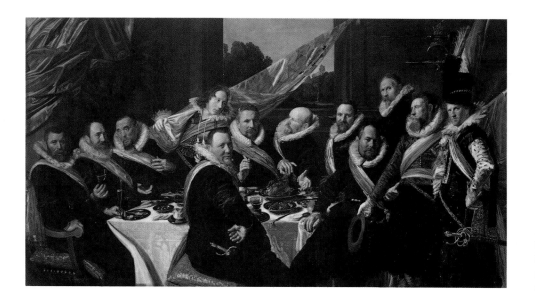

Fig. 218 Frans Hals. *Banquet of the Officers of the St. George Civic Guard Company* (detail, left side), 1616. Oil on canvas, 5 ft. 8⅞ in. x 10 ft. 7⅝ in. (1.8 x 3.2 m). Frans Hals Museum, Haarlem

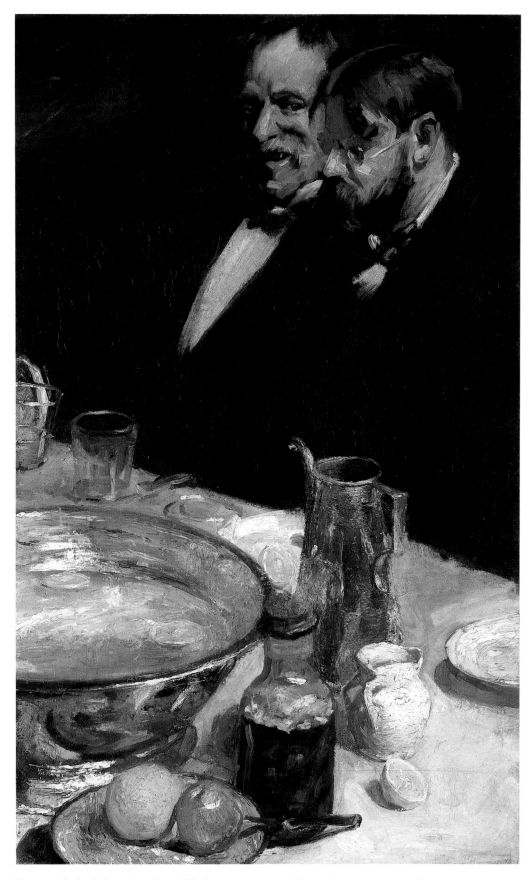

Fig. 219 Charles Webster Hawthorne. *The Story*, ca. 1898–99. Oil on canvas, 48 x 30 in. (121.9 x 76.2 cm). Hirshhorn Museum and Sculpture Garden, Smithsonian Institution, Washington, D.C., Gift of Joseph H. Hirshhorn, 1966 66.2410

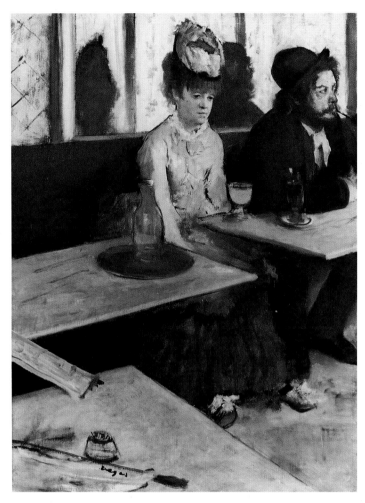

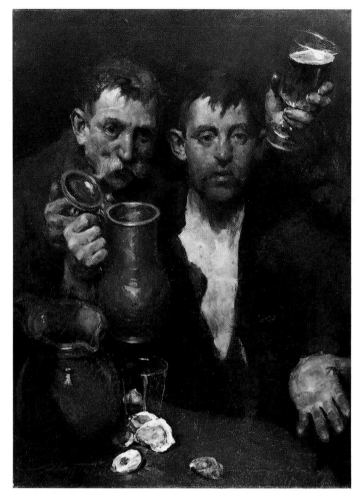

Fig. 220 Edgar Degas. *Absinthe*, 1876. Oil on canvas,
36¼ x 26¾ in. (92.1 x 67.9 cm). Musée d'Orsay,
Paris R.F. 1984

Fig. 221 Charles Webster Hawthorne. *Bums Drinking*,
1903. Oil on canvas, 40 x 30 in. (101.6 x 76.2 cm).
Mr. and Mrs. Alan D. Levy, Los Angeles

Colonel Hendrick van Berekenrode and Captain Jacob Laurensz, put them in modern dress, and filled the draped table surface with an up-to-date still life of pitcher, punch bowl, glasses, and fruit.

Works such as *The Story* gave rise to Hartmann's characterization of Hawthorne as "a painter of 'types' surrounded by a jumble of still life."[108] But what kind of types does he show in *The Story*? Like most successful painters of modern life, Hawthorne did not spin simple narrative tales. *The Story* is not as easily read as it might appear at first glance; in fact, the meaning remains open to endless interpretation. During Hawthorne's lifetime the picture was published with various titles: "The Diners," "The Story," and "The Pleasures of the Table."[109] Hawthorne kept the setting and the nature of his protagonists ambiguous. According to a document of the 1940s, an art student and a janitor may have posed for the two unidentified figures,[110] but whatever the models' actual status and relationship, if any, their evening dress is intended to suggest attendance at a chummy smoker in a men's club. In 1919 the painting was described in an auction catalogue as follows: "Two brown-haired men of merry features and rosy

complexion sit close side by side, on the right, at a table laden with things good to eat and drink—and both edibles and attendant utensils are equally good to look upon, in their richly colorful surfaces."[111] This upbeat merchandising ignores the palpably dark mood of the picture itself. One man seems to be speaking. Morose rather than merry, his companion slumps down at the table—he is nearly as grim as the café patrons in *Absinthe* by Degas (fig. 220). If this is a story, it does not seem to be amusing, and, on viewing Hawthorne's picture, we might well question whether the pleasures of the table are indeed pleasurable. Soon after he completed *The Story*, Hawthorne produced the gloomy *Bums Drinking* (fig. 221), which frankly concentrates on men of low degree, thereby sending a clearer message than its predecessor, albeit a message that again is tempered by an old-master treatment.

Early twentieth-century critics of Hawthorne's work downplayed his well-developed interest in aesthetic matters, without which he hardly could have joined Chase and Henri as a prominent American art instructor. They presented him as a representative

of vigorous, new, masculine forces that were said to be sweeping through American art. One detected "a touch of the athletic and energetic American youth"; another admired his "crude but marvelously virile" color sense that pitted "blotches of immaculate vermilion" against "permanent blue" and "chrome-yellow" to "fight for supremacy on his canvases."[112] This move away from supposedly effete aestheticism toward a purportedly more robust art, theoretically embodied in the work of Hawthorne, along with that of George Bellows, Henri, and others, played a central role in the perceived watershed that was thought to divide the American Impressionists from the Realists who followed them.

In 1952 Hans Hofmann summed up the artist-as-he-man position, which he and his fellow Abstract Expressionist painters carried to its ultimate extreme, writing that Hawthorne's pictures, although indebted to Whistler as well as to Manet, "do not have that esthetic charm so much demanded today by anemic hypersensitives. His painting is the antithesis of the prevailing misconception that admires taste and design. . . . It is more important that Hawthorne's work is robust and provocative, that it gives evidence of an abundant, vigorous mind, of a cataclysmic temperament. . . . Painting rises out of the volcanic center of the artist's temperament. Compared to this, estheticism is only shadow."[113] When the aestheticism of the 1880s and 1890s fell out of favor in the twentieth century, the genteel, well-to-do artist-businessmen who established themselves under its aegis had to make way for rougher, less advantaged types whose self-appointed task became not to mirror sacred social values in works of art but to question them.

A central arena for the discussion of such issues was the saloon, although prior to World War I normal masculine behavior in saloons and public houses could be as staid and dignified as that seen in the most decorous private club—and captured by Sloan in his painting *McSorley's Bar* (fig. 222). One journalist went so far as to label saloons "the poor man's club," adding that "the saloon exists because liquor is not all men want. Three-fourths of the saloon's patrons are impelled thither by one of the finest cravings of the soul, the craving for human fellowship."[114] Literary descriptions of pubs bear out this interpretation. The troubled Hurstwood in Dreiser's *Sister Carrie* entered a Chicago saloon "anxious to find relief" and discovered "quite a company of gentlemen were making the place lively with their conversation. A group of Cook County politicians were conferring about a round cherry-wood table in the rear portion of the room. Several young merry-makers were chattering at the bar before making a belated visit to the theater. A shabbily-genteel individual, with a red nose and an old high hat, was sipping a quiet glass of ale alone at one end of the bar."[115]

Despite their link to urban machine politics and the inflamed rhetoric of temperance reformers, many saloons functioned as neighborhood centers, providing services that went far beyond the proffering of liquor by the drink. Saloons furnished the only public toilets in cities, allowed the use of their watering troughs for teamsters' horses, cashed checks, lent money, and provided the free lunches that helped many a workingman make do with his slender paycheck.[116] These bars tended toward ethnicity but transmitted the prevalent culture to their working-class immigrant patrons. *King's Handbook of New York* reported in 1892 that "there are German Lager-beer saloons everywhere, wine shops in the Italian and French quarters, 'vodka' shops among the Russians, 'nomado' bars among the Chinese."[117] In them, as Dreiser commented, "the would-be *gilded* attempt to rub off gilt from those who have it in abundance."[118] In Dreiser's day saloons were legion; in Chicago, where his *Sister Carrie* begins, the number equaled that of all the city's groceries, meat markets, and dry-goods stores combined.[119]

Sloan's own recollection of McSorley's bar on East Seventh Street, where he occasionally "had a glass of ale and walked home," suggests a welcoming, collegial atmosphere: "McSorley's 'Old House at Home' is a favorite out-of-the-way retreat for appreciative ale drinkers. Behind its dust covered front window an ancient bar, sawdust covered floor, walls covered with old sporting and theatrical prints and programmes, it survived almost alone the modernizing of the saloon."[120]

The year after Sloan painted McSorley's, Hutchins Hapgood described the establishment for the readers of *Harper's Weekly*, echoing the painter's emphasis on its old-fashioned character. Lauding McSorley's Bar as "an ancient landmark" and "a relic of one phase of American life that has passed," Hapgood wrote:

> The quaint portrait of old Peter Cooper hangs on his saloon walls, also an old play-bill announcing a comedy by Harrigan and Hart called "McSorley's Inflation." An old copy of the *New York Herald*, framed on the wall, announced the assassination of President Lincoln. The walls are covered with old New York and national reminiscences. . . . A one-hundred-years-old safe, an ancient slanting chest, old solid chairs and tables, a sedulous care manifested to keep the place as it always was help to establish an atmosphere of tradition and permanence. Entering the saloon one seems to leave present day New York and to find oneself in a quieter and more aesthetic place . . . the heavy, solid chairs, the rich, dark colors, the trailing mementos of the past give pause to the headlong spirits, tending to take away what is unbalanced.[121]

Sloan and Hapgood share, then, the same sense of cultural change and the same longing for escape into nostalgia that tinge so much American art and literature at the turn of the century. Hapgood lovingly applied the favorite adjective—"old"—and enumerated quaint furnishings, playbills, and memorabilia to conjure up a connection with the past. Sloan called it forth with the dark palette of old-master painting, for by now artists were quite in the habit of making reference to old masters to help justify new modernisms. As Hapgood put it, "Rembrandt would

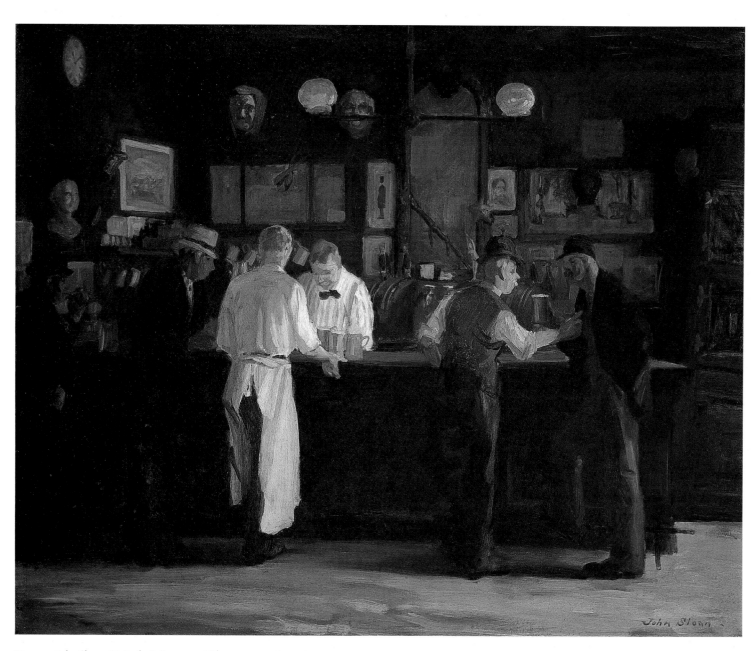

Fig. 222 John Sloan. *McSorley's Bar*, 1912. Oil on canvas, 26 x 32 in.
(66 x 81.3 cm). The Detroit Institute of Arts, Gift of the Founders' Society 24.2

have delighted in McSorley's and I think that Velázquez would have found his accent there, too, as our own John Sloan does."[122]

The nostalgic element apparent in *McSorley's Bar* is even more clearly expressed in *McSorley's Back Room* of 1912 (Hood Museum of Art, Dartmouth College, Hanover, New Hampshire), where an old man sits alone by the window, a mug of ale in front of him. The old man embodies Sloan's recollection of John McSorley, who founded the bar in 1854[123] and who was, by 1913, "dead these three years at the age of eighty-seven . . . one of the historical figures of our town."[124] The back room, said Sloan, "was like a sacristy. Here old John McSorley would sit greeting old friends and philosophizing."[125] Sloan recalled with a touch of regret, "Had all saloons been conducted with the dignity and decorum of McSorley's, prohibition could never have been brought about."[126] Sloan's portrayal of McSorley, we can see, is a reverie on a dead man who represents old values. McSorley and his bar continued to inspire Sloan in related images created as late as 1930 "from blessed memory," according to the artist.[127]

The escapism that made McSorley's attractive was, and still is, a major element in urban entertainments of all sorts; it characterized the luxurious saloons of New York that sound so alluring in Moses King's 1893 guidebook: "Hundreds of these places are very elegant, with heavy plate and cut glass, rich carved wood, fine frescoes and other decorations, and valuable pictures. Kirk's at Broadway and 27th Street, and Stewart's, in Warren Street, near Broadway, are particularly famous for their collections of rare oil paintings."[128] Sloan's picture *McSorley's Bar*, as well as his written recollection of the spot, establishes a parallel between this and grander establishments such as Stewart's, for the walls that Sloan portrayed are also encrusted with framed images. What appears to be a sporting picture in a gold-leaf molding stands out on the left in his painting, next to a carved bust; several portraits appear on the adjacent wall.

It is no accident that artists frequented saloons; patronage could be fostered there. For example, Theodore Stewart was one of several saloon proprietors who helped support the work of still-life painter William Michael Harnett. When Stewart purchased and hung Harnett's *After the Hunt* of 1883–85 (The Fine Arts Museums of San Francisco) in his Warren Street establishment, it was considered the glory of the saloon. According to an account of a witness, visitors were "riveted before it in groups."[129] Looking at Harnett's painting in a bar instead of in an art gallery was a liberating, democratic experience, similar to watching theatrical performances in a roof garden or vaudeville house rather than at the opera. The saloon as environment performed an enabling action—rather like today's museum programs designed to entice novices and to make them comfortable in the presence of fine art. Some of these saloon customers eventually became collectors themselves.

By offering food gratis at their counters and displaying works of art upon their walls, saloons for the workingman mimicked the most expensive casinos of the rich. Nightspots like Richard Canfield's gambling palace on East Forty-fourth Street, two doors down from Delmonico's restaurant, boasted a Stanford White interior and an art collection that featured several major works by Whistler now in the Frick Collection in New York.[130] Canfield's "free lunch" included not only the food but also the liquor and cigars consumed by customers. Members of The Four Hundred were discreetly entertained there, but only when they could afford the minimum bets.[131]

Offering similar opportunities to purchase an evening's entertainment in convivial surroundings, the corner saloon and the private casino had much in common as twin outlets for commodified leisure in American life. Although the customers came from various levels of society—sometimes intermingling, sometimes not—behavior was not so markedly different in either arena that standards of decorum precluded an individual from experience in both. Mammon had less respect for social position than for cash flow, and commercialized entertainment cut a wide swath across traditional boundaries of class and gender. Clearly the American painters of modern life recognized this central characteristic of a fluid turn-of-the-century society.[132]

Sporting High and Low

[An American] amuses himself by intensity, and this is the case whatever be the nature of his amusements, for he has very coarse and very refined ones. . . . The most vehement of those pleasures . . . are those of sport.

PAUL BOURGET (1895)

In the ring he struck to hurt, struck to maim, struck to destroy; but there was no animus in it. It was a plain business proposition.

JACK LONDON (1909)

When Paul Charles Joseph Bourget, member of the French Academy, visited America in the early 1890s, he took particular note of sports and the theater in his observations of "American Pleasures."[133] The two types of entertainment were linked as performance arts, in which the activities of the few were observed by the many. These arenas were not mutually exclusive—sporting champions, like actors, enjoyed public acclaim, and sports heroes sometimes even appeared on the vaudeville stage.[134]

The commercialization of leisure activities in America could hardly have escaped Bourget's notice. He would have encoun-

tered a good deal of sporting art—like the Harnett hunting still life, or images of prizefights and horse races—embellishing the walls of public gathering places. Saloons and poolrooms were among the first sponsors of commercialized sport, and gambling connected with athletic spectacles took place in such establishments.[135] Bourget also would have seen sports celebrated in commercial art, from lithographed advertisements to freestanding trade figures.

The Frenchman Bourget set out to describe, in positive if nationalistic terms, an American character very different from the Latin character of his compatriots. He postulated that Americans' pleasures seem "to imply, like their ideas and their labors, something unrestrained and immoderate, a very vigorous excitement, always bordering on violence, or, rather, on roughness and restlessness. Even in his diversions the American is too active and too self-willed. Unlike the Latin, who amuses himself by relaxation, he amuses himself by intensity, and this is the case whatever be the nature of his amusements, for he has very coarse and very refined ones. . . . The most vehement of those pleasures and the most deeply national are those of sport."[136] Bourget was particularly fascinated by "the passion for boxing," and he observed that "even the election of the future President will not excite more popular feeling."[137]

This "passion for boxing" animates *Club Night* (fig. 223), the canvas with which Bellows initiated his most powerful series of pictures.[138] Bourget's description of a boxing match could easily stand as a reading of Bellows's canvas, with its harshly lit, cruelly opposed fighters literally clad in black and blue and almost engulfed by a sea of hellish faces:

> A sort of gurgle of pleasure escapes from the audience, an interrupted gurgle which will change by and by from a sigh to a howl, as the fight becomes brisk or quiet. [One fighter] attacks with more vigor than his opponent, but. . . . His adversary has a better guard. He advances, he retires without moving his body, and his cruel face . . . is really like that of death. The blows fall more heavily as the fight progresses. The bodies bend to avoid them. The two men are furious. One hears their breathing and the dull thud of the fists as they fall on the naked flesh. After several blows of harder delivery, the "claret" is drawn, as they say, the blood flows from the eyes, the nose, the ears, it smears the cheeks and the mouth, it stains the fists with its warm and red flow, while the public expresses its delight by howls, which the striking of the gong alone stops.[139]

A journalist's reaction to Bellows's 1907 canvas is quite like Bourget's account of the real thing: "It is a brutal boxing match (surely four ounce gloves) about to degenerate into a clinch and a mixup. One pugilist is lunging in the act of delivering a 'soaker' to his adversary. You hear, you feel the dull impact of the blow. A sodden set of brute 'mugs' ring the circle—upon the platform the light is concentrated. It is not pleasing this, or edifying, but for the artists and amateur the play of muscles and the various attitudes and gestures are absolutely exciting."[140] The two writ-

ten narratives are separated by almost fifteen years, but their similarities suggest that the specifics of individual boxing matches varied little, an idea reinforced by the close compositional parallels among Bellows's boxing scenes.

In 1909, two years after he completed his first boxing canvas, Bellows landed two more telling blows in his fight for artistic recognition with a pair of pictures vigorously painted in the same dark palette as *Club Night*. Even though the three works have much in common, and each has the initial visual punch of a large bruise, Bellows escalates the emotional impact from the first to the second and from the second to the third. Smaller than *Club Night*, the second painting, *Stag at Sharkey's* (fig. 224), records a fiercer fight. The two antagonists take more exaggerated positions than the men in *Club Night* but seem evenly matched. The cartoonish faces in the crowd are more distorted. And if Bellows's first two boxing matches are contests, the third, and largest, *Both Members of This Club* (fig. 225), is a rout. The bleeding boxer on the left is close to collapse, and several onlookers are leaving their seats, trying to get into the ring.

In each of these three pictures a ringside spectator turns from the howling, bloodthirsty crowd to look back over his shoulder, engaging our attention and pulling us into the midst of the spectacle. In each Bellows creates relationships between various members of the crowd. We are reminded of the artful interlocking of audience members in Cassatt's earlier *At the Opera* (fig. 181).

Bellows may express a certain ambivalent class awareness by basing his treatment of ringside touts and swells on the conventions of popular cartooning. Noting that Bellows caricatured only the working class, Rebecca Zurier observed, "if the use of comic sources for slum subjects helped Bellows evoke contemporary imagery, it also helped him—and his audience—put these characters in their place."[141] And Marianne Doezema linked Bellows's emotions with his boxing paintings, interpreting *Club Night* as "a kind of cathartic exposé of his journey to the enticing urban underworld."[142] Like some of the spectators who populate various images of urban leisure, Bellows himself was slumming not only by attending the fights but also in electing to paint them. About the audience he encountered at the matches, the artist maintained, "the atmosphere around the fighters is a lot more immoral than the fighters themselves."[143] Jack London confirmed this idea when he described a professional boxer and the crowds that watched him in his classic prize-ring short story of 1909, "A Piece of Steak." London's battered character "bore no grudges and had few enemies. Fighting was a business with him. In the ring he struck to hurt, struck to maim, struck to destroy; but there was no animus in it. It was a plain business proposition. Audiences assembled and paid for the spectacle of men knocking each other out."[144]

The boxing pictures distill Bellows's personal perceptions,

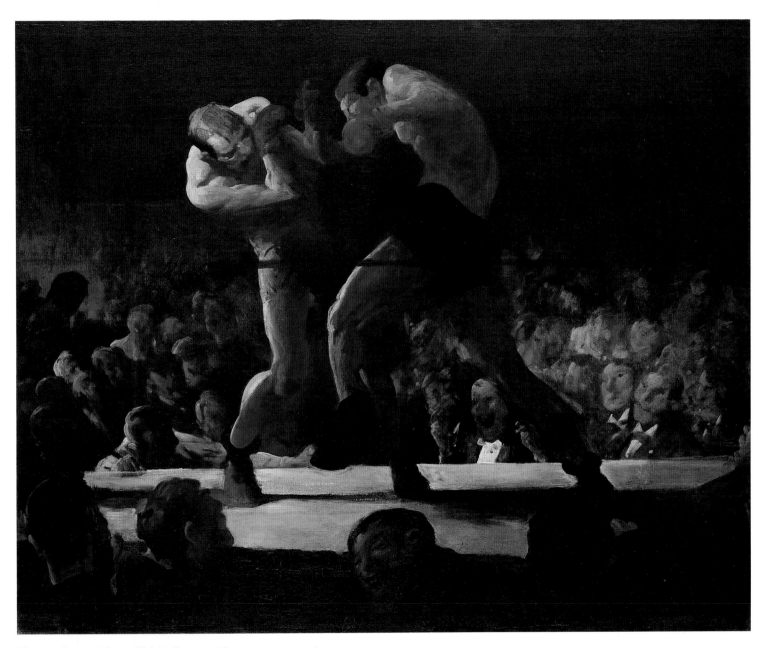

Fig. 223 George Bellows. *Club Night*, 1907. Oil on canvas, 43 x 53 in. (109.2 x 134.6 cm). National Gallery of Art, Washington, D.C., John Hay Whitney Collection 1982.76.1

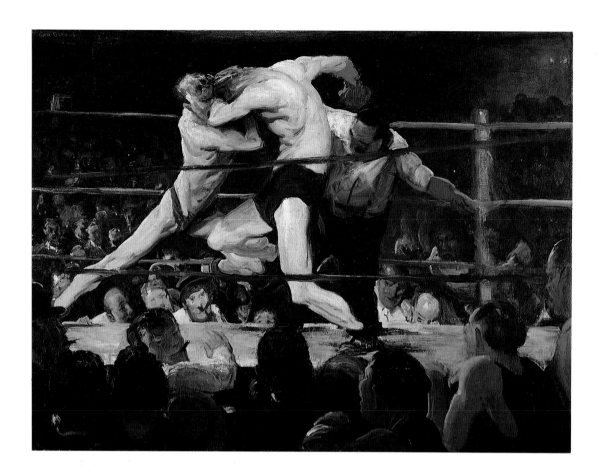

Fig. 224 George Bellows. *Stag at Sharkey's*, 1909. Oil on canvas, 36¼ x 48¼ in. (92.1 x 122.6 cm). The Cleveland Museum of Art, Hinman B. Hurlbut Collection 1133.22

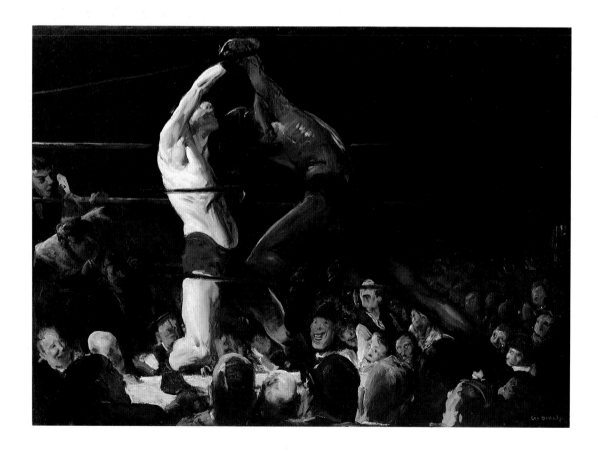

Fig. 225 George Bellows. *Both Members of This Club*, 1909. Oil on canvas, 45¼ x 63⅛ in. (114.9 x 160.3 cm). National Gallery of Art, Washington, D.C., Chester Dale Collection 1944.13.1

Fig. 226 Currier and Ives. *The Great Fight for the Championship. Between John C. Heenan "The Benicia Boy," & Tom Sagers, "Champion of England." Which took place April 17th 1860, at Farnborough, England. The battle lasted 2 hours 20 minutes 42 rounds, when the mob rushed in & ended the fight,"* n.d. Lithograph, 9¾ x 13¾ in. (24.8 x 34.9 cm). Museum of the City of New York, The Harry T. Peters Collection 58.300.209

heightened by his own fears and ambitions and tinged with a certain savvy opportunism—for the artist chose his theme at a time when the subject of boxing was widely discussed in the national press. Although the series is freighted with layers of meaning, Bellows's primary concern in them was the making of art, not anecdotal reportage. Bellows himself was forced to protest this point and defend *Club Night* as "a picture of two athletes in intense action" rather than an attempt to document the details of an actual boxing ring.[145]

Not only the stirring action of contemporary sporting events but also the static conventions of popular sporting prints fed into Bellows's work.[146] After the Civil War, lithographs representing famous pugilists were widely circulated in America. Surviving prints depict single or paired combatants, both British and American. Essentially commemorative, the prints usually record either a ceremonial pugilist-as-hero or a moment in a specific fight. One forty-two-round match (fig. 226) lasted for two hours and twenty minutes until "the mob rushed in and ended the fight." Reference to the mob and the scene's outdoor setting remind viewers that public prizefights were rowdy affairs, illegal as often as not. As a journalist of 1911 explained, such matches frequently attracted "a great many turbulent and otherwise undesirable persons" and boxing was "practised by men who do nothing else for a living."[147] Moreover, many pugilists, including Tom Sharkey, proprietor of the club-saloon Bellows frequented, came from recent immigrant groups.[148]

Bellows's boxing pictures, then, hang upon an ominous, shifting background of wrenching social and economic conflict. Despite legal difficulties and the unsavory lives some of them led, boxers attained widespread public recognition during the 1880s and 1890s, mirroring the rise of theatrical entertainers. Yet like other entertainers, boxers found themselves transformed from social outcasts to revered public personalities. Not only Bellows but also his audience sensed the whiff of the urban underworld

associated with boxing. Boxing provided the same kind of frisson that slumming uptowners sought in nightclubs and restaurants, as names like John L. Sullivan—the earliest of America's legendary sporting heroes but hardly a saint—became household words in the last decade of the nineteenth century.[149] Not surprisingly, efforts to make boxing a legitimate public entertainment (with attendant admission charges) were frequently KO'd by constantly changing and sporadically enacted regulatory legislation spurred by churchmen and other reformers who tried to limit the sport's growth on the grounds of its brutality and undeniable, often overt links to gambling.[150]

Boxing images reflect America's British cultural heritage, but legal history helps illuminate the meaning of these pictures in relation to other performance subjects regularly chosen by the French modernists and the Americans who followed them. Boxers, like actors and street performers, traditionally were members of a wandering underclass of entertainers, a fact recognized by a commentator of 1911 who wrote: "The ban upon the non-productive class that took part in prize-fights was a part of the ancient law of England.... that 'all able idle men' must be compelled to go to work in some productive employment or be driven out of the county by the sheriff. In the early days of that law the 'able idle men' at whom it was chiefly aimed were jugglers, wrestlers, tumblers, actors, and glee-men or minstrels who strolled about the country, living upon the people and producing nothing."[151] Similarly repressive laws against French street performers, in effect since the late 1700s, inform such pathetic images as Daumier's *Wandering Saltimbanques* (fig. 227), part of the visual legacy of the subject of the sad clown. Sloan's variation on this theme, *Clown Making Up* (fig. 185), was reproduced in the popular press along with Bellows's *Stag at Sharkey's* as two of four paintings representing the revolutionary spirit at the *Exhibition of Independent Artists* in April 1910, a coincidence that underscores the intersection of theatrical and boxing subjects (fig. 228).

Enterprising theater and opera house managers who engaged "professors of pugilism" to give exhibitions onstage thwarted state and local authorities who did their best to prevent matches in the early years of American boxing.[152] As a former pugilist himself, Sharkey was well aware of boxing-as-performance. In fact, he even performed for the camera: according to an obituary, "in 1899 . . . he battled Jeffries at Coney Island for 25 rib-cracking rounds under a broiling bank of 400 arc lights (for an early attempt at indoor movies)."[153]

Such paintings as *Club Night* and *Stag at Sharkey's* are themselves performances, starring the artist's vigorous, broadly brushed figures that capture the excitement of a fight in progress. In general, Bellows's boxing compositions recall a stage. The athletes performing at Sharkey's club are riveted in the glare of theatrical light. Bellows favored a low vantage point, setting the viewer

right in the middle of the overheated audience, whose varied, often loutish reactions do much to animate each scene—strategies and details not unlike those employed in paintings and prints by Daumier, with whom Bellows was often compared (see fig. 206).

Bellows's boxing pictures also resonate with earlier works by Thomas Eakins, whose *Between Rounds* (fig. 229) pointedly acknowledges the connection between boxing and the theater. Like characters in a play, the types that make up the world of boxing are distributed across the canvas: the prizefighter resting on a stool, his attendants, the timekeeper who regulates the rounds, the policeman who regulates the crowd, the reporters whose colorful journalism would describe the fight in the morning papers, and the various paying members of the audience, from the well-dressed gentlemen ringside to touts in the balcony. By hanging two theatrical posters above the ring, Eakins reinforces the sense of interrupted performance conveyed by the central image of the pugilist at rest. On one poster, an actor strikes a traditional pose; on the other, Pierrot, the sad clown, peeks up at a buxom actress. Attendants hover anxiously over Eakins's exhausted boxer, trying to keep him going for another round,

a continuing performance. The cut lemon that provides a bright yellow accent at the corner of the ring is one of the tools used in the struggle to keep the show alive—the acidic fruit was applied to stanch bleeding cuts sustained in the fight.

Eakins, like Bellows, had witnessed prizefights, and this experience is mirrored clearly in the accurate specifics he recorded in his boxing pictures. The Eakins series is so packed with detailed information that one scholar was prompted to speculate, "It is as though [Eakins] had begun to venture into the language of popular illustration to describe these subjects with mass appeal."[154] But Eakins's boxers are distanced from the athletes Bellows painted by a decade, a period during which American artists increasingly moved away from academic finish. Thus Bellows's work, unquestionably rooted in the language of popular culture, is much more agitated and active than Eakins's boxing series, with its elegant drawing, discreet measured brushwork, and static moments. Bellows's self-consciously aggressive strokes of paint, satanic bloody palette, and action-packed compositions reflect not only the loosening of academic strictures but also a tightening fear that American culture had become too feminine

Fig. 227 Honoré Daumier. *Wandering Saltimbanques*, 1847–50. Oil on wood, 12⅞ x 9¾ in. (32.7 x 24.8 cm). National Gallery of Art, Washington, D.C., Chester Dale Collection 1963.10.14

Fig. 228 "Exhibition by Independent Artists Attracts Immense Throngs," from *New York American* (April 4, 1910).

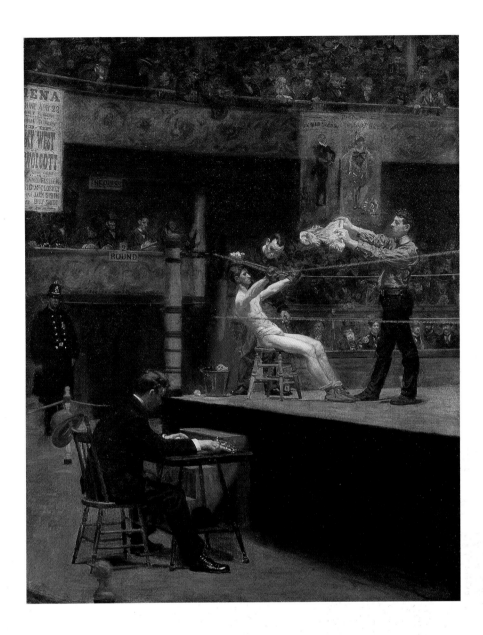

Fig. 229 Thomas Eakins. *Between Rounds*, 1899.
Oil on canvas, 50¼ x 40 in. (127.6 x 101.6 cm).
Philadelphia Museum of Art, Gift of Mrs. Thomas
Eakins and Miss Mary A. Williams 29.184.16

and effete. In this culture the manly sport of boxing, at once brutal and noble, became a metaphor for changing conceptions of masculinity. A telling defense of boxing appeared in *North American Review* in 1888:

> Come then! let thinking men who value their manhood set themselves in array, both against the army of those who, unmanly themselves, wish to see all others reduced to their own level, and against the vast following who, caught by such specious watchwords as "progress," "civilization," and "refinement," have unthinkingly thrown their weight into the falling scale. Has mawkish sentimentality become the shibboleth of the progress, civilization and refinement of this vaunted age? If so, then in Heaven's name leave us a saving touch of honest, old-fashioned barbarism! that when we come to die, we shall die, leaving men behind us, and not a race of eminently respectable female saints.[155]

It is not hard to read between the lines and find threatened virility here.

In early twentieth-century art journalism, the same spirit that inspired the popular journalist's paean to manliness prompted the common use of active, aggressive adjectives such as *virile* and *potent*. Critic Guy Pène du Bois, reviewing the Independent Artists' exhibition of April 1910 for the readers of the *New York American*, scorned the "long-haired, dreamy-eyed, velvet-coated aesthetic," affirming that the show was a "vital, manly—if artistically vulgar—record of a living, seeing, breathing set of human beings."[156] Today such vehement journalistic positions ring hollow, offering only the thinnest mask for agendas driven by race, class, or, in this case, gender. But in Pène du Bois's time, in the interest of stylistic change, it was easy enough to forget about the much publicized verbal and physical pugilism of Whistler, a recently deceased "long-haired, dreamy-eyed, velvet-coated aesthetic"—who flew fearlessly in the face of newspaper critics and once knocked his rival Seymour Haden through a plate-glass window.

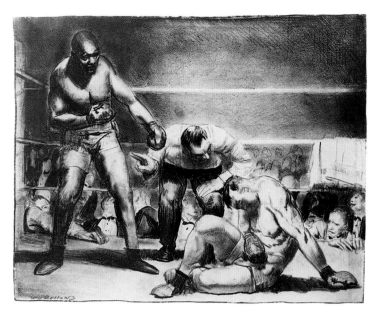

Fig. 230 George Bellows. *The White Hope*, 1921. Lithograph, 15⅛ x 19 in. (38.4 x 48.3 cm). Columbus Museum of Art, Ohio, Museum Purchase, Mrs. H. B. Arnold Memorial Fund 55.2

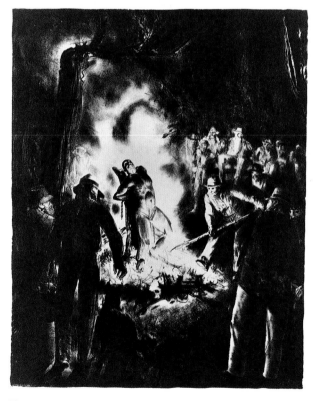

Fig. 231 George Bellows. *The Law is Too Slow*, 1923. Lithograph, 18 x 14½ in. (45.5 x 36.8 cm). Amon Carter Museum, Fort Worth 1985.145

Bellows's *Both Members of This Club* (fig. 225) is constructed as a pyramid that dramatically evokes not only physical but also social struggle. Its punning title underscores the outcast status pugilists were trying to overcome, referring to the practice of giving boxers instant membership in private clubs where matches were held to circumvent legislation against public prizefights.[157] The title also alludes to the issue of race, which the picture highlights by pitting a black against a white, giving the black the upper hand, and raising the possibility of equal status, at least in this kind of club.[158]

Black sportsmen's struggles for public acceptance were far more difficult than those of whites. To propose black boxing champions as symbols of racial equality, or superiority, as Bellows did in *Both Members of This Club* (originally titled *A Nigger and a White Man*), was to endanger the status quo. A commentator's warning, made in 1909, is charged by the volatile state of turn-of-the-century American race relations: "It is really a serious matter that, if the negro wins, thousands and thousands of other negroes will wonder whether, in claiming equality with the whites, they have not been too modest."[159] In fact, only a year after Bellows painted *Both Members of This Club*, the victory of a black boxer, Jack Johnson, over Jim Jeffries, the great white hope, caused race riots in numerous eastern and midwestern cities.[160]

Johnson himself proved a showy, hard-living champion with three interracial marriages to his credit. In trouble with the law, he fled the United States and spent an adventurous European exile on the vaudeville stage before returning home to serve a year in Leavenworth prison.[161] The controversial Johnson's "elevation [was] not of benefit to his race," opined a journalist for the *New York Times* in 1910,[162] expressing the typical point of view of his contemporaries. It was not until well after World War I that black boxers were accorded the same respect as their white counterparts.

Certainly Bellows was aware of American racial tensions when he approached his prizefight subjects. He returned to the theme of interracial boxing in 1921 with his lithograph *The White Hope* (fig. 230), in which the black man's victory is clear. The title, however, evidences the discomfort with which the entrenched majority still viewed black champions. Bellows's short-story illustration *The Law Is Too Slow* (fig. 231), executed in 1923, shows another black man in the ring, but it is a ring of fire this time: Bellows is depicting a lynching.[163]

Perhaps Bellows was seeking an antidote to the ultimately discomforting urban theme of boxing when he took up the subject of polo, a very pleasant suburban pastime he witnessed during a visit to Lakewood, New Jersey, in April 1910. Bellows brought sketches he made in Lakewood back to his studio and over the following months worked them into a pair of large canvases, *Polo at Lakewood* and *Polo Game* (figs. 232, 233);

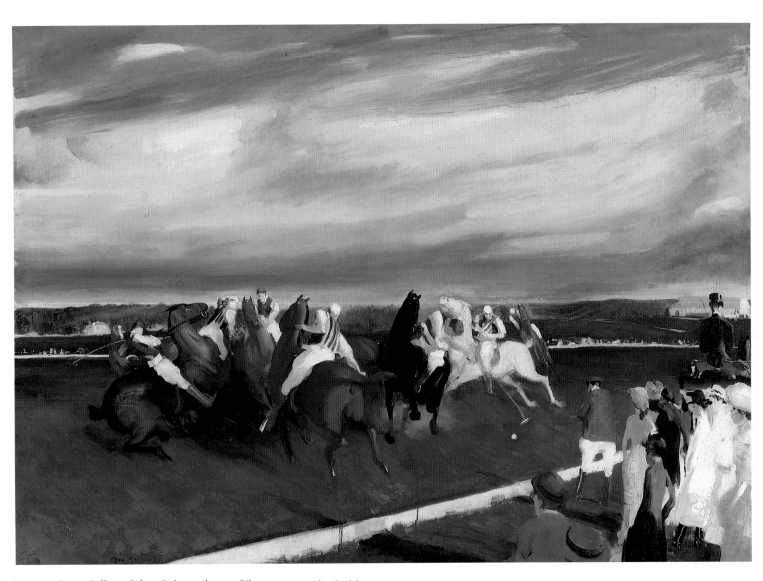

Fig. 232 George Bellows. *Polo at Lakewood*, 1910. Oil on canvas, 45¼ x 63½ in.
(114.9 x 161.3 cm). Columbus Museum of Art, Ohio, Columbus Art Association
Purchase 11.1

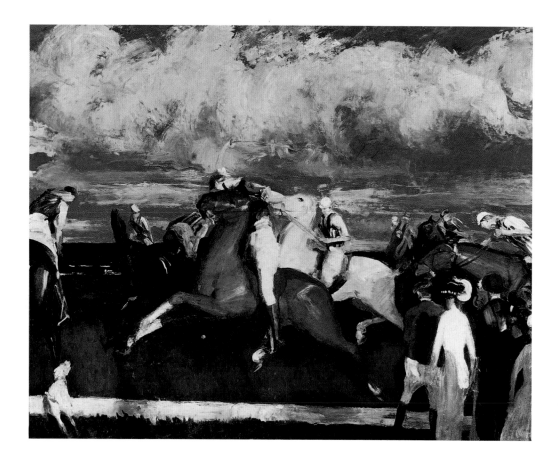

Fig. 233 George Bellows. *Polo Game*, 1910. Oil on canvas, 38 x 48 in. (96.5 x 121.9 cm). Private collection

he painted a third variation on the polo theme, *Crowd at Polo* (fig. 235), in November of that year. The game's combination of novelty—it was relatively new in America in 1910—and familiarity—like all American sport it was charged with sacred, traditional values—can help us understand how Bellows might have chosen to begin an elegant series of polo pictures on the heels of his most brutal boxing images. Polo, along with golf and tennis, which the successful artist would also paint with evident pleasure, was a rich man's sport, yet the polo scenes address some of the same issues invoked by the prizefight paintings: like *Club Night*, *Stag at Sharkey's*, and *Both Members of This Club*, they distill some of the conflicting ideas and expectations that characterize early twentieth-century American culture, in which inherent skills, as well as inherited wealth, might confer social cachet. As one sports editor and columnist put it, turning the tables on those blessed with trust funds, "We are really an unsnobbish people. We don't hold it against a guy for being rich if he can play his game like a true champion and produce those thrills."[164]

Polo, an Indian game popularized in England during the Raj, became established as a leisure activity in America during the 1880s.[165] About the time Bellows painted his polo series, journalists were writing enthusiastically of this admittedly expensive sport.[166] They advanced arguments echoing the character-building promises that have been used to justify other sports, from cro-

quet for modern young ladies of the mid-nineteenth century to boxing and other aspects of the self-consciously masculine strenuous life for the early twentieth-century American male.[167] The hint of nostalgia ever present in the arts at the turn of the century is also palpable in Percy Creed's thoughts on polo for readers of the *Fortnightly Review*: "The qualities which go to make a good polo-player are those which should . . . make a man successful in any walk in life. Dash, stamina, a cool head, good temper, a quick eye, the unselfishness which prompts a man to play for the side and not for himself, and horsemanship form an equipment which should command success. In these speed-crazy days . . . young men of means are too inclined to crouch behind the steering-wheel of a motor-car."[168]

Sloan underscores and exaggerates Creed's disdain for the modern motorcar culture in his *Gray and Brass* (fig. 234), a cartoonish vision of a machine the painter sarcastically described as "a brass-trimmed, snob, cheap, 'nouveau riche' laden automobile passing in the park."[169] Sloan's laughable carful could not offer a sharper contrast to Bellows's elegant polo horses and riders.

Bellows, as concerned as Sloan with nuances of income and taste, wrote to a friend: "I've been making studies of the wealthy game polo as played by the ultra rich. And let me say that these ultra rich have nerve tucked under their vest pocket. . . . The players are nice looking, moral looking. The horses are beautiful. I believe they brush their teeth and bathe them in goat's milk."[170]

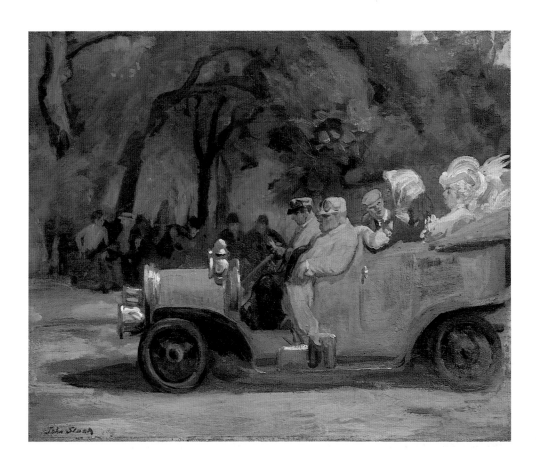

Fig. 234 John Sloan. *Gray and Brass*, 1907. Oil on canvas, 22 x 27 in. (55.9 x 68.6 cm). Private collection

Underlying Bellows's jocular but admiring comment is a certain precarious middle-class balancing—the louche boxing underworld of Sharkey's had its smoky allure, but so did the fresh, determinedly upscale attractions of an exclusive polo field and the elegant setting of Lakewood. Representing the fruits of earned leisure, turn-of-the-century Lakewood was a "little village which through enterprise had become a favorite winter home of many who appreciate an atmosphere so balmy."[171] Once prosaically named Bricksburg, the spot owed its very existence to the Industrial Revolution. The town began as a small settlement built around an ironworks but was transformed into a luxurious retreat after the Civil War, following the pattern of resort development that accompanied the expansion of urban financial centers in the late nineteenth century.[172] As the French coastal strip from Etretat to Deauville catered to artistic and wealthy Parisians or the Isles of Shoals welcomed world-weary Bostonians, so Lakewood became a haven for New Yorkers of means. A local realtor and a Wall Street banker teamed up to promote the region, lauding the area's temperate climate, acquiring nineteen thousand acres of pinewoods in 1879, and encouraging both town planning and the hotel industry. The first large hotel, Laurel House, opened in 1880 and quickly became "noted for its wonderful combination of luxurious appointments and home-like atmosphere."[173] Rudyard Kipling, Oliver Wendell Holmes, and Mark Twain were among the celebrities entertained there.

Other hotels followed, some of them vast in scale.[174] During the 1890s such socially prominent New York families as the Astors, Vanderbilts, and Rockefellers erected elaborate cottages around Lake Carasaljo. George J. Gould, son of the millionaire railroad owner Jay Gould, opened his Lakewood estate, Georgian Court, in 1896, and immediately began entertaining there on a lavish scale. In May 1899 he introduced his Lakewood polo team to play on one of four polo fields constructed on his grounds.[175]

A decade later Joseph B. Thomas invited his neighbor and friend Bellows to visit the Gould estate and see the polo matches.[176] At Georgian Court the painter was exposed to "a general display of artistic taste, wealth and good management" at a time when his own enterprise was beginning to pay off; there he would probably have seen "the Italian gardens, the bronze eagle, the electric fountain" and walked upon "the millions of loads of loam brought from Monmouth County, New Jersey, to convert the brush-bearing sand into 'velvet grassy lawns.'" He could hardly have missed "the romantic old kissing bridge which gave way to marble, granite and brick in the construction of the Sunken Garden—showing the difference between Nature and Art."[177] The synthesis of nature and art Bellows encountered at the estate would be echoed in the polo paintings that were inspired by his visit.

Polo at Lakewood captures the excitement of a fast-paced game with the same energy Bellows applied to the boxing series.

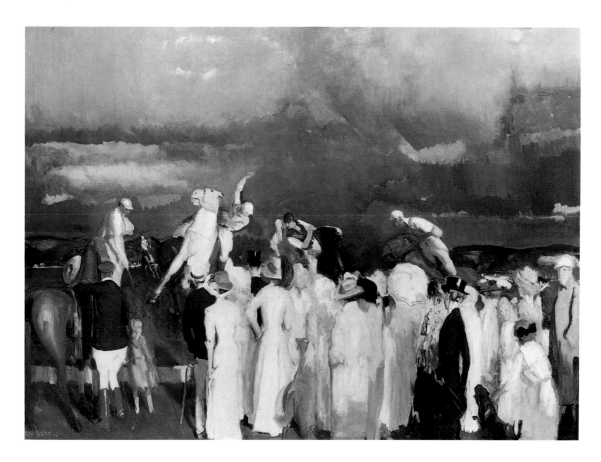

Fig. 235 George Bellows. *Crowd at Polo*, 1910. Oil on canvas, 44½ x 63 in. (113 x 160 cm). Collection of Mrs. John Hay Whitney

His composition is built on a careful geometric system, but, especially in the sky, Bellows wields his brush with the flourishing sweep of a polo mallet. A single black horse focuses the eye in the center of the melee, and the green and gray palette, enriched with brown and enlivened with dashes of red, is as fresh as the actual experience of watching a polo game was for the artist. Creed vividly described what Bellows would have seen: "The first thing which strikes the inexperienced spectator is the danger of polo, which he sees in a very exaggerated degree. The ponies galloping to an apparently inevitable collision, the strenuous bouts of hustling between the players which appear bound to unseat the rider, the seemingly reckless waving of the sticks, all give the impression of necessary disaster, but those who know will quickly remove such apprehensions by the confident assurance that for good players on trained ponies the risk is not nearly so great as it appears."[178]

After inspecting *Polo Game*, a reviewer for the *New York Sun* pointed out that its "rhythmic violence, its crash and go, betray . . . a close study of . . . the movement of horses in life" but acknowledged as well the impact of Degas,[179] whose racetrack scenes were well known in America by this time. We might add that, in his buttery handling of paint, Bellows also recalls Manet's broad brush.

Bellows reveled in the opportunity for artmaking that so dashing a subject as polo provided; he remarked with satisfaction, "It is a great subject to draw."[180] The polo scenes were grist

for his compositional theorizing, and his artfulness was evident to contemporary critics.[181] One said of *Polo Game*: "It has not merely the rattle and rush of the subject, but is also well put together. A swerving horse and dog check and balance up the onrush of the players; a conscious elongation of the figures of the onlookers, a stilting up of pony legs beyond natural proportions show that Mr. Bellows is . . . seeking an expression as well for the elegance as for the animation of his theme."[182]

Bellows populates the foregrounds of his first two polo paintings with languid, elegant spectators who observe the proceedings; perhaps they stand in for the artist-observer himself. In his third polo canvas, *Crowd at Polo* (fig. 235), he focuses exclusively on the audience, demonstrating the fact that the reaction of Americans to various forms of entertainment is as essential an element in the painting of modern life as the entertainment itself—the play, the supper out, the sporting event. We are reminded that depictions of these activities serve as visual metaphors for a changing society, a society that was becoming a nation of watchers, not doers, as far as entertainment was concerned. As one sardonic journalist put it in 1903, long before the stultifying effects of present-day commercial television could even be imagined: "For the most part the amusement consists of watching others take the exercise for an emolument. We go to the Polo Grounds and sit on a bench and watch the hired ball-tosser, or we go to the races and look at the thoroughbreds run for our

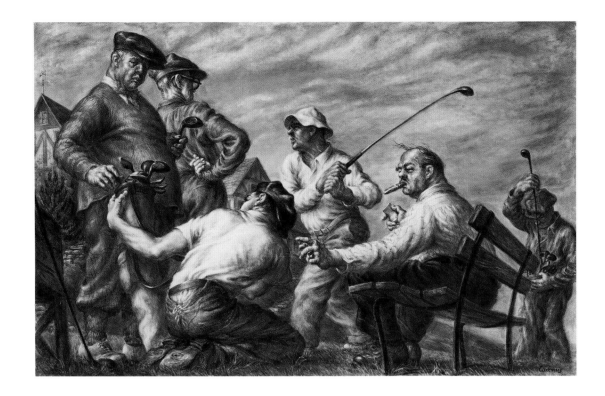

Fig. 236 Paul Cadmus. *Aspects of Suburban Life: Golf*, 1936. Oil and tempera on fiberboard, 31¾ x 50 in. (80.7 x 127 cm). National Museum of American Art, Smithsonian Institution, Washington, D.C., transfer from U.S. Department of State 1978.76.1

pleasure.... At night we escape from the baked pavements to the roof-gardens or to one of the 'ice-cooled' theatres where the poor actor sings and dances for our amusement."[183] Bellows continued to emphasize the audience in some of his late pictures of leisure activity, notably in elegant depictions of lawn tennis at Newport.[184]

By the 1920s polo, tennis, and golf were the elite sports of choice. Exclusive country clubs, many of them built at the turn of the century, promoted not only healthy exercise but also economic and social ties among members. The role of particular sports in defining status was becoming ever more clearly and firmly established.[185] The significance of sport as a benchmark of privilege is less overt in Bellows's pictures of polo and tennis, or in sylvan images of golf by both Hassam and Bellows, than in such sardonic Depression-era scenes as *Aspects of Suburban Life: Golf* by Paul Cadmus (fig. 236), in which rude and imperious golfing fatcats are contrasted with a caddy who kneels, shabbily shod, at their beck and call. It is, perhaps, a logical outcome of the commercialization of leisure in American life that participation in country-club sports, like attendance at the opera or, for that matter, the purchase of fine paintings, would be reduced in time to a matter of financial resources.

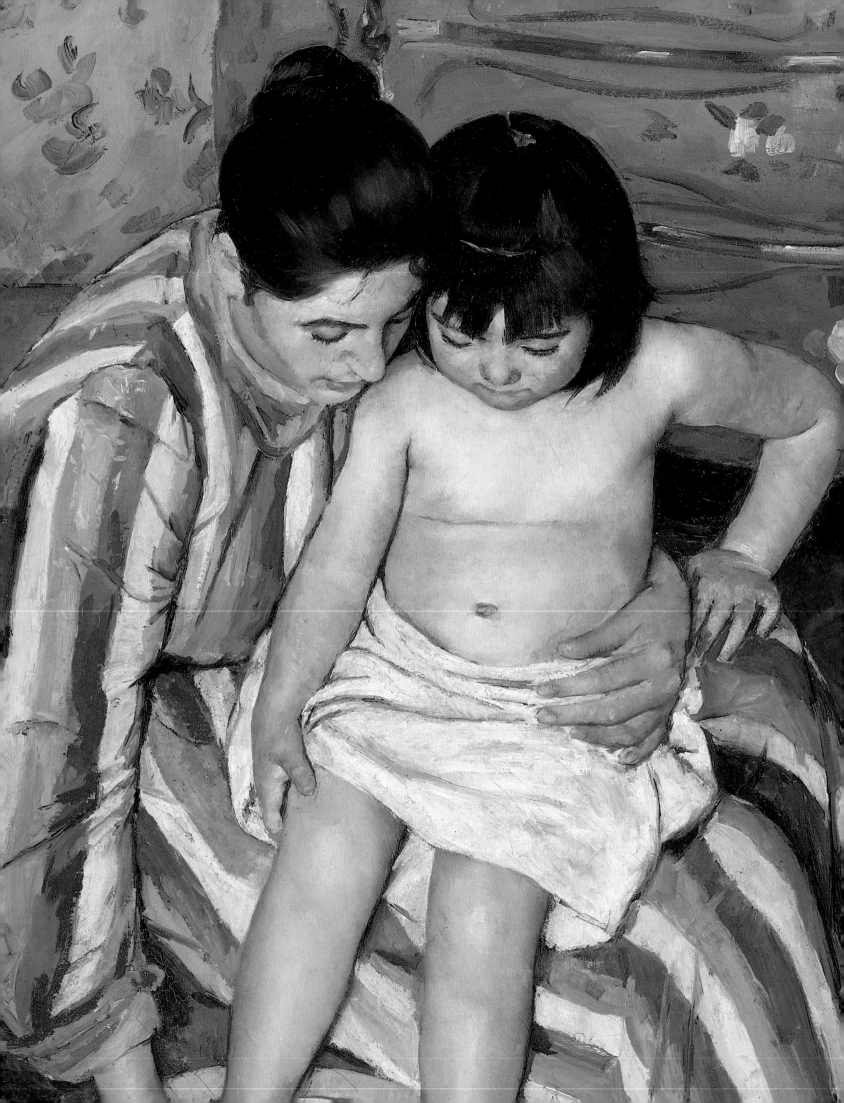

The Home

Detail, fig. 303

The Limits of Her Sphere

Home is not merely four square walls adorned with gilded pictures, but it is where love sheds its light on all the dear ones who gather round the sweet home fireside.

SERENO EDWARDS TODD (1870)

When society is rightly organized, the wife and mother will have time, wish, and will to grow intellectually, and will know that the limits of her sphere, the extent of her duties, are prescribed only by the measure of her ability.

SUSAN B. ANTHONY (1855)

Art and daily life merge in Edmund C. Tarbell's early twentieth-century tableau *The Breakfast Room* (fig. 237). The composition mirrors generally accepted ideas, established in the nineteenth century, separating home—the uplifting feminine sphere—from the abrasive masculine world of commerce.[1] Here representatives of the two worlds occupy the same space but studiously ignore each other: the man concentrates on an orange, unceremoniously impaled on a fork, while his female companion is absorbed in reading a newspaper or journal whose pages are blurred by Tarbell's soft brushwork; a maid is relegated to the background. The tension evident in the breakfast room lets us speculate on Tarbell's awareness that the cult of domesticity, as the separation of the feminine and masculine worlds was called, had begun to break down amid feminist demands for a "reordering of woman's sphere."[2]

Tarbell's woman at the table is far more aloof than the elegantly (and more fully) dressed lady of the house in William MacGregor Paxton's *Breakfast* (fig. 238). Paxton's female protagonist is not reading. Obviously distressed, she waits while a man, evidently her husband, reads his newspaper. One critic described this scene as representing the "newspaper-at-breakfast stage" of marriage.[3] That writer continued, "It is often, as this picture indicates, the first intimation that comes to the bride that the days of her husband's courtesy to her are over. It is the first awakening and a sad one."[4] For some women at the turn of the century, the domestic sphere had become a cozy trap, a scant three decades after Sereno Edwards Todd had extolled family and household life at the "sweet home fireside" where "dear ones" gathered.[5]

In contrast to Paxton, Tarbell refuses to spin out a clear narrative, encouraging an emphasis on formal interpretation. Initial reaction to *The Breakfast Room* ignored the picture's uneasy atmosphere to consider aesthetic issues and art-historical conventions. As contemporary critics did perceive, Tarbell based this, the first in a series of small interior scenes, on European precedents. He looked especially closely at the ballet pictures created thirty years earlier by Edgar Degas, which convey a

Fig. 237 ' Edmund C. Tarbell. *The Breakfast Room*, ca. 1903. Oil on canvas,
25 x 30 in. (63.5 x 76.2 cm). Pennsylvania Academy of the Fine Arts, Philadelphia,
Gift of Clement B. Newbold 1975.25.3

Fig. 238 William MacGregor Paxton. *The Breakfast*, 1911. Oil on canvas, 28 x 34 in. (71.1 x 86.4 cm). Berry-Hill Galleries, Inc., New York

pervasive sense of discomfort.[6] Critics who saw Tarbell's painting linked it to Degas as well as to the "Dutch golden age," and a Boston journalist dubbed it "one of the best modern interiors ever painted."[7] It was pronounced "clever" and "vivacious."[8]

Even negative critical responses dwelt upon the formal properties of the picture. Underscoring the fact that the opulence of its setting and props matched the artist's technical virtuosity, the unsympathetic Sadakichi Hartmann grumped, "In order to become a Tarbellite one must manage merely to cover large surfaces with pyrotechnic displays of technique.... The Tarbellites are like clever American tailors, who closely follow the latest innovations, in cut and material, of their European brothers."[9] Frederick W. Coburn comforted the readers of *International Studio*, explaining that works such as *The Breakfast Room* "are concerned solely with the things which are proper to painting, for Mr. Tarbell's art is never allegorical.... A breakfast-room of the well bred ... may furnish Mr. Tarbell with a pretext for an extraordinarily skilful arrangement of color tones.... Subject and style are alike immaterial."[10] Despite assurances that Tarbell's agenda was purely formal, it is readily apparent that the atmosphere in his elegant setting is marked by sexual tension.

Unlike Paxton's young woman, Tarbell's female model seems uninterested in the man who shares the table with her, and their relationship is not clearly defined.[11] Although each painting depicts two women—mistress and maid—who outnumber a lone male, Tarbell squeezes his man into the far-right corner, where he is hemmed in not only by his companion, who sits higher and larger in the composition, but also by the circular table laden with silver, glass, and porcelain, evidence of the enormous increase in material goods available for the well-furnished household at the end of the nineteenth century.[12] Scattered works of art, several of them casually placed, may indicate that the setting is in truth an artist's studio. But those same scattered objects, dominated by a large female reclining nude in the manner of Titian, also remind us that much of the art produced during this period was destined for the woman's sphere, those "four square walls" of Todd's home, "adorned with gilded pictures."[13]

The presence of a maid in both Tarbell's and Paxton's pictures invokes the issue of household help. As early as the 1820s middle-class Americans began staffing their homes with servants. Such assistance permitted the lady of the house time to elaborate and ritualize the domestic realm: "In hiring domestics middle-class women found the means to make domesticity more flexible, accommodating roles of authority and activity, rather than passivity and isolation."[14] Tarbell renders social division in visual terms by separating the servant from the couple at the table with a suitable expanse of empty polished floor. Hard at work in the next room, the servant is kept in her proper place by a bright white grid established by the door and window frame.

More saccharine domestic scenes, among them William H. Lippincott's *Infantry in Arms* (fig. 239), sweeten the fragmentation of domestic order that was already a fact of American life.[15]

Fig. 239 William H. Lippincott. *Infantry in Arms*, 1887. Oil on canvas, 32 x 53 ¼ in. (81.3 x 135.3 cm). Pennsylvania Academy of the Fine Arts, Philadelphia, Gift of Homer F. Emens and Francis C. Jones 1922.10

The absence of the man of the house, presumably outside in the world of commerce, is signaled by a plate of uneaten food and an empty chair, but we do not witness his departure. Lippincott also takes pains to define family and servant in a way that attempts to reinforce, even re-create, the domestic harmony he portrays. There is no doubt about the class and relationship of Lippincott's models. A nursemaid, with a babe in arms, approaches a mother at the breakfast table. The contrived title offers room for double entendre if it is read apart from the painted image. Tarbell's more ambiguous canvas, on the other hand, originally bore the simple title *People at Breakfast*.

As a studio model, Tarbell's lady at the table in her suggestive dishabille would qualify as a workingwoman. The turn of the century marked an era when women—married or not—began to move freely in society.[16] Many people feared women leaving, possibly neglecting, the domestic sphere for work outside the home, for leisure and entertainment, even for education or social reform.[17] Elizabeth Bisland, writing in 1895, only a year before Tarbell painted *The Breakfast Room*, condemned those of her sex who accepted what she called a "cruel and profligate modern creed, [that] 'Every thing pleasant is yours by right: you have no duties.'"[18] The specter of feminine selfishness—threatening a domestic order that rested firmly on feminine selflessness—was raised repeatedly. So-called fashionable women who ignored the home scene in favor of outside pleasure were roundly criticized in the press.[19] According to one disillusioned extremist, "While the American man unnaturally devotes his days to money-making, the American woman as unnaturally devotes her days to pleasure."[20] Tarbell's female model, still not dressed or ready for anything

but the most private activities, sits absorbed in her reading, seemingly one of the idle women the writer found so unnatural.

At the end of the nineteenth century, women began to acknowledge openly the difficulties and disappointments of marriage and motherhood, their assigned roles within the domestic sphere. Many sought to delay both to pursue their own interests.[21] As Constance Cary Harrison lamented in 1890, "A woman once married, however beautiful or young or clever, is pushed to the wall like the heavy furniture when a dance is under way."[22] "We must amuse ourselves before marriage," snapped an unattached young lady in 1895; "Who knows what will come afterward?"[23] These desires were not confined to women of means. In the 1903 novel *The Woman Who Toils*, penned by two women, a factory girl opined: "I ain't ready to marry him yet. Twenty-five is time enough. I'm only twenty-three. I can have a good time just as I am."[24]

Writing in 1899, Harry Thurston Peck cautiously recognized a dangerous dissatisfaction lurking just under the surface of idealized domestic tranquillity. Yet he continued with the warning that "the place [woman] occupies in the social system is so vitally important, and any change in it is fraught with such momentous consequences to every individual and even to the human race at large, as to render any plan to change it a matter of profound concern to all."[25] Denying the accuracy of feminist descriptions of the womanly life, Peck claimed that "the home which they profess to see and shudder at is most amazingly untrue to life. It is a home in which the woman, a sensitive, imaginative creature, is forced day after day to spend her hours in sordid labor over the cook-stove, the soap-vat, the pickle-jar and the wash-tub,

Fig. 240 Ralph Earl. *Esther Boardman*, 1789.
Oil on canvas, 42½ x 32 in. (108 x 81.3 cm).
The Metropolitan Museum of Art, New York,
Gift of Edith and Henry Noss, 1991 1991.338

Fig. 241 Ralph Earl. *Elijah Boardman*, 1789.
Oil on canvas, 83 x 51 in. (210.8 x 129.5 cm).
The Metropolitan Museum of Art, New York,
Bequest of Susan W. Tyler, 1979 1979.395

performing the most menial tasks. She is the one who might do great things in the larger world outside. . . . On the other hand, her husband to whom she thus devotes her life with no reward . . . goes grandly forth in a large, free way."[26] Susan B. Anthony had expressed the opposite point of view: "When society is rightly organized, the wife and mother will have time, wish, and will to grow intellectually, and will know that the limits of her sphere, the extent of her duties, are prescribed only by the measure of her ability."[27]

If we can believe journalists prone to reducing issues to black and white, women were caught between two extremes. Conservatives sought to restrict women to the domestic sphere, touting women's established responsibilities as a privilege. Progressive thinkers, however, encouraged the American woman to burst

forth from the home to better herself, her family, and the nation. For them, household duties remained an obstacle to feminine achievement.

The printed word became a significant factor in expanding the limits of the woman's sphere. In the minds of many Americans, books had long been associated with the feminine role as teacher of children and conveyor of moral propriety or had been perceived as a means of escape—through novels and poetry—from these same responsibilities.[28] In an eighteenth-century portrait by Ralph Earl, the elegantly dressed young Esther Boardman sits outdoors in a sylvan landscape, holding a single slim volume, perhaps of poetic or inspirational nature (fig. 240). Elijah Boardman's portrait (fig. 241), painted by Earl in the same year, contrasts sharply with that of his marriageable sister; his is the

Fig. 242 James McNeill Whistler. *Harmony in Green and Rose: The Music Room*, 1860–61. Oil on canvas, 37⅝ x 27⅞ in. (95.5 x 70.8 cm). Freer Gallery of Art, Smithsonian Institution, Washington, D.C. 17.234

world of business as well as of more profound culture. Mr. Boardman lays a possessive arm across his counting desk, the lower portion of which forms a bookcase filled with leather-bound ledgers and tomes, the intellectual and practical corner-stone of his successful dry-goods enterprise.[29]

American paintings after 1850 increasingly show women reading, a fact that may reflect the headway made by advocates of education for girls. Early in the nineteenth century no colleges in the United States offered admission to women, whose access to elementary and secondary schools was also limited; most received their education at home, from their mothers, or at local academies for young ladies. By the 1860s private academies and state-run normal schools trained women as teachers, and the literacy rate for white women equaled that of white men.[30] By 1900 women had made immense strides in education, gaining admission to 80 percent of the colleges, universities, and professional schools in the United States.[31]

Many female graduates, considering the choice between marriage and career (still seen as mutually exclusive options), chose the more accepted role. "I hang in a void midway between two spheres," one woman observed in 1910. "A professional career puts me beyond reach of the average woman's duties and pleasures, but the conventional limitations of the female lot put me beyond the reach of the average man's duties and pleasures."[32]

Expanding educational opportunities for women were double-edged. Turn-of-the-century views of women's education reveal several important changes of attitude about sexuality, fragility, and beauty. By the late nineteenth century many had come to perceive education as an advantage for women who would become wives and mothers.[33] As women sought higher learning, however, some voices predicted ill effects, claiming that education interfered with childbearing as well as child rearing.[34] Progressive writers of the 1890s not only disputed these widely held misconceptions but also asserted that sexual intercourse should be pleasurable for women. As birth control became more widely practiced and men struggled to maintain their authority within the family, a crisis in middle-class domestic life was precipitated.[35] "Overworked men and nervous women tending to sterility, and living upon an artificial plane, do not promise a brave future for a nation," worried H. B. Marriott-Watson in 1903.[36] Writers on family life persistently exhorted women to bear children, seen as a means for achieving physical and moral excellence.

Painters continued to pose women as readers during the final decades of the nineteenth century, but what the models read, and what it meant, were in flux.[37] James McNeill Whistler signaled a change at an early stage with *Harmony in Green and Rose: The Music Room* (fig. 242), in which the painter's young niece Annie Haden is absorbed in a large art book. One of Whistler's first tableaux of modern life, this picture is set in the London music room of Whistler's half sister Deborah Delano Haden, wife of a prominent surgeon. Her shadowy presence as a mere reflection in a mirror suggests the limits of her utterly conventional marriage. Deborah appears pale in contrast to the strongly painted woman in a black riding costume associated with the French "Amazon" or courtesan.[38] Posed between symbols of the two paths open to her, Annie maintains her privacy. We receive little information about either her thoughts or her prospects. Whistler presents an ambiguous allegory of choice couched in what Charles Baudelaire called "the beauty of circumstance and the sketch of manners."[39]

For generation after generation the world of the imagination had been the highest realm of art. As Linda J. Docherty has recently observed regarding the depiction of women in painting, the act of reading can be interpreted through what they are reading—women hold novels, suggesting the world of imagination; art books, suggesting culture; and newspapers, suggesting current events.[40] It is not surprising that while images of women reading proliferated at the end of the nineteenth century, the women shown are usually reading novels or art books, hints of interests and accomplishments outside the home. Indeed, books

themselves had been objectified to a degree as both emblems and emissaries of culture granted an aesthetic status almost as high as fine art. The readers of William John Loftie's *Plea for Art in the House, with Special Reference to the Economy of Collecting Works of Art, and the Importance of Taste in Education and Morals* of 1876 were encouraged to enrich their surroundings with books as well as paintings, for "pictures ornament a house more than anything else, but ... next to pictures I am inclined to place books."[41] The equivalence of books and paintings, as propounded in Loftie's book on house decoration, was eloquently expressed in Henry James's novel *The Bostonians*: a male character, new to the city, "had always heard Boston was a city of culture, and now there was culture in Miss Chancellor's tables and sofas, in the books that were everywhere, on little shelves like brackets (as if a book were a statuette)."[42]

Given the status accorded to books and works of art, the appearance of a newspaper in a female reader's hands is a strong mark of modernity, one that appears occasionally in works by artists from Lilly Martin Spencer to Mary Cassatt. Unlike novels, which encouraged reverie and a retreat into fantasy, the newspaper pulled its reader firmly into the present, underscoring the circumstances women actually faced.[43] As it became increasingly commonplace on the breakfast table, the newspaper linked women more closely to events outside the domestic sphere. Reading such materials had once been almost entirely the province of men. Newspapers in particular were associated with politics, commerce, and trade (see fig. 243), topics deemed unsuitable for women until the end of the century. So much a part of the male world were newspapers that literary lion Charles Dudley Warner fearfully inquired of his sex, "Is he becoming anything but a newspaper-made person? Is his mind getting to be like the newspaper?"[44] Warner praised woman's interest in more serious literature and deprecated man's absorption in the passing parade of mere quotidian events. Warner's attitude was generally held, as an illustration from 1893 makes clear (fig. 244).

Cassatt's *Reading Le Figaro* (fig. 245) depicts the artist's mother, Katherine Cassatt, "an agreeable-looking, middle-aged lady with clear skin over her well-formed features, and with soft, brown, wavy hair," as Susan N. Carter described the painted image in 1879, when the picture was exhibited in Philadelphia. Carter's praise for the work was lavish.[45] Such enthusiasm for *Reading Le Figaro* is somewhat surprising given the portrait's advanced tenor. Cassatt was just beginning to exhibit with the French Impressionists, firmly embracing innovation not only in her choice of subject but also in her bright palette and expressive brushwork. Mrs. Cassatt is represented with a fresh, no-nonsense gray, white, and brown palette as a woman quite capable of intense concentration and independent thought, whose interest in a daily newspaper devoted to politics and literature epitomizes the up-to-date.[46]

A recent arrival on the Parisian scene, Mrs. Cassatt, with her

Fig. 243 Edgar Degas. *Portraits in an Office, New Orleans.* 1873. Oil on canvas, 28¾ x 36¼ in. (73 x 92 cm). Musée des Beaux-Arts, Pau

IMPROVING THE MIND.

FOND MOTHER. "My son, this is Sunday morning; why can't you sit down quietly and read something elevating and improving to the mind?"
HER ONLY HOPE. "So I will, ma, so I will, just as soon as pa lets me have the Sunday paper."

Fig. 244 From *Harper's Weekly* 37 (January 21, 1893), p. 55

husband, Robert, had brought Mary's older sister, Lydia, to France at the end of 1877, joining the artist in her expatriate existence shortly before *Reading Le Figaro* was executed. Mr. Cassatt had retired from business, and the couple now had the time as well as the means to participate in Parisian entertainments and cultural offerings while Lydia sought treatment for a chronic illness.[47] Long since fluent in French, Mrs. Cassatt could readily absorb

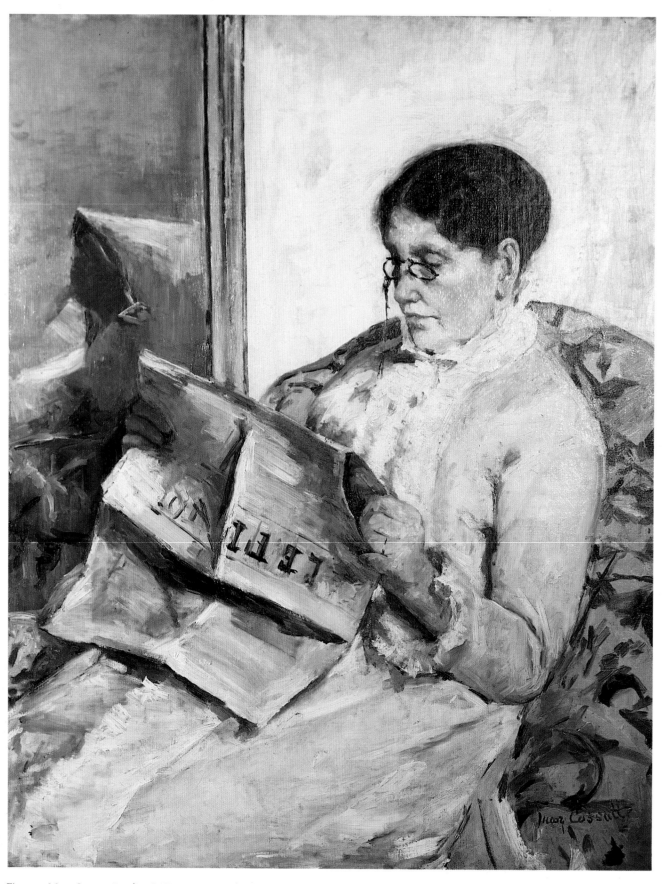

Fig. 245 Mary Cassatt. *Reading Le Figaro*, 1878. Oil on canvas, 39½ x 32 in.
(100.3 x 81.3 cm). Private collection

Fig. 246 Gustave Caillebotte. *Interior, Woman at the Window*, 1880. Oil on canvas, 45⅝ x 35 in. (116 x 89 cm). Private collection

"To cast her ignorance in her teeth."

Fig. 247 W. H. Hyde. Illustration from Robert Grant, "The Art of Living: The Case of Woman," *Scribner's Magazine* 18 (October 1895), p. 468

the news and activities of her new home. Although cultural sophistication distinguished Mrs. Cassatt from many members of the American colony in the French capital and sparked her support for avant-garde painting, the wealthy Philadelphian Cassatts probably found it easier to accept their daughter's bohemian friends in part because so many—notably Degas, Berthe Morisot, and Gustave Caillebotte—came from respectable families of means.

A woman markedly different from Mrs. Cassatt turns her back and stands by the window in a painting by Caillebotte (fig. 246). Motionless, she stares out at the street, which is both framed for and separated from her by heavy tasseled draperies and lace curtains. Meanwhile, her male companion absorbs news of the outside world from the pages of his daily paper. Despite Caillebotte's implied message of women's sequestration, the printed word, as two popular images acknowledge, had become immensely important for transmitting new ideas to them.[48] In W. H. Hyde's 1895 illustration (fig. 247), an elegantly attired gentleman clutching a newspaper gestures angrily at his wife, "To cast her ignorance in her teeth." Robert Grant, who wrote

Looking for the "Best" Type

Fig. 248 Charles Dana Gibson. *A Suffragette's Husband*, from *Other People* (1911), n.p.

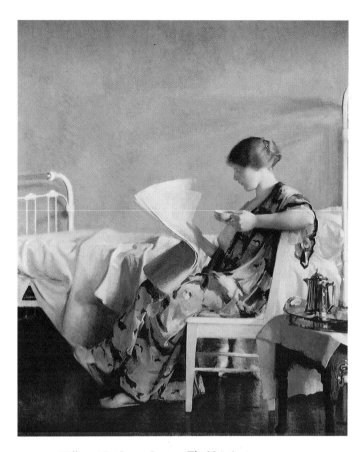

Fig. 249 William MacGregor Paxton. *The Morning Paper*, 1913. Oil on canvas, 30 x 25 in. (76.2 x 63.5 cm). Mr. and Mrs. Hugh Halff, Jr.

the commentary that accompanies the image, observed that men of this sort "allow themselves, on the slightest provocation, to be worked into a fever over the aspirations of women."[49] Charles Dana Gibson's drawing *A Suffragette's Husband* (fig. 248) suggests the extreme direction in which conservative thinkers feared reading might take women. A dejected husband sits silently at the table in front of an empty plate, his hangdog expression underscored by the forlorn terrier that has joined the couple. The lady of the house, an imposing figure, turns her back on spouse and pet; she is absorbed in the newspaper. The headline reads: "WOMEN VOTE."[50]

But paintings of women reading newspapers are not numerous in American art of the late nineteenth and early twentieth century.[51] Such imagery seems to have had the greatest appeal for the members of the Boston School, set in its milieu of genteel, literate reform. For them the notion of women reading newspapers may have carried greater shock value than it did for the Realists, many of whom had commercial expertise as illustrators. Bathed in sunlight and holding a cup of coffee, Paxton's demure model informs herself with *The Morning Paper* (fig. 249). In contrast Everett Shinn's *Newspaper Stand* (fig. 250) gives us a perfunctory glimpse of a luridly lit old harridan selling newspapers to a couple of shadowy customers.

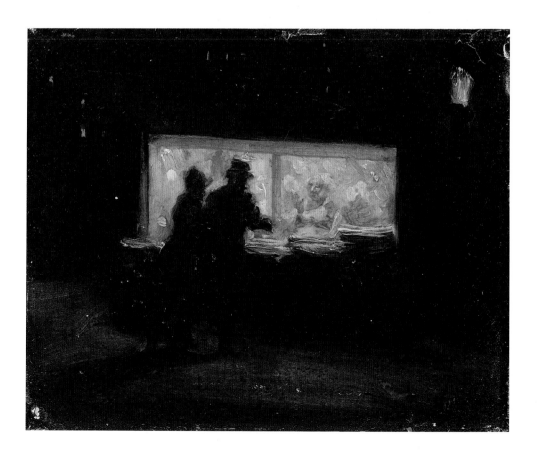

Fig. 250 Everett Shinn. *Newspaper Stand*, n.d. Oil on cardboard, 4¼ x 5¼ in. (10.8 x 13.3 cm). Private collection

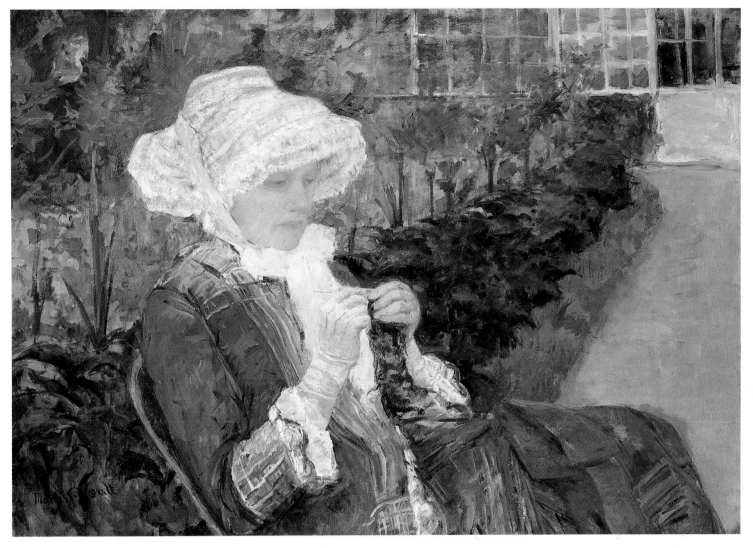

Fig. 251 Mary Cassatt. *Lydia Crocheting in the Garden at Marly*, 1880. Oil on canvas, 26 x 37 in. (66 x 94 cm). The Metropolitan Museum of Art, New York, Gift of Mrs. Gardner Cassatt, 1965 65.184

Although they occasionally hinted at the social discord apparent under the surface, the American Impressionists unquestionably embraced what they saw as the positive aspects of the domestic scene—middle-class women with "most gracious and alluring manners," who engaged in leisure of a refined sort.[52] Their narrowly defined paintings suggest satisfying lives filled with books and newspapers, music, and the time for reflection. Nourishing intellectual and creative activities were accomplished in pleasant surroundings—interiors elegantly arranged or outdoor gardens filled with sunlight and greenery. If the American Impressionists showed women at work, they celebrated especially the unpaid tasks that maintained and enhanced the domestic sphere. Some

showed mothers, the loving caretakers of their children; others favored genteel handicrafts, such as sewing or crocheting (fig. 251). It is almost as though they created images to support the assertions of men like Peck, for certainly none of these women were compelled to devote themselves to "sordid labor." Even the parlormaid who pauses in her duties to admire a piece of her mistress's china in Joseph Rodefer DeCamp's *Blue Cup* (fig. 252) seems temporarily exonerated from arduous work to provide an artistic vignette. Such detachment from the hard facts of wage labor is particularly characteristic of the Boston painters.

The American Realists' slightly broader slice of society is, in fact, not much more inclusive. Few of their pictures represent

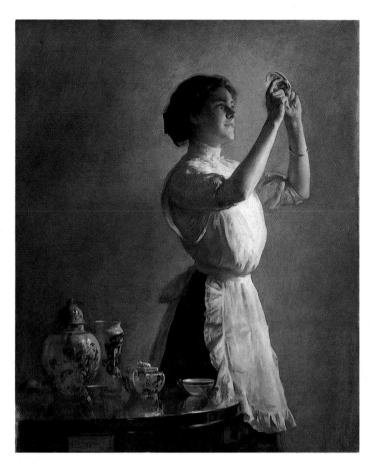

Fig. 252 Joseph Rodefer DeCamp. *The Blue Cup*, 1909. Oil on canvas, 50⅛ x 41¼ in. (127.3 x 104.8 cm). Museum of Fine Arts, Boston, Gift of Edwin S. Webster, Laurence T. Webster, and Mary S. Sampson, in memory of their father, Frank G. Webster 33.532

actual work, whether within or outside the home, and when they do show women performing domestic chores, the burdensome nature of housework is minimized. Women shop not for necessities but for indulgences such as silk lingerie, cut flowers, or paintings. Their laundry is never dirty; even the Realists show it already washed clean, snapping briskly in the breeze.

In 1900 A. L. Mearkle optimistically catalogued the evidence for women's widening arena: "The last century has seen several changes affecting the condition of women—changes that should be considered as we look at her prospects for the coming one. Education has become general. The average age at marriage is greater. The average family is smaller. The average duration of life is increased. The sphere of a woman's activities is enlarged."[53] Compared with the women portrayed by the American Impressionists, those depicted by the Realists display a more diverse social background, greater sexuality, and increased freedom. Yet images of menial tasks—such as those involving "the cook-stove, the soap-vat, the pickle-jar and the wash-tub"—remain rare. Even Realist explorations of the domestic scene fail to convey the profundity of social upheaval in turn-of-the-century America.

The New Woman

The field of labor for the women of the idle class is vast. There is no village so small, no town so free from corruption that it does not afford ample opportunity for missionary work.

M. OLIVIA SAGE (1905)

That cunning prestidigitator, miscalled Progress, laughs in its sleeve as it leads the girl bachelor to the footlights and introduces her as the woman of the future.

G. H. HEPWORTH (1893)

Portrayed less than a decade apart, John Singer Sargent's assuredly patrician Edith Stokes and Alfred Maurer's openly vulgar Jeanne (figs. 253, 258) seem to occupy completely different worlds. Sargent's double portrait of Mr. and Mrs. Isaac Newton Phelps Stokes in sporting costume presents to us a woman whose wealth and leisure afforded her ample opportunity to pursue the good works advocated by philanthropist Olivia Sage.[54] Maurer's subject was a working-class woman, a professional model, led to the footlights in a theatrical parody of grand-manner portraiture.

The Stokes portrait, a lavish wedding present from a family friend, was painted in London in 1897.[55] It began with Mrs. Stokes alone, striking a conventional pose chosen after Sargent had examined a trunkful of dresses that the sitter had sent to his studio; according to Mr. Stokes, Sargent had Edith change from costume to costume, "as if she were a mannikin."[56] Then, one morning, she arrived at the studio with her husband, carrying a straw hat and wearing more casual clothing—a starched white piqué skirt, a light shirtwaist, and a simple blue serge jacket.

Recalling the moment when Sargent began to devise the current composition, Mr. Stokes noted that "as she came into the studio, full of energy, and her cheeks aglow from the brisk walk, Sargent exclaimed at once: 'I want to paint you just as you are.'"[57] But the final image was not so easily achieved. Sargent painted, scraped off, and repainted Edith's face eight times before he was satisfied. Arrangements were made to borrow a dog to pose beside the beautiful young woman; at the last minute, however, Mr. Stokes "offered to assume the role of the Great Dane in the picture" and was added to the composition.[58]

In the end Sargent devised an imaginative solution to the double portrait, maintaining his focus on Edith while including a likeness of her husband. Mr. Stokes stands behind his wife, cast in shadow and arms folded, a vision of restraint and self-containment in contrast to his wife's youthful vigor. Edith clearly dominates the canvas. Cecilia Beaux painted Isaac's parents, Mr. and Mrs. Anson Phelps Stokes (fig. 254), about a year after Sargent completed his picture. Beaux chose a similar device: the woman again fills the foreground stage, although both of the

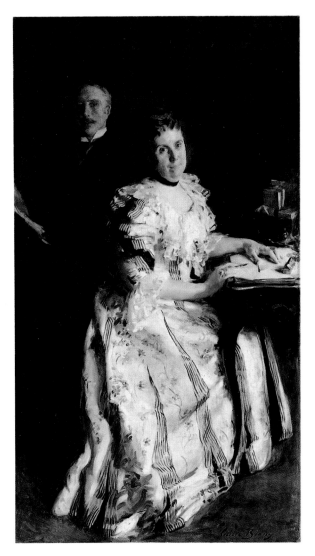

Fig. 254 Cecilia Beaux. *Mr. and Mrs. Anson Phelps Stokes*, 1898. Oil on canvas, 72⅛ x 39⅞ in. (183.2 x 101.3 cm). The Metropolitan Museum of Art, New York, Gift of the family of the Rev. and Mrs. Anson Phelps Stokes, 1965 65.252

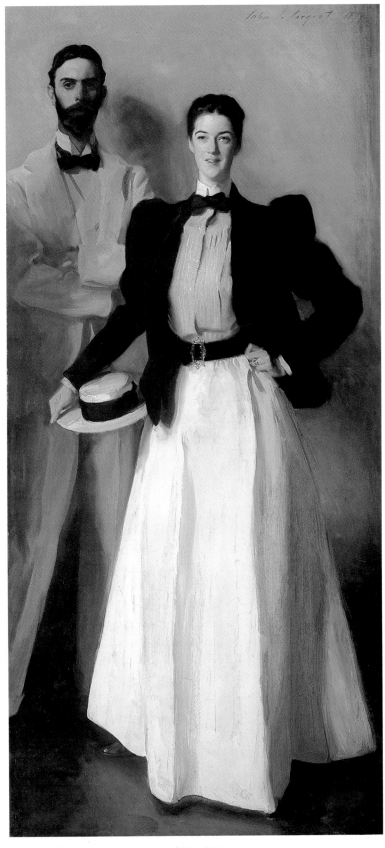

Fig. 253 John Singer Sargent. *Mr. and Mrs. I. N. Phelps Stokes*, 1897. Oil on canvas, 84¼ x 39¾ in. (214 x 101 cm). The Metropolitan Museum of Art, New York, Bequest of Edith Minturn Phelps Stokes (Mrs. I. N.), 1938 38.104

Fig. 255 *These Stylish Suits $49.98*, from Gustav Kobbé, "Fakes and Fakirs," *Century Magazine* 59 (December 1899), p. 321

Fig. 256 Charles Dana Gibson. Illustration from *The Gibson Book. A Collection of the Published Work of Charles Dana Gibson* 1 (New York, 1907), n.p.

elder Stokeses are seated. The younger Mr. Stokes, describing Beaux's work as "my mother's portrait," remarked in a letter to the artist, "how wonderfully you have painted her heart and soul"; he made no comment on his father.[59] We wonder how he felt about his similar treatment at the hands of Sargent.

Mr. and Mrs. I. N. Phelps Stokes was widely exhibited shortly after its completion. Its most telling review came from a member of the Society of Fakirs, a group of pupils at the Art Students League of New York that created and exhibited caricatures of works submitted to the Society of American Artists' annual shows. When the Stokes portrait was featured at the society in 1898, it stimulated several irreverent but revealing fakes. "One fake," reported art critic Gustav Kobbé, "showed the costumes draped on headless lay figures, such as are sometimes seen in shop-windows, and bore the inscription, 'These Stylish Suits $49.98'" (fig. 255).[60] The underlying tone of resentment toward the Stokeses, their elevated social status, and their readily apparent wealth is clearly communicated.[61]

The type of clothing in which Sargent painted Edith Stokes was rapidly becoming a popular sporting costume—for tennis, croquet, or boating—and eventually would be immortalized by illustrator Gibson through his idealized Gibson girl, who was touted as representing the best of American womanhood in the 1890s (see fig. 256).[62] As one critic proclaimed when the Stokes portrait was first exhibited in 1898, "The young woman stands there smiling at her audience with all the confidence of American assurance. It is more than an individual portrait—it is 'The American Girl' herself."[63]

This exalted ideal—with an impossibly narrow waist, elegantly upswept hair, and stylish but simple clothing—was alluring yet chaste. Athletic and outgoing, she was "the American virgin-woman," surrounded by "a refreshing aura of health, sensuality, and rebellion," feminist Lois W. Banner has explained, quickly reminding us that the Gibson girl was never "pictured in employment outside the home."[64] Constance Cary Harrison, a contemporary of the elder Mrs. Stokes, used compelling Victorian prose to describe the American girl: "Fair and brilliant, she is fearless as a nymph in Diana's train. Constantly in movement, her throne is often a saddle, her sceptre a riding crop. She rows, swims, shoots, dances with equal skill; reads novels abundantly; works not at all."[65] In spite of this and other calls to physical exertion of the leisurely kind, few turn-of-the-century artists portrayed women rowing, swimming, shooting, or dancing; more often they painted them thinking, reading, or playing the piano.[66] Many of these energetic young women were destined for boredom and inactivity following marriage, which often was accompanied by new domestic responsibilities and social strictures.

Not so, young Mrs. Stokes. Sargent's facile, fashionable society portrait belies the couple's social consciousness as well as their deep appreciation of the past. When Edith Minturn married

Isaac Stokes in 1895, she joined a family distinguished by its philanthropy and social action. Stokes's wealthy and privileged grandparents had raised a large family committed to Protestant piety and personal service to the poor.[67] Although Isaac's father had earned a fortune in banking and real estate, he remained active in progressive causes, advocating civil-service reform as well as serving on a provisional committee whose discussions on establishing an art museum in New York eventually resulted in the founding of The Metropolitan Museum of Art. Anson Stokes also amassed a particularly impressive library of Americana.[68]

Isaac himself was educated at Harvard and pursued interests similar to those of his father, working as an architect and a historian.[69] Having gathered an important collection of historic prints of New York, from 1915 to 1928 he published the six-volume *Iconography of Manhattan Island*, which is still widely used today. With John Howells he designed a colonial-revival building for New York's University Settlement. One of the many philanthropic organizations that offered medical, educational, and social support to immigrants, this group attempted to Americanize recent arrivals through classes on local history and tours of landmarks.[70] These were offered in collaboration with the City History Club. The cover of the club's annual report for 1897–98 (fig. 257), the year Sargent painted the young Stokeses, showed an illustration of a tidy chorus line of children in ethnic costume dancing before a man in colonial American dress. "Father Knickerbocker Making Good Americans of the Children of All Nationalities," reads the accompanying caption.

Edith, the daughter of a wealthy shipper, fit easily into her husband's world by virtue of her social background and reform instincts. Her philanthropic efforts, like those of her relatives, had an agenda of noblesse oblige that targeted the immigrant child and family in the hope of cultivating productive American citizens. She served for nearly two decades as the president of the New York Kindergarten Association, which took "children whose earliest education would otherwise be received on the streets" and put them "into cheerful surroundings, in relations with refined women, and [made] them feel the attractiveness of cleanness, order and courtesy."[71] Clearly, Edith Stokes and her cohorts imagined taking the sort of ill-behaved street children depicted in George Bellows's *Kids* (fig. 311) and, via the kindergarten experience, transforming them into acceptable members of society.

When Maurer painted *Jeanne* (fig. 258), he chose the full-length format then in vogue for such society portraits as Sargent's *Mr. and Mrs. I. N. Phelps Stokes*, but his subject was drawn from a very different social class. His model raises a cigarette to her lips, her eyes peeking slyly from below an outrageously elaborate straw hat festooned with birds, a ready-to-wear trophy. Her dress is clearly from an earlier era, and her long feather boa is theatrical rather than fashionable, probably a costume devised to satisfy the painter. Jeanne's credits as a professional model

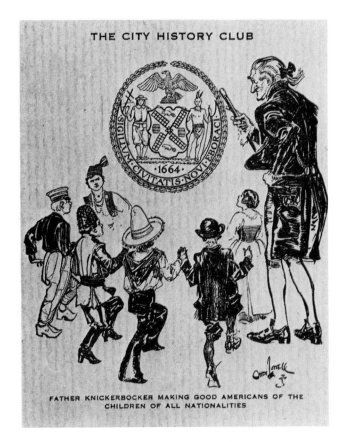

Fig. 257 Orson Lowell. Cover, City History Club, *Annual Report* (New York, 1897–98)

were hardly a social recommendation; her odd attire and evident enjoyment of such a masculine pastime as smoking signal a working-class background, perhaps one of ill repute.[72] When women were shown indulging in tobacco, they were usually considered to be what Dolores Mitchell has described as "'outsiders'—actresses, prostitutes, lesbians, degenerate society women, or 'new women' for whom cigarettes symbolized deviance."[73] Smoking also carried highly charged sexual overtones. Men frequently described a cigar or cigarette as a lover, an idea expressed visually in Maurice Prendergast's illustration for James M. Barrie's *My Lady Nicotine: A Study in Smoke* (fig. 259), in which a female form emerges from the smoke of a cigarette.

At the turn of the century, when Gibson's ideal of beauty prevailed, many feared that greater freedom accorded to women through education and employment might encourage them to neglect their appearance and to assume unattractive masculine traits.[74] In 1903 Henry T. Finck predicted a return to "the days of savagery" (and inadvertently revealed the dominant group's tendency to equate all outsiders): "our women will ultimately be 'advanced' to the position of the squaws concerning whom we read in Schoolcraft that on account of the hard work they had to perform, they were 'universally masculine in appearance, with-

out one soft blandishment to render them desirable or lovely.'"[75] In the description of "The Educated Woman of To-Morrow" she wrote in 1903, Heloise E. Hersey decried the dangers of "reverting to the squaw type" and stressed "most gracious and alluring manners" as required attributes for a modern woman.[76]

Finck cited the opinion of a professor at Rutgers Female College to affirm his fears. At coeducational institutions, he complained, "the young women lose their love for beauty and that development for a personal taste which is a part of womanhood's charm. They practice boyish manners and boyish mischief."[77] Physician and health writer S. Weir Mitchell revealed the real agenda, cautioning that "future womanly usefulness was endangered by steady use of [the] brain."[78]

In *Three Sisters—A Study in June Sunlight* (fig. 260) Tarbell celebrates the sort of life that Hersey would have considered appropriate for women of "most gracious and alluring manners."[79] This genteel family group at leisure in a sylvan setting includes the painter's wife, Emeline Souther Tarbell. She wears a bright red hat, its striking color drawing the eye to Tarbell's daughter Josephine, who sits on her mother's lap. Mrs. Tarbell is flanked by her sisters, who are engrossed in their conversation and in the child's play. Each of these ladies is modishly attired for a summer afternoon gathering out of doors: Mrs. Tarbell sports an informal but stylish sailor collar; one sister wears a blue gauze visiting dress with puffed sleeves, a fashion just emerging in smart circles; and the boldest sibling displays her ankles below tiers of ruffles.[80] Tarbell gives us few clues

Fig. 258 Alfred Maurer. *Jeanne*, ca. 1904. Oil on canvas, 74¼ x 39⅛ in. (189.9 x 100 cm). Collection of Mrs. Wendell Cherry

Fig. 259 Maurice Prendergast. Frontispiece, James M. Barrie, *My Lady Nicotine: A Study in Smoke* (Boston, 1896). The Metropolitan Museum of Art, New York, Purchase, Steuben Glass Gift, 1952 52.539.2

Fig. 260 Edmund C. Tarbell. *Three Sisters—A Study in June Sunlight*, 1890.
Oil on canvas, 35⅛ x 40⅛ in. (89.2 x 102.2 cm). Milwaukee Art Museum,
Gift of Mrs. Montgomery Sears, Boston M1925.1

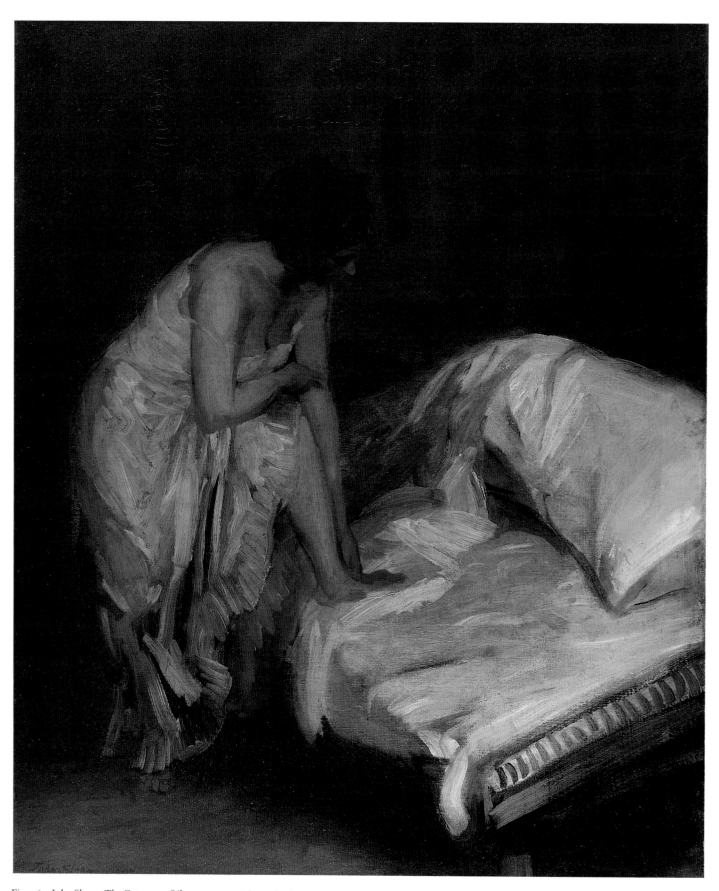

Fig. 261 John Sloan. *The Cot*, 1907. Oil on canvas, 36¼ x 30 in. (92.1 x 76.2 cm).
Bowdoin College Museum of Art, Brunswick, Maine, Bequest of George Otis
Hamlin, 1961

about their surroundings, sketched in just enough to suggest areas of light and shadow. The single chair visible amid the ladies' full skirts is not a piece of outdoor furniture but an old kitchen chair, refreshed with white paint and dragged out on the lawn, a faint reminder of household chores and responsibilities. Although Tarbell's ladies undoubtedly have some domestic obligations, even if they merely involve supervising servants, here we see them completely at ease.

John Sloan's *Cot* (fig. 261) depicts a leisure moment of a different sort.[81] Departing from the "gracious and alluring manners" of the established classes, Sloan's model unceremoniously examines her (probably aching) foot in the privacy of a dark tenement room.[82] His subject is Eugenie Stein, a Bohemian German often called "Zenka" or "Efzenka." A friend of Sloan's wife, Dolly, she worked as a professional model and posed for Robert Henri as well as for Sloan.[83] Obviously, Zenka was a working-class woman, a far cry from the American Impressionists' refined feminine ideal. When Sloan first painted Zenka's portrait, in 1904–5, he titled the work *Foreign Girl*, emphatically identifying her as an immigrant new to the American scene: "She had strong opinions on politics and society and her English was odd but understandable."[84] In *The Cot* Zenka's down-turned head obscures her features, and a loosely fitting gown partially hides her substantial physique; in another portrait, *Stein in Red Dress, White Fichu* (fig. 262), we see more clearly a woman well outside the fashionable standard of beauty canonized by Gibson's drawings. Zenka has heavy features—a fleshy face with dark brows, full nose, and thick lips—and dark curly hair that slips unrestrained over her shoulder. Her ample waist is unconfined by the tight laces of a corset, and her modest dress lacks elegance.

Sloan may have felt empowered to portray Zenka in the intimate setting of *The Cot* by her lower-class status and her literally and figuratively Bohemian background as well as by her employment as an artist's model, a profession associated with loose morals if not prostitution. Here, as in his painting *Three A.M.* (fig. 263), Sloan seems to be a voyeur. As the artist wrote of the domestic scenes he worked on at this time, "Night vigils at the back window of a Twenty-third Street studio were rewarded by motifs of this sort.... Some of the lives that I glimpsed I thought I understood."[85] Even if Sloan has posed models for both *The Cot* and *Three A.M.*, he conveys a sense of intrusion into other people's private lives that was almost unavoidable in crowded urban tenements.

Sloan's *Cot* lacks the emotive power of Degas's *Interior (The Rape)* (fig. 265)—the American boudoir scene seems much less highly charged than the French master's exploration of murder and wedding-night dissonance.[86] But Sloan's American audience may have wondered about Zenka's sense of propriety. The accepted standard of sexual behavior among working-class women was perceived as different from the rules of deportment among

Fig. 262 John Sloan. *Stein in Red Dress, White Fichu*, 1905. Oil on canvas, 30 x 25 ⅛ in. (76.2 x 63.8 cm). John Sloan Trust, Delaware Art Museum, Wilmington

middle-class ladies. It was difficult for social reformers, no less for artists and their audiences, to decide whether or not such women were respectable. Their behavior fell "between the traditional middle-class poles: they were not truly promiscuous in their actions, but neither were they models of decorum."[87] They earned wages and sought amusement during their leisure time; some negotiated overtly sexual relationships with men. Thus, unquestioned assumptions surrounding this class of women made it much easier for middle-class artists like Sloan to display them in circumstances such as those presented in *The Cot*.

Indeed, the original composition may have been more provocative than the finished painting. Sloan worked on *The Cot* over an extended period, perhaps from 1905 through 1907, revising as he went along. The artist's diary entry of June 18, 1907, tells us that there were initially two figures in the picture, and his treatment of them sounds quite a bit more risqué: "Took up the nude on the bed started months ago and painted out the figure, putting drapery on the stooped figure."[88] At that stage Zenka may have been shown naked (or at least less fully clothed), and the bed beside her was certainly occupied by a nude, not the jumble of bedclothes seen today. The disarrayed pillow and sheets survive to suggest that the bed was recently inhabited, in itself a significant visual statement during a time when such

Fig. 263 John Sloan. *Three A.M.*, 1909. Oil on canvas, 32 x 26¼ in. (81.3 x 66.7 cm). Philadelphia Museum of Art, Gift of Mrs. Cyrus McCormick, 1946 46.10.1

Fig. 264 Everett Shinn. *La Chambre*, 1910. Red chalk. Whereabouts unknown

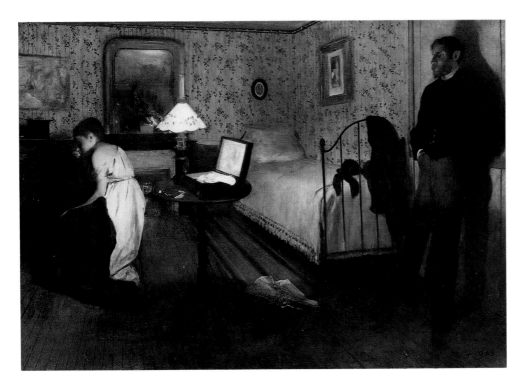

Fig. 265 Edgar Degas. *Interior (The Rape)*, 1868–69. Oil on canvas, 31⅞ x 45⅝ in. (81 x 116 cm). Philadelphia Museum of Art, The Henry P. McIlhenny Collection in Memory of Frances P. McIlhenny

intimate moments were rarely discussed in the United States and seldom represented in paint on canvas. Like Shinn's red chalk drawing *La Chambre* (fig. 264), an overtly sexual image heavily indebted to French Rococo boudoir scenes, *The Cot* reminds us that American artists, however modern their subject matter, continued to look to past European art for precedents.

The Consumer and the Consumed

If I were shabby no one would have me: a woman is asked out as much for her clothes as for herself. The clothes are the background, the frame, if you like: they don't make success but they are a part of it.

LILY BART IN EDITH WHARTON'S *HOUSE OF MIRTH* (1905)

What a pity such a girl has to work in a shop! She seems really quite like a lady.

ALICE VAN LEER CARRICK (1900)

Two roughly contemporaneous pictures, *Lady Trying on a Hat (The Black Hat)* (fig. 266) by Frank W. Benson and *The Shoppers* (fig. 272) by William Glackens, address issues of commodification and consumerism, touching upon women's twin roles as consumer and consumed in turn-of-the-century America.[89] Both artists are clearly indebted to earlier works by Degas, such as *At the Milliner's* (fig. 267). Benson, however, avoids the public set-

ting of Degas's millinery series; his scenario transpires in a private space occupied by a single figure. And, in a typically American manner, Glackens softens Degas's brutal message of class divisions. As for the American consumers we see in the oils by Benson and Glackens, Europeans envied them. A visitor from Dublin asked, "Why should not all shopping be of the very best in America? They are a progressive people; they adopt all the new fashions and new inventions with the greatest rapidity. . . . Whatever dissatisfaction American women have in their lives, it certainly cannot extend to their opportunities for shopping in every and in all directions."[90]

Benson's model is pinned in a gridwork of material possessions. The items surrounding her bespeak a refined domestic environment, at the same time acknowledging commercialism—here, Boston's historic links with the China trade. A blue-and-white jar filled with pink roses is placed prominently on the table; its cool tones set off the warmer shades in the woman's dress, and the fluid curves of the jar are carefully juxtaposed against her comely silhouette. The flowers quite literally echo the "roses" in the anonymous woman's cheeks and complement the glowing swaths of pink drapery swirling around her. Benson objectifies the beautiful but enigmatic figure, equating her with the luxurious bibelots that surround her. In appearance and milieu she recalls Mme Merle's remarks to Isabel Archer in James's *Portrait of a Lady*: "I've a great respect for *things*! One's self—for other people—is one's expression of one's self; and one's house, one's furniture, one's garments, the books one reads, the company one keeps—these things are all expressive."[91]

In Benson's picture the woman tests the expressiveness of her hat. She already owns this accessory, she is done with the rigors

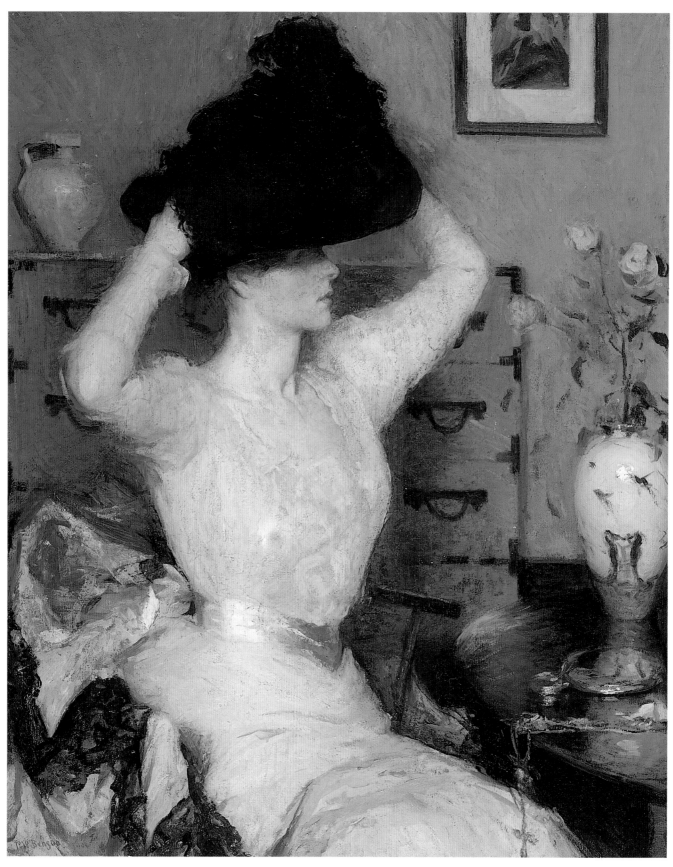

Fig. 266 Frank W. Benson. *Lady Trying on a Hat (The Black Hat)*, 1904. Oil on canvas, 40 x 32 in. (101.6 x 81.3 cm). Museum of Art, Rhode Island School of Design, Providence, Gift of Walter Callender, Henry D. Sharpe, Howard L. Clark, William Gammell, and Isaac C. Bates 06.002

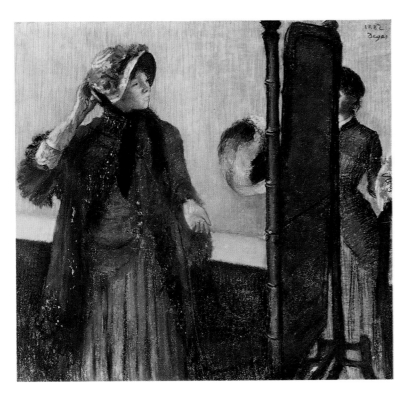

Fig. 267 Edgar Degas. *At the Milliner's*, 1882. Pastel on pale gray wove paper (industrial wrapping paper), 30 x 34 in. (76.2 x 86.4 cm). The Metropolitan Museum of Art, New York, H. O. Havemeyer Collection, Bequest of Mrs. H. O. Havemeyer, 1929 29.100.38

"My husband did not like me in this hat"

Fig. 268 Helen E. Hokinson, Cartoon, from Anne O'Hagan, "The Customer is Always Right," *Woman Citizen* 11 (May 1927), p. 10

of shopping for the moment and can enjoy her find at leisure. It is unlikely that she would appear in public wearing her gauzy white day dress with the black hat, and we can speculate that she is simply trying the hat on to appreciate its effect. Although this is a private moment, Benson subtly declares a male presence and possibly makes a wry comment on the fashionable male foppery of past centuries. Above the metal-cornered Asian chest there is a framed image, perhaps a mezzotint, of a sixteenth-century gentleman wearing a plumed hat curiously like the one the model is trying on. But by the time this painting was executed women, not men, were charged with the task of keeping up with the ever changing fashions. As one journalist put it, "The man whose thoughts and time and purse are too much absorbed in dressing is so despised that the character, once common throughout Europe, has now almost ceased to exist."[92]

Nevertheless, a man's success could still be gauged in part by the appearance of his lady, putting a certain amount of pressure on her to choose well. As Lily Bart, the tragic heroine of Edith Wharton's *House of Mirth*, complained, "If I were shabby no one would have me: a woman is asked out as much for her clothes as for herself. The clothes are the background, the frame, if you like: they don't make success but they are a part of it. Who wants a dingy woman? We are expected to be pretty and well-dressed till we drop."[93] A real New Yorker, a woman who felt she did little but shop, confided in her diary, "I am *so sick* of the

stores and the clothes . . . would rather the clothes grew on like feathers!"[94] A cartoon of 1927 on the subject of shopping for hats points out that women's endless quest for new clothes was further complicated by the ultimate requirement of a man's approval (fig. 268).

Benson's understated reference to a man in his picture of a woman recalls earlier works by Whistler. In the 1880s Whistler made several watercolors that use artworks, fabric, and clothing as props to indicate a connection between the visible female and the absent male. One of these, *Pink Note: The Novelette* (fig. 269), depicts Maud Franklin wearing a pink jacket. Color links the reading woman with the missing artist. A little picture by Whistler rests on the mantelpiece, enlivened by a touch of pink.[95] Entwined among the bedsheets is a length of pink fabric, probably the fashionable evening cape called a domino, also seen in Whistler's contemporaneous portrait of the art critic Théodore Duret (fig. 270), who holds such a cape over his arm with the proprietary air of a man waiting for his mistress.

Maud sits on the edge of the rumpled bed, engrossed in a novel. Common plots in novels of the period explored relationships between young painters and their mistresses. Late nineteenth-century French litterateurs, such as Alexandre Dumas fils, Honoré de Balzac, and Emile Zola, filled their pages with descriptions of demimondaines set apart from ordinary women by luxurious bibelots—fine furniture, figurines, jewelry, clothes, and so on. In

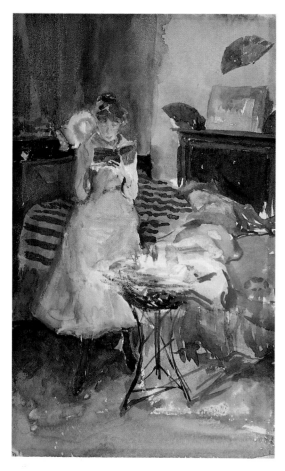

Fig. 269 James McNeill Whistler. *Pink Note: The Novelette*, early 1880s. Watercolor on paper, 10 x 6⅛ in. (25.3 x 15.5 cm). Freer Gallery of Art, Smithsonian Institution, Washington, D.C.

these novels kept women are treated as the most expensive trinkets of all. Dumas's Marguerite, the lady of the camellias, saw men as "egotistical lovers who spend their fortunes not for us, as they claim, but for their vanity. . . . We do not belong to ourselves, we are no longer beings, but things."⁹⁶ The poet Baudelaire created shimmering images of women as objets d'art. In analyzing the transformation of woman into object in French society, Rémy G. Saisselin articulates the notion of the consumer and the consumed:

> She turned into a bibelot herself, surrounded by bibelots, an expensive object of desire, to be possessed and cherished, but also exhibited. "Woman" encompassed everything from an object of beauty and art for the aesthete, of pride of possession for the successful speculator, financier, and banker, to an intimation of transcendent spirituality for poets still enamored of the ideal. But in the capitalist sublunar world, woman was also a consumer and as such she represented an extraordinary market for the creators of department stores, the grand couturier, . . . the antique dealer and sellers of bric-a-brac.⁹⁷

Women were often portrayed as "bibelot[s] . . . surrounded by bibelots." Following Whistler's lead, Maurer chose the title *An Arrangement* (fig. 271) for his view of an objectified woman who

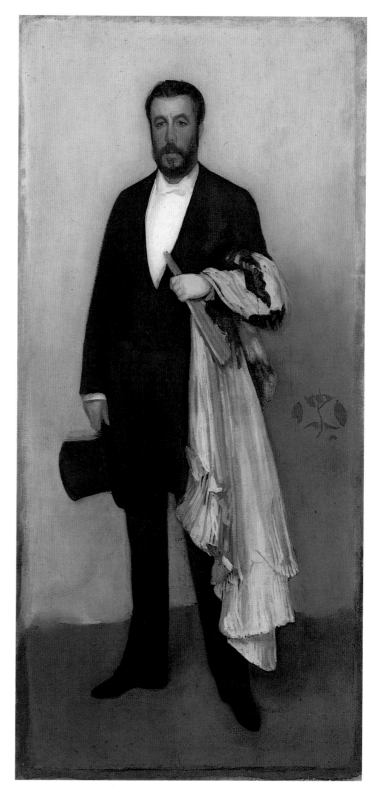

Fig. 270 James McNeill Whistler. *Arrangement in Flesh Colour and Black: Portrait of Théodore Duret*, 1883. Oil on canvas, 76⅛ x 35¾ in. (193.4 x 90.8 cm). The Metropolitan Museum of Art, New York, Catharine Lorillard Wolfe Collection, Wolfe Fund, 1913 13.20

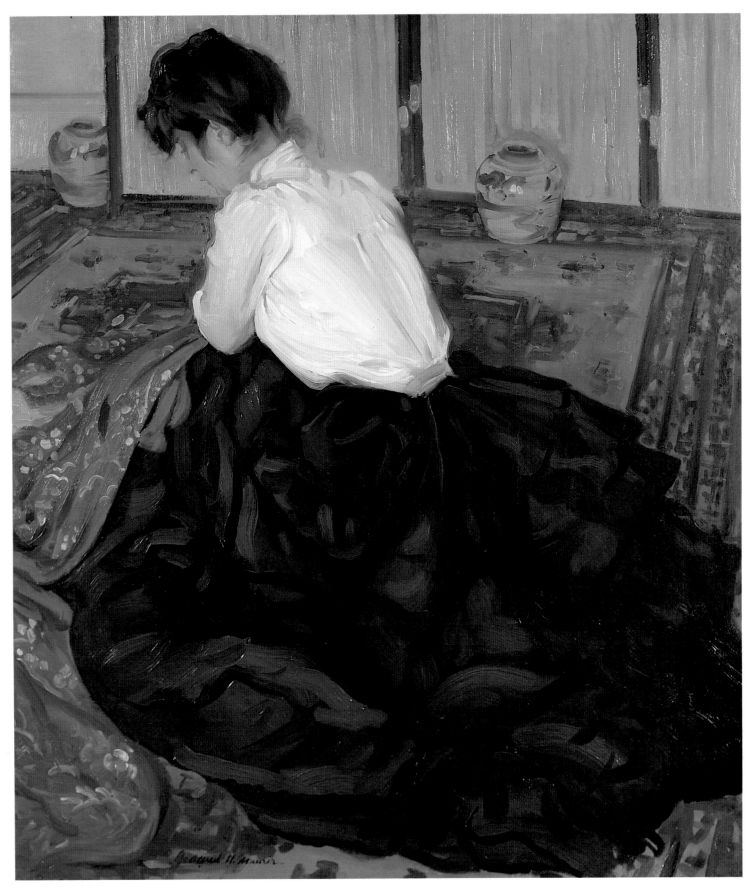

Fig. 271 Alfred Maurer. *An Arrangement*, 1901. Oil on cardboard, 36 x 31⅞ in.
(91.4 x 81 cm). Whitney Museum of American Art, New York, Gift of Mr. and
Mrs. Hudson D. Walker 50.13

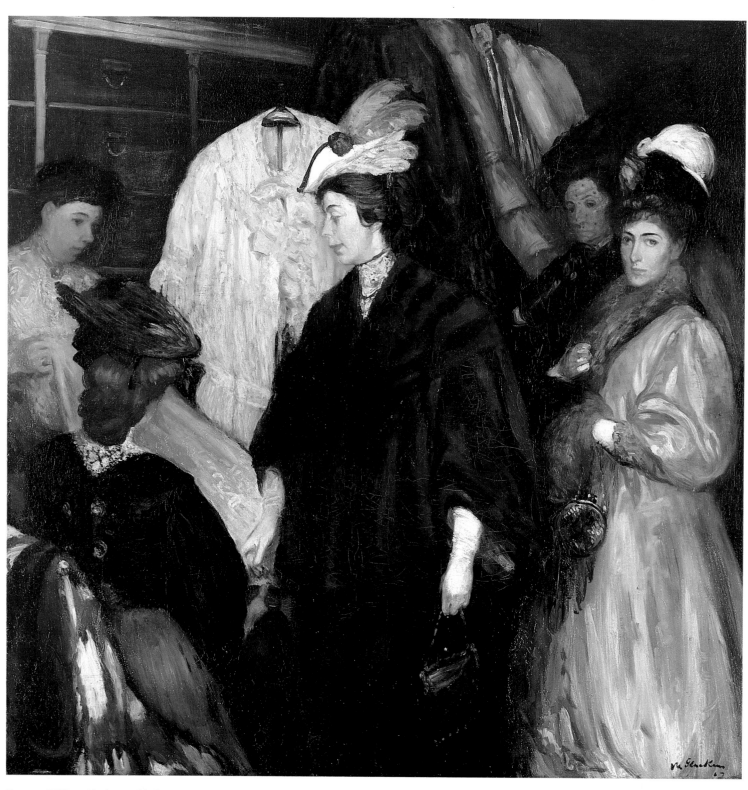

Fig. 272 William Glackens. *The Shoppers*, 1907. Oil on canvas, 60 x 60 in.
(152.4 x 152.4 cm). The Chrysler Museum, Norfolk, Virginia, Gift of Walter P.
Chrysler, Jr. 71.651

turns away from us, becoming an element in the artist's pattern of textures and surfaces. The anonymous woman is one of the *things* arranged by the painter.

One might also note, as Saisselin has done, that the objectified woman appears in American as well as French novels. James shows Gilbert Osmond in *Portrait of a Lady*—"fond of originals, of rarities; of the superior and the exquisite"—coolly contemplating the acquisition of the independent American girl Isabel Archer. Osmond "perceived a new attraction in the idea of taking to himself a young lady who had qualified herself to figure in his collection of choice objects" by declining a nobleman's offer of marriage.[98]

James endowed another character, Christopher Newman in *The American*, with commercial tastes. Newman sought "the best article on the market" as a wife, envisioning "a beautiful woman perched on the pile" of his financial success, "like a statue on a monument."[99] Benson's statuesque model with her resplendent hat might make such a wife, and the leap from licentious Paris to staid Boston is not so large.

Glackens's ambitious painting *The Shoppers* (fig. 272) introduces several types of women contemplating, we may presume, the best article on the market, in this case a piece of lingerie. The models include Edith Glackens, wife of the artist, shown clothed in fur at the center of the composition, along with two of her friends.[100] Lillian Gelston Travis, a schoolmate of Edith's from the Art Students League, sits at the counter while an anonymous shopgirl displays the garment.[101] At the far right Florence Shinn, wife of the painter, looks out toward the viewer. Both artists' wives hold purses. An unidentified fifth figure stands between them but remains partially obscured in the background shadows. The scene takes place in a department store, probably Wanamaker's huge emporium that recently had opened quite near Glackens's studio.[102] If the Mmes Glackens and Shinn—married to artistic revolutionaries—seem unlikely candidates for such avid consumerism, a review of their origins reveals that both were artistically inclined daughters of affluent, indulgent families. Each could afford the household help that released her from domestic chores; each had the money to enjoy New York's well-stocked department stores.[103]

Sloan etched his sardonic *Show Case* (fig. 273) in 1905, just two years before Glackens painted *The Shoppers*. His potshot at privilege records not only the wealthy pigeon-breasted dame of fashion on the arm of her top-hatted companion but also the intimate underpinnings necessary for her ample figure. A target of derision, she serves to show us that a gradual breakdown of privacy, decorum, and unquestioning respect increasingly threatened the established order in the early twentieth century.

Of course, the complex works of art discussed here were created in accord with focused aesthetic programs and cannot be interpreted merely as illustrations of current events. Nor are they

Fig. 273 John Sloan. *The Show Case*, 1905. Etching, 5 x 7 in. (12.7 x 17.8 cm). Delaware Art Museum, Wilmington, Gift of Helen Farr Sloan 63.20.65

visual ratifications of social analyses advanced by writers such as Thorstein Veblen, whose *Theory of the Leisure Class* appeared in 1899. Nonetheless, a common thread links various literary, social, and artistic expressions of the period. All are concerned with ownership—consumerism, possession, and display, the means by which the West was gradually transformed during the nineteenth century from a restrained, conservative culture observant of limits to an improvident society reliant on abundance, consumption, and gratification. Large department stores like the one painted by Glackens provided a commercial stage for this metamorphosis.[104]

The *Dry Goods Reporter* announced in 1904, "Progress has played havoc with many an old hidebound proverb, among them, 'Never buy anything you can do without.'"[105] Although material abundance was available to more people than ever before, mass-produced goods, manipulatively merchandised through fads and fashions, quickly became an important means of enforcing class distinctions between the carriage and the shawl trades. The type and price of merchandise as well as the style of marketing goods for sale determined who shopped where; purchases became not only status symbols but also signs of group cohesiveness, further differentiating the social classes.[106] The wealthiest New Yorkers disdained the noise and crowding of the Lower East Side, where shoppers were jammed together in the odoriferous babble George Luks captured in *Hester Street* (fig. 173).

Class distinctions quickly developed among department stores, as they did among urban restaurants and theater entertainments; a Chicago ditty of the 1890s avers that "all the girls who wear high heels / They trade down at Marshall Field's / All the girls who scrub the floor / They trade at the Boston Store."[107] The store Glackens has chosen to paint is genteel. His rich dark tones convey the air of hushed dignity characteristic of an upper-floor

Fig. 274 John Sloan. *Fifth Avenue, New York*,
1909/11. Oil on canvas, 32 x 26 in. (81.3 x 66 cm).
Private collection

Fig. 275 Florine Stettheimer. *Spring Sale at Bendel's*,
1921. Oil on canvas, 50 x 40 in. (127 x 101.6 cm).
Philadelphia Museum of Art, Given by Miss Ettie
Stettheimer 51.27.1

department in a respected emporium, where "it would be as easy
to imagine a Bowery waiter bawling an order through Delmonico's
as to picture the indifferent, impertinent saleswoman of certain
stores rapping upon the counters of certain others and calling, in
the high pitched, rasping voice affected for these occasions,
'Cash, cash!'"[108] But even the grandest department stores, wed-
ded to the creation of fantasy environments that tempted cus-
tomers to part with their money, witnessed mad scrambles for
merchandise during regularly scheduled sales periods that left
the staff, not to mention many consumers, exhausted. Seeking a
humorous metaphor that would sufficiently convey the potential
terrors of female suffrage, one opponent chose shopping, pre-
dicting that when the vote was granted to women, "every politi-
cal caucus will become a retail drygoods store."[109]

In 1907, the year Glackens painted *The Shoppers*, the number
of customers who entered New York's big stores was estimated
at 150,000 a day, 250,000 during the holiday season.[110] The
avenues on which the best shops fronted were every bit as crowded
and chaotic as a narrow street on the wrong side of the tracks, as
Sloan's *Fifth Avenue, New York* (fig. 274) reveals. In 1909, when
Sloan began working on this image in the heart of New York's

shopping district, with the Flatiron Building in the distance, the
artist's diary indicates a budding interest in socialism, fostered in
part by the sense of economic inequality that can be detected in
his mildly satirical image.[111] Sloan, however, was by no means
immune to the allure of fine merchandise. As he wrote in his
diary on May 8, 1909, "Walked down Fifth Avenue, beautiful
afternoon, all the display [of expensive, elegant clothing] was
out. I came back sort of full charged with it and started to put
some paint on canvas on the theme."[112]

The hurly-burly aspect of frantic consumerism and of the
bargain clearance did not diminish, and artists remained attracted
to it as a subject well into the twentieth century. Florine Stett-
heimer's *Spring Sale at Bendel's* (fig. 275) is a fantasy of shopping
madness at one of New York's luxury stores. More somber images,
such as Kenneth Hayes Miller's *Looking and Pricing* (fig. 276),
recall that shopping involved hard work. Clever department-
store magnates sought to mitigate any sense of drudgery with
lounges, writing rooms, tearooms, and other frankly domestic
amenities. Indeed, department stores essentially appropriated
the atmosphere of the middle-class home, while providing the
merchandise with which to furnish it.[113]

Fig. 276 Kenneth Hayes Miller. *Looking and Pricing*,
1938. Oil on canvas, 28 x 23 in. (71.1 x 58.4 cm).
Hirshhorn Museum and Sculpture Garden, Smith-
sonian Institution, Washington, D.C., Gift of Joseph
H. Hirshhorn, 1972

Fig. 277 *A Musicale in Wanamaker's Philadelphia
Store*, from Hartley Davis, "The Department Store
at Close Range," *Everybody's Magazine* 17 (September
1907), p. 315

As Glackens's carefully staged tableau with its backdrop of an
elaborate display of wares reveals to us, shopping blurs the lines
between work and entertainment. Department stores were, in
fact, a significant form of theater, sometimes housing large audi-
toriums and offering regular performances by in-house orches-
tras, not to mention guest appearances by the likes of Richard
Strauss (see fig. 277).[114]

Two characters in Glackens's scene—a shopgirl who serves
the party from behind the counter and a veiled, shadowy figure
partially emerging from the background near a fully laden gar-
ment rack—amplify the topical significance of *The Shoppers* as a
work created during a time of profound economic change. The
artist may have included these darker figures with his three avid
consumers to comment on the waning of a centuries-old system
of close bargaining between individual buyer and seller. After the
mid-nineteenth century such familiar transactions were gradually
replaced by visits to vast impersonal department stores staffed
with thousands of shopgirls and huge cadres of support personnel
unseen by the consumer.[115] These enormous dry-goods bazaars
created a system "which produces . . . bargains; which fills the
plate glass windows with gorgeous colors and rich fabrics; which

enables a buyer to costume herself for a festivity or a funeral, to
furnish her home and to mail her letters, to 'call up' her family,
to be manicured and coifed and shod and hatted, to write her
notes, to rest after her labors, and perhaps even to be enter-
tained; to have her picture taken and her bicycle equipped with
every device known to the order of the wheel."[116]

Instead of selling merchandise at the highest price the public
was willing to spend, department stores ran on the principle of
rapid stock turnover, depending on discounts from manufactur-
ers, volume sales, and overall percentages rather than bottom-
line profits from specific departments. Novelists and journalists
alike marveled over the notion of a lucrative business that could
retail merchandise at or below cost and spilled much ink warn-
ing readers about attractive displays of current fashions intended
to tempt women to spend. True, the department store supplied
urban dwellers with their wants. "But the department store of
the city does more. It creates appetites and caprices in order that
it may wax great in satisfying them."[117] As Theodore Dreiser
put it in 1900 in *Sister Carrie*, "fine clothes were to her a vast
persuasion; they spoke tenderly and Jesuitically for themselves."[118]
So great was the upheaval caused by the shift in values to con-

"ONE FIRM IN A NEW AND HYGIENICALLY CONSTRUCTED STORE SERVES ITS SALESWOMEN NOURISHING LUNCHEONS AT COST PRICE."

Fig. 278 From Anne O'Hagan, "Behind the Scenes in the Big Stores," *Munsey's Magazine* 22 (January 1900), p. 529

sumerism that kleptomania—shoplifting by middle-class women as opposed to old-fashioned pilfering by the disadvantaged—developed in tandem with the department store itself.[119]

Glackens introduces his veiled woman of indeterminate age in a subdued outfit that is eclipsed by the splendid hats and cloaks of the Mmes Glackens and Shinn. Holding one gloved hand to her chin, she seems to contemplate a parallel eclipse of the old way of doing business. Her expression is as somber as her dress; the spirit of nostalgia and loss can be felt in this commercial scene, just as it can in the most serene landscapes of the American Impressionists. As department stores assumed the mantle of cultural authority, simultaneously forming and interpreting middle-class taste, they became, in a sense, educators of the modern woman. Perceiving this, a commentator of the time remarked, "The department-store, more than any other element in her life, shows her the fallacy of mother's way in present-day environments and under modern conditions."[120]

What of Glackens's shopgirl? Here the outlook, typically American, is far more positive than that of earlier French works, including Degas's *At the Milliner's* (fig. 267). Whereas Degas concentrates on the customer, abruptly cutting off the clerk's insignificant visage with the sharp edge of a cheval glass, Glackens gives us a full view of his fresh-faced, if somewhat coarse-featured, shopgirl. No doubt the American employee had the advantage over her European counterpart at least in part because she existed in a country where many considered that "the welfare of the help is the welfare of the business."[121] Glackens's shopgirl wears the standard shirtwaist with a modest brooch at her neck. She has expectations.[122] "What a pity such a girl has to work

THE HALL MARK OF ELEGANCE IS GIVEN TO SOME ESTABLISHMENTS BY THEIR SALESPEOPLE

Fig. 279 From Anne O'Hagan, "Behind the Scenes in the Big Stores," *Munsey's Magazine* 22 (January 1900), p. 536

in a shop! She seems really quite like a lady" was a common sentiment.[123] One turn-of-the-century journalist emphasized the link between previously established roles for women in the domestic sphere and the rigors of successfully dealing with a demanding public: "to work in a store takes much patience, forbearance and an obliging disposition, three things certainly essential to an admirable womanly character."[124] Although sales work was arduous, and the wages were often lower than what could be earned in service to a family, employment in a respectable department store had some advantages, among them greater personal independence than was possible in private service, exposure to a wider range of people and ideas, and even—in the best cases—improved living standards (see fig. 278).[125]

The sometimes rather fuzzy demarcation between shopgirl and shopper underlies many illustrations of the period (see fig. 279). Just as there were hierarchies among department stores, there were status levels within the staff of an individual firm. The salesgirl's prestige was inextricably linked to the type of goods she sold, offering a sobering parallel to the function of material goods as hallmarks of status within the home. Susan Porter Benson has recently observed that managers assigned the selling of particular kinds of merchandise to particular kinds of women whom they considered appropriate; stylish salesgirls, for example, sold better apparel, while older and native-born women were placed in departments with higher-priced wares. Younger and immigrant women sold cheaper goods.[126]

Because salesgirls' wages were low, much discussion centered on whether or not they could live decently without succumbing to "cheap amusements, public dance-halls, excursion-boats, moving-picture shows," and other entertainments "conducted apparently in the interest of the powers that prey upon young girls."[127] Like the factory girls of the post–Civil War decades, the young women working in department stores were easy targets for accusations of questionable sexual morality. But available statistics do not support these allegations; neither, really, do paintings made by American Realists.[128]

However easy it might be to presume the worst of the young working-class women cooking their supper in Sloan's *Three A.M.* (fig. 263), we do not actually know their situation. Sloan wrote of what he saw here in essentially positive terms: "These two girls I took to be sisters, one of whom was engaged in some occupation that brought her home about this hour of the morning. On her arrival the other rose from her slumbers and prepared a meal. This picture is redolent with the atmosphere of a poor, back gaslit room. It has a beauty, I'll not deny it; it must be that human life is beautiful."[129] The makeup of the girls' household was not clear to the artist, who thought it might include two men. Sloan's rather juvenile reference in his diary to the National Academy's rejection of this picture in 1910—"I sent [it to] them as much as a joke like slipping a pair of men's drawers into an

old maid's laundry"—suggests a somewhat casual commitment to Realism.[130]

If, in *Three A.M.* and other works, Sloan is painting the sort of working-class girls who staffed the department stores, he seems to prefer depicting them at home, echoing the subject choices of his Impressionist predecessors. Sloan takes up the issue of personal cleanliness in the context of the home in *Sunday, Women Drying Their Hair* (fig. 280), a scene viewed from his eleventh-floor studio on West Fourth Street as he looked down on the roof of an eight-story building on Cornelia Street.[131] Bathing and laundry were so difficult to accomplish for many tenement dwellers that relatively little got done; simply heating water was a challenge, if the tenant was lucky enough to have running water (see fig. 281). The drying clothes behind the three girls in the painting remind us of the arduous laundry process.

Lack of cleanliness could easily become an obstacle when the people Sloan shows us looked for employment in homes, offices, and stores. "So long as the upper classes felt the necessity of using smelling salts whenever approached by one of the common people, just so long would they despise the vile-smelling yokels," explained John Leeds. "Cleanliness is not only next to Godliness, but it is essential to the establishment of the Brotherhood of Man."[132]

While we cannot be certain of the circumstances of the three working-class Graces on their roof, we can assume that their labor supported themselves or others, although Sloan recorded them in a moment of relaxation, however rare. "To-day five millions of women are engaged in the United States in four hundred different wage-earning occupations," proclaimed Hersey in 1904.[133] Poet Julia Ward Howe, a leading proponent of suffrage, reflected the feminine ambitions of the era when she wrote at the beginning of a volume containing a census of women's occupations, "*The theory that woman ought not to work is a corruption of the old aristocratic system. . . . A respect for labor is the foundation of a true democracy.*"[134] Nevertheless, even as late as 1910, most working women were employed as farm laborers, domestic servants, store clerks, or in manufacturing jobs; a meager 8 percent pursued such professions as teaching or nursing.[135] Wrote M. E. J. Kelley in 1898, "No factory girl or saleswoman intends to remain at her occupation more than a few years . . . If she doesn't desire to do something which she considers more respectable, then she expects to be married," a sentiment also expressed in a contemporary illustration (fig. 282).[136]

There was a clear division between work for men and work for women: women were given tasks that paid less, and their jobs were derived from traditional female endeavors. In manufacturing women pursued tasks once accomplished by piecework within the home—clothes making and millinery or commercial food production, for example—and they were rarely awarded positions of authority.[137] Katharine Pearson Woods, writing in

Fig. 280 John Sloan. *Sunday, Women Drying Their Hair*, 1912. Oil on canvas,
26 x 32 in. (66 x 81.3 cm). Addison Gallery of American Art, Phillips Academy,
Andover, Massachusetts

Fig. 281 Jacob A. Riis. *The only Bath-tub in the Block: it hangs in the Air Shaft*, from Jacob A. Riis, *The Battle with the Slum* (1902). Museum of the City of New York, The Jacob A. Riis Collection ST–5

"In the heels of their boots hoping to be married some day or other."

Fig. 282 W. H. Hyde. Illustration from Robert Grant, "The Art of Living: The Case of Woman," *Scribner's Magazine* 18 (October 1895), p. 473

1890, mocked John Ruskin's instruction to women—"queens you must always be"—and juxtaposed it to the mission of the Working Women's Society—"relief and rescue of those women now oppressed and wronged." She concluded: "The woman of exceptional ability, who knows her niche in life and climbs upward to it with unflinching courage and unswerving will, usually attains it, though often at the price of treading under her more feeble sisters. The editor of a popular paper or magazine does not often quarrel with her salary; the fashionable milliner or dressmaker can command her own price; the lady professor has her own work and her own reward. . . . But queens? Which is correct, Ruskin or the Working Women's Society?"[138] Historical distance lets us see that neither Ruskin nor the society was entirely right. By painting women as both consumer and consumed, American Impressionists and Realists tacitly recognized women's difficult, changing status.

Artful Commodities

I have no mission to preach a crusade against luxury and bad taste.

CLARENCE COOK (1878)

Shopping and collecting bridge the workaday world and the home, two realms still seen as separate at the outset of the period under study here. As the nineteenth century drew to a close, the economic and social changes that reshaped family values and relationships reordered patterns of consumption not only of mundane commodities but also of works of art, which were collected to embellish domestic surroundings. And as consumerism, possession, and display loomed large, art was commodified, altering the environment in which the painters of modern life created their images.[139]

Certainly, fashion spurs interest in art as much as intellectual curiosity does, a harsh fact of life that successive generations of artists have had to face as they brought their works forth in an atmosphere of commercialized leisure. That this situation is an easy target for satire is witnessed by Stuart Davis's irreverent cartoon of ignorant society ladies (fig. 283) published for the readers of the *Masses* during the Metropolitan Museum's 1913 exhibition of J. P. Morgan's vast art collection. Artful commodities required artful commodification. As status-conferring paintings reached an ever wider buying public in both Europe and the United States, artists themselves participated to a degree in merchandising and displaying their pictures. When he was a struggling artist, Whistler was quicker than most to grasp the advantages of self-promotion, a practice that the American Impressionists and Realists would follow. The legitimate and quite logical desire for

Fig. 283 Stuart Davis. Cartoon from *Masses* 4
(March 1913), p. 15. Collection of Earl Davis

Fig. 284 John Sloan. *Picture Shop Window*, 1907–8.
Oil on canvas, 32 x 25⅛ in. (81.3 x 63.8 cm).
Newark Museum, Gift of Mrs. Felix Fuld, 1925 25.1163

new patronage—a market share—was fundamental to the for-
mation of artists' groups that were later considered movements,
such as the independent French painters dubbed Impressionists
or the Americans known as The Ten or The Eight.

Sloan's *Picture Shop Window* (fig. 284) frankly addresses
art as commodity and does so in a positive spirit. In *Gist of Art*
Sloan commented upon this painting, "West Twenty-third Street
supplied me with many subjects. . . . I suppose that this unusual
interest in pictorial art on the part of the group here shown gave
the painter hope for the future of art in America."[140] The young
girls on West Twenty-third Street were not the only ones with
their noses pressed to the glittering windows of the art world. In
The Chapman Gallery (fig. 285), there are two similarly disposed
men, thought to be a self-portrait of Luks with an art critic.
Brightly lit paintings and prints form an enticing grid of black,
white, and gold before which the figures of artist and critic stand
like communicants at an altar rail. Here Luks seems to acknowl-
edge that in this era of commodification an artist's following
increasingly was based on the abilities of dealers to market
pictures and of critics to interpret them for the public.

The nineteenth century witnessed the advent of a number of
expositions and institutions concerned with the display and

ownership of art. Not only the great world's fairs but also the
department stores and museums that developed concomitantly
with them offered public venues for the presentation and mar-
keting of painting and sculpture.[141] These venues were supple-
mented by growing numbers of art galleries and salesrooms,
such as the American Art Association in New York, and com-
mercial art dealers.[142]

Distinctions between fine art and frankly commercial prod-
ucts had become blurred in the elaborate productions mounted at
London's Crystal Palace in 1851 and countless subsequent fairs
where a country's painting and sculpture could become an im-
portant tool in the establishment of international status. Build-
ings filled with fine art competed for ground space with halls
dedicated to new machinery or feats of agriculture or the fruits
of unfamiliar cultures around the globe. On both sides of the
Atlantic the great department stores were quick to exploit the
lessons of the fairs by featuring fine art with other forms of
merchandise—and virtually eradicating the lines that divided
them. Adjoining "the most luxurious and beautiful department
devoted to the comforts of ladies to be found in a mercantile
establishment," Macy's set up an art gallery with an extensive
display of oil paintings.[143] Wanamaker's provided art education

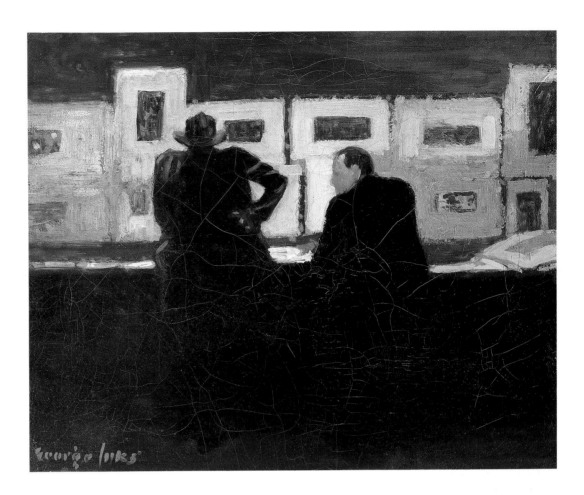

Fig. 285 George Luks. *The Chapman Gallery*. Oil on canvas, 16⅛ x 20⅛ in. (41 x 51.1 cm). Collection of Nancy Lake-Benson

to shoppers in both Philadelphia and New York by exhibiting French pictures. Indeed, this company maintained grandiosely: "There is probably no other store in the world that has gone into the Paris salons and purchased the pictures best worth having to decorate its walls. It is largely these paintings and this kind of artistic exhibition, open to all for the coming, that have helped to convert the Wanamaker stores into vast public museums, quickening the interest of thousands of visitors, and reaching a larger number than many museums owned and controlled by the city and the state."[144]

Again following the lead of the great fairs, department stores created fanciful, often exotic environments as a means of romanticizing the act of purchasing, making it more a tempting entertainment than a chore. A commercial cathedral like Alexander Turney Stewart's eight-story skyscraper with a cast-iron facade and windows of French plate glass offered New Yorkers "the treasures of the world . . . the commerce of Europe, Asia, America and far-off Africa."[145]

Zola's *Au Bonheur des Dames* of 1882, which was available in English translation almost immediately after its French publication, chronicles the rise of a fictive department store based on Au Bon Marché, the opulent emporium in Second Empire Paris that inspired numerous American enterprises, such as Wanamaker's and Macy's.[146] Among Zola's many detailed passages on mer-

chandising, the most breathless characterizes a "great exhibition of household linen" as "an orgy of white."[147] January white sales soon became a feature in American department stores, and one journalist told her readers in 1900 that "it would be a bold concern which would dare to ignore it."[148] During this turbulent period advertising as practiced by businesses in general and the department stores in particular was as fresh a form of showmanship as vaudeville and the five-cent movie.[149] But this particular form of showmanship moved merchandise, whether housewares or paintings.

Heretofore unprecedented commercialization now brought art and antiques to new middle-class audiences. Much of the art produced during the era, when the Aesthetic Movement held sway, was relatively small in scale and destined for the home. Widespread interest in house decoration stimulated a boom in collecting both decorative and fine arts, fueled by material riches available through industrial progress and made urgent by a growing perception that tokens of America's historical past were both finite and fragile. The ownership of goods, including art, became a reliable means of creating what Clarence Cook termed "The House Beautiful," simultaneously expressing financial success and maintaining all-important, reassuring links to the past.

Shortly before collecting mania swept the United States, Degas set *The Collector of Prints* (fig. 286) in a confrontational pose,

Fig. 286 Edgar Degas. *The Collector of Prints*, 1866. Oil on canvas, 20⅞ x 15¾ in. (53 x 40 cm). The Metropolitan Museum of Art, New York, H. O. Havemeyer Collection, Bequest of Mrs. H. O. Havemeyer, 1929 29.100.44

Fig. 287 From *Philadelphia Inquirer* 112 (June 9, 1885), p. 8

Fig. 288 Walter Crane. Frontispiece, Clarence Cook, *The House Beautiful: Essays on Beds and Tables, Stools and Candlesticks* (New York, 1878)

hunched over a portfolio of prints. With his legs wrapped protectively around his trove, he stares out at the viewer who interrupts his search. Robert L. Herbert identifies this urban character as "the acquisitor-collector who hunts for the rare, overlooked print, who monopolizes the shop's folio, and who looks with unfriendly eye on us, setting up a psychological tension that lets us know we face a competitor."[150] Degas's carefully constructed grid crowds the collector into a tight space, littered with an array of prints, albums, calling cards, photographs, and swatches of fabric that could be used to cover small notebooks. An antique Asian ceramic horse is safely enclosed in a cabinet behind him. This desirable object is not for just anyone—it is a treasure. The possessiveness evinced by Degas's print collector was characteristic of turn-of-the-century Americans in the grip of collecting fever. In a newspaper advertisement of 1885 (fig. 287), an acquisitive American "Monomaniac" rubs his hands before a curio cabinet filled with treasures like the statuette in Degas's painting.

Expressive of Americans' newfound obsession with material possessions was Cook's decorating book *The House Beautiful: Essays on Beds and Tables, Stools and Candlesticks*; its aestheticized frontispiece by Walter Crane (fig. 288) shares with Cassatt's

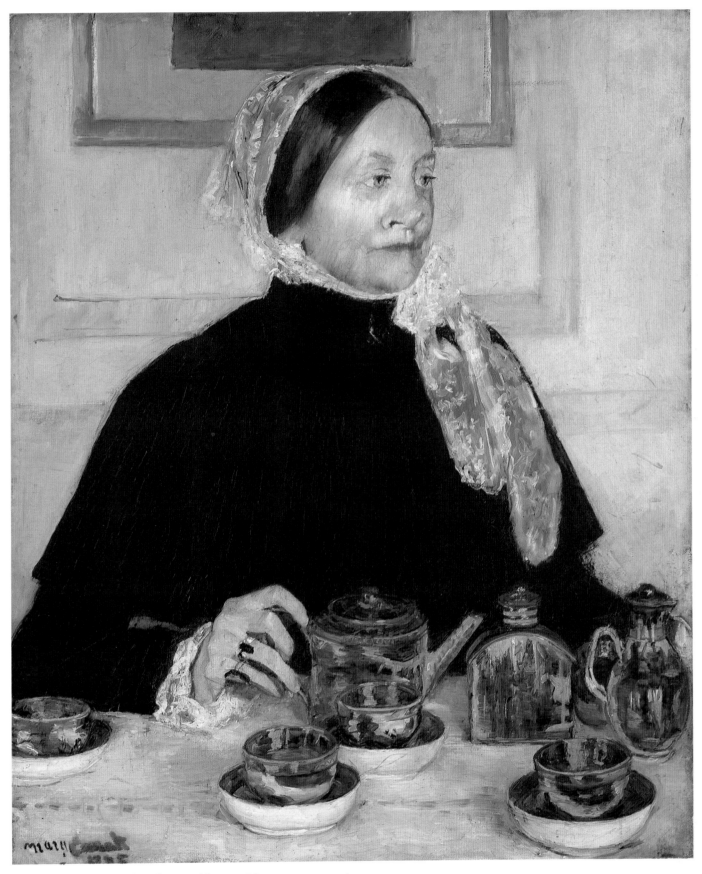

Fig. 289 Mary Cassatt. *Lady at the Tea Table*, 1885. Oil on canvas, 29 x 24 in.
(73.7 x 61 cm). The Metropolitan Museum of Art, New York, Gift of Mary
Cassatt, 1923 23.101

Fig. 290 Edward Lamson Henry. *Old Clock on the Stairs*, 1868. Oil on canvas, 20¾ x 16½ in. (52.7 x 41.9 cm). Shelburne Museum, Shelburne, Vermont 27.1.6-7

painting *Lady at the Tea Table* (fig. 289) a fascination with *things*, translated into enticing emblems that helped establish taste and social position. Cassatt shows her cousin Mrs. Robert Moore Riddle awkwardly pinned between a gilt-framed picture and a set of gold-embellished china on a crowded tabletop. Her ring-laden hand rests firmly on a blue-and-white teapot, part of a Chinese export porcelain service that Mrs. Riddle had given Cassatt in Paris.[151] The voluptuously painted pots, cups, and saucers as well as the sitter's lacy headgear are far more appealing than the austere lady herself, who eventually declined this portrait.

An advocate for comfort and individuality in decoration, Cook counseled mingling old with new objects and mining the styles of many times and places. "My purpose is not to recommend eccentricity, nor even a modified Bohemianism," he reassured his readers. "I have no mission to preach a crusade against luxury and bad taste; nor have I a hope that anything I can say will bring back simplicity and good taste."[152] American collectors on all levels, whether of modest means or affluent, looked to Europe for inspiration. The grandest, such as Isabella Stewart

Gardner, could aspire to own antiquities and works by the old masters as well as contemporary art.[153] Her interior garden at Fenway Court in Boston was liberally and literally sprinkled with bits and pieces of old Europe, including the original window surrounds from the Ca' d'Oro in Venice. Americans also began gathering up objects from their own past, especially after the Philadelphia Centennial Exhibition of 1876 featured the Colonial Kitchen and similar displays as soothing reminders of a simpler era and as comforting antidotes to such impressive yet bewildering technological advances as the Corliss engine and the telephone.[154]

Edward Lamson Henry, an avid collector and a respected preservationist as well as an artist,[155] lovingly embellished his interior scenes with Americana—in his *Old Clock on the Stairs* (fig. 290) a tall clock occupies a prominent position on the landing, a spot that no eighteenth-century householder would have chosen. Like the grandmotherly figure in the distant parlor or the use of the adjective *old* in the picture's title, the implied soft ticking of this "grandfather" clock gently evokes the passage of time for the viewer. For those who could not afford antiques like Henry's clock, reproductions became widely available.

Like bric-a-brac, both old and new, paintings were products that conferred status on their owners. To help sell them, artists and dealers on both sides of the Atlantic housed modern pictures in eighteenth-century-style frames, aggrandizing them while linking them to the past for prospective owners. Cassatt's mother reported that the artist herself was willing to attempt such packaging for her *Lady at the Tea Table*: "The picture is nearly done but Mary is waiting for a very handsome Louis Seize [frame] to be cut down to suit before showing it to [the Riddles] . . . they are not very artistic in their likes and dislikes of pictures."[156]

Taking his cue from Honoré Daumier, Sloan sardonically records this kind of commercial framing in *The Picture Buyer* (fig. 291).[157] Cloaked in self-importance, the seated patron is set off from the standing crowd at the Macbeth Galleries. As shop personnel eagerly hover around him, other gallery visitors look on with varying expressions to see what the haughty customer might select. A painting is balanced on an easel behind a palatial frame. Beside the easel the dealer's assistant holds the next available canvas, as yet unframed, with its back toward the buyer. We have the impression that the helper is about to slide the new candidate behind the opulent frame for viewing if the picture now on the easel is rejected. Hat in hand, a rather anxious young man in the background might represent an artist eager for new patronage.

Of course, advanced, hence unfamiliar, modern styles have always been difficult to sell to conservative collectors. As Sloan's *Picture Buyer* affirms, the frame could be as important as its pictorial contents when the audience was unsophisticated. Although the appreciation of fine art that burgeoned at midcentury was still

Fig. 291 John Sloan. *The Picture Buyer*, 1911. Etching, 5¼ x 7 in. (13.3 x 17.8 cm). Bowdoin College Museum of Art, Brunswick, Maine, Bequest of George Otis Hamlin 1961.69.71

growing after the turn of the century, narrative pictures, especially sentimentalized genre scenes, held sway in the marketplace, not only in original paintings but also in cheaper reproductions.

A flood of influential decorating books appeared in Britain and the United States as early as the 1860s. Slightly desperate titles, such as Loftie's *Plea for Art in the House, with Special Reference to the Economy of Collecting Works of Art, and the Importance of Taste in Education and Morals*, testify that con-

sumerism was anxious work. The pages of these governessy little books also reveal ever present links between commercialism and artistic decoration, for the authors endorse particular brands of merchandise—their publications were promotional. Then, as now, decorating advice and the purveying of certain products went hand in hand.

A standard practice recommended by the authors of such manuals for decorating houses was to trot out the tried and true styles of the past, affirming the constancy of art principles that, once studied and comprehended, could be applied to the present day.[158] This sounds suspiciously like a generic outline of how academies of the eighteenth and nineteenth centuries trained aspiring artists. The parallel once again underscores attitudinal links among painting, shopping, and decorating. Not just luxurious objects captured in portraits or still lifes but also entire historical schemes for the decoration of houses could serve as touchstones for the past and testaments to present prosperity. Would-be buyers were enabled "to learn just what a Louis Quinze room really is" by reading handbooks or visiting elaborate department-store displays.[159]

Unfortunately for the painters of modern life, the self-help decorating books and the women's journals that eventually replaced them offer lengthy discussions on suitable framing or on the overall visual coherence of a parlor or a dining room but are almost silent on how to purchase a good picture. For the authors of self-help books, many of whom were as middle class as their readers, art meant, by and large, the decorative arts. A few

Fig. 292 Charles Hunt. *My Macbeth*, 1868. Oil on canvas, 20 x 26 in. (50.8 x 66 cm). The Forbes Magazine Collection, New York

Fig. 293 Everett Shinn. Cover, *Exhibition of Pastels: Paris Types by Everett Shinn at Boussod Valadon and Co.'s Galleries*, 1901. Everett Shinn Papers, Delaware Art Museum, Wilmington

forces the commodified nature of the pastels Shinn hoped to sell at his solo exhibition.

The evidence of pictures and texts tells us that by the turn of the twentieth century opportunities to drop in on a luxurious display at a museum or art gallery or to complete mundane shopping errands amid the theatrical fantasies of a large department store were firmly established among the myriad entertainment options available to modern city dwellers. Less evident at the time was a firm understanding that the environments in which such diverting activities took place were purposefully created with home merchandising in mind: something to do and something to buy went hand in glove.

Woman's Work

Women . . . the census classes as dependent females because they get no pay envelope of a Saturday night after seven days of broiling steak, nicking dishes, running sewing machines, and nursing mumpy children.

MARY ALDEN HOPKINS (1912)

The head cashier of Macy's, who now gets $6,000 a year, began as a cash girl in that establishment at $3 a week.

HARTLEY DAVIS (1907)

Sloan's *Woman's Work* (fig. 294) represents a whole category of domestic endeavor that was a major portion of the woman's role within her sphere—cleaning, cooking, doing laundry, in general providing for the physical needs of her family. Some turn-of-the-century writers ennobled these activities.[162] Speaking in 1901 of "the New England Woman," who personified virtues ascribed to New England villages, Kate Stephens described feminine "self-limitation [as] almost Greek" and catalogued the deeper values protected by her efforts, "what Plato calls woman's work": "a pure and sober family life, a husband's protective spirit, the birth and growth of children, neighborly service . . . for all those lives should come within touch of her active hands."[163]

In *A Woman's Work* Sloan explores domestic tasks in the urban milieu. He depicts wash day, an ordinary event in the life of a New York tenement dweller, as seen from the window in his apartment at 155 East Twenty-second Street. "Painted a woman hanging out wash on fire escape. A thing I saw back of us," he wrote in his diary.[164] Sloan's vantage point through the window may have suggested the picture's vertical format. His subject has stepped outside of her apartment to perch on a narrow metal fire escape. The surrounding tenements confine our view, as they must have done for the painter; only a thin band of sky and someone else's laundry hint at open spaces beyond this man-

collectors and writers, however, did acknowledge the existence of mimetic painting.[160] Loftie conceded: "The highly finished pictures of the great Dutch school . . . contain good, downright, hard work; they are not scamped; there is no 'execution' for execution's sake in them . . . and, for the most part, their subjects, though homely, are of a kind which will always command popularity even with those who know little or nothing about art."[161]

In recalling the ongoing, uphill battle against received taste we can understand how discouraging it must have been for any artist accused of "scamping" to confront the ready market for tightly finished narrative pictures like *My Macbeth* by Charles Hunt (fig. 292). The proud owner who points to his latest acquisition, placed in front of his admiring family and in the midst of a room filled with possessions, underscores not only the concept of art as merchandise but also the predictable limits of popular culture.

Like Sloan, Shinn acknowledges the connection between art and merchandise: on the cover of the catalogue for his own exhibition of pastels at Boussod, Valadon and Company, a Parisian dealership with a New York branch, he shows a fashionable if cartoonish woman shopping for hats (fig. 293). She is a type, the artist tells us. So is the milliner's boutique and so is the shop next door, occupied by a purveyor of antiques and used frames. He is open for business, as indicated with an empty slat-backed chair set near the entrance. By juxtaposing hats, antiques, frames, and the pictures listed in the catalogue, this little sketch rein-

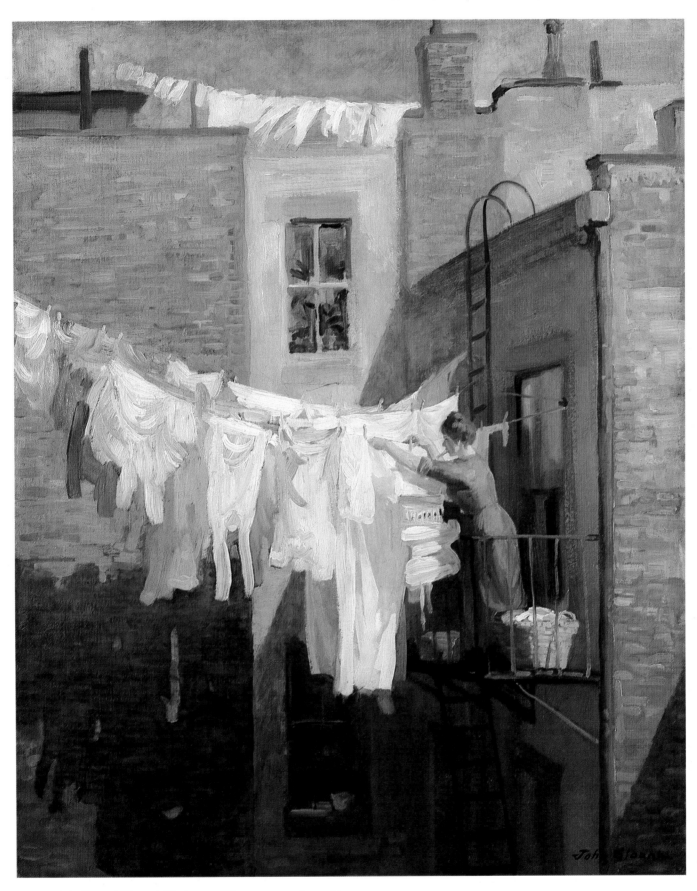

Fig. 294 John Sloan. *A Woman's Work*, 1912. Oil on canvas, 31⅝ x 25¾ in. (80.3 x 65.4 cm). The Cleveland Museum of Art, Gift of Amelia Elizabeth White 64.160

Fig. 295 *The 'Torture Corset', From Photo Posed by Miss Calder* from Harriet Hubbard Ayer, *Harriet Hubbard Ayer's Book: A Complete and Authentic Treatise on the Laws of Health and Beauty* (Springfield, Mass. 1902), p. 273

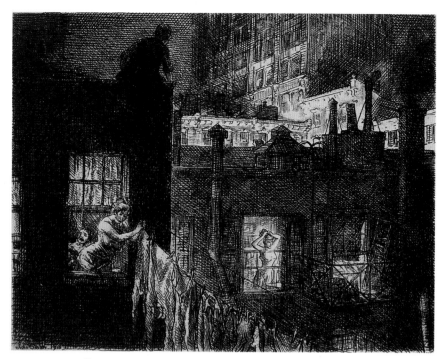

Fig. 296 John Sloan. *Night Windows*, 1910. Etching, 5¼ x 7 in. (13.3 x 17.8 cm). The Metropolitan Museum of Art, New York, Harris Brisbane Dick Fund, 1924 24.30.35

made canyon of brick and mortar. The family wash—shirts, nightgowns, and sheets—flutters in the sunshine for all the world to see. A corset hangs precariously over the edge of the fire escape. This undergarment—one of the sort by this time denounced as "torture corsets" (fig. 295) that harmed women's health while forcing their figures into the prevailing hourglass ideal—suggests that the sturdy, simply dressed woman hanging wash in Sloan's picture might be striving, however unsuccessfully, for this standard of appearance.[165]

"The subject, a woman putting out her wash, is one that never loses its charm for me," Sloan admitted.[166] Commenting on another laundry scene he painted, *Sun and Wind on the Roof* of 1915 (Maier Museum of Art, Randolph-Macon Woman's College, Lynchburg, Virginia), he confessed what attracted his eye: "An urge to record my strong emotional response to the city women, any woman running up the colors of a fresh, clean wash. Sun, wind, scant clothing, blowing hair, unconscious grace give me great joy."[167] Sloan's evocation of outdoor elements and the "fresh, clean wash" sounds as if he were describing a sporty racing sloop, effectively masking his desire to observe these women in intimate moments. Voyeurism, already evidenced in *Three A.M.* (fig. 263), is manifested more clearly in the etching *Night Windows* (fig. 296), than in his oil paintings of women doing laundry. The etching shows two women at lit windows—one a solitary figure at her toilette and the other a wife and mother, minding children and hanging laundry while her hus-

band (perhaps a surrogate for Sloan himself) sits on the roof, smoking his pipe and, as Sloan put it, "taking in the charms" of the window opposite.[168]

In 1915 Jennie Doyle, a socialist who modeled for Sloan, sent the artist an "interview" she conjured up between a painter and a journalist.[169] J. Flinerty Slam, a thinly disguised Sloan, discusses his urban subjects with Miss Bjones, who works for the *Squall*, a clever mutation of the *Call*, the socialist newspaper read by Sloan and his circle. This amusing parody could easily be applied to the excesses of art-historical interpretation. Bjones provides the first-person narrative, with Slam praising the view through his window, which he deems "extraordinary [in] . . . its beautiful human ordinariness."

"Behold those clothes lines swaying rhythmically in the breeze. . . . You observe how the breeze forces the wash to assume different attitudes and expressions as it were. Look at that underdrawer for instance—it is full of character especially at the knees which are large and like the owners will, I doubt not, almost inflexible. A study of that drawers . . . would enable one to draw a characterful portrait of the owner. . . . It is . . . the coarse garment of a workingman.["] . . .

"How would you picture the owner of the petticoat?"

"The owner of the petticoat is the wife of the owner of the drawers" said the artist with conviction. "That much can be gathered from it[s] impressive air, from the absence of coyness or invitation. She loves him no doubt but the arts that captured him are no longer employed or seemed necessary, more's the pity," he concluded with a sigh.[170]

After the hapless Miss Bjones completes her interview, she exits to see a sign on the building she and Mr. Slam had discussed so ardently. "'Laundry taken in by the dozen or Bundle, open air drying on roof.'"[171]

We can presume that Sloan's faithful wife, Dolly, took care of *his* laundry, but we have no way of knowing how *she* felt as she washed each piece, then hung it to dry, sorted it, ironed it, folded it, and stowed it away, only to repeat the entire cycle from clean to dirty and back again. Sloan the Realist has chosen to depict the most pleasant moment in the washing process—the dirt is gone; no soapy water is in evidence; and the heavy iron has yet to be heated up. He makes it easy to forget how time consuming laundry was before the advent of electric washers and dryers and easy-care fabrics. At the turn of the century laundry—described as "the Herculean task which women all dread" and "the white woman's burden"—occupied as much as a third of a housewife's working time.[172] The very title of Sloan's painting— *A Woman's Work*—underscores the laborious aspects of domestic life often overlooked or minimized by the American Impressionists and slighted also by their Realist successors.[173]

A Woman's Work, with its backdrop of wall and windows, reminds us that advances in domestic technology addressed new needs of tenement and apartment dwellers, whose fire escapes provided a very different setting from that of Charles Courtney Curran's *Breezy Day* or J. Alden Weir's *Laundry, Branchville* (figs. 298, 47), both of which show laundry billowing over verdant meadows, drying in the fresh country air. As urban land costs rose precipitously, economics encouraged real-estate developers to build multistory residences, work spaces, and stores. City land was so valuable that only the wealthiest citizens could afford single-family homes; the less affluent chose between apartments and suburban houses. The demand for efficient housing prompted developers to seek new conveniences—refrigeration

Fig. 297 The Happy Day Electric Home Laundry Machine, advertisement for National Sewing Machine Company, Belvidere, Illinois, ca. 1910. The New-York Historical Society, Bella C. Landauer Collection SB83/4

for food preservation, gas for cooking, elevators for easy movement from floor to floor. Plumbing had eliminated the need for pumping water and lifting buckets; new washing conveniences saved time and effort; and soon washers would be powered by electricity (see fig. 297).[174] All such domestic progress was dependent upon a large, sophisticated mercantile system, symbolized by the modern department store, which brought food and other products to eager feminine consumers through a delivery system "as remarkable as the United States mail delivery."[175]

Relief on the domestic front due to technological and commercial advances enabled more and more women to pursue opportunities for employment outside the home. Some even saw increases in their wages. "The head cashier of Macy's, who now

Fig. 298 Charles Courtney Curran. *A Breezy Day*, 1887. Oil on canvas, 12 x 20 in. (30.5 x 50.8 cm). Pennsylvania Academy of the Fine Arts, Philadelphia, Henry D. Gilpin Fund 1899.1

"They ain't so awful mannish, Pop"

Fig. 299 John Sloan. Illustration from Mary Alden Hopkins, "Women March," *Collier's, the National Weekly* 49 (May 18, 1912), p. 13

"Aw, Susie, be them dishes washed?"

Fig. 300 John Sloan. Illustration from Mary Alden Hopkins, "Women March," *Collier's, the National Weekly* 49 (May 18, 1912), p. 13

gets $6,000 a year, began as a cash girl in that establishment at $3 a week," noted an optimistic Hartley Davis in 1907.[176] Yet by 1912 only one in fifteen American families could afford to hire domestics and thus relieve the woman of the house of such oppressive chores as laundry.[177] Much was written about the decline of household help—in number and in quality—at the turn of the century, and women often expressed the desire to obtain virtually any other type of employment.[178] Sloan, while painting *A Woman's Work*, illustrated a whimsical short story by Ralph Bergengren, "The Queen of the Girls," which took up the "Servant Girl Question."[179] In Bergengren's tale the bartender of McGinnis's tavern, which sounds suspiciously like McSorley's Manhattan bar (see fig. 222) transplanted to Boston, explains the American domestic system to a group of colorful patrons, whom he assumes are foreigners unacquainted with national customs. "The first thing that happens when a young woman marries is that she gets too feeble to do the housework," opines McGinnis. "Her husband must hire an unmarried girl to do it for her."[180] He describes the results of this arrangement: "Theoretically, you hire the girl, the girl does the housework, and your wife cultivates herself."[181] The message in this fictional account mirrors the subtext of more serious-minded writing in contemporaneous journals: American women sought domestic help because they wanted more freedom from "woman's work" to pursue "cultivation," but self-fulfilling activities might well threaten the established social order.

Slam was probably correct about the working-class origins of the woman in Sloan's *Woman's Work*. Unlike the ladies who resided in stylish, well-to-do homes, hiring servants to do their housework while they pursued entertainment or uplifting activities, she probably did her laundry by hand, for when Sloan painted her, an automated washer at fifteen dollars was still beyond the reach of the average factory girl, who worked for nine or ten cents an hour, taking sixty hours to earn less than ten dollars.[182] The laundress in his painting would still have had to resort to elbow grease or simple wringers that required her constant intervention not only to start and stop the machine but also to add soap and water as well as remove them.[183]

The persistent difficulty of household laundry discouraged cleanliness, particularly among the poor. As one home economist observed in 1913, "Some women have the feeling that cleanliness is a condition only for the rich and if one is poor it follows as a matter of course that one is dirty."[184] In this context, as Ruth Schwartz Cowan has explained, "the laundry that hung from many tenement windows was more than just laundry; it was a signal and a symbol that the housewife had found the time to do the laundry, and *that* fact might well have meant that the fortunes and prospects of the family were improving."[185]

A journal article that Sloan illustrated while painting *A Woman's Work* pointedly addressed the issue of improving the lot

of American women. His drawings (see figs. 299, 300) accompanied Mary Alden Hopkins's account of a suffrage march that took place in New York on May 4, 1912.[186] Ten thousand people—men as well as women—marched up Fifth Avenue from Washington Square toward Carnegie Hall. Hopkins described the onlookers, from crude young men downtown who "whet[ted] sharp tongues on 'Here come the Loidy Boilermaker's Union'" or catcalled "Be them dishes washed?" to affluent patrons of uptown shops and clubs who greeted marchers with silence—sometimes thoughtful, sometimes chilly. One marcher's humble assertion that she was "nothing but a married woman" provoked Hopkins to excoriate a social system that failed to recognize and recompense woman's work: "Thousands of 'just married women'—women whom the census classes as dependent females because they get no pay envelope of a Saturday night after seven days of broiling steak, nicking dishes, running sewing machines, and nursing mumpy children—thousands of these industrious housekeepers marched in a glory of yellow splendor."[187]

These women had much to protest. The great liberating experience of the Civil War years, which offered new opportunities for satisfying work, had led many women to believe that an enlarged role for them was probable in the near future. Yet progress in women's rights slowed in subsequent decades, complicated in part by the concomitant push for African-American suffrage and in part by the conflicting strategies women's groups devised to achieve their goals. Although some advances had been made in women's rights by the turn of the last century, much remained to be accomplished. Common law, which had reduced the status of women to that of chattel belonging to their husbands, with no legal rights over their own finances or property, had been redressed in some states by new laws. As late as 1890, however, thirty-seven of the then forty-six states denied women control of their children except in cases of divorce, when custody was most often awarded to mothers.[188] It was not until 1920 that suffrage advocates succeeded in winning the vote for women, and then only after an extended struggle.[189]

Nevertheless, women were growing independent, a condition perceived as distinctly American. A puzzled Frenchman, Paul Bourget, toured the United States in the 1890s, asking, "How does it come to pass that the men of this country—so energetic, so strong-willed, so dominating—have permitted their wives to shake off masculine authority more completely than in any other part of the world?"[190] "In America," wrote Price Collins in 1894 in his comparison of the home scene here and in England, "the establishment is carried on with a prime view to the comfort of the woman."[191] Marriott-Watson, writing in 1903, believed that the American woman had exceeded independence: "she is anarchical."[192] These changes in women's roles were reflected strongly in the structure of family life and the child's world, subjects interpreted by the painters of modern life.

In the Hands of Women

The destiny of the nations lies far more in the hands of women—the mothers—than in the hands of those who possess power.

ELIZABETH HARRISON (1895)

The hand of a woman encloses that of a tiny child in Beaux's *Ernesta (Child with Nurse)* (fig. 301). The artist's niece Ernesta Drinker, a toddler at the time this portrait was painted, is the composition's focal point. Standing in the center of the canvas, Ernesta looks out at us confidently as she grasps the hand of her nurse, Mattie, who is cropped at the waist, giving us the child's view of her heavily starched apron. Mattie remains a cipher; she belongs to a class of women, caretakers of children, who were not only underpaid (sixteen dollars a month seems to have been the going rate) but also maligned by writers and advisers, who condemned "fashionable women" for turning over their precious children to "strangers."[193] "The average nurse is too often narrow-minded, ignorant, and indifferent to aught in the fulfillment of her duty save what is absolutely nominated in the bond," warned Constance Cary Harrison in 1883. "Her charges, washed, combed, and fed, are abandoned to seek amusement or occupation as they may."[194] During the course of the nineteenth century family size decreased markedly, and the care women took with their offsprings' upbringing and education increased.[195] E. S. Martin wrote in 1899, "Conscientious parents, be they rich or poor, don't want to neglect their children, or turn them over entirely to hired supervision. You might as well not have children as not live with them and be bothered with them."[196]

Beaux's cosmopolitan and somewhat adventurous life as a painter in Philadelphia, New York, and, later, Gloucester, Massachusetts, was not the obvious choice for a young girl of her background. Her mother, who had married a Frenchman, died when she was an infant; Beaux grew up in a sheltered environment created by her maternal grandmother and aunts. Her family initially opposed her decision to attend the Pennsylvania Academy of the Fine Arts and may have disapproved of her romantic involvements as well. When her older sister, Aimée, married Henry S. Drinker, the brother of Beaux's early art instructor, Beaux thought wistfully, "Happy is she. . . . Shall I ever come to it?"[197] This sentiment might have applied equally to motherhood, which, like marriage, the artist never experienced firsthand. Beaux celebrates her sister's mother-and-son relationship in *Les Derniers Jours d'enfance* (fig. 302). This Aesthetic interior scene borrows heavily from Whistler's *Arrangement in Gray and Black No. 1: Portrait of the Painter's Mother* of 1871 (Musée d'Orsay, Paris). Beaux focuses on the gesture that unites Aimée and her child, Harry, noting, "Nearly the highest point of

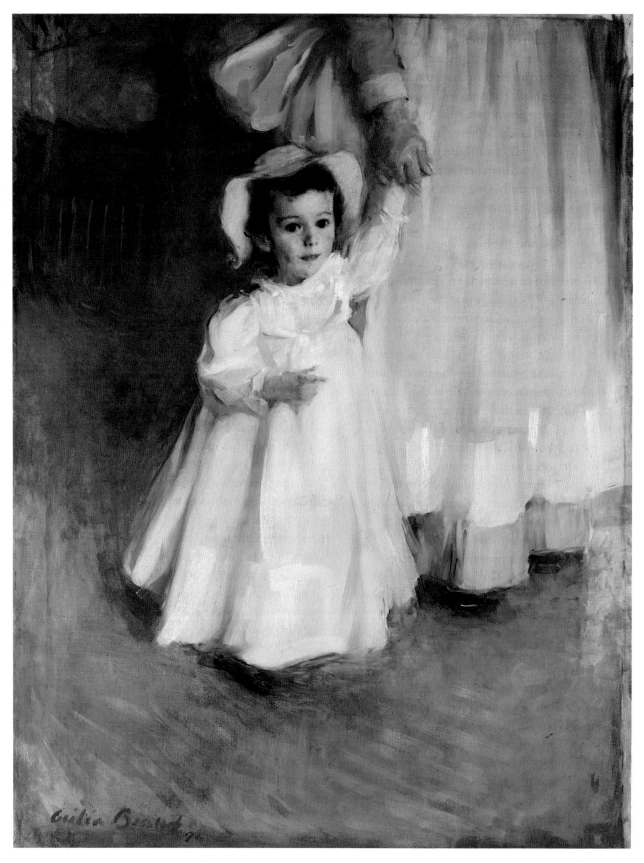

Fig. 301 Cecilia Beaux. *Ernesta (Child with Nurse)*, 1894. Oil on canvas,
50½ x 38⅛ in. (128.3 x 96.8 cm). The Metropolitan Museum of Art, New York,
Maria DeWitt Jesup Fund, 1965 65.49

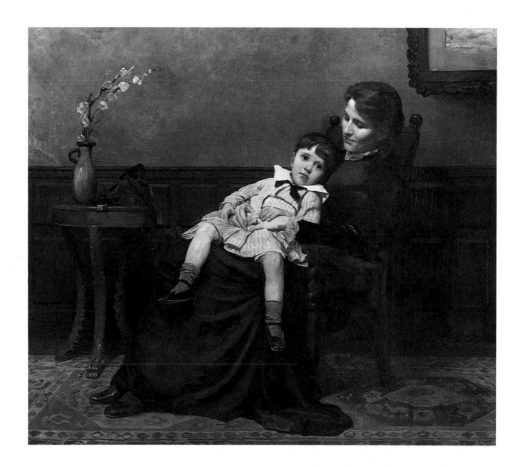

Fig. 302 Cecilia Beaux. *Les Derniers Jours d'enfance*, ca. 1885. Oil on canvas, 46 x 54 in. (116.8 x 137.2 cm). Pennsylvania Academy of the Fine Arts, Philadelphia, Gift of Cecilia Drinker Saltonstall 1989.21

interest lay in the group of four hands which occupied the very centre of the composition, the boy's fingers showing a little dark upon the back of the mother's white hand."[198] Although Beaux devotes a similar attention to the supportive and protective gesture between Ernesta and her caretaker, the artist's decision to show us little of Mattie signals, perhaps, the privileged woman's dismissive attitude toward hired help.

American Impressionists portrayed a fairly narrow, upper-middle-class slice of society, frequently their families; their paintings represent daily life of the few rather than the many. In their lives and in the art they created, these painters sought to isolate themselves from the forces of change—the influx of immigrants, the unpleasantness of urbanization, and the quickened pace of modern life.[199] Like many of the French painters who inspired their work, they gave visual expression to the middle-class idea that the child was to be nurtured, exonerated from labor and protected from other harsh realities of everyday life.[200] Important social changes placed a high value on children and the mothers who cared for them.[201]

In 1893, when Amelia E. Barr rewrote the cardinal virtues of faith, hope, and charity in secular terms for the modern woman, she preached, "Family! Country! Humanity! these three, but the greatest of these three is Family; and the heart of the family is the good mother."[202] Publications such as the *Ladies' Home Journal*, established in 1889, celebrated motherhood, as did child-rearing organizations, many of which were marshaled into the Federa-

tion for Child Study in 1912.[203] In 1914 the declaration of the second Sunday in May as an official Mother's Day further glorified motherhood.[204] Despite numerous battles for suffrage, economic change, and social reform, the woman's principal role remained that of homemaker and, in most cases, mother.[205]

Acknowledgment of the importance and complexity of youngsters brought fresh emphasis to the many responsibilities of motherhood. "The destiny of the nations lies far more in the hands of women—the mothers—than in the hands of those who possess power," avowed Elizabeth Harrison of the new recognition of feminine influence in 1895.[206] Women were believed to evince a natural "instinct" to love their offspring; in men this was considered "a cultivated emotion."[207] Yet progressive educator Mary Stanley Boone explained in 1904, "Everyone will concede, I am sure, that it is the mother's hand that moulds, but she needs preparation for the process.... The average mother has little or no training."[208]

Most middle-class women presided over families later described by sociologists as "companionate." Husbands and wives were both friends and lovers to each other; children were educated and did not engage in wage labor; and parents, while more involved than before in the day-to-day nurturing of their children, depended heavily on professional advice from teachers, doctors, and others who encountered the child outside of the home.[209] This domestic trend paralleled economic developments that moved sources of family income from the family farm to the

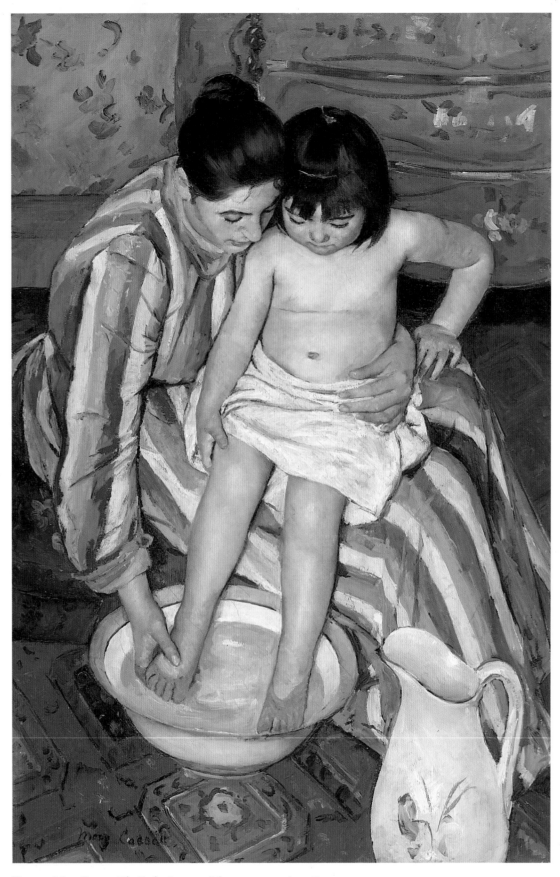

Fig. 303 Mary Cassatt. *The Bath*, 1891–92. Oil on canvas, 39½ x 26 in. (100.3 x 66 cm). The Art Institute of Chicago, Robert A. Waller Fund 1910.2

office or the factory, increasingly specialized locales away from the family circle.[210]

Although we might suspect that great interest in and respect for motherhood and domesticity inspired tranquillity and satisfaction in the middle-class home, such was not the case. That parents felt the pressure of social change and the new complications affecting parental roles is evident in the works of American painters of modern life. Fathers are noticeably absent from American Impressionist views of the home scene. As often as the artists painted their families, they rarely chose to do more than hint at their own presence (painting was work too).

In fact, during the day most workingmen were absent from the domestic sphere. As the workplace moved from the rural family farm or small-town business to the factory or the urban office, men increasingly earned their livings outside the home.[211] Wives' and mothers' roles had expanded as well as changed; responsible not only for managing the household, women were also called on to make judgments about behavior, manners, decoration, and child rearing—all after considering the by then copious recommendations of experts. The recipients of more and more attention, children became less and less able to participate in this complex adult world.[212]

Children were no longer viewed as inherently depraved and sinful—the Enlightenment had relieved families of that burden.[213] But the recognition that children were eminently trainable imposed new obligations on their parents, especially their mothers. Faced with Darwinian theories, writers on child rearing, such as Charlotte Perkins Gilman and William J. Shearer, acknowledged the role of heredity but maintained that children could be positively influenced by nurturing.[214] "How to manage young children," pondered one writer on the subject of motherhood in 1893, as she catalogued the range of maternal responsibilities: "how to strengthen them physically; how to best awaken their intellects, engage their affections and win their confidence; how to make the home the sweetest spot on earth, a place of love, order and repose, a temple of purity where innocence is respected, and where no one is permitted to talk of indecent subjects or to read indecent books; these are the duties of a good mother: and her position, if so filled, is one of dignity and grave importance."[215] Ideas of this kind encouraged middle-class women to create sanctuaries for their children within their homes and, as their sphere of influence spread beyond the domestic realm, to seek social reforms that would inspire moral improvement among the population at large. Increased activism for protecting children from labor and abuse also grew out of these sentiments.[216] By 1903, for example, one writer recognized "the vital connection" between conditions in the factories where children worked and "every home into which ready-made garments enter."[217]

Cassatt's *Bath* (fig. 303) studies the intimate mother-child relationship. Like Beaux an educated and wealthy woman artist who never married or had children, Cassatt often chose a maternal theme for her paintings and prints. Utilizing a bird's-eye perspective, Cassatt here fills the canvas with the seated woman and the child in her lap, establishing an enclosed and very private space for the act of bathing. The tender bond between the mother and child is suggested by their poses—the mother's arm around the child's waist, the child's hand resting on the mother's knee, and, in a gesture of affection, the mother holding the child's foot. The adult model could, of course, be a servant, but her rather elegant striped dress and the similarities of coloring between her and the child—underscored by the placement of their heads side by side, their dark hair and brows, rosy cheeks, and pink lips aligned to invite comparison—reinforce the notion that this is a mother. She is, moreover, a mother involved in the most routine aspects of the physical care of her child. In *Mother About to Wash Her Sleepy Child* (fig. 304) Cassatt once again expresses intimacy and tenderness through formal devices. The upright chairback and striped wallpaper behind the figures block our view into the distance and draw our attention to the foreground. Cassatt places the basin, the mother's hand, and the child's awkwardly splayed legs close to the picture plane and to us, thereby including us in this personal scene. No sentimentalized child, this flesh-and-blood toddler slumps in its mother's lap, a less than willing recipient of her ministrations.

Few American Impressionist painters concentrated on the mundane activities that appear in Cassatt's images of mothers and children. Many focused instead on children's play,[218] a topic that engendered much discussion at the turn of the century among parents, educators, physicians, and scientists, who recognized its developmental value. As E. A. Kirkpatrick, a professor at a Massachusetts school, observed in 1899, "Taking into account the importance of play in animal life and the physical, mental, social, and moral development that the child gets in this his most intense form of activity, there is good reason for claiming that children's plays do at least as much to bring out their latent capabilities and prepare them for life as their school training."[219]

In the decades following the Civil War a growing number of toys, games, and books, many of them relatively inexpensive, became available for the entertainment of middle-class youngsters. Children's literature assumed a lighter tone, emphasizing enjoyment over moral enlightenment. Miniaturized household goods, among them small-scale furniture and dishes, became increasingly commonplace toys. More popular, too, was the nursery, the area in larger middle-class homes where young children slept and played.[220]

Childhood energy was channeled away from bad influences to pleasant, productive recreational alternatives through the efforts of Mariana Van Rensselaer and others.[221] The growth of child study and reforms of school curricula—including the creation of

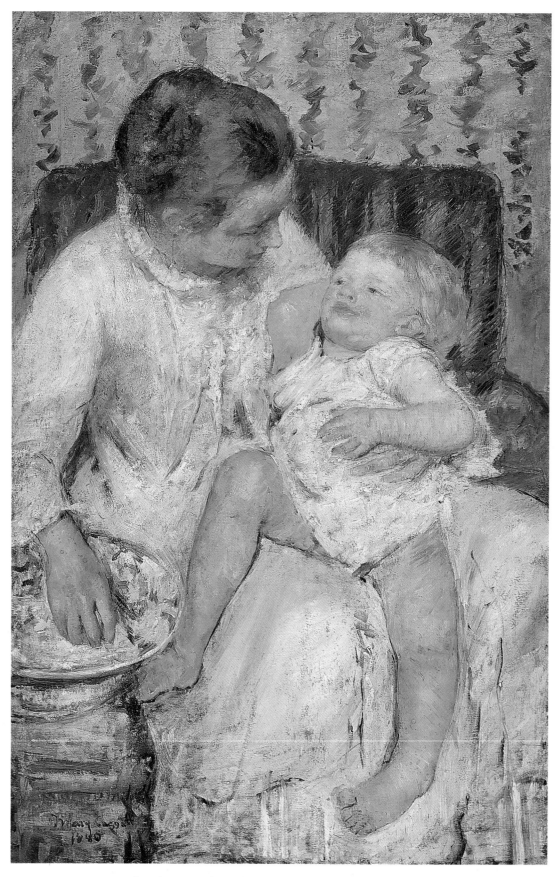

Fig. 304 Mary Cassatt. *Mother About to Wash Her Sleepy Child*, 1880. Oil on canvas, 39½ x 25¾ in. (100.3 x 65.4 cm). Los Angeles County Museum of Art, Mrs. Fred Hathaway Bixby Bequest M62.8.14

kindergarten classes and other programs inspired by the new sense that education should encompass the body and soul as well as the mind of a child—encouraged recreation.[222] Physical training was added to the school day, and organized play in vacation schools and in new open-air playgrounds was scheduled for the summer months. Access to even the most modest outdoor playground was considered therapeutic to any child who used it and, by extension, to society as a whole.[223] Visiting one playground on the Lower East Side of New York, Van Rensselaer described both its shortcomings and its value: "It was pitiful to think that this was the best that the beautiful word 'outdoors' could mean to so many thousands—just a big, dusty, open space without a flower or a leaf of green. But it was delightful to think that this at least, instead of nothing whatsoever, had been given them—a place of their own, a place to help them to grow happier and better in ways that no school-house, no church, and very surely no court and jail, could ever accomplish."[224] Parents were urged to seek out summer resorts that would provide wholesome activities for children—hotels with facilities in which children could be entertained and enlightened —and to spend time with them engaged in nature study, reading and telling stories, and sports and other pastimes.[225] Commentators also urged a thoughtful balance between play and work, even for children on summer vacation, when "a little work—if only half an hour—spent at something in the line of duty or service strengthens the moral fiber."[226]

Daily recreation for the middle-class American child usually took place under the protective eye of a parent or caretaker or within the safe haven of a domestic space. Although these children were granted some freedom for exercise, exploration, and adventure, they were to remain within the confines of well-defined and carefully supervised areas. Some of William Merritt Chase's plein air paintings of Central and Prospect parks illustrate this practice.[227] In Chase's *Lake for Miniature Yachts* (fig. 140) the children who sail toy boats are watched by adults seated on the benches at the pond's edge. As viewers we join this group of onlookers, perhaps as caretakers for the closest children, who launch a boat, its white sails and American flag fluttering in the breeze. The children's isolation, heightened by a nearly empty foreground, underscores their need for supervision. Separated from the harsh realities of everyday urban life, they are preoccupied with charming toys that recall adult tasks and pursuits yet emphasize the innocence of a privileged childhood.[228] The out-of-town equivalent of this urban park scene can be found in Chase's Shinnecock landscapes, in which children relax on stretches of sand or in groves of scrub pines and bayberry bushes populated by attentive friends and family.

Chase depicted his own children at play within his home and studio, showing us that middle-class children, once regular contributors to the family economy, were now excused from this obligation. *Ring Toss* (fig. 305) is set in the painter's studio.

Chase's daughters play a parlor game advertised at the turn of the century as "being perfectly harmless to the wall or furniture" when played indoors (see fig. 306). These hoops are fashioned of rattan and then "wound with fancy colored webbing" so that they are far less dangerous missiles than the metal and wooden hoops sometimes used. To make room for the children, Chase has rolled aside an easel containing a framed picture and turned around a large stretched canvas to face the wall. We see only the blank back of the canvas and its stretcher, which Chase has signed, marking his presence nearby. The viewer, like the artist, stands just outside the picture's frame, a spectator rather than a participant in the game. Although the girl who is about to throw her ring seems engrossed in the effort, her companions are not. One bends down to pick up a ring while the other expresses disinterest or distraction—perhaps because all the rings in play are the same rather large size and therefore easily tossed atop the pointed stick. When Chase's friend Clarence H. White made a Pictorialist photograph of the same theme in 1899 (fig. 307), he undoubtedly used Chase's image as his model.[229]

At first glance the enclosed space in Sloan's *Backyards, Greenwich Village* (fig. 308) seems a far cry from the large studio where Chase's children played; a graphic comparison of floor plans published by journalist-photographer Jacob A. Riis in *The Battle with the Slum* of 1902 (fig. 309), however, establishes the relative spaciousness of this urban backyard. It certainly offers far more light and air to its building's inhabitants than did the most densely packed tenements, which provided only "the air shaft—first concession to tenant."[230] Sloan's scene presents an episode of child's play outdoors in the prosperous middle-class neighborhood visible from his studio loft on Sixth Avenue.[231] At the time Sloan worked there, Greenwich Village housed an extremely diverse population: a diminishing number of New York's elite; the students and teachers of New York University; aspiring young writers and artists who occupied rooming houses in former single-family residences; comfortable middle-class families, many of them second-generation Irish; and a huge number of newly arrived immigrants, mainly Italians.[232] Sloan celebrated Greenwich Village's social mixture and its distinction from other neighborhoods in the city. In 1916 he and some friends, including Marcel Duchamp, climbed Washington Arch, where they playfully shot cap pistols and announced that the community was a "free Republic, Independent of Uptown."[233]

Sloan recalled that *Backyards* "was painted from memory after careful observance."[234] Here the children play beneath a canopy of hanging laundry, an offhand suggestion of adult responsibilities awaiting these carefree souls. Comfortably dressed in warm hats and coats, two children put the finishing touches on a snowman. Only the sleek cat stretched atop a snowdrift seems interested in their activities. No adult supervision is evident, yet these children play in a secure, enclosed environment.

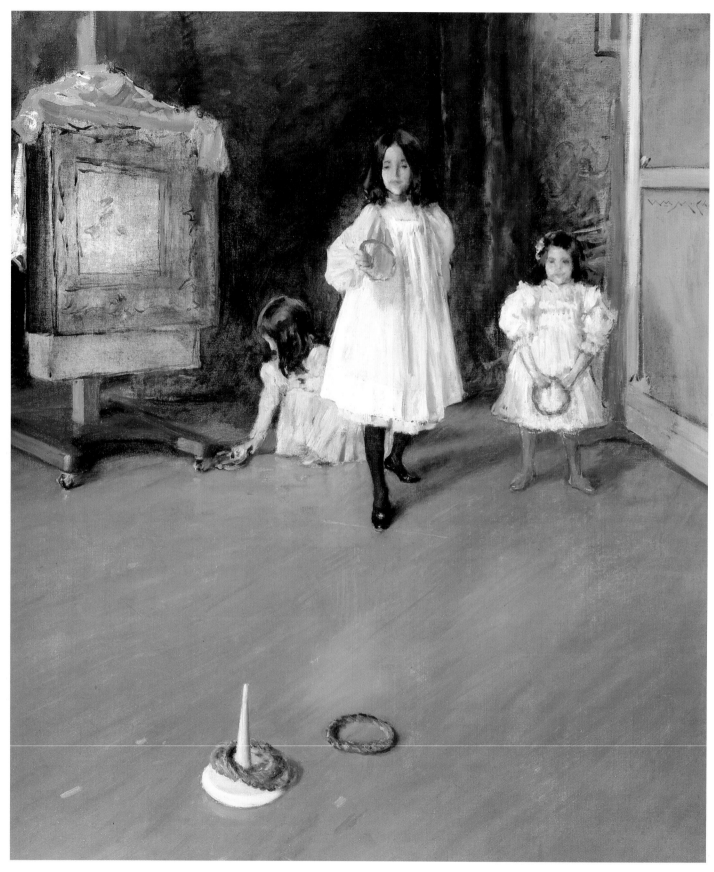

Fig. 305 William Merritt Chase. *Ring Toss*, 1896. Oil on canvas, 40⅜ x 35⅛ in.
(102.6 x 89.2 cm). Mr. and Mrs. Hugh Halff, Jr.

RING TOSS FOR PARLOR OR FIELD.

128. There are five rings or hoops, some large and some small. The game is to throw these over the standard or target post at a given distance. The hoops are made of rattan, graded in size, and wound with fancy colored webbing, thus presenting a beautiful appearance, and at the same time being perfectly harmless to the wall or furniture when played in the house. Equally adapted to the lawn. It is a healthful and fascinating game. The stake is jointed and can be placed in the box when not in use.

PRICE, PER DOZEN, 8.00.

WIRE RING TOSS.

' 129. Very neat painted box. Stick jointed in two parts. Five wire rings, nickeled. All packed in box. Very neat to retail at 50c.
PRICE 4.00 PER DOZEN.

PITCH A RING.

NEW STYLE.

130. A very neat painted box. Four stakes for pitching rings on, and 5 rings Excellent 50c. toy.

PRICE 4.00 PER DOZEN.

NEW BLOCK WAGONS.

This line of Wagon Blocks is NEW, and will be found very salable. They are put up very compact. The Wheels detach and all parts are packed up in one square, neat package, and can be readily set up by the purchaser.

131.	No. 55,	Box 15x8x4½ in.	Contains 80 blocks	Per Dozen, 8 50
132.	56,	" 11½x6⅞x3½ in.	" 45 "	" 6 00
133.	57,	" 9½x6¼x3 in.	" 40 "	" 4 00
134.	58,	" 7¼x5x2¾ in.	" 28 "	" 2 00

SEND FOR LINE OF SAMPLES.
Prices Subject to Change Without Notice.

Fig. 306 Selchow and Righter, *Wholesale Catalogue, Games and Home Amusements* (Jersey City, New Jersey, October 1, 1888), p. 36

Fig. 307 Clarence H. White. *Ring Toss*, 1899. Photograph, 7⅛ x 5½ in. (18.1 x 14 cm). The Metropolitan Museum of Art, New York, Alfred Stieglitz Collection, 1933 33.43.303

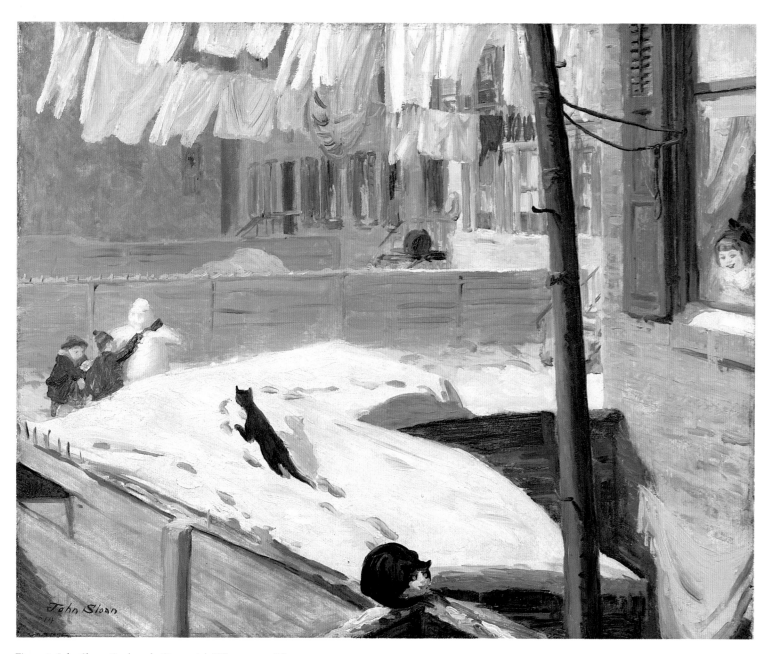

Fig. 308 John Sloan. *Backyards, Greenwich Village*, 1914. Oil on canvas,
26 x 32 in. (66 x 81.3 cm). Whitney Museum of American Art, New York,
Purchase 36.153

Although the children Sloan has shown us in *Backyards* are firmly middle class, the Realists frequently portrayed poorer youngsters, many of them immigrants, who were less protected and lived less pleasantly than their contemporaries. These were children whose families were organized along an old-fashioned model of cooperative interdependence, with individuals expected to place the good of the family ahead of their own interests—including education, marriage, or personal material comfort.[235] The labors of these youngsters, who had to contribute to the financial welfare of their families, were described by Riis as he photographed them for *The Children of the Poor* in 1892 (see fig. 310): "Of Susie's hundred little companions in the alley—playmates they could scarcely be called—some made artificial flowers, some paper-boxes, while the boys earned money at 'shinin'' or selling newspapers. The smaller girls 'minded the baby,' so leaving mother free to work."[236]

The New York experienced by children of the poor is dramatically represented by Bellows's *Cliff Dwellers* (fig. 176).[237] In nearly every aspect it is the Realist analogue for Chase's Impressionist views of more advantaged children at leisure in Central Park, a spot that Bellows, as Chase's student, knew well.[238] As Riis was quick to tell his readers about life among the poorer

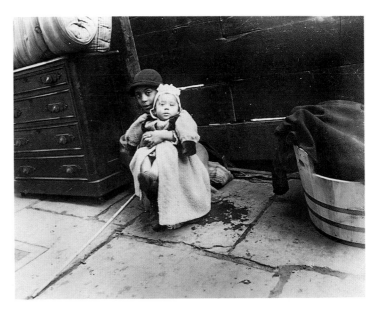

Fig. 310 Jacob A. Riis. *Minding the Baby, Cherry Hill,* n.d. Photograph. Museum of the City of New York, The Jacob A. Riis Collection 187

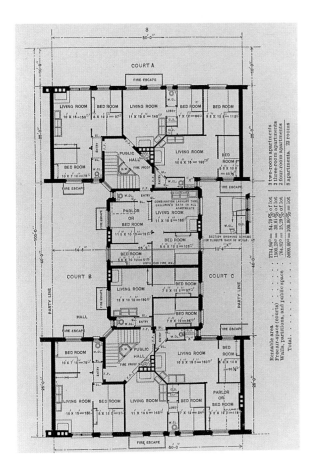

Fig. 309 Floor plan of tenements, from Jacob A. Riis, *The Battle with the Slum* (New York, 1902), following p. 149

classes, "The street has to do for [their] playground. There is no other. Central Park is miles away."[239] The serene security of Chase's park scenes has been replaced by chaos: scantily clad children sit, not on cool, soft grass but on scorching pavement; in the lower left corner a group of boys plays leapfrog dangerously close to the street, where pushcarts and trolleys rumble by, peddlers hawk their wares, and a vast sea of humanity makes its way in and out of tenement buildings.[240] In 1892 John H. Finley offered a passionate account of the conditions experienced by children such as these, describing "the overcrowding, the literal packing, of population in these great foul dwellings."[241] Clearly out of the sanctuary of the home, these children command the public street. Irving Howe, a former Lower East Side street urchin, recalled: "The streets were ours. Everyplace else—home, school, shop—belonged to the grownups. But the streets belonged to us."[242]

Is *anyone* watching or protecting the children Bellows has painted?[243] A little mother lifts her infant charge aloft, but no one notices her or her ward. To her right a red-haired woman leans sharply over a small, barefoot boy and shakes her finger at him. The other women seem present in body but not in mind or will; reformers such as Lilian Brandt lamented the neglect of household responsibilities by tenement dwellers, noting that "there are always women to be seen gazing out of the windows, sitting on the steps, and standing on the sidewalks, engaged in no more fruitful activity than an interchange of ideas."[244]

Bellows's public would find itself discommoded by images of slum children. His painting *Kids* (fig. 311) shows the powerful influence of Henri, who became his teacher in 1904.[245] Art writer Izola Forrester, during a visit in 1906 to Henri's composition

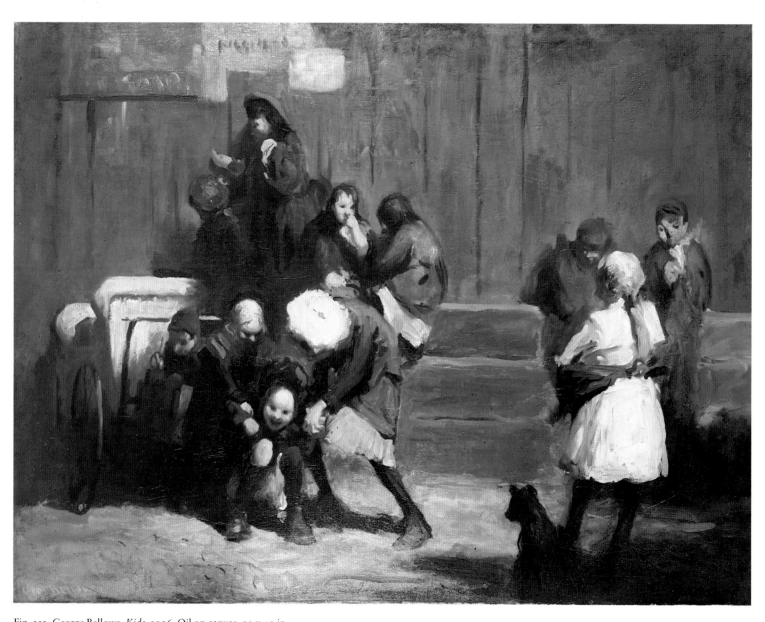

Fig. 311 George Bellows. *Kids*, 1906. Oil on canvas, 32 x 42 in.
(81.3 x 106.7 cm). Collection of Rita and Daniel Fraad

class at the New York School of Art, where Bellows was a student, remarked that in the class pupils represented "Manhattan everyday life . . . not idealized and worked up into unnatural 'effect' but truthfully and powerfully and without flattery."[246] Bellows's choice of the title *Kids* is suggestive, for this slang term was reserved for the streetwise children of working-class parents.[247] Use of the word increased during the nineteenth century, connoting at times avaricious thieves, conniving cheats, or mischievous, teasing monkeys.[248]

Kids does not flatter its youthful models. Eleven children are assembled on a street or in an alley that Riis might have decried. These children seem to be engaged in activities that are at best impolite and at worst dangerous. The group at the left, although gathered around a baby carriage, engages in rough-and-tumble behavior. The action in the foreground is not entirely clear. Two girls rush to help the fallen girl whose stocking has dropped indecorously below her knee. Their unkempt clothes suggest poor circumstances: one is hatless and the other wears a coat that looks outgrown, her pink dress hanging several inches below its hem. A boy sporting a cap reaches boldly into a shopping bag the fallen child may have dropped. Are these well-intentioned Good Samaritans, or are they accomplices to a theft? At the right the blond girl in white, who appears to be holding a child bound in the shawl tied about her waist, assumes the mother's role— "minding the baby," as Riis might have put it.[249] The best dressed of the children, she is a foil to the two boys she faces; one of them puffs happily on a cigarette. Bellows's slashing brushwork makes it difficult to determine whether the child seated atop a ledge to the left of the steps is sucking its thumb or picking its nose. Unattended, these kids reflect the lack of both supervision and family structure experienced by less fortunate children.

And there is much here to worry the reformers of the period. The likes of Bellows's immigrant children caused native-born Americans to fear that the traditions they esteemed were threatened by the unfamiliar practices of new arrivals who flooded into the United States.[250] Gathered not in a park, a school, or a playground, the children Bellows shows are on the street, with no team sports or organized play of any kind that might transform them through supervision, education, and effort from cunning immigrants to hardworking Americans.[251] A report of the University Settlement described such street settings as "free field[s] in which the most evil and corrupting influence may work against the community."[252]

Settlement houses offered a clear alternative to the street life seen in *Kids*. A 1915 view of the entrance to the Henry Street Settlement (fig. 312), founded in 1895 by midwesterner Lillian D. Wald, shows several adults together on the sidewalk. One woman watches over a toddler and an infant in the ubiquitous baby carriage, while a group of clean and relatively well-behaved children sits on the settlement steps, perhaps waiting for yet another enlightening class. The seemingly simple facade belies the significance of the site and its history.[253]

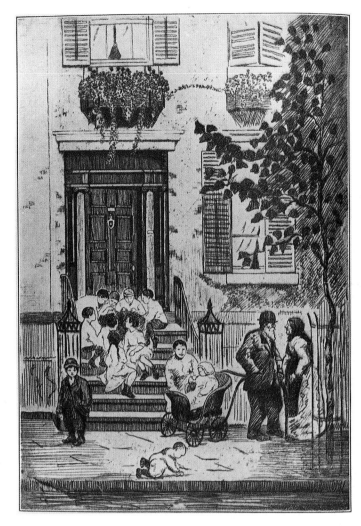

Fig. 312 Abraham Phillips. Frontispiece, 1915, Lillian D. Wald, *The House on Henry Street* (New York, 1935)

As slang, the title *Kids* conveys a message that becomes even more strident in Bellow's epic *Forty-two Kids* (fig. 313) and *River Rats* of 1906 (Private collection, Washington, D.C.).[254] In these paintings, poses and gestures—as well as cartoonish faces— highlight the psychological complexity of the children. Bellows took up a similar theme in such roughly contemporaneous portraits as *Frankie the Organ Boy* of 1907 (Nelson-Atkins Museum of Art, Kansas City, Missouri) and *Paddy Flannigan* (fig. 314). These models are neither sweet nor sentimentalized; they are sly, sensual, and capable of exceeding the conventional boundaries of behavior so clearly defined for middle-class children.

As can be seen in *Kids* and *Forty-two Kids*, Bellows often exaggerated the facial expressions of his figures to the point of caricature, much in the vein of Daumier, whose lithographs he and his teacher Henri admired.[255] In fact, the spontaneity, reduced modeling, and summary brushwork of Bellows's paintings tie him not only to a long tradition of nineteenth-century caricature but also to the French Impressionists, who employed aspects of the graphic arts in their paintings, challenging the established

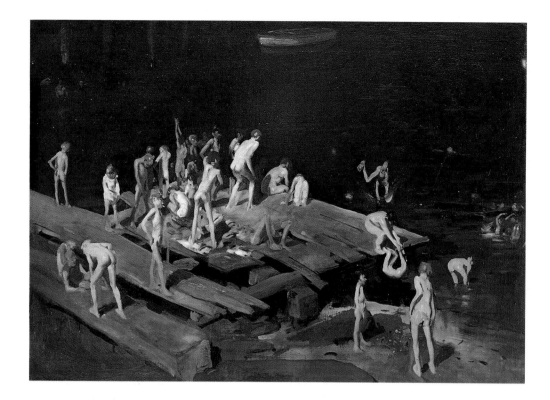

Fig. 313 George Bellows. *Forty-Two Kids*, 1907.
Oil on canvas, 42⅜ x 60¼ in. (107.6 x 153 cm).
Corcoran Gallery of Art, Washington, D.C.,
Museum purchase, William A. Clark Fund 31.12

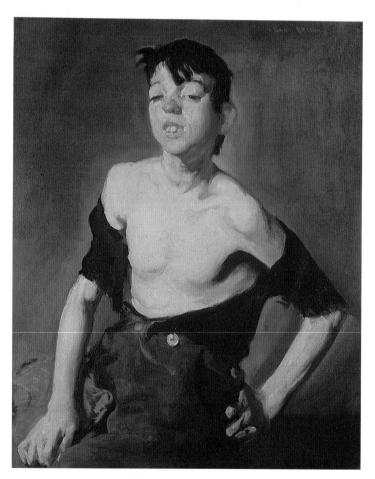

Fig. 314 George Bellows. *Paddy Flannigan*, 1908.
Oil on canvas, 30¼ x 25¼ in. (76.8 x 64.1 cm).
Collection of Erving and Joyce Wolf

standards of academic practice.[256] Moving beyond the relative restraint of the American Impressionists, Bellows used amorphous brushwork that had a life of its own, separate from the forms it was intended to represent.

Despite the differences that separated them from the American Impressionists, Bellows and other Realists held to a sense of optimism. Although the American Impressionists created euphemistic images by choosing well-cared-for, middle-class models, their Realist successors achieved a similarly positive effect by different means: their neglected and deprived lower-class subjects may have had to work, but the artists painted them in energetic moments of leisure.

The Most and the Best from Music

Home is the best place on earth, and therefore it deserves the best that earth can offer. On the home rest Church and State, society and the Nation. . . . How can the home get the most and the best from music?
J. W. CHICKERING (1894)

I bless that organ-man—a very Orpheus in hell! I bless his music. I stand in that foul street where the blessed sun shines, and where the music is playing; I give the man a penny to prolong the happiness of those poor people, of those hungry, pale, and ragged children.
REV. HUGH REGINALD HAWEIS (1872)

In an age before recorded music, public and private concerts were supplemented by amateur music performed at home. "The family circle which has learned three or four instruments, the brothers who can sing part songs, are to be envied," pronounced Mary Elizabeth Sherwood in 1881. "They can never suffer from a dull evening."[257] Theodore Robinson's *At the Piano* (fig. 315) and Luks's *Spielers* (fig. 318) both take up the theme of music, each representing the focus of its own generation of American painters.[258]

Robinson lets us share a private moment. His model sits before a parlor grand piano, probably in her home; the pianist is self-absorbed, lost in her music.[259] Her loose-fitting wrapper or peignoir—an informal garment suitable only for home wear—has fallen open, revealing the darker skirt beneath it.[260] She seems to have sat down to play before completing her toilette and beginning the day's more public activities. The refined setting and the substantial piano suggest that she is a middle-class woman with the leisure time to pursue her own interests, music among them.

By the late nineteenth century the piano was a commonplace furnishing for parlors here and abroad.[261] Its presence reflected the desire for cultural accomplishment on the part of the lady of the house.[262] As piano manufacturer J. W. Chickering elaborated in 1894, "Home is the best place on earth, and therefore it deserves the best that earth can offer. On the home rest Church and State, society and the Nation. . . . We all recognize literature, art, and music as essential elements of true culture. How can the home get the most and the best from music?"[263] The introduction in 1897 of the home player piano, with its mechanized melodies, only somewhat lessened the piano's claim to cultural prestige.[264]

Pianos and piano players increasingly made their way into American paintings, often in images such as Charles Ulrich's *Moment Musicale* (fig. 316), in which the instrument is covered with bric-a-brac and surrounded by reminders of the Orient, among them a Chinese plant stand and a Japanese vase awaiting a decorative floral arrangement.[265] Robinson's composition is more spare. Only a pot of flowers, casually placed beside the bulbous piano leg, enlivens the bare polished floor; his pianist and her instrument are locked in a grid of geometric moldings. Acknowledging the austerity of his work, Robinson wrote, "My painting is good as far as it goes but I have confused simplicity with other qualities and it is apt to be rather *poor*, not full or rich enough in vocabulary, like my writing. Good Monets have an extraordinary 'fullness' together with no lack of simplicity . . . and restraint."[266] Robinson's inspiration for the picture's sober palette was certainly not found in the paintings of his French mentor; perhaps it was Whistler's *At the Piano* (fig. 317), which he may have known.[267]

Far less dignified than these piano pictures, Luks's *Spielers* portrays two working-class children dancing frenetically. Luks has allied himself with a very different set of precedents—the

Frenchman Daumier, even the Spaniard Goya, both artists who used exaggeration to heighten the expressiveness of their figures. The demeanor of the dancers, particularly the fetching gaze of the redheaded girl on the left, suggests that this scene occurs in a public place and that there are onlookers (see fig. 319). Any music to which they dance is far less restrained than that emanating from Robinson's piano, and its source lies well outside the picture frame.

By 1907 *The Spielers* had acquired the additional title *East Side Children Dancing to Hand-Organ Music*, which conveyed a distinct impression to the viewer.[268] These girls are probably impoverished immigrants, denizens of the Lower East Side, an area of New York teeming with recently arrived Europeans. Writing about Luks's career in 1907, only two years after *The Spielers* was painted, John Spargo either drew information from Luks himself about the picture or embellished his own interpretation of the canvas. In describing Luks's attitude toward the dancing girls and the unseen organ-grinder whose unheard music lends such a hurdy-gurdy air to the scene, Spargo surmised that "down on the East Side he sees two little maidens, waltzing on the sidewalk to the tune ground out by an Italian organ-grinder, and again his spirit is like that of Dickens. The little blonde German maiden with the wonderful hair that floats in the breeze, and the demure little daughter of Erin with the thick mass of red hair, dancing together, would have gladdened Dickens."[269] The barrel organ that presumably accompanies the spielers is a vulgar but rather popular instrument cranked by street musicians, frequently men of unsavory reputation.

A portable version of mechanical organs used in church and chamber, the barrel organ first appeared in Italy in the eighteenth century but had become commonplace in Europe and America by the nineteenth century, as seen in Daumier's *L'Orgue de Barbarie* (fig. 320).[270] It is composed of a wooden case—often inlaid, carved, or otherwise flamboyantly decorated—that contains a powerful bellows, a barrel, a chest, and a rack or more of pipes. Following the Italian economic woes of the 1860s and 1870s, the instrument gained wider use (and strong associations with its country of origin) as Italian makers of barrel organs settled elsewhere and continued to produce instruments that were sold or rented to their fellow countrymen, who used them to earn a living on the street.

Street musicians were held in low esteem not only because their racket was offensive and difficult to escape but also because they were considered musicians for the masses. One British writer, Rev. Hugh Reginald Haweis, cautioned his readers in 1872 about abolishing street entertainment provided by London organ-grinders on the grounds that they were admired by the servant class. Instead of condemning the organ-grinder, Haweis advocated generosity to him and to his needy audience: "I bless that organ-man—a very Orpheus in hell! I bless his music. I

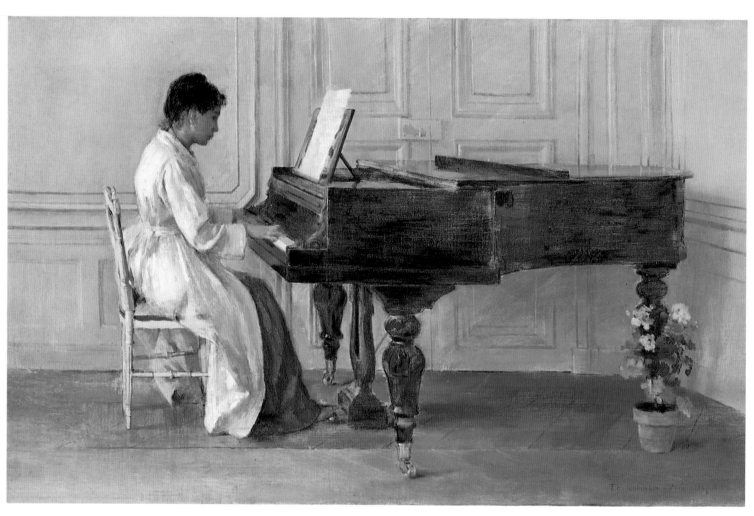

Fig. 315 Theodore Robinson. *At the Piano*, 1887. Oil on canvas, 16½ x 25¼ in.
(41.9 x 64.1 cm). National Museum of American Art, Smithsonian Institution,
Washington, D.C., Gift of John Gellatly 1929.6.90

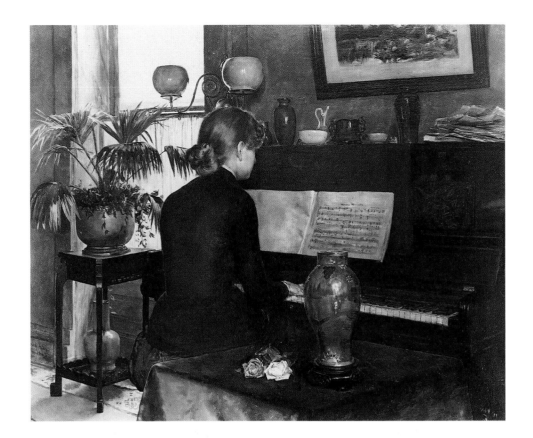

Fig. 316 Charles Ulrich. *Moment Musicale*, 1883. Oil on wood, 14⅞ x 19¼ in. (37.8 x 48.9 cm). The Fine Arts Museums of San Francisco, Gift of Mr. and Mrs. John D. Rockefeller III 1977.7.99

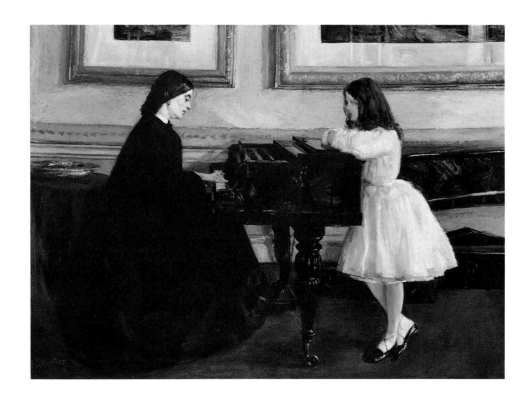

Fig. 317 James McNeill Whistler. *At the Piano*, 1858–59. Oil on canvas, 26⅜ x 36⅛ in. (67 x 91.8 cm). Taft Museum, Cincinnati, Bequest of Louise Taft Semple 1962.7

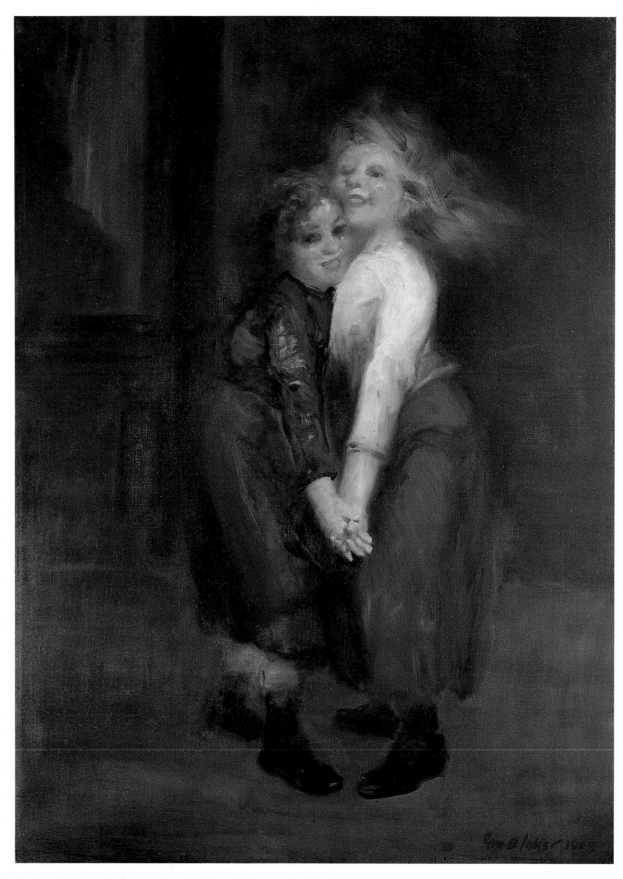

Fig. 318 George Luks. *The Spielers*, 1905. Oil on canvas, 36⅛ x 26¼ in.
(91.8 x 66.7 cm). Addison Gallery of American Art, Phillips Academy, Andover,
Massachusetts, gift of anonymous donor 1931.9

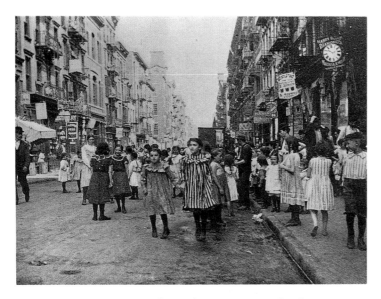

Fig. 319 Oscar Maurer. *Tiny Italian Girls Dance to Tunes Played by the Organ Man*, from Edith Davids, "The Kindergarten of the Streets," *Everybody's Magazine* 9 (July 1903), p. 67

stand in that foul street where the blessed sun shines, and where the music is playing; I give the man a penny to prolong the happiness of those poor people, of those hungry, pale, and ragged children."[271] Such street musicians have been described alternately as romantics or rogues—in neither case the sort of companions reformers would have sought for impressionable children.[272]

In *The Spielers* (fig. 318) Luks has edited out the organ-grinder to concentrate on the animated dancers. The painting has long been titled with a word of German derivation meaning "dancers," implying that the girls depicted are recent European arrivals who would have described their actions in their native tongue. At the time *spieling* also had a more specific meaning, denoting a type of dancing, sometimes called "pivoting," that was extremely popular among the working class in the 1890s and early 1900s.[273] This dancing style, practiced in lower-class commercial dance halls, has recently been called "a loose parody of the fast waltz."[274] Unlike the waltz, which limited contact between members of the opposite sex because the dance required skill and restraint, spieling bordered on the unacceptable. Clasped together, couples revolved wildly, their bodily contact promoting familiarity and even sexual excitement.[275] In 1896 Julian Ralph watched a couple spieling at Coney Island: "Julia stands erect, with her body as rigid as a poker and with her left arm straight out from her shoulder like an upraised pumphandle. Barney slouches up to her, and bends his back so that he can put his chin on one of Julia's shoulders and she can do the same by him. Then instead of dancing with a free, lissome, graceful, gliding step, they pivot or spin, around and around with the smallest circle that can be drawn around them."[276]

Luks's audience would have been well aware of this scandal-

ous dance rage. Although the painter's message was toned down by his choice of young girls not yet adolescents rather than a heterosexual couple more likely to experience sexual stirrings, its content was quite clear. These were children whose dancing (and other behavior) was out of line. Nonetheless, the painting was perceived in extremely positive terms. As John Cournos, writing as early as 1915, described the work and its subject, "It is a joyous canvas, a picture to live with. For all their ragged attire, the two little maidens, locking their hands together, are as happy as princesses."[277]

Here, as in many other instances, the Realists drew subjects from a wider spectrum of society than did the American Impressionists, showing immigrants and working-class people rather than the established middle class and placing their models in more public settings, such as the street or dance hall rather than the private parlor. Yet in their presentation, the Realists display a potent optimism more often associated with their genteel predecessors than themselves. These two groups of artists, separated by a generation and swept into the increasingly tumultuous current of social change, reflect remarkably consistent attitudes toward American life—attitudes inflected not only by optimism but also by euphemism, nationalism, and nostalgia.

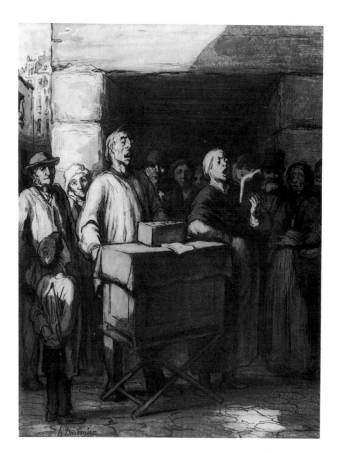

Fig. 320 Honoré Daumier. *L'Orgue de Barbarie*, ca. 1858–60. Crayon, ink, and watercolor on paper, 13⅝ x 10¼ in. (34 x 26 cm). Musée des Beaux Arts de la Ville de Paris, Petit Palais, Paris

NOTES

INTRODUCTION

Passionate Spectators

[1] See, for example, Bennard B. Perlman, *The Immortal Eight: American Painting from Eakins to the Armory Show (1870–1913)* (New York, 1962); Donelson F. Hoopes, *The American Impressionists* (New York, 1972); Richard J. Boyle, *American Impressionism* (Boston, 1974); William H. Gerdts, *American Impressionism* (New York, 1984), which contains an extensive bibliography; and William H. Gerdts, *American Impressionism: Masterworks from Public and Private Collections in the United States* (exh. cat., Lugano-Castagnola, Switz.: Villa Favorita, Thyssen-Bornemisza Foundation, 1990).

[2] Quoted in A. E. Ives, "Talks with Artists: Mr. Childe Hassam on Painting Street Scenes," *Art Amateur* 27 (Oct. 1892), p. 116.

[3] Some of the American Impressionists most deeply committed to the expression of locale—the Connecticut Impressionists, the Pennsylvania Impressionists, the Hoosier Group, among others—are associated with this later moment. For an introduction to these groups and bibliography, see Gerdts, *American Impressionism* (1984). That the American Impressionists were entirely tame and officially acceptable by 1915 is signaled by the fact that so many of them were extensively represented and so many won medals in the art display at the Panama-Pacific International Exhibition, held that year in San Francisco.

[4] The early nomenclature is summarized in Holger Cahill and Alfred H. Barr, Jr., *Art in America in Modern Times* (New York, 1934), p. 31. For The Eight, see *Exhibition of Paintings . . .* (exh. cat., New York: Macbeth Galleries, 1908), which included Prendergast, Davies, and Lawson, along with Glackens, Henri, Luks, Shinn, and Sloan; and Elizabeth Milroy, *Painters of a New Century: The Eight and American Art* (exh. cat., Milwaukee: Milwaukee Art Museum, 1991).

[5] Cahill and Barr, *Art in America in Modern Times*, p. 31.

[6] For the American Realists' identification with the working class, see Rebecca Zurier, "Picturing the City: New York in the Press and Art of the Ashcan School, 1890–1917" (Ph.D. diss., Yale University, New Haven, 1988). For Riis and other turn-of-the-century urban photographers and journalists, see Peter B. Hales, *Silver Cities: The Photography of American Urbanization, 1839–1915* (Philadelphia, 1984), especially pp. 163–217.

[7] George Cotkin, *Reluctant Modernism: American Thought and Culture, 1880–1900* (New York and Toronto, 1992), p. xi.

[8] See, for example, Van Wyck Brooks, *John Sloan: A Painter's Life* (New York, 1955). Dreiser modeled his archetypal American painter in his novel *The Genius* of 1915 on Shinn. Other sources with a cultural-nationalist bias include Thomas Beers, *The Mauve Decade: American Life at the End of the Nineteenth Century* (New York, 1926); Van Wyck Brooks, *America's Coming of Age* (New York, 1913); Lewis Mumford, *The Brown Decades: A Study of the Arts in America, 1865–1895* (New York, 1931; reprint, New York, 1971); and Van Wyck Brooks, *The Confident Years, 1885–1915* (New York, 1952).

[9] William M. Chase, "The Import of Art: An Interview with Walter Pach," *Outlook* 95 (June 25, 1910), p. 442; and Robert Henri, *The Art Spirit: Notes, Articles, Fragments of Letters and Talks to Students, Bearing on the Concept and Technique of Picture Making, the Study of Art Generally, and on Appreciation,* comp. Margery Ryerson (Philadelphia, 1923; reprint, New York, 1984), p. 116.

[10] John La Farge, "Concerning Painters Who Would Express Themselves in Words," *Scribner's Magazine* 26 (Aug. 1899), p. 256, quoted in Michael Kammen, *Meadows of Memory: Images of Time and Tradition in American Art and Culture* (Austin, Tex., 1992), p. xv.

[11] See P. G. Hamerton in *Saturday Review,* June 1, 1867, reprinted in "Critic's Analysis," in James McNeill Whistler, *The Gentle Art of Making Enemies* (London, 1890), p. 44; Whistler's response, dated "Chelsea, June, 1867," appeared as "The Critic's Mind Considered" (ibid., p. 45).

[12] See Robert L. Herbert, *Impressionism: Art, Leisure, and Parisian Society* (New Haven, 1988); as well as Theodore Reff, *Manet and Modern Paris: One Hundred Paintings, Drawings, Prints, and Photographs by Manet and His Contemporaries* (exh. cat., Washington, D.C.: National Gallery of Art, 1982); T[imothy] J. Clark, *The Painting of Modern Life: Paris in the Art of Manet and His Followers* (Princeton, 1984); *A Day in the Country: Impressionism and the French Landscape* (exh. cat., Los Angeles: Los Angeles County Museum of Art, 1984); George T. M. Shackelford and Mary Tavener Holmes, *A Magic Mirror: The Portrait in France, 1700–1900* (exh. cat., Houston: Museum of Fine Arts, 1986); Charles F. Stuckey and William P. Scott, with the assistance of Suzanne G. Lindsay, *Berthe Morisot: Impressionist* (exh. cat., South Hadley, Mass.: Mount Holyoke College Art Museum; Washington, D.C.: National Gallery of Art, 1987); Paul Hayes Tucker, *Monet in the '90s: The Series Paintings* (exh. cat., Boston: Museum of Fine Arts, 1989); Richard R. Brettell, *Pissarro and Pontoise: The Painter in a Landscape* (New Haven, 1990); and Richard R. Brettell, *The Impressionist and the City: Pissarro's Series Paintings* (exh. cat., Dallas: Dallas Museum of Art, 1992).

[13] The interpretive directions in American art history since the 1970s are described in Wanda M. Corn, "Coming of Age: Historical Scholarship in American Art," *Art Bulletin* 70 (June 1988), pp. 188–207, especially pp. 199–206. Recent investigations of turn-of-the-century American paintings in cultural context include, for example, Ilene Susan Fort, *The Flag Paintings of Childe Hassam* (exh. cat., Los Angeles: Los Angeles

County Museum of Art, 1988); Zurier, "Picturing the City"; David Park Curry, *Childe Hassam: An Island Garden Revisited* (exh. cat., Denver: Denver Art Museum, 1990); Bruce Robertson, *Reckoning with Winslow Homer: His Late Paintings and Their Influence* (exh. cat., Cleveland: Cleveland Museum of Art, 1990); Doreen Bolger, Marc Simpson, and John Wilmerding, eds., *William M. Harnett* (exh. cat., New York: The Metropolitan Museum of Art; Fort Worth: Amon Carter Museum, 1992); and Marianne Doezema, *George Bellows and Urban America* (New Haven, 1992).

[14] Within the vast literature on the period in the United States, the following provide useful overviews: Robert H. Wiebe, *The Search for Order, 1877–1920* (New York, 1967); Neil Harris, ed., *The Land of Contrasts, 1880–1901* (New York, 1970), an anthology of primary source materials with an excellent introduction by Harris; Howard Mumford Jones, *The Age of Energy: Varieties of American Experience, 1865–1915* (New York, 1970); and Alan Trachtenberg, *The Incorporation of America: Culture and Society in the Gilded Age* (New York, 1982). For the international context Eric Hobsbawm, *The Age of Empire, 1875–1914* (New York, 1987), is helpful. Thomas J. Schlereth, *Victorian America: Transformations in Everyday Life, 1876–1915* (New York, 1991), provides an encyclopedic overview of the period's material culture. Adele Heller and Lois Rudnick, eds., *1915, the Cultural Moment: The New Politics, the New Woman, the New Psychology, the New Art, and the New Theatre in America* (New Brunswick, N.J., 1991), presents a cross section of American thought at the end of the period. Also helpful are Arthur M. Schlesinger, Jr., *The Almanac of American History* (New York, 1983), and Gorton Carruth, *The Encyclopedia of American Facts and Dates*, 8th ed. (New York, 1987).

[15] Overviews of the development of the consumer culture are provided in Simon J. Bronner, ed., *Consuming Visions: Accumulation and Display of Goods in America, 1880–1920* (New York, 1989); and William Leach, *Land of Desire: Merchants, Power, and the Rise of a New American Culture* (New York, 1993).

[16] For discussion of Koehler's *Strike*, see Gabriel P. Weisberg, *Beyond Impressionism: The Naturalist Impulse* (New York, 1992), pp. 165–67; and the entry by Judith Hayward in Annette Blaugrund et al., *Paris 1889: American Artists at the Universal Exposition* (exh. cat., Philadelphia: Pennsylvania Academy of the Fine Arts, 1989), p. 181.

[17] W[illiam] D[ean] Howells, *Criticism and Fiction* (New York, 1891), p. 128. Howells himself departed from that prescription in such works as *A Modern Instance* (Boston, 1881), which treats suicide and divorce.

[18] A paradigm of the distinction between French and American social-realist art is discussed in Lisa N. Peters, "Images of the Homeless in American Art, 1860–1910," in Rick Beard, ed., *On Being Homeless: Historical Perspectives* (exh. cat., New York: Museum of the City of New York, 1987), pp. 42–67.

[19] Public and private patrons and collectors of American Impressionist painting are discussed in Teresa A. Carbone, "An Imitation Is Worth Nothing: Patronage of the First American Impressionists," Wadsworth Atheneum Collectors' Council, Hartford, Conn., Dec. 1991; an earlier version of this lecture (manuscript, Graduate School and University Center, City University of New York, 1985) is acknowledged as the basis for William H. Gerdts, "Collectors of American Impressionism," in William H. Gerdts, *Masterworks of American Impressionism from the Pfeil Collection* (exh. cat., Alexandria, Va.: Art Services International, 1992), pp. 31–38.

[20] Stanley Coben, *Rebellion Against Victorianism: The Impetus for Cultural Change in 1920s America* (New York, 1991), p. 17. For the extent of prostitution in the United States, see Ronald G. Waters, *Primers for Prudery: Sexual Advice to Victorian America* (Englewood Cliffs, N.J., 1974); and Ruth Rosen, *The Lost Sisterhood: Prostitution in America, 1900–1918* (Baltimore, 1982). American moral reform movements, which reflect the widespread nature of prostitution, are reviewed in David J. Pivar, *Purity Crusade: Sexual Morality and Social Control, 1868–1900* (Westport, Conn., 1973). John D'Emilio and Estelle B. Freedman, *Intimate Matters: A History of Sexuality in America* (New York, 1988), pp. 208–15, describes early twentieth-century efforts to curb prostitution.

[21] "New York the Beauty City: Hassam Declares That Paris and London Have Nothing to Compare with It, Though We May Not Know It," *New York Sun*, Feb. 23, 1913, Sunday magazine (section 4), p. 16.

[22] The site has been tentatively identified by Teresa A. Carbone, the principal author of the forthcoming catalogue of the American paintings collection of The Brooklyn Museum.

[23] James A. McNeill Whistler, *"Ten O'Clock"* (1885; Portland, Maine, 1916), pp. 13–14. Donelson F. Hoopes invoked this passage from Whistler in connection with Hassam's *Late Afternoon, New York: Winter* in Donelson F. Hoopes, *Childe Hassam* (New York, 1979), p. 54.

[24] Closely related to this painting is Henri's *New York Street in Winter*, also dated 1902 (National Gallery of Art, Washington, D.C.), which compresses similar elements into a vertical format. For a discussion of both works and related issues in Henri's oeuvre, see Bruce Chambers, "Robert Henri's *Street Scene with Snow (57th Street, N.Y.C.):* An Idea of City in Snow Effect," *Yale University Art Gallery Bulletin* 39 (Winter 1986), pp. 30–39.

[25] Henri, *Art Spirit*, p. 85.

[26] The 1901–2 Edison Catalogue noted this film, which represented innovation in rotating the camera, or panning: "Our camera is revolved from right to left and takes in Madison Square, Madison Square Garden, looks up Broadway from South to North, passes the Fifth Avenue Hotel, and ends looking down 23rd Street West," quoted in Carruth, *Encyclopedia of American Facts and Dates*, p. 393.

[27] Robert C. Reed, *The New York Elevated* (South Brunswick, N.J., New York, and London, 1978), p. 110, notes the route of the spur line; the main line turned westward at Fiftieth Street, running through Fifty-third Street to Ninth Avenue, which it followed north. The Sixth Avenue elevated line was taken out of service in 1938.

[28] Photographs of the Fifty-seventh Street locale that Henri depicted appear in "Fifty-seventh Street: New York City's Rue de la Paix," *New York Tribune*, Dec. 2, 1923, section 7, p. 1 (photograph taken in 1923); and William R. De Plata, *Tell It from Calvary* (New York, 1972), p. 30 (photograph taken in 1889). David G. Lowe, "An Ashcan View of Gotham," in *New York, N.Y.* (New York, 1968), p. 75, claims incorrectly that the view is looking west. The old Calvary Church was razed in 1929 and replaced on the same site in 1931 by a church-hotel complex. See De Plata, *Tell It from Calvary*, pp. 53–59.

[29] "New York City's Rue de la Paix," pp. 13–20.

[30] Hassam had moved into the Rembrandt Building at 152 West Fifty-seventh Street in 1893 and Henri had a studio in the Sherwood Building at the corner of Sixth Avenue.

[31] For an introduction to Pictorialist photography in New York, see Alan Trachtenberg, "Image and Ideology: New York in the Photographer's Eye," *Journal of Urban History* 10 (Aug. 1984), pp. 453–64.

[32] Jacob A. Riis, "Midwinter in New York," *Century* 59 (Feb. 1900), pp. 523, 524.

[33] J. Alden Weir, Letter to his parents, Mr. and Mrs. Robert W. Weir, Paris, Apr. 15, 1877, quoted in Dorothy Weir Young, *The Life and Letters of J. Alden Weir*, ed. Lawrence W. Chisolm (New Haven, 1960; reprint, New York, 1971), p. 123.

[34] The notion that an academic armature exists in American Impressionism and a rejection of the long-standing cultural-nationalist rationale that vestigial Luminism produced a cautious and conceptual version of the style were first proposed in H. Barbara Weinberg, "Robert Reid: 'Academic Impressionist,'" *Archives of American Art Journal* 15, no. 1 (1975), pp. 2–11, and expanded in H. Barbara Weinberg, "American Impressionism in Cosmopolitan Context," *Arts Magazine* 55 (Nov. 1980), pp. 160–65.

[35] Robert Henri, "The New York Exhibition of Independent Artists," *Craftsman* 18 (May 1910), p. 167.

[36] Ibid., p. 161.

[37] Ibid., p. 162.

38 For another discussion of this painting, see Jefferson C. Harrison, *The Chrysler Museum: Handbook of the European and American Collections: Selected Paintings, Sculpture, and Drawings* (Norfolk, Va., 1991), p. 149.

39 Recent accounts of American painters' responses to French academic art are Lois Marie Fink, *American Art at the Nineteenth-Century Paris Salons* (Washington, D.C., 1990); and H. Barbara Weinberg, *The Lure of Paris: Nineteenth-Century American Painters and Their French Teachers* (New York, 1991). For emulation of Barbizon art, see Peter Bermingham, *American Art in the Barbizon Mood* (exh. cat., Washington, D.C.: National Collection of Fine Arts, Smithsonian Institution, 1975).

40 We are grateful to Chris P. Giftos, Coordinator, Great Hall and Plaza, and Manager for Special Events, Metropolitan Museum, for identifying flora in the painting.

41 John Sloan, Diary, Mar. 28, 1907, quoted in Bruce St. John, ed., *John Sloan's New York Scene from the Diaries, Notes, and Correspondence, 1906–1913* (New York, 1965), p. 116.

42 E. S. Martin, "New York's Easter Parade," *Harper's Weekly* 49 (Apr. 22, 1905), p. 567.

43 Sloan, Diary, Apr. 1, Mar. 31, 1907, quoted in St. John, *John Sloan's New York Scene*, pp. 116–17.

44 Charles Baudelaire, "Le Peintre de la vie moderne" (1863), in *The Painter of Modern Life and Other Essays*, trans. Jonathan Mayne (London, 1964), p. 9. Robert L. Herbert (*Impressionism*, p. 33) offers this definition: "The *flâneur*, the purposeful male stroller, was a principal performer in the theater of daily life in Paris in mid-century, if we judge by his importance in writings of the era. A journalist, writer, or illustrator, he looked about with the acute eye of a detective, sizing up persons and events with a clinical detachment as though natural events could tell him their own stories, without his interference." See Herbert's discussion of "The Artist as *Flâneur*" (ibid., pp. 33–37).

45 The most successful of these new schools, which served students from all over the world, was the Académie Julian, whose critics—including Boulanger, Lefebvre, and Bouguereau—provided technical instruction that coincided with Beaux-Arts standards. Julian's impact on aspiring American painters, hundreds of whom studied there, was immense. The extent of Julian's influence on the future American Impressionists is reflected in the fact that eight members of The Ten—the most conspicuous group of American Impressionists at the turn of the century—had worked there under Boulanger and Lefebvre.

46 Autobiographical notes by H. Siddons Mowbray, provided to DeWitt McClellan Lockman, Dec. 1925, Lockman Papers, New-York Historical Society (Archives of American Art, DeWitt McClellan Lockman Papers [microfilm, reels 502–4]).

47 George Moore, *Confessions of a Young Man* (1886), quoted in Hans Huth, "Impressionism Comes to America," *Gazette des Beaux-Arts*, ser. 6, 29 (Apr. 1946), p. 225. Bouguereau and Lefebvre were popular academic painters as well as prominent critics at the Académie Julian.

48 The appeal of picturesque peasant subjects to an American public clinging to old-fashioned values in the face of the bewildering new urban-industrial society is the subject of Julia Rowland Myers, "The American Expatriate Painters of the French Peasantry, 1863–1893" (Ph.D. diss., University of Maryland, College Park, 1989). Myers argues (pp. 369–87) that the decline of peasant painting in the 1890s was linked to burgeoning nationalism and acceptance of the new order of things.

49 For a summary of the early American response to French Impressionism, see Gerdts, *American Impressionism* (1984), pp. 48–53. Still helpful earlier summaries of this subject include Huth, "Impressionism Comes to America," pp. 225–52; Dianne H. Pilgrim, *American Impressionist and Realist Paintings and Drawings from the Collection of Mr. and Mrs. Raymond J. Horowitz*, intro. John K. Howat (exh. cat., New York: The Metropolitan Museum of Art, 1973); and H. Wayne Morgan, *New Muses: Art in American Culture, 1865–1920* (Norman, Okla., 1978), pp. 112–44.

50 Henry James, Jr., "Parisian Festivity," Letter to the *New York Tribune*, Paris, Apr. 22, 1876, quoted in Henry James, *Parisian Sketches: Letters to the New York Tribune, 1875–1876*, ed. Leon Edel and Ilse Dusoir Lind (New York, 1957), p. 131.

51 See John Moran, "The American Water-Colour Society's Exhibition," *Art Journal* (New York) 4 (1878), p. 92; "The Old Cabinet," *Century* 15 (Apr. 1878), pp. 888–89; and L. Lejeune, "The Impressionist School of Painting," *Lippincott's Magazine* 24 (Dec. 1879), pp. 720–27. All three articles are cited in Gerdts, *American Impressionism* (1984), p. 49.

52 "Manet and Zola," *Art Interchange* 3 (Dec. 10, 1879), pp. 100–101.

53 K[enyon] C[ox], "The Paris Salon—III," Cincinnati *Daily Gazette*, July 9, 1879 (earlier installments appeared on June 11 and July 5, 1879); unpaginated clippings courtesy of H. Wayne Morgan.

54 Frances Weitzenhoffer, "First Manet Paintings to Enter an American Museum," *Gazette des Beaux-Arts*, ser. 6, no. 97 (Mar. 1981), pp. 125–29. Laura L. Meixner's forthcoming study, *French Images in American Society, 1865–1900*, will explore the critical reception of works by Manet and other French modernists.

55 For a detailed discussion of this exhibition and the European paintings included in it, see Maureen C. O'Brien, *In Support of Liberty: European Paintings at the 1883 Pedestal Fund Art Loan Exhibition* (exh. cat., Southampton, N.Y.: Parrish Art Museum, 1986).

56 The exhibition opened in March at the American Art Association, a commercial gallery; by public demand it was enlarged and transferred to the National Academy of Design in May. The catalogue for this exhibition includes critical commentary, much of it translated from French into English. See *Works in Oil and Pastel by the Impressionists of Paris* (exh. cat., New York: American Art Association, 1886); and *Special Exhibition: Works in Oil and Pastel by the Impressionists of Paris* (exh. cat., New York: National Academy of Design, 1886).

57 "The Fine Arts: The French Impressionists," *Critic*, n.s. 5, no. 120 (Apr. 17, 1886), p. 195.

58 The success of the 1886 exhibition encouraged Durand-Ruel to hold a second—but far more conservative—display the following year. See *Catalogue of Celebrated Paintings by Great French Masters Brought to This Country from Paris for Exhibition Only* (exh. cat., New York: National Academy of Design, 1887). Huth, "Impressionism Comes to America," pp. 248–49, provides a summary. For contemporary commentary on the 1887 show, see Montezuma [Montague Marks], "My Note Book," *Art Amateur* 17 (June 1887), p. 2; and "French Paintings at the Academy," *Art Amateur* 17 (July 1887), p. 32.

59 Huth, "Impressionism Comes to America," p. 246.

60 For a thoughtful discussion of the American critical response to French Impressionism, see Morgan, *New Muses*, pp. 112–44.

61 William Howe Downes, "Impressionism in Painting," *New England Magazine*, n.s. 6, no. 5 (July 1892), p. 601.

62 R[oger] R[iordan], "The Impressionist Exhibition," *Art Amateur* 15 (June 1886), p. 4.

63 "The Impressionist Exhibition," *Art Amateur* 14 (May 1886), p. 6. It was not unusual for commentators to draw analogies between Impressionists and past masters. Theodore Child, "A Note on Impressionist Painting," *Harper's New Monthly Magazine* 74 (Jan. 1887), p. 313, asked: "Have there not been impressionists ever since Piero della Francesca and the masters of the fifteenth century down to Corot?" Other critics located the roots of the French Impressionists in Velázquez. See, for example, Downes, "Impressionism in Painting," p. 600; and "Velasquez and Impressionism," *Art Amateur* 34 (Mar. 1886), p. 87.

64 *New York Times*, May 28, 1886, quoted in Morgan, *New Muses*, p. 123.

65 Child, "Note on Impressionist Painting," p. 314.

66 Montezuma, "My Note Book," p. 87.

67 "Fine Arts: French Impressionists," p. 196.

68 "The Impressionists," *Art Age* 3 (Apr. 1886), p. 166.

69 See Tucker, *Monet in the '90s*.

70 Gerdts, *Pfeil Collection*, mentions an exhibition at New York's Century Association in May 1885

that included eight landscapes and marines by Monet and one painting each by Pissarro and Cassatt. Other New York and Boston exhibitions of French Impressionists before 1895 include displays at Durand-Ruel and the Union League Club, New York, and at the Eastman Chase Gallery and St. Botolph Club, Boston, variously featuring Sisley, Monet, Pissarro, Renoir, Degas, and Manet. Between 1888 and 1895 American Impressionists Sargent, Metcalf, Breck, Bunker, Tarbell, Benson, Twachtman, Weir, Wendel, and Robinson were shown in Boston at the St. Botolph Club, the Doll and Richards Gallery, and the Williams and Everett Gallery or in New York at Durand-Ruel, the Blakeslee Gallery, the Wunder-lich Gallery, and the Macbeth Galleries. The American Art Galleries, New York, staged an exhibition that compared Weir and Twachtman, Monet and Besnard in 1893.

71 The fullest account appears in William H. Gerdts et al., *Ten American Painters* (exh. cat., New York: Spanierman Gallery, 1990).

72 Alfred Trumble, "Impressionists and Imitators," *Art Collector* 2 (Nov. 15, 1889), p. 11, as quoted in Carbone, "An Imitation Is Worth Nothing."

73 Carbone, "An Imitation Is Worth Nothing."

74 For an account of Macbeth's career, see Malcolm Goldstein, "William Macbeth: Art Dealer," *Drawing* 15 (Sept.–Oct. 1993), pp. 53–58.

75 Carbone, "An Imitation Is Worth Nothing"; and Gerdts, "Collectors of American Impressionism," p. 37. Few of these collectors have been the subjects of individual studies; for one, see William H. Truettner, "William T. Evans, Collector of American Paintings," *American Art Journal* 3 (Fall 1971), pp. 50–79.

76 Gerdts, "Collectors of American Impressionism," pp. 36–37.

77 Ibid., p. 34. For an extended discussion of the academy's support and collection of American Impressionism, see Susan Danly, *Light, Air, and Color: American Impressionist Paintings from the Collection of the Pennsylvania Academy of the Fine Arts* (exh. cat., Philadelphia: Pennsylvania Academy of the Fine Arts, 1990).

78 Gerdts, "Collectors of American Impressionism," p. 32.

79 Regarding changes in American painting instruction, see William H. Gerdts, "The Teaching of Painting Out-of-Doors in America in the Late Nineteenth Century," in Bruce Weber and William H. Gerdts, *In Nature's Ways: American Landscape Painting of the Late Nineteenth Century* (exh. cat., West Palm Beach, Fla.: Norton Gallery of Art, 1987), pp. 25–40; and Doreen Bolger, "The Education of the American Artist," in Richard J. Boyle and Frank H. Goodyear, Jr., *In This Academy: The Pennsylvania Academy of the Fine Arts, 1805–1976* (exh. cat., Philadelphia: Pennsylvania Academy of the Fine Arts, 1976), pp. 51–74.

80 For a general account of the phenomenon, see Morgan, *New Muses*; and Doreen Bolger Burke et al., *In Pursuit of Beauty: Americans and the Aesthetic Movement* (exh. cat., New York: The Metropolitan Museum of Art, 1986).

81 For a summary of these developments, see Doreen Bolger Burke, *American Paintings in The Metropolitan Museum of Art*, vol. 3, *A Catalogue of Works by Artists Born Between 1846 and 1864*, ed. Kathleen Luhrs (New York, 1980), pp. xvii–xxxii.

82 The best account of the commercial aspects of American Realism appears in Milroy, *Painters of a New Century*. We are also indebted to Elizabeth Milroy for providing additional information in conversation, Oct. 14, 1993.

83 Henri, "New York Exhibition of Independent Artists," p. 161.

84 The tendency of Americans to reconstruct their past to meet the needs of their present and the coincidence of modernism and nostalgia are brilliantly described in Michael Kammen, *Mystic Chords of Memory: The Transformation of Tradition in American Culture* (New York, 1991). Kammen elaborates on the long-standing impulse of American painters to seek emblems of tradition in his *Meadows of Memory* (especially pp. 133–81). A specific instance of the re-creation of the American past in civic celebrations in the same period is studied in David Glassberg, *American Historical Pageantry: The Uses of Tradition in the Early Twentieth Century* (Chapel Hill, N.C., 1990). Turn-of-the-century Americans' interest in the American past should be viewed against the diverse forms of antimodernism that are the subject of T. J. Jackson Lears, *No Place of Grace: Antimodernism and the Transformation of American Culture, 1880–1920* (New York, 1981). The reinvention of the past in the United States can also be viewed against the international background, for which, see Eric Hobsbawm and Terence Ranger, eds., *The Invention of Tradition* (Cambridge, 1983); and Stephen Kern, *The Culture of Time and Space, 1880–1918* (Cambridge, Mass., 1983). For an introduction to the meanings of New England after the Civil War, see John Brinckerhoff Jackson, *American Space: The Centennial Years, 1865–1876* (New York, 1972), pp. 87–136.

85 Warren I. Susman, *Culture as History: The Transformation of American Society in the Twentieth Century* (New York, 1984), p. 42.

86 We are indebted to Kimberly Paice, who researched this picture in a seminar taught by Doreen Bolger at the Graduate School and University Center, City University of New York, in fall 1987, and to Margaret Ellen Fein, who wrote "J. Alden Weir: Paintings of the Willimantic Linen Company, 1893–1897" for H. Barbara Weinberg's fall 1990 seminar, "American Art at the Turn of the Century," Graduate School and University Center, City University of New York. For published

discussions of this painting, see Doreen Bolger Burke, *J. Alden Weir: An American Impressionist* (Newark, Del., 1983), pp. 218–19; and Doreen Bolger in Gerdts et al., *Ten American Painters*, p. 171.

87 *Windham Herald*, Nov. 1811, quoted in "Willimantic and Its Points of Interest," p. 8, unidentified and undated article in the files of the Departments of American Art, Metropolitan Museum.

88 "Willimantic and Its Points of Interest," pp. 10–11. From 1870 to 1890 Willimantic's population grew from 4,000 to 11,000.

89 See "A Brief History of the American Thread Company Willimantic Mills" (manuscript, revised 1983), files of the Departments of American Art, Metropolitan Museum; and *A Memorial Volume of the Bi-centennial Celebration of the Town of Windham, Connecticut; Containing the Historical Addresses, Poems, and a Description of Events Connected with the Observance of the Two Hundredth Anniversary of the Incorporation of the Town, as Held in the Year 1892* (Hartford, Conn., 1893), pp. 75–80.

90 "Spool-Cotton Thread," p. 1134, unidentified and undated article in the files of the Departments of American Art, Metropolitan Museum.

91 The general context of labor history within which Weir's painted commentary on industry and labor may be viewed is available in such recent sources as Herbert G. Gutman, *Work, Culture, and Society in Industrializing America: Essays in American Working-Class and Social History* (New York, 1977); and David Montgomery, *The Fall of the House of Labor: The Workplace, the State, and American Labor Activism, 1865–1925* (Cambridge and Paris, 1987).

92 The best account of the formation of these collections appears in Edward Strahan [Earl Shinn], *The Art Treasures of America*, 3 vols. (Philadelphia, 1879–[82]; reprint, New York, 1977).

93 "America in Pictures," *New York Times*, Apr. 16, 1879, p. 6.

94 George William Sheldon, *Recent Ideals of American Art: One Hundred and Seventy-five Oil Paintings and Water Colors in the Galleries of Private Collectors, Reproduced in Paris on Copper Plates by the Goupil Photogravure and Typogravure Processes* (New York and London, 1888–90; reprint, New York, 1977), p. 38.

95 See H. Barbara Weinberg, "Cosmopolitan Attitudes: The Coming of Age of American Art," in Blaugrund et al., *Paris 1889*, p. 50.

96 Sheldon, *Recent Ideals of American Art*, p. 37. Throughout the 1880s the call for American subjects remained a subtext in art criticism. See, for example, "Why Americans Should Buy American Pictures," *Studio and Musical Review* 1 (Feb. 19, 1881), p. 51; and W. Mackay Laffan, "The Material of American Landscape," *American Art Review* 1 [1880?], pp. 29–32. We are grateful to Anne Terhune for bringing these articles to our attention.

[97] H[ippolyte] Taine, *Lectures on Art* (1865), trans. John Durand, 2 vols. (New York, 1875), vol. 1, pp. 34, 89, 93, 95. A Tainean argument for nationality in painting appears in Chase, "Import of Art," p. 442. For a discussion of Taine's influence in America, see Roger B. Stein, *John Ruskin and Aesthetic Thought in America, 1840–1900* (Cambridge, Mass., 1967), pp. 220–23.

[98] See Tucker, *Monet in the '90s.*

[99] Raymond Daily, "Raffaëlli on American Art," *Collector* 6 (Sept. 1, 1895), p. 294 (excerpted from the *Sun*). See Theodore Robinson, Diaries, Feb. 14, 1895, Frick Art Reference Library, New York, for the American Impressionist's conversation with Raffaëlli at J. Alden Weir's home during the French artist's 1895 American tour.

[100] See, for example, H. G. Cutler, "The American: Not a New Englishman, But a New Man," *New England Magazine*, n.s. 9 (Sept. 1893), pp. 24–31; Theodore Roosevelt, "What 'Americanism' Means," *Forum* 17 (Apr. 1894), pp. 196–206; Thomas Davidson, "The Ideal Training of an American Boy," *Forum* 17 (July 1894), pp. 571–81; "American Optimism," *Spectator* 73 (Sept. 22, 1894), pp. 365–67; William Dean Howells, "The Modern American Mood," *Harper's New Monthly Magazine* 95 (July 1897), pp. 199–204; and Robert Grant, "Search-Light Letters: Letter to a Young Man Wishing to Be an American," *Scribner's Magazine* 26 (July 1899), pp. 104–16.

[101] John Higham, "The Reorientation of American Culture in the 1890's," in Horace John Weiss, ed., *The Origins of Modern Consciousness* (Detroit, 1965), pp. 25–48, posits a generalized revulsion toward European cultural leadership among American artists and intellectuals in the 1890s.

[102] Donald Pizer, ed., *American Thought and Writing: The 1890's* (Boston, 1972), provides an overview of the literature of the decade. Alan Axelrod, ed., *The Colonial Revival in America* (Winterthur, Del., 1985), details many manifestations of nostalgia for eighteenth-century America.

[103] Garland had studied Taine as well as the Social Darwinist philosophy of Spencer, who encouraged economic competition and anticipated the survival of the fittest nation, which Americans understood to be their own. For a discussion of the application of Spencer's philosophy to American landscape painting, see Kathleen A. Pyne, "John Twachtman and the Therapeutic Landscape," in Deborah Chotner, Lisa N. Peters, and Kathleen A. Pyne, *John Twachtman: Connecticut Landscapes* (exh. cat., Washington, D.C.: National Gallery of Art, 1989), p. 57.

[104] Hamlin Garland, "Local Color in Art," in Hamlin Garland, *Crumbling Idols: Twelve Essays on Art Dealing Chiefly with Literature, Painting, and the Drama* (1894), new ed., ed. Jane Johnson (Cambridge, Mass., 1960), pp. 53–54.

[105] Hamlin Garland, "Impressionism," in Garland, *Crumbling Idols*, p. 104.

[106] Clarence Cook, "National Academy of Design," *Studio* (New York), n.s. 3 (June 1888), p. 112.

[107] "The Fine Arts," *Boston Evening Transcript*, Jan. 20, 1890, p. 3.

[108] Theodore Robinson, Letter to Kenyon Cox, Newport, R.I., May 31, 1883, Kenyon Cox Papers, Avery Architectural and Fine Arts Library, Columbia University, New York.

[109] John Henry Twachtman, Letter to J. Alden Weir, Jan. 2, 1885, Weir Family Papers.

[110] Dennis Miller Bunker, Letter to Joe Evans, Nov. 25, 1885, Dennis Miller Bunker Papers, Archives of American Art, Smithsonian Institution, Washington, D.C. (microfilm, reel 1201).

[111] Ibid., July 26, 1886.

[112] Ralph Waldo Emerson, "The American Scholar" (1837), in *The Selected Writings of Ralph Waldo Emerson*, ed. Brooks Atkinson (New York, 1950), p. 45.

[113] For a discussion of modern art at the fair, see John D. Kysela, "Sara Hallowell Brings 'Modern Art' to the Midwest," *Art Quarterly* 27, no. 2 (1964), pp. 150–67. For extended discussion of the display of American paintings, see Carolyn Kinder Carr and George Gurney, *Revisiting the White City: American Art at the 1893 World's Fair*, with essays by Robert W. Rydell and Carolyn Kinder Carr (exh. cat., Washington, D.C.: National Museum of American Art and National Portrait Gallery, Smithsonian Institution, 1993).

[114] This display, *Loan Collection of Foreign Works from Private Galleries in the United States*, included loans of French Impressionist works from the Havemeyers, Alexander Cassatt, the Palmers, and other collectors. Among the paintings were *Dead Toreador* of 1864 (National Gallery of Art, Washington, D.C.) and two marines by Manet; canvases by Degas (including one of ballet dancers and one of racehorses); several landscapes by Pissarro and one by Sisley; and four paintings by Monet.

[115] Tonalist landscape painting, exemplified by the works of Inness and the artists he influenced, including Wyant, Martin, and Tryon, flourished concurrently with American Impressionism and offered a similar rejection of the academic and a revival of the traditional American devotion to landscape subjects.

[116] See Brandon Brame Fortune and Michelle Mead, "Catalogue of American Paintings and Sculptures Exhibited at the World's Columbian Exposition, Revised and Updated," in Carr and Gurney, *Revisiting the White City*, pp. 193–353, passim.

[117] Garland, "Impressionism," p. 103.

[118] [Charles Francis Browne, Hamlin Garland, and Lorado Taft], *Impressions on Impressionism; Being a Discussion of the American Art Exhibition at the Art Institute, Chicago, by a Critical Triumvirate* (Chicago, 1894), p. 23.

[119] See *The Hoosier Group: Five American Painters,* intro. William H. Gerdts, essays by Judith Vale Newton, works selected by Jane and Henry Eckert (Indianapolis, 1985).

[120] Recent accounts of turn-of-the-century American art and criticism that highlight emerging cultural nationalism include Linda J. Docherty, "Native Art/National Art: Art Criticism, Scientific Culture, and American Identity, 1876–1893" (manuscript based on the author's Ph.D. diss., University of North Carolina, Chapel Hill, 1985); Sarah J. Moore, "John White Alexander (1856–1915): In Search of the Decorative" (Ph.D. diss., City University of New York, 1991); and Diane Pietrucha Fischer, "The 'American School' in Paris: The Repatriation of American Art at the Exposition Universelle of 1900" (Ph.D. diss., City University of New York, 1993).

[121] Robertson, *Reckoning with Winslow Homer*, especially pp. 63–80. Robertson wrote: "*American* was set against *European*, of course. . . . The question of Americanness reached fundamental levels: what was it to be native-born (or Anglo-Saxon), to be white, to be male, even to be human in a world in which machines and nature both loomed larger than any man (women, blacks, and foreigners were seldom privileged to ask these questions). For Homer and his generation, the question was inward directed and sometimes paralyzing. . . . These were men in a republic whose dream of national mission had been shattered by the Civil War and had never really healed. Healing now seemed impossible, the pastoral past irrevocably displaced by industry, immigrants, corporations" (pp. 63, 64).

[122] Twentieth-century accounts that stress the American qualities of American Impressionism include Bayard Boyesen, "The National Note in American Art," *Putnam's Monthly and The Reader* 4 (May 1908), pp. 131–40; Christian Brinton, "Willard L. Metcalf," *Century* 77 (Nov. 1908), p. 155; Israel L. White, "Childe Hassam—a Puritan," *International Studio* 45 (Dec. 1911), pp. 29–36; Frederic Newlin Price, "Childe Hassam—Puritan," *International Studio* 77 (Apr. 1923), pp. 3–7; and Catherine Beach Ely, "Willard L. Metcalf," *Art in America* 13 (Oct. 1925), pp. 332–36, which notes (p. 332) Metcalf's "thoroughly American temperament" and his ability to paint a "portrait of a scene essentially American."

[123] Docherty, "Native Art/National Art," summarizes the rationales that were offered in the late nineteenth century to support the creation of American art from foreign sources. For the acceptance of Barbizon inspiration for Tonalist paintings, which were considered very American, see Fischer, "'American School' in Paris."

[124] "Foreword," in *Official Catalogue of Exhibitors, Universal Exposition*, rev. ed. (St. Louis, 1904), p. 17. The unsigned commentary may have been written by Halsey Ives, Chief of the Exposition's Department of Art.

The Studio

1. "Janitor Brother Tells How Chance Aided W.M. Chase," *Indianapolis Star*, Mar. 25, 1917, quoted in Ronald G. Pisano, *A Leading Spirit in American Art: William Merritt Chase, 1849–1916* (exh. cat., Seattle: Henry Art Gallery, University of Washington, 1983), p. 25.

2. Robert Henri, Diary, Sept. 22, 1888, Archives of American Art, quoted in William Innes Homer, *Robert Henri and His Circle* (Ithaca, N.Y., 1969; rev. ed., New York, 1988), p. 40.

3. Homer, *Robert Henri and His Circle*, p. 4. An exhibition of Henri's work was held in October and November 1897 at the Pennsylvania Academy of the Fine Arts, Philadelphia, where Chase was an instructor, and it seems likely that they met by then, if not earlier.

4. Guy Pène du Bois, "Henri Memorial Exhibition," *Arts* 17 (Apr. 1931), p. 497.

5. For another discussion of the portrait, see Doreen Bolger Burke, *American Paintings in The Metropolitan Museum of Art*, vol. 3, *A Catalogue of Works by Artists Born Between 1846 and 1864*, ed. Kathleen Luhrs (New York, 1980), pp. 81–85. For an account of the friendship between Chase and Whistler, see Pisano, *Leading Spirit in American Art*, pp. 77–83.

6. Russell Lynes, *The Art-Makers of Nineteenth-Century America* (New York, 1970), p. 410.

7. William M. Chase, "The Two Whistlers: Recollections of a Summer with the Great Etcher," *Century* 80 (June 1910), p. 222, quoted in Burke, *American Paintings in the Metropolitan Museum*, p. 83.

8. Frances Lauderbach, "Notes from Talks by William M. Chase: Summer Class, Carmel-by-the-Sea, California; Memoranda from a Student's Note Book," *American Magazine of Art* 8 (Sept. 1917), p. 438.

9. William M. Chase, "The Import of Art: An Interview with Walter Pach," *Outlook* 95 (June 25, 1910), p. 444.

10. For a full discussion of the *flâneur* in French art, see Robert L. Herbert, *Impressionism: Art, Leisure, and Parisian Society* (New Haven, 1988), pp. 43–47.

11. William M. Chase, "Painting," *American Magazine of Art* 8 (Nov. 1916), p. 50. The late nineteenth-century professionalization of artists should be viewed against the phenomenon of professionalization in other fields. See, for example, Burton J. Bledstein, *The Culture of Professionalism: The Middle Class and the Development of Higher Education in America* (1976; reprint, New York, 1978), especially pp. 80–128 and 159–202; and Thomas L. Haskell, ed., *The Authority of Experts: Studies in History and Theory* (Bloomington, Ind., 1984).

12. Whistler's remarks appeared in a letter to a friend that was published in the *New York Tribune*, Oct. 12, 1886, p. 1, quoted in Burke, *American Paintings in the Metropolitan Museum*, p. 83. Whistler's portrait of Chase is currently unlocated, making it difficult to assess the veracity of Whistler's claims.

13. Robert Henri, *The Art Spirit: Notes, Articles, Fragments of Letters and Talks to Students, Bearing on the Concept and Technique of Picture Making, the Study of Art Generally, and on Appreciation*, comp. Margery Ryerson (Philadelphia, 1923; reprint, New York, 1984), p. 1.

14. Forbes Watson, "George Luks: Artist and Character," *American Magazine of Art* 28 (Jan. 1935), p. 22.

15. For a discussion of Luks's personality and behavior, see ibid., pp. 21–22. For commentary on the nature of Realist indecorousness, see Marianne Doezema, *George Bellows and Urban America* (New Haven, 1992), p. 119.

16. Bennard B. Perlman, "Drawing on Deadline," *Art and Antiques*, Oct. 1988, pp. 115–16, 118, 120.

17. Charles de Kay, "Six Impressionists: Startling Works by Red-Hot American Painters," *New York Times*, Jan. 20, 1904, p. 9.

18. For illuminating commentary on this painting, see Karal Ann Marling, "Portrait of the Artist as a Young Woman: Miss Dora Wheeler," *Bulletin of the Cleveland Museum of Art* 65 (Feb. 1978), pp. 47–57.

19. Candace Wheeler's partners were Louis Comfort Tiffany, Samuel Colman, and Lockwood de Forest. She continued to use the name Associated American Artists after the partnership dissolved in 1883. See Catherine Hoover Voorsanger, "Candace Wheeler," in Doreen Bolger Burke et al., *In Pursuit of Beauty: Americans and the Aesthetic Movement* (exh. cat., New York: The Metropolitan Museum of Art, 1986), pp. 481–83.

20. For a discussion of the professionalization of the woman artist and its relationship to developments in the decorative arts, see Linda Nochlin, "Women Artists After the French Revolution," in Ann Sutherland Harris and Linda Nochlin, *Women Artists: 1550–1950* (exh. cat., Los Angeles: Los Angeles County Museum of Art, 1976), pp. 59–61. See also Roger B. Stein, "Artifact as Ideology: The Aesthetic Movement in Its American Cultural Context," in Burke et al., *In Pursuit of Beauty*, pp. 22–51. In her textiles Dora Wheeler aspired to high artistic achievement; she used the abstract patterns typical of British design and also included the human figure in such works as *The Air Spirit* and *The Water Spirit*, which were among the eleven tapestries she designed for Cornelius Vanderbilt. For a discussion of women and the American Aesthetic Movement and Dora Wheeler's role in it, see Karal Ann Marling, "American Art and the American Woman," in *7 American Women: The Depression Decade* (exh. cat., Poughkeepsie, N.Y.: Vassar College Art Gallery, 1976), pp. 10–11.

21. Marling, "Portrait of the Artist as a Young Woman," pp. 47, 56, n. 6. Marling, who provides the most complete discussion of this artistic device, expresses some doubt about whether the form the cat pursues is a reflection of itself, conceding that it "can be read in several ways—as a reflection, or a very cat-like fish" (p. 56, n. 6).

22. Homer, *Robert Henri and His Circle*, p. 120.

23. For Nivison, see Eleanor Munro, *Originals: American Women Artists* (New York, 1979), p. 479, n. 37; and Gail Levin, *Edward Hopper: The Art and the Artist* (exh. cat., New York: Whitney Museum of American Art, 1980), pp. 10–12, 36–40.

24. Munro, *Originals: American Women Artists*, p. 479, n. 37.

25. Raphael Soyer, *Diary of an Artist* (Washington, D.C., 1977), p. 250.

26. Munro, *Originals: American Women Artists*, p. 479, n. 37. For more on women's changing roles, see "The Home: The Limits of Her Sphere," this publication.

27. A. A. Harwood, "The Painter's Study," a short story illustrated by A. Lawson's engraving after Mount's *Painter's Triumph*, in *The Gift: A Christmas and New Year's Present for 1840*, ed. Miss Leslie (Philadelphia, 1839), p. 216; the narrative describes the picture in full on pp. 216–18.

28. E. T. L., "Studio-Life in New York," *Art Journal* 3 (Sept. 1877), p. 267. Recent accounts of the Tenth Street Studio Building include Annette Blaugrund, "The Tenth Street Studio Building" (Ph.D. diss., Columbia University, New York, 1987); and related articles by her: "Edward Lamson Henry: The Tenth Street Studio Building," in Barbara Novak and Annette Blaugrund, eds., *Next to Nature: Landscape Paintings from the National Academy of Design* (exh. cat., New York: National Academy of Design, 1980), pp. 18–22; and "The Tenth Street Studio Building: A Roster, 1857–1895," *American Art Journal* 14, no. 2 (1982), pp. 64–71.

29. E. T. L., "Studio-Life in New York," p. 268.

30. See "Preface," Stein, "Artifact as Ideology," and Doreen Bolger Burke, "Painters and Sculptors in a Decorative Age," in Burke et al., *In Pursuit of Beauty*, pp. 19–21, 22–51, and 294–339.

31. Chase, "Import of Art," p. 441.

32. In 1878, shortly after Chase returned to New York from Europe, he rented an imposing atelier in the Tenth Street Studio Building. In the 1890s his Shinnecock house and studio provided a summer analogue to this famous city studio. Chase gave up the Tenth Street studio in 1895; after the turn of the century he maintained four different studios in New York (one for portraits and figure studies, one dedicated to male and one to female students, and a fourth where he painted fish still lifes), as well as studios in Philadelphia and Florence, but none of these quite duplicated the flamboyant splendor of his first location. For discussions of Chase's Tenth Street studio, see Nicolai Cikovsky, Jr., "William Merritt

Chase's Tenth Street Studio," *Archives of American Art Journal* 16, no. 2 (1976), pp. 2–13; and Gustav Kobbé, "Artists of Many Studios," *New York Herald*, Nov. 20, 1910, magazine section, p. 11. For a discussion of the changing appearance of the artist's studio in America, see Nicolai Cikovsky, Jr., "Introduction," in Richard N. Gregg, *The Artist's Studio in American Painting, 1840–1983* (exh. cat., Allentown, Pa.: Allentown Art Museum, 1983).

[33] Elizabeth Bisland, "The Studios of New York," *Cosmopolitan* 7 (May 1889), pp. 5–6. The shrunken heads beside the tapestries and copies of the old masters remind us that we can trace the origins of the decor of the nineteenth-century artist's studio in part to the cabinets of curiosities that predate public museums.

[34] In Chase's *Interior of the Artist's Studio* of 1880 (The St. Louis Art Museum) a seated painter lolls in the shadows, holding his palette and chatting with the elegant woman who, with her dog, occupies the center of the composition. In his *Corner of My Studio* of about 1880 (The Fine Arts Museums of San Francisco) a woman painter is seen at a distance through an open door. Chase's self-portrait of 1915–16 (Art Association of Richmond, Indiana) is one of the few paintings in which he shows himself at work: here, palette in hand, he stands before an unfinished canvas.

[35] S[amuel] G. W. Benjamin, *Our American Artists; with Portraits, Studios, and Engravings of Paintings* (Boston, 1886), p. 72.

[36] The engraving after Hals, as Cikovsky has pointed out, assumes "a votive character" by virtue of its prominent placement and graphic legibility. Cikovsky, "Chase's Tenth Street Studio," p. 8.

[37] Chase, "Import of Art," p. 444.

[38] Ibid., p. 442. For commentary on Chase's use of motifs from Velázquez, see Nicolai Cikovsky, Jr., "William Merritt Chase at Shinnecock Hills," *Antiques* 132 (Aug. 1987), p. 295.

[39] For a recent discussion of the mirrored image that appears in *Las Meninas* and its significance, see Jonathan Brown, *Velázquez, Painter and Courtier* (New Haven, 1986), pp. 259–60.

[40] Chase, "Import of Art," p. 442.

[41] For another discussion of *The Studio*, see Jane Myers, "'The Most Searching Place in the World': Bellows's Portraiture," in Michael Quick et al., *The Paintings of George Bellows* (exh. cat., Fort Worth: Amon Carter Museum; Los Angeles: Los Angeles County Museum of Art, 1992), pp. 170–72.

[42] "The Relation of Painting to Architecture: An Interview with George Bellows, N. A., in Which Certain Characteristics of the Truly Original Artist Are Shown to Have a Vital Relation to the Architect and His Profession," *American Architect* 118 (Dec. 29, 1920), p. 848.

[43] Hubert von Sonnenburg, Sherman Fairchild Chairman of Paintings Conservation, Metropolitan

Museum, made this observation while examining the painting, Dec. 28, 1992.

[44] "Studios in New York," *New York Tribune*, May 17, 1903, suppl., p. 14, quoted in Cikovsky, "Chase's Tenth Street Studio," p. 8.

[45] For a discussion of Bellows's reliance on the Spanish artists Goya and Velázquez, see Eleanor Tufts, "Realism Revisited: Goya's Impact on George Bellows and Other American Responses to the Spanish Presence in Art," *Arts Magazine* 57 (Feb. 1983), pp. 108–10. In translating his 1916 print to the 1919 canvas, Bellows made significant changes in the portrait of Emma. In the lithograph the portrait is fairly advanced, but in the oil Bellows regresses to an earlier stage. He emphasizes the process of painting by focusing on the application of scientific theory to art, the aspect of his craft that he would have regarded as particularly modern. A less evident but equally important alteration from lithograph to oil occurred in the palette lying on the table beside the working artist. For an illustration of the lithograph, see Linda Ayres and Jane Myers, *George Bellows: The Artist and His Lithographs, 1916–1924* (exh. cat., Fort Worth: Amon Carter Museum, 1988), p. 145.

[46] Ameen Rihani, "Luks and Bellows," *International Studio* 81 (Aug. 1920), p. xxii.

[47] The sitting may have been invented as a device for featuring Mrs. Bellows in the composition: the costume she wears does not correspond to that in any of the known portraits Bellows undertook of Emma in this period, which are listed in his rather complete record book. We are grateful to Jane Myers for this observation.

[48] For a discussion of Bellows's reliance on mathematical formats, see Michael Quick, "Technique and Theory: The Evolution of George Bellows's Painting Style," in Quick et al., *Paintings of George Bellows*, pp. 9–96.

[49] We are grateful to Dorothy Mahon of the Paintings Conservation Department, Metropolitan Museum, for conducting a thorough scientific examination of this painting with an infrared vidicon and to Barbara Bridgers and Joseph Coscia, Jr., of the Photograph Studio, Metropolitan Museum, for taking an infrared photograph of it.

[50] Here Bellows rotates the shorter width of this canvas upon the longer height and uses the width (or fractions of it) to establish the divisions of his composition. If the width of *The Studio* were rotated on its height and a line were drawn across the painting at just that point, it would run along the bottom edge of the balcony—and, in fact, this is precisely where Bellows did draw one of seven systematic horizontal lines, the other six being located at carefully measured intervals. Two of these horizontal lines intersect xs that Bellows drew in the precise center of the width, 18½ inches from either vertical side. One, under the framed landscape painting that hangs above

the window, is obscured by pigment, but the other, in the center of the curtained window, is still visible upon close examination. The lower *x*, in the curtains, is 18¾ inches from the bottom of the canvas, making it almost precisely equidistant from the bottom and the two vertical sides of the canvas. A similar system is applied vertically.

[51] " Relation of Painting to Architecture," p. 848.

[52] Patricia Hills, "'Painted Diaries': Sargent's Late Subject Pictures," in Patricia Hills et al., *John Singer Sargent* (exh. cat., New York: Whitney Museum of American Art, 1986), p. 203.

[53] Hills observed: "What Sargent wanted to see was not reality, but the holiday, aestheticized world of the late nineteenth and the early twentieth centuries" (ibid.).

[54] Chase, "Import of Art," p. 442; and "Relation of Painting to Architecture," p. 848.

THE COUNTRY

Modern Painters in Landscape

[1] For an account of Sargent's Impressionist phase, see William H. Gerdts, "The Arch-Apostle of the Dab-and-Spot School: John Singer Sargent as an Impressionist," in Patricia Hills et al., *John Singer Sargent* (exh. cat., New York: Whitney Museum of American Art, 1986), p. 131; and Donelson F. Hoopes, "John S. Sargent: Worcestershire Interlude, 1885–89," *Brooklyn Museum Annual* 7 (1965–66), pp. 74–89.

[2] Hoopes, "John S. Sargent," pp. 76–77. For a discussion of the artist's colony at Broadway, see Marc Simpson, "Windows on the Past: Edwin Austin Abbey and Francis Davis Millet in England," *American Art Journal* 22 (June 1991), pp. 64–89.

[3] *Paul Helleu* (exh. cat., Dieppe: Musée de Dieppe, 1962), p. 8.

[4] M[ariana] G[riswold] Van Rensselaer, "Introduction," in *Book of American Figure Painters* (Philadelphia, 1886), unpaged.

[5] Marcel Proust, "Seascape, with Frieze of Girls," in *Remembrance of Things Past*, trans. C. K. Scott Moncrief, 7 vols. in 2 (New York, 1934), vol. 1, p. 639.

[6] "The Fine Arts: The French Impressionists," *Critic*, n.s. 5 (Apr. 17, 1886), p. 195.

[7] Of course, there were even earlier European landscape painters who broke away from academic strictures, particularly in their plein air sketches. See Peter Galassi, *Before Photography: Painting and the Invention of Photography* (exh. cat., New York: Museum of Modern Art, 1981).

[8] Charles Daubigny quoted in Robert L. Herbert, *Barbizon Revisited* (exh. cat., San Francisco: California Palace of the Legion of Honor, 1962), p. 64.

9 For a discussion of the Barbizon influence in the United States, see Peter Bermingham, *American Art in the Barbizon Mood* (exh. cat., Washington, D.C.: National Collection of Fine Arts, Smithsonian Institution, 1975).

10 For a discussion of Tonalism, see Wanda M. Corn, *The Color of Mood: American Tonalism, 1880–1910* (exh. cat., San Francisco: M. H. de Young Memorial Museum and the California Palace of the Legion of Honor, 1972); and William H. Gerdts, Diana Dimodica Sweet, and Robert R. Preato, *Tonalism, an American Experience* (exh. cat., New York: Grand Central Art Galleries, 1982).

11 Corn, *Color of Mood*, p. 1.

12 For a discussion of the differences between the French Barbizon painters and the French Impressionists, see Scott Schaefer, "The French Landscape Sensibility," in *A Day in the Country: Impressionism and the French Landscape* (exh. cat., Los Angeles: Los Angeles County Museum of Art, 1984), pp. 53–61.

13 Childe Hassam, in T[homas] W. Dewing et al., "John H. Twachtman: An Estimation," *North American Review* 176, no. 557 (Apr. 1903), p. 556. Hassam, of course, took similar liberties himself.

14 Ibid.

15 The American Impressionists' deep familiarity with and appreciation of the native landscape they depicted has already been noted; see Charles Eldredge, "Connecticut Impressionists: The Spirit of Place," *Art in America* 62 (Sept. 1974), pp. 84–90; and Harold Spencer, "The Artists and the Landscape," in *Connecticut and American Impressionism* (exh. cat., Storrs: William Benton Museum of Art, University of Connecticut, 1980), pp. 46–51. This devotion to native subjects, particularly to New England scenery, was to a certain extent overlooked by art writers and critics between the two world wars, when cultural nationalism prevailed and historians were critical of the American Impressionists for their obvious dependence on a French style.

16 Edward E. Simmons quoted in Dewing et al., "Twachtman: An Estimation," p. 561.

17 Hamlin Garland, "Impressionism," in Hamlin Garland, *Crumbling Idols: Twelve Essays on Art Dealing Chiefly with Literature, Painting, and the Drama* (1894), new ed., ed. Jane Johnson (Cambridge, Mass., 1960), p. 104.

18 Hamlin Garland, *Roadside Meetings* (New York, 1930), p. 27.

19 Schaefer, "French Landscape Sensibility," p. 56.

20 For a discussion of Monet's commitment to the French landscape, see Paul Hayes Tucker, *Monet in the '90s: The Series Paintings* (exh. cat., Boston: Museum of Fine Arts, 1989).

21 Theodore Robinson, Diaries, Feb. 20, 1893, Frick Art Reference Library, New York.

22 For other discussions of this painting, see Doreen Bolger Burke, *American Paintings in The Metropolitan Museum of Art*, vol. 3, *A Catalogue of Works by Artists Born Between 1846 and 1864*, ed. Kathleen Luhrs (New York, 1980), pp. 127–29; and Sona Johnston, *Theodore Robinson, 1852–1896* (exh. cat., Baltimore: Baltimore Museum of Art, 1973), p. 24.

23 See David Sellin, *Americans in Brittany and Normandy, 1860–1910* (exh. cat., Phoenix: Phoenix Art Museum, 1982), p. 66; and Edward Breck, Letter to the editor, dated Mar. 8, 1895, *Boston Evening Transcript*, Mar. 9, 1895, p. 13.

24 Will H. Low, *A Chronicle of Friendships* (New York, 1908), pp. 446–47, quoted in Sellin, *Americans in Brittany and Normandy*, p. 68.

25 For a discussion of the American artists who painted at Giverny, see Laura L. Meixner, *An International Episode: Millet, Monet, and Their North American Counterparts* (exh. cat., Memphis, Tenn.: Dixon Gallery and Gardens, 1982); William H. Gerdts et al., *Lasting Impressions: American Painters in France, 1865–1915* (exh. cat., Giverny: Musée Américain, 1992); and William H. Gerdts, *Monet's Giverny: An Impressionist Colony* (New York, 1993).

26 Birge Harrison, "Subjects for the Painter in American Landscape," *Scribner's Magazine* 52 (Dec. 1912), p. 765. This is a recurrent theme in the literature on American art. See, for example, J. Nilsen Laurvik, "Art in America, IV: American Landscape Painters," *Woman's Home Companion* 38 (May 1911), pp. 48–49, 72–73.

27 Dennis Miller Bunker, Letter to Anne Page, Sept. 3, 1886, Dennis Miller Bunker Papers, Archives of American Art, Smithsonian Institution, Washington, D.C. (microfilm, reel 1201, frame 738).

28 Robinson, Diaries, Nov. 25, 1894, Frick Art Reference Library.

29 Theodore Robinson, Letter to Kenyon Cox, Apr. 15, 1883, Kenyon Cox Papers, Avery Architectural and Fine Arts Library, Columbia University, New York.

30 Ibid., Newport, R.I., May 31, 1883.

31 Robinson, Diaries, Aug. 10, 1892, Frick Art Reference Library.

32 Ibid., Oct. 10, 1894.

33 Ibid., Apr. 11, 1895.

34 Theodore Robinson, Letter to Hamlin Garland, Nov. 14, 1895, Hamlin Garland Collection, University of Southern California, Los Angeles.

35 Robinson, Diaries, Oct. 30, 1895, Frick Art Reference Library. Robinson described this as "Native American Art."

36 Ibid., Oct. 27 and Sept. 2, 1895.

37 Ibid., Apr. 25, 1894. Robinson wrote a "defence of Modernism" for Garland, who gave him the pamphlet [Charles Francis Browne, Hamlin Garland, and Lorado Taft], *Impressions on Impressionism; Being a Discussion of the American Art Exhibition at the Art Institute, Chicago, by a Critical Triumvirate* (Chicago, 1894). Robinson gave the writer a painting; Garland presented him with two of his books (Robinson, Diaries, Nov. 12 and Dec. 19, 1894, Jan. 1, 1896, Frick Art Reference Library).

38 Robinson's interview with Garland, quoted in Hamlin Garland, "Theodore Robinson," *Brush and Pencil* 4 (Sept. 1899), pp. 285–86.

39 For a discussion of Weir's country retreats, see Spencer, "Artists and the Landscape," pp. 47–48; and Hildegard Cummings, Helen K. Fusscas, and Susan G. Larkin, *J. Alden Weir: A Place of His Own* (exh. cat., Storrs: William Benton Museum of Art, University of Connecticut, 1991).

40 J. Alden Weir, Letter to Mr. and Mrs. Robert W. Weir, n.d. [1883], quoted in Dorothy Weir Young, *The Life and Letters of J. Alden Weir*, ed. Lawrence W. Chisolm (New Haven, 1960), p. 161.

41 J. Alden Weir, Letter to Mr. and Mrs. Charles Taintor Baker, n.d. [1883], quoted in Young, *Life and Letters of Weir*, p. 161.

42 John F. Weir, Letter to J. Alden Weir, Aug. 2, 1883, quoted in Young, *Life and Letters of Weir*, p. 161. Painter John Ferguson Weir, J. Alden Weir's half brother, selected the inscription.

43 J. Alden Weir to an unidentified friend, n.d. [Oct. 1901], quoted in Young, *Life and Letters of Weir*, p. 205.

44 H. de Raasloff, "Weir the Fisherman," in *Julian Alden Weir: An Appreciation of His Life and Works*, reprint ed. (New York, 1922), p. 90.

45 For information on this town and its history, see *A Memorial Volume of the Bi-centennial Celebration of the Town of Windham, Connecticut. Containing the Historical Addresses, Poems, and a Description of Events Connected with the Observance of the Two Hundredth Anniversary of the Incorporation of the Town, As Held in the Year 1892* (Hartford, Conn., 1893), pp. 63–64.

46 J. Alden Weir, Letter to Anna Baker [Weir], May 16, 1882, quoted in Spencer, "Artists and the Landscape," p. 47.

47 For the designation of Windham as "Summerville" and an account of its resort activities, see "The Local Lenox: Summer Season at Windham Center," *Willimantic Daily Chronicle*, July 7, 1897, [p. 4].

48 "City and Vicinity News," a regular feature of the *Willimantic Daily Chronicle*, listed announcements of these events, as well as dinners and parties in private homes. One of these columns indicates that early in September 1897 Weir hosted a "blazer party" in Windham ("Affairs in Windham," *Willimantic Daily Chronicle*, Sept. 10, 1897, [p. 8]).

49 Twachtman's movements in the years following his return from Europe are unclear. See Lisa N. Peters, "Twachtman's Greenwich Paintings: Context and Chronology," in Deborah Chotner, Lisa N. Peters, and Kathleen A. Pyne, *John Twachtman: Connecticut Landscapes* (exh. cat., Washington, D.C.: National Gallery of Art, 1989), p. 15.

50 For information on Twachtman's Connecticut work, see Chotner, Peters, and Pyne, *John Twachtman: Connecticut Landscapes*; see also Eliot Clark, *John Twachtman* (New York, 1924), pp. 26–27; and Susan G. Larkin, "The Cos Cob Clapboard School," in *Connecticut and American Impressionism*, p. 89.

51 Alfred Henry Goodwin, "An Artist's Unspoiled Country Home," *Country Life in America* 8 (Oct. 1905), p. 625.

52 John H. Twachtman, Letter to J. Alden Weir, postmarked Dec. 16, 1891, quoted in Young, *Life and Letters of Weir*, pp. 189–90.

53 For another discussion of this picture, see James L. Yarnall, "John H. Twachtman's *Icebound*," *Bulletin of the Art Institute of Chicago* 71 (Jan.–Feb. 1977), pp. 2–5.

54 Twachtman, Letter to J. Alden Weir, postmarked Dec. 16, 1891, quoted in Young, *Life and Letters of Weir*, p. 190.

55 J. Alden Weir, Letter to Alden Twachtman, Jan. 3, 1892, quoted in Young, *Life and Letters of Weir*, p. 177.

56 It seems likely that Weir knew one or both of the versions of Thomas Cole's *Voyage of Life* (1840, Munson-Williams-Proctor Institute, Utica, N.Y.; and 1842, National Gallery of Art, Washington, D.C.), each of which includes four allegorical views of the journey through life—from birth to old age—in a boat that traverses a river larger and more tumultuous than Twachtman's little stream. Not only was Cole a friend of Weir's father's, but also these images were well known throughout the United States because James Smillie had made engravings after the Utica version. See Ellwood C. Parry III, *The Art of Thomas Cole: Ambition and Imagination* (Newark, Del., 1988); and Ellwood C. Parry III, Paul D. Schweizer, and Dan A. Kushel, *The Voyage of Life by Thomas Cole: Paintings, Drawings, and Prints* (exh. cat., Utica, N.Y.: Munson-Williams-Proctor Institute, Museum of Art, 1985).

57 Weir, Letter to Alden Twachtman, Jan. 3, 1892, quoted in Young, *Life and Letters of Weir*, p. 177.

58 The patron's wife, Evelyn R. Carey, later personified the falls as a beautiful woman for a poster for the Pan-American Exposition of 1901 (The Charles Rand Penney Collection). For further discussion of Twachtman's Niagara pictures, see Jeremy Elwell Adamson, *Niagara: Two Centuries of Changing Attitudes, 1697–1901* (exh. cat., Washington, D.C.: Corcoran Gallery of Art, 1985), pp. 73–75; and Dianne H. Pilgrim, *American Impressionist and Realist Paintings and Drawings from the Collection of Mr. and Mrs. Raymond J. Horowitz*, intro. John K. Howat (exh. cat., New York: The Metropolitan Museum of Art, 1973), pp. 68–69.

59 John H. Twachtman, Letter to W[illiam] A. Wadsworth, 1895, Wadsworth Family Papers, College Libraries, State University of New York College

of Arts and Sciences, Geneseo, quoted in Peters, "Twachtman's Greenwich Paintings," p. 33.

60 William H. Gerdts, *American Impressionism* (New York, 1984), pp. 159, 161.

61 Doreen Bolger, "American Artists and the Japanese Print: J. Alden Weir, Theodore Robinson, and John H. Twachtman," in Doreen Bolger and Nicolai Cikovsky, Jr., eds., *American Art Around 1900: Lectures in Memory of Daniel Fraad* (Washington, D.C., 1990), p. 20.

62 Walter Jack Duncan, "Foreword," in *Paintings by Willard L. Metcalf* (exh. cat., Washington, D.C.: Corcoran Gallery of Art, 1925), unpaged.

63 Elisabeth de Veer and Richard J. Boyle, *Sunlight and Shadow: The Life and Art of Willard L. Metcalf* (New York, 1987), p. 264.

64 For additional discussions of this painting, see William H. Gerdts, *American Impressionism: Masterworks from Public and Private Collections in the United States* (exh. cat., Lugano-Castagnola, Switz.: Villa Favorita, Thyssen-Bornemisza Foundation, 1990), p. 110; and the entry by Richard J. Boyle in William H. Gerdts et al., *Ten American Painters* (exh. cat., New York: Spanierman Gallery, 1990), p. 157. On the Cornish colony, see Deborah Elizabeth Van Buren, "The Cornish Colony: Expressions of Attachment to Place" (Ph.D. diss., George Washington University, Washington, D.C., 1987); and Susan Faxon Olney et al., *A Circle of Friends: Art Colonies of Cornish and Dublin* (exh. cat., Durham, N.H.: University Art Galleries, University of New Hampshire; Keene, N.H.: Thorne-Sagendorph Art Gallery, State College, 1985). A useful contemporary account is Helen W. Henderson, "An Impression of Cornish," *Lamp* 27 (Oct. 1903), pp. 185–96. The Van Buren dissertation merits particular mention for its consideration of the broader issues of late nineteenth-century attitudes toward land and the landscape. On Metcalf's presence in Cornish, see Elizabeth de Veer, "Willard Metcalf in Cornish, New Hampshire," *Antiques* 126 (Nov. 1984), pp. 1208–15.

65 Van Buren, "Cornish Colony," pp. 11–13; and William Henry Child, *A History of the Town of Cornish, New Hampshire, 1763–1910* (Concord, N.H., 1911), p. 1.

66 William A. Shurcliff, Cambridge, Mass., Letter to Thomas W. Barwick, Mar. 31, 1985, copy in the files of the Departments of American Art, Metropolitan Museum; and Gerdts, *American Impressionism: Masterworks*, p. 110.

67 Van Buren, "Cornish Colony," pp. 4, 10, n. 2. In an undated letter to an unidentified editor, Rev. E. N. Goddard of Windsor, Vermont, suggested that the name of the brook had a direct connection with a passage in *Evangeline* (*Blowmedown Record*, Cornish Colony Collection, Dartmouth College Library, Hanover, N.H.). Van Buren credits Susan Hobbs with bringing this information to her attention.

68 Van Buren, "Cornish Colony," pp. 19, 171–72.

69 Ibid., pp. 4–5. For a discussion of American notions about nature, the landscape, and Arcadia, see Peter J. Schmitt, *Back to Nature: The Arcadian Myth in Urban America* (New York, 1969).

70 Percy MacKaye, *Yankee Fantasies* (New York, 1912), p. 96, quoted in Van Buren, "Cornish Colony," p. 207.

71 [Robert] W. Macbeth, "Secessionists Exhibit in New York," *Christian Science Monitor*, Apr. 1, 1911, p. 15, quoted by Boyle in Gerdts et al., *Ten American Painters*, p. 182.

72 For a history of the actual New England landscape and its historical ecology, see William Cronon, *Changes in the Land: Indians, Colonists, and the Ecology of New England* (New York, 1983). For an evaluation of the changing attitudes of Americans toward the past and reminders of it in the landscape, see David Lowenthal, "The Place of the Past in the American Landscape," in David Lowenthal and Martyn J. Bowden, eds., *Geographies of the Mind: Essays in Historical Geosophy in Honor of John Kirtland Wright* (New York, 1976), pp. 88–117. For a discussion of the traditional aspects of the historic New England communities, see Lewis Mumford, *The Brown Decades: A Study of the Arts in America, 1865–1895* (1931; reprint, New York, 1971), p. 36.

73 William Dean Howells quoted in John Brinckerhoff Jackson, *American Space: The Centennial Years, 1865–1876* (New York, 1972), p. 88. Jackson (pp. 87–136) discusses the New England landscape in the decade following the Civil War.

74 Jackson, *American Space*, p. 101.

75 Henry James quoted in ibid., p. 111.

76 David Lowenthal, "Past Time, Present Place: Landscape and Meaning," *Geographical Review* 65 (Jan. 1975), p. 4.

77 Lowenthal (ibid., pp. 1–36) lists these contemporary examples of nostalgia and places the feeling in a solid historical context.

78 Leila Mechlin, "American Landscape Painting," *Scrip* 3 (Nov. 1907), p. 37.

79 George Inness quoted in Samuel Isham, *The History of American Painting* (New York, 1905), p. 256, as quoted in Patricia Hills, *Turn-of-the-Century America: Painting, Graphics, Photographs, 1890–1910* (exh. cat., New York: Whitney Museum of American Art, 1977), p. 23.

80 Giles Edgerton, "American Painters of Outdoors: Their Rank and Their Success," *Craftsman* 16 (June 1909), p. 282.

81 For another discussion of the painting, see Carol Troyen, *The Boston Tradition: American Paintings from the Museum of Fine Arts, Boston* (exh. cat., New York: American Federation of Arts, 1980), p. 196.

82 Mary P. Conley, Ipswich Historical Society, Letter to N. Mishoe Brennecke, 1991, files of the Departments of American Art, Metropolitan Museum; Town of Ipswich, Public Works Department, *Green Street Bridge: Historical Documentation*, prepared by McGinley Hart and Assoc. (Concord, Mass., 1992); and Thomas Franklin Waters, "Ipswich River, Its Bridges, Wharves, and Industries," *Publications of the Ipswich Historical Society* 25 (1923), pp. 15–16.

83 William Howe Downes, "The Charles River Basin," *New England Magazine*, n.s. 15 (Oct. 1896), p. 210.

84 Troyen, *Boston Tradition*, p. 196.

85 See Jesse Fewkes, "Fine Thread, Lace, and Hosiery in Ipswich," and T[homas] Frank[lin] Waters, "Ipswich Mills and Factories," *Publications of the Ipswich Historical Society* 13 (1904). For a discussion of the social unrest that occurred in 1913, see Edgar Fletcher Allen, "Aftermath of Industrial War at Ipswich, Mass.," *Survey* 32 (May 23, 1914), pp. 216–17.

86 Barbara Buff, "Cragsmoor, an Early American Art Colony," *Antiques* 114 (Nov. 1978), pp. 1056–67.

87 "Our Local Studios: The Brooklyn Art School Holds Its Session on the Mountain Side," *Brooklyn Daily Eagle*, Oct. 9, 1893, p. 10.

88 For other discussions of this painting, see Susan Danly, *Light, Air, and Color: American Impressionist Paintings from the Collection of the Pennsylvania Academy of the Fine Arts* (exh. cat., Philadelphia: Pennsylvania Academy of the Fine Arts, 1990), pp. 70–71; and Johnston, *Theodore Robinson, 1852–1896*, no. 49.

89 For information on the Delaware and Hudson Canal, see Alvin F. Harlow, *Old Towpaths: The Story of the American Canal Era* (New York, 1926); Manville B. Wakefield, *Coal Boats to Tidewater: The Story of the Delaware and Hudson Canal* (Grahamsville, N.Y., 1965); E. D. LeRoy, *The Delaware and Hudson Canal and It's* [sic] *Gravity Railroads* (Honesdale, Pa., 1980); and Ronald E. Shaw, *Canals for a Nation: The Canal Era and the United States, 1790–1860* (Lexington, Ky., 1990), pp. 85–87.

90 See Seymour Dunbar, *A History of Travel in America* (New York, 1937), pp. 847–71.

91 Shaw, *Canals for a Nation*, pp. 234–35.

92 Ibid., p. 85.

93 Wakefield, *Coal Boats to Tidewater*, p. 198; LeRoy, *Delaware and Hudson Canal*, p. 77.

94 Unidentified clipping, quoted in Johnston, *Theodore Robinson, 1852–1896*, p. xxiii. This was not the first artistic excursion along New York State's canal system: in 1879 members of the Tile Club, a group of artists who gathered to paint on ceramic tiles, had fitted out a barge elaborately and made a canal trip to Lake Champlain. Robinson did not join this trip, but he must have heard about its artistic and social success from such friends as Weir.

95 Ann Gilchrist, *Canalling Along the Delaware and Hudson* (High Falls, N.Y., 1982), pp. 28, 31; Wakefield, *Coal Boats to Tidewater*, p. 197.

96 Robinson, Diaries, Oct. 28, 1893, Frick Art Reference Library.

97 Ibid., Oct. 29, 1893.

98 Ibid.

99 Larkin, "Cos Cob Clapboard School," p. 83.

100 Lincoln Steffens, *The Autobiography of Lincoln Steffens* (New York, 1931), p. 436.

101 "An Art School at Cos Cob," *Art Interchange* 43 (Sept. 1899), p. 56, as quoted in Susan G. Larkin, *On Home Ground: Elmer Livingston MacRae at the Holley House* (exh. cat., Greenwich, Conn.: Historical Society of the Town of Greenwich, 1990), pp. 20–21.

102 The authors are indebted to the work of Susan G. Larkin, who first comprehensively addressed the topic of Robinson's Cos Cob pictures in a research paper, "Balancing the Seesaw: Theodore Robinson's Nautical Paintings of Cos Cob, 1894," in a seminar in late nineteenth-century American painting offered by H. Barbara Weinberg at the Graduate School and University Center, City University of New York, in 1990. Larkin has since published a revised version of this paper, "Light, Time, and Tide: Theodore Robinson at Cos Cob," *American Art Journal* 23, no. 2 (1991), pp. 74–108.

103 Larkin discusses this picture at length in "Light, Time, and Tide," pp. 100–104.

104 For another discussion of this picture, see the entry by Jane Myers in Linda Ayres and Jane Myers, *American Paintings, Watercolors, and Drawings from the Collection of Rita and Daniel Fraad* (exh. cat., Fort Worth: Amon Carter Museum, 1985), pp. 40–41. Larkin discusses this picture and a related one at length in "Light, Time, and Tide," pp. 92–99.

105 For information on the Riverside Yacht Club, see Larkin, "Light, Time, and Tide," pp. 88–89; and Anthony Anable, *The History of the Riverside Yacht Club, 1888–1972* (Riverside, Conn., 1974).

106 For other discussions of *Low Tide*, see the entry by Marc Simpson in *American Paintings from the Manoogian Collection* (exh. cat., Washington, D.C.: National Gallery of Art, 1989), pp. 158–59; and Larkin, "Light, Time, and Tide," pp. 88–95. For discussions of *Low Tide, Riverside Yacht Club*, see Pilgrim, *American Impressionist and Realist Paintings and Drawings*, pp. 62–63; and Larkin, "Light, Time, and Tide," pp. 88–95. In the same article (p. 107, n. 36), Larkin notes that this building housed the Continental Mower and Reaper Company from 1865 to 1867 and a cottonseed oil plant from 1867 to 1870.

107 Robinson records his visits to Monet at Rouen in his Diaries, May 23, 1892, Frick Art Reference Library. For discussions of this important Seine series of pictures by Robinson, see Gerdts, *American Impressionism* (1984), pp. 73–74; and Meixner, *International Episode*, pp. 139–43.

108 Robinson, Diaries, June 3, 1892, Frick Art Reference Library.

109 See Bolger, "American Artists and the Japanese Print," pp. 22–23.

110 Robinson, Diaries, Feb. 17, 1894, Frick Art Reference Library.

111 Larkin, "Cos Cob Clapboard School," p. 87.

112 Twachtman quoted in "Art School at Cos Cob," p. 57.

113 John H. Twachtman, Letter to Josephine Holley, postmarked Jan. 17, 1902, Collection of the Historical Society of the Town of Greenwich, quoted in Larkin, "Cos Cob Clapboard School," p. 89. In nineteenth-century literary sources, snow was often used as a symbol of redemption (James Russell Lowell) and of purification (Henry Thoreau). See Deborah Chotner, "Twachtman and the American Winter Landscape," in Chotner, Peters, and Pyne, *John Twachtman: Connecticut Landscapes*, pp. 76–77.

114 For a discussion of this painting, see Troyen, *Boston Tradition*, pp. 174–75.

115 Tarbell quoted by Frank W. Benson, in Robert Hale Ives Gammell, *Dennis Miller Bunker* (New York, 1953), p. 65.

116 Bunker, Letter to Anne Page, Sept. 3, 1886, Bunker Papers, Archives of American Art (microfilm, reel 1201, frame [737]).

117 Ibid., frame [739].

118 Ibid.

119 Troyen, *Boston Tradition*, p. 174.

120 Ibid., p. 176.

121 Hon. Eugene C. Hultman, "The Charles River Basin" (a paper read before the Bostonian Society, Oct. 7, 1939), *Proceedings of the Bostonian Society*, 1940, p. 39.

122 Monet quoted in Douglas Skeggs, *River of Light: Monet's Impressions of the Seine* (New York, 1987), p. 130.

123 Augusta W. Kellogg, "The Charles River Valley," *New England Magazine*, n.s. 26 (Aug. 1902), p. 647.

124 Ibid., p. 666.

125 Hultman, "Charles River Basin," pp. 39–40. For the continuing discussion of the debate over the project, see also *The Improvement of the Charles River Basin: A Brief Consideration of the Arguments for and Against the Establishment of a Water Park near the Centre of Metropolitan Boston* (Boston, 1901); and Sylvester Baxter, "Parkways and Boulevards in American Cities, II," *American Architect and Building News* 62 (Oct. 22, 1898), pp. 27–28.

126 For information on Auburndale, see M. F. Sweetser, *King's Handbook of Newton, Massachusetts*

(Boston, 1889), pp. 189–204; and *Newton's 19th Century Architecture: Auburndale* (Newton, Mass., 1980).

[127] William Dean Howells, "Scene," in *Suburban Sketches* (New York, 1871), p. 190.

[128] Ibid., p. 194.

[129] For another discussion of *The Red Bridge*, see Burke, *American Paintings in the Metropolitan Museum*, pp. 140–42.

[130] For a discussion of iron bridges, see Carl W. Condit, *American Building: Materials and Techniques from the First Colonial Settlements to the Present*, 2d ed. (Chicago, 1982), pp. 92–112.

[131] For information on advances in the railroads, see James A. Ward, *Railroads and the Character of America, 1820–1887* (Knoxville, Tenn., 1986); and John R. Stilgoe, *Metropolitan Corridor: Railroads and the American Scene* (New Haven, 1983).

[132] See David M. Roth, *Connecticut: A Bicentennial History* (New York and Nashville, 1979), pp. 30–31; and Henry V. Poor, *Manual of the Railroads of the United States for 1888, Showing Their Route and Mileage; Stocks, Bonds, Debts, Costs, Traffic, Earnings, Expenses, and Dividends; Their Organizations, Directors, Officers, Etc.* (New York, 1888), pp. 63–66.

[133] Young, *Life and Letters of Weir*, p. 187. The first covered bridge in the United States was completed in 1800 in Philadelphia; this type of bridge soon became popular throughout the northeast (Richard Sanders Allen, *Covered Bridges of the Middle Atlantic States* [Brattleboro, Vt., 1959], pp. 1–6).

[134] Young, *Life and Letters of Weir*, p. 187.

[135] Bolger, "American Artists and the Japanese Print," pp. 21–22, 24.

[136] We are grateful to Margaret Ellen Fein for sharing with us the paper she wrote on this painting in the fall 1990 seminar, "American Art at the Turn of the Century," taught by H. Barbara Weinberg at the Graduate School and University Center, City University of New York; see Margaret Ellen Fein, "J. Alden Weir: Paintings of the Willimantic Linen Company, 1893–1897" (manuscript, Graduate School and University Center, City University of New York, 1990).

[137] For a general discussion of this subject, see Jackson, *American Space*, pp. 114–17.

[138] Betsy Fahlman, "John Ferguson Weir: Painter of Romantic and Industrial Icons," *Archives of American Art Journal* 20, no. 2 (1980), pp. 9–20; and Richard S. Field, "Passion and Industry in the Art of John Ferguson Weir," *Yale University Art Gallery Bulletin*, 1991, pp. 49–67. For a survey of American industrial imagery, see Patricia Hills, "The Fine Arts in America: Images of Labor from 1800 to 1950," in *Essays from the Lowell Conference on Industrial History, 1982 and 1983: The Arts and Industrialism; the Industrial City*, ed. Robert Weible (North Andover, Mass., 1985), pp. 120–64.

[139] Daniel Pigeon, "The Willimantic Thread Company—'Benevolent' Mill Owning," in Daniel Pigeon, *Old-World Questions and New-World Answers* (London, 1884), p. 218, reprinted in *Harper's Handy Series* (Sept. 4, 1885), p. 115.

[140] Pigeon, "The Willimantic Thread Company," pp. 231–32; and Tom Beardsley, *Willimantic Women: Their Lives and Labors* (Windham, Conn., 1990), p. 1. See also Paul Boyer, *Urban Masses and Moral Order in America, 1820–1920* (Cambridge, Mass., 1978) pp. 123–90.

[141] Fein, "Weir: Paintings of Willimantic Linen Company," p. 2.

[142] Beardsley, *Willimantic Women*, pp. 8–10.

[143] *The Willimantic Journal: Souvenir Edition*, comp. H. F. Donlan (Willimantic, Conn., 1894), p. 2.

[144] Helen K. Fusscas, "The Mystery of a New Path," in Cummings, Fusscas, and Larkin, *J. Alden Weir*, p. 39.

[145] The summer Weir painted *The Factory Village* the local Willimantic newspaper contained numerous accounts of venerable elms and oaks in the town and in neighboring areas; each of these trees was tied to a historic figure or event. The prominent tree in *The Factory Village* would have brought these associations to mind for the artist and his contemporaries. See "The Big Trees of Mansfield," *Willimantic Daily Chronicle*, Aug. 4, 1897 [p. 4]; and "Big Trees," *Willimantic Daily Chronicle*, Aug. 12, 1897, [p. 1].

[146] "Operatives Out of Work," *Willimantic Daily Chronicle*, July 10, 1897 [p. 5]; "The Thread Mills," *Willimantic Daily Chronicle*, Aug. 2, 1897 [p. 5]; and "Manufacturing Situation," *Willimantic Daily Chronicle*, Aug. 18, 1897, [p. 8].

[147] "Town's Needy Poor," *Willimantic Daily Chronicle*, Sept. 11, 1897 [p. 4]; and "Willimantic's Poor," *Willimantic Daily Chronicle*, Aug. 7, 1897, [p. 4].

[148] For information on the popularity of Monhegan Island as an artistic retreat, see Christopher Huntington, *Maine: 50 Artists of the 20th Century* (exh. cat., Waterville, Maine: Colby College Art Museum, 1964); Eunice Agar, "Monhegan—An Artist's Island," *American Artist* 51 (May 1987), pp. 46–51, 76, 82–83; and Lloyd Goodrich, "The Sea and the Land, 1865–1914," in Gertrud A. Mellon and Elizabeth F. Wilder, eds., *Maine and Its Role in American Art, 1740–1963* (New York, 1963), pp. 92–117.

[149] Bruce Robertson, *Reckoning with Winslow Homer: His Late Paintings and Their Influence* (exh. cat., Cleveland: Cleveland Museum of Art, 1990), p. 102.

[150] Ibid., p. 105.

[151] Rockwell Kent, *It's Me O Lord: The Autobiography of Rockwell Kent* (New York, 1955; reprint, New York, 1977), p. 121.

[152] Ibid., p. 78.

[153] Ibid., p. 76.

[154] Ibid., p. 77.

[155] Ibid., p. 76.

[156] Ibid., p. 77.

[157] William Cronon and Susan Prendergast Schoelwer, brochure for the exhibition *Discovered Lands, Invented Pasts*, organized by the Gilcrease Museum, Tulsa, Okla., the Yale University Art Gallery, and the Yale Western Americana Collection, 1992–93 (Beinecke Rare Book and Manuscript Library, New Haven). The exhibition was accompanied by an enlightening publication, Jules David Prown et al., *Discovered Lands, Invented Pasts: Transforming Visions of the American West* (New Haven, 1992).

The Country Retreat and the Suburban Resort

[1] The definitive study of Hassam at Appledore is David Park Curry, *Childe Hassam: An Island Garden Revisited* (exh. cat., Denver: Denver Art Museum, 1990).

[2] Celia Thaxter, *An Island Garden* (Boston and New York, 1894), p. 102.

[3] Curry, *Childe Hassam*, p. 17.

[4] Pertinent overviews of leisure and recreation in the United States from colonial times to the mid-twentieth century appear in Foster Rhea Dulles, *A History of Recreation: America Learns to Play*, 2d ed. (New York, 1965); and Donna R. Braden, *Leisure and Entertainment in America: Based on the Collections of Henry Ford Museum and Greenfield Village* (Dearborn, Mich., 1988). A recent consideration of work and rest is Witold Rybczynski, *Waiting for the Weekend* (New York, 1991).

[5] Despite the increasing exodus to the cities, two-thirds of Americans continued to live in the country and remained subject to relentless work and isolation. In fact, the contrast between urban energy and rural stagnation encouraged the drift to cities. The new leisure was also dissociated from the small leisure class, those who worked little or not at all, which emerged during the prosperous last decades of the nineteenth century in America. Peter J. Schmitt, *Back to Nature: The Arcadian Myth in Urban America* (New York, 1969), explains the development of a wide variety of rural pursuits in terms of urban pressures. A summary of leisure and recreation in the late nineteenth century appears in Dulles, *History of Recreation*, pp. 271–88. See also Dale A. Somers, "The Leisure Revolution: Recreation in the American City, 1820–1920," *Journal of Popular Culture* 5 (1971), pp. 125–47.

[6] Garfield quoted in Jesse Lyman Hurlbut, *The Story of Chautauqua* (New York, 1921), p. 184.

[7] See, among other sources, M. Jules Rochard, "Summer Outings in Europe," *Chautauquan* 21 (Sept. 1895), pp. 709–13.

8 Herbert Spencer, Farewell banquet address, Nov. 9, 1882, quoted in Daniel T. Rodgers, *The Work Ethic in Industrial America, 1850–1920* (Chicago, 1978), p. 94. Rodgers (pp. 94–124) provides a useful introduction to the new leisure, its advocates and detractors. For Spencer's views, see Herbert Spencer, "The Gospel of Recreation," *Popular Science Monthly* 22 (1883), pp. 354–59.

9 H. W. Horwill, "Leisurely America," *Living Age* 253 (May 11, 1907), p. 333.

10 See Franklin Matthews, "Vacations for the Workers," *World's Work* 6 (June 1903), pp. 3516–17.

11 See Dulles, *History of Recreation*, p. 201. See also John H. Mandigo, "Outdoor Sports," *Chautauquan* 19 (July 1894), p. 387; and "From *Macmillan's Magazine*: Americans at Play," *Living Age* 214 (July 24, 1897), pp. 259–67.

12 Lauding visits to seaside parks, for example, a writer of 1902 remarked: "The burden of clothing is reduced to the lowest permissible terms [at the seaside]; convention's bars are dropped" (Sylvester Baxter, "City Ownership of Seaside Parks," *Cosmopolitan* 33 [Aug. 1902], p. 426). One of the most popular forms of outing, the picnic, is examined in Mary Ellen W. Hern, "Picnicking in the Northeastern United States, 1840–1900," *Winterthur Portfolio* 24 (Summer–Autumn 1989), pp. 139–52. Hern notes (pp. 150–51) the opportunities afforded for "mild sexual license."

13 Kate Gannett Wells, "Free Summer Pleasures for the People in Boston," *New England Magazine*, n.s. 6 (Aug. 1892), p. 789. The growth of education also helped to "create a desire for leisure in which part of life may be reclaimed from sordid uses," according to "American Development of Leisure," *Andover Review* 6 (Aug. 1886), pp. 185–86. For a summary of the relationship between recreation and social control, see Roy Rosenzweig, *Eight Hours for What We Will: Workers and Leisure in an Industrial City, 1870–1920* (Cambridge, 1983). For the development of New York's playgrounds in reaction to street life, see Cary Goodman, *Choosing Sides: Playground and Street Life in the Lower East Side* (New York, 1979), especially pp. 33–80.

14 Gustav Kobbé, "The Country Club and Its Influence upon American Social Life," *Outlook* 68 (June 1, 1901), pp. 255–56. See also Robert Dunn, "The Country Club: A National Expression, Where Woman Is Really Free," *Outing* 47 (Nov. 1905), pp. 160–73.

15 E. S. Martin, "Random Reading. Miniature Essays on Life: The Country," *Harper's Monthly Magazine* 104 (Apr. 1902), p. 684. For serious disaffection with urban life by the turn of the century, see Thomas Dixon, Jr., "From the Horrors of City Life," *World's Work* 4 (Oct. 1902), pp. 2603–11.

16 "American Development of Leisure," pp. 184–88 passim. For a brief account of an increased

interest in amusements, see also Edward Eggleston, "Americans at Play," *Century* 6 (Aug. 1884), pp. 554–56. Franklin Matthews ("Vacations for the Workers," p. 3517) describes the growth of vacations for skilled workmen in all trades.

17 See, for example, Henry James Ten Eyck, "Open Letters: Educational Value of Summer Resorts," *Century* 28 (Sept. 1884), pp. 796–97; Agnes Repplier, "Leisure," *Scribner's Magazine* 14 (July 1893), pp. 63–67; and "Work and Rest," *Outlook* 65 (Aug. 25, 1900), p. 956.

18 Arthur Stanwood Pier, "Work and Play," *Atlantic Monthly* 94 (Nov. 1904), p. 670. By 1908 the spirit of leisure could be the subject of a poetic meditation in which no effort was made to document its necessity: see "The Spirit of Leisure," *Atlantic Monthly* 102 (Oct. 1908), pp. 572–74.

19 See Ronald G. Pisano, *Idle Hours: Americans at Leisure, 1865–1914* (Boston, 1988), p. vii.

20 Matthews, "Vacations for the Workers," p. 3519.

21 Rafford Pyke, "Summer Types of Men and Women," *Cosmopolitan* 35 (Sept. 1903), p. 479.

22 Matthews, "Vacations for the Workers," p. 3519.

23 Lawrence Perry, "The Business of Vacations," *World's Work* 6 (June 1903), p. 3506.

24 A summary of "respectable resorts" is offered in Glenn Uminowicz, "Recreation in Christian America: Ocean Grove and Asbury Park, New Jersey, 1865–1914," in *Hard at Play: Leisure in America, 1840–1940*, ed. Kathryn Grover (Amherst, Mass., and Rochester, N.Y., 1992), pp. 8–38. Pertinent essays are included in Richard Guy Wilson, ed., *Victorian Resorts and Hotels: Essays from a Victorian Society Autumn Symposium* (Philadelphia, 1982).

25 Dr. A. T. Bristow, "The Most Healthful Vacation," *World's Work* 6 (June 1903), pp. 3549–51 passim. Echoes of these recommendations are found in William Frederick Dix, "Summer Life in Luxurious Adirondack Camps," *Independent* 55 (July 2, 1903), pp. 1556–62; and E. P. Powell, "Living Out of Doors," *Independent* 55 (Sept. 17, 1903), pp. 2227–32.

26 Matthews, "Vacations for the Workers," p. 3519. A useful consideration of the phenomenon of "Old Home Week" appears in Dona L. Brown, "The Tourist's New England: Creating an Industry, 1820–1900" (Ph.D. diss., University of Massachusetts, Amherst, 1989), pp. 176–223.

27 A. W. Greely, "Where Shall We Spend Our Summer?" *Scribner's Magazine* 3 (Apr. 1888), p. 481. On dual residences, see Walter H. Page et al., "The People at Play," *World's Work* 4 (Aug. 1902), p. 2377.

28 See Paul Bourget, *Outre-Mer: Impressions of America* (New York, 1895), pp. 43–70. The appeal of Newport to vacationers at the turn of the century is documented in Ada Sterling, "Midsummer Days at Newport," *Harper's Bazar* 33 (July 21, 1900), pp. 711–16. For remarks on "the

extreme of luxury" at Newport, see Jonathan Thayer Lincoln, "Newport: The City of Luxury," *Atlantic Monthly* 102 (Aug. 1908), pp. 162–68; and for an account of manifestations of wealth in Newport and of the contemptuous attitudes of Americans toward the town, see Gouverneur Morris, "Newport the Maligned," *Everybody's Magazine* 19 (Sept. 1908), pp. 311–25.

29 For a survey of the phenomenon of the artists' community, see Michael Jacobs, *The Good and Simple Life: Artist Colonies in Europe and America* (Oxford, 1985). For an introduction to the preoccupation with the peasant, see Gabriel P. Weisberg, ed., *The European Realist Tradition: French Painting and Drawing, 1830–1900* (exh. cat., Cleveland: Cleveland Museum of Art, 1980); and Richard R. Brettell and Caroline B. Brettell, *Painters and Peasants in the Nineteenth Century* (Geneva, 1983).

30 For a summary of Americans at or inspired by Barbizon, see Peter Bermingham, *American Art in the Barbizon Mood* (exh. cat., Washington, D.C.: National Collection of Fine Arts, Smithsonian Institution, 1975); and Laura L. Meixner, *An International Episode: Millet, Monet, and Their North American Counterparts* (exh. cat., Memphis: Dixon Gallery and Gardens, 1982).

31 See May Brawley Hill, *Grez Days: Robert Vonnoh in France* (exh. cat., New York: Berry-Hill Galleries, 1987).

32 A summary of various hypotheses regarding the identities of the men pictured appears in Elizabeth de Veer, "Willard Metcalf's *The Ten Cent Breakfast*," *Nineteenth Century* 3 (Winter 1977), pp. 51–53.

33 The Hôtel Baudy is described by Claire Joyes, "Giverny's Meeting House, the Hôtel Baudy," in David Sellin, *Americans in Brittany and Normandy, 1860–1910* (exh. cat., Phoenix: Phoenix Art Museum, 1982), pp. 97–102.

34 The sequence of American painters' arrival in Giverny is discussed in William H. Gerdts, *American Impressionism* (New York, 1984), pp. 57–89; Gerdts enumerates a second generation of American painters at Giverny (pp. 261–73). He also discusses Americans at Giverny in "American Art and the French Experience," in William H. Gerdts et al., *Lasting Impressions: American Painters in France, 1865–1915* (exh. cat., Giverny: Musée Américain, 1992), pp. 45–64.

35 Paul Hayes Tucker, *Monet in the '90s: The Series Paintings* (exh. cat., Boston: Museum of Fine Arts, 1989).

36 Jacobs, *Good and Simple Life*, p. 15.

37 For an introduction to two of them, see *En Plein Air: The Art Colonies at East Hampton and Old Lyme, 1880–1930* (exh. cat., Old Lyme, Conn.: Florence Griswold Museum; East Hampton, N.Y.: Guild Hall Museum, 1989).

38 See Brown, "Tourist's New England," p. vii. For a summary of the transformations in New

England after the Civil War and the perceived meanings of the region, see John Brinckerhoff Jackson, *American Space: The Centennial Years, 1865–1876* (New York, 1972), pp. 87–136.

39 Charles Burr Todd, "The American Barbison [*sic*]," *Lippincott's Magazine*, n.s. 5 (Apr. 1883), p. 323.

40 A useful survey of the phenomenon of American beach imagery is Valerie Ann Leeds et al., *At the Water's Edge: 19th and 20th Century American Beach Scenes* (exh. cat., Tampa, Fla.: Tampa Museum of Art, 1989).

41 The Maine coast was of little interest to the American Impressionists, but Kent, who had been a student of Chase's, was indebted to the heritage of Homer and often depicted Monhegan Island, off Maine. One of his many Maine coast images is considered in "Modern Painters in Landscape," this publication.

42 Curry, *Childe Hassam*, p. 17.

43 Curry discusses the poppy paintings at length (ibid., pp. 77–108).

44 See Julian Ralph, "Old Monmouth," *Harper's New Monthly Magazine* 89 (Aug. 1894), pp. 326–42.

45 Duffield Osborne, "Surf and Surf-Bathing," *Scribner's Magazine* 8 (July 1890), p. 100. See also "Summer on the Sands," *Munsey's Magazine* 17 (Aug. 1897), pp. 651–56, for the extent of beach development "from Maine to Florida, and from Pescadero to San Diego" (p. 651).

46 Francis H. Hardy, "Seaside Life in America," *Cornhill*, n.s. 1 (Nov. 1896), pp. 605, 606.

47 Gabriel Furman, *Antiquities of Long Island*, ed. Frank Moore (New York, 1874).

48 *Long Island Democrat* (Jamaica), July 6, 1880, p. 2, quoted in Marilyn E. Weigold, *The American Mediterranean—An Environmental, Economic, and Social History of Long Island Sound* (New York, 1974), pp. 57–58. For a comprehensive account of the artistic encounter with Long Island, see Ronald G. Pisano, *Long Island Landscape Painting, 1820–1920* (Boston, 1985). Our discussion of Long Island, especially Shinnecock, is also indebted to Giovanna P. Fiorino, "At the Seaside" (manuscript, Graduate School and University Center, City University of New York, 1991).

49 These guides are mentioned in Charles L. Sachs, *The Blessed Isle: Hal B. Fullerton and His Image of Long Island, 1897–1927* (Interlaken, N.Y., 1991), p. 32. This source also describes the region's development as a tourist area.

50 Several other examples of this mode by Sanford Robinson Gifford, Jasper Francis Cropsey, Edward Moran, and Mauritz Frederick Hendrik de Haas are reproduced in Pisano, *Long Island Landscape Painting*, pp. 64–80 passim.

51 The definitive study of Carr is Deborah Chotner, *S. S. Carr* (exh. cat., Northampton, Mass.: Smith College Museum of Art, 1976).

52 For an extended consideration of Coney Island, see John F. Kasson, *Amusing the Million: Coney Island at the Turn of the Century* (New York, 1978); Kathy Peiss, *Cheap Amusements: Working Women and Leisure in Turn-of-the-Century New York* (Philadelphia, 1986), pp. 115–38; and Stephen F. Weinstein, "The Nickel Empire: Coney Island and the Creation of Urban Seaside Resorts in the United States" (Ph.D. diss., Columbia University, New York, 1984).

53 William H. Bishop, "To Coney Island," *Scribner's Monthly* 20 (July 1880), pp. 365, 363, quoted in Pisano, *Long Island Landscape Painting*, p. 48.

54 Hardy, "Seaside Life in America," p. 616.

55 Alfred Trumble, "Art's Summer Outings," *Quarterly Illustrator* 2 (Oct.–Dec. 1894), p. 385, quoted in Pisano, *Long Island Landscape Painting*, p. 8.

56 The Tile Club's activities are summarized in Pisano, *Long Island Landscape Painting*, pp. 3–6, on the basis of the following publications: W. MacKay Laffan, "The Tile Club at Work," *Scribner's Monthly* 17 (Jan. 1879), pp. 401–9; W. MacKay Laffan and Edward Strahan [Earl Shinn], "The Tile Club at Play," *Scribner's Monthly* 17 (Feb. 1879), pp. 457–78; *The New Long Island: A Handbook of Summer Travel* (New York, 1879); W. MacKay Laffan and Edward Strahan [Earl Shinn], "The Tile Club Afloat," *Scribner's Monthly* 19 (Mar. 1880), pp. 641–71; W. MacKay Laffan, "The Tile Club Ashore," *Century* 23 (Feb. 1882), pp. 481–98; and F. Hopkinson Smith, *Book of the Tile Club* (Boston, 1886).

57 Laffan, "Tile Club Ashore," p. 498.

58 Lizzie [Elizabeth W.] Champney, "The Summer Haunts of American Artists," *Century* 30 (Oct. 1885), pp. 850–51, quoted in Pisano, *Long Island Landscape Painting*, p. 9.

59 For Chase as a teacher at Shinnecock, see Ronald G. Pisano, *The Students of William Merritt Chase* (exh. cat., Huntington, N.Y.: Heckscher Museum; Southampton, N.Y.: Parrish Art Museum, 1973); Ronald G. Pisano, *William Merritt Chase in the Company of Friends* (exh. cat., Southampton, N.Y.: Parrish Art Museum, 1979); and D. Scott Atkinson and Nicolai Cikovsky, Jr., *William Merritt Chase: Summers at Shinnecock, 1891–1902* (exh. cat., Washington, D.C.: National Gallery of Art, 1987). John H. Morice, *The First Out-of-Door Art School in the United States* (n.p., 1945), discusses the founding of the school. The most useful older sources are John Gilmer Speed, "An Artist's Summer Vacation," *Harper's New Monthly Magazine* 87 (June 1893), pp. 3–14; and Rosina H. Emmet, "The Shinnecock Hills Art School," *Art Interchange* 31 (Oct. 1893), pp. 89–90.

60 Speed, "An Artist's Summer Vacation," p. 4.

61 A useful description of the Art Village appears in Alastair Gordon, "Village Voice," *Art and Antiques*, May 1991, pp. 91–97.

62 For a recent description and photographs, see Jeanine Larmoth, "Historic Architecture: Stanford White—the Southampton House of William Merritt Chase," *Architectural Digest* 43 (June 1986), pp. 158–63.

63 Speed, "An Artist's Summer Vacation," p. 4.

64 Lillian Baynes, "Summer School at Shinnecock Hills," *Art Amateur* 31 (Oct. 1894), p. 92. The article reiterates "A School in the Sands," *Brooklyn Daily Eagle*, Oct. 14, 1894, p. 9, cols. 6–7.

65 Elizabeth W. Champney, *Witch Winnie at Shinnecock; or, The King's Daughter in a Summer Art School* (New York, 1894), pp. 12–13.

66 Kenyon Cox, "William M. Chase, Painter," *Harper's New Monthly Magazine* 78 (Mar. 1889), p. 556.

67 Rockwell Kent, *It's Me O Lord: The Autobiography of Rockwell Kent* (New York, 1955), pp. 76, 78, quoted in Charles C. Eldredge, "William Merritt Chase and the Shinnecock Landscape," *Register of the Museum of Art, University of Kansas, Lawrence* 5 (1976), p. 12.

68 For a discussion of parallels between some of Chase's Shinnecock landscapes and works by de Nittis, see Dianne H. Pilgrim, "The Revival of Pastels in Nineteenth-Century America: The Society of Painters in Pastel," *American Art Journal* 10 (Nov. 1978), pp. 48–52. More work needs to be done to determine Chase's access to work by de Nittis.

69 For the debt of French artists to Dutch painting, see Petra T. D. Chu, *French Realism and the Dutch Masters: The Influence of Dutch Seventeenth-Century Painting on the Development of French Painting Between 1830 and 1870* (Utrecht, 1974).

70 "Complete Guide to the Day Summer Resorts About New York," *New York Sunday Press*, suppl., June 12, 1892, p. 19, quoted in Fiorino, "At the Seaside," pp. 9–10.

71 A summary history of Southampton and a useful description of sites and facilities appear in Henry Isham Hazelton, *The Boroughs of Brooklyn and Queens, Counties of Nassau and Suffolk, Long Island, New York, 1609–1924*, 4 vols. (New York, 1925), vol. 2, pp. 784–804. See also John Gilmer Speed, "The Passing of the Shinnecocks," *Harper's Weekly* 36 (Dec. 31, 1892), p. 1258.

72 Ernest Knaufft, "An American Painter—William M. Chase," *International Studio* 12 (Jan. 1901), pp. 156–57.

73 M. R. Harrington, "Shinnecock Notes," *Journal of American Folklore* 16 (Jan.–Mar. 1903), pp. 37–39. See also Speed, "Passing of the Shinnecocks," p. 1258.

74 William M. Chase, "Talk on Art by William M. Chase," *Art Interchange* 39 (Dec. 1897), p. 127, quoted in Ronald G. Pisano, *A Leading Spirit in American Art: William Merritt Chase, 1849–1916* (exh. cat., Seattle: Henry Art Gallery, University of Washington, 1983), p. 135.

75 Charles de Kay, "East Hampton the Restful," *New York Times Illustrated Magazine*, Oct. 30, 1898, p. 11, quoted in Pisano, *Long Island Landscape Painting*, p. 9.

76 *Southampton Press*, Aug. 28, 1897, quoted in Pisano, *Leading Spirit in American Art*, p. 121.

77 Ernest Ingersoll, "Around the Peconics," *Harper's New Monthly Magazine* 57 (Oct. 1878), p. 723, quoted in Pisano, *Long Island Landscape Painting*, p. 112.

78 Katherine M. Roof, "William Merritt Chase: An American Painter," *Craftsman* 18 (Apr. 1910), p. 34.

79 W[illiam] H[enry] F[ox], "Chase on 'Still Life,'" *Brooklyn Museum Quarterly* 1 (Jan. 1915), p. 198.

80 "William M. Chase, His Life and Work," *Arts for America* 7 (Dec. 1897), p. 198.

81 Speed, "An Artist's Summer Vacation," p. 8.

82 William H. Gerdts, *American Impressionism: Masterworks from Public and Private Collections in the United States* (exh. cat., Lugano-Castagnola, Switz.: Villa Favorita, Thyssen-Bornemisza Foundation, 1990), p. 98, identifies Robbin's Island in the picture.

83 The painting was first exhibited under the title *A Sunny Day* in February 1893 at Gill's Art Galleries, Springfield, Massachusetts. The present title was conferred in time for its second exhibition, at the 1893 show of the Society of American Artists in New York. See Gerdts, *American Impressionism: Masterworks*, p. 98. The new title may have been invented in response to the prevailing debate over the appropriateness of fairy tales as stories for children, for which, see George Ebers, "A Plea for the Fairy Tale," *Review of Reviews* 2 (Sept. 1890), p. 253.

84 For another discussion of the painting, see Doreen Bolger Burke, *American Paintings in The Metropolitan Museum of Art*, vol. 3, *A Catalogue of Works by Artists Born Between 1846 and 1864*, ed. Kathleen Luhrs (New York, 1980), pp. 81–84.

85 For the demographics of resort use, see "Complete Guide to Day Summer Resorts," pp. 9, 24. Henry James, Notebook entry for Nov. 26, 1892, in F. O. Matthiessen and Kenneth B. Murdock, eds., *Henry James: The Notebooks* (New York, 1947), p. 129, quoted in Larzer Ziff, *The American 1890s: Life and Times of a Lost Generation* (New York, 1966), p. 275. For both citations we are indebted to Fiorino, "At the Seaside," pp. 4–6.

86 William Dean Howells, *The Rise of Silas Lapham* (1885; reprint, Harmondsworth and New York, 1983), p. 26.

87 Osborne, "Surf and Surf-Bathing," pp. 100–112. See also Ishbel Ross, *Taste in America* (New York, 1967), p. 189; and Mary Cable, *American Manners and Morals: A Picture History of How We Behaved and Misbehaved* (New York, 1969), p. 137, cited in Fiorino, "At the Seaside," pp.

22–23, in a useful summary of American bathing and bathing costumes.

88 "Summer on the Sands," p. 655.

89 Baynes, "Summer School at Shinnecock Hills," p. 91.

90 William Merritt Chase, Lecture notes and speeches, n.d., William Merritt Chase Papers, Archives of American Art, Smithsonian Institution, Washington, D.C. (microfilm, reel N69–137), quoted in Burke, *American Paintings in the Metropolitan Museum*, p. 92.

91 "William Merritt Chase," *Outlook* 114 (Nov. 8, 1916), p. 537, quoted in Ronald G. Pisano, *William Merritt Chase* (New York, 1979), p. 62.

92 Speed, "An Artist's Summer Vacation," p. 8.

93 William Howe Downes, "William Merritt Chase, a Typical American Artist," *International Studio* 39 (Dec. 1909), p. 32.

94 Nicolai Cikovsky, Jr., "Interiors and Interiority," in Atkinson and Cikovsky, *William Merritt Chase*, p. 52; the entire thoughtful and provocative essay encompasses pp. 39–65.

95 William Merritt Chase, "Velasquez," *Quartier Latin* 1 (July 1896), p. 4, quoted in Cikovsky, "Interiors and Interiority," p. 53.

96 For elaboration of this point, see Cikovsky, "Interiors and Interiority."

97 Chase had been involved with the works of Manet since the early 1880s, when he helped Weir acquire the French artist's *Woman with a Parrot*, 1866 (The Metropolitan Museum of Art, New York, Gift of Erwin Davis, 1889, 89.21.3), and *Boy with a Sword*, 1861 (The Metropolitan Museum of Art, New York, Gift of Erwin Davis, 1889, 89.21.2), in Paris for Erwin Davis. He may have seen Manet's *Zola* in the wood engraving made by Prunaire in 1890, or even in Paris in the early summer of 1883, when the portrait appeared in the exhibition *Portraits du siècle* (no. 304), which opened at the Ecole des Beaux-Arts on April 25. See Paul Jamot and Georges Wildenstein, *Manet*, 2 vols. (Paris, 1932), vol. 1, p. 135, no. 146. Chase sailed for Europe on June 2, 1883, and may have visited Paris to see his own *Miss Dora Wheeler*, 1883 (fig. 29), at the Salon prior to settling in Holland for the summer.

98 Duncan Phillips, "William M. Chase," *American Magazine of Art* 8 (Dec. 1916), pp. 49–50, quoted in Pisano, *William Merritt Chase*, p. 64.

99 *Art Amateur* 38 (May 1895), p. 157, quoted in Pisano, *William Merritt Chase*, p. 70.

100 Cikovsky, "Interiors and Interiority," p. 49, suggests that Chase included the engraving as "an emblem of the challenge to authority and received opinion that had been a central motivation of [his] artistic life."

101 See Alfred H. Bellot, *History of the Rockaways from the Year 1685 to 1917: Being a Complete Record and Review of Events of Historical Importance During the Period in the Rockaway

Peninsula, Comprising the Villages of Hewlett, Woodmere, Cedarhurst, Lawrence, Inwood, Far Rockaway, Arverne, Rockaway Beach, Belle Harbor, Neponsit, and Rockaway Point* (Far Rockaway, N.Y., 1917).

102 Robert Henri, Diary, July 14, 1902, Archives of American Art, Smithsonian Institution, Washington, D.C. (microfilm, reel 885, frame 871).

103 Robert Henri, *The Art Spirit: Notes, Articles, Fragments of Letters and Talks to Students, Bearing on the Concept and Technique of Picture Making, the Study of Art Generally, and on Appreciation*, comp. Margery Ryerson (Philadelphia, 1923; reprint, New York, 1984), p. 82.

104 William Dean Howells, "The Beach at Rockaway," in *Literature and Life: Studies* (New York, 1902), p. 170.

105 See Richard J. Wattenmaker, "William Glackens's Beach Scenes at Bellport," *Smithsonian Studies in American Art* 2 (Spring 1988), pp. 74–94.

106 Baxter, "City Ownership of Seaside Parks," pp. 427–30 passim.

107 For Cape Ann and Gloucester in general, see James R. Pringle, *History of the Town and City of Gloucester, Cape Ann, Massachusetts* (Gloucester, Mass., 1892); John J. Babson, *History of the Town of Gloucester, Cape Ann—Including the Town of Rockport* (Gloucester, Mass., 1972); and Melvin T. Copeland and Elliott C. Rogers, *The Saga of Cape Ann* (Freeport, Maine, 1960).

108 See Harrison Cady, "Cape Ann, America's Oldest Art Colony," *American Artist* 16 (May 1952), p. 37.

109 Lillian W. Betts, "Gloucester: The Fishing City," *Outlook* 68 (May 4, 1901), p. 63. For a slightly later account of the Gloucester fishing industry, see James R. Coffin, "Le Beau Port: The Sea-Browned Fishing Town of Gloucester," *New England Magazine* 42 (Apr. 1910), pp. 166–78.

110 See "Gloucester and Rockport," in *The WPA Guide to Massachusetts: The Federal Writers' Project Guide to 1930s Massachusetts* (New York, 1937), p. 236.

111 For a survey of private houses on the North Shore, see Winfield S. Nevins, "Summer Days on the North Shore," *New England Magazine*, n.s. 5 (Sept. 1891), pp. 17–37.

112 Robert Grant, "The North Shore of Massachusetts," *Scribner's Magazine* 16 (July 1894), pp. 2–20 passim.

113 An overview of American painters' encounters with Gloucester is provided in *Portrait of a Place: Some American Landscape Painters in Gloucester* (Gloucester, Mass., 1973), which reprints John Wilmerding, "Interpretations of Place: Views of Gloucester, Massachusetts, by American Artists," *Essex Institute Historical Collections* 103 (Jan. 1967), pp. 53–65.

114 For general consideration of Gloucester in relation to American painting, see *Portrait of a Place*. Also useful is James F. O'Gorman, *This Other*

Gloucester: Occasional Papers on the Arts of Cape Ann, Massachusetts (Boston, 1976); and William H. Gerdts, "John Twachtman and the Artistic Colony in Gloucester at the Turn of the Century," in John D. Hale et al., *Twachtman in Gloucester: His Last Years, 1900–1902* (exh. cat., New York: Spanierman Gallery, 1987), pp. 27–43. For Homer at Gloucester, see D. Scott Atkinson and Jochen Wierich, *Winslow Homer in Gloucester* (exh. cat., Chicago: Terra Museum of American Art, 1990).

[115] See Reginald Cleveland Coxe, "In Gloucester Harbor," *Century* 44 (Aug. 1892), pp. 518–22.

[116] See "Gloucester and Rockport," in *WPA Guide to Massachusetts*, p. 237.

[117] Helen M. Knowlton, "A Home-Colony of Artists," *Studio* 5 (July 19, 1890), p. 326.

[118] James F. O'Gorman, "Catalogue," in *Portrait of a Place*, p. 58.

[119] F. W. Coburn quoted in O'Gorman, *This Other Gloucester*, p. 78.

[120] Edwin A. Start, "Round About Gloucester," *New England Magazine* 6 (Aug. 1892), pp. 688–89. Another celebration of the rugged fishermen of Gloucester appears in A. W. Dimock, "With the Gloucester Fishermen," *Outlook* 75 (Sept. 5, 1903), pp. 43–52.

[121] For example, Lillian W. Betts ("Gloucester: The Fishing City," p. 61) observed, "Of the courage and tenacity of the Anglo-Saxon blood in keeping its grip on this rocky Cape, a walk through the streets of Gloucester furnishes hourly evidence."

[122] See O'Gorman, *This Other Gloucester*, pp. 9–15; and Cady, "Cape Ann," pp. 62–63.

[123] Sarah Orne Jewett, *Deephaven* (Boston, 1877; new ed., Boston and New York, 1894), p. 4, quoted in Atkinson and Wierich, *Winslow Homer in Gloucester*, p. 31.

[124] Sherman T. Franklin, "A Sea Lover's Paradise," *New England Magazine*, n.s. 38 (Aug. 1908), p. 696.

[125] A summary of the critical response to Metcalf's Gloucester paintings at the 1896 Society of American Artists exhibition appears in Gerdts, *American Impressionism: Masterworks*, p. 102.

[126] See Elizabeth de Veer and Richard J. Boyle, *Sunlight and Shadow: The Life and Art of Willard L. Metcalf* (New York, 1987), p. 59.

[127] This discussion of Hassam's paintings is indebted to Thomas Parker, "Gloucester and Childe Hassam's American Vision" (manuscript, Graduate School and University Center, City University of New York, 1991).

[128] For Twachtman at Gloucester, see Hale et al., *Twachtman in Gloucester*.

[129] Eliot Clark, *John H. Twachtman* (New York, 1924), p. 53.

[130] Ibid.

[131] Grant Holcomb, "John Sloan: The Gloucester Years," in *John Sloan: The Gloucester Years* (exh. cat., Springfield, Mass.: Museum of Fine

Arts, 1980), pp. 8–11. For Sloan's Gloucester years, see also Rowland Elzea, *John Sloan's Oil Paintings: A Catalogue Raisonné*, 2 vols. (Newark, Del., 1991), vol. 1, pp. 24–26.

[132] "Souls of Our Cities Seen in Colors," *New York Times Magazine*, Feb. 22, 1925, p. 23, quoted in Holcomb, "John Sloan," p. 12.

[133] John Sloan, *Gist of Art: Principles and Practise Expounded in the Classroom and Studio*, recorded with the assistance of Helen Farr (New York, 1939), p. 146, quoted in Holcomb, "John Sloan," p. 15.

[134] Betts, "Gloucester: The Fishing City," p. 66.

[135] Ibid., p. 69.

[136] For another discussion of the painting, see Burke, *American Paintings in the Metropolitan Museum*, pp. 362–63.

[137] The durable motif of the traditional New England church is considered by Michael Kammen, *Meadows of Memory: Images of Time and Tradition in American Art and Culture* (Austin, Tex., 1992), pp. 163–67.

[138] O'Gorman, *This Other Gloucester*, pp. 81–89 passim, summarizes the art activities and spirit in Gloucester during the American involvement in World War I.

[139] The church was known as the Independent Christian Church by the 1890s. For the early history of the congregation, see Start, "Round About Gloucester," pp. 692–95; the remark on Gloucester as "the Mecca or Epworth of Universalism" appears on p. 695. O'Gorman, *This Other Gloucester*, pp. 16–24, discusses the history of the Universalist Meeting House. Also useful was Ita G. Krebs, "Childe Hassam's *The Church at Gloucester*" (manuscript, Graduate School and University Center, City University of New York, 1990).

[140] Childe Hassam, Autobiographical and biographical material, American Academy of Arts and Letters, Childe Hassam Papers, Correspondence, and Newspaper Clippings, 1883–1936, Archives of American Art, Smithsonian Institution, Washington, D.C. (microfilm, reel NAA–1, frames 741–42).

[141] The colonial-revival style as the visual counterpart to other forms of Americanization—English-language classes and instruction in American history and government, for example—is discussed in William B. Rhoads, "The Colonial Revival and the Americanization of Immigrants," in Alan Axelrod, ed., *The Colonial Revival in America* (Winterthur, Del., 1985), pp. 341–61.

THE CITY

The Urban Scene

[1] Samuel Lane Loomis, "The Growth of Great Cities," *Andover Review* 7 (Apr. 1887), pp. 341–42. For his characterization of the period

Loomis refers to Robert Vaughan, *The Age of Great Cities* (London, 1843). An overview of the development of cities and their impact on the arts appears in Anthony Sutcliffe, ed., *Metropolis, 1890–1940* (Chicago, 1984); and in that anthology, Theda Shapiro ("The Metropolis in the Visual Arts: Paris, Berlin, New York, 1890–1940," pp. 95–128) concentrates on twentieth-century representations of cities. Other pertinent survey studies include Dominic Ricciotti, "The Urban Scene: Images of the City in American Painting, 1890–1930" (Ph.D. diss., Indiana University, Bloomington, 1977); and Alice Marie O'Mara Piron, "Urban Metaphor in American Art and Literature, 1910–1930" (Ph.D. diss., Northwestern University, Evanston, Ill., 1982).

[2] Translated from Edmond de Goncourt and Jules de Goncourt, *Journal: Mémoires de la vie littéraire, 1851–1863*, 4 vols. (Paris, 1956), vol. 1, p. 252.

[3] Edmond Duranty, "The New Painting: Concerning a Group of Artists Exhibiting at the Durand-Ruel Galleries," in Linda Nochlin, ed., *Impressionism and Post-Impressionism, 1874–1904* (Englewood Cliffs, N.J., 1966), p. 7.

[4] Recent accounts of the development of nineteenth-century Paris include Donald J. Olsen, *The City as a Work of Art: London, Paris, Vienna* (New Haven, 1986); and François Loyer, *Paris, Nineteenth Century: Architecture and Urbanism* (New York, 1988).

[5] Robert L. Herbert, *Impressionism: Art, Leisure, and Parisian Society* (New Haven, 1988), p. 2.

[6] For a recent comprehensive account of gardens, see Monique Mosser and Georges Teyssot, eds., *The Architecture of Western Gardens: A Design History from the Renaissance to the Present Day* (Cambridge, Mass., 1991).

[7] Herbert, *Impressionism*, pp. 141–42; see pp. 142–52 for a consideration of French Impressionist park images.

[8] A. Hustin, *Le Luxembourg: Le Palais, le Petit-Luxembourg, le jardin, le musée, les carrières* (Paris, 1905), pp. 154–56.

[9] Translated from ibid., p. 134. Hustin provides photographs of the garden, of which *Le Luxembourg—Façade sur le jardin* (p. 133) is helpful for locating Sargent's scene.

[10] For the Second Empire renovations of the gardens and the historical background against which they occurred, see Gustave Hirschfeld, *Le Palais du Luxembourg* (Paris, 1931), pp. 120–32. Hirschfeld provides an aerial view of the Luxembourg palace and gardens (p. 121) and a view of the parterres (p. 131; see also fig. 126, this publication), which are helpful for locating Sargent's scene.

[11] W. Robinson, *The Parks, Promenades, and Gardens of Paris* (London, 1869), pp. 76–81. Robinson provides a plan of the Luxembourg Gardens (p. 78).

[12] The direction is verified by Sargent's large-scale oil study *Luxembourg Gardens at Twilight* of 1879 (Minneapolis Institute of Arts), almost iden-

tical with the final canvas but for the dome of the Panthéon rising over the treetops to the southeast of the Luxembourg complex.

[13] Hirschfeld, *Le Palais du Luxembourg*, p. 128. A census of the statues appears in Hustin, *Le Luxembourg*, pp. 143–44.

[14] Walter Wellman, "Rise of the American City: The Wonderful Story of the Census of 1900," *McClure's Magazine* 17 (Sept. 1901), p. 470. The national population grew from about 5 million in 1800 to about 76 million in 1900; urban population in 1800 was 5.1 percent of the whole, and in 1900 it was 47.1 percent. The literature on American urbanism is vast. For an introduction, see Howard Gillette, Jr., and Zale L. Miller, eds., *American Urbanism: A Historiographical Review* (New York, 1987). A thoughtful social history is Gunther Barth, *City People: The Rise of Modern City Culture in Nineteenth-Century America* (New York, 1980); Barth's bibliography (pp. 265–75) is especially helpful.

[15] Herbert, *Impressionism*, p. 2.

[16] Hubert Beck, "Urban Iconography in Nineteenth-Century American Painting: From Impressionism to the Ash Can School," in Thomas W. Gaehtgens and Heinz Ickstadt, eds., *American Icons: Transatlantic Perspectives on Eighteenth- and Nineteenth-Century American Art* (Santa Monica, Calif., 1992), pp. 319–47, discusses the creation of "urban pastorals" and "the repression of the city" by American painters.

[17] William H. Gerdts, *American Impressionism: Masterworks from Public and Private Collections in the United States* (exh. cat., Lugano-Castagnola, Switz.: Villa Favorita, Thyssen-Bornemisza Foundation, 1990), p. 94.

[18] See Frederick Law Olmsted and Calvert Vaux, *The Improvement of Central Park* (New York, 1858), which outlines plans for the park and provides rationales for its development in general and for particular features of the proposed plan. The bibliography on Olmsted and the parks of New York is extensive. Among the many pertinent secondary sources are: Paul B. Schumm, "The Central Park of New York City," *Landscape Architecture* 27 (Apr. 1937), pp. 115–44, which includes a summary of crucial early documents, maps, prints, and photographs; Robert Blumstock, "The Park Movement in Metropolitan New York: A Study of the Growth and Importance of Parks in an Urban Environment" (M.A. thesis, City College, New York, 1957), which reviews the development of parks in New York; Henry Hope Reed and Sophia Duckworth, *Central Park: A History and a Guide* (New York, 1967), which summarizes most available documentation; Clay Lancaster, *Prospect Park Handbook* (New York, 1967); Albert Fein, ed., *Landscape into Cityscape: Frederick Law Olmsted's Plans for a Greater New York City* (Ithaca, N.Y., 1967); Elizabeth Barlow, *Frederick Law Olmsted's New York* (exh. cat., New York: Whitney Mu-

seum of American Art, 1972), which summarizes the history of parks designed by Olmsted and Vaux, with an emphasis on Central Park; Albert Fein, *Frederick Law Olmsted and the American Environmental Tradition* (New York, 1972); Donald E. Simon, *Historic Prospect Park, Brooklyn, New York* (New York, 1974); Bruce Kelly et al., *Art of the Olmsted Landscape: Exhibited at The Metropolitan Museum of Art*, 2 vols. (exh. cat., New York: New York City Landmarks Preservation Commission, 1981); Charles E. Beveridge and David Schuyler, eds., *Creating Central Park, 1857–1861*, vol. 3 of *The Papers of Frederick Law Olmsted*, ed. Charles Capen McLaughlin (Baltimore, 1983), which compiles Olmsted's correspondence concerning the development of the park and provides a detailed account of the project; M. M. Graff, *Central Park, Prospect Park: A New Perspective* (New York, 1985); and most recently, in the first full-scale history of the park, Roy Rosenzweig and Elizabeth Blackmar, *The Park and the People: A History of Central Park* (Ithaca, N.Y., 1992), its development is reinterpreted and examined against a complex social, economic, and cultural context, emphasizing the contribution of Vaux and noting the ways in which democratic forces altered Olmsted's genteel schema. For Vaux, see *Calvert Vaux, Architect and Planner* (exh. cat., New York: Museum of the City of New York, 1989). The authors acknowledge with thanks the assistance of Deborah Solon, who prepared a preliminary bibliography of pertinent sources on Central Park (manuscript, Graduate School and University Center, City University of New York, 1989). Galen Cranz, *The Politics of Park Design: A History of Urban Parks in America* (Cambridge, Mass., 1982), traces the history of park usage and the politics of park design and provides a substantial bibliography on the subject in general.

[19] See this essay below and n. 225.

[20] Henry Whitney Bellows, "Cities and Parks: With Special Reference to the New York Central Park," *Atlantic Monthly* 7 (Apr. 1861), pp. 416–29. For an early illustrated historical sketch and remarks on the general significance of the park, see Fred B. Perkins, *The Central Park* (New York, 1864). For a scholarly survey of the sociopolitical relevance of urban design in America, see Paul Boyer, *Urban Masses and Moral Order in America, 1820–1920* (Cambridge, Mass., 1978).

[21] H. B. Merwin, "Park-Making as a National Art," *World's Work* 1 (Jan. 1901), pp. 296–99.

[22] Mary Caroline Robbins, "Park-Making as a National Art," *Atlantic Monthly* 79 (Jan. 1897), p. 87.

[23] Raymond S. Spears, "Central Park in Winter," *Munsey's Magazine* 22 (Feb. 1900), p. 633.

[24] A summary of resistance based on economic factors and of reconciliation appears in M. O. Stone, "Our Public Pleasure Grounds," *American Review of Reviews* 26 (Oct. 1902), pp. 458–60.

[25] For encomia regarding Central Park and Prospect Park, see Arthur Wakeley, "The Playground of the Metropolis," *Munsey's Magazine* 13 (Sept. 1895), pp. 565, 568; *A Hand Book for Prospect Park, Brooklyn, L. I., with Passing Notices of Its Natural and Artistic Beauty, Scenery, etc.* (New York, 1874), p. 64; Robbins, "Park-Making as a National Art," pp. 86–98, especially p. 92; and Samuel Parsons, Jr., "The Parks and the People," *Outlook* 59 (May 7, 1898), p. 27. Parsons summarizes the glories of both parks as well as the differences between them.

[26] Robbins, "Park-Making as a National Art," p. 86.

[27] Parsons, "Parks and the People," p. 22, notes the slow process of construction. Excellent early guidebooks are Clarence Cook, *Description of the New York Central Park* (New York, 1869), which offers an art critic's walking tour of major park sites and discusses those still under construction; *Hand Book for Prospect Park* (1874); and T. Addison Richards, *Guide to the Central Park* (New York, 1876), which provides brief descriptions of many features of the park.

[28] See *Currier and Ives, a Catalogue Raisonné*, intro. Bernard F. Reilly, Jr., 2 vols. (Detroit, 1984), vol. 1 passim.

[29] Kenyon Cox, "William M. Chase, Painter," *Harper's New Monthly Magazine* 78 (Mar. 1889), p. 549. See also Montezuma [Montague Marks], "My Note Book," *Art Amateur* 18 (Jan. 1888), p. 28; and "Paintings and Pastels by William M. Chase," *Critic*, no. 375 (Mar. 7, 1891), p. 128.

[30] "From a Talk by William M. Chase with Mr. Benjamin Northrop, of The Mail and Express," *Art Amateur* 30 (Feb. 1894), p. 77.

[31] Charles Baudelaire, "Le Peintre de la vie moderne" (1863), in *The Painter of Modern Life and Other Essays*, trans. Jonathan Mayne (London, 1964), p. 9.

[32] See Maureen C. O'Brien, *In Support of Liberty: European Paintings at the 1883 Pedestal Fund Art Loan Exhibition* (exh. cat., Southampton, N.Y.: Parrish Art Museum, 1986); and "The Country Retreat and the Suburban Resort," n. 97, this publication.

[33] See *Illustrated Catalogue of the Valuable Paintings Forming the Private Collection of William Merritt Chase, N.A., to Be Sold* [March 7–8] (sale cat., New York: American Art Association, 1912); and *Catalogue of the Completed Pictures ... Left by the Late William Merritt Chase, N.A., the Artistic Studio Effects and an Important Collection of Paintings ... to Be Sold* [May 14–17] (sale cat., New York: American Art Association, 1917).

[34] William Merritt Chase, Lecture notes and speeches, n.d., William Merritt Chase Papers, Archives of American Art, Smithsonian Institution, Washington, D.C. (microfilm, reel N69–137, frame 475).

[35] The painting was purchased from the artist by New York collector John Sherwood, who lent it

to the December 1879 exhibition at the National Academy of Design, New York (no. 61), but sold it at Chickering Hall, New York (Dec. 17, 1879, lot 61, as *The Luxembourg Gardens*). The canvas appeared again at Williams and Everett Gallery, Boston, in 1882, was sold to New York collector J. Mortimer Lichtenauer in 1884, and was shown at Knoedler and Company, New York, in 1887, from which it was purchased by John G. Johnson of Philadelphia.

36 Chase, Lecture notes and speeches, n.d., Chase Papers, Archives of American Art (microfilm, reel N69–137, frame 475).

37 For Chase's admiration of the Spanish master, see William M. Chase, "Velasquez," *Quartier Latin* 1 (July 1896), pp. 4–5; and Arthur Hoeber, "American Artists and Their Art, II: William M. Chase," *Women's Home Companion* 37 (Sept. 1910), p. 51.

38 David Park Curry, *James McNeill Whistler at the Freer Gallery of Art* (exh. cat., Washington, D.C.: Freer Gallery of Art, Smithsonian Institution, 1984), pp. 71–95, examines Whistler's portrayals of the Cremorne Gardens in the context of contemporary London social conditions.

39 For Chase's account of the episode, see William M. Chase, "The Two Whistlers: Recollections of a Summer with the Great Etcher," *Century* 80 (June 1910), pp. 218–26.

40 For a discussion of Weir's reliance on the tradition of Hals and of his painting *In the Park*, see Doreen Bolger Burke, *J. Alden Weir: An American Impressionist* (Newark, Del., 1983), pp. 94–102.

41 Ronald G. Pisano, *A Leading Spirit in American Art: William Merritt Chase, 1849–1916* (exh. cat., Seattle: Henry Art Gallery, University of Washington, 1983), p. 149.

42 A. E. Ives, "Suburban Sketching Grounds, I: Talks with Mr. W. M. Chase, Mr. Edward Moran, Mr. William Sartain, and Mr. Leonard Ochtman," *Art Amateur* 25 (Sept. 1891), p. 80.

43 Pisano, *Leading Spirit in American Art*, p. 89. Pisano bases his claims for Chase's exclusive commitment to optical issues on material gathered from the following sources: Perriton Maxwell, "William Merritt Chase—Artist, Wit, and Philosopher," *Saturday Evening Post* 172 (Nov. 4, 1899), p. 347; William M. Chase, "The Import of Art: An Interview with Walter Pach," *Outlook* 95 (June 25, 1910), pp. 441–45; William M. Chase, "Painting," *American Magazine of Art* 8 (Nov. 1916), pp. 50–53; and Marietta Minnegerode Andrews, *Memoirs of a Poor Relation* (New York, 1927).

44 See, for example, Schumm, "Central Park of New York," p. 118. Rosenzweig and Blackmar (*The Park and the People*) dispute such readings and emphasize the fundamental elitism of Olmsted and his plans.

45 Robbins, "Park-Making as a National Art," pp. 86–87. See also Merwin, "Park-Making as a

National Art," p. 293. One observer acknowledged that there was in Central Park a minor undercurrent of cosmopolitanism in its statues of foreigners, musical performances, and carefully selected exotic vegetation. J. Crawford Hamilton, "Snap Shots in Central Park," *Munsey's Magazine* 6 (Oct. 1891), p. 6.

46 Cox, "William M. Chase, Painter," p. 556.

47 Charles de Kay, "Mr. Chase and Central Park," *Harper's Weekly* 35 (May 2, 1891), p. 328.

48 Wakeley, "Playground of the Metropolis," p. 566.

49 Theodore Reff, *Manet and Modern Paris: One Hundred Paintings, Drawings, Prints, and Photographs by Manet and His Contemporaries* (exh. cat., Washington, D.C.: National Gallery of Art, 1982), p. 17.

50 "Central Park, II," *Scribner's Monthly* 6 (Oct. 1873), p. 677.

51 Frederick Law Olmsted and Calvert Vaux, "Description of a Plan for the Improvement of the Central Park, 'Greensward'" (1858), in Beveridge and Schuyler, *Creating Central Park*, pp. 127, 154.

52 "Central Park, II," p. 683. See also "Central Park," *Scribner's Monthly* 6 (Sept. 1873), pp. 534–35.

53 John C. Van Dyke, *The New New York: A Commentary on the Place and the People* (New York, 1909), p. 349.

54 Charles S. Sargent, "Park Boards and Their Professional Advisers," *Garden and Forest* 7 (Nov. 21, 1894), p. 461, quoted in Fein, *Olmsted and American Environmental Tradition*, p. 63.

55 Richards, *Guide to Central Park*, pp. 43, 44.

56 Ibid., p. 74.

57 The painting is discussed by Ronald G. Pisano in *American Paintings from the Manoogian Collection* (exh. cat., Washington, D.C.: National Gallery of Art, 1989), pp. 140–43.

58 De Kay, "Mr. Chase and Central Park," p. 328.

59 Parsons, "Parks and the People," p. 27.

60 William Merritt Chase, "Talk on the Old Masters," Chase Papers, Archives of American Art (microfilm, reel N69–137, frame 498).

61 Chase, Lecture notes and speeches, n.d. Chase Papers, Archives of American Art (microfilm, reel N69–137, frames 488–89).

62 Wakeley, "Playground of the Metropolis," p. 568.

63 Schumm, "Central Park of New York," p. 134. Schumm also noted: "Olmsted viewed with a jaundiced eye what he considered the misuse of the drives in too lively a manner. He states that the drives were deliberately laid out in a meandering and roundabout way to make them unattractive to through traffic, and the surrounding streets were widened to aid and abet his purpose."

64 Hamilton, "Snap Shots in Central Park," p. 8.

65 See "Central Park, II," p. 691. The value of proximity to parks for the poorer classes is a common theme in the commentary that encouraged park development.

66 Karen Zukowski (in Annette Blaugrund et al., *Paris 1889: American Artists at the Universal Exposition* [exh. cat., Philadelphia: Pennsylvania Academy of the Fine Arts, 1989], p. 127) posits—incorrectly, we believe—that this is a composite of the two parks.

67 Hamilton, "Snap Shots in Central Park," p. 10.

68 Edward W. Earle, ed., *Points of View: The Stereograph in America—A Cultural History* (Rochester, N.Y., 1979), chronicles the development of American stereography in relation to social history. Frederick S. Lightfoot, ed., *Nineteenth-Century New York in Rare Photographic Views* (New York, 1981), focuses on New York City imagery. William C. Darrah, *The World of Stereographs* (Gettysburg, Pa., 1977), provides a detailed history of stereography with an international subject index. Peter B. Hales, *Silver Cities: The Photography of American Urbanization, 1839–1915* (Philadelphia, 1984), considers the effect of urbanization on photography.

69 For an account of the sequential picturesqueness of Central Park, see Wakeley, "Playground of the Metropolis," p. 568.

70 Cranz, *Politics of Park Design*, p. 41.

71 Merwin, "Park-Making as a National Art," p. 299, articulates Olmsted and Vaux's principles: "The ideal park is planned to show Nature in as many aspects as may be reproduced. If in the heart of a city, it is so laid out that the visitor will catch no glimpse of surrounding buildings. Hills are raised and trees are planted to give a mysterious effect of farther distances."

72 Wakeley, "Playground of the Metropolis," pp. 576–77.

73 Another view by Chase of the same site, *Lilliputian Boats in the Park*, whereabouts unknown, was illustrated in Clarence Cook, *Art and Artists of Our Time*, 3 vols. (New York [1888]), vol. 3, p. 281.

74 De Kay, "Mr. Chase and Central Park," p. 324.

75 Captain Roland F. Coffin, "The History of American Yachting, V: From 1876 to 1878," *Outing* 9 (Oct. 1886), p. 24. The article appeared in a six-part series on the history of American yachting, published in *Outing* 8–10 (1886–87).

76 Wakeley, "Playground of the Metropolis," pp. 569–70.

77 See, for example [Clarence Cook], "American Notes," *Studio* 5 (Sept. 27, 1890), p. 425.

78 For Beacon Hill, see Allen Chamberlain, *Beacon Hill: Its Ancient Pastures and Early Mansions* (Boston and New York, 1925). Simmons's painting, signed and dated 1893, appeared as no. 120, *Boston Common*, in *Fifteenth Annual Exhibition of the Society of American Artists* (exh. cat., New York, 1893), and as no. 22, *Boston Common*, in *Fifteenth Annual Exhibition: Ten American Painters* (exh. cat., New York: Montross Gallery, 1912).

79 The original home of the club was at 85 Boylston

Street; it occupied the Newbury Street house from 1887 to 1941 and is operating today at 199 Commonwealth Avenue, Boston. A recent consideration of the club's activity in the exhibition of art, especially Impressionism, is Doris A. Birmingham, "Boston's St. Botolph Club: Home of the Impressionists," *Archives of American Art Journal* 31, no. 3 (1991), pp. 26–34. Helpful in terms of the club's history are the following sources: Talcott Miner Banks, Jr., "St. Botolph Club, Highlights from the First Forty Years, 1880–circa 1920" (manuscript, St. Botolph Club Records, Massachusetts Historical Society, Boston, n.d.); and Joseph Henry Curtis, *The St. Botolph Club: Its Birth and Early Club History* (pamphlet, n.d. n.p.,). A view of the Public Garden by Breck entitled *The Gilded Dome, Spring,* similar to Simmons's *Boston Public Garden* and also apparently painted from one of the windows of the St. Botolph Club, appeared at auction, Sotheby's, New York, Nov. 29, 1990, lot 71.

[80] Edwin M. Bacon, *King's Dictionary of Boston* (Cambridge, Mass., 1883), pp. 128–29. Holly Wagoner, Curatorial Assistant, Terra Museum of American Art, Chicago, to N. Mishoe Brennecke, Aug. 24, 1993, notes: "Our records show that the Terra Museum purchased the painting from Taggart, Jorgensen and Putnam in Washington, D.C., in 1984. The only provenance given from this dealer was St. Botolph Club."

[81] *Boston and Its Suburbs: A Guide Book* (Boston, 1888), p. 33.

[82] Christopher E. Eliot, "The Boston Public Garden," *Proceedings of the Bostonian Society,* 1939, pp. 26–45, summarizes the early history of the Public Garden.

[83] City of Boston, *Report of Committee on the Improvement of the Public Garden,* Oct. 31, 1859 (City Document no. 63–1859), pp. 3, 7, quoted in Cynthia Zaitzevsky, *Frederick Law Olmsted and the Boston Park System* (Cambridge, Mass., 1982), pp. 33–34.

[84] Moses King, *The Back Bay District and the Vendome, Boston,* 3d ed. (Boston, 1881), pp. 8, 10.

[85] See Justin Winsor, ed., *The Memorial History of Boston,* 4 vols. (Boston, 1881), vol. 4, part 2, pp. 36–37, 614–15; Edwin M. Bacon, ed., *Boston Illustrated: A Familiar Guide to Boston and Its Neighborhood* (Boston, 1893), pp. 88–96; Charles W. Stevens, "The Boston Public Garden," *New England Magazine* 24 (June 1901), pp. 343–56; and Zaitzevsky, *Olmsted and Boston Park System,* pp. 33–34.

[86] See, for example, Clarence Pullen, "The Boston Park and Parkway System," *Harper's Weekly* 34 (Sept. 27, 1890), p. 745.

[87] For the Boston park movement, see Joan Holtz Kay, *Lost Boston* (Boston, 1980), especially pp. 229–69; Zaitzevsky, *Olmsted and Boston Park System,* pp. 33–47; and Stephen Hardy,

How Boston Played: Sport, Recreation, and Community, 1865–1915 (Boston, 1982), especially pp. 65–84.

[88] *New York Herald,* Apr. 7, 1907, quoted in Grace M. Mayer, *Once upon a City: New York from 1890 to 1910* (New York, 1958), p. 45.

[89] Glackens illustrated John J. A'Becket, "Autumn Days in Central Park," *Harper's Bazar* 33 (Nov. 17, 1900), pp. 1814–19.

[90] Spears, "Central Park in Winter," pp. 634, 636.

[91] A[lbert] E. Gallatin, *Modern Art at Venice and Other Notes by A.E.G.* (New York, 1910), pp. 64–65. For a similar evaluation of Glackens's characteristic optimism, see Guy Pène du Bois, "William Glackens, Normal Man," *Arts and Decoration* 4 (Sept. 1914), pp. 404–6.

[92] Spears, "Central Park in Winter," p. 633.

[93] Ibid., p. 634.

[94] For a detailed consideration of the painting, see Doreen Bolger Burke, *American Paintings in The Metropolitan Museum of Art,* vol. 3, *A Catalogue of Works by Artists Born Between 1846 and 1864,* ed. Kathleen Luhrs (New York, 1980), pp. 339–41.

[95] Jenny Carson examines Prendergast's painting *Franklin Park* of about 1895 (Daniel J. Terra Collection) and summarizes documentation pertaining to the site (Jenny Carson, "Maurice Prendergast's *Franklin Park*: A Symbol of Democracy in Turn of the Century Boston" [manuscript, Graduate School and University Center, City University of New York, 1990]).

[96] [Charles S. Sargent], "The Proper Use of Public Parks," *Garden and Forest* 2 (Sept. 1889), p. 457, noted that Boston's public parks offered essential refreshment for the masses, which, unlike the upper classes, had no access to the countryside. Carol Clark remarked on the occurrence of the independent woman in Prendergast's park scenes in "'Modern' America and the 'New' Woman: Maurice Prendergast in the 1890s," Doris and Harry Rubin Lecture on American Painting, The Metropolitan Museum of Art, New York, May 3, 1988.

[97] See George Szabo, *Maurice Prendergast: The Large Boston Public Garden Sketchbook* (exh. cat., Oklahoma City: Oklahoma Museum of Art, 1981); *Maurice Prendergast: Large Boston Public Garden Sketchbook,* facsimile, intro. George Szabo (New York, 1987); and Carol Clark, *The Robert Lehman Collection,* vol. 8, *American Drawings and Watercolors* (New York, 1992), pp. 60–131.

[98] Carol Clark, Nancy Mowll Mathews, and Gwendolyn Owens, *Maurice Brazil Prendergast, Charles Prendergast: A Catalogue Raisonné* (Munich and Williamstown, Mass., 1990), no. 400, p. 299.

[99] "Central Park," *Scribner's Monthly* 6 (Sept. 1873), p. 533.

[100] Moses King, *King's Handbook of New York City*

(Boston, 1892), p. 146, gives the lengths of the various roadways.

[101] Ellen Glavin, "Maurice Prendergast and Central Park," *Archives of American Art Journal* 31, no. 4 (1991), pp. 20–26, discusses the relationship between aesthetic principles espoused by Olmsted and articulated in Prendergast's paintings. In the Metropolitan Museum's painting the prominence of riders on horseback and pedestrians, as well as of the wheeled carriages that used the Promenade, suggests that the painting does not merely reiterate Prendergast's watercolor images of the Promenade alone, as Glavin suggests (pp. 25–26).

[102] James H. Tuckerman, "Park Driving," *Outing* 56 (June 1905), p. 259.

[103] John Sloan, Diary entries for May 30 and June 2, 1906, quoted in Bruce St. John, ed., *John Sloan's New York Scene from the Diaries, Notes, and Correspondence, 1906–1913* (New York, 1965), pp. 38, 39.

[104] John Sloan, *Gist of Art: Principles and Practise Expounded in the Classroom and Studio,* recorded with the assistance of Helen Farr (New York, 1939), p. 208. In a letter of 1942 the artist called attention to the whitewashed tree trunks in the scene, which, he said "were a device used to enable visitors to stroll about at night." The whitewashing also points up the artificiality of the setting and the role of human mediation in designing nature in the park. See John Sloan, Letter to Margit Varga, Feb. 27, 1942, quoted in Rowland Elzea, *John Sloan's Oil Paintings: A Catalogue Raisonné,* 2 vols. (Newark, Del., 1991), vol. 1, p. 70.

[105] Patterson Sims, *Whitney Museum of American Art: Selected Works from the Permanent Collection* (New York, 1985), pp. 26–27.

[106] Cranz, *Politics of Park Design,* p. 3.

[107] The figure of forty-four miles is from M. G. Cunniff, "What a City Might Be," *World's Work* 10 (July 1905), p. 6357.

[108] Wanda M. Corn, "The New New York," *Art in America* 61 (July–Aug. 1973), pp. 58–65.

[109] "My Note Book," *Art Amateur* 29 (June 1903), p. 2.

[110] Richard J. Boyle, "The Art," in Elizabeth de Veer and Richard J. Boyle, *Sunlight and Shadow: The Life and Art of Willard L. Metcalf* (New York, 1987), p. 220.

[111] William Loring Andrews, *The Iconography of the Battery and Castle Garden* (New York, 1901), p. 3. Richard J. Boyle ("Art," p. 220) has noted that the history of the park, and its old-fashioned character, would have been of interest to Metcalf.

[112] Viola Roseboro, "Down-Town New York," *Cosmopolitan* 1 (June 1886), p. 221.

[113] *Reconstruction of Battery Park* (New York: Department of Parks, 1942), p. 3.

[114] Roseboro, "Down-Town New York," p. 222.

[115] Mrs. Schuyler [Mariana Griswold] Van Rensselaer, "Midsummer in New York," *Century* 62 (Aug.

1901), p. 491. See also Richard Harding Davis, "A Summer Night on the Battery," *Harper's Weekly* 34 (Aug. 2, 1890), p. 594; and Albert Shaw, "The Higher Life of New York City," *Outlook* 53 (Jan. 25, 1896), p. 133.

[116] Rodman Gilder, *The Battery: The Story of the Adventurers, Artists, Statesmen, Grafters, Songsters, Mariners, Pirates, Guzzlers, Indians, Thieves, Stuffed-shirts, Turn-coats, Millionaires, Inventors, Poets, Heroes, Soldiers, Harlots, Bootlicks, Nobles, Nonentities, Burghers, Martyrs, and Murderers Who Played Their Parts During Full Four Centuries on Manhattan Island's Tip* (Boston, 1936), pp. 212–13.

[117] *New York Times*, July 10, 1891, quoted in Gilder, *The Battery*, p. 213.

[118] James Huneker quoted in Gilder, *The Battery*, p. 214.

[119] [James Huneker], "Things Seen in the World of Art: Pictures by Willard L. Metcalf of American Landscapes on Exhibition," *New York Sun*, Jan. 7, 1912, photocopy in the files of the Departments of American Art, Metropolitan Museum. The "mosque" is Temple Beth El.

[120] For information on this bridge, see Carl W. Condit, *American Building Art: The Nineteenth Century* (New York, 1960), pp. 194–95.

[121] Corn, "New New York," p. 59.

[122] *New York: A Series of Wood Engravings in Colour and a Note on Colour Printing by Rudolph Ruzicka with Prose Impressions by Walter Prichard Eaton* (New York, 1915), p. 112.

[123] M[ariana] G[riswold] Van Rensselaer, "Picturesque New York," *Century* 45, n.s. 23 (Dec. 1892), p. 168.

[124] Duncan Phillips, "Ernest Lawson," *American Magazine of Art* 8 (May 1917), pp. 260–61.

[125] Ibid., p. 261.

[126] For another discussion of this painting, see the entry by Judith Hansen O'Toole in Paul D. Schweizer, ed., *Masterworks of American Art from the Munson-Williams-Proctor Institute* (New York, 1989), pp. 104–5.

[127] *Insurance Maps of the City of New York, Borough of the Bronx*, vol. 10 (New York, 1909), p. 39.

[128] King, *King's Handbook of New York*, p. 176.

[129] James Huneker, *Bedouins . . .* (New York, 1920), quoted in Stanley L. Cuba, "George Luks (1866–1933)," in *George Luks: An American Artist* (exh. cat., Wilkes-Barre, Pa.: Sardoni Art Gallery, Wilkes College, 1987), p. 32.

[130] Marianne Doezema, *George Bellows and Urban America* (New Haven, 1992), p. 55.

[131] For other discussions of this picture, see Maureen C. O'Brien's entry in Patricia C. F. Mandel, *Selection VII: American Paintings from the Museum's Collection, c. 1800–1930* (exh. cat., Providence: Rhode Island School of Design, 1977), pp. 204–6; and Doezema, *George Bellows and Urban America*, pp. 55–65.

[132] Sadakichi Hartmann, "A Plea for the Picturesqueness of New York," *Camera Work* 4 (Oct. 1900), pp. 93, 92, 94, quoted in Doezema, *George Bellows and Urban America*, p. 62.

[133] Doezema, *George Bellows and Urban America*, p. 209, n. 101, provides excellent documentation of this urban project.

[134] Doezema gives the definitive word on Bellows's knowledge of and participation in the Hudson-Fulton Celebration, as on so many questions about the artist. For this particular subject, see ibid., pp. 62–63, 209, n. 102.

[135] Ibid., p. 62.

[136] Ada Sterling, "New York's Charm in Summer," *Harper's Bazar* 33 (Aug. 18, 1900), p. 977.

[137] Charles H. Morgan, *George Bellows, Painter of America* (New York, 1965), p. 88.

[138] Michael Quick discusses these compositional devices in his essay "Technique and Theory: The Evolution of George Bellows's Painting Style," in Michael Quick et al., *The Paintings of George Bellows* (exh. cat., Fort Worth: Amon Carter Museum; Los Angeles: Los Angeles County Museum of Art, 1992), p. 26.

[139] See Jennifer A. Martin Bienenstock, "Childe Hassam's Early Boston Cityscapes," *Arts Magazine* 55 (Nov. 1980), pp. 168–71.

[140] Material pertaining to the filling of the South End and the Back Bay and much other information pertinent to the development of Boston appear in Zaitzevsky, *Olmsted and Boston Park System*, pp. 3–18.

[141] King, *Back Bay District and Vendome*, p. 7.

[142] A. E. Ives, "Talks with Artists: Mr. Childe Hassam on Painting Street Scenes," *Art Amateur* 27 (Oct. 1892), p. 117.

[143] The site is specified in Susan E. Strickler, *The Toledo Museum of Art: American Paintings* (Toledo, Ohio, 1979), p. 58.

[144] Beck, "Urban Iconography in Nineteenth-Century American Painting," p. 324. Caillebotte's painting appeared in the third Impressionist exhibition in 1877 and was in the possession of the artist until his death in 1894 and of his estate until 1954. J. Kirk T. Varnedoe and Thomas P. Lee, *Gustave Caillebotte: A Retrospective Exhibition* (exh. cat., Houston: Museum of Fine Arts, 1976), p. 110.

[145] A useful account of another of Hassam's Boston street scenes, *Boston Common at Twilight* (1885–86; Museum of Fine Arts, Boston), appears in Trevor J. Fairbrother et al., *The Bostonians: Painters of an Elegant Age, 1870–1930* (exh. cat., Boston: Museum of Fine Arts, 1986), p. 47.

[146] Zaitzevsky, *Olmsted and Boston Park System*, p. 10.

[147] Walter Blackburn Harte, "The Back Bay: Boston's Throne of Wealth," *Arena* 10 (June 1894), pp. 1–22. For the development of the Back Bay, see Walter Muir Whitehill, *Boston, a Topograph-*

ical History, 2d ed., enl. (Cambridge, Mass., 1968), pp. 141–73; Bainbridge Bunting, *Houses of Boston's Back Bay: An Architectural History, 1840–1917* (Cambridge, Mass., 1967); and Lewis Mumford and Walter Muir Whitehill, *Back Bay Boston: The City as a Work of Art* (exh. cat., Boston: Museum of Fine Arts, 1969). Sam Bass Warner, Jr., *Streetcar Suburbs: The Process of Growth in Boston, 1870–1900*, 2d ed. (Cambridge, Mass., 1978), discusses late nineteenth-century changes in Boston, including the Back Bay, and the emergence of its suburbs. Recent urban histories of Boston include Robert Campbell and Peter Vanderwarker, *Cityscapes of Boston: An American City Through Time* (Boston, 1992); and Lawrence W. Kennedy, *Planning the City upon a Hill: Boston Since 1630* (Amherst, Mass., 1992).

[148] Lewis Mumford, "The Significance of Back Bay Boston," in Mumford and Whitehill, *Back Bay Boston*, p. 18.

[149] King, *Back Bay District and Vendome*, p. 3. Similar remarks appear in Bacon, *King's Dictionary of Boston*, p. 43.

[150] Mumford, "Significance of Back Bay Boston," p. 19.

[151] Carol Troyen, *The Boston Tradition: American Paintings from the Museum of Fine Arts, Boston* (exh. cat., New York: American Federation of Arts, 1980), p. 166.

[152] William Dean Howells, *The Rise of Silas Lapham* (1885; reprint, Harmondsworth and New York, 1983), p. 32.

[153] William Howe Downes, "The Charles River Basin," *New England Magazine*, n.s. 15 (Oct. 1896), pp. 204–5. J. T. T[rowbridge], "Boston Vistas," *Outlook* 78 (Sept. 3, 1904), p. 64, echoed Downes's sentiments.

[154] William Howe Downes, "Boston as an Art Centre," *New England Magazine*, n.s. 30 (Apr. 1904), p. 162. For discussion of this renovation and its history, see Hon. Eugene C. Hultman, "The Charles River Basin" (a paper read before the Bostonian Society, Oct. 7, 1939), *Proceedings of the Bostonian Society*, 1940, pp. 39–48.

[155] Troyen, *Boston Tradition*, p. 166.

[156] Samuel M. Crothers, "Outdoor Boston," *Century* 74 (July 1907), p. 444.

[157] Hassam also repeated the composition of *Grand Prix Day* in a pastel; this pastel, shown at Doll and Richards Gallery, Boston, in 1891, has not been located. See Troyen, *Boston Tradition*, p. 164.

[158] Ibid.

[159] *Exhibition and Private Sale of Paintings by Mr. Childe Hassam* (exh. cat., Boston: Noyes, Cobb and Co., Mar. 1889), no. 16.

[160] Adeline Adams, *Childe Hassam* (New York, 1938), p. 61.

[161] Kathleen Burnside, "New York City as Subject in the Gilded Age: The Proliferation of Genteel

and Picturesque Urban Imagery" (manuscript, Graduate School and University Center, City University of New York, 1989), p. 1. Burnside is the codirector of the Childe Hassam catalogue raisonné, Hirschl and Adler Galleries, Inc., New York; her manuscript, cited here, was of great assistance to the authors.

162 Ives, "Hassam on Painting Street Scenes," p. 117. This article provides a useful account by Hassam himself of his working procedures and his Impressionist technique.

163 Ibid., p. 116.

164 "Some Students' Questions Briefly Answered by Mr. W. M. Chase," *Art Amateur* 36 (Mar. 1897), p. 68.

165 Julian Ralph ("Eight Days in Paris," *Harper's Weekly* 35 [July 4, 1891], p. 507, quoted in Burnside, "New York City as Subject," pp. 7–8) was one of many writers who noted the similarities between the two cities. Van Rensselaer also remarked ("Picturesque New York," p. 166) on the affinities between the two cities, concluding that New York had a character that would reward an artist's consideration even though it lacked the beauty of Paris. Charles Henry White, "In the Street," *Harper's Monthly Magazine* 110 (Feb. 1905), pp. 365–76, also described the picturesque elements of New York and its potential for artists; Louis Baury, "The Message of Manhattan," *Bookman* 33 (Aug. 1911), pp. 592–601, surveyed artists' attitudes toward New York, citing comments and works by Cooper, Pennell, and others.

166 See Ward McAllister, *Society As I Have Found It* (New York, 1890); and Jacob A. Riis, *How the Other Half Lives: Studies Among the Tenements of New York* (New York, 1890).

167 Wellman, "Rise of the American City," p. 471.

168 A fine overview of turn-of-the-century architectural developments is Robert A. M. Stern, Gregory Gilmartin, and John Montague Massengale, *New York 1900: Metropolitan Architecture and Urbanism, 1890–1915* (New York, 1983).

169 Henry James, *The American Scene* (1907), quoted in Alan Trachtenberg, "Image and Ideology: New York in the Photographer's Eye," *Journal of Urban History* 10 (Aug. 1984), p. 456.

170 Hassam's illustrations and reproductions of his paintings appear in Thomas Curtis Clarke, "Rapid Transit in Cities, I—The Problem," *Scribner's Magazine* 11 (May 1892), pp. 566–78, and "Rapid Transit in Cities, II—The Solution," *Scribner's Magazine* 11 (June 1892), pp. 743–58; Royal Cortissoz, "Landmarks of Manhattan," *Scribner's Magazine* 18 (Nov. 1895), pp. 531–44 (which also includes illustrations by Robinson); and M[ariana] G[riswold] Van Rensselaer, "Fifth Avenue, with Pictures by Childe Hassam," *Century* 47, n.s. 25 (Nov. 1893), pp. 5–18.

171 See, for example, King, *King's Handbook of New York* (1892; and 2d ed., Boston, 1893);

Carolyn Faville Ober and Cynthia M. Westover, *Manhattan Historic and Artistic: A Six Day Tour of New York City* (New York, 1892); Frank Moss, *The American Metropolis: From Knickerbocker Days to the Present Time; New York City Life in All Its Various Phases*, 3 vols. (New York, 1897); and Van Dyke, *New New York*. A comprehensive annotated list of books on New York published between 1853 and 1976 is Alan Burnham, *New York City, the Development of the Metropolis: An Annotated Bibliography* (New York, 1988). Corollary material includes numerous turn-of-the-century articles recommending remedies for the problems of cities, especially New York, and proposals for their beautification. The recent scholarly and popular bibliography on the history and development of the American city, and of New York in particular, is vast. Among useful sources, see Barth, *City People*; Gillette and Miller, *American Urbanism*; and Raymond A. Mohl, ed., *The Making of Urban America* (Wilmington, Del., 1988).

172 Rupert Hughes, *The Real New York* (London and New York, 1904), p. 21, quoted in Burnside, "New York City as Subject," p. 29, n. 15.

173 Corn, "New New York," pp. 58–65, surveys New York images by the early modernists' antecedents, including Hassam, Prendergast, and the Ashcan School.

174 Frances Lauderbach, "Notes from Talks by William M. Chase: Summer Class, Carmel-by-the-Sea, California. Memoranda from a Student's Note Book," *American Magazine of Art* 8 (Sept. 1917), p. 437.

175 Van Rensselaer, "Picturesque New York," p. 168. The international context for optimistic portrayals of American urban life is discussed in Andrew Lees, *Cities Perceived: Urban Society in European and American Thought, 1820–1940* (Manchester, 1985), especially pp. 139–225.

176 Elizabeth Steele, Paintings Conservator, The Phillips Collection, Washington, D.C., noted in a report of Jan. 11, 1990, that "Hassam painted out buildings which originally extended to the edge of the canvas, thereby altering the composition to give it a great sense of depth," quoted in Gina d'Angelo, "Childe Hassam's *Washington Arch, Spring*" (manuscript, Graduate School and University Center, City University of New York, 1990), p. 12, n. 33. The authors acknowledge with appreciation d'Angelo's extremely informative investigation of the painting. Also useful is Mindy Cantor, "Washington Arch and the Changing Neighborhood," in Mindy Cantor, ed., *Around the Square, 1830–1890: Essays on Life, Letters, and Architecture in Greenwich Village* (New York, 1982), pp. 40–51. For Greenwich Village in general, see Edmund T. Delaney, *New York's Greenwich Village* (Barre, Mass., 1968); and Rick Beard and Leslie Cohen Berkowitz, eds., *Greenwich Village: Culture and Counterculture* (New Brunswick, N.J., 1993).

177 The painting was shown as *Fifth Avenue and the Washington Arch in May* at Doll and Richards Gallery, Boston, in February 1895, and as *Washington Arch, May* at the St. Botolph Club, Boston, in November 1900, according to Gerdts, *American Impressionism: Masterworks*, p. 54.

178 Van Rensselaer, "Picturesque New York," p. 166.

179 "Even Baby's Perambulator Must Keep up with the Times," *New York Herald*, Apr. 8, 1900, section 9, p. 6, quoted in Mayer, *Once upon a City*, p. 41, observed that Washington Square was one of the areas in which "the fashions in [baby] carriages can be seen to best advantage."

180 Carol Ruth Berkin, "Washington Square: A Woman's World," in Cantor, *Around the Square, 1830–1890*, pp. 78–79.

181 Ives, "Hassam on Painting Street Scenes," pp. 116–17.

182 The tragic fire that took 146 lives at the Triangle Shirtwaist Company in 1911 occurred in the Asch Building on Washington Place, one block east of Washington Square.

183 William Dean Howells, *A Hazard of New Fortunes* (New York, 1890; reprint, New York, 1983), p. 48; see pp. 158–59 for Basil March's thoughts on the picturesqueness of immigrants. Jan Seidler Ramirez calls attention to this apposite source in "Within Bohemia's Borders: Greenwich Village, 1830–1930" (interpretive script accompanying an exhibition, New York: Museum of the City of New York [1990]), p. 8. For a summary of Howells's role in New York literary life and for commentary on *A Hazard of New Fortunes*, his first New York novel, see Thomas Bender, *New York Intellect: A History of Intellectual Life in New York City, from 1750 to the Beginnings of Our Own Time* (New York, 1987), pp. 191–94.

184 An overview of these developments appears in Steven Watson, *Strange Bedfellows: The First American Avant-Garde* (New York, 1991), pp. 122–65. Extremely helpful has been Ramirez, "Within Bohemia's Borders"; this exhibition provided the foundation for Beard and Berkowitz, *Greenwich Village: Culture and Counterculture*.

185 Unless otherwise cited, information regarding the centennial celebration and the Washington Arch is derived from *The History of Washington Arch in Washington Square* (New York, 1896).

186 Marquand's remarks appeared in "In Honor of Washington: Laying of the Cornerstone of the Memorial Arch," *New York Times*, May 31, 1890, pp. 1–2, quoted in d'Angelo, "Childe Hassam's *Washington Arch, Spring*," p. 6.

187 See, for example, Gerdts, *American Impressionism: Masterworks*, p. 54.

188 Van Rensselaer, "Fifth Avenue, with Pictures by Hassam," p. 6. The reason for the apparently incorrect date is mysterious: Hassam may have signed and incorrectly dated the painting after its completion or may have painted the canvas to

promote the scheme for the new arch, as Marc Simpson has suggested to the authors in a note of July 12, 1993. The authors are indebted to d'Angelo, "Childe Hassam's *Washington Arch, Spring*," for demonstrating by reference to contemporary photographs that Hassam depicted the permanent arch. Arthur M. Barnes, "Washington Square," *Harper's Weekly* 38 (July 14, 1894), p. 660, remarked on the marble arch's "power to quicken patriotism." The permanent arch was dedicated on May 4, 1895.

189 See William W. Ellsworth, "Colonel Waring's 'White Angels': A Sketch of the Street-Cleaning Department of New York," *Outlook* 53 (June 27, 1896), pp. 1191–94.

190 Shaw, "Higher Life of New York City," p. 132.

191 See George E. Waring, Jr., "The Cleaning of a Great City," *McClure's Magazine* 9 (Sept. 1897), pp. 911–24.

192 Hassam's *Winter in Union Square* was the subject of an excellent study by Jytte R. Willumstad, "Childe Hassam, *Union Square in Winter*, 1890" (manuscript, Graduate School and University Center, City University of New York, 1990), to which the authors are much indebted. The series to which such works as *Winter in Union Square* belongs seems to have announced to the critics Hassam's succession to the ideas of the French painters; two of them agreed in 1895: "Hassam is a brilliant painter, a sort of Watteau of the Boulevards" ([William Henry] Howe and [George] Torrey, "Childe Hassam," *Art Interchange* 34 [May 1895], p. 133).

193 Burke, *American Paintings in the Metropolitan Museum*, p. 356.

194 Hassam's enthusiasm for hansom cabs and their drivers is noted in Ives, "Hassam on Painting Street Scenes," p. 116.

195 Margot Gayle and Michele Cohen, *The Art Commission and the Municipal Art Society Guide to Manhattan's Outdoor Sculpture* (New York, 1988), pp. 90–97, identifies and documents this and other sculpture in Union Square.

196 John W. Frick, *New York's First Theatrical Center: The Rialto at Union Square* (Ann Arbor, Mich., 1985), pp. 6ff., summarizes the early history. See also M. Christine Boyer, *Manhattan Manners: Architecture and Style, 1850–1900* (New York, 1985), pp. 44–82.

197 David Cronin, "Union Square" (manuscript, New-York Historical Society, 1923), p. 12.

198 Boyer, *Manhattan Manners*, p. 76. Boyer surveyed Manhattan business directories and concluded that artists were installed in these buildings. See also Bender, *New York Intellect*, pp. 216–22.

199 Edward E. Simmons, *From Seven to Seventy: Memories of a Painter and a Yankee* (New York, 1922; reprint, New York, 1976), p. 203.

200 See Edward B. Watson, *New York Then and Now: 83 Manhattan Sites Photographed in the Past and in the Present* (New York, 1976), p. 154.

201 See Mary C. Henderson, *The City and the Theatre* (Clifton, N.J., 1973), pp. 139–49; and Frick, *New York's First Theatrical Center*.

202 The Academy of Music was supplanted by the Metropolitan Opera House at Broadway and Thirty-ninth Street, which was built by the city's nouveaux riches and opened in 1883; the Academy's building was demolished in 1926 and replaced by the headquarters of Con Edison.

203 Frick, *New York's First Theatrical Center*, p. 6.

204 Joseph G. Rayback, *A History of American Labor*, expanded and updated (New York, 1966), p. 169.

205 Samuel Isham, *The History of American Painting* (New York, 1905), p. 500.

206 In embracing Broadway's departure from reticulated regularity, Hassam seems to have echoed the feelings of contemporary critic Jean Schopfer, who praised the avenue for "destroying all frightful symmetries, and creating all along its course picturesque fantasy. . . . In straight New York, Broadway runs riot." Jean Schopfer, "The Plan of a City," *Architectural Record* 12 (Dec. 1902), p. 696.

207 Joseph S. Czestochowski, "Childe Hassam: Paintings from 1880 to 1900," *American Art Review* 4 (Jan. 1978), p. 48.

208 Van Rensselaer, "Picturesque New York," p. 167.

209 For an introduction to Pictorialist photography of New York, see Trachtenberg, "Image and Ideology: New York in Photographer's Eye," pp. 453–64.

210 James, "New York Revisited," in *American Scene*, p. 73.

211 *Leslie's Weekly*, Nov. 7, 1907, quoted in Mayer, *Once upon a City*, p. 44.

212 These women are of the sort for whom Sloan had expressed admiration in a diary entry of July 15, 1908: "A beautiful day and the breezes about the Flatiron Building show the beautiful forms of the women in their summer gowns. There are so many lovely women in New York and they dress so very charmingly, I'd like to spend hours watching them." Sloan quoted in St. John, *John Sloan's New York Scene*, p. 231.

213 Sloan, Diary, May 1, 1912, quoted in St. John, *John Sloan's New York Scene*, p. 620.

214 Sloan, *Gist of Art*, p. 233.

215 Ellen Wiley Todd, *The "New Woman" Revised: Painting and Gender Politics on Fourteenth Street* (Berkeley and Los Angeles, 1993), based on Ellen Wiley Todd, "Gender, Occupation, and Class in Paintings by the Fourteenth Street School, 1925–1940" (Ph.D. diss., Stanford University, 1987), provides an overview of the later generation of painters in Union Square and an extensive bibliography.

216 Luks's painting was mistakenly captioned *Houston Street* in a reproduction in John Cournos, "Three Painters of the New York School," *International Studio* 56 (Oct. 1915), p. 244. General

sources on immigration and ethnic populations include Nathan Glazer and Daniel P. Moynihan, *Beyond the Melting Pot: The Negroes, Puerto Ricans, Jews, Italians and Irish of New York City, 1800–1915* (New York, 1977); David C. Hammack, *Power and Society: Greater New York at the Turn of the Century* (New York, 1982); and John Bodnar, *The Transplanted: A History of Immigrants in Urban America* (Bloomington, Ind., 1985). For street life in the Lower East Side, see Cary Goodman, *Choosing Sides: Playground and Street Life in the Lower East Side* (New York, 1979), especially pp. 3–19.

217 For the arrival and establishment of the Jews in the United States, see Howard M. Sachar, *A History of the Jews in America* (New York, 1992).

218 Allon Schoener, ed., *The Lower East Side: Portal to American Life, 1870–1924* (exh. cat., New York: Jewish Museum, 1966), provides an overview and an extensive bibliography. See also Allon Schoener, comp., *Portal to America: The Lower East Side, 1870–1924, Photographs and Chronicles* (New York, 1967), which collects photographs, newspaper articles, and other primary documentation on the Lower East Side; Diana Cavallo, *The Lower East Side, A Portrait in Time* (New York, 1971); and Ronald Sanders, *The Lower East Side: A Guide to Its Jewish Past with 99 New Photographs* (New York, 1979).

219 John A. Kouwenhoven, *The Columbia Historical Portrait of New York* (Garden City, N.Y., 1953), p. 381.

220 Charles Edward Russell, "The Slum as a National Asset," *Everybody's Magazine* 20 (Feb. 1909), p. 177.

221 "East Side Street Vendors," *New York Times*, July 30, 1893; reproduced in Schoener, *Portal to America*, pp. 57–58. A tone of revulsion with respect to the new immigrants and their Lower East Side slums characterizes Van Dyke, *New New York*, pp. 255–69. A recent chronicle of the seamiest characters of the Lower East Side from 1840 to 1919 and of reform efforts is Luc Sante, *Low Life: Lures and Snares of Old New York* (New York, 1991).

222 "The Ghetto Market, Hester Street," *New York Times*, Nov. 14, 1897, reproduced in Schoener, *Portal to America*, p. 56. See also "Thursday in Hester Street," *New York Tribune*, Sept. 15, 1898, reproduced in Schoener, *Portal to America*, pp. 58–59. Picturesqueness is the keynote of commentary on the Lower East Side in Anne O'Hagen, "A Midsummer Morning in New York," *Munsey's Magazine* 21 (July 1899), pp. 537, 540.

223 Van Rensselaer, "Picturesque New York," p. 172.

224 Archibald A. Hill, "The Pushcart Peddlers of New York," *Independent* 61 (Oct. 18, 1906), p. 917.

225 Joel Perlmann, *Ethnic Differences: Schooling and Social Structure Among the Irish, Italians,*

Jews, and Blacks in an American City, 1880–1935 (Cambridge, 1988), pp. 83, 122, discusses the size of the Italian and Jewish immigrations: "In the great immigrations of 1880–1920, the Italians composed the largest single group, with some 4 million of them reaching the United States.... Despite the huge numbers who went back ... those who remained in the United States still outnumbered the arrivals in every other group" (p. 83). The Italians who came at the turn of the century displaced an enclave of African-Americans on Carmine Street. An account of Italians in Greenwich Village is presented in Josephine Gattuso Hendin, "Italian Neighbors," in Cantor, *Around the Square, 1830–1890*, pp. 54–63.

226 W. Bengough, "The Foreign Element in New York: The Mulberry Bend Italian Colony," *Harper's Weekly* 39 (June 29, 1895), p. 607.

227 Howells, *Hazard of New Fortunes*, p. 259.

228 Ibid., p. 262.

229 Henry McBride, "What's Doing in World of Art, Artists and Art Dealers," *New York Sun*, Oct. 26, 1913, section 7, p. 2, quoted in Marianne Doezema, "The Real New York," in Quick et al., *Paintings of George Bellows*, p. 119.

230 Doezema, "Real New York," p. 119.

231 Doezema, *George Bellows and Urban America*, p. 189.

232 Contrasting with Doezema's analyses of *Cliff Dwellers* (see nn. 229–31 above), which emphasize Bellows's negative social commentary and critical assessment of it as a catalogue of social ills, is the description in Ilene Susan Fort and Michael Quick, *American Art: A Catalogue of the Los Angeles County Museum of Art Collection* (Los Angeles, 1991), pp. 240–44. Fort and Quick give a summary of pertinent documentation.

233 Bellows's interest in Maratta's theories is described in Quick, "Technique and Theory," in Quick et al., *Paintings of George Bellows*, pp. 9–95.

234 Doezema, *George Bellows and Urban America*, pp. 189, 195.

235 See, for example, "The Tenement Problem," *Independent* 53 (Mar. 28, 1901), pp. 737–39; "Success of the Tenement Law," *Nation* 76 (Jan. 15, 1903), p. 46; "'Low Rent or No Rent': The Tenement Dwellers' Rebellion in New York," *Harper's Weekly* 52 (Jan. 25, 1908), pp. 16–17.

236 Van Dyke, *New New York*, p. 269.

237 Howells, *Hazard of New Fortunes*, p. 57.

238 "The Big Idea: George Bellows Talks About Patriotism for Beauty," *Touchstone* 1 (July 1917), p. 275.

239 Acknowledgment by Caroline H. Griffiths and Helen S. Hitchcock, in Alfred Noyes, *The Avenue of the Allies and Victory* (New York, 1918), p. 7, quoted in Ilene Susan Fort, *The Flag Paintings of Childe Hassam* (exh. cat., Los Angeles: Los Angeles County Museum of Art, 1988), p. 46.

240 "Painting America: Childe Hassam's Way," *Touchstone* 5 (July 1919), p. 272.

241 DeWitt McClellan Lockman, Interview with Childe Hassam, Feb. 2, 1927, transcript, p. 26, Lockman Papers, New-York Historical Society (Archives of American Art microfilm, reel 503, frame 384), quoted in Fort, *Flag Paintings of Childe Hassam*, p. 8.

242 "New York the Beauty City: Childe Hassam Declares That Paris and London Have Nothing to Compare with It, Though We May Not Know It," *New York Sun*, Feb. 23, 1913, Sunday magazine (section 4), p. 16.

Urban Leisure

1 Paul J. Staiti, "Illusionism, Trompe l'Oeil, and the Perils of Viewership," in Doreen Bolger, Marc Simpson, and John Wilmerding, eds., *William M. Harnett* (exh. cat., New York: The Metropolitan Museum of Art; Fort Worth: Amon Carter Museum, 1992), pp. 31–48.

2 Mariana Griswold Van Rensselaer, "People in New York," *Century* 49 (Feb. 1895), p. 546.

3 By 1882 one could look out over New York from the city's first roof garden, Kimball and Wisedell's Casino Theatre, located on the busy corner of Broadway at Thirty-ninth Street. Charles C. Haight's American Theatre, built in 1893 at Forty-second Street and Eighth Avenue, was rebuilt in 1909 by Thomas Lamb with "a promenade which took advantage of the American's three-street frontage." See Nicholas van Hoogstraten, *Lost Broadway Theatres* (New York, 1991), pp. 15, 30.

4 Theodore Dreiser, *Sister Carrie* (1900; reprint, New York, 1982), p. 232.

5 "The Point of View," *Scribner's Magazine* 48 (Oct. 1910), p. 505.

6 John C. Van Dyke, *The New New York: A Commentary on the Place and the People* (New York, 1909), p. 220.

7 See, for example, David Park Curry, "Total Control: Whistler at an Exhibition," in Ruth E. Fine, ed., "James McNeill Whistler: A Reexamination," *Studies in the History of Art* 19 (1987), pp. 67–84; and Martha Ward, "Impressionist Installations and Private Exhibitions," *Art Bulletin* 73 (Dec. 1991), pp. 599–622.

8 Foster Coates, "Popular Amusements in New York," *Chautauquan* 24 (Mar. 1897), p. 706. The museums he mentions are the dime museums, not art museums.

9 *Variety* 31 (Aug. 22, 1913), p. 19, quoted in Lewis A. Erenberg, *Steppin' Out: New York Nightlife and the Transformation of American Culture, 1890–1930* (Westport, Conn., 1981), p. 145, n. 50.

10 George Jean Nathan, "The Deadly Cabaret," *Theatre* 16 (Dec. 1912), p. 184, cited in Erenberg, *Steppin' Out*, p. 140, n. 51. Erenberg's book provides a lengthy and insightful analysis of social behavior and change in the nightspots of New York.

11 Erenberg, *Steppin' Out*, p. 140.

12 See Carol Duncan, "The Persistence and Re-emergence of the Rococo in French Romantic Painting" (Ph.D. diss., Columbia University, New York, 1969); Donald Posner, "Watteau mélancolique: La Formation d'un mythe," *Bulletin de la Société de l'Histoire de l'Art Français*, 1973 (1974), pp. 345–61; Francis Haskell, "The Sad Clown: Some Notes on a Nineteenth-Century Myth," in Ulrich Finke, *French Nineteenth Century Painting and Literature* (Manchester, 1972), pp. 2–16; Norman Bryson, "Watteau and Reverie: A Test Case in Combined Analysis," *Eighteenth Century: Theory and Interpretation* 22 (Spring 1981), pp. 97–126; and David Park Curry, *James McNeill Whistler at the Freer Gallery of Art* (exh. cat., Washington, D.C.: Freer Gallery of Art, Smithsonian Institution, 1984), pp. 38–42. The image of the sad clown continues to resonate in American circus pictures up through the 1940s, as, for example, in Walt Kuhn's work. Sloan recalled after he completed *Clown Making Up*, "Truth to tell this picture was painted under the inspiration of an enthusiastic model with a clown suit" (David W. Scott and E. John Bullard, *John Sloan, 1871–1951: His Life and Paintings* [exh. cat., Washington, D.C.: National Gallery of Art, 1971], p. 114). However, Sloan cast his composition following the evocative old sad clown model.

13 See Robert L. Herbert, *Impressionism: Art, Leisure, and Parisian Society* (New Haven, 1988), pp. 99ff.

14 "What they display ... is not sensuous maturity, but the rigid correctness of upper-class adolescents, well schooled by their elders in polite demeanor. They had to distinguish themselves from young *cocottes* who would be brought here by certain men, so their stiffness is proof of their social worth" (ibid., p. 100).

15 The Realist Shinn, whose gritty background in urban journalism the patrician Cassatt did not share, created a far more obvious contrast between the rowdy "gallery gods" packing the cheap seats at the top of another Parisian theater and more circumspect figures who occupy the expensive seats below. See *The Balcony* of about 1900 (oil on board, 15 x 18½ in. [38.1 x 47 cm], Private collection; Linda Ferber, "Stagestruck: The Theater Subjects of Everett Shinn," in Doreen Bolger and Nicolai Cikovsky, Jr., eds., *American Art Around 1900: Lectures in Memory of Daniel Fraad* [Washington, D.C., 1990], p. 56).

16 See Nancy Mowll Mathews, *Mary Cassatt* (New York, 1987), p. 47, nos. 29, 30. Additional sketches existed but are at present unlocated.

[17] For the phenomenon of pageants, especially as they involved artists, see Susan Hobbs, "Thomas Dewing in Cornish, 1885–1905," *American Art Journal* 17 (Spring 1985), pp. 2–32; and Trudy Baltz, "Pageantry and Mural Painting: Community Rituals in Allegorical Form," *Winterthur Portfolio* 15 (Autumn 1980), pp. 211–28.

[18] Robert A. M. Stern, Gregory Gilmartin, and John Montague Massengale, *New York 1900: Metropolitan Architecture and Urbanism, 1890–1915* (New York, 1983), p. 232.

[19] John Tauranac, *Elegant New York: The Builders and the Buildings, 1885–1915* (New York, 1985), p. 44.

[20] George Barry Mallon, "The Hunt for Bohemia," *Everybody's Magazine* 12 (Feb. 1905), p. 195.

[21] Ibid.

[22] Ibid.

[23] See Ronald G. Pisano, *William Merritt Chase* (New York, 1979), p. 52; and Bennard B. Perlman, *Robert Henri, Painter* (exh. cat., Wilmington: Delaware Art Museum, 1984), p. 101.

[24] Benjamin Silliman, *A Journal of Travels in England, Holland, and Scotland . . . in the Years 1805 and 1806*, 2 vols. (Boston, 1812), vol. 1, p. 215. See also Curry, *Whistler at the Freer Gallery*, pp. 71–87.

[25] At the Bal Mabille in 1870 men paid three to five francs, women only half a franc to enter, reported Robert L. Herbert, adding, "This rather cynical policy fostered the customary Parisian sexual market: well-to-do men and lower-class women" (Herbert, *Impressionism*, p. 133).

[26] Mrs. Schuyler [Mariana Griswold] Van Rensselaer, "Midsummer in New York," *Century* 62 (Aug. 1901), p. 490.

[27] James Weber Linn, "How a Great City Amuses Itself," *World To-day* 1 (Dec. 1904), p. 1543. Linn based his comment on the number of columns devoted to different kinds of news. The statistics indicated that "the per cent of space given to amusements never falls below ten, and it frequently rises as high as twenty-five" (ibid., p. 1544). This was after advertisement space had been subtracted.

[28] Such muting is less evident in American journalism. An illustration for *Harper's Weekly* contrasted but carefully separated ice cream customers on Broadway and the Bowery to "convey to the minds of . . . distant readers . . . the vast difference between the two great streets, and the two great classes of the metropolis" (Thomas Hogan, "Up Among the Nineties," *Harper's Weekly* 12 [Aug. 15, 1868], p. 520).

[29] The Haymarket in New York was an infamous old dance hall on Sixth Avenue to which certain women were admitted without charge, as was common in French dance halls. Helen Farr Sloan quoted her husband, who commented after he painted the nightspot, "Ladies whose dress and general deportment were satisfactory to the door-man were admitted free. Gents paid" (Bruce St. John, ed., *John Sloan's New York Scene from the Diaries, Notes, and Correspondence, 1906–1913* [New York, 1965], p. 152). For the Haymarket's unsavory activities as a restaurant, dance hall, and variety show, where "the fun, like the females, was loud and lurid," and where customers included the notorious Diamond Jim Brady, see Lloyd Morris, *Incredible New York: High Life and Low Life of the Last Hundred Years* (New York, 1951), p. 221.

[30] Coates, "Popular Amusements in New York," pp. 706, 707. Indeed, the history of the Metropolitan Opera is marked by conscious social striving. It was built in 1883 "to provide box seats for the *nouxeaux riches* [*sic*] unable to acquire them at the lions' den of New York's old aristocracy, the Academy of Music on Fourteenth Street. The Academy quickly fell victim to the competition, and its company and audience consolidated with the Metropolitan." After a catastrophic fire the house was rebuilt with fewer box seats, in recognition of the increasing demand for less expensive accommodation (Stern, Gilmartin, and Massengale, *New York 1900*, p. 203).

[31] Stern, Gilmartin, and Massengale, *New York 1900*, p. 220.

[32] The city's first hub of theatrical activity was at Union Square. See John W. Frick, *New York's First Theatrical Center: The Rialto at Union Square* (Ann Arbor, Mich., 1985), pp. 59–70; and Mary Henderson, *The City and the Theatre* (Clifton, N.J., 1973), pp. 270–79. The Republic was the earliest theater built on Forty-second Street. According to Henderson (p. 196): "Within a decade of Hammerstein's first ventures into Times Square, theatres were springing up like mushrooms on the square and in the side streets from Forty-second to Fiftieth Streets. From 1900 to 1930, the boundaries of the district were established . . . by the theatres which attracted strong patronage. Thus the southern boundary was marked by the Metropolitan Opera House and the Empire Theatre, the northern by Carnegie Hall and the theatres at Columbus Circle, the eastern by the Hippodrome and the Ziegfeld Theatre, and the western by the Martin Beck Theatre and Madison Square Garden." For a map with locations of theaters built in the Broadway theater district after 1882, see Van Hoogstraten, *Lost Broadway Theatres*, frontispiece. Businesses, department stores, hotels, and entertainments moved more or less simultaneously into this area as the wealthy residences moved farther uptown.

[33] Stephen Burge Johnson, *The Roof Gardens of Broadway Theatres, 1883–1942* (Ann Arbor, Mich., 1985), p. 78. In 1901, the year Glackens painted his picture, the Paradise Roof Garden atop the Victoria was enclosed and expanded to the west over the top of Hammerstein's adjacent theater, the Republic. Eventually the Victoria and the Paradise Roof Garden were combined under the name Hammerstein's. This was not unusual, as theaters in New York frequently change names. See Van Hoogstraten, *Lost Broadway Theatres*, pp. 42–43.

[34] Johnson, *Roof Gardens of Broadway Theatres*, p. 78.

[35] Outdoor amusement parks such as Ranleigh and Cremorne Gardens, on the outskirts of London, had their modern American counterparts in Steeplechase Park and Luna Park at Coney Island. See Curry, *Whistler at the Freer Gallery*, pp. 71–87. See also John F. Kasson, *Amusing the Million: Coney Island at the Turn of the Century* (New York, 1978); and Michele H. Bogart, "Barking Architecture: The Sculpture of Coney Island," *Smithsonian Studies in American Art* 2 (Winter 1988), pp. 3–18. Some of the same entrepreneurs who created amusement parks in America translated their amenities to theaters in the heart of the city. Most spectacular among them was the Hippodrome, an enormous theater established in 1905 by Frederic Thompson, along with a promoter, Elmer S. Dundy, and the financier John Dundy-Gates, whose apt nickname was "Bet-a-Million." After building Luna Park on Coney Island, they opened the Hippodrome on April 12, 1905. Its stage, twelve times larger than a regular Broadway house, offered a double bill that included 280 chorus girls, 480 men dressed as soldiers of the Civil War, a parade of elephants, an equestrienne ballet, acrobats, and a cavalry charge through a lake. See Van Hoogstraten, *Lost Broadway Theatres*, pp. 95–98. The pleasures of vaudeville also proved transportable—during the summer several steamboats that sailed the Hudson were "fitted up as floating vaudeville theatres and concert halls. They leave about sundown and without any definite itinerary move leisurely between Sandy Hook and the Palisades of the Hudson, returning their passengers to the city before midnight" ("The City as a Summer Resort," *World's Work* 4 [Aug. 1902], p. 2378).

[36] The Bourbon kings provided important inspiration for the historically self-conscious architectural interiors of New York theaters and roof gardens. There were the Olympia, 1895, decorated in Louis XIV and Louis XVI styles; the Empire, redecorated in 1903 in Louis XIV style; the Gaiety, 1908, Louis XV; Nazimova's 39th Street Theatre, 1910, Louis XVI. See Van Hoogstraten, *Lost Broadway Theatres*. The Folies Bergère, 1911, one of the first dinner theaters in New York, was decorated in a rococo style, including paintings by William DeLeftwich Dodge in the manner of Watteau at either side of the proscenium arch (Stern, Gilmartin, and Massengale, *New York 1900*, p. 217).

[37] Henderson, *City and the Theatre*, p. 279.

[38] See Erenberg, *Steppin' Out*, pp. 113–45.

[39] Van Hoogstraten, *Lost Broadway Theatres*, p. 45. The "green, ivory, and old gold" decorations

described by the *New York Times* just before the theater opened sound suspiciously like a late efflorescence of the Aesthetic Movement's hallmark "greenery-yallery" color scheme.

40 *New York Telegraph* cited in Van Hoogstraten, *Lost Broadway Theatres*, p. 105.

41 Stern, Gilmartin, and Massengale, *New York 1900*, p. 220, n. 30.

42 Gunther Barth, *City People: The Rise of Modern City Culture in Nineteenth-Century America* (New York, 1980), p. 223. Social freedoms went even further in the cabarets, which stressed adult— as opposed to family—entertainment. For a discussion of this subject, see Erenberg, *Steppin' Out*, pp. 113–45.

43 Barth, *City People*, p. 223.

44 Allen Churchill, *The Great White Way* (New York, 1962), pp. 8–10. Perhaps the most successful of all was Marie Wilson, who grossed $750,000 from stock tips proffered by an admirer—who was a Morgan partner—before eventually marrying Freddie Gebhard, a New York millionaire.

45 Van Hoogstraten, *Lost Broadway Theatres*, p. 15.

46 Ibid., p. 42. Hammerstein's opera house continued "the process of democratization that had begun when the Metropolitan was set up in competition with the Academy of Music. It had fewer box seats than the Metropolitan, and interior decoration that catered to less patrician tastes with a fulsome, opulent display of plasterwork" (Stern, Gilmartin, and Massengale, *New York 1900*, p. 209).

47 Opera was too expensive for most people in 1936, as it had been at the turn of the century and earlier. According to Coates, in 1897 the cheapest New York Metropolitan Opera ticket went for a dollar, while a good seat could cost up to five dollars, box rental for the season cost around four thousand dollars, and additional attendant expenses, for clothing, dinners, carriages, and the like, for the fashionable amounted "to a small fortune." He also reported that legitimate theater tickets were more reasonable, with cheap seats at fifty cents, expensive ones at two and a half dollars, or a box for the evening at twenty dollars, but noted that two and a half dollars was "considerably more than the average man in New York earns per day" (Coates, "Popular Amusements in New York," p. 707). It is not hard to see why vaudeville at fifteen to fifty cents, the dime museum, and eventually the five-cent movie were far more popular than opera and legitimate theater.

48 Herbert Croly, "New York as the American Metropolis," *Architectural Record* 13 (Mar. 1903), p. 202.

49 Mabelle Gilman Corey, "Art and American Society," *Cosmopolitan* 46 (Mar. 1909), p. 434.

50 Croly, "New York as American Metropolis," p.203.

51 For the subsequent fate of the building and the sequence of sites in which Rush's figures were installed and preserved, see Linda Bantel et al., *William Rush, American Sculptor* (exh. cat., Philadelphia: Pennsylvania Academy of the Fine Arts, 1982), pp. 108–11.

52 For Shinn's connections to Elsie de Wolfe, actress turned interior decorator, who led him to lucrative stage-decoration jobs, see Edith DeShazo, *Everett Shinn, 1876–1953: A Figure in His Time* (New York, 1974), pp. 82–111. See also Ferber, "Stagestruck: Theater Subjects of Shinn," pp. 51–67. Ferber writes (p. 51), "The world of the theater was a critical element . . . not only as a source of artistic inspiration, but as a well-connected social and professional milieu providing patronage and support." Later (p. 62) she discusses Shinn's connection with de Wolfe.

53 For a discussion of how portraiture changed in France during the nineteenth century, combining with genre painting, see George T. M. Shackelford and Mary Tavener Holmes, *A Magic Mirror: The Portrait in France, 1700–1900* (exh. cat., Houston: Museum of Fine Arts, 1986).

54 See Herbert, *Impressionism*, p. 36. On both sides of the Atlantic the lifted skirt showing a bit of ankle was a visual trope implying loose behavior. See David Park Curry, *Winslow Homer: The Croquet Game* (exh. cat., New Haven: Yale University Art Gallery, 1984). Homer's images of croquet are roughly coeval with Manet's *Street Singer*.

55 For a discussion of Degas's picture, see Herbert, *Impressionism*, pp. 94–95.

56 Ferber, "Stagestruck: Theater Subjects of Shinn," p. 61.

57 Corey, "Art and American Society," p. 436.

58 Marie Burress quoted in *New York Herald*, Mar. 27, 1894, p. 9, quoted in Barth, *City People*, p. 192. Barth argues that the patrons of vaudeville "came from almost every walk of life and considered themselves far removed from the dissolute loafers and insolent debauchees who, they assumed, had been the patrons of the old variety hall" (p. 195).

59 William M. Marston, *F. F. Proctor: Vaudeville Pioneer* (New York, 1943), p. 54. These transformations could move along a two-way street, however. The legitimate theater retained its magical aura, and vaudeville stars, Lillian Russell for one, sometimes became stage stars. See Barth, *City People*, p. 209.

60 "Proctor Makes Another Coup," *New York Herald*, Mar. 4, 1900, p. 10, quoted in Marston, *F. F. Proctor*, p. 56.

61 Keith had introduced the continuous show in Boston at the Bijou Theatre, which opened with this innovation in 1885. He and E. F. Albee were the impresarios. Their theater was studiously ignored, it would seem, by the large contingent of American Impressionists centered in the Boston area.

62 Barth, *City People*, p. 207.

63 Ibid., p. 208.

64 Hutchins Hapgood quoted in ibid.

65 Marston, *F. F. Proctor*, p. 57.

66 Barth, *City People*, pp. 211–12.

67 For a discussion of the rising popularity of inexpensive movies among the working classes, see Kathy Peiss, *Cheap Amusements: Working Women and Leisure in Turn-of-the-Century New York* (Philadelphia, 1986), pp. 139–62.

68 Stern, Gilmartin, and Massengale, *New York 1900*, p. 220.

69 "Point of View," p. 505.

70 Cleveland Moffett, "Mid-air Dining Clubs," *Century* 62 (Sept. 1901), p. 644.

71 "The Last Delmonico's," *Harper's Weekly* 28 (Jan. 26, 1884), p. 56.

72 Amy Lyman Phillips et al., "Famous American Restaurants and Some of the Delicacies for Which They Are Noted," *Good Housekeeping* 48 (Jan. 1909), p. 22.

73 Ibid.

74 See Stern, Gilmartin, and Massengale, *New York 1900*, pp. 224ff.

75 Benjamin DeCasseres, "Mouquin's," *American Mercury* 25 (Mar. 1932), p. 364.

76 "Murray's Roman Gardens," *Architects' and Builders' Magazine* 8 (Sept. 1907), pp. 574–79, cited in Stern, Gilmartin, and Massengale, *New York 1900*, p. 463, n. 44.

77 Terry Miller, *Greenwich Village and How It Got That Way* (New York, 1990), pp. 211–12. For a discussion of Sloan's painting, see Rowland Elzea, *John Sloan's Oil Paintings: A Catalogue Raisonné*, 2 vols. (Newark, Del., 1991), vol. 1, p. 120. On May 10, 1912, Sloan moved into his new studio on Sixth Avenue. He was to remain in this neighborhood until subway construction forced him out in 1928. See Sloan, Diary, May 10, 1912, quoted in St. John, *John Sloan's New York Scene*, p. 620.

78 Sloan, *Gist of Art*, p. 237, quoted in Elzea, *John Sloan's Oil Paintings*, vol. 1, p. 120.

79 The mirrored café was downstairs; a formal dining room was located upstairs. See James N. Wood and Katherine C. Lee, *Master Paintings in the Art Institute of Chicago* ([Chicago] and Boston, 1988), p. 107. Ira Glackens reported that his father and his father's friends "were in the habit of dining at Mouquin's, where they stayed until 2:00 A.M., closing time. Then they repaired to Shanley's . . . which stayed open all night, and finished off the evening with deviled kidneys washed down with cream ale. This ritual occurred night after night. . . . When they left Shanley's they visited an all-night drugstore hard by and consumed a patented beverage called Zoolac" (Ira Glackens, *William Glackens and the Ashcan Group: The Emergence of Realism in American Art* [New York, 1957], p. 31).

80 "At this bar—and at the tables—there were

present at various times Charles A. Dana, James Gordon Bennett, William Cullen Bryant, Henry Ward Beecher, Cardinal McCloskey, Whitelaw Reid, Amos J. Cummings, Horace Greeley, John Hay, Chester A. Arthur, General Grant, Larry Godkin, Walt Whitman—almost everybody who was anybody in that era . . ." (DeCasseres, "Mouquin's," p. 367). For another interior image of the flashy restaurant, see George Luks's undated oil *At Mouquin's* (Mr. and Mrs. Harold L. Renfield; *George Luks, 1866–1933* [exh. cat., Utica, N.Y.: Munson-Williams-Proctor Institute, Museum of Art, 1973], no. 91). A pastel by Shinn dated 1904 (The Newark Museum) shows the facade of the old Fulton Street branch of Mouquin's.

81 Phillips et al., "Famous American Restaurants," p. 23.

82 Ibid.

83 James Huneker quoted in Glackens, *William Glackens and the Ashcan Group*, p. 91.

84 Glackens, *William Glackens and the Ashcan Group*, p. 54.

85 Dreiser, *Sister Carrie*, p. 254.

86 Phillips et al., "Famous American Restaurants," p. 22.

87 Dreiser, *Sister Carrie*, pp. 253–54.

88 Mallon, "Hunt for Bohemia," pp. 189, 190.

89 For an in-depth discussion of this painting, see Elzea, *John Sloan's Oil Paintings*, vol. 1, p. 57.

90 John Sloan, *Gist of Art: Principles and Practise Expounded in the Classroom and Studio*, recorded with the assistance of Helen Farr (New York, 1939), p. 203, quoted in Elzea, *John Sloan's Oil Paintings*, vol. 1, p. 57.

91 *New York Sun*, Apr. 15, 1907, quoted in Elzea, *John Sloan's Oil Paintings*, vol. 1, p. 57.

92 For a discussion of this picture, see Herbert, *Impressionism*, pp. 44–47.

93 A critic called "The Gilder," quoted in Glackens, *William Glackens and the Ashcan Group*, p. 89.

94 For an in-depth discussion of this painting, see Elzea, *John Sloan's Oil Paintings*, vol. 1, p. 150.

95 Sloan, Diary, Feb. 23, 1909, quoted in St. John, *John Sloan's New York Scene*, p. 292. Sloan began the painting on March 15 (ibid., p. 299). On March 18 Sloan added, "Went to the restaurant for my dinner to refresh my memory of the place. Just in time, for tomorrow they move to the corner below (29th St.)" (ibid., p. 300). He wrote, "Just about finished" on April 12 but complained that it was hung badly at the National Academy in December. The reproduction in the March 1910 issue of the *Craftsman* did not please Sloan either (see ibid., pp. 305, 359, 392).

96 Sloan, *Gist of Art*, p. 221.

97 John Herbert Greusel, "Some Oddities of Chinatown," *Once a Week*, July 1, 1893, quoted in Grace M. Mayer, *Once upon a City: New York from 1890 to 1910* (New York, 1958), pp. 417–18.

98 Mallon, "Hunt for Bohemia," pp. 188–89.

99 Ibid., p. 193.

100 Sloan recorded the visit he and his wife paid to the nightspot in his journal entry of July 8, 1906, noting, "Expensive tho'. $1.50 each for the dinner" (St. John, *John Sloan's New York Scene*, p. 45).

101 The Glackens illustrated Bruno Lessing, "Ingratitude of Mr. Rosenfeld," *Cosmopolitan* 41 (Aug. 1906), pp. 387–92. The original drawing is illustrated in *William Glackens in Retrospect* (exh. cat., St. Louis: City Art Museum, 1966), no. 102.

102 Phillips et al., "Famous American Restaurants," p. 24, where she also wrote, "the music is Hungarian—a real Hungarian gypsy band; and native Hungarians . . . apparently enjoying their dinner, suddenly break into song, and some glorious quartet from grand opera is well under way before one realizes that this is not impromptu."

103 "The Old Adam and the Spare Rib," in Morris, *Incredible New York*, pp. 215–33.

104 See Scott and Bullard, *John Sloan, 1871–1951*, p. 152.

105 Sadakichi Hartmann, "Studio Talk," *International Studio* 26 (July 1905), p. 264.

106 Frederick C. Benjamin, "C. W. Hawthorne, Painter," *Brush and Pencil* 4 (Aug. 1899), pp. 255–57. The painting was illustrated as *The Diners* (p. 257).

107 *Banquet of the Officers of the St. George Civic Guard Company* has been exhibited at the Frans Hals Museum since 1862. See Seymour Slive, *Frans Hals*, 3 vols. (Washington, D.C., and London, 1970), vol. 3, p. 5.

108 Hartmann, "Studio Talk," p. 261.

109 Reproduced as *The Diners* in Benjamin, "C. W. Hawthorne, Painter," p. 257; and again in Clara Ruge, "Charles W. Hawthorne," *Art Interchange* 52 (June 1904), p. 143. Published as *The Story* in Hartmann, "Studio Talk," p. 261, not illustrated. Published as *The Pleasures of the Table* in the Ballard White sale catalogue, reported in *American Art News*, Mar. 22, 1919, p. 6, not illustrated.

110 "Two middle-aged men, one an art student, the other a janitor, with ruddy complexions, standing beside a table on which are a punch bowl, jugs, glasses, fruits and other objects" (*J. F. Braun Collection* [sale cat., Kende Gallery, New York, Jan. 16, 1942], lot 56, as *The Story*).

111 *Modern Paintings by Celebrated Masters* (sale cat., American Art Association, New York, Mar. 13, 1919), lot 80.

112 Ruge, "Charles W. Hawthorne," p. 138; Hartmann, "Studio Talk," p. 261.

113 Hans Hofmann, "Hawthorne—the Painter: an Appreciation," in Carl Murchison, *Charles W. Hawthorne, 1872–1930* (exh. cat., Provincetown, Mass.: Provincetown Art Association, 1952), unpaged.

114 Frank Charles Laubach, "What the Church May Learn from the Saloon," *Survey* 30 (Sept. 27, 1913), p. 751. The author of an earlier article takes a more cautious view, warning readers not "to contend that the saloon, as an institution, is the workingman's club." However, he admits, "some saloons are, in part. In others, the social element predominates. Many of them exist to satisfy a thirst pure and simple, and seldom entertain a workingman; and in all of them you can drink too much if you choose" (Robert Alston Stevenson, "Saloons," *Scribner's Magazine* 29 [May 1901], p. 571).

115 Dreiser, *Sister Carrie*, pp. 204–5.

116 See Jon M. Kingsdale, "The 'Poor Man's Club': Social Functions of the Urban Working-Class Saloon," in Raymond A. Mohl, ed., *The Making of Urban America* (Wilmington, Del., 1988), pp. 122–37.

117 Moses King, *King's Handbook of New York City* (Boston, 1892), p. 216. For ethnicity, see also Stevenson, "Saloons," pp. 571–79.

118 Dreiser, *Sister Carrie*, p. 205.

119 Laubauch ("Church May Learn from Saloon," p. 751) noted that in New York "there are sixty-four corners between Thirty-fourth and Forty-second Streets and Seventh and Ninth Avenues in New York City. On thirty-five of these corners are saloons. They are the thirty-five best business corners in the section." By 1897 there were more than 215,000 licensed liquor dealers in the United States and an estimated 50,000 additional unlicensed establishments. See Kingsdale, "'Poor Man's Club,'" p. 122.

120 Sloan quoted in *John Sloan Retrospective Exhibition* (exh. cat., Andover, Mass.: Addison Gallery of American Art, Phillips Academy, 1938), p. 32. The modernizing to which Sloan referred was the transformation of the old-time saloons into outlets for commercial breweries. See "The Experience and Observations of a New York Saloon-Keeper As Told by Himself," *McClure's Magazine* 32 (Jan. 1909), pp. 301–12.

121 Hutchins Hapgood, "McSorley's Saloon," *Harper's Weekly* 58 (Oct. 25, 1913), p. 15.

122 Ibid.

123 *Greenwich Village: A Brief Architectural and Historic Guide* (New York, 1976), p. 29.

124 Hapgood, "McSorley's Saloon," p. 15.

125 Sloan, *Gist of Art*, p. 235.

126 Sloan quoted in *John Sloan Retrospective Exhibition*, p. 62.

127 *McSorley's at Home*, 1928 (Private collection; Elzea, *John Sloan's Oil Paintings*, vol. 2, p. 300, no. 819, ill.); *McSorley's Cats*, 1929 (Huntington Library Art Collections and Botanical Gardens, San Marino, California); *McSorley's Saturday Night*, 1930 (Hirshhorn Museum and Sculpture Garden, Smithsonian Institution, Washington, D.C.).

[128] King, *King's Handbook of New York*, p. 216.

[129] "Theodore Stewart's Collection," unidentified clipping, Blemley scrapbook, Alfred Frankenstein Papers, Archives of American Art, Smithsonian Institution, Washington, D.C. (microfilm, reel 1374, frame 328), cited in Staiti, "Illusionism, Trompe l'Oeil, and Viewership," p. 34, n. 15.

[130] *Arrangement in Brown and Black, Portrait of Miss Rosa Corder* (Andrew McLaren Young, Margaret MacDonald, and Robin Spencer, *The Paintings of James McNeill Whistler*, 2 vols. [New Haven, 1980], vol. 1, no. 203); and *Arrangement in Black and Gold, Comte Robert de Montesquiou-Fezensac* (ibid., no. 398), are among the Whistler pictures Canfield eventually sold through Knoedler Galleries. His collections also included ancient art and Sheraton and Hepplewhite furniture. See E[dna] Y[ost], "Canfield, Richard A.," in Allen Johnson, ed., *Dictionary of American Biography* (New York, 1929), vol. 3, pp. 472–73.

[131] "Old Adam and Spare Rib," p. 226.

[132] Of course, an open attitude toward social status was neither universally shared nor permanent. In his recent study *Highbrow/Lowbrow: The Emergence of Cultural Hierarchy in America* (Cambridge, Mass., 1988), Lawrence W. Levine explores the gradual separation of high art from popular culture that has taken place during the twentieth century. In American painting the vulgarization of high art is well expressed in works such as Marsh's *Monday Night at the Metropolitan* (fig. 198).

[133] Paul Bourget, *Outre-Mer: Impressions of America* (New York, 1895), pp. 326–70.

[134] For example, Mike "King" Kelly (1857–1894), a showman both on and off the baseball diamond, played on the vaudeville stage during the off-season. See Red Smith et al., *Champions of American Sport* (exh. cat., Washington, D.C.: National Portrait Gallery, Smithsonian Institution, 1981), pp. 22–23.

[135] John Rickards Betts, *America's Sporting Heritage: 1850–1950* (Reading, Mass., 1974), p. 162.

[136] Bourget, *Outre-Mer*, pp. 327–28.

[137] Ibid., p. 333.

[138] The first oil was preceded by a somewhat anecdotal pastel and India ink drawing, *The Knock Out* of 1907 (Rita and Daniel Fraad Collection). Titles can be confusing in this series. Now known as *Club Night*, the 1907 oil was originally titled *A Stag at Sharkey's*. In August 1909 Bellows painted *Stag at Sharkey's*, which was originally titled *Club Night*. In October 1909 he executed *Both Members of This Club*, originally titled *A Nigger and a White Man*. He continued to revisit the subject; his later boxing images follow some of the ideas expressed in these first pictures but revert to the sort of anecdotal specificity that characterizes Ashcan School illustrations such as Glackens's *O'Rourke Started to Climb Through the Ropes* for H. R. Durant,

"A Sucker," *Cosmopolitan* 39 (May 1905), p. 89. Eventually Bellows made a lithograph of *Stag at Sharkey's*. An oil of 1923, *Introducing John L. Sullivan* (Butler Institute of American Art, Youngstown, Ohio), and two oils of 1924, *Ringside Seats* (Hirshhorn Museum and Sculpture Garden, Smithsonian Institution, Washington, D.C.) and *Dempsey-Firpo* (Whitney Museum of American Art, New York), were preceded by lithographs. See *George Bellows Memorial Exhibition, 1882–1925* (exh. cat., New York: The Metropolitan Museum of Art, 1925).

[139] Bourget, *Outre-Mer*, pp. 334–35.

[140] "Academy Exhibition—Second Notice," *New York Sun*, Dec. 23, 1907, p. 4, quoted in Marianne Doezema, *George Bellows and Urban America* (New Haven, 1992), p. 67, n. 1. Doezema (pp. 66–121) provides a thoughtful analysis of the early boxing pictures.

[141] She compares the cartoonish faces in *Both Members of This Club* with the much more elegant figures in *Crowd at Polo* (fig. 235). See Rebecca Zurier, "Hey Kids: Children in the Comics and the Art of George Bellows," *Print Collector's Newsletter* 18 (Jan.–Feb. 1988), p. 200.

[142] Doezema, *George Bellows and Urban America*, p. 83.

[143] Bellows quoted in ibid., p. 87, n. 81.

[144] Jack London, "A Piece of Steak" (1909), in Harry T. Paxton, ed., *Sport U.S.A.: The Best from the Saturday Evening Post* (New York, 1961), pp. 28–29.

[145] Bellows quoted in Charles Grant, "Stag at Sharkey's," *Beta Theta P. Magazine*, May 1947, pp. 647–79, cited in Doezema, *George Bellows and Urban America*, p. 97, n. 111.

[146] Sporting subjects published by Currier and Ives include fishing, trapping, hunting, cockfighting, billiards, card playing, rowing, and baseball, as well as boxing. For a discussion of early boxing images, see John Wilmerding, "George Bellows's Boxing Pictures and the American Tradition," in John Wilmerding, *American Views: Essays on American Art* (Princeton, 1991), pp. 305–45.

[147] William Inglis, "The State and the Boxing Business," *Harper's Weekly* 55 (Sept. 16, 1911), p. 19.

[148] Like Bourget, Bellows witnessed fights in the back room of a private club—in Bellows's case a dingy loft on Lincoln Square conveniently located near his studio. Thomas Joseph (Sailor Tom) Sharkey was a boxing great of the 1890s, "always a contender, but never a champion," according to his obituary. He left his native Ireland at age twelve to go to sea and eventually became a prizefighter. Although successful, he lost crucial bouts with heavyweight champions Jim Jeffries, Bob Fitzsimmons, and Gentleman Jim Corbett. See Sharkey obituary, *Time* 61 (Apr. 27, 1953), p. 67.

[149] Sullivan himself was a drunk, a philanderer, and

a brawler and even had been indicted for assault and battery. See Doezema, *George Bellows and Urban America*, p. 77, n. 60. Elliott Gorn's history of bare-knuckle prizefighting, *The Manly Art: Bare-knuckle Prize Fighting in America* (Ithaca, N.Y., 1986), explores the boxing ring as a place at once thrilling and repellent.

[150] Betts, *America's Sporting Heritage*, pp. 164–69.

[151] Inglis, "State and Boxing Business," p. 19.

[152] Betts, *America's Sporting Heritage*, p. 165.

[153] Sharkey obituary, p. 67.

[154] William Innes Homer, *Thomas Eakins: His Life and Art* (New York, 1992), p. 239. The series also includes *Taking the Count* of 1898 (Yale University Art Gallery, New Haven) and *Salutat* of the same year (Addison Gallery of American Art, Phillips Academy, Andover, Massachusetts).

[155] Duffield Osborne, "A Defense of Pugilism," *North American Review* 146 (Apr. 1888), p. 435, quoted in Doezema, *George Bellows and Urban America*, p. 68, n. 5; see also pp. 68–72.

[156] Guy Pène du Bois, "Exhibition by Independent Artists Attracts Immense Throngs," *New York American*, Apr. 4, 1910, p. 6, cited in Doezema, *George Bellows and Urban America*, p. 113, n. 132.

[157] Bellows's first three oils on the subject of boxing depict fights that took place in a private club during the eight-year period when the Horton Law, which banned public prizefights in New York, was in force. Just two years after Bellows finished *Both Members of This Club*, the law was repealed and replaced by the Frawley Law, which allowed prizefights again. See "Prize-fighting in New York," *Outlook* 99 (Sept. 9, 1911), p. 57.

[158] Bellows used the basic composition of *Both Members of This Club* again in 1917 for a disturbing drawing, *The Drunk* (Addison Gallery of American Art, Phillips Academy, Andover, Massachusetts), which he followed with several lithographic versions during the 1920s. The starkly geometric, shamelessly melodramatic image of the drawing is set in a domestic, traditionally feminine environment, rather than a public, raucous, masculine space. Two women struggle to protect children against the onslaught of their enraged, inebriated father. It is interesting to go beyond the obvious temperance message implicit in *The Drunk* to note its resemblance to *Both Members of This Club* in light of the self-conscious quest for virility that characterizes the art criticism of the time. Black boxers, like "eminently respectable female saints," occupied an uncertain position in American society. Bellows's related lithograph illustrated an article by Mabel Potter Daggett, "Why We Prohibit," in *Good Housekeeping* 78 (May 1924). The article explored the terrible impact of drink on the family and essentially was written in support of the Volstead Act, which established Prohibition. See Linda Ayres and Jane Myers, *George Bellows: The Artist and His*

Lithographs (exh. cat., Fort Worth: Amon Carter Museum, 1988), p. 122.

159 "Topics of the Times: And May the Best Man Win!" New York Times, Nov. 1, 1909, p. 10, quoted in Doezema, George Bellows and Urban America, pp. 106–7, 218, n. 124.

160 Betts, America's Sporting Heritage, p. 168. See also Doezema's discussion of racial politics (George Bellows and Urban America, pp. 104–13).

161 His additional exploits included delivering an address on sportsmanship to a klavern of the Ku Klux Klan and playing the role of an Ethiopian general in a New York production of Aïda. See Smith et al., Champions of American Sport, p. 78.

162 New York Times quoted in Betts, America's Sporting Heritage, p. 168.

163 The Law Is Too Slow illustrated Mary Johnston, "Nemesis," Century 106 (May 1923), p. 2. This moralizing tale begins ominously with Bellows's illustration and the words "They said that the man, a black man, had done the crime. Perhaps he had, perhaps he had not.... Those who conducted the lynching proceeded, of course, upon the assumption that he was guilty. His guilt might make a difference, and then again it might make no difference at all. In the way you take it, I mean" (p. 3).

164 Paul Gallico quoted in Smith et al., Champions of American Sport, p. 212. Gallico linked theater and sport, serving as motion-picture critic, sports editor, and columnist on the New York Daily News. In 1938 he denounced the commercialization of leisure, decrying professionalism in supposedly amateur sports in his book Farewell to Sport.

165 "Thirty-five years ago polo was unknown in America. To-day there are forty clubs registering nearly six hundred players, enrolled as members of the American Polo Association. There are thirty-two United States Army clubs which are honorary members. Unconnected with the association chiefly in Colorado, California, and Canada there are about fifteen more, making a total of nearly one hundred polo playing organizations on the North American continent" (David Gray, "Polo, the Best Game in the World," Collier's Outdoor America 47 [June 10, 1911], p. 15).

166 Gray enumerated the rather horrifying expenses of polo, including "the best polo ponies" selling at prices between $2,500 and $3,500 (ibid.). Clearly the game of polo fascinated and still fascinates in part because it establishes economic and social status. See Jack Smith, "The Patrones of Polo," M: The Civilized Man 7 (May 1990), pp. 68–73. Smith cavils, albeit with relish, that "corporate money men—the world's new royalty—are buying into the sport of privilege."

167 Gray, for example, explained that "it must be remembered that one of the great ends of sport is to teach self-reliance" ("Polo, the Best Game in the World," p. 15). On this theme, see also Curry,

Homer: The Croquet Game; and Doezema, George Bellows and Urban America, pp. 69–72.

168 Percy Creed, "Polo," Fortnightly Review 86 (Dec. 1, 1909), p. 1093.

169 Sloan, Diary, Sept. 15, 1907, quoted in Elzea, John Sloan's Oil Paintings, vol. 1, p. 82.

170 George Bellows, Letter to Joseph Taylor, May 1910, quoted in Lauris Mason and Joan Ludman, The Lithographs of George Bellows: A Catalogue Raisonné (Millwood, N.Y., 1977), p. 128.

171 Percival R. Eaton, "Lakewood, a Famous Winter Resort," New England Magazine 33 (Jan. 1906), p. 608. Bellows was by no means alone in alternating between slumming subjects and higher-toned images. Richard Outcault, creator of the lucrative, low-class cartoon character the Yellow Kid, eventually went on to draw Buster Brown, a wealthy and much better behaved child. See Zurier, "Hey Kids," p. 200.

172 The Bricksburg Land and Development Company formed to launch a town-development plan in 1866. The town changed its name in 1880. See William McMahon, South Jersey Towns: History and Legend (New Brunswick, N.J., 1973), pp. 321–23. See also Federal Writers' Project of the Works Progress Administration for the State of New Jersey, New Jersey: A Guide to Its Present and Past (New York, 1946), pp. 555–56.

173 Eaton, "Lakewood, a Famous Winter Resort," p. 609.

174 The eight leading hotels of Lakewood, which opened between 1880 and 1904, accommodated from thirty to seven hundred guests each (ibid., p. 619).

175 McMahon, South Jersey Towns, pp. 321–23.

176 Mason and Ludman, Lithographs of George Bellows, p. 128.

177 Eaton, "Lakewood, a Famous Winter Resort," p. 616.

178 Creed, "Polo," p. 1092.

179 "The Winter Academy," New York Sun, Dec. 14, 1910, p. 8, cited in Michael Quick et al., The Paintings of George Bellows (exh. cat., Fort Worth: Amon Carter Museum; Los Angeles: Los Angeles County Museum of Art, 1992), p. 91, n. 24.

180 Bellows, Letter to Taylor, ca. 1909, cited in Mason and Ludman, Lithographs of George Bellows, p. 128.

181 See Quick et al., Paintings of George Bellows, pp. 9–96, especially pp. 21–25.

182 Frank Jewett Mather, "The Winter Academy," New York Evening Post, Dec. 15, 1910, p. 9, quoted in Quick et al., Paintings of George Bellows, p. 91, n. 23.

183 Charles Belmont Davis, "New York in the Good Old Summer Time," Outing 42 (Sept. 1903), p. 668.

184 For example, in Tennis at Newport (Private collection; Quick et al., Paintings of George Bellows, p. 74, ill.) the actual game does not outweigh

assorted interchanges going on around the grass lawn. A nattily clad gentleman doffs his hat to a lady on a red chair in the foreground, a clutch of ladies near the net gossip under a red umbrella, and the clubhouse verandah and balcony are thronged with spectators like the boxholders in Cassatt's At the Opera, painted forty years earlier.

185 For a precise summary of the role of sport in marking status, see Steven A. Riess, "Sport and the Urban Social Structure," in City Games: The Evolution of American Urban Society and the Rise of Sports (Urbana, Ill., 1989), pp. 53–92.

THE HOME

1 The domestic sphere as woman's world is discussed at length in Sheila M. Rothman, Woman's Proper Place: A History of Changing Ideals and Practices, 1870 to the Present (New York, 1978), pp. 13–62; Ruth Schwartz Cowan, More Work for Mother: The Ironies of Household Technology from the Open Hearth to the Microwave (New York, 1983), pp. 18–19; Glenda Riley, Inventing the American Woman: A Perspective on Women's History (Arlington Heights, Ill., 1986), pp. 153–82; and Glenna Matthews, "Just a Housewife": The Rise and Fall of Domesticity in America (New York and Oxford, 1987), pp. 3–91. For a consideration of artists' responses to the domestic scene during the period 1840 to 1910, see Edwards's essay in Lee M. Edwards, with Jan Seidler Ramirez and Timothy Anglin Burgard, Domestic Bliss: Family Life in American Painting, 1840–1910 (exh. cat., Yonkers, N.Y.: Hudson River Museum, 1986), pp. 14–31.

2 Charlotte Perkins Gilman, quoted in Riley, Inventing the American Woman, p. 158. For discussions of this "reordering," see Dolores Hayden, The Grand Domestic Revolution: A History of Feminist Designs for American Homes, Neighborhoods, and Cities (Cambridge, Mass., 1981); and George Cotkin, Reluctant Modernism: American Thought and Culture, 1880–1900 (New York and Toronto, 1992), pp. 74–100.

3 "Breakfast: Painted by William M. Paxton," Ladies Home Journal 30 (Mar. 1913), p. 17, quoted in Linda J. Docherty, "The Open Book and the American Woman," presented at the conference The Iconography of the Book, American Antiquarian Society, Worcester, Mass., June 15, 1991.

4 Ibid.

5 Sereno Edwards Todd, Todd's Country Homes and How to Save Money (Hartford, Conn., 1870), p. 33; an earlier edition was quoted in Suzaan Boettger, "Eastman Johnson's Blodgett Family and Domestic Values During the Civil War Era," American Art 6 (Fall 1992), p. 51.

6 Robert L. Herbert, Impressionism: Art, Leisure, and Parisian Society (New Haven, 1988), pp. 115–21.

7 "The Fine Arts: Mr. Tarbell's Exhibition at the St. Botolph Club," *Boston Evening Transcript*, Feb. 17, 1904, p. 9, quoted in Trevor J. Fairbrother, "Edmund C. Tarbell's Paintings of Interiors," *Antiques* 131 (Jan. 1987), pp. 224–35. Fairbrother noted, "It is indicative of artistic taste in Boston that Degas' paintings of as many as thirty years earlier were cited as examples of 'modern' interiors, and that the more recent paintings by Edouard Vuillard (1868–1940) were either discounted or unknown" (p. 230).

8 "The Council of Ten: Annual Exhibition of Ten American Impressionists at the Durand-Ruel Galleries," *New York Times*, Apr. 22, 1903, p. 9; and "Art Exhibitions: The Ten American Painters," *New York Daily Tribune*, Apr. 21, 1903, p. 3, quoted in Fairbrother, "Tarbell's Paintings of Interiors," p. 229.

9 Sadakichi Hartmann, *A History of American Art*, 2 vols. (Boston, 1902), vol. 2, p. 241, cited in Fairbrother, "Tarbell's Paintings of Interiors," p. 233.

10 Frederick W. Coburn, "Edmund C. Tarbell," *International Studio* 32 (Sept. 1907), pp. lxxxii–lxxxiii.

11 The models in Tarbell's picture have been identified as Mary Josephine Sullivan, later the wife of architect Steven R. H. Codman, and possibly the painter Philip Leslie Hale, who taught with Tarbell at the School of the Museum of Fine Arts, Boston. See Fairbrother, "Tarbell's Paintings of Interiors," p. 234, n. 10.

12 On the proliferation of household objects, see Matthews, *"Just a Housewife,"* p. 12.

13 Todd, *Todd's Country Homes*, p. 3.

14 Faye Dudden, *Serving Women: Household Service in Nineteenth-Century America* (Middletown, Conn., 1983), p. 44.

15 For another discussion of this painting, see H. Barbara Weinberg, *The Lure of Paris: Nineteenth-Century American Painters and Their French Teachers* (New York, 1991), p. 179.

16 The controversy over changes in manners that permitted such freedoms is endless. For a few samples, see M. Jeune, "Decay of the Chaperon," *Living Age* 227 (Nov. 10, 1900), pp. 372–79; and Paul Bourget, *Outre-Mer: Impressions of America* (New York, 1895), pp. 80–81.

17 For a discussion of women as "social housekeepers"—activists and reformers—see Rothman, *Woman's Proper Place*, pp. 106–12; Lois W. Banner, *Women in Modern America: A Brief History*, 2d ed. (San Diego and New York, 1984), pp. 18–21; and Nancy Woloch, *Women and the American Experience* (New York, 1984), pp. 299–303.

18 Elizabeth Bisland, "Notes and Comments: The Modern Woman and Marriage," *North American Review* 160 (June 1895), p. 753.

19 These were women who were "having what they consider a perfectly lovely time, posing at the opera or gyrating in some ballroom, exquisitely dressed, and laughing as lightly as though there were no painful echoes from their neglected nurseries" (Mrs. Amelia E. Barr, "Good and Bad Mothers," *North American Review* 156 [Apr. 1893], p. 411). Such chiding was constant in the literature of the period. See H. B. Marriott-Watson, "Deleterious Effect of Americanisation upon Woman," *Nineteenth Century* 54 (Nov. 1903), pp. 782–92; H. B. Marriott-Watson, "The American Woman: An Analysis," *Nineteenth Century* 56 (Sept. 1904), pp. 433–42; and "Extravagance of Women in New York," *Spectator* 75 (Dec. 14, 1895), pp. 852–53. To forestall these adult faults, writers on domestic topics urged that young girls be trained thoroughly in their proper domestic roles. See Julia Ward Howe, "Defects in the Education of American Girls," *Chautauquan* 8 (Feb. 1888), pp. 289–91.

20 Marriott-Watson, "Deleterious Effect of Americanisation," p. 791.

21 This resistance to marriage was discussed often in contemporary periodicals. See, for example, Mrs. Kate Gannett Wells, "Why More Girls Do Not Marry," *North American Review* 152 (Feb. 1891), pp. 175–81. The changing relationships between the sexes also were discussed incessantly. See, for example, Junius Henri Browne, "Are Women Companionable to Men?" *Cosmopolitan* 4 (Feb. 1888), pp. 452–55; Charles Dudley Warner, "Editor's Drawer: What We Are, What We Were," *Harper's New Monthly Magazine* 80 (May 1890), pp. 972–73; Mona Caird, "The Emancipation of the Family," *North American Review* 151 (July 1890), pp. 22–37; Helen Churchill Candee, "The Old Home and the New," *Outlook* 49 (Jan. 20, 1894), pp. 127–28; Helen Campbell, "Is American Domesticity Decreasing, and If So, Why?" *Arena* 19 (Jan. 1898), pp. 86–96; Tom Masson, "The Decadence of Husbands," *Harper's Weekly* 50 (Nov. 17, 1906), pp. 1636–37; Anna A. Rogers, "Why American Marriages Fail," *Atlantic Monthly* 100 (Sept. 1907), pp. 289–98; Ida M. Tarbell, "The Business of Being a Woman," *American Magazine* 73 (Mar. 1912), pp. 563–68; and Harrison Rhodes, "How Modern Men May Hope to Please Women," *Century* 87 (Dec. 1913), pp. 312–14.

22 Constance Cary Harrison, "Maidens and Matrons in American Society," *North American Review* 151 (Dec. 1890), p. 713.

23 Quoted in Bourget, *Outre-Mer*, p. 81.

24 Mrs. John Van Vorst and Miss Marie Van Vorst, *The Woman Who Toils: Being the Experiences of Two Ladies as Factory Girls* (New York, 1903), p. 84. Much of the text of this publication appeared in *Everybody's Magazine* before it was gathered together and amplified in book form. Theodore Roosevelt, who contributed a prefatory letter to the book-length publication, reminded readers that virtuous living, specifically marriage and child rearing, supported "the prac-tice of strong, racial qualities without which there can be no races" (Van Vorst and Van Vorst, *Woman Who Toils*, p. vii), and he proclaimed that the individual who purposely avoids marriage and dislikes having children "is in effect a criminal against the race" (ibid., p. viii).

25 Harry Thurston Peck, "For Maids and Mothers: The Woman of To-day and of To-morrow," *Cosmopolitan* 27 (June 1899), p. 151. Peck's article (pp. 149–62) was represented by the editor of *Cosmopolitan* as one extreme of the view of women. It was followed in July 1899 (pp. 309–13) by an opposing opinion ("Woman's Economic Place") as expressed by Charlotte Perkins Stetson [Gilman] (1860–1935), feminist, lecturer, and author of such works as *Women and Economics* (1898), which argues for female economic independence.

26 Peck, "For Maids and Mothers," p. 157.

27 Quoted in Ida Husted Harper, *The Life and Work of Susan B. Anthony: Including Public Addresses, Her Own Letters, and Many from Her Contemporaries During Fifty Years*, 3 vols. (1899; reprint, New York, 1969), vol. 1, p. 134.

28 Docherty, "Open Book and American Woman." For a discussion of reading, a form of relaxation and home entertainment that was well established as the right of all citizens by the end of the eighteenth century, see Donna R. Braden, *Leisure and Entertainment in America: Based on the Collections of Henry Ford Museum and Greenfield Village* (Dearborn, Mich., 1988), pp. 77–86.

29 For further discussion of this painting, see the entry by Aileen Ribeiro in Elizabeth Mankin Kornhauser et al., *Ralph Earl: The Face of the Young Republic* (exh. cat., Hartford, Conn.: Wadsworth Atheneum, 1991), pp. 154–56, no. 29. Boardman's inventory reveals that he owned almost two hundred books on religion, theater, foreign languages, literature, American politics, history, and philosophy. Works by Shakespeare, Milton's *Paradise Lost*, and a volume of Samuel Johnson's *Dictionary* are among those depicted in his portrait.

30 See Carl N. Degler, *At Odds: Women and the Family in America from the Revolution to the Present* (New York, 1980), pp. 308–10.

31 Banner, *Women in Modern America*, p. 5. Between 1900 and 1920 the number of college-educated women grew dramatically, from 85,000 to 250,000; see Rothman, *Woman's Proper Place*, p. 106. In 1903 one writer actually deemed women's educational opportunities *greater* than those open to men: "In 1840 there was not a college in the world open to women. In 1890 in this country 303 colleges were open to both men and women, 127 to men alone, and 170 to women alone, an actual advantage of 43 in favor of women" (Heloise E. Hersey, "The Educated Woman of To-morrow," *Outlook* 74 [Aug. 1, 1903], p. 837).

32 Quoted in Riley, *Inventing the American Woman*, p. 164.

33 On the subject of the educated mother, see Rothman, *Woman's Proper Place*, pp. 97–132. For period comment, see A. L. Mearkle, "The Higher Education of Women: Education and Marriage," *Arena* 23 (June 1900), pp. 661–68.

34 Dr. Edward H. Clarke's influential *Sex in Education; or, A Fair Chance for the Girls* (Boston, 1873) maintained that education placed an enormous, even unbearable strain on women and that they would become sterile from mental exertion. Earlier in the nineteenth century menstruation, pregnancy, and childbirth had been treated as illnesses (Banner, *Women in Modern America*, p. 15).

35 For a discussion of these developments, see Barbara Epstein, "Family, Sexual Morality, and Popular Movements in Turn-of-the-Century America," in Ann Snitow, Christine Stansell, and Sharon Thompson, eds., *Powers of Desire: The Politics of Sexuality* (New York, 1983), pp. 117–30; Banner, *Women in Modern America*, pp. 16–17; and Harvey Green, with Mary-Ellen Perry, *The Light of the Home: An Intimate View of the Lives of Women in Victorian America* (New York, 1983), pp. 30–32. In 1903 Margaret Bisland expressed openly the underlying fear of those she described as "native-Americans" that the growth of the population in the United States was not due to their childbearing but to "the artificial assistance of immigration" (Margaret Bisland, "The Curse of Eve," *North American Review* 177 [July 1903], p. 111). When she reviewed the census of 1900 to evaluate the birthrate, Bisland advocated deducting all immigrants and children of immigrants as well as African-Americans from the population totals (p. 111). There was clearly a racial motivation to the distress over the declining "American" birthrate.

36 Marriott-Watson, "Deleterious Effect of Americanisation," pp. 791–92.

37 For a discussion of reading during this period, see Braden, *Leisure and Entertainment in America*, pp. 77–86.

38 See David Park Curry, *James McNeill Whistler at the Freer Gallery of Art* (exh. cat., Washington, D.C.: Freer Gallery of Art, Smithsonian Institution, 1984), p. 102, pl. 3.

39 Charles Baudelaire, "Le Peintre de la vie moderne" (1863), translated in *The Painter of Modern Life*, ed. Sydney J. Freedberg (New York, 1979), p. 11.

40 Docherty, "Open Book and American Woman."

41 W[illiam] J[ohn] Loftie, *A Plea for Art in the House, with Special Reference to the Economy of Collecting Works of Art, and the Importance of Taste in Education and Morals* (Philadelphia, 1876), p. 71.

42 Henry James, *The Bostonians* (1885–86), ed. Alfred Habegger (Indianapolis, 1976), p. 16, quoted in William R. Vance, "Redefining 'Bos-

tonian,'" in Trevor J. Fairbrother et al., *The Bostonians: Painters of an Elegant Age, 1870–1930* (exh. cat., Boston: Museum of Fine Arts, 1986), pp. 20–21.

43 Docherty, "Open Book and American Woman."

44 Warner, "What We Are, What We Were," p. 972.

45 S[usan] N. Carter, "Exhibition of the Society of American Artists," *Art Journal* 5 (1879), p. 157, quoted in Suzanne G. Lindsay, *Mary Cassatt and Philadelphia* (exh. cat., Philadelphia: Philadelphia Museum of Art, 1985), p. 95.

46 In 1878 *Le Figaro* would have been filled with news of the Paris Exposition and was itself in a transitional period in terms of its editorship and its relationship with the French government. See Jacques de Lacretelle, *Face à l'événement: Le Figaro, 1826–1966* (Paris, 1966).

47 For a discussion of Cassatt's career during these years, see Nancy Mowll Mathews, ed., *Cassatt and Her Circle, Selected Letters* (New York, 1984), pp. 131–36.

48 In the 1850s there was a deluge of novels whose positive view of the housewife's role advanced the cult of domesticity. Cookbooks and other advice books began to emerge, reaching flood tide during the English and American Aesthetic Movements of the 1870s and 1880s. Women were avid readers by the 1890s, when the automatic acceptance of a domestic role came into broad question.

49 Robert Grant, "The Art of Living," *Scribner's Magazine* 18 (Oct. 1895), p. 465.

50 The Gibson illustration and its interpretation were brought to our attention in Docherty, "Open Book and American Woman."

51 A minuscule number of these subjects appear in Cassatt's oeuvre, where they are vastly outnumbered by women occupied with children. See Adelyn D. Breeskin, *Mary Cassatt: A Catalogue Raisonné of the Oils, Pastels, Watercolors, and Drawings* (Washington, D.C., 1970).

52 Hersey, "Educated Woman of To-Morrow," p. 838.

53 Mearkle, "Higher Education of Women," p. 668.

54 For another discussion of this portrait, see Doreen Bolger Burke, *American Paintings in The Metropolitan Museum of Art*, vol. 3, *A Catalogue of Works by Artists Born Between 1846 and 1864*, ed. Kathleen Luhrs (New York, 1980), pp. 247–51. The social projects recommended by Sage appear in M. Olivia Sage, "Opportunities and Responsibilities of Leisured Women," *North American Review* 181 (Nov. 1905), p. 719. For another, less earnest discussion of the upper-class woman and her sphere of influence, see "Vanity Fair; Fads, Foibles, and Fashions: Daily Life of an Ambitious Society Woman," *Current Literature* 32 (Apr. 1902), pp. 440–41.

55 Sargent, then the leading society portraitist of his generation, was unlikely to record any sitter

unable to afford a steep fee. When Sargent agreed to paint the portrait of actress Ada Rehan in 1894, he told his patron that he would charge her only $2,500, "below my usual price" (Burke, *American Paintings in the Metropolitan Museum*, p. 245). The Stokes portrait was undoubtedly more expensive. For discussions of Sargent's work in this genre, see Gary A. Reynolds, "Sargent's Late Portraits," in Patricia Hills et al., *John Singer Sargent* (exh. cat., New York: Whitney Museum of American Art, 1986), pp. 146–79; and Gary A. Reynolds, "John Singer Sargent's Portraits: Building a Cosmopolitan Career," *Arts Magazine* 62 (Nov. 1987), pp. 42–46.

56 I[saac] N[ewton] P[helps] Stokes, "Random Recollections of a Happy Life" (1923), revised 1941 (manuscript, New-York Historical Society), p. 116.

57 Ibid.

58 Ibid., p. 117.

59 Isaac Newton Phelps Stokes, Letter to Cecilia Beaux [1898–1900], Cecilia Beaux Papers, Archives of American Art, Smithsonian Institution, Washington, D.C. (microfilm, reel 427).

60 Gustav Kobbé, "Fakes and Fakirs," *Century* 59 (Dec. 1899), p. 321. For a discussion of this amusing group, see Bruce Weber and Ronald G. Pisano, *Parodies of the American Masters: Rediscovering the Society of American Fakirs, 1891–1914* (exh. cat., New York: Art Students League and Berry-Hill Galleries; Stony Brook, N.Y.: Museums at Stony Brook, 1993).

61 The fashionable elegance and seeming nonchalance of Sargent's two models are deceptive. Edith actually had a reputation for frugality. Her husband recalled an incident on their honeymoon: "She was shocked because I gave the porter a quarter to carry our two heavy bags to the carriage, and made me promise that I would turn over a new leaf, and be more careful in the future in such an important matter as tips" (Stokes, "Random Recollections," p. 117).

62 Douglas A. Russell, *Costume History and Style* (Englewood Cliffs, N.J., 1983), pp. 395–96. On the Gibson girl, see Gerald Carson, *The Polite Americans: A Wide-Angle View of Our More or Less Good Manners over 300 Years* (New York, 1966), pp. 142–54; and Banner, *Women in Modern America*, pp. 21–23.

63 "American Studio Talk," *International Studio* 4 (1898), supplement, p. x, quoted in Trevor J. Fairbrother, "John Singer Sargent and America" (Ph.D. diss., Boston University, 1981), p. 369.

64 Banner, *Women in Modern America*, p. 22. For a discussion of women's roles and their redefinition in the 1890s, see Woloch, *Women and the American Experience*, pp. 269–324; and Martha Banta, *Imaging American Women: Idea and Ideals in Cultural History* (New York, 1981), pp. 45–91. The issue of women and their work is explored in Robert W. Smuts, *Women and Work in America*, 2d ed. (New York, 1972).

65 Harrison, "Maidens and Matrons in American Society," p. 716.

66 A full menu of athletic activities is described in Anna Wentworth Sears, "The Modern Woman Out-of-Doors," *Cosmopolitan* 21 (Oct. 1896), pp. 630–40.

67 Isaac's grandmother Caroline Phelps Stokes was an advocate of temperance and abolition. Her daughters pursued similar good works and supported philanthropies, among them efforts to improve tenement housing in New York City. Their brother James Stokes was an active socialist. See Roy Lubove, "Olivia Egleston Phelps Stokes and Caroline Stokes," and David A. Shannon, "Rose Harriet Pastor Stokes," in Edward T. James, ed., *Notable American Women*, 3 vols. (Cambridge, Mass., 1971), vol. 3, pp. 382–86.

68 See H[arris] E[lwood] S[tarr], "Stokes, Anson Phelps," in Dumas Malone, ed., *Dictionary of American Biography* (New York, 1936), vol. 18, pp. 66–67; and Winifred Howe, *A History of The Metropolitan Museum of Art* (New York, 1913), p. 116.

69 In 1899 Stokes was a member of the Tenement House Committee of the Charity Organization Society, which organized an exhibition on existing urban housing conditions. In 1900 he was appointed to Governor Theodore Roosevelt's State Tenement House Commission, serving as chairman of the Committee of New Buildings; he was one of three people who drafted the State Tenement House Law of 1901. He also helped form the United States Housing Corporation, among numerous other activities related to housing. See "I. N. Phelps Stokes, Architect, 77, Dead," *New York Times*, Dec. 19, 1944, p. 21.

70 William B. Rhoads, "The Colonial Revival and the Americanization of Immigrants," in Alan Axelrod, ed., *The Colonial Revival in America* (Winterthur, Del., 1985), pp. 342–44.

71 New York Kindergarten Association, *Fourteenth Annual Report, . . . June 1903–June 1904* (New York [1904]), p. 8, quoted in Rothman, *Woman's Proper Place*, p. 102.

72 Elizabeth McCausland, *A. H. Maurer* (New York, 1951), pp. 64, 66, 83–84, 184.

73 Dolores Mitchell, "The 'New Woman' as Prometheus: Women Artists Depict Women Smoking," *Woman's Art Journal* 12 (Spring–Summer 1991), pp. 3–9.

74 Sally Helvenston, "Popular Advice for the Well Dressed Woman in the 19th Century," *Dress* 31 (1980), pp. 37–39.

75 Henry T. Finck, "Are Womanly Women Doomed?" *Independent* 53 (Jan. 31, 1903), p. 268. Henry Rowe Schoolcraft was an explorer and ethnologist who avidly studied Native American society and culture.

76 Hersey, "Educated Woman of To-morrow," pp. 838, 839.

77 Quoted in Finck, "Are Womanly Women Doomed?" p. 267.

78 S. Weir Mitchell quoted in Green, with Perry, *Light of the Home*, p. 117.

79 These outdoor leisure-time subjects were characteristic of the American Impressionists. See Ronald G. Pisano, *Idle Hours: Americans at Leisure, 1865–1914* (Boston, 1988), pp. 14–21.

80 See Russell, *Costume History and Style*, pp. 394–96.

81 For another discussion of this painting, see Rowland Elzea, *John Sloan's Oil Paintings: A Catalogue Raisonné*, 2 vols. (Newark, Del., 1991), vol. 1, pp. 73–74.

82 "Standing all day can not fail to be physically harmful, although the girls do not mind it after the first month or two. A woman who had been in a department store for three years told me her ankles had increased one-half during that time, but beyond that she was not conscious of physical strain. It probably exists and will make itself felt in time. Seats are required by law in several states, but their use is not always encouraged [by floor walkers and managers]" (Mary Rankin Cranston, "The Girl Behind the Counter," *World To-day* 10 [Mar. 1906], p. 271).

83 Zenka is discussed in Bruce St. John, ed., *John Sloan's New York Scene from the Diaries, Notes, and Correspondence, 1906–1913* (New York, 1965), p. 44; and Elzea, *John Sloan's Oil Paintings*, vol. 1, pp. 65, 73, where she is identified as the model here. Eugenie Stein is listed as an artist's model in the 1916–17 New York directory; Eugenie B. Stein is listed as an artist in 1920–21, but it is not clear whether this is the same woman.

84 This first portrait of Zenka, currently unlocated, was sold at Christie's, New York, on May 31, 1985, lot 152. For an illustration, see Elzea, *John Sloan's Oil Paintings*, vol. 1, p. 65. Other paintings for which Stein served as a model are discussed in ibid., pp. 69, 71, 212, 228, 239–40. For Sloan's comment on Zenka, see John Sloan, *Gist of Art: Principles and Practise Expounded in the Classroom and Studio*, recorded with the assistance of Helen Farr (New York, 1939), p. 257, quoted in Elzea, *John Sloan's Oil Paintings*, vol. 1, p. 228.

85 Sloan, *Gist of Art*, p. 220, quoted in Elzea, *John Sloan's Oil Paintings*, vol. 1, p. 97.

86 Degas's painting was based on a scene from Zola's *Thérèse Raquin*, in which Thérèse and her lover, Laurent, come together on their wedding night a year after murdering Thérèse's first husband. Before this literary source was identified, the painting was known as *The Rape*. For a discussion of this picture, see Herbert, *Impressionism*, p. 50.

87 Kathy Peiss, "'Charity Girls' and City Pleasures: Historical Notes on Working-Class Sexuality, 1880–1920," in Snitow, Stansell, and Thompson, *Powers of Desire*, p. 75.

88 John Sloan, Diary, June 18, 1907, quoted in Elzea, *John Sloan's Oil Paintings*, vol. 1, p. 73.

89 Benson's painting was published in Charles H. Caffin, "The Art of Frank W. Benson," *Harper's Monthly Magazine* 119 (June 1909), p. 107, as *Girl with Black Hat*. For another discussion of the Benson picture, see Patricia C. F. Mandel, *Selection VII: American Paintings from the Museum's Collection, c. 1800–1930* (exh. cat., Providence: Rhode Island School of Design, 1977), pp. 198–99. For another discussion of the Glackens painting, see Jefferson C. Harrison, *The Chrysler Museum: Handbook of the European and American Collections: Selected Paintings, Sculpture, and Drawings* (Norfolk, Va., 1991), pp. 168–69.

90 Mrs. T. P. O'Connor, "Shopping in America," *Independent* 61 (Dec. 27, 1906), p. 1560.

91 Henry James, *The Portrait of a Lady*, 2 vols. (1881; reprint, Boston and New York, 1909), vol. 1, pp. 287–88, as quoted in Docherty, "Open Book and American Woman."

92 "Female Extravagance in New York," *Spectator*, no. 3520 (Dec. 14, 1895), p. 852.

93 Edith Wharton, *The House of Mirth* (1905), in *Edith Wharton: Novels* (New York, 1984), p. 12. We are grateful to Cynthia Roznoy, who shared this and other information on *The Shoppers* from her paper, "Social Discourse in William Glackens' *The Shoppers*," prepared for a seminar offered by H. Barbara Weinberg at the Graduate School and University Center, City University of New York, fall 1990.

94 Clara Burton Pardee, Diaries, 1883–1938, entry for May 26, 1909, New-York Historical Society, cited in Elaine S. Abelson, *When Ladies Go A-Thieving: Middle-Class Shoplifters in the Victorian Department Store* (New York, 1989), p. 40. At the turn of the century arbiters of fashion were as divided in their opinions about dress as social commentators were on defining the limits of the domestic sphere. Two divergent attitudes toward women's dress emerged—a romanticized view in which women dressed elaborately to ornament the home and a more pragmatic stance advocating simpler dress to free women to perform their roles in society unfettered by extravagant stylishness. The latter position, while progressive in terms of women's status, reaffirmed the traditional values of piety, frugality, and familial responsibility undermined by consumerism. For further discussion, see Helvenston, "Popular Advice for the Well Dressed Woman," pp. 31–46.

95 In a more overt image, *Resting in Bed* of about 1880 (Freer Gallery of Art, Smithsonian Institution, Washington, D.C.), Whistler declared his presence with a black silk top hat, entangled in the black and pink folds of an evening cape at the far end of the room.

96 Alexandre Dumas fils, *La Dame aux camélias* (Paris, n.d.), pp. 166–67, quoted in Rémy G.

Saisselin, *The Bourgeois and the Bibelot* (New Brunswick, N.J., 1984), p. 57.

⁹⁷ Saisselin, *Bourgeois and the Bibelot*, p. 62, with an extended discussion on pp. 53–74.

⁹⁸ James, *Portrait of a Lady*, vol. 2, p. 9. Saisselin (*Bourgeois and the Bibelot*, p. 61) brought this citation to our attention.

⁹⁹ Henry James, *The American* (1877), in *Henry James: Novels, 1871–1880* (New York, 1984), pp. 548–49.

¹⁰⁰ Mrs. Glackens studied at the Art Students League from 1895 to 1899 (Archives, Art Students League, New York).

¹⁰¹ Mrs. Travis studied at the league from 1896 to 1901, but, judging from the incomplete records available, she did not attend the same classes as Mrs. Glackens (Archives, Art Students League, New York).

¹⁰² Roznoy, "Social Discourse in Glackens' *Shoppers*."

¹⁰³ Edith's father, Ira Dimock, was president of the prosperous Nonotuck Silk Company and a member of one of New England's oldest families. For biographical information on Ira Dimock and family, see *Encyclopedia of Connecticut Biography*, 10 vols. (New York, 1917–23), vol. 5, pp. 272–76; and "Ira Dimock Dies Within a Few Days of Wife's Death," *Hartford Courant*, May 11, 1917, files of the Connecticut Historical Society, Hartford. Edith grew up on an eleven-acre estate originally built for Cornelius Jeremiah Vanderbilt. See Ira Glackens, *William Glackens and the Ashcan Group: The Emergence of Realism in American Art* (New York, 1957), pp. 32–48. An independent woman, Edith was able to overcome her family's objections to a career in art and a marriage to an artist who struggled to support himself as an illustrator. Mrs. Shinn, born Florence Scovel, was a close friend of Edith's. She was an illustrator and a distant relative of the Philadelphia Biddles, who, as Shinn's biographer Edith DeShazo put it, "sported their blue blood in the way only old Philadelphia families can" and disapproved of her suitor. Their fears may have been justified. Florence and Shinn were divorced in 1912, and Shinn married three more times. See Edith DeShazo, *Everett Shinn, 1876–1953: A Figure in His Time* (New York, 1974), pp. 73–74.

¹⁰⁴ For a discussion of the department store and a bibliographic essay on the subject, see Susan Porter Benson, *Counter Cultures: Saleswomen, Managers, and Customers in American Department Stores, 1890–1940* (Urbana, Ill., 1986).

¹⁰⁵ *Dry Goods Reporter*, Feb. 6, 1904, p. 55, quoted in Abelson, *When Ladies Go A-Thieving*, p. 33.

¹⁰⁶ See Abelson, *When Ladies Go A-Thieving*, p. 33. For a discussion of the social significance of household goods marketed in trade catalogues, see Kenneth L. Ames et al., *Accumulation and Display: Mass Marketing Household Goods in America, 1880–1920* (exh. cat., Winterthur,

Del.: Henry Francis du Pont Winterthur Museum, 1986).

¹⁰⁷ Quoted in Abelson, *When Ladies Go A-Thieving*, p. 31.

¹⁰⁸ Anne O'Hagan, "Behind the Scenes in the Big Stores," *Munsey's Magazine* 22 (Jan. 1900), p. 533. "Departments like those devoted to cloaks and suits and millinery are on the upper floors, where they can have plenty of space and customers can be served comfortably, without crowding" (Hartley Davis, "The Department Store at Close Range," *Everybody's Magazine* 17 [Sept. 1907], p. 313).

¹⁰⁹ Grant, "Art of Living," p. 465.

¹¹⁰ Davis, "Department Store at Close Range," p. 322.

¹¹¹ Elzea, *John Sloan's Oil Paintings*, vol. 1, p. 98. Sloan described the site as "an impression of the Avenue walking south from Thirty-fifth Street" (Sloan, *Gist of Art*, p. 221, quoted in Elzea, *John Sloan's Oil Paintings*, vol. 1, p. 98). According to Sloan's diary entry for May 5, 1909, just a few days before he started this picture, he met with socialist Piet Vlag, who introduced him to Herman Block, an art journalist for the *Call*, a socialist newspaper.

¹¹² Sloan, Diary, May 8, 1909, quoted in Elzea, *John Sloan's Oil Paintings*, vol. 1, p. 98.

¹¹³ As Elaine Abelson reports, "Macy's carried some types of furniture and rugs in 1873, and Lord & Taylor opened a special furniture department the following year. In the 1880s Marshall Field displayed the first model rooms. Descriptions in the *D[ry] G[oods] E[conomist]* indicate how elaborate some of these so-called models had become by the late 1890s. One store showed not just a kitchen or a drawing-room but a 'whole furnished flat'" (Abelson, *When Ladies Go A-Thieving*, p. 52).

¹¹⁴ Wanamaker's theater accommodated 1,500 people and offered two daily concerts during most of the year. A reporter noted, "It has its own singers and instrumentalists and in addition employs some of the great masters. Richard Strauss was paid $3,000 for three concerts. It costs about $50,000 a year to give these concerts and admission is free" (Davis, "Department Store at Close Range," p. 323).

¹¹⁵ "In the shopping district of New York City—Fifth and Sixth Avenues and Broadway between Thirty-fifth Street and Eighth Street, and Fourteenth, Eighteenth and Twenty-third Streets between Fifth and Sixth Avenues—there are between twenty and thirty thousand girls and women employed in the dry-goods and department stores, and nearly three thousand more who are employed in the smaller shops and in the dry-goods and department stores of the outlying districts of the city. Between two and three thousand girls and women are employed in each of the larger department stores, and in the smaller department

stores between three hundred and eighteen hundred" (Mary K. Maule, "What Is a Shop-Girl's Life? Her Pay, Hours, 'Home,' Outlook, and Chance of Enjoyment," *World's Work* 14 [Sept. 1907], p. 9311).

¹¹⁶ O'Hagan, "Behind the Scenes," p. 530.

¹¹⁷ Ibid., p. 537.

¹¹⁸ Theodore Dreiser, *Sister Carrie* (New York, 1900), p. 111; a later edition ([Baltimore, 1981], p. 98) is quoted in Saisselin, *Bourgeois and the Bibelot*, p. 36.

¹¹⁹ For a discussion of this subject, see Abelson, *When Ladies Go A-Thieving*, p. 213.

¹²⁰ Anna Steese Richardson, "The Modern Woman's Paradise," *Woman's Home Companion* 38 (Sept. 1911), p. 22, quoted in Abelson, *When Ladies Go A-Thieving*, p. 51.

¹²¹ Maule, "What Is a Shop-Girl's Life?" p. 9311. Another journalist noted, "A department store is more or less of a public institution, and the employees who are on exhibition are in a way advertisements. The public resents the worn out, famished type of clerk, and its feelings are hurt by seeing women faint behind counters" (O'Hagan, "Behind the Scenes," p. 535).

¹²² A shopgirl might spend one-sixth of her income on clothing. Members of St. George's Working Girls' Club in New York, according to figures published in the Consumers' League reports, estimated clothing costs at about sixty-five dollars per year. An average shopgirl's salary was about seven dollars per week (Anne O'Hagan, "The Shop-Girl and Her Wages," *Munsey's Magazine* 50 [Nov. 1913], p. 256).

¹²³ Alice Van Leer Carrick, "Shop Girls As They Are," *National Magazine* 11 (Feb. 1900), p. 526.

¹²⁴ Ibid.

¹²⁵ Many of the journalistic essays of the period are essentially positive in reporting this new avenue of activity for women; see, for example, O'Hagan, "Shop-Girl and Her Wages," pp. 252–59. Later historians have fully recorded the negative aspects along with the positive. See especially Dorothy Davis, *A History of Shopping* (London, 1966); Abelson, *When Ladies Go A-Thieving*; and Benson, *Counter Cultures*. We are grateful to Natalie Kampen for bringing the latter source to our attention. Benson analyzes the department store from the standpoint of three major presences on the selling floor: saleswomen, managers, and customers. This dangerous triangle was characterized by shifting alliances.

¹²⁶ Benson, *Counter Cultures*, p. 242.

¹²⁷ O'Hagan, "Shop-Girl and Her Wages," p. 259.

¹²⁸ A report by Mary Conyngton looked at several cities under the direction of the Federal Commissioner of Labor. According to Anne O'Hagan, Conyngton discovered that "domestic and personal service furnish seventy-seven per cent of the female criminals, although they furnish only forty

per cent of all the women wage-earners! As for the girls employed in stores and offices—those unprotected young women upon whom so much sympathy, so much advice, and so many misgivings have been expended— only two per cent of the total female delinquency was charged against them" (O'Hagan, "Shop-Girl and Her Wages," p. 259).

[129] Sloan, *Gist of Art*, p. 220, quoted in Elzea, *John Sloan's Oil Paintings*, vol. 1, p. 97.

[130] Sloan, Diary, Mar. 9, 1910, quoted in Elzea, *John Sloan's Oil Paintings*, vol. 1, p. 97.

[131] For a complete account of this painting, see Elzea, *John Sloan's Oil Paintings*, vol. 1, pp. 119–20.

[132] John B. Leeds, "The Household Budget: With a Special Inquiry into the Amount and Value of Household Work" (Ph.D. diss., Columbia University, New York, 1917), p. 57, quoted in Cowan, *More Work for Mother*, p. 167.

[133] Hersey, "Educated Woman of To-Morrow," p. 837. More women had jobs—20 percent of the women over sixteen in 1900, as opposed to 15 percent of the same group in 1870—and the types of jobs available to them had expanded (Banner, *Women in Modern America*, p. 6). As Banner points out, there may have been an even larger number of women working than is readily documented. These figures are based on census records, which could easily fail to record a woman's lifetime pattern of employment if it was episodic or discontinuous. Women were represented in all but 9 of the 369 occupations listed in the census of 1890 (ibid., p. 7).

[134] Julia Ward Howe quoted in Bourget, *Outre-Mer*, p. 75.

[135] Banner, *Women in Modern America*, p. 8.

[136] M. E. J. Kelley, "Women Factory Workers," *Outlook* 58 (Jan. 29, 1898), p. 269.

[137] Banner, *Women in Modern America*, pp. 8–9.

[138] Katharine Pearson Woods, "Queens of the Shop, the Workroom and the Tenement," *Cosmopolitan* 10 (Nov. 1890), p. 99.

[139] During this period more men than women were collectors of major artworks, although the decorating of the home remained the feminine domain. There were, however, some notable exceptions. See Kathleen D. McCarthy, *Women's Culture: American Philanthropy and Art, 1830–1930* (Chicago, 1991).

[140] Sloan, *Gist of Art*, p. 216, quoted in Elzea, *John Sloan's Oil Paintings*, vol. 1, p. 83.

[141] For a discussion of the architecture of these sites, see Nikolaus Pevsner, *A History of Building Types* (Princeton, N.J., 1976).

[142] Neil Harris, "Museums, Merchandising, and Popular Taste: The Struggle for Influence," in Ian M. G. Quimby, ed., *Material Culture and the Study of American Life* (New York, 1978), pp. 140–74.

[143] Ralph M. Hower, *History of Macy's of New York, 1858–1919* (Cambridge, Mass., 1943), p. 284, cited in Rothman, *Woman's Proper Place*, p. 20.

[144] John Wanamaker Firm, *The Golden Book of Wanamaker Stores (Jubilee Year, 1861–1911)* (Philadelphia, 1911), quoted in Saisselin, *Bourgeois and the Bibelot*, pp. 45–46.

[145] See "Reflections of a Fashionable Girl," *Hearth and Home*, May 15, 1869, quoted in William Leach, *True Love and Perfect Union: The Feminist Reform of Sex and Society*, 2d ed. (Middletown, Conn., 1989), pp. 223, 405, n. 51.

[146] Aristide Boucicault's Au Bon Marché (which means "well marketed," that is, a bargain) opened in Paris in 1852. For a discussion of the American stores that followed, see Leach, *True Love and Perfect Union*, pp. 213–62.

[147] Emile Zola, *Au Bonheur des Dames* (Paris, 1882), translated as *Ladies' Delight*, by April Fitzlyon (London and New York, 1958), pp. 374–75.

[148] O'Hagan, "Behind the Scenes," p. 537.

[149] In 1907 Hartley Davis reported that advertising was the second largest expense of the average department store, after the money spent to acquire goods for sale. See Davis, "Department Store at Close Range," p. 319.

[150] Herbert, *Impressionism*, p. 52.

[151] Nancy Mowll Mathews, *Mary Cassatt* (New York, 1987), p. 60.

[152] Clarence Cook, *The House Beautiful: Essays on Beds and Tables, Stools and Candlesticks* (New York, 1878), p. 22.

[153] For information on Gardner, see George L. Watson, "Isabella Stewart Gardner," in James, *Notable American Women*, vol. 2, pp. 15–17; Morris Carter, *Isabella Stewart Gardner and Fenway Court* (Boston, 1925); Louise Hall Tharp, *Mrs. Jack: A Biography of Isabella Stewart Gardner* (Boston, 1965); and McCarthy, *Women's Culture*, pp. 149–76.

[154] Rodris Roth, "The New England or 'Old Tyme' Kitchen Exhibit at Nineteenth-Century Fairs," in Axelrod, *Colonial Revival in America*, pp. 159–83. For a discussion of American nostalgia during this period, see David M. Lubin, "Permanent Objects in a Changing World: Harnett's Still Lifes as a Hold on the Past," in Doreen Bolger, Marc Simpson, and John Wilmerding, eds., *William M. Harnett* (exh. cat., New York: The Metropolitan Museum of Art; Fort Worth: Amon Carter Museum, 1992), pp. 49–60.

[155] See *The Works of E. L. Henry: Recollections of a Time Gone By* (exh. cat., Shreveport, La.: R. W. Norton Art Gallery, 1987).

[156] Mrs. Robert R. Cassatt, Letter to Alexander J. Cassatt, Nov. 30, 1883, quoted in Frederick A. Sweet, *Miss Mary Cassatt, Impressionist from Pennsylvania* (Norman, Okla., 1966), pp. 85–86.

[157] For Sloan's source in Daumier, see K. E. Maison, *Honoré Daumier: Catalogue Raisonné of the Paintings, Watercolors, and Drawings*, 2 vols. (London, 1968), vol. 2, no. 385, pl. 126, *Visiteurs dans l'atelier d'un artiste*, which was sold in New York the year before Sloan made his print (Cyrus J. Lawrence sale, American Art Galleries, New York, Jan. 21–22, 1910, lot 34) and purchased in 1910 by the Walters Art Gallery, Baltimore.

[158] Marilynn Johnson, "The Artful Interior," in Doreen Bolger Burke et al., *In Pursuit of Beauty: Americans and the Aesthetic Movement* (exh. cat., New York: The Metropolitan Museum of Art, 1986), p. 111.

[159] O'Hagan, "Behind the Scenes," p. 530.

[160] American trompe-l'oeil still-life painters working at this time received relatively little critical acknowledgment although they were supported by middle-class patrons. See Doreen Bolger, "The Patrons of the Artist: Emblems of Commerce and Culture," and William H. Gerdts, "The Artist's Public Face: Lifetime Exhibitions and Critical Reception," in Bolger, Simpson, and Wilmerding, *William M. Harnett*, pp. 72–99.

[161] Loftie, *Plea for Art*, pp. 49–50.

[162] For a complete account of this painting, see Elzea, *John Sloan's Oil Paintings*, vol. 1, pp. 115–16.

[163] Kate Stephens, "The New England Woman," *Atlantic Monthly* 88 (July 1901), p. 60. For discussions of the esteem in which the New England village was held in this period, see "Modern Painters in Landscape" and "The Country Retreat and the Suburban Resort," this catalogue.

[164] Sloan, Diary, Mar. 11, 1912, quoted in Elzea, *John Sloan's Oil Paintings*, vol. 1, p. 116.

[165] For a discussion of corset dangers ("tight lacing"), see Green, with Perry, *Light of the Home*, pp. 120–26. For a discussion of the ideal feminine type in this period, see Helvenston, "Popular Advice for the Well Dressed Woman," pp. 31–46. Such unrealistic ideals of feminine beauty have been a problem through the ages; see Bernard Rudofsky, *The Unfashionable Human Body* (Garden City, N.Y., 1971).

[166] Sloan, *Gist of Art*, p. 229, quoted in Elzea, *John Sloan's Oil Paintings*, vol. 1, p. 116.

[167] Sloan, *Gist of Art*, p. 244, quoted in Elzea, *John Sloan's Oil Paintings*, vol. 1, p. 155. For an account of this painting, see ibid.

[168] Helen Farr Sloan, ed., *John Sloan: New York Etchings (1905–1949)* (New York, 1978), nos. 17, 21.

[169] Although their dialogue could have been about *Woman's Work* or *Sun and Wind on the Roof*, the date of the correspondence, 1915, makes the later picture a more likely choice. See Jennie Doyle, Letter to Sloan, May 1, 1915, with interview enclosed, John Sloan Archives, Delaware Art Museum, Wilmington. An inscription on a

letter from Doyle, perhaps in the hand of the artist's second wife, Helen Farr Sloan, suggests that the artist did not know Doyle, but Rowland Elzea, the author of the Sloan catalogue raisonné, has identified Doyle as one of Sloan's models (Lee Ann Dean, Archivist, Helen Farr Sloan Library, Delaware Art Museum, Wilmington, Letter to the authors, Mar. 18, 1993). Little is known about Doyle. Listings for her name in New York directories appear with the occupations of clerk and dressmaker.

[170] Doyle, Letter to Sloan, May 1, 1915, with interview enclosed, John Sloan Archives.

[171] Ibid.

[172] Rachel Haskell quoted in Susan Strasser, *Never Done: A History of American Housework* (New York, 1982), p. 104; and Marion Harland, *The Housekeeper's Week* (Indianapolis, 1908), p. 13, quoted in Rothman, *Woman's Proper Place*, p. 15. Rothman (p. 15) also provides information on the amount of time required for laundry. For a larger discussion of technology and the housewife, see Sheila M. Rothman, "Technology and the White Woman's Burden" (ibid., pp. 14–21); Cowan, *More Work for Mother*; Woloch, *Women and the American Experience*; and Clifford Edward Clark, Jr., *The American Family Home, 1800–1960* (Chapel Hill, N.C., 1986), pp. 131–70.

[173] For an account of domestic work during the golden age of housework, see Cowan, *More Work for Mother*, pp. 154–72.

[174] The electric washing machine did not appear on the home front until 1914, two years after Sloan painted *Woman's Work* (ibid., p. 166). For a recent account of the marketing of washing machines, see Ellen Lupton, *Mechanical Brides: Women and Machines from Home to Office* (exh. cat., New York: Cooper-Hewitt National Museum of Design, Smithsonian Institution, 1993).

[175] O'Hagan, "Behind the Scenes," p. 530.

[176] Davis, "Department Store at Close Range," p. 322.

[177] Rothman, *Woman's Proper Place*, pp. 16–17.

[178] For period discussions of domestic service and its issues, see Christina Goodwin, "Appeal to Housekeepers," *Forum* 19 (Aug. 1895), pp. 753–60; and Harriet Gillespie, "Labor-Saving Devices Supplant Servants," *Good Housekeeping* 56 (Oct. 1914), pp. 69–72.

[179] Ralph Bergengren, "The Queen of the Girls," *Everybody's Magazine* 27 (July 1912), pp. 81–93. See Elzea, *John Sloan's Oil Paintings*, vol. 1, p. 155.

[180] Bergengren, "Queen of the Girls," p. 82.

[181] Ibid., p. 81.

[182] Smuts, *Women and Work in America*, p. 89. For a pictorial survey of laundry activities and apparatus, see Cowan, *More Work for Mother*, pls. following p. 150.

[183] For an excellent discussion of home laundry, see Strasser, *Never Done*, pp. 104–24.

[184] Annie L. Hansen, "Two Years as a Domestic Educator in Buffalo, New York," *Journal of Home Economics* 5 (1913), p. 435, quoted in Cowan, *More Work for Mother*, p. 167.

[185] Cowan, *More Work for Mother*, pp. 167–68.

[186] Mary Alden Hopkins, "Women's March," *Collier's* 49 (May 18, 1912), pp. 13, 30–31.

[187] Ibid., p. 30.

[188] Banner, *Women in Modern America*, p. i. Banner (pp. 1–22) presents the overall status of women in 1890, covering legal codes, educational opportunities, occupations, and medicine and sexuality.

[189] For a summary of suffrage issues during this period, see Woloch, *Women and the American Experience*, pp. 307–58; and Riley, *Inventing the American Woman*, pp. 121–30. There were two distinct groups seeking woman suffrage, both founded in 1869: the National Woman Suffrage Association, led by Elizabeth Cady Stanton and Susan B. Anthony, and the American Woman Suffrage Association, led by Lucy Stone, Mary Livermore, and Julia Ward Howe (Riley, *Inventing the American Woman*, p. 127). For a period survey of suffrage, see Frank Foxcroft, "The Check to Woman Suffrage in the United States," *Nineteenth Century* 56 (Nov. 1904), pp. 833–41.

[190] Bourget, *Outre-Mer*, pp. 73–74.

[191] Price Collins, "Home Life, English and American," *Forum* 17 (May 1894), p. 345.

[192] Marriott-Watson, "Deleterious Effect of Americanisation," p. 789.

[193] Barr, "Good and Bad Mothers," p. 411.

[194] Constance Cary Harrison, "American Children at Home and in Society," *Century* 25 (Apr. 1883), p. 796.

[195] The birthrate, which stood at 7 children per family in 1804, declined from 4.24 children per family in 1880 to 3.56 in 1900 (Banner, *Women in Modern America*, p. 17).

[196] E. S. Martin, "Children," *Harper's New Monthly Magazine* 100 (Dec. 1899), p. 13.

[197] Cecilia Beaux, *Background with Figures: Autobiography of Cecilia Beaux* (Boston, 1930), p. 86.

[198] Ibid.

[199] Their choices reflect the same sharp social divisions and desire for isolation that historian Philippe Ariès has observed in his evaluation of late nineteenth-century European cities: "the middle class could no longer bear the pressure of the multitude or the contact of the lower classes. It seceded: it withdrew from the vast polymorphous society to organize itself separately" (Philippe Ariès, *Centuries of Childhood: A Social History of Family Life*, trans. Robert Baldick [New York, 1962], p. 415, quoted in George Herland, "Centuries of Childhood in New York," in Robin Lester et al., *Centuries of Childhood in New*

York [exh. cat., New York: New-York Historical Society, 1984], p. 31).

[200] Herbert, *Impressionism*, p. 188. Herbert's comments are addressed to Renoir's work.

[201] For a discussion of the reevaluation of the child's worth from 1870 to 1930, presented as a series of case studies, see Viviana Zelizer, *Pricing the Priceless Child: The Changing Social Value of Children* (New York, 1985).

[202] Barr, "Good and Bad Mothers," pp. 409–10.

[203] Banner, *Women in Modern America*, p. 55.

[204] Ibid.

[205] Barbara Ehrenreich and Deirdre English, *For Their Own Good: 150 Years of the Experts' Advice to Women* (Garden City, N.Y., 1978), p.128.

[206] Elizabeth Harrison, *A Study of Child Nature from the Kindergarten Standpoint* (Chicago, 1895), p. 10, as quoted in Rothman, *Woman's Proper Place*, p. 103.

[207] Bisland, "Modern Woman and Marriage," p. 753.

[208] Mary Stanley Boone, "The Kindergarten from a Mother's Point of View," *Education* 25 (Nov. 1904), p. 143, quoted in Rothman, *Woman's Proper Place*, p. 98. For an analysis of the developing role of the mother, see ibid., pp. 97–132. For period comment on the educated mother, see Ellen Kay, "Education for Motherhood," parts 1, 2, *Atlantic Monthly* 112 (July 1913), pp. 48–56, (Aug. 1913), pp. 191–97. Advice to mothers abounded; see, for example, "How I Run My Home and Educate My Children There, by the Woman Who Does It," *Ladies' Home Journal* 30 (Nov. 1913), p. 26.

[209] Thomas J. Schlereth, *Victorian America: Transformations in Everyday Life, 1876–1915* (New York, 1991), p. 277. Schlereth (p. 339, n. 9) notes precedents for the term *companionate*: Ben J. Lindsay and Wainright Evans, *Revolt of Modern Youth* (New York, 1925); and Charles Larson, "Introduction," in Ben J. Lindsay and Wainright Evans, *The Companionate Marriage*, ed. Charles Larson (1927; reprint, New York, 1977). See also Steven Mintz and Susan Kellogg, *Domestic Revolutions: A Social History of American Family Life* (New York and London, 1988), pp. 107–31.

[210] Banner, *Women in Modern America*, p. 51.

[211] See John Higham, "Reorientation of American Culture in the 1890's," in Horace John Weiss, ed., *The Origins of Modern Consciousness* (Detroit, 1965), pp. 25–32; and Smuts, *Women and Work in America*, pp. 24–27.

[212] Mary Lynn Stevens Heininger, "Children, Childhood, and Change in America, 1820–1920," in *A Century of Childhood, 1820–1920* (exh. cat., Rochester, N.Y.: Margaret Woodbury Strong Museum, 1984), pp. 19–21. Some writers even feared that children had become old before their time—spoiled by adultlike toys and fast living. See O. O'B. Strayer, "Old Children," *Century* 25 (Feb. 1883), p. 633.

213 Articles discussing the more negative aspects of child character nonetheless continued to appear in the late nineteenth century. See Viola Roseboro, "Childhood," *Century* 43 (Dec. 1891), pp. 238–42.

214 Green, with Perry, *Light of the Home*, pp. 35–36. For a period discussion of the effects of nurturing on children, see B. O. Flower, "Early Environment in Home Life," *Arena* 10 (Sept. 1894), pp. 483–93.

215 Barr, "Good and Bad Mothers," p. 409. For a period discussion of the increasingly complex role of the mother, see Lyman Abbott, "The Profession of Motherhood," *Outlook* 91 (Apr. 10, 1909), pp. 836–40.

216 Lillian W. Betts, "Child Labor in Shops and Homes," *Outlook* 73 (Apr. 18, 1903), pp. 921–27.

217 Ibid., p. 921.

218 On the subject of children and play, see Randy Kritkausky, "Living Pictures and Still Images: Child's Play and the Creation of Social Identities in Shoetown (1890–1920)," in *The Preserve of Childhood; Adult Artifice and Construction: Images of Late-Nineteenth-Century American Childhood* (exh. cat., Binghamton: University Art Gallery, State University of New York, 1985), pp. 14–33.

219 E. A. Kirkpatrick, "Play as a Factor in Social and Educational Reforms," *American Monthly Review of Reviews* 20 (Aug. 1899), p. 192.

220 Heininger, "Children, Childhood, and Change," pp. 16–18. For a period description of artful nurseries, see "The Art Movement: Art for Babes," *Magazine of Art* 25 (Oct. 1901), pp. 558–62.

221 Van Rensselaer, better known for her art and architectural criticism, served as the president of the Public Education Association, which sponsored boys' and girls' clubs and play centers. See G. W. Wharton, "The City for the Children," *Outlook* 72 (Sept. 6, 1902), p. 35.

222 For a discussion of the lamentable physical condition of children (with particular emphasis on the poor state of girls later to be mothers), see [W. Blakie], "Our Children's Bodies," *Harper's New Monthly Magazine* 67 (Nov. 1883), pp. 899–908.

223 Bertha M. Smith, "Health and Recreation for City Children," *Craftsman* 8 (Sept. 1905), pp. 735–46.

224 Mrs. Schuyler [Mariana Griswold] Van Rensselaer, "Midsummer in New York," *Century* 62 (Aug. 1901), p. 501.

225 Cynthia P. Dozier, "The Children at the Seashore and on the Mountains," *Outlook* 54 (July 18, 1896), pp. 97–98.

226 Ibid., p. 97.

227 For a fuller consideration of Chase's park paintings, see "Urban Scene," this publication.

228 Herbert, *Impressionism*, p. 188. Herbert's comments are addressed to Renoir's work.

229 This comparison was made in Pisano, *Idle Hours*, pp. 68–69. White's three players faced a more difficult task. Their rings vary noticeably in diameter, with some quite small, which required greater skill than the larger ones and undoubtedly gained the tosser the most points in the contest. White's models also confronted a more difficult target, aiming for one of four posts at the corners of a rectangular support or the taller shaft in the center.

230 Jacob A. Riis, *The Battle with the Slum* (New York, 1902), pl. following p. 149.

231 See David W. Scott and E. John Bullard, *John Sloan, 1871–1951: His Life and Paintings* (exh. cat., Washington, D.C.: National Gallery of Art, 1971), p. 140.

232 For a discussion of Greenwich Village during this period, see Edmund T. Delaney, *New York's Greenwich Village* (Barre, Mass., 1968), pp. 99–101. See also "Urban Scene," this publication.

233 Ibid., pp. 106–7.

234 Sloan quoted in *John Sloan Retrospective Exhibition* (exh. cat., Andover, Mass.: Addison Gallery of American Art, Phillips Academy, 1938), p. 38.

235 Schlereth, *Victorian America*, p. 277. For a discussion of the working-class family during this period, see Mintz and Kellogg, *Domestic Revolutions*, pp. 82–105.

236 Jacob A. Riis, *The Children of the Poor* (New York, 1892), quoted in Alexander Alland, Sr., *Jacob A. Riis: Photographer and Citizen* (Millerton, N.Y., 1974), p. 140.

237 This painting and the drawing that preceded it are discussed eloquently by Marianne Doezema, *George Bellows and Urban America* (New Haven, 1992), pp. 187–96; see also "Urban Scene," this publication. For a discussion of the lives of "the children of the poor," see David Nasaw, *Children of the City: At Work and at Play* (Garden City, N.Y., 1985).

238 In many respects Bellows's attitude toward park subjects is not unlike those of his early teacher. Bellows eliminated the ills of city life, and the restrictions they placed on childhood, in what Marianne Doezema has described as his "popular, commodious subjects." Paintings such as *May Day in Central Park* of 1905 (formerly Ira Spanierman Gallery, Inc., New York) and drawings such as *Children Playing in a Park* of about 1905 (The Corcoran Gallery of Art, Washington, D.C.) capture middle-class children at leisure using a figure style that recalls the elegant elongation of Gibson's illustrations. See Doezema, *George Bellows and Urban America*, pp. 122–24.

239 Jacob A. Riis, "The Children of the Poor," *Scribner's Magazine* 11 (May 1892), p. 550.

240 For a discussion of turn-of-the-century street games played by children, see Stewart Culin, "Street Games of Boys in Brooklyn, N.Y.," *Journal of American Folklore* 4 (July 1891),

pp. 221–37; Robert Dunn, "Games of the City Street," *Outing* 44 (June 1904), pp. 271–79; and Nasaw, *Children of the City*, pp. 17–38.

241 John H. Finley, "The Child Problem in Cities," *Review of Reviews* 4 (Jan. 1892), p. 684. For discussions of efforts to redress these problems, see Charles Loring Brace, "What Cities Are Doing for the Children of the Poor," *New England Magazine* 25 (Sept. 1901), pp. 63–73.

242 Irving Howe, *World of Our Fathers* (New York, 1976), p. 258, quoted in Martin E. Dann, "'Little Citizens': Working Class and Immigrant Childhood in New York City, 1890–1915" (Ph.D. diss., City University of New York, 1978), p. 227.

243 Innumerable period accounts detail the plight of urban street children. See, for example, Jacob A. Riis, *How the Other Half Lives: Studies Among the Tenements of New York* (New York, 1890); and Riis, *Battle with the Slum.*

244 Lilian Brandt, "In Behalf of the Overcrowded," *Charities* 12 (June 4, 1904), p. 585, quoted in Doezema, *George Bellows and Urban America*, p. 193.

245 For an excellent discussion of *Kids* and its social implications, see Doezema, *George Bellows and Urban America*, pp. 140–47. For the influence of Henri, see ibid., pp. 124, 126.

246 Izola Forrester, "New York's Anarchists: Here Is the Revolutionary Creed of Robert Henri and His Followers," *New York World*, June 10, 1906, magazine section, p. 6, quoted in Doezema, *George Bellows and Urban America*, p. 126.

247 Doezema, *George Bellows and Urban America*, p. 124.

248 For the history of the word *kids*, see J. S. Farmer and W. E. Henley, *Slang and Its Analogues* (New York, 1970), pp. 101–3.

249 For a discussion of disadvantaged girls of this kind, see Nasaw, *Children of the City*, pp. 101–14.

250 See Edward George Hartman, *The Movement to Americanize the Immigrant* (New York, 1948); and John Higham, *Strangers in the Land: Patterns of American Nativism, 1860–1925* (New York, 1969), pp. 234–63.

251 For a discussion of society's changing perceptions of working-class children at the turn of the century, see Dann, "'Little Citizens.'"

252 University Settlement, New York, *Annual Report 1899* (New York [1900]), quoted in Doezema, *George Bellows and Urban America*, p. 142.

253 Wald chose the building because in the 1830s it had been "built by cabinetmakers who came over from England during the War of 1812 and remained here as citizens" (Lillian D. Wald, *The House on Henry Street* [New York, 1915], quoted in Rhoads, "Colonial Revival and Americanization of Immigrants," p. 345). She considered the building exemplary "of good American taste because upstanding citizens had already been created there" (Rhoads, "Colonial Revival and

Americanization of Immigrants," p. 345). The conservative art and architecture of the turn of the century was heavily charged with messages intended to inform, if not reform, the immigrant mind. Well aware of the great politically motivated mural cycles of France and Italy, muralist Edwin Howland Blashfield described public art as a "municipal educator" and asserted that "the decoration of temples and cathedrals and town halls has naturally taught patriotism, morals, aesthetics" (Edwin Howland Blashfield, *Mural Painting in America: The Scammon Lectures Delivered Before the Art Institute of Chicago, March, 1912, and Since Greatly Enlarged* [New York, 1913], p. 24, quoted in part in Rhoads, "Colonial Revival and Americanization of Immigrants," p. 342).

254 For insightful discussions of *Forty-two Kids*, see Rebecca Zurier, "Hey Kids: Children in the Comics and the Art of George Bellows," *Print Collector's Newsletter* 18 (Jan.–Feb. 1988), pp. 196–203; and Doezema, *George Bellows and Urban America*, pp. 147–62. For an illustration of *River Rats*, see Michael Quick et al., *The Paintings of George Bellows* (exh. cat., Fort Worth: Amon Carter Museum; Los Angeles: Los Angeles County Museum of Art, 1992), p. 100.

255 Francine Tyler, "The Impact of Daumier's Graphics on American Artists: c.1863–c.1923," *Print Review* 11 (1980), pp. 123–25.

256 See Herbert, *Impressionism*, p. 40.

257 Mary Elizabeth Sherwood, *Home Amusements* (New York, 1881), quoted in Braden, *Leisure and Entertainment in America*, p. 111.

258 For summaries of information on *At the Piano*, see Sona Johnston, *Theodore Robinson, 1852–1896* (exh. cat., Baltimore: Baltimore Museum of Art, 1973), p. 16; and John I. H. Baur, *Theodore Robinson, 1852–1896* (exh. cat., Brooklyn: Brooklyn Museum, 1946), p. 57.

259 In 1991 Laurence Libin, Frederick P. Rose Curator, Department of Musical Instruments, Metropolitan Museum, identified this instrument as a rather ordinary mid-nineteenth-century European piano. The European provenance is suggested both by the inscription on the painting —"Th. Robinson, Paris / 1887"—and by the knob on the side of the piano, a characteristic feature of European instruments.

260 Caroline Goldthorpe, The Costume Institute, Metropolitan Museum, 1991, provided information on the sitter's costume.

261 For discussions of the piano's importance in America, see Carson, *Polite Americans*, pp. 155–65; and also Arthur Loesser, *Men, Women, and Pianos: A Social History* (New York, 1954), pp. 476–518.

262 Elisabeth Donahy Garrett, *At Home: The American Family, 1750–1870* (New York, 1990), p. 52.

263 J. W. Chickering, "Music in the Home," *Outlook* 50 (July 28, 1894), p. 138.

264 See Braden, *Leisure and Entertainment in America*, p. 115; and Kenneth L. Ames, *Death in the Dining Room and Other Tales of Victorian Culture* (Philadelphia, 1992), pp. 150–84.

265 For a discussion of this theme, see Pisano, *Idle Hours*, pp. 15–22.

266 Theodore Robinson, Diaries, Feb. 23, 1893, Frick Art Reference Library, New York.

267 For an in-depth account of this picture and its history, see Andrew McLaren Young, Margaret MacDonald, and Robin Spencer, *The Paintings of James McNeill Whistler*, 2 vols. (New Haven, 1980), vol. 1, pp. 8–9, no. 24.

268 John Spargo, "George Luks: An American Painter of Great Originality and Force, Whose Art Relates to All the Experiences and Interests of Life," *Craftsman* 12 (Sept. 1907), ill. p. 603.

269 Ibid., p. 602.

270 For a discussion of the barrel organ and its street version, see Arthur W. J. G. Ord-Hume, *Barrel Organ: The Story of the Mechanical Organ and Its Repair* (South Brunswick, N.J., and New York, 1978), especially pp. 233–53.

271 Rev. Hugh Reginald Haweis, *Music and Morals* (New York, 1872), p. 461. A later edition is quoted in Ord-Hume, *Barrel Organ*, pp. 246–47.

272 See Francis C. Woodworth, "The Hand-Organ: A Dialogue Between Theodore and His Friend Henry," in *The Holiday Book; with Illustrations* (New York, 1856), pp. 88–90.

273 For a discussion of this type of dancing and the locales in which it was practiced, see Kathy Peiss, *Cheap Amusements: Working Women and Leisure in Turn-of-the-Century New York* (Philadelphia, 1986), pp. 100–101. We are grateful to Marianne Doezema for directing our attention to this informative discussion of spieling.

274 Ibid., p. 101.

275 Ibid.

276 Julian Ralph, "Coney Island," *Scribner's Magazine* 20 (July 1896), p. 18, quoted in Peiss, *Cheap Amusements*, pp. 100–101. Unfortunately, the illustrations for this article, drawn by Henry McCarter, do not include one that represents spieling.

277 John Cournos, "Three Painters of the New York School," *International Studio* 56 (Oct. 1915), p.241.

THE PAINTERS

CECILIA BEAUX
1855–1942

Cecilia Beaux, n.d.

Born in Philadelphia to a genteel family; her mother died soon after her birth and her father returned to his native France, leaving Beaux and her older sister to be raised by their maternal grandmother and aunts. Educated at home, received drawing lessons from her aunt. Attended the Lyman School for Girls, Philadelphia. Took art lessons from Catherine Ann Drinker, a distant relative and painter of historical and biblical subjects. Began studying in 1872 or 1873 with Adolf Van der Whelen, a Dutch artist who worked in Philadelphia. Tried to become financially independent in the 1870s by teaching drawing at a local girls' school, executing lithographs and painting children's portraits on porcelain plates. Enrolled at the Pennsylvania Academy of the Fine Arts, Philadelphia, from 1877 to 1879 but, in order to conform to family's sense of propriety, did not take life classes with Thomas Eakins. Studied from 1881 to 1883 with William Sartain. Showed often at the Pennsylvania Academy and received important prizes there. In 1887 made debut in the Paris Salon. Went to Paris chaperoned by a cousin in 1888 and enrolled in the Académie Julian under Adolphe-William Bouguereau and Tony Robert-Fleury. Copied old masters at the Louvre. Spent the summer of 1888 with several American expatriates painting outdoors in Concarneau, Brittany; Switzerland; and Italy. Back in Paris continued at the Académie Julian and enrolled in the Atelier Colarossi under Pascal Adolphe Jean Dagnan-Bouveret and Gustave Courtois and studied privately under Jean Joseph Benjamin-Constant. Returned to the United States in August 1889 and settled in Philadelphia amid her supportive family. After 1892 spent more and more time in New York, where she joined the circle of Richard Watson Gilder, editor of the *Century*. Hired in 1895 as a teacher at the Pennsylvania Academy, a position she held until 1916. Gave biweekly critiques for a private painting class organized in New York by feminist Elizabeth Cady Stanton. In 1896, on second European trip, met Claude Monet in France and John Singer Sargent in England. Settled in New York about 1900; spent summers in Gloucester, Massachusetts, after 1905. Following World War I painted portraits of major international figures. During her final years was incapacitated by a poorly healed broken hip; became less productive as an artist and wrote her autobiography. Died in Gloucester at age eighty-seven.

Beaux, a respected painter with a wide reputation as a teacher, is perhaps best remembered for her portraits, which are distinguished by fluent paint application, rich color, and, occasionally, a dazzling chromatic palette and high key associated with Impressionism. At their finest these portraits transcend the fashionable society format popular at the turn of the century, merging the stylishness of portraits by Sargent with some of Eakins's psychological probing. Particularly in depictions of her beloved family, she achieved remarkable characterizations and risked unconventional compositions, sometimes setting her figures outdoors. LS

Bibliography Cecilia Beaux Papers, Archives of American Art, Smithsonian Institution, Washington, D.C. // Cecilia Beaux, *Background with Figures: Autobiography of Cecilia Beaux* (Boston, 1930) // Henry S. Drinker, *The Paintings and Drawings of Cecilia Beaux* (Philadelphia, 1955) // Frank H. Goodyear, *Cecilia Beaux: Portrait of an Artist* (exh. cat., Philadelphia: Pennsylvania Academy of the Fine Arts, 1974) // Tara L. Tappert, "Choices—the Life and Career of Cecilia Beaux: A Professional Biography" (Ph.D. diss., George Washington University, Washington, D.C., 1990).

GEORGE BELLOWS
1882–1925

Born in Columbus, Ohio; beginning in 1901 attended Ohio State University, Columbus, where he was an avid athlete and artist. In 1904 withdrew from college and went to New York, where he studied with Robert Henri at the New York School of Art (formerly the Chase School of Art and now the Parsons School of Design). Achieved early recognition through awards, sales, and his election to the National Academy of Design as an associate in 1909 and a full member in 1913. In 1910 was appointed life-class instructor at the Art Students League and married Emma Story, a pupil there. The following year was given his first one-man show, at Madison Gallery, New York. Also in 1911 visited Monhegan Island, Maine, spending the first of many summers in that state, where the uncompromising and powerful elements of nature inspired his bold land- and seascapes. Assisted with the installation of the Armory Show in New York in 1913. Impressed with the advanced European works shown there, sought a new order in his own paintings by utilizing dynamic symmetry and the compositional theory of Jay Hambidge, as well as the color system of Hardesty Maratta. Between 1913 and 1917 contributed drawings and served as art editor for the socialist magazine the *Masses*. In 1916 began to produce lithographs. Final years devoted to portraits of friends and family. Died suddenly at the age of forty-two.

George Bellows, n.d.

Bellows's art was distinguished by its direct reportorial style and provocative subject matter. A leading Realist of the first quarter of the twentieth century, he sought inspiration in the work of Thomas Eakins and Winslow Homer, painters who preceded the generation of genteel American Impressionists who held sway in his youth. Although he was not a member of The Eight, Bellows followed Henri's mandate to paint urban subjects, producing an impressive series of New York scenes from 1906 to 1913. His views of everyday life on the Lower East Side, the rivers that surround Manhattan, and the construction of Pennsylvania Station and his violent prizefight images are executed in a bold, direct, unprettified technique well suited to these gritty urban subjects. NMB

Bibliography Lauris Mason and Joan Ludman, *The Lithographs of George Bellows: A Catalogue Raisonné* (Millwood, N.Y., 1977) // E. A. Carmean, Jr., et al., *Bellows: The Boxing Pictures* (exh. cat., Washington, D.C.: National Gallery of Art, 1982) // Linda Ayers and Jane Myers, *George Bellows: The Artist and His Lithographs* (exh. cat., Fort Worth: Amon Carter Museum, 1988) // Marianne Doezema, *George Bellows and Urban America* (New Haven, 1992) // Michael Quick et al., *The Paintings of George Bellows* (exh. cat., Fort Worth: Amon Carter Museum; Los Angeles: Los Angeles County Museum of Art, 1992).

FRANK W. BENSON
1862–1951

Born in Salem, Massachusetts, to a distinguished family; his father was a successful cotton merchant. Studied from 1880 to 1883 at the School of the Museum of Fine Arts, Boston, under Otto Grundmann and Frederic Crowninshield. Abroad from 1883 to 1885, continued studies at the Académie Julian, Paris, under Gustave-Rodolphe Boulanger and Jules-Joseph Lefebvre. After a summer at Concarneau, Brittany, and a brief period of residence in London, came home to America in spring 1885. Taught at the Portland School of Art in Maine, probably in 1887 and 1888. Settled with his wife, whom he married in 1888, in Salem and commuted to Boston, where he maintained a studio until 1944. Taught

Frank Benson painting his family, Newcastle, New Hampshire, ca. 1893

on staff at the School of the Museum of Fine Arts, Boston, where Edmund C. Tarbell was a close colleague, from 1889 until 1912 and as a visiting instructor until 1917. Summered in Newcastle, New Hampshire, from 1893 to 1899 and North Haven, Maine, after 1901. In 1896 received commission for a mural cycle of the Three Graces and the Four Seasons for the Library of Congress. Was a founding member of the Ten American Painters in 1897.

A leading exponent of Boston Impressionism, Benson enjoyed a long and successful career. He is often associated with his friend Tarbell, but unlike the Boston painters described by Sadakichi Hartmann in 1897 as "Tarbellites,"[1] Benson shaped a strong individual artistic identity. He balanced academic standards with the progressive ideas of Impressionism, creating memorable scenes of his wife and children posed outdoors in sun-filled, brightly colored landscapes and in elegant interiors. TT

Bibliography John Wilmerding, Sheila Dugan, and William H. Gerdts, *Frank W. Benson: The Impressionist Years* (exh. cat., New York: Spanierman Gallery, 1988) // Faith Andrews Bedford, Susan C. Faxon, and Bruce W. Chambers, *Frank W. Benson: A Retrospective* (exh. cat., New York: Berry-Hill Galleries, Inc., 1989).

[1] Sadakichi Hartmann, "The Tarbellites," *Art News* 1 (Mar. 1897), pp. 3–4.

JOHN LESLIE BRECK
1860–1899

Born at sea near the Pacific island of Guam, the son of a Massachusetts navy captain; lived in San Francisco until his father's death in 1865, when his mother moved the family to Boston. Family's affluence permitted Breck to pursue his art free from financial constraints. In 1877 began three years of study at the Royal Academy, Munich, under Alexander Straehuber. Continued training in 1881 with Charles Verlat in Antwerp. Lived in the United States from 1882 to 1886. Spent 1886 to 1890 abroad. Studied at the Académie Julian, Paris, under Gustave-Rodolphe Boulanger and Jules-Joseph Lefebvre. Worked in Giverny beginning in 1887 and became close to Claude Monet and his family. Showed two paintings in the 1889 Exposition Universelle, Paris, for which he was awarded honorable mention. Returned to Boston in 1890. Was given a large exhibition at the St. Botolph Club, Boston, of which he became a member in 1890. Most of the paintings shown were landscapes executed in Giverny or on the North Shore of Massachusetts. In 1891 went back to Giverny, where he followed Monet's example and began to experiment with serial painting. Worked in the English countryside at Kent in 1891–92. Had important Boston exhibitions in 1893 and 1895. Settled in suburban Auburndale, Massachusetts, about 1896. Traveled to Venice in 1896 but returned to America by 1898. Suffered accidental death in Boston.

Breck made a dramatic debut as an Impressionist landscape painter in 1890 with the exhibition of his

Joseph Rodefer DeCamp. *John Leslie Breck*, 1892. Oil on canvas, 22 x 18 in. (55.9 x 45.7 cm). St. Botolph Club, Boston

Giverny paintings at the St. Botolph Club. "Artistic Boston was nearly pushed off its critical equilibrium," as one newspaper writer put it.[1] Among the first Americans to visit Giverny, Breck was unmistakably influenced by Monet, particularly in his serial paintings of grain stacks. In America Breck applied the Impressionist approach to New England subjects—stretches of the Charles River near Boston, the rugged coastal scenery of the Massachusetts North Shore, and the mountainous terrain of New Hampshire—and revealed in his paintings an acute sensitivity to season, time of day, and weather conditions. NMB

Bibliography Kathryn Corbin, "John Leslie Breck, American Impressionist," *Antiques* 134 (Nov. 1988), pp. 1142–49.

[1] D. W. X., "Mr. John L. Breck's Landscapes," *Boston Daily Globe*, Jan. 25, 1893, p. 10.

DENNIS MILLER BUNKER
1861–1890

Born in New York, where his father was the secretary-treasurer of the Union Ferry Company; a descendant of Nantucket, Massachusetts, Quakers. Grew up in Garden City, Long Island. Worked in New York from 1876 to 1879 at the National Academy of Design under Lemuel E. Wilmarth and from 1877 to 1882 at the Art Students League under William Merritt Chase. From 1881 to 1882 worked again at the National Academy and studied landscape painting with independent teacher Charles Melville Dewey. Among Bunker's earliest paintings are Nantucket views from the summers of 1881 and 1882. Went to Paris in 1882 and began to study at the Ecole des Beaux-Arts, first with Antoine Auguste Ernest Hébert and then with Jean-Léon Gérôme, matriculating in the spring 1884 semester. Spent the summer months traveling in the French countryside with painters Charles Adams Platt and Kenneth R. Cranford. Returned to the United States in 1885 and accepted a position as an instructor at the Cowles Art School, Boston. His students included Lilla Cabot Perry, later a devoted admirer of Claude Monet's and promoter of French and American Impressionism, and William MacGregor Paxton. Was awarded

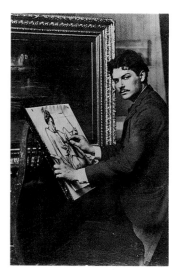

Dennis Miller Bunker in his studio, n.d.

the Hallgarten Prize for figural work for his entries at the National Academy's 1885 annual exhibition. That same year was given a one-man exhibition, predominantly of portraits and landscapes, at Boston's Noyes and Blakeslee Gallery and was elected a member of the Society of American Artists. Mingled with the cultural and intellectual elite of Boston, including Isabella Stewart Gardner, who helped him obtain portrait commissions from her friends and family. From 1886 to 1890 left Boston each summer to paint landscapes at locations that included South Woodstock, Connecticut; Newburyport, Massachusetts; Medfield, Massachusetts; and Windsor, Vermont. Turning point in Bunker's approach to landscape came in 1888 during summer spent with John Singer Sargent in Calcot Mill, near Reading, England. Finding Boston socially and intellectually confining, took a studio in New York in 1889. Received few portrait commissions there and painted idealized figure studies. In 1890 married Eleanor Hardy, a wealthy Bostonian. Worked on mural designs for the Whitelaw Reid house in New York as well as a number of portraits of his bride. Died suddenly during a trip to Boston.

In his brief career, which lasted only a decade, Bunker produced paintings remarkable for their quality and variety of subjects—society portraits, idealized figures, still lifes, and some of the earliest and most beautiful American Impressionist landscapes. At heart a bohemian—an outlook quite inconsistent with his Quaker roots—Bunker longed to dedicate himself completely to his art—free

even from the distraction of teaching. His summer landscape paintings, which show the influence of Abbott H. Thayer and Sargent, culminated in views painted in Medfield during the last two years of his life. The freely brushed and richly colored views of meadows and streams in Medfield attest to Bunker's assimilation of the Impressionist aesthetic and reveal a personality deeply attuned to beauty even in unspectacular aspects of nature. NMB

Bibliography Robert Hale Ives Gammell, *Dennis Miller Bunker* (New York, 1953) // Theodore Stebbins and Charles B. Ferguson, *Dennis Miller Bunker (1861–1890): Rediscovered* (exh. cat., New Britain, Conn.: New Britain Museum of Art, 1978).

MARY CASSATT
1844–1926

Born in Allegheny City (now part of Pittsburgh), Pennsylvania, and grew up in Philadelphia, the daughter of an affluent investment banker. Educated at home and exposed to European life and culture at an early age: lived for five years in France and Germany as a child. Returned to the United States in 1855. Between 1860 and 1865 studied sporadically at the Pennsylvania Academy of the Fine Arts, Philadelphia, and with Christian Schussele and Peter Rothermel. Arrived in Paris in 1866 and applied for a permit to copy at the Louvre. Studied privately with Jean-Léon Gérôme and took classes with Charles Chaplin. Toured the French countryside in 1866, stopping at the villages of Courances, Ecouen, and Villiers-le-Bel, where she received advice from Thomas Couture. Outbreak of the Franco-Prussian War forced her to return to Philadelphia in 1870. Traveled to Europe again in 1871 with a commission to copy Correggios in Parma; remained abroad thereafter, briefly visiting the United States in 1898 and 1908. Toured in Italy, Spain, Belgium, Holland, and France; finally settled in Paris in 1875. Having shown in the Salon since 1868, made her debut with the Société Anonyme, or Impressionists, as they were dubbed by the press, in 1879; however, was aware of their work, especially that of Edgar Degas and Camille Pissarro, long before this. Lent considerable

time and energy to organizing annual Impressionist exhibitions and contributed pictures to them in 1879, 1880, 1881, and 1886. Following the last Impressionist group exhibition in 1886 found new ways to display and sell her work, notably through the Parisian dealer Paul Durand-Ruel, with whom she had her first solo shows in 1893. Printmaking became a central preoccupation in the 1890s; in her work in this medium the influence of Japanese prints is particularly apparent. Received commission to paint a mural (now lost) for the Woman's Building of the Chicago world's fair of 1893. Also in 1893 acquired Château de Beaufresne, in a village outside Paris, where she spent much of her time in later years. Deteriorating eyesight ended her career in 1913. Died at Château de Beaufresne.

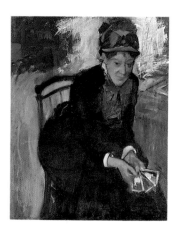

Edgar Degas. *Mary Cassatt*, ca. 1880–84. Oil on canvas, 28⅛ x 23⅛ in. (71.4 x 58.7 cm). National Portrait Gallery, Washington, D.C., Gift of the Morris and Gwendolyn Cafritz Foundation and the Regents' Major Acquisitions Fund, Smithsonian Institution NPG 84.34

Cassatt's place in the history of American art is unique. She was one of the few women artists to succeed professionally in her era as well as the only American invited to exhibit with the French Impressionists. At the Salon of 1874 her work caught the attention of Degas, the unofficial organizer of the Impressionists' exhibitions, who is said to have exclaimed, "Voilà! There is someone who feels as I do."[1] She embraced both the technique of the Impressionists and their commitment to painting scenes of everyday life. Using her family and friends as models, she produced a series of remarkable oils, pastels, and prints

depicting the lives of upper-middle-class women in Paris in the last two decades of the nineteenth century. Now best known for her treatment of the mother-and-child theme, which dominated her art after 1893, Cassatt actually explored a much wider range of modern subjects in her early work, painting a number of scenes of public life in Paris.

Despite her decision to live abroad, she played a significant role at home by exhibiting in the United States and advising important collectors. She had ties, both through her family and her work, to many wealthy American art patrons, among them her brother Alexander; Louisine and H. O. Havemeyer; John G. Johnson; Alfred Atmore Pope and his wife, Ada; and Berthe Honoré Palmer. "I am an American, simply and frankly an American," she told her French biographer in 1913.[2] KR

Bibliography Frederick A. Sweet, *Miss Mary Cassatt, Impressionism from Pennsylvania* (Norman, Okla., 1966) // Adelyn D. Breeskin, *Mary Cassatt: A Catalogue Raisonné of the Oils, Pastels, Watercolors, and Drawings* (Washington, D.C., 1970) // Nancy Hale, *Mary Cassatt* (New York, 1975) // Adelyn D. Breeskin, *Mary Cassatt: A Catalogue Raisonné of the Graphic Work,* 2d ed., rev. (Washington, D.C., 1979) // Nancy Mowll Mathews, ed., *Cassatt and Her Circle, Selected Letters* (New York, 1984) // Suzanne G. Lindsay, *Mary Cassatt and Philadelphia* (exh. cat., Philadelphia: Philadelphia Museum of Art, 1985) // Nancy Mowll Mathews, *Mary Cassatt* (New York, 1987).

[1] Quoted in Mathews, *Mary Cassatt,* pp. 29–30.

[2] Achille Segard, *Mary Cassatt: Un Peintre des enfants et des mères* (Paris, 1913), p. 9.

WILLIAM MERRITT CHASE
1849–1916

Born in Williamsburg (now Nineveh), Indiana; in 1861 moved with family to Indianapolis, where he studied with Barton S. Hays. Went to New York in 1869 to work at the National Academy of Design under Lemuel E. Wilmarth for two years, until his father could no longer support him. Joined his family in St. Louis but left for Munich in 1872, when local art

William Merritt Chase in His Tenth Street Studio, Mimicking the Pose of His Wife in the Pastel Meditation *(Private Collection) Hanging Behind Him,* ca. 1895. Gelatin silver print. The Parrish Art Museum, Southampton, New York, William Merritt Chase Archives, Gift of Jackson Chase Storm

patrons offered to finance his study abroad. Painted at the Royal Academy, Munich, from 1872 to 1878 under Alexander von Wagner and then Karl Theodor von Piloty and was influenced by the German realist Wilhelm Leibl. Traveled to Venice with fellow students Frank Duveneck and John H. Twachtman in 1877. Returned to New York in 1878 to begin brilliant teaching career, first at the Art Students League and subsequently at the Brooklyn Art School, the School of The Art Institute of Chicago, the Pennsylvania Academy of the Fine Arts, Philadelphia, and the Chase School of Art (later the New York School of Art and today the Parsons School of Design), as well as privately at his studio. Conducted important classes outdoors on Long Island at his Shinnecock Hills Summer School of Art from 1891 to 1902. Took groups of students to Europe annually from 1903 to 1913. Was a leader of progressive art organizations, such as the Society of American Artists and the Society of Painters in Pastel, and, after Twachtman's death in 1902, a regular participant in the annual shows of Ten American Painters. Exhibited widely to great acclaim. Died in New York.

Chase's reputation was built upon multiple roles—tastemaker, teacher, and painter. His famous, lavishly decorated studio and the aesthetic personal appearance he contrived presented a worldly and cultured image to patrons, who not only commissioned works but also were influenced by his taste and his own collecting habits. Arguably the most important American teacher of his generation, Chase emphasized technique, particularly the mastery of brushwork and use of color. Many of his students simply emulated his Impressionist style, but he also taught Rockwell Kent and Charles Webster Hawthorne, as well as early exponents of abstraction, such as Joseph Stella and Georgia O'Keeffe. In his own work Chase explored a wide range of subjects and responded to many international art currents. Two principal styles are discernible in his painting: a somber realism, reserved for portraits, interior scenes, and still lifes, and a brilliant Impressionism, used for landscapes and outdoor genre scenes. Chase was among the first Americans to practice plein air painting and, in the mid-1880s, was the first to apply French innovations to scenes of urban life, principally set in New York's parks. In Chase's Shinnecock landscapes he transformed unpicturesque topography into expressions of dazzling beauty, replete with effects of brilliant sunlight and vivid color. NMB

Bibliography William Merritt Chase Papers, Archives of American Art, Smithsonian Institution, Washington, D.C. // Katharine M. Roof, *The Life and Art of William Merritt Chase* (New York, 1917) // Ronald G. Pisano, *The Students of William Merritt Chase* (exh. cat., Huntington, N.Y.: Heckscher Museum; Southampton, N.Y.: Parrish Art Museum, 1973) // Ronald G. Pisano, *William Merritt Chase* (New York, 1979) // Ronald G. Pisano, *William Merritt Chase in the Company of Friends* (exh. cat., Southampton, N.Y.: Parrish Art Museum, 1979) // Ronald G. Pisano, *A Leading Spirit in American Art: William Merritt Chase, 1849–1916* (exh. cat., Seattle: Henry Art Gallery, University of Washington, 1983) // D. Scott Atkinson and Nicolai Cikovsky, Jr., *William Merritt Chase: Summers at Shinnecock, 1891–1902* (exh. cat., Washington, D.C.: National Gallery of Art, 1987).

WILLIAM GLACKENS
1870–1938

Born in Philadelphia, where his father was a railroad employee. Took a job as an artist-reporter at the *Philadelphia Record* in 1891 and a year later joined the *Philadelphia Press,* working with John Sloan, George Luks, and Everett Shinn. Attended evening painting classes at the Pennsylvania Academy of the Fine Arts, Philadelphia, where his instructor was Thomas Anshutz. In June 1895 embarked on a fifteen-month stay in Paris, where he often saw Robert Henri, a friend from Philadelphia, and Canadian artist James Wilson Morrice. Traveled in Belgium and Holland, studying paintings by Rembrandt and Hals, and in northern France. Returned briefly to Philadelphia in fall 1896 but soon moved to New York; here he shared a studio with Luks and executed illustrations for the *New York World* and later the *New York Herald.* In 1898, as a special correspondent for *McClure's Magazine,* drew scenes of the Spanish-American War. Married Edith Dimock, an art student and the daughter of a wealthy Hartford silk manufacturer, in 1904, achieving financial security that permitted frequent travel to Europe and provided support for his painting. In 1906 went to Spain, where he viewed works by Goya and Velázquez, and to Paris. Participated in the exhibition of The Eight at the Macbeth Galleries, New York, in 1908. Spent summers in

Gertrude Käsebier. *William Glackens,* 1907. Platinum print, 8⅛ x 6¼ in. (20.6 x 15.9 cm). Delaware Art Museum, Wilmington, Gift of Helen Farr Sloan 78-589.14

Bellport, Long Island, each year from 1911 to 1914. Returned to Paris in 1912 with Alfred Maurer to buy pictures for collector and former schoolmate Albert C. Barnes. Served as chairman of the Domestic Committee for the New York Armory Show of 1913. Summered in New London, Connecticut, in 1918 and Gloucester, Massachusetts, in 1919. Resided in Paris from 1925 to 1927, during which time he also traveled to London and to Vence in the south of France. Died in Connecticut.

Glackens shared with most of his fellow New York Realists early training as an illustrator, which equipped him to represent with objectivity and economy the drama and humanity of urban life. Through Henri, Glackens was drawn to the works of Edouard Manet; he emulated these French models in a number of café scenes but gave them an American inflection. However, more than the others in Henri's circle he adopted the cheerful outlook of such French Impressionists as Pierre-Auguste Renoir and Claude Monet and, particularly after about 1908, increasingly employed Renoir's high-key palette and feathery brushwork. As a result, in some respects Glackens's work more closely recalls the sunny art of the American Impressionists than the tougher pictures of his American Realist colleagues. VJR

Bibliography William J. Glackens, "The American Section: The National Art; an Interview with the Chairman of the Domestic Committee, Wm. J. Glackens," *Arts and Decoration* 3 (Mar. 1913), pp. 159–64 // Ira Glackens, *William Glackens and the Ashcan Group: The Emergence of Realism in American Art* (New York, 1957; rev. ed., New York, 1983, with the title *William Glackens and The Eight*) // Richard J. Wattenmaker, "William Glackens's Beach Scenes at Bellport," *Smithsonian Studies in American Art* 2 (Spring 1988), pp. 75–94 // *William Glackens: The Formative Years* (exh. cat., New York: Kraushaar Galleries, 1991).

CHILDE HASSAM
1859–1935

Born in Dorchester (now part of Boston), Massachusetts, the son of a wealthy merchant. Took drawing instruction from Walter Smith. Went to work for the publisher Little, Brown and Company as a bookkeeper in 1876, but soon left to design and cut woodblocks for Boston engraver George E. Johnston. In 1877–78 studied at the Boston Art Club and the Lowell Institute, Boston, and, beginning about 1879, attended a painting class taught by Munich-trained Ignaz Marcel Gaugengigl. Established a studio in Boston in the early 1880s and supported himself by doing illustrations for *Scribner's Monthly*, *Harper's New Monthly Magazine*, and the *Century*. Influenced by Boston Art Club landscape artists, painted outdoor views of Boston and its inhabitants. Traveled in Great Britain and on the Continent with fellow painter Edmund H. Garrett in 1883. In Paris from 1886 to 1889; studied at the Académie Julian under Jules-Joseph Lefebvre, Henri-Lucien Doucet, and Gustave-Rodolphe Boulanger. Worked independently in a studio in a fashionable area near place Pigalle and by 1887 produced canvases that respond to contemporary paintings by the Impressionists. After return to the United States, stayed briefly in Boston and then settled in New York, where John H. Twachtman and J. Alden Weir became close friends and professional colleagues. From the mid-1880s through 1916 summered at resorts popular with artists, such as Appledore Island, in the Isles of Shoals, off the New Hampshire coast; Gloucester, Massachusetts; and Cos Cob, Connecticut, which offered subjects for his pictures. Went to Europe for a year beginning late in 1896, visiting Italy, France, and England. Helped organize the Ten American Painters in 1897. Began to frequent other Connecticut retreats, most notably Old Lyme, in 1903. Extensive travels continued: to the West Coast a number of times, beginning in 1908, and Europe again in 1910. From 1916 through 1919 demonstrated the continued viability of the Impressionist style in a series of flag pictures that express his love of New York and his country. Began extensive printmaking in the 1920s. During the 1920s and 1930s divided his time between New York and East Hampton, Long Island, where he died.

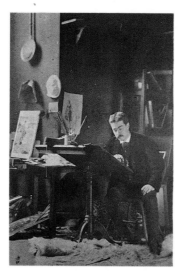

Childe Hassam in his studio, ca. 1890. Boston Public Library, Print Department, Gift of Charles Childs

Hassam worked in a style close to that of the French Impressionists, although he acknowledged only the influence of English painters John Constable and J. M. W. Turner. Hassam's first Impressionist canvases, painted in Paris in the late 1880s, are restrained: his outlines are crisp and his brushwork is broken yet delicate and tightly controlled. By the 1890s, when New York became the subject of his urban views, he employed roughened paint surfaces, a light palette, and innovative compositional elements he had observed in paintings by Camille Pissarro and Claude Monet. Hassam concentrated on recording, as if for an impressionistic social history, the pleasant aspects of New York, which he considered to be the most beautiful of all cities. He also explored his own New England heritage in landscapes and views of churches, always celebrating the positiveness of the American spirit. VJR

Bibliography Childe Hassam Papers, Correspondence, and Newspaper Clippings, 1883–1936, Archives of American Art, Smithsonian Institution, Washington, D.C. // A. E. Ives, "Talks with Artists: Mr. Childe Hassam on Painting Street Scenes," *Art Amateur* 27 (Oct. 1892), pp. 116–17 // Childe Hassam, "Twenty-five Years of American Painting," *Art News*, supplement 26 (Apr. 14, 1928), pp. 22, 27–28 // Adeline Adams, *Childe Hassam* (New York, 1938) // Donelson F. Hoopes, *Childe Hassam* (New York, 1979) // Jennifer A. Martin Bienenstock, "Childe Hassam's Early Boston Cityscapes," *Arts Magazine* 55 (Nov. 1980), pp. 168–

71 // Kathleen Burnside, *Childe Hassam in Connecticut* (exh. cat., Old Lyme, Connecticut: Florence Griswold Museum, 1988) // Ilene Susan Fort, *The Flag Paintings of Childe Hassam* (exh. cat., Los Angeles: Los Angeles County Museum of Art, 1988) // David Park Curry, *Childe Hassam: An Island Garden Revisited* (exh. cat., Denver: Denver Art Museum, 1990).

CHARLES WEBSTER
HAWTHORNE
1872–1930

Born in Lodi, Illinois, but raised in Richmond, Maine, where his father was a ship's captain. Settled about 1890 in New York, working on the docks and then in a stained-glass factory. Studied at the Art Students League from 1893 to 1895 with Frank Vincent Du Mond, George de Forest Brush, and H. Siddons Mowbray. Attended William Merritt Chase's outdoor class at the Shinnecock Hills Summer School of Art in 1896 and served as the school's secretary and treasurer the following summer. Helped found and manage the Chase School of Art (later the New York School of Art and today the Parsons School of Design). Traveled in 1898 to Holland and was impressed by the work of Hals there. Established the Cape Cod School of Art in Provincetown, Massachusetts, where he taught every summer from 1899 to 1930, except 1907 and 1929, when he was abroad. Resided in New York during the winters but traveled widely.

Hawthorne's reputation is based on sensitive genre studies of New Englanders, hardworking people of humble origins involved in the fishing industry. He endowed his models with dignity and monumentality, revealing their complex personalities and strong characters. "One of the greatest things in the world is to train ourselves to see beauty in the commonplace," he explained to his students.[1] Drawing upon his studies with Chase and his great admiration for Hals, he worked in a dark, rich palette, employing powerful brushwork and sometimes using a palette knife to create simplified forms. Throughout his long teaching career Hawthorne encouraged his students to pursue individualistic styles and to embrace contemporary subject matter. His school closed after his death,

but his presence had helped establish Provincetown as an artistic center. His paintings fulfill his artistic goal: "to express something about the humanity of my time that will live."[2] TT

Bibliography Carl Murchison, *Charles W. Hawthorne, 1872–1930* exh. cat., Provincetown, Mass.: Provincetown Art Association, 1952) // Charles W. Hawthorne, *Hawthorne on Painting: From Students' Notes Collected by Mrs. Charles W. Hawthorne* (New York, 1938; reprint, New York, 1960) // Elizabeth McCausland, *Charles W. Hawthorne: An American Figure Painter* (New York, 1947) // Edgar P. Richardson, *Hawthorne Retrospective* (exh. cat., Provincetown, Mass.: Chrysler Art Museum, 1961) // Marvin S. Sadik, *The Paintings of Charles W. Hawthorne* (exh. cat., Storrs, Conn.: University of Connecticut Museum of Art, 1968) // Janet Altic Flint, *Charles W. Hawthorne: The Late Watercolors* (exh. cat., Washington, D.C.: National Museum of American Art, Smithsonian Institution, 1983).

[1] Hawthorne, *Hawthorne on Painting*, p. 10.
[2] Charles W. Hawthorne, Letter to William Macbeth, Feb. 20, 1914, Macbeth Galleries Papers, Archives of American Art, Smithsonian Institution (microfilm, reel NMc7, frame 565).

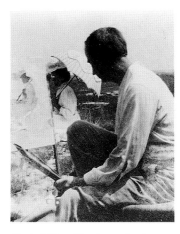

Charles Webster Hawthorne, Provincetown, Massachusetts, n.d.

ROBERT HENRI
1865–1929

Born Robert Henry Cozad in Cincinnati. Father was a riverboat gambler turned real-estate speculator, who moved the family west to the town of Cozad, Nebraska, which he founded. When his father killed a workman in a dispute, the family fled, changed names, and lived thereafter under assumed identities. In 1886 Henri left home in Atlantic City, New Jersey, to begin schooling at the Pennsylvania Academy of the Fine Arts, Philadelphia, with Thomas Anshutz. Sailed for Europe in 1888 and settled in Paris, where he worked with Adolphe-William Bouguereau and Tony Robert-Fleury at the Académie Julian. After several unsuccessful attempts, matriculated in the Ecole des Beaux-Arts for one semester in 1891 but chafed at the rigors of academic study. In 1889 and 1890 traveled to popular sketching locales and to see works by the old masters. Departed for home in September 1891 and by January 1892 resumed study at the Pennsylvania Academy, with Robert Vonnoh. During the 1890s became the leader of a circle of independent artists and art students, several of whom later reunited with him in New York to form the nucleus of The Eight. In 1892 began his long and distinguished teaching career, when he took a post at the Philadelphia School of Design for Women.

From 1886 to 1900 traveled often to Paris and other European locations. By 1900, when he and his wife moved to New York after two years in Paris, was an established artist and instructor. In New York taught at the Chase School of Art (later the New York School of Art and today the Parsons School of Design) from 1902 until 1909, presided over the Henri School of Art from 1909 until 1912, and taught at the Modern School of the Ferrer Society from 1911 until 1916 and the Art Students League from 1912 until 1928. Elected an associate of the National Academy of Design in 1905 and a full academician the following year. Served on National Academy exhibition juries but, frustrated by that institution's conservative stance, planned shows outside it. Went often to sites popular with artists on Monhegan Island, Maine, in Santa Fe, and San Diego; also spent time in Spain and later, with his second wife, an Irish-American, in Ireland.

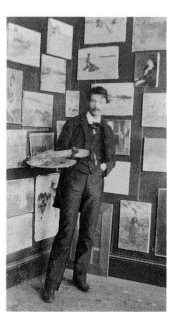

Robert Henri in his Philadelphia studio, ca. 1894

Henri's reputation rests as much on his efforts as a teacher and anti-establishment rebel as on his artistic achievements. He taught Realists George Bellows, Edward Hopper, Rockwell Kent, and William Gropper, as well as modernists Patrick Henry Bruce, Randall Davey, Andrew Dasburg, Morgan Russell, Man Ray, Yasuo Kuniyoshi, and Stuart Davis. Clearly, his teaching opened the door for his students to pursue directions that he did not choose for himself. Henri energized and inspired the Ashcan School and in 1908 helped bring about the landmark show of The Eight at the Macbeth Galleries, New York, that challenged the hegemony of the National Academy. In 1910 he was an organizer of the *Exhibition of Independent Artists* in New York. After the Armory Show of 1913 Henri's work was esteemed mainly by conservative American artists and critics who resisted European-inspired modernism, especially abstraction.

Committed to social issues, Henri advocated an art that was relevant to life. "Life and art cannot be disassociated," he said;[1] and he wrote, "Art when really understood is the province of every human being."[2] His work reflects these dicta as well as the legacy of the masters he revered—Rembrandt, Velázquez, Hals, Edouard Manet, James McNeill Whistler, and Thomas Eakins. AKN

Bibliography Robert Henri, Scrapbooks, Diaries, and Papers, Collection of Janet J. Le Clair, New York, microfilm, Archives of American Art, Smithsonian Institution, Washington, D.C. // Robert Henri, *The Art Spirit: Notes, Articles, Fragments of Letters and Talks to Students, Bearing on the Concept and Technique of Picture Making, the Study of Art Generally, and on Appreciation*, comp. Margery Ryerson (Philadelphia, 1923; reissued with an introduction by Forbes Watson, Philadelphia, 1930; reprint, New York, 1984) // William Innes Homer, *Robert Henri and His Circle* (Ithaca, N.Y., 1969; rev. ed., New York, 1988) // Bennard B. Perlman, *Robert Henri, Painter* (exh. cat., Wilmington: Delaware Art Museum, 1984) // Bennard B. Perlman, *Robert Henri: His Life and Art* (New York, 1991).

[1] Robert Henri quoted in Garnett McCoy, "Reaction and Revolution," *Art in America* 53 (Aug.–Sept. 1965), p. 68.
[2] Henri, *Art Spirit* (1984), p. 15.

ROCKWELL KENT
1882–1971

Born in Tarrytown, New York, to a genteel but impecunious family. About 1900 studied architecture at Columbia University, New York, and, during the summers, painted at Shinnecock Hills, Long Island, with William Merritt Chase. In 1904 enrolled at the New York School of Art (formerly the Chase School of Art and now the Parsons School of Design), where his instructors included Robert Henri and Kenneth Hayes Miller, and served as a studio assistant to painter Abbott H. Thayer in Dublin, New Hampshire. Worked as a draftsman for the architectural firm Ewing and Chappell, New York, sporadically from 1904 to 1913. First visited Monhegan Island, Maine, at Henri's suggestion in 1905; worked as a laborer there until 1910 and, inspired by Winslow Homer, painted scenes on the themes of winter, the sea, and fishermen. Exhibited Monhegan Island pictures at Clausen Galleries, New York, in 1907 to much acclaim. Two years later began to teach summer classes on Monhegan Island with Julius Golz. Traveled to Newfoundland in 1910 and lived there in 1914–15, until the Canadian government expelled him for his anti-war views. Visited remote unspoiled sites that became the subject matter

of much of his art and writing. Painted on Fox Island, Resurrection Bay, Alaska, in 1918–19. In 1920 moved to Vermont; published his first book, *Wilderness*; and, encouraged by print connoisseur Carl Zigrosser, began making wood engravings. Voyaged to Tierra del Fuego and the Strait of Magellan in 1922. From 1925 to 1928 toured in France and Ireland and lived in Glenlough, county Donegal, in 1926. Traveled to Greenland in 1928–29, 1931–32, and 1934–35. In 1927 in New York State's Adirondacks established Asgaard Farm, his principal residence for the remainder of his life.

Rockwell Kent. *Self-Portrait*, ca. 1905. Oil on canvas mounted on panel, 18 x 15 in. (45.7 x 38.1 cm). Plattsburgh Star Art Galleries, State University of New York, Gift of Sally Kent Gorton

Kent, who achieved recognition as a painter, printmaker, book designer, and writer, worked actively for almost sixty-five years, but only during the first two decades of the twentieth century did he maintain close ties to the American Impressionists and Realists. Joining his mentor Henri as an advocate for artist's causes, Kent took part in the *Exhibition of Independent Artists* in New York in 1910 and the following year organized an independent exhibition in which he called for participants to forgo showing at the National Academy of Design. Although Kent was a committed and outspoken socialist and political activist, he did not address the urban scene in his paintings. As Bruce Robertson has observed, "The poles of Kent's art were his passionate identifications with the North and with the working class. He ennobled hard labor and suffering in his art, identifying class struggle not with the urban proletariat

but with the honest peasant."[1] Kent's early paintings evince a great vitality and a deep appreciation of isolated landscape settings, but as early as 1909 his work is characterized by a somber mood, often conveyed through the treatment of figures. Over the next decade he developed an increasingly expressive style that relied on symbolic content and, responding to a new awareness of modernism, a reduction of detail. DB

Bibliography Rockwell Kent, *It's Me O Lord: The Autobiography of Rockwell Kent* (New York, 1955; reprint, New York, 1977) // Richard V. West, *Rockwell Kent: The Early Years* (exh. cat., Brunswick, Maine: Bowdoin College, Museum of Art, 1969) // David Traxel, *An American Saga: The Life and Times of Rockwell Kent* (New York, 1980) // Richard V. West, *"An Enkindled Eye": The Paintings of Rockwell Kent* (exh. cat., Santa Barbara: Santa Barbara Museum of Art, 1985) // Bruce Robertson, *Reckoning with Winslow Homer: His Late Paintings and Their Influence* (exh. cat., Cleveland: Cleveland Museum of Art, 1990), pp. 101–36.

[1] Robertson, *Reckoning with Winslow Homer*, p. 105.

ERNEST LAWSON
1873–1939

Born in Halifax, Nova Scotia, the son of a physician. Raised by relatives in Kingston, Ontario, from 1883 to 1888, when he rejoined his immediate family in Kansas City, Missouri. Worked for a textile designer and studied in 1888–89 at the Kansas City Art Institute. Was hired in 1890 as a draftsman for an engineering firm in Mexico City, where he attended evening classes at the Academia Nacional de San Carlos. Moved to New York in 1891 and continued studies at the Art Students League with John H. Twachtman and took a plein air class in Cos Cob, Connecticut, with Twachtman and J. Alden Weir in summer 1892. Lived in France from 1893 to 1896 except for a trip to Kansas City in 1894. Studied at the Académie Julian in Paris in 1893 with Jean-Paul Laurens and Jean Joseph Benjamin-Constant and met Impressionist Alfred Sisley at Moret-sur-Loing. Resided in various Canadian and United States cities until he settled in 1898 in Washington Heights,

William Glackens. *Portrait of Ernest Lawson* [1910], Oil on canvas, 30 x 25 in. (76.2 x 63.5 cm). National Academy of Design, New York

on the northern tip of Manhattan, the site of most of his painting activity for the next fifteen years. Through his friendship with William Glackens, joined forces with The Eight. Pictures were purchased by such major collectors as Albert C. Barnes, Duncan Phillips, and John Quinn. By the 1920s his work was regarded as *retardataire*. Suffered from alcoholism and rheumatoid arthritis, separated from his wife, and experienced financial problems. Traveled and taught widely in the United States and, beginning in 1931, made annual trips to Florida, where he remained after 1936. Worked productively until his death in Coral Gables, Florida.

A second-generation Impressionist whose style was inspired by Weir and Twachtman, Lawson departed from his mentors by boldly and consistently applying the Impressionist approach to modern urban scenes, principally the landscape in and around New York. His was an expressively heightened version of Impressionism, with distinctive, variegated colors that led one contemporary critic to dub him "Lawson, of the 'Crushed Jewels.'"[1] He was particularly fascinated by subjects that reflected the increasing urbanization of Manhattan. While a member of The Eight, Lawson maintained a career-long alliance with the National Academy of Design, moving comfortably in both progressive and conservative art circles. His paintings contain little social comment and often reflect a romantic idealization and nostalgia. By effectively reconciling an older style with new subject matter Lawson bridged the poles of American Impressionism and Realism. TT

Bibliography Guy Pène du Bois, *Ernest Lawson* (New York, 1932) // Henry Berry-Hill and Sidney Berry-Hill, *Ernest Lawson: American Impressionist, 1873–1939* (Leigh-on-Sea, Eng., 1968) // Adeline Lee Karpiscak, *Ernest Lawson, 1873–1939: A Retrospective Exhibition of His Paintings* (exh. cat., Tucson: University of Arizona, Museum of Art, 1979).

[1] F. Newlin Price, "Lawson, of the 'Crushed Jewels,'" *International Studio* 78 (Feb. 1924), p. 367.

GEORGE LUKS
1866–1933

The son of cultured and educated German immigrants, born in the lumber town of Williamsport, Pennsylvania. At age six moved to Shenandoah, Pennsylvania, where his parents actively supported miners' fight for better working conditions and higher wages. Studied briefly at the Pennsylvania Academy of the Fine Arts, Philadelphia, in 1883 but soon left to tour the country as a comedian. Departed in 1889 for Düsseldorf, where he enrolled at the National Art Academy and, during October of that year, at the Düsseldorf Academy. Visited museums and galleries in Paris and London. After return to the United States in 1890 or 1891, drew illustrations for the satirical magazines *Puck* and *Truth*. Traveled during the winter of 1892–93 in Spain, where he admired the work of Goya and Velázquez. Back in Philadelphia began work as an illustrator for the *Philadelphia Press* in 1894, when he took up painting in earnest.

Gertrude Käsebier. *George Luks*, 1907. Platinum print, 8⅛ x 6¼ in. (20.6 x 15.9 cm). Delaware Art Museum, Wilmington, Gift of Helen Farr Sloan 78-589.16

Formed close friendships with Robert Henri, John Sloan, William Glackens, and Everett Shinn, all of whom later constituted the nucleus of the Ashcan School in New York. Was an illustrator-reporter in Cuba in 1895 but was fired for drunkenness and tardiness. Settled in New York in 1896 and soon secured a job drawing illustrations, caricatures, and the weekly cartoon page known variously as "The Yellow Kid," "Hogan's Alley," and "McFadden's Flats" for the *New York World*. After a trip to Spain in 1902 settled in New York's Greenwich Village. Participated in a show organized by Henri at the National Arts Club, New York, in 1904 and the landmark exhibition of The Eight at the Macbeth Galleries, New York, in 1908. In 1912 moved to an apartment-studio in upper Manhattan near High Bridge Park, where the rocky landscape, railroad yard and tracks, bridges, and river became favored subjects. Taught in New York at the Art Students League from 1920 to 1924, when he opened his own school in this city. Visited Maine's Cape Elizabeth in 1922. Married three times; divorced twice. Died in New York from injuries sustained in a speakeasy fight.

A man of extreme contradictions, Luks was known to change quickly from barroom brawler to gentleman and back again. He immersed himself completely in the New York urban scene, which he painted with the same gusto and aggressively confrontational, direct approach he brought to his life. Early in his career he was influenced by the old masters, finding particular inspiration in the dramatic lighting of Rembrandt and the loose, painterly brushwork of Hals, as well as in the work of Edouard Manet. His sensitive portrayals of washerwomen, street urchins, and ordinary shopclerks were animated by his empathy with common people and his reporter's ability to observe and record. These feelings and talents are eminently visible in Luks's most successful representations of New York's street life and its ghetto dwellers, painted from 1900 to 1910. VJR

Bibliography John Spargo, "George Luks: An American Painter of Great Originality and Force, Whose Art Relates to All the Experiences and Interests of Life," *Craftsman* 12 (Sept. 1907), pp. 599–607 // "Luks Speaks Up," *Art Digest* 7 (Jan. 1933), pp. 12, 29 // "Everett Shinn on George Luks: An Unpublished Memoir," *Journal of the Archives of American Art* 6 (Apr. 1966), pp. 1–12 // *George Luks, 1866–1933: An Exhibition of Paintings and Drawings Dating from 1889 to 1931* (exh. cat., Utica, N.Y.: Munson-Williams-Proctor Institute, Museum of Art, 1973) // Stanley L. Cuba, Nina Kasanof, and Judith O'Toole, *George Luks: An American Artist* (exh. cat., Wilkes-Barre, Pa.: Sardoni Art Gallery, Wilkes College, 1987) // Bennard B. Perlman, "Drawing on Deadline," *Art and Antiques*, Oct. 1988, pp. 115–20.

ALFRED MAURER
1868–1932

Born in New York, to Louis Maurer, a German-born lithographer and carver who at one point studied painting with William Merritt Chase. Apprenticed in his father's lithography shop but by 1894 was moving in the direction of fine art. Took classes with Edgar Melville Ward privately and at the National Academy of Design, New York, from 1885 to 1888 and 1889 to 1896. In 1897 left New York to study art in Paris and, ultimately, to live there. Studied briefly at the Académie Julian, but there is no further record of his instruction. Showed at the Paris Salons of 1899 and 1900 and won recognition at home, participating in group exhibitions in Chicago, Philadelphia, and New York, including one at the Allen Gallery, New York, in 1901, organized by Robert Henri, whom he had met in Paris. In Paris in about 1904 was introduced to Gertrude and Leo Stein and exposed to the work of the French avant-garde, whose influence soon transformed his art so completely that it could no longer be shown compatibly with that of Henri and his associates. In 1909 his new paintings were paired with those of John Marin in a show at Alfred Stieglitz's gallery, 291, in New York; the following year he participated in a group show at the same gallery. He did not exhibit again in New York until 1913, when his works were included in the Armory Show. Returned to New York in 1914 to escape the war in Europe. Counted William Glackens and Arthur Dove among his closest friends. In 1919 was elected a director of the Society of Independent Artists, a coalition of anti-academics and modernists who came together in New York to show American art. Was given a one-man show at Weyhe Gallery, New York, in 1924. After nearly two decades of experimentation and little critical praise, committed suicide only a few weeks after the death of his more acclaimed hundred-year-old father.

Alfred Maurer. *Self-Portrait*, 1897. Oil on canvas, 28¾ x 21 in. (73 x 53.3 cm). Frederick R. Weisman Art Museum, University of Minnesota, Minneapolis, Gift of Ione and Hudson Walker 53.301

Maurer absorbed many influences, joining no school and working in a succession of idioms, moving from commercial lithography through painting in a Realist manner, finally inventing a personal style that proclaimed his affinity with the European avant-garde. In the 1920s he produced still lifes and a series of disturbing studies of women, shown alone or in pairs; most are heads, but some are full or half views, recognizable but distorted. Maurer was one of the first painters from the United States to appreciate European modernism and to translate it into an idiosyncratic, peculiarly American language. AKN

Bibliography Elizabeth McCausland, *A. H. Maurer* (New York, 1951) // Sheldon Reich, *Alfred H. Maurer, 1868–1932* (exh. cat., Washington, D.C.: National Collection of Fine Arts, Smithsonian Institution, 1973) // Dominic Madormo, "The Early Career of Alfred Maurer: Paintings of Popular Entertainments," *American Art Journal* 15 (Winter 1983), pp. 4–34.

WILLARD METCALF
1858–1925

Born in Lowell, Massachusetts, to working-class parents. Lived in various locations in Massachusetts until his family settled in Cambridgeport in that state in 1871. While apprenticed to a wood engraver at age sixteen, attended the Massachusetts Normal Art School, Boston. Apprenticed to painter George Loring Brown and attended the Lowell Institute in 1875. The next year enrolled in the School of the Museum of Fine Arts, Boston, where his instructor was Otto Grundmann. Earned enough money from work as an illustrator for *Harper's New Monthly Magazine* and proceeds from the auction of his work at the J. Eastman Chase Gallery, Boston, to finance a trip to Europe. Abroad from 1883 to the end of 1888, studied in Paris in 1883–84 at the Académie Julian under Gustave-Rodolphe Boulanger and Jules-Joseph Lefebvre and spent summers in the villages of Grez-sur-Loing and Giverny, where Claude Monet made his home. Traveled to North Africa in 1887. In 1889 returned to Boston, where he was given a solo exhibition at the St. Botolph Club. In 1890 moved to New York and supported himself by teaching at the Art Students League in 1891–92 and the Cooper Institute from 1891 to 1903 and with commissions for magazine illustrations. In 1897 was a founding member of the Ten American Painters. Suffered from alcoholism and experienced two failed marriages. Worked in a number of country retreats: Gloucester, Massachusetts, in 1895; Walpole, Maine, in winter 1903–4; Old Lyme, Connecticut, in 1903 and from 1905 to 1907; and Cornish, New Hampshire, from 1909 to 1911.

Willard Metcalf in his studio, ca. 1883–90

One of the first Americans to discover and paint in Giverny, Metcalf spent part of each year there from 1885 to 1888 and became an integral part of its artists' colony. The works he exhibited at the St. Botolph Club upon his return home were among the first glimpses the American public had of their own school of Impressionism. Critically and financially successful, Metcalf devoted his career to painting the New England landscape, demonstrating what at his death was hailed as "a masterly gift for drawing the portrait of a place."[1] His large-scale panoramic views of Vermont and New Hampshire, many done as late as the 1920s, are testimony to the enduring vitality of the Impressionist style. LS

Bibliography Willard Metcalf Papers, Archives of American Art, Smithsonian Institution, Washington, D.C. // Francis Murphy, *Willard Leroy Metcalf: A Retrospective* (exh. cat., Springfield, Mass.: Museum of Fine Arts, 1976) // Elizabeth de Veer and Richard J. Boyle, *Sunlight and Shadow: The Life and Art of Willard L. Metcalf* (New York, 1987).

[1] Clipping, *New York Tribune* [1925], Willard Metcalf Papers, Archives of American Art, (microfilm, reel N70/13, frame 544).

MAURICE PRENDERGAST
1858–1924

Born in St. John's, Newfoundland, to a shopkeeper, who moved the family to Boston in 1868. Left school after only eight or nine years. Worked for a firm that made display cards. Never married and throughout his life was accompanied and supported by his brother Charles, a gifted framemaker and artist. Visited England with Charles in 1886. Returned to Boston in 1887 and again designed display cards. By 1889 began to spend summers painting at various beach resorts. Remained in Boston from 1887 to 1891, a period in which he became a self-sufficient artist. Arrived in Paris in 1891 with Charles, who soon returned home; stayed until 1894. Enrolled at the Académie Julian and the Atelier Colarossi from 1891 to 1893. While in Paris his work began to reflect the Nabi, Symbolist, Whistlerian, Art Nouveau, and Japanesque influences that would coalesce into his distinctive style. Lived in Boston again from 1894 to 1898. Worked mostly in watercolor

Gertrude Käsebier. *Maurice Prendergast*, 1907–8. Platinum print, 8¾ x 6½ in. (22.2 x 16.5 cm). Delaware Art Museum, Wilmington, Gift of Helen Farr Sloan 78-589-18

and monotype and undertook commissions for book illustrations and poster designs. Made his gallery debut in 1895 at the Boston Art Club. Started to exhibit widely in Boston and New York during the late 1890s. Serious commitment to oil painting began after the turn of the century. With financial help from Boston artist and art patron Sarah Choate Sears, spent eighteen months in Italy in 1898–99. Thereafter divided his time between Boston and New York, until encouragement of friends in New York convinced him to relocate there in 1914. Introduced by William Glackens to Robert Henri, whose circle he joined. In 1904 showed at the National Arts Club, New York, with Henri, Glackens, George Luks, John Sloan, and Arthur B. Davies. Summered in Paris in 1907 and was profoundly affected by the work of Paul Cézanne and the Fauves. Participated in the show of The Eight at the Macbeth Galleries, New York, in 1908, and the *Exhibition of Independent Artists* in New York in 1910. The following year returned to Italy with Charles. In the United States in 1912 helped plan the Armory Show of 1913 in New York. After 1914 painted arcadian scenes in a classicized, monumental symbolist mode. Died in New York.

Despite the traditional view of Prendergast's career as a struggle against obscurity, it is now clear that he had always enjoyed some level of recognition and support. Although Prendergast achieved fame as a member of The Eight, his style is unlike that of any of his colleagues in that

group, incorporating impulses from European modernism—especially Fauvism—which had little effect upon the work of his confreres. Yet his commitment to subjects drawn from common experiences of modern life links him with his contemporaries among the American Impressionists and Realists. Perhaps even more than his associates, though, he transformed the mundane world of city parks and day-trip beaches into glorious feasts of movement, color, and pattern. AKN

Bibliography Van Wyck Brooks, "Anecdotes of Maurice Prendergast," in *The Prendergasts: Retrospective Exhibition of the Work of Maurice and Charles Prendergast* (exh. cat., Andover, Mass.: Addison Gallery of American Art, Phillips Academy, 1938) // Hamilton Basso, "A Glimpse of Heaven" (parts 1, 2) *New Yorker* 22 (July 27, 1946), pp. 24–28, 30; (Aug. 3, 1946), pp. 28–32, 34, 36, 37 // Eleanor Gavin, Eleanor Green, and Jeffrey R. Hayes, *Maurice Prendergast: Art of Impulse and Color* (exh. cat., College Park: University of Maryland Art Gallery, 1976) // Carol Clark, Nancy Mowll Mathews, and Gwendolyn Owens, *Maurice Brazil Prendergast, Charles Prendergast: A Catalogue Raisonné* (Munich and Williamstown, Mass., 1990) // Nancy Mowll Mathews, *Maurice Prendergast* (exh. cat., New York: Whitney Museum of American Art; Williamstown, Mass.: Williams College Museum of Art, 1990).

THEODORE ROBINSON
1852–1896

Born in Irasburg, Vermont, and raised in Townshend, Vermont, and Evansville, Wisconsin. Suffered from chronic asthma, which caused his death at age forty-three. Studied in Chicago in 1869 or 1870 and in New York from 1874 to 1875 at the National Academy of Design. He is said to have been involved in founding the Art Students League in New York. Continued training in Paris from 1876 to 1879 in the independent atelier of Charles-Emile-Auguste Durand (Carolus-Duran) and at the Ecole des Beaux-Arts, where his atelier instructor was Jean-Léon Gérôme and where he matriculated for four semesters of drawing under Adolph Yvon. Returned to the United States in 1879; settled in New York in 1881. From 1879 to 1884 supported

himself by teaching and doing decorative work, such as murals and panels for projects undertaken by John La Farge. From 1884 to 1892 divided his time between the United States and France. Salon catalogues of 1887 to 1890 identify him as a pupil of Jean Joseph Benjamin-Constant, but his works show the influence first of the Barbizon paintings of Jean-François Millet and then of the Impressionism of Claude Monet. Spent the final four years of his life in America, where close associates included J. Alden Weir and John H. Twachtman. Worked in New York, New Jersey, and New England, teaching outdoor painting classes. Major retrospective at the Macbeth Galleries, New York, in 1895 was greeted with warm reviews but few sales. Died in New York, penniless and alone.

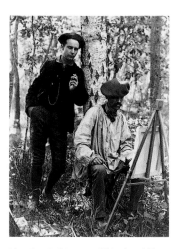

Theodore Robinson and friend, n.d. Terra Museum of American Art, Chicago, Gift of Mr. Ira Spanierman 1985.1.25

An early and leading American Impressionist, Robinson met Monet at Giverny in 1888 and, although never his pupil, worked closely with him. Robinson adopted the characteristic features of the Impressionist style and working technique, integrating the lessons of his academic training and earlier study of French Barbizon painting with the innovations of the new mode. Following Monet's example, he explored several major themes serially—panoramic views of the Seine valley in France and landscapes that represented the Delaware and Hudson Canal in Napanoch, New York, and the harbor at Cos Cob, Connecticut. He also emulated Monet's devotion to native landscape by seeking subjects in New England,

particularly in his native Vermont, that expressed national pride and nostalgia for the past. Through the exhibition of his paintings and contact with colleagues on regular trips home, Robinson became an important conduit for the spread of Impressionism in the United States. The diary he compiled from 1892 to 1896 chronicles the evolution of American Impressionism during its heyday. LS

Bibliography Theodore Robinson, Diaries, 1892–96, Frick Art Reference Library, New York // John I. H. Baur, *Theodore Robinson, 1852–1896* (exh. cat., Brooklyn: Brooklyn Museum, 1946) // Sona Johnston, *Theodore Robinson, 1852–1896* (exh. cat., Baltimore: Baltimore Museum of Art, 1973).

JOHN SINGER SARGENT
1856–1925

Born in Florence, the son of an expatriate American family originally from Gloucester, Massachusetts; led a peripatetic childhood abroad and was taught academic subjects informally by his father. Learned to draw, paint watercolors, and play the piano while very young and was proficient in four languages at an early age. Received some art instruction at the Accademia delle Belle Arti, Florence. Moved to Paris in 1874 and enrolled in the independent atelier of portraitist Charles-Emile-Auguste Durand (Carolus-Duran). Supplemented this training with studies in drawing at the Ecole des Beaux-Arts, where he matriculated in October 1874. Appears to have received additional instruction from the portraitist Léon Bonnat, another independent teacher. Made his first trip to the United States in 1876. In 1877, when he was twenty-one, his first submission to the Paris Salon was accepted, marking the beginning of a series of critical triumphs. Traveled to Spain in 1879 and Holland in 1880, studying first-hand the works of Velázquez and Hals. Sojourned in Venice in 1880 and 1882 but worked primarily in Paris until 1884, when his provocative portrait *Madame X (Madame Pierre Gautreau)* of that year (The Metropolitan Museum of Art, New York) created a scandal. Settled in London by 1886, when he was among the founding members of the New English Art Club. During the summers of 1885 and 1886 stayed in

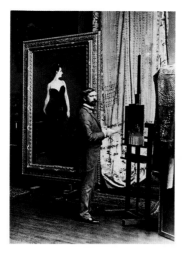

John Singer Sargent in his Paris studio, ca. 1884–86

Broadway, England, in the company of Francis Davis Millet and his family, Edwin Austin Abbey, and Alfred Parsons. Spent the summers of 1887 through 1889 in Henley, Calcot Mill, and Fladbury, respectively. Worked in the United States in 1887–88, when his first one-man exhibition was mounted in this country, completing about twenty portrait commissions. After further travel in Europe, returned to the United States in the winter of 1889–90 in order to paint approximately forty more portraits. At this time received a commission for mural decorations for the new Boston Public Library, a project not completed until 1916. Was elected an academician of both London's Royal Academy and New York's National Academy of Design in 1897. Comprehensive exhibition of his paintings was held in Boston in 1899. About 1908 gave up portrait painting but continued to draw informal charcoal portraits. Traveled extensively in the United States and overseas, recording in oil and watercolor the scenic places he visited and the friends and family members who often accompanied him. During World War I went to the French front in 1918 to execute watercolor and charcoal sketches of American and British troops. Painted murals for the Museum of Fine Arts, Boston, from 1916 to 1925 and in 1921 accepted a commission for two panels for the Widener Memorial Library at Harvard University. Died in London.

American by birth but European by virtue of his cosmopolitan upbringing and lifestyle, Sargent produced both portraits and informal works; it is in these latter paintings that he experimented with the innovations of French Impressionism. He discovered Impressionist painting during his Paris years, when all of the exhibitions of the French group took place. Sargent's magnificent plein air landscapes, done in the English countryside from 1885 to 1889, reveal the direct influence of his friend Claude Monet, whom he probably met in Paris in 1876 and whom he visited in Giverny, first in 1887 and twice more by 1891. A second and even more productive episode of Impressionist experimentation by Sargent occurred in the first two decades of the twentieth century, when he ceased painting portraits on commission. NMB

Bibliography Richard Ormond, *John Singer Sargent: Paintings, Drawings, Watercolors* (New York, 1970) // James Lomax and Richard Ormond, *John Singer Sargent and the Edwardian Age* (exh. cat., Leeds, Eng.: Leeds Art Galleries, 1979) // Trevor J. Fairbrother, "John Singer Sargent and America" (Ph.D. diss., Boston University, 1981) // Warren Adelson, Stanley Olson, and Richard Ormond, *Sargent at Broadway: The Impressionist Years* (New York, 1986) // Patricia Hills et al., *John Singer Sargent* (exh. cat., New York: Whitney Museum of American Art, 1986).

EVERETT SHINN
1876–1953

Born in Woodstown, New Jersey; his father was a bank teller and his family Quaker. Went to Philadelphia in 1888 to enter the Spring Garden Institute, where he studied mechanical drawing. In 1891 worked as a designer for the Thackery Gas Fixture works in Philadelphia. Enrolled at the Pennsylvania Academy of the Fine Arts, Philadelphia, in 1893, and studied there until 1897. Worked days as an artist-reporter at the *Philadelphia Press*, an experience he later described as a "school that trained memory and quick perception."[1] Became acquainted with the young artists and illustrators who gathered in Robert Henri's studio, including John Sloan, William Glackens, and George Luks. Moved in 1897 to New York, where he lived for most

of the rest of his life. Initially employed as a staff artist on the *New York World*, was hired as an art editor at *Ainslee's Magazine* in 1899. His first color illustration appeared in *Harper's Weekly* in 1900, beginning a long and successful career as an illustrator for popular magazines, among them *Harper's Weekly*, the *Century*, *Collier's*, and *Everybody's Magazine*. Began to exhibit his pastels and drawings of New York life: showed pastels at the Pennsylvania Academy in 1899 and in 1900 was given his first major one-man show, at Boussod, Valadon and Company, New York. Sent abroad by Boussod, Valadon in 1900 to record scenes of London and Parisian life. While abroad, began to paint in oils, marking his emergence as a fine artist, rather than an illustrator. Upon return to New York in the winter of 1900–1901 mounted *Paris Types*, an exhibition at Boussod, Valadon that signaled his indebtedness to Edgar Degas. After 1900 theatrical scenes dominated his paintings. Starting in 1907 had a second career producing murals for private homes and public buildings, such as the Stuyvesant Theatre on West Forty-fourth Street in New York (1907) and City Hall in Trenton, New Jersey (1911). After about 1913 largely abandoned easel painting and worked as a set designer and later as artistic director for a number of early film companies. Married four times. Died in New York.

Gertrude Käsebier. *Everett Shinn*, 1907. Platinum print, 8 x 6½ in. (20.3 x 16.5 cm). Delaware Art Museum, Wilmington, Gift of Helen Farr Sloan 78-589.12

Of all the artists who joined together briefly in 1908 to form The Eight, Shinn was perhaps the most versatile and eclectic. He specialized in New York street scenes with subjects ranging from dockyard workers to crowds of shoppers and pedestrians on lower Broadway to the denizens of the more genteel precincts of Fifth Avenue and Gramercy Park. After his trip abroad in 1900 he became famous for his pastels and oil paintings of the *cafés-chantants*, dance halls, and music halls of London and Paris and their American equivalents: New York's vaudeville theaters and their dancers, acrobats, and singers. Although he is associated with the portrayal of theatrical scenes, in fact, Shinn rarely painted the legitimate stage or other upper-class diversions, preferring instead to depict the new world of popular entertainment. KR

Bibliography C. H. Frohman, "Everett Shinn, the Versatile," *International Studio* 78 (October 1923), pp. 85–89 // Edith DeShazo, *Everett Shinn, 1876–1953* (exh. cat., Trenton: New Jersey State Museum; Wilmington: Delaware Art Museum, 1973) // Edith DeShazo, *Everett Shinn, 1876–1953: A Figure in His Time* (New York, 1974) // Linda Ferber, "Stagestruck: The Theater Subjects of Everett Shinn," in Doreen Bolger and Nicolai Cikovsky, Jr., eds., *American Art Around 1900: Lectures in Memory of Daniel Fraad* (Washington, D.C., 1990), pp. 51–67.

¹ DeShazo, *Everett Shinn* (1974), p. 24.

EDWARD E. SIMMONS
1852–1931

Born in Concord, Massachusetts, the son of a Unitarian minister and the nephew of Ralph Waldo Emerson; his distinguished New England family had ties to such major literary figures as Henry David Thoreau. Attended Harvard College, where he founded the *Harvard Crimson*. After graduation in 1874 traveled in the American West. Studied in Boston under William Rimmer. In 1877 enrolled in the School of the Museum of Fine Arts, Boston, where he worked under Frederic Crowninshield. Went to Paris in 1879, enrolling at the Académie Julian under Jules-Joseph Lefebvre and Gustave-Rodolphe Boulanger and matriculating in the Ecole des Beaux-Arts in spring 1880.

Will Simmons. *Edward Simmons in 1893*, 1922. Frontispiece, Edward Simmons, *From Seven to Seventy: Memories of a Painter and a Yankee* (New York and London, 1922)

Chose to paint in Europe, becoming in 1881 one of the first American artists to work at Concarneau in Brittany. Influenced by the work of Jules Bastien-Lepage, executed portraits and picturesque scenes. Publication in 1883 of *Guenn: A Wave on the Breton Coast*, a novel by American Blanche Willis Howard, whose hero was said to have been based on Simmons, brought him to public attention. Married writer Vesta Schallenberger in 1883. Settled in the coastal village of St. Ives, Cornwall, in 1886, and abandoned highly finished sentimental narrative style of earlier pictures in favor of freer seascapes that established his reputation in the United States. In 1888 was elected a member of the Society of American Artists. Three years later returned to America to design a stained-glass window for Harvard's Memorial Hall. Thereafter painted murals for many public and private buildings, including the Manufacturers and Liberal Arts Building at the 1893 Chicago World's Columbian Exposition; the Massachusetts State House, Boston; the Library of Congress, Washington, D.C.; the Criminal Courts Building, the Appellate Division Court Building, the Metropolitan Club, and the Players Club, New York. In 1897 was a founding member of The Ten, with whom he exhibited continuously, with the exception of six annuals, until the group's last show in 1917. In Paris in 1904 returned to easel painting. Divorced his first wife and remarried about 1905. Spent summer of 1906 in Old Lyme, Connecticut, at the

invitation of Childe Hassam. Resumed landscape painting, producing Impressionist scenes of Connecticut, Massachusetts, and Puerto Rico, most of which are now lost. Spent his final years with one of his sons in Baltimore, where he died.

Simmons's career exemplifies the course taken by many American artists of his generation. Trained as an academic painter, he responded to a succession of European influences, exploring Impressionism only to a limited degree and usually alternating Impressionist experiments with figure studies and portraits in a more traditional style. Between 1891 and about 1905 he was employed almost exclusively in the design and execution of decorative work and therefore produced few easel paintings. Simmons believed that the arts in America should serve nationalism and be free from dependence on Europe. His murals celebrate civic virtues, and the unveiling of his work often occasioned displays of public pageantry and national pride. His memoirs, *From Seven to Seventy: Memories of a Painter and a Yankee*, published in 1922, remain an informative account of the life of a successful American artist at the turn of the last century. KR

Bibliography William Henry Howe and George Torrey, "Edward E. Simmons," *Art Interchange* 33 (Dec. 1894), p. 121 // Arthur Hoeber, "Edward Emerson Simmons," *Brush and Pencil* 5 (Mar. 1900), pp. 241–49 // Edward E. Simmons, "The Fine Arts Related to the People," *International Studio* 63 (Nov. 1917), pp. 9–13 // Edward E. Simmons, *From Seven to Seventy: Memories of a Painter and a Yankee* (New York, 1922; reprint, New York, 1976).

JOHN SLOAN
1871–1951

Born in Lock Haven, Pennsylvania. Moved with his family to Philadelphia, where he worked first as a cashier for a book dealer and then as a designer of greeting cards and calendars. In 1892 enrolled at the Pennsylvania Academy of the Fine Arts, Philadelphia, where he studied under Thomas Anshutz. With Robert Henri, William Glackens, and others established the Charcoal Club in Philadelphia in 1893. Met regularly with Henri, Glackens, George Luks, and

Everett Shinn at Henri's studio during the next two years, forming the nucleus of the Ashcan School. Worked as a newspaper illustrator at the *Philadelphia Inquirer* from 1892 to 1895 and the *Philadelphia Press* from 1895 to 1904. Moved to New York, the location most closely associated with his artistic career, in 1904. Active in the independent movement, which condemned the use of juries for admitting works to exhibitions. Helped plan and participated in the exhibition of The Eight at the Macbeth Galleries, New York, in 1908 and the *Exhibition of Independent Artists* in New York in 1910. Served as president of the Society of Independent Artists from 1917 to 1944. Joined the Socialist Party in 1910. Produced illustrations throughout 1910 for the New York socialist paper the *Call* and, from 1912 to 1916, served as acting art editor for the *Masses*, also in New York. Summered in Gloucester, Massachusetts, from 1914 through 1918 and began regular visits to Santa Fe in 1919.

Through newspaper illustration Sloan honed his skills in observation and reportage. Henri introduced him to the larger artistic tradition of the French Impressionists and the Dutch and Flemish old masters. Synthesizing his experiences in illustration and the inspiration of these European models, he created a direct and vigorous painting style that he used to capture the reality of the urban scene, often with a lighthearted touch. His New York paintings of the early 1900s

John Sloan in his Philadelphia studio, 1893. Delaware Art Museum, Wilmington, John Sloan Collection

reveal the lives of the working class in the city streets, on tenement rooftops, and in the bars, shops, and restaurants where ordinary people spent their leisure time. By 1909 Sloan increasingly concerned himself with formal issues and, especially after he saw the Armory Show of 1913, responded to the abstract elements of painting. In the late 1920s he began a series of nudes in which he emulated the work of such old masters as Titian and Rubens. Nevertheless, of the Americans of his generation, with the possible exception of George Bellows, Sloan achieved the most satisfying application of the Realist style to the broadest array of urban subjects. VJR

Bibliography John Sloan Archives, Delaware Art Museum, Wilmington // *John Sloan Retrospective Exhibition* (exh. cat., Andover, Mass.: Addison Gallery of American Art, Phillips Academy, 1938) // John Sloan, *Gist of Art: Principles and Practise Expounded in the Classroom and Studio*, recorded with the assistance of Helen Farr (New York, 1939) // Van Wyck Brooks, *John Sloan: A Painter's Life* (New York, 1955) // Bruce St. John, ed., *John Sloan's New York Scene from the Diaries, Notes, and Correspondence, 1906–1913* (New York, 1965) // David W. Scott and E. John Bullard, *John Sloan, 1871–1951: His Life and Paintings* (exh. cat., Washington, D.C.: National Gallery of Art, 1971) // Helen Farr Sloan, ed., *John Sloan: New York Etchings (1905–1949)* (New York, 1978) // *John Sloan: The Gloucester Years* (exh. cat., Springfield, Mass.: Museum of Fine Arts, 1980) // Rowland Elzea, *John Sloan's Oil Paintings: A Catalogue Raisonné*, 2 vols. (Newark, Del., 1991).

EDMUND C. TARBELL
1862–1938

Born in West Groton, Massachusetts, to an old New England family. After father's death, was brought up in Dorchester, Massachusetts, where he attended public schools. Took evening classes in drawing at the Massachusetts Normal Art School, Boston in 1877. Apprenticed in 1877 to the W. H. Forbes Lithographic Company in Boston. Enrolled in 1879 or 1880 in the School of the Museum of Fine Arts, Boston, where fellow students included Frank Benson

Edmund C. Tarbell. *Self-Portrait*, 1889. Oil on canvas, 21 x 17 in. (53.3 x 43.2 cm). National Academy of Design, New York

and Robert Reid. Instructor Otto Grundmann offered him a student-teaching position and encouraged him to go abroad for further study. Left for Paris in 1883 or 1884, accompanied by Benson and Reid. Worked at the Académie Julian until 1886 under Gustave-Rodolphe Boulanger and Jules-Joseph Lefebvre, Adolphe-William Bouguereau and Tony Robert Fleury. Also studied privately with American expatriate figure painter William T. Dannat. Spent summers traveling in the French countryside and in Holland, Belgium, and Germany. Upon return to the United States in 1886, began a career as a portrait and genre painter. Married in 1888 and settled in Dorchester, commuting to Boston, where he shared a studio with Benson. Supported himself and his growing family by painting portraits, taking on private pupils, and drawing magazine illustrations. In 1889 was hired to teach at the School of the Museum of Fine Arts, Boston, and in 1890 was made head of the department of painting, an influential position he held until 1912; taught at the school of the Corcoran Gallery of Art, Washington, D.C., from 1918 to 1926. Formed ties to the progressive art scene in New York: a member of the Society of American Artists and, in 1897, a founding member of the Ten American Painters.

Tarbell's sunlit, brilliantly colored paintings, set in New England's orchards and gardens and often featuring his wife and her family, quickly won him a national reputation. He was arguably the leader of the Boston Impressionists—indeed, they were referred to as "the Tarbellites"[1]—who

developed a modified form of the French style. They combined a concern with light and color with more traditional modeling and detail in genre paintings of well-to-do women in beautifully appointed interiors and plein air landscapes. Tarbell's commitment to the realistic depiction of contemporary life remained constant, but his career is usually divided into two major periods: the first was characterized by plein air works executed in an Impressionist manner and the second more often by interiors with figures realized in a warm, muted palette in a style frequently compared to that of Vermeer and the Dutch old masters. KR

Bibliography Philip L. Hale, "Edmund C. Tarbell, Painter of Pictures," *Art and Decoration* 2 (Feb. 1912), pp. 129–31 // Susan Faxon Olney, *Two American Impressionists: Frank W. Benson and Edmund C. Tarbell* (exh. cat., Durham, N.H.: University Art Galleries, University of New Hampshire, 1979) // Patricia Jobe Pierce, *Edmund C. Tarbell and the Boston School of Painting, 1889–1980* (Hingham, Mass.: Pierce Galleries, 1980) // Trevor J. Fairbrother et al., *The Bostonians: Painters of an Elegant Age, 1870–1930* (exh. cat., Boston: Museum of Fine Arts, 1986) // Bethany Tarbell, "Edmund Tarbell in Private, a New England Painter and the Family that Inspired Him," *Art and Antiques*, Jan. 1993, pp. 42–50.

[1] Sadakichi Hartmann, "The Tarbellites," *Art News* 1 (Mar. 1897), pp. 3–4.

JOHN H. TWACHTMAN
1853–1902

Born in Cincinnati, to German immigrants. Apprenticed in a local factory at age sixteen. Studied at the Ohio Mechanics Institute, Cincinnati, from 1868 to 1871; in 1871 enrolled in the McMicken School of Design (later affiliated with the University of Cincinnati), working there under Munich-trained Frank Duveneck. In 1875 accompanied Duveneck to Munich, where he spent three years at the Royal Academy and in the summers painted in the German countryside. Returned to the United States in 1878 and worked for two years at the Art Students League, New York but traveled abroad in 1880–81 and in 1882. In Paris from 1883 to 1885; studied at the Académie Julian under

Jules-Joseph Lefebvre and Gustave-Rodolphe Boulanger. Met many American artists who later embraced the Impressionist style; painted in the French countryside and visited Holland. Moved back to the United States in 1885, living in various locales until 1889 or 1890, when he purchased land and a home in Greenwich, Connecticut. Supported himself by drawing illustrations for *Scribner's Magazine* and teaching in nearby Cos Cob, Connecticut, and in New York. Founding member of the Ten American Painters in 1897. Beginning in 1900 spent summers in Gloucester, Massachusetts, where he died.

Gertrude Käsebier. *J. H. Twachtman and His Family at Their Home in Greenwich, Connecticut* (detail), n.d., from *Craftsman* 14 (June 1908), p. 344

Primarily a landscape painter, Twachtman applied the lessons he learned in Munich and Paris to the New England countryside he loved, finding his inspiration in the farmland, woods, and harbors of Connecticut and, later, Massachusetts. Working outdoors and mixing pigments directly on the canvas, he created pictures that display remarkable strength of design and subtlety of effect achieved through muted tonal harmonies, highly textured brushwork, and rough paint surfaces. Twachtman developed an increasingly free and bold painting style that is radical, highly individual, and distinguished by his poetic, subjective approach. Although he achieved little commercial success or critical acclaim during his lifetime, Twachtman was

widely admired by his fellow artists. Painter Thomas Dewing eulogized him as "the most modern spirit, too modern, probably, to be fully recognized or appreciated in his own day."[1] KR

Bibliography Eliot Clark, *John H. Twachtman* (New York, 1924) // John D. Hale, "The Life and Creative Development of John H. Twachtman," 2 vols. (Ph.D. diss., Ohio State University, Columbus, 1957) // Richard J. Boyle, *John Twachtman* (New York, 1979) // John D. Hale et al., *Twachtman in Gloucester: His Last Years, 1900–1902* (exh. cat., New York: Spanierman Gallery, 1987) // Deborah Chotner, Lisa N. Peters, and Kathleen A. Pyne, *John Twachtman: Connecticut Landscapes* (exh. cat., Washington, D.C.: National Gallery of Art, 1989) // Lisa N. Peters et al., *In the Sunlight: The Floral and Figurative Art of J. H. Twachtman* (exh. cat., New York: Spanierman Gallery, 1989).

[1] Thomas W. Dewing, in Thomas W. Dewing et al., "John H. Twachtman: An Estimation," *North American Review* 176 (Apr. 1903), p. 554.

J. ALDEN WEIR
1852–1919

Born and raised in West Point, New York, where his father, painter Robert Walter Weir, was drawing instructor at the United States Military Academy. Began studies with his father and at the National Academy of Design, New York, from 1870 to 1872. Continued schooling in Paris from 1873 to 1877, principally at the Ecole des Beaux-Arts as a student of Jean-Léon Gérôme but also at the Ecole Gratuite de Dessin under Aimé Millet and in the private studio of Louis-Marie-François Jacquesson de la Chevreuse. Traveled to Spain and Holland and, during the summers, painted in the French countryside. In 1877 returned to New York, the locus of most of his professional activities for the remainder of his career. In the early 1880s began to spend summers in rural Connecticut, at Branchville, where he owned a farm, and Windham. Became a leader in many prominent artists' groups, including the Society of American Artists and the Ten American Painters, and at the National Academy of Design. Was also an important teacher, notably at the Art Students League, New York.

J. Alden Weir. *Self-Portrait*, 1886. Oil on canvas, 21¼ x 17¼ in. (54 x 43.8 cm). National Academy of Design, New York

Because of his thorough training as an academic artist, Weir's conversion to Impressionism was gradual. His reaction to the 1877 exhibition of the French Impressionists when he was a student is often quoted: "It was worse than a Chamber of Horrors."[1] Nevertheless, he greatly admired the work of Edouard Manet, three of whose pictures he acquired for New York collector Erwin Davis in 1881. Manet's strong influence can be seen in Weir's figure and still-life paintings of the 1880s. As he worked more often in the Connecticut countryside, landscapes assumed new importance for him. Influenced by his friends Theodore Robinson and John H. Twachtman and inspired by his avid study of Japanese prints, he lightened his palette to delicate pastel colors and adopted broken brushwork without compromising the form and structure of his subjects. Weir's love of the New England village and its surrounding landscape is expressed particularly well in views of his farm in Branchville and of the industrial town of Willimantic. He also embraced other characteristic Impressionist themes, notably scenes of family life and representations of contemplative women, but his work always evidences a genteel elegance and restraint that distinguishes it from that of his French predecessors. His paintings done after 1900 show a renewed academicism, with subjects treated less naturalistically and with greater emphasis on drawing and design. Like many of his generation, Weir had gone full circle, from academic student resistant to Impressionism to a more radical position to aging conservative. DB

Bibliography *Julian Alden Weir: An Appreciation of His Life and Works* (New York, 1921; reprint, New York, 1922) // Dorothy Weir Young, *The Life and Letters of J. Alden Weir*, ed. Lawrence W. Chisholm (New Haven, 1960; reprint, New York, 1971) // Doreen Bolger Burke, *J. Alden Weir: An American Impressionist* (Newark, Del., 1983) // Hildegard Cummings, Helen K. Fusscas, and Susan G. Larkin, *J. Alden Weir: A Place of His Own* (exh. cat., Storrs: William Benton Museum of Art, University of Connecticut, 1991).

[1] J. Alden Weir, Letter to his parents, Mr. and Mrs. Robert W. Weir, Apr. 15, 1877, quoted in Young, *Life and Letters of Weir*, p. 123.

THEODORE WENDEL
1859–1932

Born in Midway, Ohio, the son of a German immigrant storekeeper. Studied at the University of Cincinnati School of Design (formerly the McMicken School of Design), beginning in 1876, and at the Royal Academy in Munich during the 1878–79 school year. Worked with American painter Frank Duveneck in the Bavarian village of Polling in the summer of 1879 and then for nearly two years in Italy, where fellow students, known as Duveneck's Boys, included Joseph Rodefer DeCamp and Louis Ritter. Worked in Cincinnati from 1883 to 1884 and in Newport, Rhode Island, in 1885. Studied at the Académie Julian in Paris in 1886 and painted for three summers with Claude Monet in Giverny. Returned to the United States in 1889 and settled in Boston. Exhibited regularly in Boston and taught there, as well as in Newport and in East Gloucester, Massachusetts. Was director of the School of Art at Wellesley College from 1892 to 1894. During 1890s also taught at the Cowles Art School, Boston, and in his own studio. Married in 1897 and two years later settled on his wife's family's farm in Ipswich, Massachusetts. Although increasingly involved with the farm, continued to produce landscapes until 1917, when poor health forced him to give up painting. Died in Ipswich.

Wendel's early introduction to plein air painting and bravura brushwork under Duveneck's tutelage and his exposure in Venice to the summary treatment of James McNeill Whistler's work appear to have prepared him to accept the innovations of Impressionism. He created a highly personal style based in Impressionism that was characterized by a high-key palette, textural handling of paint, and a direct, almost naive, approach to subject matter. Among the first Americans to work in Giverny, Wendel absorbed the lessons of French Impressionism and applied them to native landscape subjects. For him the Massachusetts coast around Gloucester and Ipswich resonated with timeless and picturesque qualities associated with the Old World. He exhibited his paintings and pastels often in Boston during the 1890s, but a fire in his studio in 1897 destroyed much of his work, leaving us with an incomplete record of his artistic achievements. NMB

Bibliography John I. H. Baur, "Introducing Theodore Wendel," *Art in America* 64 (Nov.-Dec. 1976), pp. 102–5.

Kenyon Cox. *Portrait of Theodore Wendel*, 1884. Oil on canvas laid down on board, 10 x 8 in. (25.4 x 20.3 cm). Private collection

SELECTED BIBLIOGRAPHY

This list concentrates on general sources in art history and cultural, social, and economic history and includes studies with extensive bibliographies for further reference. Except for material on Boston and New York, sources relevant to a single site are usually omitted. The great majority of articles from journals and newspapers and most collection catalogues cited in the endnotes are not reiterated. Monographs on artists in the exhibition accompany their biographies.

Abelson, Elaine S. *When Ladies Go A-Thieving: Middle-Class Shoplifters in the Victorian Department Store*. New York, 1989.

Alland, Alexander, Sr. *Jacob A. Riis: Photographer and Citizen*. Millerton, N.Y., 1974.

Ames, Kenneth L. *Death in the Dining Room and Other Tales of Victorian Culture*. Philadelphia, 1992.

Ames, Kenneth L., et al. *Accumulation and Display: Mass Marketing Household Goods in America, 1880–1920*. Exh. cat. Winterthur, Del.: Henry Francis du Pont Winterthur Museum, 1986.

Ariès, Philippe. *Centuries of Childhood: A Social History of Family Life*. Trans. Robert Baldick. New York, 1962.

Axelrod, Alan, ed. *The Colonial Revival in America*. Winterthur, Del., 1985.

Bacon, Edwin M. *King's Dictionary of Boston*. Cambridge, Mass., 1883.

————, ed. *Boston Illustrated: A Familiar Guide to Boston and Its Neighborhood*. Boston, 1893.

Banner, Lois W. *Women in Modern America: A Brief History*. 2d ed. San Diego and New York, 1984.

Banta, Martha. *Imaging American Women: Idea and Ideals in Cultural History*. New York, 1981.

Barlow, Elizabeth. *Frederick Law Olmsted's New York*. Exh. cat. New York: Whitney Museum of American Art, 1972.

Barth, Gunther. *City People: The Rise of Modern City Culture in Nineteenth-Century America*. New York, 1980.

Baudelaire, Charles. *The Painter of Modern Life and Other Essays*. Trans. Jonathan Mayne. London, 1964.

Beard, Rick, ed. *On Being Homeless: Historical Perspectives*. Exh. cat. New York: Museum of the City of New York, 1987.

Beard, Rick, and Leslie Cohen Berkowitz, eds. *Greenwich Village: Culture and Counterculture*. New Brunswick, N.J., 1993.

Beers, Thomas. *The Mauve Decade: American Life at the End of the Nineteenth Century*. New York, 1926.

Bender, Thomas. *New York Intellect: A History of Intellectual Life in New York City, from 1750 to the Beginnings of Our Own Time*. New York, 1987.

Benjamin, S[amuel] G. W. *Our American Artists; with Portraits, Studios, and Engravings of Paintings.* Boston, 1886.

Benson, Susan Porter. *Counter Cultures: Saleswomen, Managers, and Customers in American Department Stores, 1890–1940.* Urbana, Ill., 1986.

Bermingham, Peter. *American Art in the Barbizon Mood.* Exh. cat. Washington, D.C.: National Collection of Fine Arts, Smithsonian Institution, 1975.

Betts, John Rickards. *America's Sporting Heritage: 1850–1950.* Reading, Mass., 1974.

Blaugrund, Annette. "The Tenth Street Studio Building." Ph.D. diss., Columbia University, New York, 1987.

Blaugrund, Annette, et al. *Paris 1889: American Artists at the Universal Exposition.* Exh. cat. Philadelphia: Pennsylvania Academy of the Fine Arts, 1989.

Bledstein, Burton J. *The Culture of Professionalism: The Middle Class and the Development of Higher Education in America.* New York, 1976. Reprint. New York, 1978.

Bodnar, John. *The Transplanted: A History of Immigrants in Urban America.* Bloomington, Ind., 1985.

Bolger, Doreen, and Nicolai Cikovsky, Jr., eds. *American Art Around 1900: Lectures in Memory of Daniel Fraad.* Washington, D.C., 1990.

Bolger, Doreen, Marc Simpson, and John Wilmerding, eds. *William M. Harnett.* Exh. cat. New York: The Metropolitan Museum of Art; Fort Worth: Amon Carter Museum, 1992.

Bourget, Paul. *Outre-Mer: Impressions of America.* New York, 1895.

Boyer, M. Christine. *Manhattan Manners: Architecture and Style, 1850–1900.* New York, 1985.

Boyer, Paul. *Urban Masses and Moral Order in America, 1820–1920.* Cambridge, Mass., 1978.

Boyle, Richard J. *American Impressionism.* Boston, 1974.

Boyle, Richard J., and Frank H. Goodyear, Jr. *In This Academy: The Pennsylvania Academy of the Fine Arts, 1805–1976.* Exh. cat. Philadelphia: Pennsylvania Academy of the Fine Arts, 1976.

Braden, Donna R. *Leisure and Entertainment in America: Based on the Collections of Henry Ford Museum and Greenfield Village.* Dearborn, Mich., 1988.

Brettell, Richard R. *Pissarro and Pontoise: The Painter in a Landscape.* New Haven, 1990.

———. *The Impressionist and the City: Pissarro's Series Paintings.* Exh. cat. Dallas: Dallas Museum of Art, 1992.

Brettell, Richard R., and Caroline B. Brettell. *Painters and Peasants in the Nineteenth Century.* Geneva, 1983.

Bronner, Simon J., ed. *Consuming Visions: Accumulation and Display of Goods in America, 1880–1920.* New York, 1989.

Brooks, Van Wyck. *America's Coming of Age.* New York, 1913.

———. *The Confident Years, 1885–1915.* New York, 1952.

Brown, Dona L. "The Tourist's New England: Creating an Industry, 1820–1900." Ph.D. diss., University of Massachusetts, Amherst, 1989.

[Browne, Charles Francis, Hamlin Garland, and Lorado Taft]. *Impressions on Impressionism; Being a Discussion of the American Art Exhibition at the Art Institute, Chicago, by a Critical Triumvirate.* Chicago, 1894.

Bunting, Bainbridge. *Houses of Boston's Back Bay: An Architectural History, 1840–1917.* Cambridge, Mass., 1967.

Burke, Doreen Bolger. *American Paintings in The Metropolitan Museum of Art.* Vol. 3, *A Catalogue of Works by Artists Born Between 1846 and 1864,* ed. Kathleen Luhrs. New York, 1980.

Burke, Doreen Bolger, et al. *In Pursuit of Beauty: Americans and the Aesthetic Movement.* Exh. cat. New York: The Metropolitan Museum of Art, 1986.

Burnham, Alan. *New York City, the Development of the Metropolis: An Annotated Bibliography.* New York, 1988.

Cable, Mary. *American Manners and Morals: A Picture History of How We Behaved and Misbehaved.* New York, 1969.

Cahill, Holger, and Alfred H. Barr, Jr. *Art in America in Modern Times.* New York, 1934.

Campbell, Robert, and Peter Vanderwarker. *Cityscapes of Boston: An American City Through Time.* Boston, 1992.

Cantor, Mindy, ed. *Around the Square, 1830–1890: Essays on Life, Letters, and Architecture in Greenwich Village.* New York, 1982.

Carbone, Teresa A. "An Imitation Is Worth Nothing: Patronage of the First American Impressionists." Paper presented at the Wadsworth Atheneum Collectors' Council, Hartford, Conn., Dec. 1991. Originally a seminar paper, Graduate School and University Center, City University of New York, 1985.

Carr, Carolyn Kinder, and George Gurney. *Revisiting the White City: American Art at the 1893 World's Fair.* Essays by Robert W. Rydell and Carolyn Kinder Carr. Exh. cat. Washington, D.C.: National Museum of American Art and National Portrait Gallery, Smithsonian Institution, 1993.

Carruth, Gorton. *The Encyclopedia of American Facts and Dates.* 8th ed. New York, 1987.

Carson, Gerald. *The Polite Americans: A Wide-Angle View of Our More or Less Good Manners over 300 Years.* New York, 1966.

Catalogue of Celebrated Paintings by Great French Masters Brought to This Country from Paris for Exhibition Only. Exh. cat. New York: National Academy of Design, 1887.

A Century of Childhood, 1820–1920. Exh. cat. Rochester, N.Y.: Margaret Woodbury Strong Museum, 1984.

Chadwick, George. *The Park and the Town: Public Landscape in the 19th and 20th Centuries.* New York, 1966.

Champney, Elizabeth W. *Witch Winnie at Shinnecock; or, The King's Daughter in a Summer Art School.* New York, 1894.

Chu, Petra T. D. *French Realism and the Dutch Masters: The Influence of Dutch Seventeenth-Century Painting on the Development of French Painting Between 1830 and 1870.* Utrecht, 1974.

Clark, Clifford Edward, Jr. *The American Family Home, 1800–1960.* Chapel Hill, N.C., 1986.

Clark, T[imothy] J. *The Painting of Modern Life: Paris in the Art of Manet and His Followers.* Princeton, 1984.

Coben, Stanley. *Rebellion Against Victorianism: The Impetus for Cultural Change in 1920s America.* New York, 1991.

Condit, Carl W. *American Building: Materials and Techniques from the First Colonial Settlements to the Present.* 2d ed. Chicago, 1982.

Connecticut and American Impressionism. Exh. cat. Storrs: William Benton Museum of Art, University of Connecticut, 1980.

Cook, Clarence. *The House Beautiful: Essays on Beds and Tables, Stools and Candlesticks.* New York, 1878.

———. *Art and Artists of Our Time.* 3 vols. New York [1888].

Corn, Wanda M. *The Color of Mood: American Tonalism, 1880–1910.* Exh. cat. San Francisco: M. H. de Young Memorial Museum and the California Palace of the Legion of Honor, 1972.

———. "The New New York." *Art in America* 61 (July–Aug. 1973), pp. 58–65.

———. "Coming of Age: Historical Scholarship in American Art." *Art Bulletin* 70 (June 1988), pp. 188–207.

Cotkin, George. *Reluctant Modernism: American Thought and Culture, 1880–1900.* New York and Toronto, 1992.

Cowan, Ruth Schwartz. *More Work for Mother: The Ironies of Household Technology from the Open Hearth to the Microwave.* New York, 1983.

Cranz, Galen. *The Politics of Park Design: A History of Urban Parks in America.* Cambridge, Mass., 1982.

Cronon, William. *Changes in the Land: Indians, Colonists, and the Ecology of New England.* New York, 1983.

Curry, David Park. *James McNeill Whistler at the Freer Gallery of Art.* Exh. cat. Washington, D.C.: Freer Gallery of Art, Smithsonian Institution, 1984.

———. *Winslow Homer: The Croquet Game.* Exh. cat. New Haven: Yale University Art Gallery, 1984.

Danly, Susan. *Light, Air, and Color: American Impressionist Paintings from the Collection of the Pennsylvania Academy of the Fine Arts.* Exh. cat. Philadelphia: Pennsylvania Academy of the Fine Arts, 1990.

Dann, Martin E. "'Little Citizens': Working Class and Immigrant Childhood in New York City, 1890–1915." Ph.D. diss., City University of New York, 1978.

Darrah, William C. *The World of Stereographs.* Gettysburg, Pa., 1977.

Davis, Dorothy. *A History of Shopping.* London, 1966.

A Day in the Country: Impressionism and the French Landscape. Exh. cat. Los Angeles: Los Angeles County Museum of Art, 1984.

Degler, Carl N. *At Odds: Women and the Family in America from the Revolution to the Present.* New York, 1980.

D'Emilio, John, and Estelle B. Freedman. *Intimate Matters: A History of Sexuality in America.* New York, 1988.

Docherty, Linda J. "Native Art/National Art: Art Criticism, Scientific Culture, and American Identity, 1876–1893." Manuscript based on the author's Ph.D. diss., University of North Carolina, Chapel Hill, 1985.

———. "The Open Book and the American Woman." Paper presented at the conference The Iconography of the Book, American Antiquarian Society, Worcester, Mass., June 15, 1991.

Dreiser, Theodore. *Sister Carrie.* New York, 1900.

Dudden, Faye. *Serving Women: Household Service in Nineteenth-Century America.* Middletown, Conn., 1983.

Dulles, Foster Rhea. *A History of Recreation: America Learns to Play.* 2d ed. New York, 1965.

Dunbar, Seymour. *A History of Travel in America.* New York, 1937.

Earle, Edward W., ed. *Points of View: The Stereograph in America—A Cultural History.* Rochester, N.Y., 1979.

Edwards, Lee M., with Jan Seidler Ramirez and Timothy Anglin Burgard. *Domestic Bliss: Family Life in American Painting, 1840–1910.* Exh. cat. Yonkers, N.Y.: Hudson River Museum, 1986.

Ehrenreich, Barbara, and Deirdre English. *For Their Own Good: 150 Years of the Experts' Advice to Women.* Garden City, N.Y., 1978.

Erenberg, Lewis A. *Steppin' Out: New York Nightlife and the Transformation of American Culture, 1890–1930.* Westport, Conn., 1981.

Exhibition of Paintings by Arthur B. Davies [et al.]. Exh. cat. New York: Macbeth Galleries, 1908.

Fairbrother, Trevor J., et al. *The Bostonians: Painters of an Elegant Age, 1870–1930.* Exh. cat. Boston: Museum of Fine Arts, 1986.

Farmer, J. S., and W. E. Henley. *Slang and Its Analogues.* New York, 1970.

Fein, Albert, ed. *Landscape into Cityscape: Frederick Law Olmsted's Plans for a Greater New York City.* Ithaca, N.Y., 1967.

Fink, Lois Marie. *American Art at the Nineteenth-Century Paris Salons.* Washington, D.C., 1990.

Fischer, Diane Pietrucha. "The 'American School' in Paris: The Repatriation of American Art at the Exposition Universelle of 1900." Ph.D. diss., City University of New York, 1993.

Frick, John W. *New York's First Theatrical Center: The Rialto at Union Square.* Ann Arbor, Mich., 1985.

Galassi, Peter. *Before Photography: Painting and the Invention of Photography.* Exh. cat. New York: Museum of Modern Art, 1981.

Garland, Hamlin. *Crumbling Idols: Twelve Essays on Art Dealing Chiefly with Literature, Painting, and the Drama.* Chicago, 1894. New ed., ed. Jane Johnson. Cambridge, Mass., 1960.

———. *Roadside Meetings.* New York, 1930.

Garrett, Elisabeth Donaghy. *At Home: The American Family, 1750–1870.* New York, 1990.

Gerdts, William H. *American Impressionism.* New York, 1984.

———. *American Impressionism: Masterworks from Public and Private Collections in the United States.* Exh. cat. Lugano-Castagnola, Switz.: Villa Favorita, Thyssen-Bornemisza Foundation, 1990.

———. *Masterworks of American Impressionism from the Pfeil Collection.* Exh. cat. Alexandria, Va.: Art Services International, 1992.

———. *Monet's Giverny: An Impressionist Colony.* New York, 1993.

Gerdts, William H., et al. *Ten American Painters.* Exh. cat. New York: Spanierman Gallery, 1990.

———. *Lasting Impressions: American Painters in France, 1865–1915.* Exh. cat. Giverny: Musée Américain, 1992.

Gerdts, William H., Diana Dimodica Sweet, and Robert R. Preato. *Tonalism, an American Experience.* Exh. cat. New York: Grand Central Art Galleries, 1982.

Gillette, Howard, Jr., and Zale L. Miller, eds. *American Urbanism: A Historiographical Review.* New York, 1987.

Glassberg, David. *American Historical Pageantry: The Uses of Tradition in the Early Twentieth Century.* Chapel Hill, N.C., 1990.

Glazer, Nathan, and Daniel P. Moynihan. *Beyond the Melting Pot: The Negroes, Puerto Ricans, Jews, Italians, and Irish of New York City, 1800–1915.* New York, 1977.

Goodman, Cary. *Choosing Sides: Playground and Street Life in the Lower East Side.* New York, 1979.

Gorn, Elliott. *The Manly Art: Bare-knuckle Prize Fighting in America.* Ithaca, N.Y., 1986.

Green, Harvey, with Mary-Ellen Perry. *The Light of the Home: An Intimate View of the Lives of Women in Victorian America.* New York, 1983.

Gregg, Richard N. *The Artist's Studio in American Painting, 1840–1983.* Exh. cat. Allentown, Pa.: Allentown Art Museum, 1983.

Grover, Kathryn, ed. *Hard at Play: Leisure in America, 1840–1940.* Amherst, Mass., and Rochester, N.Y., 1992.

Gutman, Herbert G. *Work, Culture, and Society in Industrializing America: Essays in American Working-Class and Social History.* New York, 1977.

Hales, Peter B. *Silver Cities: The Photography of American Urbanization, 1839–1915.* Philadelphia, 1984.

Hammack, David C. *Power and Society: Greater New York at the Turn of the Century.* New York, 1982.

Hardy, Stephen. *How Boston Played: Sport, Recreation, and Community, 1865–1915.* Boston, 1982.

Harris, Ann Sutherland, and Linda Nochlin. *Women Artists: 1550–1950.* Exh. cat. Los Angeles: Los Angeles County Museum of Art, 1976.

Harris, Neil, ed. *The Land of Contrasts, 1880–1901.* New York, 1970.

Hartman, Edward George. *The Movement to Americanize the Immigrant.* New York, 1948.

Hartmann, Sadakichi. *A History of American Art.* 2 vols. Boston, 1902.

Haskell, Thomas L., ed. *The Authority of Experts: Studies in History and Theory.* Bloomington, Ind., 1984.

Hayden, Dolores. *The Grand Domestic Revolution: A History of Feminist Designs for American Homes, Neighborhoods, and Cities.* Cambridge, Mass., 1981.

Heller, Adele, and Lois Rudnick, eds. *1915, the Cultural Moment: The New Politics, the New Woman, the New Psychology, the New Art, and the New Theatre in America.* New Brunswick, N.J., 1991.

Henderson, Mary C. *The City and the Theatre.* Clifton, N.J., 1973.

Herbert, Robert L. *Barbizon Revisited.* Exh. cat. San Francisco: California Palace of the Legion of Honor, 1962.

———. *Impressionism: Art, Leisure, and Parisian Society.* New Haven, 1988.

Higham, John. *Strangers in the Land: Patterns of American Nativism, 1860–1925.* New York, 1969.

Hills, Patricia. *Turn-of-the-Century America: Painting, Graphics, Photographs, 1890–1910.* Exh. cat. New York: Whitney Museum of American Art, 1977.

Hobsbawm, Eric. *The Age of Empire, 1875–1914*. New York, 1987.

Hobsbawm, Eric, and Terence Ranger, eds. *The Invention of Tradition*. Cambridge, 1983.

Hoopes, Donelson F. *The American Impressionists*. New York, 1972.

The Hoosier Group: Five American Painters. Intro. William H. Gerdts, essays by Judith Vale Newton, works selected by Jane and Henry Eckert. Indianapolis, 1985.

Howells, William Dean. *Suburban Sketches*. New York, 1871.

———. *The Rise of Silas Lapham*. New York, 1884; Boston, 1885.

———. *A Hazard of New Fortunes*. New York, 1890.

Hughes, Rupert. *The Real New York*. London and New York, 1904.

Huth, Hans. "Impressionism Comes to America." *Gazette des Beaux-Arts*, ser. 6, 29 (Apr. 1946), pp. 225–52.

Isham, Samuel. *The History of American Painting*. New ed., with chaps. by Royal Cortissoz. New York, 1936.

Jackson, John Brinckerhoff. *American Space: The Centennial Years, 1865–1876*. New York, 1972.

Jacobs, Michael. *The Good and Simple Life: Artist Colonies in Europe and America*. Oxford, 1985.

James, Edward T., ed. *Notable American Women*. 3 vols. Cambridge, Mass., 1971.

James, Henry. *The American*. Boston, 1877.

———. *The Portrait of a Lady*. Boston, 1881.

Jewett, Sarah Orne. *Deephaven*. Boston, 1877. New ed. Boston and New York, 1894.

Johnson, Stephen Burge. *The Roof Gardens of Broadway Theatres, 1883–1942*. Ann Arbor, Mich., 1985.

Jones, Howard Mumford. *The Age of Energy: Varieties of American Experience, 1865–1915*. New York, 1970.

Kammen, Michael. *Mystic Chords of Memory: The Transformation of Tradition in American Culture*. New York, 1991.

———. *Meadows of Memory: Images of Time and Tradition in American Art and Culture*. Austin, Tex., 1992.

Kay, Joan Holtz. *Lost Boston*. Boston, 1980.

Kelly, Bruce, et al. *Art of the Olmsted Landscape: Exhibited at The Metropolitan Museum of Art*. 2 vols. Exh. cat. New York: New York City Landmarks Preservation Commission, 1981.

Kennedy, Lawrence W. *Planning the City upon a Hill: Boston Since 1630*. Amherst, Mass., 1992.

Kern, Stephen. *The Culture of Time and Space, 1880–1918*. Cambridge, Mass., 1983.

King, Moses. *The Back Bay District and the Vendome, Boston*. 3d ed. Boston, 1881.

———. *King's Handbook of New York City*. Boston, 1892.

Kouwenhoven, John A. *The Columbia Historical Portrait of New York*. Garden City, N.Y., 1953.

Larkin, Susan G. *On Home Ground: Elmer Livingston MacRae at the Holley House*. Exh. cat. Greenwich, Conn.: Historical Society of the Town of Greenwich, 1990.

Leach, William. *True Love and Perfect Union: The Feminist Reform of Sex and Society*. 2d ed. Middletown, Conn., 1989.

———. *Land of Desire: Merchants, Power, and the Rise of a New American Culture*. New York, 1993.

Lears, T. J. Jackson. *No Place of Grace: Antimodernism and the Transformation of American Culture, 1880–1920*. New York, 1981.

Leeds, Valerie Ann, et al. *At the Water's Edge: 19th and 20th Century American Beach Scenes*. Exh. cat. Tampa, Fla.: Tampa Museum of Art, 1989.

Lees, Andrew. *Cities Perceived: Urban Society in European and American Thought, 1820–1940*. Manchester, 1985.

Lester, Robin, et al. *Centuries of Childhood in New York*. Exh. cat. New York: New-York Historical Society, 1984.

Levine, Lawrence W. *Highbrow/Lowbrow: The Emergence of Cultural Hierarchy in America*. Cambridge, Mass., 1988.

Lightfoot, Frederick S., ed. *Nineteenth-Century New York in Rare Photographic Views*. New York, 1981.

Lindsay, Ben J., and Wainright Evans. *Revolt of Modern Youth*. New York, 1925.

———. *The Companionate Marriage*. 1927. Reprint, ed. Charles Larson. New York, 1977.

Lockman, DeWitt McClellan. Lockman Papers. New-York Historical Society. Microfilm, Archives of American Art, Smithsonian Institution, Washington, D.C.

Loftie, W[illiam] J[ohn]. *A Plea for Art in the House, with Special Reference to the Economy of Collecting Works of Art, and the Importance of Taste in Education and Morals*. Philadelphia, 1876.

Low, Will H. *A Chronicle of Friendships*. New York, 1908.

Lowenthal, David, and Martyn J. Bowden, eds. *Geographies of the Mind: Essays in Historical Geosophy in Honor of John Kirtland Wright*. New York, 1976.

Loyer, François. *Paris, Nineteenth Century: Architecture and Urbanism*. New York, 1988.

Lupton, Ellen. *Mechanical Brides: Women and Machines from Home to Office*. Exh. cat. New York: Cooper-Hewitt National Museum of Design, Smithsonian Institution, 1993.

Lynes, Russell. *The Art-Makers of Nineteenth-Century America*. New York, 1970.

McAllister, Ward. *Society As I Have Found It*. New York, 1890.

McCarthy, Kathleen D. *Women's Culture: American Philanthropy and Art, 1830–1930*. Chicago, 1991.

Matthews, Glenna. *"Just a Housewife": The Rise and Fall of Domesticity in America*. New York and Oxford, 1987.

Mayer, Grace M. *Once upon a City: New York from 1890 to 1910*. New York, 1958.

Meixner, Laura L. *An International Episode: Millet, Monet, and Their North American Counterparts*. Exh. cat. Memphis.: Dixon Gallery and Gardens, 1982.

Milroy, Elizabeth. *Painters of a New Century: The Eight and American Art*. Exh. cat. Milwaukee: Milwaukee Art Museum, 1991.

Mintz, Steven, and Susan Kellogg. *Domestic Revolutions: A Social History of American Family Life*. New York and London, 1988.

Mohl, Raymond A., ed. *The Making of Urban America*. Wilmington, Del., 1988.

Montgomery, David. *The Fall of the House of Labor: The Workplace, the State, and American Labor Activism, 1865–1925*. Cambridge and Paris, 1987.

Morgan, H. Wayne. *New Muses: Art in American Culture, 1865–1920*. Norman, Okla., 1978.

Morris, Lloyd. *Incredible New York: High Life and Low Life of the Last Hundred Years*. New York, 1951.

Mumford, Lewis. *The Brown Decades: A Study of the Arts in America, 1865–1895*. New York, 1931. Reprint. New York, 1971.

Mumford, Lewis, and Walter Muir Whitehill. *Back Bay Boston: The City as a Work of Art*. Exh. cat. Boston: Museum of Fine Arts, 1969.

Munro, Eleanor. *Originals: American Women Artists*. New York, 1979.

Myers, Julia Rowland. "The American Expatriate Painters of the French Peasantry, 1863–1893." Ph.D. diss., University of Maryland, College Park, 1989.

Nasaw, David. *Children of the City: At Work and at Play*. Garden City, N.Y., 1985.

Nochlin, Linda, ed. *Impressionism and Post-Impressionism, 1874–1904*. Englewood Cliffs, N.J., 1966.

Novak, Barbara, and Annette Blaugrund, eds. *Next to Nature: Landscape Paintings from the National Academy of Design*. Exh. cat. New York: National Academy of Design, 1980.

O'Brien, Maureen C. *In Support of Liberty:*

European Paintings at the 1883 Pedestal Fund Art Loan Exhibition. Exh. cat. Southampton, N.Y.: Parrish Art Museum, 1986.

Olsen, Donald J. *The City as a Work of Art: London, Paris, Vienna.* New Haven, 1986.

Peiss, Kathy. *Cheap Amusements: Working Women and Leisure in Turn-of-the-Century New York.* Philadelphia, 1986.

Perlman, Bennard B. *The Immortal Eight: American Painting from Eakins to the Armory Show (1870–1913).* New York, 1962.

Perlmann, Joel. *Ethnic Differences: Schooling and Social Structure Among the Irish, Italians, Jews, and Blacks in an American City, 1880–1935.* Cambridge, 1988.

Pilgrim, Dianne H. *American Impressionist and Realist Paintings and Drawings from the Collection of Mr. and Mrs. Raymond J. Horowitz.* Intro. John K. Howat. Exh. cat. New York: The Metropolitan Museum of Art, 1973.

Piron, Alice Marie O'Mara. "Urban Metaphor in American Art and Literature, 1910–1930." Ph.D. diss., Northwestern University, Evanston, Ill., 1982.

Pisano, Ronald G. *Long Island Landscape Painting, 1820–1920.* Boston, 1985.

———. *Idle Hours: Americans at Leisure, 1865–1914.* Boston, 1988.

Pivar, David J. *Purity Crusade: Sexual Morality and Social Control, 1868–1900.* Westport, Conn., 1973.

Pizer, Donald, ed. *American Thought and Writing: The 1890's.* Boston, 1972.

The Preserve of Childhood; Adult Artifice and Construction: Images of Late-Nineteenth-Century American Childhood. Exh. cat. Binghamton: University Art Gallery, State University of New York, 1985.

Quimby, Ian M. G., ed. *Material Culture and the Study of American Life.* New York, 1978.

Rayback, Joseph G. *A History of American Labor.* Expanded and updated. New York, 1966.

Reff, Theodore. *Manet and Modern Paris: One Hundred Paintings, Drawings, Prints, and Photographs by Manet and His Contemporaries.* Exh. cat. Washington, D.C.: National Gallery of Art, 1982.

Reiss, Steven A. *City Games: The Evolution of American Urban Society and the Rise of Sports.* Urbana, Ill., 1989.

Ricciotti, Dominic. "The Urban Scene: Images of the City in American Painting, 1890–1930." Ph.D. diss., Indiana University, Bloomington, 1977.

Riis, Jacob A. *How the Other Half Lives: Studies Among the Tenements of New York.* New York, 1890.

———. *The Children of the Poor.* New York, 1892.

———. *The Battle with the Slum.* New York, 1902.

Riley, Glenda. *Inventing the American Woman: A Perspective on Women's History.* Arlington Heights, Ill., 1986.

Robertson, Bruce. *Reckoning with Winslow Homer: His Late Paintings and Their Influence.* Exh. cat. Cleveland: Cleveland Museum of Art, 1990.

Rodgers, Daniel T. *The Work Ethic in Industrial America, 1850–1920.* Chicago, 1978.

Rosen, Ruth. *The Lost Sisterhood: Prostitution in America, 1900–1918.* Baltimore, 1982.

Rosenzweig, Roy. *Eight Hours for What We Will: Workers and Leisure in an Industrial City, 1870–1920.* Cambridge, 1983.

Ross, Ishbel. *Taste in America.* New York, 1967.

Rothman, Sheila M. *Woman's Proper Place: A History of Changing Ideals and Practices, 1870 to the Present.* New York, 1978.

Rudofsky, Bernard. *The Unfashionable Human Body.* Garden City, N.Y., 1971.

Russell, Douglas A. *Costume History and Style.* Englewood Cliffs, N.J., 1983.

Rybczynski, Witold. *Waiting for the Weekend.* New York, 1991.

Saisselin, Rémy G. *The Bourgeois and the Bibelot.* New Brunswick, N.J., 1984.

Sante, Luc. *Low Life: Lures and Snares of Old New York.* New York, 1991.

Schlereth, Thomas J. *Victorian America: Transformations in Everyday Life, 1876–1915.* New York, 1991.

Schlesinger, Arthur M., Jr. *The Almanac of American History.* New York, 1983.

Schmitt, Peter J. *Back to Nature: The Arcadian Myth in Urban America.* New York, 1969.

Schoener, Allon, ed. *The Lower East Side: Portal to American Life, 1870–1924.* Exh. cat. New York: Jewish Museum, 1966.

———, comp. *Portal to America: The Lower East Side, 1870–1924, Photographs and Chronicles.* New York, 1967.

Sellin, David. *Americans in Brittany and Normandy, 1860–1910.* Exh. cat. Phoenix: Phoenix Art Museum, 1982.

Shackelford, George T. M., and Mary Tavener Holmes. *A Magic Mirror: The Portrait in France, 1700–1900.* Exh. cat. Houston: Museum of Fine Arts, 1986.

Sheldon, George William. *Recent Ideals of American Art: One Hundred and Seventy-five Oil Paintings and Water Colors in the Galleries of Private Collectors, Reproduced in Paris on Copper Plates by the Goupil Photogravure and Typogravure Processes.* New York and London, 1888–90. Reprint. New York, 1977.

Skeggs, Douglas. *River of Light: Monet's Impressions of the Seine.* New York, 1987.

Smith, F. Hopkinson. *Book of the Tile Club.* Boston, 1886.

Smith, Red, et al. *Champions of American Sport.* Exh. cat. Washington, D.C.: National Portrait Gallery, Smithsonian Institution, 1981.

Smuts, Robert W. *Women and Work in America.* 2d ed. New York, 1972.

Snitow, Ann, Christine Stansell, and Sharon Thompson, eds. *Powers of Desire: The Politics of Sexuality.* New York, 1983.

Special Exhibition: Works in Oil and Pastel by the Impressionists of Paris. Exh. cat. New York: National Academy of Design, 1886.

Steffens, Lincoln. *The Autobiography of Lincoln Steffens.* New York, 1931.

Stein, Roger B. *John Ruskin and Aesthetic Thought in America, 1840–1900.* Cambridge, Mass., 1967.

Stern, Robert A. M., Gregory Gilmartin, and John Montague Massengale. *New York 1900: Metropolitan Architecture and Urbanism, 1890–1915.* New York, 1983.

Stilgoe, John R. *Metropolitan Corridor: Railroads and the American Scene.* New Haven, 1983.

Strahan, Edward [Earl Shinn]. *The Art Treasures of America.* 3 vols. Philadelphia, 1879–[82]. Reprint. New York, 1977.

Strasser, Susan. *Never Done: A History of American Housework.* New York, 1982.

Stuckey, Charles F., and William P. Scott, with the assistance of Suzanne G. Lindsay. *Berthe Morisot: Impressionist.* Exh. cat. South Hadley, Mass.: Mount Holyoke College Art Museum; Washington, D.C.: National Gallery of Art, 1987.

Susman, Warren I. *Culture as History: The Transformation of American Society in the Twentieth Century.* New York, 1984.

Sutcliffe, Anthony, ed. *Metropolis, 1890–1940.* Chicago, 1984.

Taine, H[ippolyte]. *Lectures on Art* (1865). Trans. John Durand. 2 vols. New York, 1875.

Tauranac, John. *Elegant New York: The Builders and the Buildings, 1885–1915.* New York, 1985.

Thaxter, Celia. *An Island Garden.* Boston and New York, 1894.

Trachtenberg, Alan. *The Incorporation of America: Culture and Society in the Gilded Age.* New York, 1982.

Troyen, Carol. *The Boston Tradition: American Paintings from the Museum of Fine Arts, Boston.* Exh. cat. New York: American Federation of Arts, 1980.

Tucker, Paul Hayes. *Monet in the '90s: The Series Paintings.* Exh. cat. Boston: Museum of Fine Arts, 1989.

Van Dyke, John C. *The New New York: A Commentary on the Place and the People.* New York, 1909.

van Hoogstraten, Nicholas. *Lost Broadway Theatres.* New York, 1991.

Van Rensselaer, M[ariana] G[riswold]. *Book of American Figure Painters*. Philadelphia, 1886.

Van Vorst, Mrs. John, and Miss Marie Van Vorst. *The Woman Who Toils: Being the Experiences of Two Ladies as Factory Girls*. New York, 1903.

Ward, James A. *Railroads and the Character of America, 1820–1887*. Knoxville, Tenn., 1986.

Warner, Sam Bass, Jr. *Streetcar Suburbs: The Process of Growth in Boston, 1870–1900*. 2d ed. Cambridge, Mass., 1978.

Waters, Ronald G. *Primers for Prudery: Sexual Advice to Victorian America*. Englewood Cliffs, N.J., 1974.

Watson, Edward B. *New York Then and Now: 83 Manhattan Sites Photographed in the Past and in the Present*. New York, 1976.

Weber, Bruce, and William H. Gerdts. *In Nature's Ways: American Landscape Painting of the Late Nineteenth Century*. Exh. cat. West Palm Beach, Fla.: Norton Gallery of Art, 1987.

Weible, Robert, ed. *Essays from the Lowell Conference on Industrial History, 1982 and 1983:*

The Arts and Industrialism; the Industrial City. North Andover, Mass., 1985.

Weinberg, H. Barbara. "Robert Reid: 'Academic Impressionist.'" *Archives of American Art Journal* 15, no. 1 (1975), pp. 2–11.

———. "American Impressionism in Cosmopolitan Context." *Arts Magazine* 55 (Nov. 1980), pp. 160–65.

———. *The Lure of Paris: Nineteenth-Century American Painters and Their French Teachers*. New York, 1991.

Weisberg, Gabriel P., ed. *The European Realist Tradition: French Painting and Drawing, 1830–1900*. Exh. cat. Cleveland: Cleveland Museum of Art, 1980.

———. *Beyond Impressionism: The Naturalist Impulse*. New York, 1992.

Weiss, Horace John, ed. *The Origins of Modern Consciousness*. Detroit, 1965.

Wharton, Edith. *The House of Mirth*. London, 1905.

Whitehill, Walter Muir. *Boston, a Topographical History*. 2d ed., enlarged. Cambridge, Mass., 1968.

Wiebe, Robert H. *The Search for Order, 1877–1920*. New York, 1967.

Wilson, Richard Guy, ed. *Victorian Resorts and Hotels: Essays from a Victorian Society Autumn Symposium*. Philadelphia, 1982.

Winsor, Justin, ed. *The Memorial History of Boston*. 4 vols. Boston, 1881.

Woloch, Nancy. *Women and the American Experience*. New York, 1984.

Works in Oil and Pastel by the Impressionists of Paris. Exh. cat. New York: American Art Association, 1886.

Zaitzevsky, Cynthia. *Frederick Law Olmsted and the Boston Park System*. Cambridge, Mass., 1982.

Zelizer, Viviana. *Pricing the Priceless Child: The Changing Social Value of Children*. New York, 1985.

Ziff, Larzer. *The American 1890s: Life and Times of a Lost Generation*. New York, 1966.

Zurier, Rebecca. "Picturing the City: New York in the Press and Art of the Ashcan School, 1890–1917." Ph.D. diss., Yale University, New Haven, 1988.

WORKS IN THE EXHIBITION

The paintings appear in all venues, except as specified.

MMA The Metropolitan Museum of Art,
 New York
ACM Amon Carter Museum, Fort Worth
DAM The Denver Art Museum
LACMA Los Angeles County Museum of Art

CECILIA BEAUX

1. *Ernesta (Child with Nurse)*, 1894
Oil on canvas, 50½ x 38⅛ in. (128.3 x 96.8 cm)
The Metropolitan Museum of Art, New York,
Maria DeWitt Jesup Fund, 1965 65.49

GEORGE BELLOWS

2. *Cliff Dwellers*, 1913
Oil on canvas, 40¼ x 42⅛ in. (102.2 x 107 cm)
Los Angeles County Museum of Art, Los Angeles
County Funds 16.4

3. *Club Night*, 1907
Oil on canvas, 43 x 53 in. (109.2 x 134.6 cm)
National Gallery of Art, Washington, D.C.,
John Hay Whitney Collection 1982.76.1

4. *Kids*, 1906
Oil on canvas, 32 x 42 in. (81.3 x 106.7 cm)
Collection of Rita and Daniel Fraad
MMA/LACMA only

5. *A Morning Snow—Hudson River*, 1910
Oil on canvas, 45⅜ x 63¼ in. (115.3 x 160.7 cm)
The Brooklyn Museum, New York, Gift of
Mrs. Daniel Catlin 51.96
MMA only

6. *Polo at Lakewood*, 1910
Oil on canvas, 45¼ x 63½ in. (114.9 x 161.3 cm)
Columbus Museum of Art, Ohio, Columbus Art
Association Purchase 11.1
MMA/LACMA only

7. *Rain on the River*, 1908
Oil on canvas, 32¼ x 38¼ in. (81.9 x 97.2 cm)
Museum of Art, Rhode Island School of Design,
Providence, Jesse Metcalf Fund 15.063

8. *The Studio*, 1919
Oil on canvas, 48 x 38 in. (121.9 x 96.5 cm)
Collection of Rita and Daniel Fraad
MMA/ACM only

FRANK W. BENSON

9. *Lady Trying on a Hat (The Black Hat)*, 1904
Oil on canvas, 40 x 32 in. (101.6 x 81.3 cm)
Museum of Art, Rhode Island School of Design,
Providence, Gift of Walter Callender, Henry D.
Sharpe, Howard L. Clark, William Gammell, and
Isaac C. Bates 06.002

JOHN LESLIE BRECK

10. *Grey Day on the Charles*, 1894
Oil on canvas, 18 x 22 in. (45.7 x 55.9 cm)
Virginia Museum of Fine Arts, Richmond, The V. J.
Harwood and Louise B. Cochrane Fund for American
Art 90.151

DENNIS MILLER BUNKER

11. *The Pool, Medfield*, 1889
Oil on canvas, 18 x 24 in. (45.7 x 61 cm)
Museum of Fine Arts, Boston, Emily L. Ainsley
Fund 45.475
MMA/ACM only

MARY CASSATT

12. *At the Opera*, 1879
Oil on canvas, 31½ x 25½ in. (80 x 64.8 cm)
Museum of Fine Arts, Boston, The Hayden
Collection 10.35

13. *The Bath*, 1891–92
Oil on canvas, 39½ x 26 in. (100.3 x 66 cm)
The Art Institute of Chicago, Robert A. Waller
Fund 1910.2
MMA only

14. *Lady at the Tea Table*, 1885
Oil on canvas, 29 x 24 in. (73.7 x 61 cm)
The Metropolitan Museum of Art, New York,
Gift of Mary Cassatt, 1923 23.101
MMA only

15. *Lydia Crocheting in the Garden at Marly*, 1880
Oil on canvas, 26 x 37 in. (66 x 94 cm)
The Metropolitan Museum of Art, New York,
Gift of Mrs. Gardner Cassatt, 1965 65.184

16. *Mother About to Wash Her Sleepy Child*, 1880
Oil on canvas, 39½ x 25¾ in. (100.3 x 65.4 cm)
Los Angeles County Museum of Art, Mrs. Fred
Hathaway Bixby Bequest M.62.8.14
ACM/DAM/LACMA only

17. *Reading Le Figaro*, 1878
Oil on canvas, 39½ x 32 in. (100.3 x 81.3 cm)
Private collection
MMA only

WILLIAM MERRITT CHASE

18. *At the Seaside*, ca. 1892
Oil on canvas, 20 x 34 in. (50.8 x 86.4 cm)
The Metropolitan Museum of Art, New York, Bequest
of Miss Adelaide Milton de Groot (1876–1967),
1967 67.187.123

19. *The Fairy Tale*, 1892
Oil on canvas, 16½ x 24½ in. (41.9 x 62.2 cm)
Collection of Mrs. and Mrs. Raymond J. Horowitz
MMA/ACM only

20. *Idle Hours*, ca. 1894
Oil on canvas, 25½ x 35½ in. (64.8 x 90.2 cm)
Amon Carter Museum, Fort Worth 1982.1

21. *In the Studio*, ca. 1880
Oil on canvas, 28⅛ x 40⅛ in. (71.4 x 101.9 cm)
The Brooklyn Museum, New York, Gift of Mrs.
Carll H. de Silver in memory of her husband 13.50

22. *James Abbott McNeill Whistler*, 1885
Oil on canvas, 74⅛ x 36¼ in. (188.3 x 92.1 cm)
The Metropolitan Museum of Art, New York, Bequest
of William H. Walker, 1918 18.22.2

23. *The Lake for Miniature Yachts*, ca. 1890
Oil on canvas, 16 x 24 in. (40.6 x 61 cm)
Collection of Peter G. Terian, New York
MMA/ACM only

24. *Portrait of Miss Dora Wheeler*, 1883
Oil on canvas, 62½ x 65¼ in. (158.8 x 165.7 cm)
The Cleveland Museum of Art, Gift of Mrs. Boudinot
Keith, in memory of Mr. and Mrs. J.H. Wade 21.1239
MMA only

25. *Prospect Park, Brooklyn*, ca. 1886
Oil on canvas, 17⅜ x 22⅜ in. (44.1 x 56.8 cm)
Colby College Museum of Art, Waterville, Maine,

Gift of Miss Adeline F. and Miss Caroline R. Wing
63-P-036

26. *Ring Toss*, 1896
Oil on canvas, 40⅜ x 35⅛ in. (102.6 x 89.2 cm)
Mr. and Mrs. Hugh Halff, Jr.

WILLIAM GLACKENS

27. *Central Park in Winter*, ca. 1905
Oil on canvas, 25 x 30 in. (63.5 x 76.2 cm)
The Metropolitan Museum of Art, New York,
George A. Hearn Fund, 1921 21.164

28. *Chez Mouquin*, 1905
Oil on canvas, 48 x 39 in. (121.9 x 99.1 cm)
The Art Institute of Chicago, Friends of American
Art 1925.295

29. *Hammerstein's Roof Garden*, ca. 1901
Oil on canvas, 30 x 25 in. (76.2 x 63.5 cm)
Whitney Museum of American Art, New York,
Purchase 53.46
MMA/ACM only

30. *The Shoppers*, 1907
Oil on canvas, 60 x 60 in. (152.4 x 152.4 cm)
The Chrysler Museum, Norfolk, Virginia, Gift of
Walter P. Chrysler, Jr. 71.651

CHILDE HASSAM

31. *Allies Day, May 1917*, 1917
Oil on canvas, 36¾ x 30¼ in. (93.4 x 76.8 cm)
National Gallery of Art, Washington, D.C.,
Gift of Ethelyn McKinney in memory of her brother,
Glenn Ford McKinney 1943.9.1

32. *At the Florist*, 1889
Oil on canvas, 36¾ x 54¼ in. (93.4 x 137.8 cm)
The Chrysler Museum, Norfolk, Virginia, Gift of
Walter P. Chrysler, Jr. 71.500

33. *Charles River and Beacon Hill*, ca. 1892
Oil on canvas, 18⅞ x 20⅞ in. (47.9 x 53 cm)
Museum of Fine Arts, Boston, Tompkins Collection
1978.178

34. *The Church at Gloucester*, 1918
Oil on canvas, 30 x 25 in. (76.2 x 63.5 cm)
The Metropolitan Museum of Art, New York,
Arthur Hoppock Hearn Fund, 1925 25.206

35. *In the Garden (Celia Thaxter in Her Garden)*,
1892
Oil on canvas, 22⅛ x 18⅛ in. (56.2 x 46 cm)
National Museum of American Art, Smithsonian
Institution, Washington, D.C., Gift of John Gellatly,
1929 1929.6.52

36. *Late Afternoon, New York: Winter*, 1900
Oil on canvas, 37 x 29 in. (94 x 73.7 cm)
The Brooklyn Museum, New York, Dick S. Ramsay
Fund 62.68

37. *Poppies*, 1891
Oil on canvas, 19¼ x 24 in. (50.2 x 61 cm)
Collection of Mr. and Mrs. Raymond J. Horowitz
MMA/ACM only

38. *The Room of Flowers*, 1894
Oil on canvas, 34 x 34 in. (86.4 x 86.4 cm)
Private collection
MMA only

39. *Union Square in Spring*, 1896
Oil on canvas, 21½ x 21 in. (54.6 x 53.3 cm)
Smith College Museum of Art, Northampton,
Massachusetts, Purchase, 1905 1905:3-1

CHARLES WEBSTER HAWTHORNE

40. *The Story*, ca. 1898–99
Oil on canvas, 48 x 30 in. (121.9 x 76.2 cm)
Hirshhorn Museum and Sculpture Garden,
Smithsonian Institution, Washington, D.C., Gift of
Joseph H. Hirshhorn, 1966 66.2410

ROBERT HENRI

41. *The Art Student (Miss Josephine Nivison)*, 1906
Oil on canvas, 77¼ x 38½ in. (196.2 x 97.8 cm)
Milwaukee Art Museum, Purchase M1965.34

42. *At Far Rockaway*, 1902
Oil on canvas, 26 x 32 in. (66 x 81.3 cm)
Private collection

43. *George Luks*, 1904
Oil on canvas, 76½ x 38¼ in. (194.3 x 97.2 cm)
National Gallery of Canada, Ottawa 9587
MMA/ACM only

44. *Street Scene with Snow (57th Street, N.Y.C.)*,
1902
Oil on canvas, 26 x 32 in. (66 x 81.3 cm)
Yale University Art Gallery, New Haven, The Mabel
Brady Garvan Collection 1947.185

ROCKWELL KENT

45. *Maine Coast*, 1907
Oil on canvas, 34⅛ x 44⅛ in. (86.7 x 112.1 cm)
The Cleveland Museum of Art, Hinman B. Hurlbut
Collection 1132.22

ERNEST LAWSON

46. *Spring Night, Harlem River*, 1913
Oil on canvas mounted on wood, 25⅛ x 30⅛ in.
(63.8 x 76.5 cm)
The Phillips Collection, Washington, D.C. 1191

GEORGE LUKS

47. *Bleecker and Carmine Streets*, ca. 1915
Oil on canvas, 25 x 30 in. (63.5 x 76.2 cm)
Milwaukee Art Museum, Gift of Mr. and Mrs.
Donald Abert and Mrs. Barbara Abert Tooman
M1976.14

48. *Hester Street*, 1905
Oil on canvas, 26⅛ x 36⅛ in. (66.4 x 91.8 cm)
The Brooklyn Museum, New York, Dick S. Ramsay
Fund 40.339

49. *Roundhouse at High Bridge*, 1909–10
Oil on canvas, 30⅜ x 36¼ in. (77.2 x 92.1 cm)
Munson-Williams-Proctor Institute, Museum of Art,
Utica, New York 50.17

50. *The Spielers*, 1905
Oil on canvas, 36⅛ x 26¼ in. (91.8 x 66.7 cm)
Addison Gallery of American Art, Phillips Academy,
Andover, Massachusetts, gift of anonymous donor
1931.9
MMA/ACM/DAM only

ALFRED MAURER

51. *An Arrangement*, 1901
Oil on cardboard, 36 x 31⅞ in. (91.4 x 81 cm)
Whitney Museum of American Art, New York,
Gift of Mr. and Mrs. Hudson D. Walker 50.13
MMA/ACM

52. *Jeanne*, ca. 1904
Oil on canvas, 74¾ x 39⅛ in. (189.9 x 100 cm)
Collection of Mrs. Wendell Cherry
MMA only

WILLARD METCALF

53. *Battery Park, Spring*, 1902
Oil on canvas, 26 x 29 in. (66 x 73.7 cm)
Private collection

54. *Cornish Hills*, 1911
Oil on canvas, 60 x 40 in. (152.4 x 101.6 cm)
Thomas W. and Ann M. Barwick

55. *Gloucester Harbor*, 1895
Oil on canvas, 26 x 28¾ in. (66 x 73 cm)
Mead Art Museum, Amherst College, Massachusetts,
Gift of George D. Pratt, Class of 1893 P1932.16

56. *The Ten Cent Breakfast*, 1887
Oil on canvas, 15¼ x 22 in. (38.7 x 55.9 cm)
The Denver Art Museum, The T. Edward and Tullah
Hanley Memorial Gift to the People of Denver and
the Area 1974.418

MAURICE PRENDERGAST

57. *Central Park*, ca. 1908–10
Oil on canvas, 20¾ x 27 in. (52.7 x 68.6 cm)
The Metropolitan Museum of Art, New York,
George A. Hearn Fund, 1950 50.25

THEODORE ROBINSON

58. *At the Piano*, 1887
Oil on canvas, 16½ x 25¼ in. (41.9 x 64.1 cm)
National Museum of American Art, Smithsonian
Institution, Washington, D.C., Gift of John Gellatly
1929.6.90

59. *A Bird's-Eye View*, 1889
Oil on canvas, 25¾ x 32 in. (65.4 x 81.3 cm)
The Metropolitan Museum of Art, New York,
Gift of George A. Hearn, 1910 10.64.9

60. *Low Tide*, 1894
Oil on canvas, 16 x 22¼ in. (40.6 x 56.5 cm)
Manoogian Collection
DAM/LACMA only

61. *Low Tide, Riverside Yacht Club*, 1894
Oil on canvas, 18 x 24 in. (45.7 x 61 cm)
Mr. and Mrs. Raymond J. Horowitz
MMA/ACM only

62. *Port Ben, Delaware and Hudson Canal*, 1893
Oil on canvas, 28¼ x 32¼ in. (71.8 x 81.9 cm)
Pennsylvania Academy of the Fine Arts, Philadelphia,
Gift of the Society of American Artists as a memorial
to Theodore Robinson 1900.5

JOHN SINGER SARGENT

63. *In the Luxembourg Gardens*, 1879
Oil on canvas, 25½ x 36 in. (64.8 x 91.4 cm)

Philadelphia Museum of Art, The John G. Johnson Collection J.C.1080

64. *Mr. and Mrs. I.N. Phelps Stokes*, 1897
Oil on canvas, 84¼ x 39¾ in. (214 x 101 cm)
The Metropolitan Museum of Art, New York,
Bequest of Edith Minturn Phelps Stokes (Mrs. I.N.),
1938 38.104

65. *Paul Helleu Sketching with His Wife*, 1889
Oil on canvas, 26⅛ x 32⅛ in. (66.4 x 81.6 cm)
The Brooklyn Museum, New York, Museum
Collection Fund 20.640

66. *The Sketchers*, 1914
Oil on canvas, 22 x 28 in. (55.9 x 71.1 cm)
Virginia Museum of Fine Arts, Richmond, The Arthur
and Margaret Glasgow Fund 58.11

EVERETT SHINN

67. *The Orchestra Pit, Old Proctor's Fifth Avenue
Theatre*, ca. 1906–7
Oil on canvas, 17¼ x 19½ in. (43.8 x 49.5 cm)
Collection of Arthur G. Altschul

EDWARD E. SIMMONS

68. *Boston Public Garden*, 1893
Oil on canvas, 18 x 26 in. (45.7 x 66 cm)
Daniel J. Terra Collection 34.1984

JOHN SLOAN

69. *Backyards, Greenwich Village*, 1914
Oil on canvas, 26 x 32 in. (66 x 81.3 cm)
Whitney Museum of American Art, New York,
Purchase 36.153
MMA/ACM only

70. *Chinese Restaurant*, 1909
Oil on canvas, 26 x 32 in. (66 x 81.3 cm)
Memorial Art Gallery of the University of Rochester,
New York, Marion Stratton Gould Fund 51.12

71. *The Cot*, 1907
Oil on canvas, 36¼ x 30 in. (92.1 x 76.2 cm)
Bowdoin College Museum of Art, Brunswick, Maine,
Bequest of George Otis Hamlin, 1961

72. *Easter Eve*, 1907
Oil on canvas, 32 x 26 in. (81.3 x 66 cm)
Collection of Deborah and Edward Shein

73. *Gloucester Harbor*, 1916
Oil on canvas, 26 x 32 in. (66 x 81.3 cm)
Syracuse University Art Collection, New York
S.U.62.61

74. *McSorley's Bar*, 1912
Oil on canvas, 26 x 32 in. (66 x 81.3 cm)
The Detroit Institute of Arts, Gift of the Founders'
Society 24.2

75. *The Picnic Grounds*, 1906–7
Oil on canvas, 24 x 36 in. (61 x 91.4 cm)
Whitney Museum of American Art, New York,
Purchase 41.34
MMA/ACM only

76. *Sunday, Women Drying Their Hair*, 1912
Oil on canvas, 26 x 32 in. (66 x 81.3 cm)
Addison Gallery of American Art, Phillips Academy,
Andover, Massachusetts
MMA/ACM/DAM only

77. *A Woman's Work*, 1912
Oil on canvas, 31⅝ x 25¾ in. (80.3 x 65.4 cm)
The Cleveland Museum of Art, Gift of Amelia
Elizabeth White 64.160

EDMUND C. TARBELL

78. *The Breakfast Room*, ca. 1903
Oil on canvas, 25 x 30 in. (63.5 x 76.2 cm)
Pennsylvania Academy of the Fine Arts, Philadelphia,
Gift of Clement B. Newbold 1975.25.3

79. *In the Orchard*, 1891
Oil on canvas, 60¾ x 65½ in. (154.3 x 166.4 cm)
Daniel J. Terra Collection 1.1992
MMA/ACM only

80. *Three Sisters—A Study in June Sunlight*, 1890
Oil on canvas, 35⅛ x 40⅛ in. (89.2 x 102.2 cm)
Milwaukee Art Museum, Gift of Mrs. Montgomery
Sears, Boston M1925.1

JOHN H. TWACHTMAN

81. *Icebound*, 1889–1900
Oil on canvas, 25¼ x 30⅛ in. (64.1 x 76.5 cm)
The Art Institute of Chicago, Friends of American
Art Collection 1917.200

82. *View from the Holley House, Winter*, ca. 1901
Oil on canvas, 25⅛ x 25⅛ in. (63.8 x 63.8 cm)
Hevrdejs Collection of American Art

J. ALDEN WEIR

83. *The Factory Village*, 1897
Oil on canvas, 29 x 38 in. (73.7 x 96.5 cm)
The Metropolitan Museum of Art, New York, Jointly
owned by The Metropolitan Museum of Art (through
Gift of Cora Weir Burlingham) and The Weir Farm
Heritage Trust, Inc., 1979 1979.487

84. *The Red Bridge*, ca. 1895
Oil on canvas, 24¼ x 33¼ in. (61.6 x 84.5 cm)
The Metropolitan Museum of Art, New York,
Gift of Mrs. John A. Rutherfurd, 1914 14.141

THEODORE WENDEL

85. *Bridge at Ipswich*, ca. 1905
Oil on canvas, 24¼ x 30 in. (61.6 x 76.2 cm)
Museum of Fine Arts, Boston, Gift of Mr. and
Mrs. Daniel S. Wendel, Tompkins Collection, and
Seth K. Sweetser Fund, by exchange 1978.179

LENDERS TO THE EXHIBITION

Addison Gallery of American Art, Phillips Academy, Andover, Massachusetts 50, 76

Amon Carter Museum, Fort Worth 20

The Art Institute of Chicago 13, 28, 81

Bowdoin College Museum of Art, Brunswick, Maine 71

The Brooklyn Museum, New York 5, 21, 36, 48, 65

The Chrysler Museum, Norfolk, Virginia 30, 32

The Cleveland Museum of Art 24, 45, 77

Colby College Museum of Art, Waterville, Maine 25

Columbus Museum of Art, Ohio 6

The Denver Art Museum 56

The Detroit Institute of Arts 74

Hirshhorn Museum and Sculpture Garden, Smithsonian Institution, Washington, D.C. 40

Los Angeles County Museum of Art 2, 16

Mead Art Museum, Amherst College, Massachusetts 55

Memorial Art Gallery, University of Rochester, New York 70

The Metropolitan Museum of Art, New York 1, 14, 15, 18, 22, 27, 34, 57, 59, 64, 83, 84

Milwaukee Art Museum 41, 47, 80

Munson-Williams-Proctor Institute, Museum of Art, Utica, New York 49

Museum of Art, Rhode Island School of Design, Providence 7, 9

Museum of Fine Arts, Boston 11, 12, 33, 85

National Gallery of Art, Washington, D.C. 3, 31

National Gallery of Canada, Ottawa 43

National Museum of American Art, Smithsonian Institution, Washington, D.C. 35, 58

Pennsylvania Academy of the Fine Arts, Philadelphia 62, 78

Philadelphia Museum of Art, The John G. Johnson Collection 63

The Phillips Collection, Washington, D.C. 46

Smith College Museum of Art, Northampton, Massachusetts 39

Syracuse University Art Collection, New York 73

Virginia Museum of Fine Arts, Richmond 10, 66

Weir Farm Heritage Trust, Inc., Wilton, Connecticut 83

Whitney Museum of American Art, New York 29, 51, 69, 75

Yale University Art Gallery, New Haven 44

Arthur G. Altschul 67

Thomas W. and Ann M. Barwick 54

Mrs. Wendell Cherry 52

Rita and Daniel Fraad 4, 8

Mr. and Mrs. Hugh Halff, Jr. 26

Hevrdejs Collection of American Art 82

Mr. and Mrs. Raymond J. Horowitz 19, 37, 61

Manoogian Collection 60

Deborah and Edward Shein 72

Peter G. Terian, New York 23

The Honorable Daniel J. Terra 68, 79

Anonymous lenders 17, 38, 42, 53

INDEX

bathtub, tenement, 279
Battery Park (New York City), *Battery Park, Spring* (Metcalf), 162–65, *163*
Baudelaire, Charles, 3, 15, 136, 142, 252, 270
Bayberry Bush, The (The Chase Homestead, Shinnecock Hills) (Chase), 109, *109*
Bayonne (New Jersey), *Picnic Grounds* (Sloan), 161–62, *161*
beaches, 95, 100–102
 At Far Rockaway (Henri), 88–89, 112–14, *113*
 At the Seaside (Chase), 112, 113–14, 117, *119*
 Baby Is King (Beach Scene) (Bricher), 106, *106*
 The Beach at Villerville (Boudin), 102, *102*
 Beach Scene (Carr), 104–5, *104*, 113
 Beach Side (Glackens), 120, *121*
 Eagle Head, Manchester, Massachusetts (High Tide) (Homer), 113, *113*
 Eaton's Neck, Long Island (Kensett), 99, 103, *103*
 End of the Season (Chase), 106, *107*
 A Holiday (Potthast), 121, *121*
 of Long Island, 103–5
 Manhattan Beach (Brooklyn, New York City), 102
 Revere Beach (Prendergast), 121–22, *121*
 Rockaway Beach (photograph), *119*
 Rockaway Beach, Long Island, New York (Blakelock), *104*
 The Schooner "Progress" Wrecked at Coney Island, July 4th, 1874 (Silva), 104, *104*
 South Beach Bathers (Sloan), 119, *120*
Beach Scene (Carr), 104–5, *104*, 113
Beach Side (Glackens), *120*, 121
Beacon Hill (Boston), *Charles River and Beacon Hill* (Hassam), 2–3, 175–78, *176*
Beacon Street (Boston), 177
Beaman, Charles C., 64
Beaman picnic, 93
Beaux, Cecilia
 background of, 5, 291
 biography of, 346
 Les Derniers Jours d'enfance, 291–93, *293*
 Ernesta (Child with Nurse), 291, *292*
 Mr. and Mrs. Anson Phelps Stokes, 258–60, *259*
Beck, Hubert, 174
Belasco, David, 24
Bellamy, Edward, 4
Bellows, Emma, 46, 47, 48
Bellows, George
 background of, 4, 5, 33, 55, 85, 87, 98
 biography of, 347
 Both Members of This Club, 234, 236, 240, 242
 brushwork of, 303–4
 Cliff Dwellers, 194, 196, 199, 301
 Club Night, 234–37, *235*, 242
 commercial success of, 24
 Crowd at Polo, 242, 244, *244*
 Eakins compared to, 238
 Forty-two Kids, 303–4, *304*
 Frankie the Organ Boy, 303
 Kids, 261, 301–3, *302*
 The Law Is Too Slow (lithograph), 240, *240*
 on "living art," 49
 A Morning Snow—Hudson River, 171–73, *172*
 Paddy Flannigan, 303, *304*
 on painting street scenes, 135
 Polo at Lakewood, 240, *241*, 243–44

Polo Game, 240, 242, 244
Rain on the River, 168–71, *170*
River Rats, 303
Stag at Sharkey's, 234, 236, *237*, 242
studio of
 photograph, 48, *48*
 The Studio, 34–35, 43–48, *47*
The White Hope (lithograph), 240, *240*
Why Don't They Go to the Country for a Vacation? (lithograph), 195, *196*
Bellport (Long Island, New York), 95, 98
 Beach Side (Glackens), 120, *121*
Benjamin, Samuel G. W., 43
Bennett, *Five Penny Fan*, 228
Benson, Frank W.
 background of, 5, 25, 160
 biography of, 347–48
 Lady Trying on a Hat (The Black Hat), 267–69, *268*, 273
 as member of The Ten, 22
Benson, Susan Porter, 277
Bensonhurst (Brooklyn, New York City), 105
Béraud, Jean, 143, 173, 178
 The Church of Saint-Philippe-du-Roule, 174, *175*
Bergengren, Ralph, short story by, 290
Berkin, Carol Ruth, 181
Between Rounds (Eakins), 238, *239*
Beverly Farms (Massachusetts), 123
Bierstadt, Albert, 63, 99
Birch, Charles, 96, *97*
Birch, Reginald, 96, 97
Birch, Thomas, 99
Bird's Eye View, A (Robinson), 56, *57*
birth control, 252
Bishop, Isabel, 189
Bishop, William H., 105
Bisland, Elizabeth, 250
Black Hat, The (Lady Trying on a Hat) (Benson), 267–69, *268*, 273
blacks. *See* African-Americans
Blakelock, Albert, *Rockaway Beach, Long Island, New York*, 104
Blaney, Dwight, 24
Bleecker and Carmine Streets (Luks), 193, 195–96
Blow-Me-Down Brook (Cornish, New Hampshire), 64, 65
Blue Cup, The (DeCamp), 257, *258*
Blue Point (Long Island, New York), 85
Boardman, Elijah, Earl's portrait of, 251–52, *251*
Boardman, Esther, Earl's portrait of, 251, *251*
boats
 A Basket of Clams (Homer), 124, *127*
 Boating (Manet), 20, *21*
 Boats at a Landing (Robinson), 75, *75*
 E. M. J. Betty (Robinson), 71–72, *73*
 Excursion of the Harem (Gérôme), 28, *29*
 Gloucester Harbor (Hassam), 127, *128*
 Gloucester Harbor (Sloan), 127–30, *129*
 Low Tide, Riverside Yacht Club (Robinson), 72, 74, *75*
 Low Tide (Robinson), 72, 74, 75
 Maine Coast (Kent), 86, *87*
 Max Schmitt in a Single Scull (The Champion Single Sculls) (Eakins), 28, *29*
 A Morning Snow—Hudson River (Bellows), 171–73, *172*
 Rain on the River (Bellows), 168–71, *170*
 See also ships
Boats at a Landing (Robinson), 75, *75*

Bois de Boulogne (Paris), 178, *179*
Bonnard, Pierre, 158
Boone, Mary Stanley, 293
Boothbay Harbor (Maine), 98
Boston
 commuting to the North Shore from, 123
 culture in, 253
 immigration to, 173
 Impressionist exhibitions in, 20, 22
 See also Back Bay; Beacon Hill; Boston Public Garden; Charles River; Columbus Avenue; Fenway Court; Franklin Park; Revere Beach; St. Botolph Club
Boston and Maine Railroad, 123
Boston Public Garden, 158
 Boston Public Garden (Simmons), 152–55, *153*, 177
 Large Boston Public Garden Sketchbook (Prendergast), 160, *160*
 photograph of, 154, *154*
Boston School, 160, 257
Boston Store (Chicago), 273
Both Members of This Club (Bellows), 234, 236, 240, 242
Boudin, Eugène, 107, 121
 The Beach at Villerville, 102, *102*
boudoir scenes, 264, 265–67, *266*
Bouguereau, Adolphe-William, 18, 28, 32
Boulanger, Gustave-Rodolphe, 178
Bourget, Paul Charles Joseph, 233–34, 291
Boussod, Valadon and Company, 24, 286, *286*
boxing, 234–40
 Between Rounds (Eakins), 238, *239*
 Both Members of This Club (Bellows), 234, 236, 240, 242
 Club Night (Bellows), 234–37, *235*, 242
 Stag at Sharkey's (Bellows), 234, 236, *237*, 242
 The White Hope (Bellows's lithograph), 240, *240*
Boy with a Sword (Manet), 20, 142
Branchville (Connecticut), 58–60, 98
 The Laundry, Branchville (Weir), 60, *60*, 289
Brandt, Lilian, 301
Braque, Georges, 127
Breakfast, The (Paxton), 247, *249*
Breakfast Room, The (Tarbell), 247–49, *248*
Breck, John Leslie, 22, 25, 96, 98
 biography of, 347–48
 Grey Day on the Charles, 79–81, *80*
Breezy Day, A (Curran), 289, *289*
Bricher, Alfred T.
 Baby Is King (Beach Scene), 106, *106*
 In My Neighbor's Garden, 106
 Morning at Grand Manan, 99, *99*
Bridge: Nocturne, The (Nocturne: Queensboro Bridge) (Weir), 165–68, *167*
Bridgehampton (Long Island, New York), 105
bridges, 54
 The Bridge: Nocturne (Nocturne: Queensboro Bridge) (Weir), 165–68, *167*
 Bridge at Ipswich (Wendel), 67, *68*
 Drawbridge—Long Branch Rail Road, near Mianus (Robinson), 72, *73*
 Fireworks over the Ryōgoku Bridge, Famous Views of Edo (Hiroshige's woodblock print), 75, *75*
 The Red Bridge (Weir), 82, *83*, 165
 Roundhouse at High Bridge (Luks), 168, *169*
 Spring Night, Harlem River (Lawson), 165–68, *166*, 173

PHOTOGRAPH CREDITS

Photographs are supplied by the owners of the works and are reproduced by permission of the owners, except as indicated in the following additional credits.

Courtesy Amherst College Library, Special Collections Department, George Bellows Papers, Massachusetts: p. 347, col. 1

Courtesy Amon Carter Museum, Fort Worth: figs. 39, 132, 143, 154, 188, 190, 191, 208, 209, 211, 212, 244, 247, 255, 268, 277–79, 282, 287, 288, 299, 300, 306, 309, 312, 319

Courtesy Archives of American Art, Smithsonian Institution, Washington, D.C.: p. 346, p. 355, col. 2

Courtesy Berry-Hill Galleries, New York: p. 348, col. 2

Scott Bowron: fig. 283

Ken Burris: fig. 290

Cathy Carver: fig. 266

Geoffrey Clements: fig. 271

Tom Haartsen: fig. 218

Courtesy Janet Le Clair, Estate of Robert Henri: p. 351, col. 3

Jay McNelly: fig. 221

Courtesy Willard Metcalf Catalogue Raisonné project: p. 353, col. 4

Courtesy Peabody and Essex Museum, Salem, Massachusetts: p. 347, col. 3

Courtesy Photograph Studio, The Metropolitan Museum of Art, New York: figs. 38, 60, 80, 81, 87, 98, 102, 126, 203, 205, 228, 246, 248, 250, 256, 257, 264, 293, 295, p. 349, col. 4, p. 352, col. 4, p. 354, col. 2, p. 355, col. 4, p. 356, col. 4

Courtesy Photothèque des Musées de la Ville de Paris: fig. 320

Courtesy Provincetown Art Association and Museum, Massachusetts: p. 351, col. 1

Tony Rinaldo: p. 347, col. 4

Courtesy Réunion des Musées Nationaux, Paris: figs. 180, 183, 204, 214, 220

Lee Stalsworth: figs. 106, 155, 219, 276

Courtesy Terra Museum of American Art, Chicago, photographs by Henderson Photography: figs. 18, 36, 142